Primitivism

AND TWENTIETH-CENTURY ART

A Documentary History

EDITED BY

JACK FLAM WITH MIRIAM DEUTCH

UNIVERSITY OF CALIFORNIA PRESS

Berkeley Los Angeles London

*The publisher gratefully acknowledges the contribution toward the publication
of this book provided by the Art Endowment Fund of the University of California
Press Associates, which is supported by a major gift from the Ahmanson Foundation.*

University of California Press
Berkeley and Los Angeles, California

University of California Press, Ltd.
London, England

© 2003. Preface and Introduction © Jack Flam.
Editorial apparatus © Jack Flam and Miriam Deutch.
Translation of Carl Einstein's *Negerplastik* © Joachim Neugroschel.

Library of Congress Cataloging-in-Publication Data

Primitivism and twentieth-century art : a documentary history /
edited by Jack Flam with Miriam Deutch.
 p. cm. — (The documents of twentieth-century art)
 Includes bibliographical references and index.
 ISBN 0-520-21278-9 (cloth : alk. paper) — ISBN 0-520-21503-6 (pbk. : alk. paper)
 1. Primitivism and art—History—20th century. 2. Art, Primitive. I. Title: Primitivism
and 20th-century art. II. Flam, Jack D. III. Deutch, Miriam, 1952– IV. Series.

 N72.P68 P75 2003
 709'.04—dc21
 2002029144

Manufactured in the United States of America
12 11 10 09 08 07 06 05 04 03
10 9 8 7 6 5 4 3 2 1

The paper used in this publication meets the minimum requirements of
ANSI/NISO Z39.48–1992 (R 1997) (*Permanence of Paper*). ∞

CONTENTS

ILLUSTRATIONS

PREFACE

This book brings together for the first time texts pertaining to the encounter between Western artists and writers and what has historically, and problematically, been called Primitive art (the traditional, indigenous arts of Africa, Oceania, and North America).

The anthology begins with the "discovery" of that art by European artists and writers at the beginning of the twentieth century. It then documents the evolving pictorial responses, artistic aspirations, aesthetic theories, and cultural debates that have developed around this encounter, culminating in the radical reappraisal that has taken place in recent years, when previous attitudes toward both the art and the historical and cultural implications of the encounter with it have been called into question.

This history is part of a somewhat longer one that has to do with the idea of Primitivism as a force in regenerating modern Western culture. Primitivism does not designate a specific movement or group of artists, but rather a pervasive notion that has played a crucial role in the development of twentieth-century art and in modern thinking generally. In its various manifestations, Primitivism has underlain both the practice and theory of advanced art, and it has also played an important role in critical writing about that art. When we speak of Primitivism, we refer not only to artists' use of formal ideas from the works of so-called Primitive cultures, but also to a complex network of attitudes about the processes, meanings, and functions of art, and about culture itself. The texts have been chosen to show the wide range of issues that the encounter with Primitive arts and cultures provoked. And since this encounter took place at the height of Western colonialism, a number of racial and political issues also come to the fore, either overtly or implicitly, in writings about both the art and the people who produced it.

This situation has created a persistent problem with regard to the terminology used to denote the art in question. For several decades, it was called Primitive art. (The Museum of Primitive Art proudly bore that name until it was absorbed in 1969 by the Metropolitan Museum of Art. The Metropolitan then founded a Department of Primitive Art that retained the name until 1991, when it was changed to the Department of the Arts of Africa, Oceania, and the Americas.) But during the 1970s there was an increasing feeling that "Primitive" implied deficiency or lack and was inherently critical—even insulting—to the peoples who created the art. For a while, during the 1970s, *Tribal art* came to be the preferred term, but that term, too, was problematic, since many of the

emerging nations in the areas involved were building their idea of statehood in direct opposition to notions of tribality. And besides, tribalism was itself an inaccurate and condescending term, associated with cultural and historical dispossession. Nowadays, American universities and museums tend to use the umbrella description of the geographical locations, for it has proved difficult to find a single, concise term that is generally acceptable.

Miriam Deutch and I acknowledge this, but for historical purposes we retain the words *Primitivism* and *Primitive art* (the latter capitalized, as in Romanesque, Gothic, or Renaissance art). The first is a cultural concept that clearly says what it means; the second is a historical designation which, although burdened by all sorts of negative connotations, is useful for its brevity and conciseness. (It is understood, of course, that we do not feel that either the art in question or the peoples who produced it should be considered "primitive" in the sense of crude, unformed, etc.) The difficulty of finding the right term is well reflected in the terminology that has become current in France during the past few years. There the art in question is now referred to as *Arts Premiers* ("Primal Arts"), or as *Arts Primordiaux* ("Primordial Arts")—both of which seem to be misnomers that unfortunately revive the idea that such art is part of the "childhood" of humankind.

The texts in this book have been chosen with a number of (sometimes conflicting) criteria in mind: their inherent interest, their historical importance, and the importance of their authors within the discourse on the subject. Because the ways in which Westerners perceived supposedly primitive peoples affected the ways in which they perceived their art, we have included a number of texts that deal with Primitive art per se. The texts in this book are thus of three rather different kinds. The first deals with the relationships between Primitive art and modern European and American art. The second deals with the nature of Primitive art and the peoples who created it. The third discusses the cultural interactions between "primitive" peoples and the West.

The texts are arranged chronologically so as to give an idea of how thinking about the subject developed. In a few cases, however, where the accounts of events were published after they occurred, we felt that they would best be placed in the context of the events recounted rather than of their publication dates; such instances are clearly indicated. The source for each text is given in a note at the bottom of the page on which it begins, and each note also includes some brief introductory remarks about the text. Excerpts are marked as such; all other texts are given in full. (Since we were not able to include all the illustrations that accompanied the original texts, occasional references are made to objects which are not illustrated in this book.) Most of the translations have been done specially for this book, but in cases where good English translations existed we have reprinted them; in such cases, the source of the translation will be clear from the initial footnote.

Most of these texts have never been translated or reprinted before, and some, such as the essays about the 1913–14 exhibitions of Picasso's Cubist paintings along with African sculpture, had been almost completely forgotten. Because this is the first time that such a collection has been put together, and because the texts speak to each other in interesting and provocative ways, we believe that this anthology will give a unique overview of its subject and allow fresh ways of seeing it. Moreover, because many of the texts refer to broad cultural and political issues, especially with regard to geopolitics and race, this book should be of interest far beyond the bounds of art and art history.

The development of interest in Primitive art coincided with interest in prehistoric art and various kinds of archaic art. Serious illustrated articles on paleolithic cave painting began to appear at the turn of the century, just before European artists became interested in Primitive art, and the first book on Archaic Greek sculpture appeared in 1915, the same year that Carl Einstein's *Negerplastik* was published. In order to delimit what was already a vast literature, we have given little attention to writings on paleolithic art (although the early development of that field of study is outlined in the Chronology). Prehistoric art did not pose the same challenges and problems as did living "primitive" cultures. What separated Primitive art from all other forms of archaic, nonnaturalistic arts was that it was produced by peoples whose cultures were still alive and vital and who were seen as throwbacks to some sort of primordial state, the "childhood of man," as it was often phrased at the time.

Another distinguishing characteristic of this art—unlike paleolithic art, Archaic Greek art, or Romanesque art—was that it was produced by non-European peoples. Moreover, during an extended period of economic exploitation, religious conversion, and cultural domination, those peoples had been considered generally inferior. Thus, right from the beginning, consideration of their art was inextricable from certain racial and cultural prejudices. Because of this, in addition to texts about the relationship between modern art and Primitive art, we have included texts that are primarily about Primitive art and culture. But at the same time, in order to keep the length of the book manageable, we have largely omitted texts from the more specialized anthropological literature that do not directly consider art, as well as texts such as Raymond Firth's excellent essay "The Social Framework of Primitive Art" (1951), which does have some very interesting things to say about Primitive art but within a more specialized anthropological context.

In the early part of the book we include a number of brief texts by artists about their early reactions to Primitive art and some other texts that are interesting primarily because of their early date. After the First World War, writing about the subject increased enormously, and a number of new issues arose. Between the wars, particular emphasis was given to questions of art and culture generally, and a number of the themes that occur in later writings appear for the

first time. Because of the seminal nature of the writing during this period, we have given it a fair amount of space. We have tried to include the complete texts of the essays we have chosen; when that was not possible, we have given substantial excerpts. In contrast, the reader will notice that there are relatively few texts from the 1950s and 1960s. Although a fair amount was published about the subject at that time, much of it tended to recapitulate—though often with great intelligence and eloquence—elements of the narrative of discovery that readers of this anthology will already be rather familiar with by the time they reach that part of the book.

To avoid making the book impossibly long, we regretfully decided to omit certain texts that were associated with important historical events but that in themselves were either not especially interesting or that repeated notions which had been better articulated in earlier texts. These included, among others, Stewart Culin's introduction to the catalogue for the Brooklyn Museum's *Primitive Negro Art, Chiefly from the Belgian Congo,* the first exhibition of African sculpture in an American art museum; and the catalogue essay for the important 1930 exhibition at the Galerie Pigalle in Paris. It was also with regret that we decided to omit Douglas Fraser's 1957 essay, "The Discovery of Primitive Art," and Robert Goldwater's equally interesting "Judgements of Primitive Art, 1905–1965." Despite their excellence, both basically recount events that have by now become familiar and they did not seem to add much to the conceptual framework of this book; and both have already been reprinted elsewhere.

A similar problem was encountered when we confronted historically important books, such as Jean Laude's *La Peinture française et l'art nègre (1905–1914),* a detailed and complex work that helped to define certain aspects of the field. Although it is impossible to do such a book justice in excerpts, we nonetheless felt that it should be represented, and we have reprinted sections that we believe give some sense of its general thrust.

Another problematic area had to do with recent texts. As we began to do our final editing, it occurred to us that most of the recent books were still in print or easily available, and given the choice between including excerpts from them—however interesting—or including some of the more inaccessible earlier material, we opted with only two exceptions for the earlier material. Some recent responses to various aspects of Primitive art will be found in the Coda section of the book, which we have included as a kind of anthology-within-the-anthology consisting of disparate, rather pithy comments about the subject by a wide variety of artists and writers.

During the time we worked on this book, we incurred debts of gratitude to a number of people and institutions whom we would like to thank. In particular, acquiring the hundreds of documents for this book required great effort from many people. The staff at the Brooklyn College Library was enormously help-

ful, and we extend our special thanks to Sherry Warman, Theresa Ferrara, Carol McLoughlin, and Robert Litwin. We greatly appreciate the assistance we received from the staff at the Robert Goldwater Library of the Metropolitan Museum of Art, especially Ross Day and Barbara Mathé, and from Virginia Webb at the Metropolitan Museum. Our thanks also to the Library staff at The Museum of Modern Art, to Janet Stanley at the Museum for African Art, and to Alexandra de Luise at the Queens College Art Library. The Bibliothèque Nationale de France, Staatsbibliothek zu Berlin, Städtische Bibliotheken Dresden, and National Library of the Czech Republic (Národní knihovna České republiky), all excellent resources, were most helpful.

The translation of numerous texts was made possible through a grant to Miriam Deutch from the Research Foundation of the Professional Staff Congress of the City University of New York. We wish to express our thanks to Philip Beitchman for his work on the French translations; to Joachim Neugroschel for his translation of Carl Einstein's *Negerplastik;* to Ulrike Dorda for her translations of the other German texts; to Thomas Barran for translations from the Russian; and to Eva Heyd for translations from Czech. Our thanks also to Roberta Engleman for her thoughtful and thorough index. We are also grateful for assistance from Rhea Anastas, Christa Clarke, George Corbin, John Field, Emma K. Himeno, and Helen Shannon; and we want to give special thanks to Sally Bowdoin, Poly Colovos, Martha Corpus, Tony Cucchiara, Anne McDonnell, Denyse Montegut, and Joel Singer for their help.

Finally, we want to thank our editors at the University of California Press for their help in bringing this project to fruition. While the book was being conceived and given form we benefited from the excellent judgment and great patience of Charlene Woodcock, then managing editor of the Documents of Twentieth-Century Art series. For the final editing and production of the book, we benefited from the broad knowledge and dedicated participation of Tony Hicks and Rose Vekony, who helped to improve this volume in countless ways.

INTRODUCTION

One day the poet Charles Baudelaire visited a naval officer who had recently come back from the South Seas with a number of strange objects. While Baudelaire was examining a small carving, the naval officer, eager to draw his attention to something else, referred to the object in Baudelaire's hands as "merely a Negro totem." Instead of putting down the carving and turning to what the officer wanted to show him, the poet raised his hand and said: "Take care, my friend, it is perhaps the true God." [1]

Primitivism and the awareness of Primitive art have played a crucial role in the history and development of twentieth-century European and American art, in a number of different ways. The dynamics of how this happened are complex and varied. As can be seen in the texts that are reprinted in this book, it is a history that has been addressed by many different voices and that contains within it many different narratives, each of which has a special kind of claim on our attention.

In recent years especially, the subject has become ideologically charged; so much so, that it was only after a certain amount of hesitation that we decided to use the terms "Primitivism" and "Primitive art" in this book. As stated in the preface, we do so because the term was in common use during much of the history covered in this book, and because it also seems best to identify the subject in a concise way. But we are also aware that our use of these words is bound to upset some people. The history evoked in this book is a living one with many unresolved strands, and it still arouses strong feelings.

If the terms "Primitivism" and "Primitive art" are now so charged that the use of the words themselves has become problematic, that is in no small measure because the consideration of Primitive art and of so-called primitive peoples has been tainted by a considerable amount of racism, and because it has been linked to a number of cultural issues that may be only indirectly related to the art but have had an enormous impact on how that art has been studied and written about. These issues include the history and ongoing discourse about colonialism, the economic disparities between what came to be known as the Developed and Third Worlds, and the stresses and strains created by the increasingly hybrid nature of modern culture. Hence, although the texts included in this anthology focus largely on the plastic arts, there are unmistakably strong undercurrents of all these other discourses. One of the most interesting aspects of the texts in this book has to do with the way they show how these discourses themselves were in constant flux throughout the twentieth century.

One way to tell this story, which is the way it was first told in Europe, is that

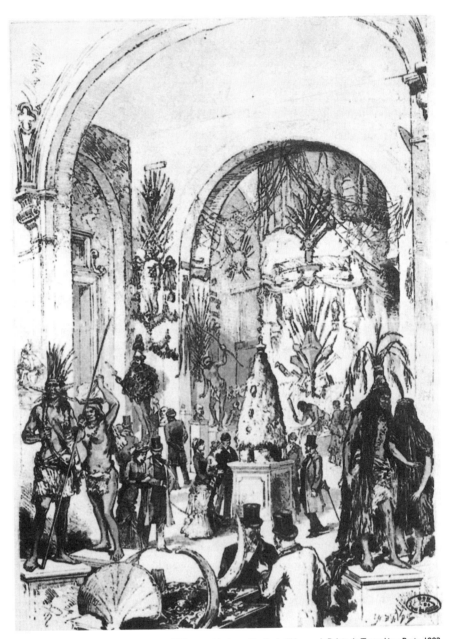

Figure 1. Entrance hall of the new Musée d'Ethnographie (now Musée de l'Homme), Palais du Trocadéro, Paris, 1882. Engraving after a drawing by de Haenon. From *Le Monde illustré* (May 16, 1882). Bibliothèque Nationale, Paris.

sometime around 1906 a number of young artists—mostly French, but also some German—began for the first time to look seriously at sculptural objects that had been made in Africa, in the South Seas, and in the Americas. Up until then, such objects had not been considered art, but were treated rather as curiosities—like the "Negro totem" that the sea captain showed to Baudelaire. These artists saw in Primitive art a unique kind of pictorial inventiveness and imagination, which was especially suggestive and meaningful in relation to their own ambitions. They expressed great enthusiasm and admiration for the objects they saw, they collected and studied them, and the objects had a marked influence on their own art.

For many years, this part of the story was dominated by Maurice Vlaminck, who by his own account "discovered" African art in a bistro near Paris sometime in 1904 or 1905, depending on which of Vlaminck's versions one reads.[2] For a long time Vlaminck's accounts were taken at face value, and when his reputation as an artist began to decline his supposed "discovery" of Primitive art remained one of his main claims to fame. It is now clear, however, that Vlaminck's first purchase of African sculpture actually took place in 1906—the same year that Derain, Matisse, and Picasso first began to look carefully at African art.[3]

The earliest European interest in Primitive art was strongly related to a drastic shift in conceptions of representation and of form at a time when advanced artists were moving away from the Renaissance tradition of verisimilitude and naturalism. The Post-Impressionists, especially Cézanne, had played an important role in opening the eyes of the younger artists to the possibilities of non-mimetic representation and of using "distortions" from naturalistic norms for expressive ends. In doing so, the younger artists saw themselves as being very modern, and also as making contact with ancient traditions—such as Egyptian, archaic Greek, and medieval European art—that had not only eschewed naturalism but seemed to be involved with deeper, more spiritually compelling kinds of expression. When Primitive art was first discovered by modern artists, it seemed to contain a freer sense of plastic inventiveness and a greater emphasis on pictorial structure than any other art forms they knew, and it also seemed to evoke a deeper and more universal sense of humanity.

Primitive art was different from all the other exotic arts that these artists were familiar with—such as Chinese, Japanese, Indian, and Islamic—in a number of significant ways. Unlike those other arts, Primitive art had no known historical development and seemed to exist in a kind of temporal vacuum. The idea that the origins of Primitive art, like those of prehistoric art, were lost in the mists of time allowed for a fair amount of romantic speculation and rumination about it, even though a number of writers tried to place it in some kind of historical context. For example, although Guillaume Apollinaire (1917) acknowledged that it was difficult to date African sculptures, he believed that they unquestionably were related to Egyptian art, from which he felt they probably derived—

though he allowed for the possibility that it was the African works that influenced the Egyptians. A few years later, in a postscript to "Negro Art" (1920), André Salmon asserted that African art definitely influenced Egyptian art: "Negro art preceded all the other arts." This historical issue remained an open one throughout most of the century. As Georges Salles pointed out in 1927, Primitive art had not been able to "find shelter in the field of archaeology," as had Asian art, because of its relative perishability and because of the climactic and social circumstances in which it was created. For much of the century, the idea persisted that African art continued prototypes that had remained unchanged since time immemorial. Only in the 1990s did this notion begin to be widely challenged, allowing for the possibility that it had changed and developed over time—that it too had a "history."[4]

Because Primitive art was held to have had no history, it appeared to confirm widely held beliefs about the immutability and universality of great art. Visibly, Primitive art offered an alternative to the naturalistic representation of the world and suggested new and imaginative ways of conceiving and organizing forms in accordance with abstract ideas. The European artists saw African and Oceanic art in a particular way. From it, they understood something new about form, which was initially their primary concern; but they also learned something new about expression and subject matter. For unlike Asian or Islamic art, which often depicted complex, narrative subjects and had a history and development that could be traced and analyzed, the history of Primitive art was unknown and its main subject appeared to be simple and direct. Most of the works of Primitive art that were collected and reproduced in early publications represent single figures, symmetrically composed, with emphasis on the plastic rather than on the anatomical organization and structure of the figure. The figures are usually represented as being outside of ordinary activities and outside of ordinary time and space.

The early reactions to Primitive art were quite varied. Matisse's account of his discovery of African art, in which he refers to how African sculptures showed him a new way of conceiving the "planes and proportions" of the human figure, typifies what might be characterized as an analytic-constructive approach. But African art was also understood to involve other, less clearly visible ideas about the very nature and function of art. This is evident in Vlaminck's and Derain's initial responses to it, which emphasized its romantic exoticness, and is especially vivid in Picasso's reaction to the African works he saw at the Trocadéro ethnographic museum in the early months of 1907. Though Picasso may have gone to the museum in search of solutions to formal problems, while he was there he realized something about African sculpture that he had not been aware of when looking at it a few months earlier with Matisse. At the Trocadéro, he became intensely aware of the magical or power-inducing possibilities of African sculpture. And equally important, he also seems to have understood that African

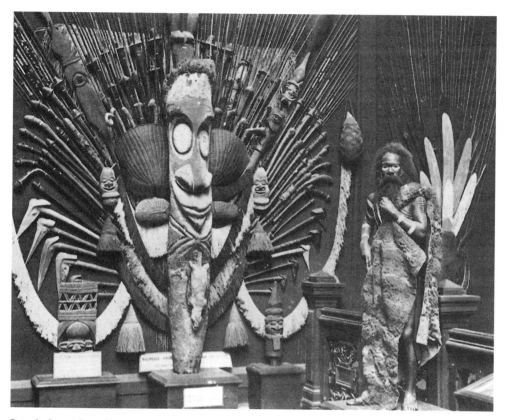

Figure 2. Oceanic Room, Musée d'Ethnographie (now Musée de l'Homme), Palais du Trocadéro, Paris, 1895.

art was meant to be *used* rather than merely looked at; used by its creator as well as by its audience, so that the process of making a work of art could be conceived as an integral part of its function—as with an African "fetish," or power object.

These initial responses to African art can be taken as fairly indicative of the ways in which Primitive art would be used by Western artists throughout much of the century: both as a visible influence on the way modern art looked and as a kind of invisible presence that affected the aspirations and functions of art—as a model for both forms and practices. The variety of the early reactions to Primitive art also anticipates the broad variety of responses that would develop over the course of the century, which is evident in the texts that are brought together in this book. Different issues come to the fore, contradictory ideas are sometimes held by the same people, and the nature of the discourse keeps changing in relation to contemporary events.

In the early literature, African and Oceanic art were grouped together (in French under the term *l'art nègre,* roughly translatable as "Negro art") as if they were part of a single entity, even though they are of course quite different and were

produced by very different peoples. In part, this was because both African and Oceanic art differed from European norms in similar ways, and because both were produced by nonliterate peoples, thereby posing similar sorts of historiographic problems. But there was no doubt also a racial bias involved in this blending together, which had to do with classifying the art of various dark-skinned peoples under a single category.

It is no coincidence that some of the first studies of the art of primitive peoples had an evolutionary bias and were done by men such as Alfred Haddon, the nineteenth-century British biologist, who considered naturalistic representation as the pinnacle of artistic achievement. This attitude, which implicitly privileged the European Renaissance tradition and the naturalism characteristic of nineteenth-century academic art, provided the normative frame through which other kinds of art were seen. Such aesthetic biases had obvious cultural implications and affected the way in which Primitive art was seen (or not seen) at the time. Even after they were discovered to be "art" by Western artists, the objects created by the dark-skinned peoples of the tropical colonies were treated with the same condescension as were their makers, and they were generally thought unworthy of being included within the hallowed walls of the institutions dedicated to high art. Such attitudes persisted well after the qualities of Primitive art were hailed by Europeans, as can be seen in the long-running argument among French writers about whether Primitive art should be allowed into the Louvre—an argument which persisted until the very last year of the twentieth century. (Apollinaire, one of the first writers to voice aesthetic appreciation of Primitive art, was in 1909 the first to encourage its being exhibited in the Louvre; the art itself did not make it there until the year 2000.)

In fact, only a few years before they discovered Primitive art, Western artists had been almost totally blind to it. Neither Matisse nor Picasso, for example, seems to have remarked on any of the African objects at the 1900 Exposition Universelle in Paris, even though a number of the French African colonies were elaborately represented there. The consideration of African objects as "art" had to be accompanied by a change in thinking about Africa itself, which would allow for a taxonomic shift about the objects produced there. In 1906 the massive European colonization of Africa had been going on for only about 25 years and was still in its first phase, which consisted of (often brutally) effacing local cultures and replacing them with European administrative structures. The objects that came back from the newly acquired colonies at the turn of the century were still seen as trophies or curiosities—evidence of the "savage" or childlike aspects of the people who made them.

The tropical colonies were conceived of in two different ways, both of which suited the colonial ambitions of the European powers, as can be vividly seen in relation to Africa. On the one hand, there was the romanticized view that Africans embodied a surviving instance of the noble savage, a precivilized state

of humanity that worshipped nature gods and whose naturalness and authenticity was set in contrast to the decadent West. On the other hand, Africa was thought of as the Dark Continent, a place of human sacrifice, witchcraft, and mysterious, primeval spirits. Africa was at once both attractive and repellent, grotesque and beautiful, and this duality was also extended to African art.[5]

This is reflected in the writings even of liberal-minded authors who were in some way involved with the avant-garde. In the selection from "Wild Men of Paris" (1910), for example, Gelett Burgess associates a new aesthetic of "ugliness" with Primitivism in general and with the growing popularity of African art in particular. A couple of years later, Elie Faure, who was the first writer to include Primitive art in a general history of art (1912), asserted that the people of Africa, even "in the heart of modern times, have preserved practically intact the spirit of their most distant ancestors." Although Faure was enthusiastic about the art, he was deeply skeptical about the people who made it, whom he characterized in distinctly condescending, racist terms.

An even more extreme instance of a divided attitude toward the art and its creators is found in Marius de Zayas's *African Negro Art: Its Influence on Modern Art* (1916). De Zayas noted that "Negro art has re-awakened in us the feeling for abstract form, it has brought into our art the means to express our purely sensorial feelings in regard to form, or to find new form in our ideas." But at the same time, he subscribed to the worst kinds of racist clichés. He believed that Africans remained "in a mental state very similar to that of the children of the white race," and to back up his ideas he even cited a number of pseudo-scientific statements about the supposed cerebral formation of Africans. Moreover, despite his passion for modern art, De Zayas constructed an evolutionary version of artistic development that is surprisingly traditional, in that it "follows an uninterrupted chain, beginning with the geometrical construction of the Negro art and ending in the naturalistic art of the European." De Zayas's discussion of the extreme intelligence of African children and their later "turning stupid" around the age of puberty is especially interesting. He attributes this to "a rapid declension" of mental abilities rather than to the extremely disadvantageous social situation in which colonized Africans found themselves when they reached adolescence. De Zayas's argument on this point resembles similar discussions around the same time of women's supposed biologically limited mental powers. Even the influential critic Roger Fry, writing in 1920, found problematical the relationship between the supposed inferiority of African culture and the superiority of African art. Although Fry had great respect and admiration for African sculpture, he nonetheless was able to attribute the African artist's "exquisite taste in his handling of material" to "his endless leisure," and in conclusion found it "curious that a people who produced such great artists did not produce also a culture in our sense of the word."

One of the few early writers to confront the issue of racism head-on was the

German writer Carl Einstein, whose *Negerplastik* (1915) was the first published book-length study of African art. Virtually alone among the early writers on African art, Einstein called into question a number of the racist assumptions about Africans. He also developed what amounted to a theory of sculptural form in relation to African sculpture, based on its extraordinarily disembodied and spiritualized quality, in which form occupies space but appears to be free of the gross substance of mass. This characteristic, which Einstein referred to as a "cubic" conception, was later sometimes confounded with "cubistic" form—a term which for decades was mistakenly applied to African sculpture. Einstein's discussion of sculptural theory reminds us that while Primitive art comprised mainly sculpture, the artists interested in it were mostly painters, at a time when painting held a dominant position among the visual arts. At first, those artists were intent on translating their new discoveries into pictorial terms. But later, Primitive art would play an important role in the redefinition of artistic categories and in the ascendancy of sculpture in relation to painting.

Because Primitive art is so closely allied with the idea of Otherness, it has served as a lightning rod for attitudes not only toward race but also toward the relations between different cultures. In many ways it was (and remains) like a reversible mirror that alternately could show either what was felt to be desirable or what was lacking in the self-image of the societies that regarded it.

Underlying these discourses is the incontrovertible fact that the exchange between the West and the so-called Primitive cultures was basically a dialogue between "white people" and "people of color," and that virtually all such exchanges over the course of the nineteenth and twentieth centuries were based on unequal political, economic, and technological power—with missionary and anthropological approaches to native peoples implicitly used to justify military and political conquest. In the early years of the twentieth century, blatantly racist pronouncements were made with complete lack of self-consciousness, as can be seen in many of the texts below. At that time the unequal relationship between Europe and its colonies was taken for granted and became part of an oddly self-reinforcing syndrome of thought. If certain people were supposed to be inferior, it was perfectly acceptable to rule and exploit them; and since they were ruled and exploited, the reasoning went, they were obviously inferior. This kind of circular reasoning has had a long history—which goes far beyond issues of race to the relationships between social classes and the sexes. In all of these domains, issues of authority and supposed moral superiority often come to the fore. The long European tradition of belief in Providence, for example, led to the possibility of interpreting all sorts of events as somehow reinforcing some God-given notion of the social order, and to justify economic exploitation and imposed social inequality.[6] This was reflected in the vast missionary enterprises conducted by various Christian denominations throughout the parts of the

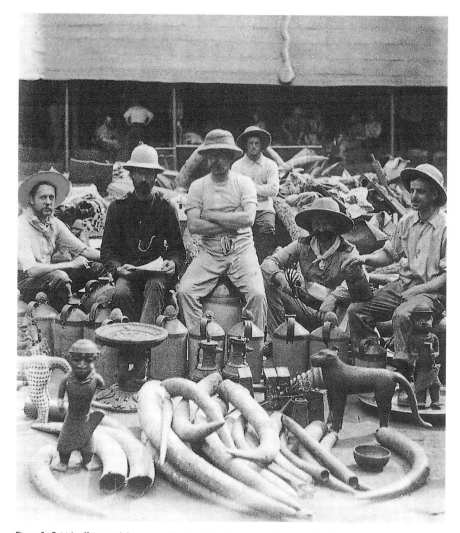

Figure 3. British officers with bronzes and ivories taken from the royal compound during a punitive expedition, Benin City, 1897. © The British Museum.

world that were populated by "primitive peoples." The grotesque consequences that could result from the practice of exchanging knowledge of God for raw materials can be attested by the grim history of the Belgian Congo and the later Congo Free State, which involved one of the most shameless exploitations of human and natural resources during the Colonial period.

Yet relations such as those between the colonizer and the colonized, the exploiter and the exploited, are more complicated than they at first seem. For they are paralleled by another phenomenon: the desire of the privileged party to in some way imitate or return to what was perceived as the "purer" or more "natural" state of the exploited. Thus condescension is often undermined by envy,

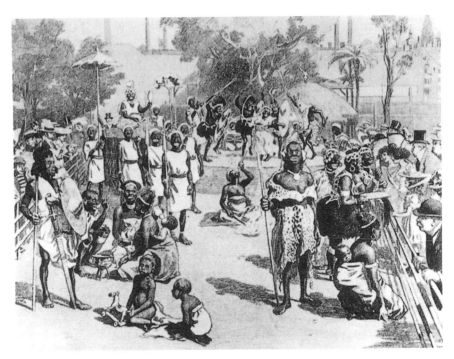

Figure 4. "The Blacks Visiting the Whites," from *Fliegende Blätter* (1905).

Figure 5. "The Whites Visiting the Blacks," from *Fliegende Blätter* (1905).

and envy in turn intensifies the need for condescension. "Primitivism," as Michael Bell has written, "is born of the interplay of the civilized self and the desire to reject or transform it. . . . Primitivism, we might say, is the projection by the civilized sensibility of an inverted image of the self. Its characteristic focus is the gap or tension that subsists between these two selves and its most characteristic resultant is impasse." [7]

Out of this kind of impasse, a good deal of significant art was produced; in fact, a good deal of twentieth-century art may even be characterized as an art marked by impasse: by a complex network of deadlocked struggles—between localism and universalism, between high and low culture, between abstraction and figuration, and between notions of purity in the use of individual mediums and the desire to cross boundaries and insist upon "impurity." It is important to remember that although modernism is now often thought of as a somewhat monolithic undertaking, the early modernists were quite diverse in their aims and in the kinds of art they actually produced, ranging as it did from enterprises as diverse as those of Picasso and Brancusi, to those of Matisse and Duchamp.

Much is sometimes made of the ways in which the modernist artists appropriated Primitive art, which are compared to the way the colonial powers appropriated raw materials. But one must be wary of reading the situation in such a reductive way. Appropriation is a basic dynamic of all artistic exchange; artists constantly borrow from other artists, whether within their own culture or from others. Moreover, the Western artists who appropriated forms from Primitive art did not inflict harm on the people who made the art, and in fact helped to encourage recognition and appreciation of their humanity and culture. That the modern artists' response was based on deep respect and admiration for Primitive art is apparent in their writings as well as in their works. So although they were engaged with Primitive art at the same time that the European governments were exploiting the colonies that produced the art, one must be cautious about drawing direct parallels. One might even say that the cultural interaction produced by Western artists' enthusiasm for Primitive art was one of the few aspects of the colonial encounter that had saving grace.

Although what we have called invisible factors had played an important role in the first phase of the encounter between Primitive art and the West, after World War I they would play an even greater role. The traumas of the war called forth a good deal of social questioning, as can be seen in the essay by the German critic Hermann Bahr (1916), who after witnessing the horrors of the war drew a parallel between the way "primitive man, driven by fear of nature, sought refuge within himself," and the necessity for Europeans to "adopt flight from a 'civilisation' which is out to devour our souls." In reaction to the senseless bloodshed, the Dadaists embraced ideas of Negritude and used primitivist modalities to challenge what they felt to be the tragic shortcomings of European civilization.

In their evenings at the Cabaret Voltaire (founded in Zurich early in 1916), they invented theatrical events that were often based on general notions about African rituals and language. Tristan Tzara, whose eloquent "Note 6 on African Art" (1917) is included here, used pseudo-African words in his 1916 play *La Première Aventure céleste de M. Antipyrine*.[8] During the "African Nights" at the Cabaret Voltaire, Richard Huelsenbeck chanted "authentic" Negro poems. According to Hans Richter, "Huelsenbeck was obsessed with Negro rhythms. . . . His preference was for the big tomtom which he used to accompany his defiantly tarred-and-feathered 'Prayers.'" Richter has further described how the spiritual force of Primitive art was embodied in the abstract African-style masks of Marcel Janco, "which carried the audience from the primeval language of the new poems into the primeval forests of the artistic imagination."[9]

After the war was over, Primitive art began to be gradually accepted into the larger canon of world art, though it was still largely confined to ethnographic museums. As the relationships between the European nations and their colonies changed, a good deal of effort was given to reevaluating the native cultures of the colonies and their connections to the West. In the meantime, many aspects of the formal vocabulary of Primitive art had been absorbed into modernist art, and many avant-garde artists came to see it as old hat. This is reflected in Jean Cocteau's acerbic statement in the 1920 survey conducted by *Action*: "The Negro crisis has become as boring as Mallarméan Japonisme."

The literature after World War I clearly reflects the changing attitudes of the European powers toward their colonies. This was especially evident in France, where the war had brought a marked change in attitude because of the courage the African troops had displayed during the war.[10] After the war an increased emphasis was also given to the economic importance of the colonies, and a greater attempt was made to see not only the colonial enterprise but also the colonized populations in a more positive light. At the 1922 Exposition Coloniale de Marseille, although pride of place was given to the colonies in Indochina, a substantial exhibition was also devoted to French West Africa.

The rising popularity of Primitive art served to stimulate the dialogue about it. In the fall of 1920, when Félix Fénéon conducted a survey about whether Primitive art should be admitted into the Louvre, the question drew mixed responses. While some, such as the painter Lucie Cousturier, thought that "once the Louvre Museum admits Negro art, it will find not only its complement but its essence," others retained their old prejudices. Salomon Reinach, the curator of the Museum of National Antiquities, responded that such art was "hideous," and that to pretend otherwise would be "an aberration, if not simply a joke." The Louvre's curator of paintings, Jean Guiffrey, concurred that it would be unreasonable to compare the "stammerings" of civilizations that had remained "in their infancy" with "the most perfect creations of human genius."

While reactionaries were repeating their pre-war cliches, Primitive art was

entering new public arenas. In 1921, African art was prominently shown at the Thirteenth International Exposition of Art at Venice (the forerunner of the Venice Biennale), leading the Italian critic Carlo Anti to write that African art had "achieved entrance into one of the most important temples dedicated to contemporary art . . . exhibited on equal terms with the work of the greatest living artists of the world." Anti, who saw this popularity as a falling away from purity and symptom of decline, also made the important and at the time rare observation that "negro-sculpture has been judged from a European and a twentieth-century point-of-view."

The interest in African art was also connected to the more general passion for Negritude that swept Europe at the time. Louis Mitchell's band, with Sidney Bechet, played in Paris from 1917 on; American jazz was incorporated into the Apollinaire-Satie-Cocteau ballet *Parade* that same year; and in August 1918, a soiree at the home of Etienne de Beaumont included Francis Poulenc's *Rhapsodie nègre*. Shortly afterwards, Josephine Baker would make her French debut and become the toast of Paris. Among the figures who emerged as important advocates and dealers, one of the most important was Paul Guillaume, a major dealer in both modern French painting and African art, and one of the greatest promoters of Primitive art. In 1917, Guillaume had published *Sculptures nègres*, the first French book on African art, for which Apollinaire wrote "Concerning the Art of the Blacks." After the war, he gave a new dimension to art promotion by publishing numerous essays and books pertaining to African sculpture and modern art, and he played a substantial role in making "Negro" art fashionable (as recounted in his 1919 article "A New Aesthetic"). With the help of the art collector André Level, he organized the "Première Exposition d'Art Nègre et d'Art Océanien," at the Galerie Devambez in May 1919, which consisted mostly of objects from the French colonies. The catalogue essay for the Devambez exhibition, written by Level and Henri Clouzot, suggests a growing appreciation of African and Oceanic art and claims that Western art evolved from those arts. In 1919 Guillaume also organized the celebrated Fête Nègre at the Théâtre des Champs-Elysées, which featured poetry compiled by Blaise Cendrars from his recently published *Anthologie nègre*, and at which Guillaume himself performed African-style dances. Poetry from Cendrars's *Anthologie nègre* was also used in the Ballets Suédois production of *The Creation of the World* (1923), which was designed by Fernand Léger, using African motifs, and for which Darius Milhaud wrote a score enlivened by jazz rhythms. By the early 1920s, the interest in African art had become strong enough to have provoked a considerable industry in fakes, alluded to by Guillaume in 1919 and Fels in 1923.

The Galerie Davambez exhibition and the Fête Nègre marked a turning point in attitudes toward African art. Whereas before the war it had been of interest mainly to the artistic avant-garde, after 1919 it began to be a fashionable part of French culture—which had the effect of mitigating its identification

with artistic originality and social transgression. In reaction to this the Surrealists, who were much more interested in the invisible forces contained within Primitive art than they were in its formal innovations, expressed a clear preference for Oceanic and American Indian art, which they felt was in deeper communion with the unconscious. Among the Surrealists, African art was criticized as being too "rational" and too "naturalistic." (When the "Surrealist Map of the World" was published in *Variétés* in 1929, the Pacific islands and Alaska were disproportionately large while Africa was represented as a minuscule pendant of the Eurasian land mass.) After the publication of Lucien Lévy-Bruhl's *La Mentalité primitive* in 1922, increased emphasis was placed on the dualism between the material and the spiritual in Primitive societies, and on spiritualism in relation to dream states, which centered around the rapport between humans and spirits. Primitive peoples were supposed to be in constant communication between these two states.

This position is articulated by Christian Zervos (1929) when he speaks about how modern artists share with Oceanic peoples the belief that "the invisible and intangible things that constantly touch their souls are no less real than other things." Although Zervos discusses some of the particularities of Oceanic religious beliefs, he constantly brings his discussion back to contemporary artists, who he believes share with Oceanic artists a "closer rapport with the spirit of things than with their material aspects and so touch on the very essence of art, as well as on what most intimately inspires it."

The Surrealists, who gave greater emphasis to the spiritual qualities of Primitive art, inspired a surge in publications. *Documents,* edited by Georges Bataille, and *Cahiers d'art,* edited by Zervos, devoted many pages to ethnographic information about Primitive art, especially Oceanic art. More anthropologically and psychologically oriented writers sought to understand the relationships between art objects and the religions, philosophies, and social organizations of the cultures that created them. In *L'Art primitif* (1930), G. H. Luquet revived the debate about the relationship between Primitive art and children's art, but now in the context of current anthropological and psychological theories. (An astute review of Luquet's book by Bataille points out the weaknesses in his argument and adds some characteristically trenchant observations on the subject.) In 1930 a major exhibition of African and Oceanic art was mounted at the Galerie Pigalle in Paris, containing nearly 300 African objects and 138 pieces from Oceania selected from among the major French collections of the time. Waldemar George's open letter to Paul Guillaume, one of the many published responses to that exhibition, remains one of the most interesting critiques of the Surrealists' attitudes toward Primitive art.

Unlike earlier artists, who had focused on art that had been brought away from its place of production, the Surrealists were especially interested in Primitive art *in situ,* such as could be known through photographs. As the ethno-

graphic study of primitive cultures intensified, a kind of duality developed in the approach to Primitive art, which increasingly became the province of ethnographers and anthropologists rather than artists and art historians. On the whole, these two groups remained fairly distinct, although in 1933 the second issue of the Surrealist-dominated periodical *Minotaure* devoted an entire issue to the 1931–33 Dakar-Djibouti expedition to the Western Sudan, directed by Marcel Griaule. The materials brought back by Griaule's team—which had collected some 3,500 objects, documented 30 languages and dialects, taken some 6,000 photographs, and made extensive sound recordings—remain a basic research source today.

Primitive art was received differently in Europe and America. Until the 1940s, Americans were themselves considered to be outside the metropolitan center of art production, and Primitive art often came to them filtered through a European sensibility. Americans were at once admiring of European art and trying to distance themselves from it in order to forge an independent artistic identity. In order to do this, American artists and writers frequently turned to American Indian art, finding in it a model that was quintessentially American while being in touch with the same primordial feelings that were associated with Primitive art in general. The case for recognizing the importance of Native Americans within American culture is eloquently made by Edgar Hewett (1916) and in passionate essays by Walter Pach and Marsden Hartley (1920). The importance of American Indian Art within mainstream United States artistic culture was to become especially apparent during the 1940s.

America differed from Europe in another important way, in that it had a large black population which had historically been disenfranchised and legally excluded. As a result, the "African" question was much more directly charged in the United States—as is apparent in the somewhat ambivalent and at times apologetic tone that white writers take in relation to African art. Nor were black writers on the subject unified in how they felt Americans of African descent should respond to the art of black Africa. One of the outstanding voices from the black intellectual community was the philosopher Alain Locke, who was deeply involved with the New Negro Movement. Locke was the first to identify the issues that African art posed for the black community, urging scholars not to dismiss African art as a fad but to study and interpret it in the same manner as other important kinds of art. Locke, who believed that "art is universally organic," called for the elimination of distinctions between European artistic expression and that of other peoples. He also believed that African art would naturally have a unique influence on black artists because "nothing is more galvanizing than the sense of a cultural past." In his 1925 essay "Legacy of the Ancestral Arts," Locke argues that the Negro artist, lacking a mature tradition, might consider the new-found African arts as his real heritage and draw inspira-

tion from them. Locke's views were passionately opposed by the black art historian James A. Porter, who in 1937 accused Locke of supporting the "defeatist philosophy" of the segregationists. (These were especially strong and personal words, since both men were on the faculty of Howard University.)[11] This is an issue which, like many others treated in this book, has remained open-ended and is still argued among artists of color.

In 1935—some thirty years after it was "discovered" by modern artists—African art was shown for the first time at the world's first museum dedicated to modern art. According to Alfred Barr, the Museum of Modern Art's landmark exhibition was conceived as part of "a ten-year program of exhibitions in which the Primitive arts were to be covered. . . . This program was approved because it was evident at that time that museums in this country with ethnographical collections were little interested in the esthetic value of their material and that few museums of art were concerned with the field even in a marginal way."[12] (The museum's African show was followed by ambitious exhibitions of American Indian art in 1941 and of Oceanic art in 1946.)

Although the very existence of the Museum of Modern Art's 1935 "African Negro Art" exhibition implied a strong relationship between African art and modern Western art, the accompanying catalogue, written by James Johnson Sweeney, emphasized the independence and maturity of African art, and also the West's independence from it. Sweeney questioned "whether or not African Negro art has made any fundamental contribution to the general European tradition through the interest shown in it by the artists of the last thirty years," and instead emphasized the importance of Cézanne, who "not only laid the foundation for subsequent developments in European art but also played an important part in opening European eyes to the qualities of African art."

This exhibition traveled to a number of American cities, where it received a good deal of publicity, was widely reviewed, and was seen by many artists. Not surprisingly, the exhibition was often placed within the larger context of black culture in America. The journalist Arthur Millier began his *Los Angeles Times* article about the exhibition with a reference to the boxer Joe Louis (a "gentleman of African lineage" whose ancestors "brought the equally difficult art of wood sculpture to at least an equally high state of development") and remarked that the exhibition could be seen within the context of the Harlem Renaissance and the writings of black authors such as Richard Wright.[13]

In subsequent years, as American art began to come into its own and to assert itself in an international arena, African art was somewhat less important than American Indian art to most American artists, largely because Indian art was more pictorial and thus of greater direct interest to painters. But African art nonetheless remained a powerful force in the growing desire of American artists to create an art that Mark Rothko and Adolph Gottlieb (1943) characterized as mythic, "tragic and timeless."

During the 1940s, the approach to Primitive art by both artists and art historians underwent important changes. Robert Goldwater's *Primitivism in Modern Painting* (1938), the first scholarly book-length study of the subject, greatly influenced the way art historians thought about it. And following World War II, the most innovative thinking about Primitive art shifted to the United States. The 1941 "Indian Art of the United States" exhibition at the Museum of Modern Art played an important role in changing the perception of Native American art among both artists and the general public. Five years later, that same museum's "Arts of the South Seas" exhibition, which reflected both the attention that had been given to Oceanic art by the Surrealists and the increased awareness of the Pacific Basin that had been inculcated by the war in the Pacific, helped focus attention on Oceanic art.

Around the same time, among critics and scholars a good deal of attention was beginning to be given to the historiographical questions raised by the relationship of Primitivism to modern art. For the most part, the subject was studied in terms of the ways in which Western artists had been affected by the formal qualities of Primitive art, and increasing attention was given to questions of specific influences and sources. During this period, the study of Primitive art itself also began to expand. From the late 1930s on, it was dominated by what might be characterized as a scientifically oriented anthropological approach, and studies of the aesthetics of primitive peoples also began to appear. As studies of Primitive arts and primitive societies multiplied, attention also began to be given to the relationship of primitive societies to the industrialized West, and to the effect of Western values on traditional societies, although there was still a tendency to treat Primitive art itself in a rather ahistorical way.[14] This phase of study reached a kind of culmination in the Museum of Modern Art's 1984 exhibition, "'Primitivism' in 20th Century Art: Affinities of the Tribal and the Modern," which marked an important turning point in the study of Primitivism and of the relationships between Primitive art and modern Western art.[15]

Although that exhibition marked a turning point in the study of the subject, it was not in the way that its organizers, William Rubin and Kirk Varnedoe, had anticipated. Certain of the criticisms of the exhibition and its catalogue were not surprising even to people who had contributed to the project, but many were taken aback by the violence with which the criticisms were articulated. Clearly something had changed. Rubin and Varnedoe had conceived their exhibition in one cultural climate and in doing so helped to provoke the overt manifestation of another. It is not simply that the Museum of Modern Art's exhibition misread the times, but rather that in doing so it provoked a number of thoughtful people to articulate feelings about the relationships between various aspects of world culture and between different segments of contemporary Western society that had not quite been given voice within such a context.

I myself had become aware of a similar situation only a few years earlier in a graduate seminar I gave on Primitivism and modern art, in which a number of the issues that were later raised in the criticism of the Museum of Modern Art exhibition came to the fore. But then, as my students and I grappled with those issues, it was difficult to find an adequately defined and sufficiently monolithic entity (or target) in relation to which we could focus our arguments. The literature on the subject was widely dispersed, and the ideological lines had not been clearly enough drawn to provide a sufficient framework for fully crystallizing the main issues. The Museum of Modern Art exhibition provided exactly that sort of focus and that sort of target. And it did so, moreover, from within an institution which, although it had been a pioneer in the exhibition of Primitive art, had for several years been under criticism for a perceived lack of sensitivity toward a number of other cultural issues that were being related to the debate about Primitivism, such as the small numbers of women and people of color in its exhibitions; and for its failure to give adequate attention to various kinds of "alternate" art practices, such as installation art, performance art, and video. The Museum of Modern Art, then considered a bastion of high modernism, had come to be viewed by its adversaries as having some of the same kind of cultural arrogance as the imperial nation-states at the beginning of the century.

In their criticisms of the exhibition and its catalogue, writers such as Thomas McEvilley and James Clifford pointed out—with a certain amount of righteous fury—a number of problems with the curators' approach. McEvilley discounted Rubin's stated aims, suggesting instead that the exhibition was simply an attempt to validate the superiority of classical modernism and reflected no interest in or recognition of Primitive art as "art." Clifford stated that neither the exhibition nor the catalogue succeeded in demonstrating "any essential affinity between tribal and modern . . . but rather the restless desire and power of the modern West to collect the world." Clifford also contended that if modern artists' supposed "discovery" of Primitive art were considered in a properly broad context, it would raise "questions about aesthetic appropriation of non-Western others, issues of race, gender and power." What had started out as a rather traditional art-historical project was soon being judged in terms of contemporary culture wars. This was especially apparent in the heated exchanges between Rubin, Varnedoe, and McEvilley that appeared in the letters column of *Artforum,* which continued well into 1985. Since this debate would in itself comprise a small volume, we have included only those texts that we feel articulate the main points on both sides: a substantial excerpt from Rubin's introduction to the catalogue, the reviews by McEvilley and Clifford, and Varnedoe's more general defense of the museum's position.

The debate precipitated by this exhibition reflected a real change in cultural attitudes, both in the United States and abroad. And as a result of this change, the voices of peoples who for the past eighty years had been considered "mute"

were suddenly being listened to quite carefully. Conceiving of the world in terms of a clear division of "us" and "them" was clearly no longer tenable—indeed, such an approach was now perceived to be part of a racist, imperialist undertaking that conceived the flow of ideas from so-called Primitive artists to modern Western artists as a fairly exact parallel to the flow of raw materials from the colonized peoples of the Third World to the industrialized West. Whatever the merits and shortcomings of the exhibition, or the degree to which it did or did not misread other cultures, it clearly had misread our own culture by accepting as fixed and stable many values and ideas that were actually quite volatile and just then undergoing radical change. One of the things that became apparent in the criticism of the exhibition was that the historian's task had come to be conceived somewhat differently from the way Rubin and Varnedoe had framed it: it was no longer to create as complete an edifice as possible to stand within but to find a new place in which to stand.[16]

The texts in the last part of our book center around this cultural debate and show how attitudes toward Primitive art and Primitive cultures underwent a distinct transformation. The increased self-reflexiveness that resulted from this debate, and the widespread feeling that it was necessary to construct a new view of both Primitivism and Primitive art, indicated that the idea of Primitivism had not been fully historicized but was still very much part of an ongoing cultural debate. Among its consequences, for the first time many artists of color from within our own culture began to take a visible part in the discourse, bringing yet another important voice to it—as can be seen in the Coda.

If the controversy that stormed around the 1984 exhibition and catalogue forced important changes in ways of thinking about Primitivism, it became clear in its aftermath that while it was easy to criticize it was not so easy to improve upon. This became apparent a few years later in the 1989 "Magiciens de la Terre" exhibition in Paris, of which McEvilley's 1990 review gives an excellent critique, not only of the exhibition but of the problems inherent in the very idea of it, from an especially sympathetic viewpoint. In 1991, the equally well-intentioned "Africa Explores" exhibition, which focused on the ways in which African artists had responded to Western art, came up against a number of similar problems.

In any case, the 1984 Primitivism exhibition provoked a flood of publications and exhibitions about the subject and made it the center of focus that it richly deserves to be. Books such as Sally Price's *Primitive Art in Civilized Places* (1989) and Marianna Torgovnick's *Gone Primitive* (1990) carried the discussion to popular culture and modern literature, and in recent years there have been a dozen or so very good books on various aspects of the subject, as will be seen in the bibliography. Whether these issues can ever be resolved remains an open question, especially in a society that has become increasingly multicultural and in

which it is increasingly difficult to define any historical stance as having a particularly privileged position, while at the same time trying to avoid the chaotic mire of extreme relativism. The intensity with which varying positions are taken is evident in virtually all academic disciplines today, and has filtered down into popular culture, advertising, and marketing. Controversies have erupted over whether or not Joseph Conrad's *Heart of Darkness* is to be seen as a work of liberal enlightenment or of the most abominable racism. Gananath Obeyesekere and Marshall Sahlins have joined in battle about how historical truth can be constructed—and the particular standpoint of the historian has become such an important element in the construction of what are taken to be historical truths that it is difficult to see how such opposing positions can even begin to be reconciled.[17]

In this book we have tried to present as many of the main arguments as possible, so as to help further the discourse by providing some of the essential documents on which it is based. Although cultural discourse has become extremely politicized by both the left and the right, it is also clear that over the past twenty years our notion of what constitutes cultural awareness has generally expanded. In defining culture we are dealing not with one story but with many, and more than ever we are constantly aware of the question that James Clifford posed in 1984: "Could the story of this intercultural encounter be told differently?" One of the things that we have come to realize is that of course it can—and must—be told in several different ways. As Sieglinde Lemke points out in the last selection in this book, in cultural terms we can no longer make clear separations between "black" and "white" and Self and Other. These have now become entwined and "mutually constitutive" elements in a "cultural hybridity" that may have been at the very core of early modernist culture and is surely at the core of our own.

One thing we should keep in mind as we read through the texts in this book is that this kind of cultural hybridity was seriously considered and sometimes clearly sought by many of the earlier writers on the subject. Although in recent years modernism has often been constructed as a kind of monolithic entity that is made to resemble colonial imperialism, modernism was in fact itself an extremely hybrid, various, and diverse undertaking. Whatever their faults, it was the early modernists who led the way in opening our eyes to the arts of the then-dispossessed peoples of the world. And this in turn has allowed those peoples, a century later, to speak with a voice that is not only heard but is becoming less and less distinguishable from our own.

NOTES

1. See William M. Ivins, Jr., *Prints and Visual Communication* (Cambridge and London: MIT Press, 1953), p. 147.

2. Vlaminck's accounts are given in *Tournant dangereux: Souvenirs de ma vie* (Paris, 1929), pp. 88–89; and *Portraits avant décès* (Paris, 1943), pp. 105–7 (translated below).

3. See Jean-Louis Paudrat, "From Africa," in William Rubin, ed., *"Primitivism" in 20th Century Art: Affinity of the Tribal and the Modern* (New York: Museum of Modern Art, 1984), vol. I, pp. 137–41.

4. See Susan Vogel and Ima Ebong, *Africa Explores: 20th Century African Art* (New York: The Center for African Art; and Munich: Prestel, 1991).

5. See Patricia Leighten, "The White Peril and *L'Art Nègre:* Picasso, Primitivism, and Anticolonialism," *Art Bulletin* 72, no. 4 (December 1990): 609–30.

6. See the interesting discussion of this in Jacob Viner, *The Role of Providence in the Social Order: An Essay in Intellectual History* (Princeton, 1972).

7. Michael Bell, *Primitivism* (London: Methuen, 1972), p. 80.

8. A year later, in June 1917, Apollinaire's *Les Mamelles de Tirésias* included an actor cast as "the people of Zanzibar," a mute part articulated by noise makers.

9. Hans Richter, *Dada: Art and Anti-art* (New York and Toronto: Oxford University Press, 1965), p. 20.

10. Paudrat, "From Africa," in Rubin, *"Primitivism,"* vol. I, p. 157.

11. For a detailed discussion, see Romare Bearden and Harry Anderson, *A History of African-American Artists, from 1792 to the Present* (New York: Pantheon, 1993), pp. 376–77.

12. Alfred H. Barr, Jr., Letter to the Editor, *College Art Journal* 10, no.1 (Fall 1950): 57. Barr was responding to an article by Erna Gunther that asserted that anthropologists had led the way in the discovery of African art. In his letter he countered that it was artists rather than anthropologists who first discovered African art.

13. Arthur Millier, "African Sculpture Excels in Fundamentals of Art," *Los Angeles Times,* September 29, 1935.

14. As in Janheinz Jahn's *Muntu: An Outline of the New African Culture* (New York: Grove Press, 1961), first published in German in 1958.

15. Here I should declare a personal interest, since I contributed to the catalogue for that exhibition; and perhaps I also ought to say something about my own relationship to the subject in general. When I first began to work with this material, during the 1960s, it was as a Primitivist rather than as a modernist. Early in my career, I was actively involved in research and writing about African art, which I had studied with Douglas Fraser and Paul Wingert, two of the pioneering Primitivists in the United States, and most of my early scholarly publications were on African art. In subsequent years I shifted my focus almost entirely to modern art, but I continued to teach courses on Primitive art and, increasingly, on the relationships between Primitive art and modern art. During the early 1980s I considered writing a book on the subject, but I abandoned those plans when I learned that the Museum of Modern Art was planning a large exhibition on the subject, for which I was invited to contribute a catalogue essay.

16. That being said, it should also be pointed out that the exhibition catalogue still remains a basic text on the subject and is still in print in both Europe and America. And many aspects of the exhibition that came in for particular criticism (such as the relative lack of information in the labels for the Primitive objects) still persist, even in specialized museums, largely because such information is often hard to come by.

17. See Gananath Obeyesekere, *The Apotheosis of Captain Cook: European Mythmaking in the Pacific* (Princeton: Princeton University Press; and Honolulu: Bishop Museum, 1992); Marshall Sahlins, *How "Natives" Think, About Captain Cook, for Example* (Chicago: University of Chicago Press, 1994); and Clifford Geertz's review of both books in *The New York Review of Books* (November 30, 1995), 4–6.

PART I

DISCOVERY · 1905–1918

During this first phase, Western artists were concerned with the exciting new formal and expressive possibilities offered by Primitive art and also with the new kinds of thought that it provoked about artistic processes and the social function of art. The earliest texts reflect the circumstances in which Primitive art was first encountered and the ways in which artists and critics came to see it as art. Eventually, broad principles about art and aesthetics in general came to be drawn from encounters with Primitive art, and these in turn led to a questioning of many of the traditional assumptions of post-Renaissance Western art. Some of the texts, such as Carl Einstein's *African Sculpture* (1915), have been chosen because of the thoughtful (and pioneering) ways in which they analyze Primitive art, and because of the subtlety with which they consider the cultural conditions in which the art was created. Others, such as Marius De Zayas's *African Negro Art: Its Influence on Modern Art* (1916), reflect an odd combination of admiration and condescension; De Zayas takes the contradictory and racist position that although African art is brilliant, the people who produced it are mentally inferior. Still others associate Primitive art with a breakdown of aesthetic values and associate it with the modern penchant for ugliness (as in Gelett Burgess's 1910 characterization of African sculpture as "horrid little black gods and horrid goddesses with conical breasts, deformed, hideous"). Some writers make thoughtful attempts to locate the art within a larger historical context, although they do not always prove to be free of racist attitudes toward the people who created it. A good example of this is Elie Faure's chapter on "The Tropics" in the *Medieval Art* volume (1912) of his four-volume *History of Art,* which was the first general history of art to include a chapter on Primitive art. (Faure describes African sculptures with an almost Conradian lyrical intensity: "These sculptures in wood—black wood on which the pure blues, the raw greens, the brown reds take on a violence so naive that it becomes terrifying—have a simplicity in their ferocity, an innocence in their mood of murder, that command a kind of respect. Brute nature circulates in them, and burning sap and black blood.") Other writers, such as Guillaume Apollinaire, proselytized for the universal aesthetic values that they saw in Primitive art and played down the circumstances in which the art was produced. In the United States, attention was beginning to be given to the aesthetic value of American Indian art, as can be seen in Edgar L. Hewett's 1916 essay.

During this period, writers frequently compare Primitive art to children's art. Primitive peoples are still conceived of largely as peoples without history, and analogies are frequently made between primitive cultures and the "childhood of mankind."

MAURICE DE VLAMINCK

DISCOVERY OF AFRICAN ART · 1906

One afternoon in 1905 I found myself at Argenteuil. I had just finished painting the Seine, the boats, the quays. The sun was blazing hot. Having put away my paint and brushes, I packed up my canvas and went into a bistro. Sailors and coal-stevedores were gathered around the counter. While sipping my white wine and seltzer, I noticed, on the shelf behind the bar, between the bottles of Pernod, anisette, and curaçao, three Negro sculptures. Two were statuettes from Dahomey, daubed in red ochre, yellow ochre, and white, and the third, from the Ivory Coast, was completely black.

Was it because I had just been working in the bright sun for two or three hours? Or was it the particular state of mind I was in that day? Or did it just confirm some thoughts that were preoccupying me at that time? These three sculptures really struck me. I intuitively sensed their power. They revealed Negro Art to me.

Derain and I had explored the Trocadéro Museum several times. We had become thoroughly familiar with the museum, having looked at everything with great interest. But neither Derain nor I viewed the works on display there as anything other than barbarous fetishes. The notion that these were the expressions of an instinctive art had always eluded us.

These three Negro statuettes in the Argenteuil bistro were showing me something of a very different order entirely! I was moved to the depths of my being.

I asked the owner to sell them to me. He initially refused, but I insisted, and after many more refusals and excuses, he gave them to me on condition that I pay for a round of drinks. I finally left with the three statues.

Shortly afterward, I showed my acquisition to a friend of my father's. He offered to give me some of his African sculptures since his wife wanted to get rid of "these horrors." I went to his place, and I took a large white mask and two superb Ivory Coast statues.

I hung the white mask over my bed. I was at once entranced and disturbed:

Excerpt from *Portraits avant décès* (1943), 105–7.

For many years, Maurice de Vlaminck (1876–1958) credited himself with being the first Western artist to "discover" or become aware of the aesthetic value of African art and to actually own a piece of African sculpture. In this, his most detailed account of his first encounter with African art, he places the event in 1905, though it is now widely believed to have occurred a year later.

27

Negro Art was revealed to me in all its primitivism and all its grandeur. When Derain visited and saw the white mask he was speechless. He stammered out an offer of twenty francs. I refused. Eight days later he offered me fifty. That day I was broke, so I accepted. He took the object to his atelier on the Rue Tourlaque and hung it on a wall. When Picasso and Matisse saw it at Derain's they were absolutely thunderstruck. From that day on, Negro Art became all the rage!

It was Picasso who first understood the lessons one could learn from the sculptural conceptions of African and Oceanic art and progressively incorporated these into his painting. He stretched the forms, lengthened, flattened and recomposed them on his canvas. He colored assemblages with red, ochre, black, or yellow ochre, just as the Negroes did for their idols and fetishes.

Picasso was immediately imitated by others, who, incapable of expressing themselves in traditional ways, thought they would succeed in this new idiom—like a stutterer who thinks he will speak more easily in English or Spanish! Picasso thereby started the movement whose novelty made people think of him as a revolutionary: *Cubism.*

ANDRÉ DERAIN

EARLY ENCOUNTER WITH AFRICAN ART · 1906

London, 7 March [1906]

It is absolutely essential for us to break out of the circle the realists have locked us into.

I've been rather moved by my visits around London and to the National Museum [National Gallery], as well as to the Negro Museum [the anthropological collection of the British Museum]. It's amazing, disquieting in expression. But there is a double reason behind this surfeit of expression: the forms issue from full outdoor light and are meant to be seen in full light.

This is something to which we should pay close attention, in terms of what, in a parallel way, we can deduce from it.

It is thus understood that the relations between volumes can express light or the coincidence of light with this or that form.

Excerpt from *Lettres à Vlaminck* (1955), 196–97. © 2002 Artists Rights Society (ARS), New York, and ADAGP, Paris.

This letter suggests that André Derain (1880–1954) was interested in African art before he purchased the Fang mask from Vlaminck that became one of the early "icons" of African influence on Western art.

Figure 6. Mask. Fang. Gabon. Painted wood, 18⅞″ (48 cm) high. Formerly collections of Maurice de Vlaminck, André Derain.

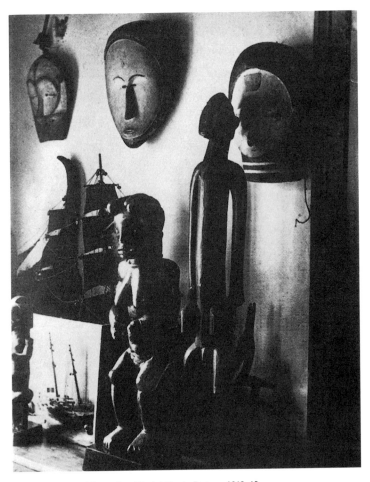

Figure 7. Corner of the studio of André Derain, Paris, ca. 1912–13.

HENRI MATISSE

FIRST ENCOUNTER WITH AFRICAN ART · 1906

Yes, I came to [African sculpture] directly. I frequently walked through the Rue de Rennes past a curio shop owned by a merchant of curiosities called "chez le Père Sauvage" and saw a variety of things in the window. There was a whole corner of little wooden statues, of Negro origin. I was astonished to see how they were conceived from the point of view of sculptural language; how it was close to the Egyptians. That is to say that compared to European sculpture, which always took its point of departure from musculature and started from the description of the object, these Negro statues were made in terms of their material, according to invented planes and proportions.

I often used to look at them, stopping each time I passed by, but without any intention at all of buying anything, and then one fine day I went in and bought one for fifty francs.

I went to Gertrude Stein's apartment on the Rue de Fleurus. I showed her the statue, then Picasso came by, and we chatted. That was when Picasso became aware of African sculpture. That's why Gertrude Stein speaks of it.

Derain bought a large mask. It became something of interest for the group of advanced painters.

Excerpt from Pierre Courthion, typescript of nine interviews with Henri Matisse, 1941. (Archives of the History of Art, Getty Center for the History of Art and Humanities, Los Angeles, p. 54.) © 2002 Succession H. Matisse, Paris, and Artists Rights Society (ARS), New York.

Henri Matisse (1869–1954) became interested in African sculpture in the spring of 1906, at about the same time as did Vlaminck and Derain, and it was he who first introduced Picasso to it that fall.

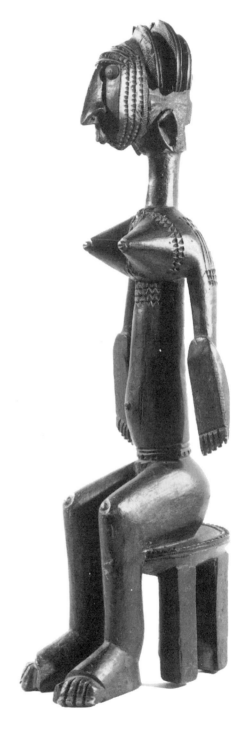

Figure 8. *Top:* Seated figure. Vili. Republic of
the Congo. Wood, 9⅜″ (24 cm) high. Private
collection. Formerly collection of Henri Matisse,
acquired c. 1906. *Bottom:* Seated figure. Bambara.
Mali. Wood, 24″ (61 cm) high. Private collection,
France. Formerly collection of Henri Matisse,
acquired c. 1915.

PABLO PICASSO

DISCOVERY OF AFRICAN ART · 1906–1907

Everyone always talks about the influence of the Negroes on me. What can I do? We all loved fetishes. Van Gogh said: "Japanese art, we all had that in common." For us it was the Negroes. Their forms had no more influence on me than they had on Matisse. Or on Derain. But for them the masks were just like any other kinds of sculpture. When Matisse showed me his first Negro head, he spoke to me about Egyptian art.

When I went to the Trocadéro it was disgusting. The flea market. The smell. I was all alone. I wanted to get away. But I didn't leave. I stayed. I stayed. I understood something very important: something was happening to me, wasn't it?

The masks weren't like other kinds of sculpture. Not at all. They were magical things. And why weren't the Egyptian or the Chaldean pieces? We hadn't realized it. Those were primitive [archaic], not magical things. The Negroes' sculptures were intercessors, I've known the French word ever since. Against everything; against unknown, threatening spirits. I kept looking at the fetishes. I understood: I too am against everything. I too think that everything is unknown, is the enemy! Everything! Not just the details—women, children, animals, tobacco, playing—but everything! I understood what the purpose of the sculpture was for the Negroes. Why sculpt like that and not some other way? After all, they weren't Cubists! Since Cubism didn't exist. Clearly some fellows had invented the models and others had imitated them, that's what we call tradition, isn't it? But all the fetishes were used for the same thing. They were weapons. To help people stop being dominated by spirits, to become independent. Tools. If we give form to the spirits, we become independent of them. The spirits, the unconscious (which wasn't yet much spoken of then), emotion, it's the same thing. I understood why I was a painter. All alone in that awful museum, the masks, the Red Indian dolls, the dusty mannequins. *Les Demoiselles d'Avignon* must have come to me that day, but not at all because of the forms: but because it was my first canvas of exorcism—yes, absolutely! . . .

Excerpt from André Malraux, *La Tête d'obsidienne* (Paris: Gallimard, 1974), 17–19. © Gallimard, 1974.

This 1937 conversation with André Malraux was the first time that Pablo Picasso (1881–1973) publicly acknowledged that he studied African art before finishing the *Demoiselles d'Avignon* thirty years earlier. The passion of Picasso's description suggests that, contrary to Gertrude Stein's assertion in the following text (p. 35), Picasso was affected in his "imagination" as well as his "vision."

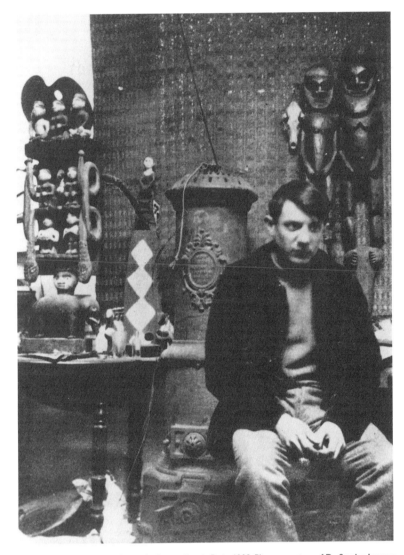

Figure 9. Picasso in his studio in the Bateau-Lavoir, Paris, 1908. Photo courtesy of Dr. Stanley Jernow.

That's also what separated me from Braque. He loved the Negro pieces, but as I've said: because they were good sculptures. He wasn't ever afraid of them. Exorcism didn't interest him. Because he didn't feel what I called Everything, life, or I don't know what, the Earth? everything that surrounds us, everything that isn't us, he didn't find at all hostile. Not even—imagine!—not even strange! He always felt at home. And still does. He doesn't understand these things at all: he isn't superstitious!

GERTRUDE STEIN

MATISSE AND PICASSO AND AFRICAN ART · 1906–1907

Derain and Braque became followers of Picasso about six months after Picasso had, through Gertrude Stein and her brother, met Matisse. Matisse had in the meantime introduced Picasso to negro sculpture.

At that time negro sculpture had been well known to curio hunters but not to artists. Who first recognised its potential value for the modern artist I am sure I do not know. Perhaps it was Maillol who came from the Perpignan region and knew Matisse in the south and called his attention to it. There is a tradition that it was Derain. It is also very possible that it was Matisse himself because for many years there was a curio-dealer in the rue de Rennes who always had a great many things of this kind in his window and Matisse often went up the rue de Rennes to go to one of the sketch classes.

In any case it was Matisse who first was influenced, not so much in his painting but in his sculpture, by the african statues and it was Matisse who drew Picasso's attention to it just after Picasso had finished painting Gertrude Stein's portrait.

The effect of this african art upon Matisse and Picasso was entirely different. Matisse through it was affected more in his imagination than in his vision. Picasso more in his vision than in his imagination.

Excerpt from *The Autobiography of Alice B. Toklas* (1933), 77–78. By permission of the Gertrude Stein Estate and David Higham Associates.

Gertrude Stein (1874–1946) confirms that Matisse first showed Picasso African sculpture in the fall of 1906, shortly after Picasso had finished her portrait.

GUILLAUME APOLLINAIRE

ON MUSEUMS · 1909

[We should] create a reserve fund to dip into for new acquisitions. These are indispensable for the Louvre, where certain epochs and schools are very badly represented.

We should also make an effort on behalf of certain artistic manifestations that have been completely ignored until now. These are works of art from certain regions, certain colonies, such as Australia, Easter Island, New Caledonia, New Hebrides, Tahiti, various African lands, Madagascar, etc.

Until now, we have only admitted works of art from these countries into ethnographic collections, where they have been conserved only as curiosities, as documents, pell-mell among the most common and vulgar objects, and along with the natural products of these regions.

The Louvre should welcome certain exotic masterpieces that are no less moving than the beautiful examples of Western statuary.

For some time now, many artists have not hidden their admiration for the unknown sculptors of the Congo, or for the passionate precision of works by the Kanak Islanders or the Maoris.

As always, the museums lag behind the times. It is high time for France to collect works of art while they are still low in cost; since they are priceless, they will soon command much greater sums because they are sure to become rare. They are already being collected in England, Germany, and elsewhere. Certain Easter Island sculptures, which should be in Paris, are in Copenhagen. One of these statues, possibly the only that they bothered to bring here, has been set up in front of the museum. This is a work of great antiquity and of a style that is reminiscent of nothing that can be found anywhere else.

There is a special section of the Musée Guimet already devoted to Egypt and Asia, which is at once museum, temple, library, and laboratory. We need to create in Paris a great, exotic museum to replace the ethnographic museum at the Trocadéro, which met the oddest fate that can befall a museum.

Excerpt from *Le Journal du soir* (October 3, 1909). © Gallimard, Bibliothèque de la Pléiade, 1991.

The French poet and critic Guillaume Apollinaire (1880–1918) played an important role in promoting awareness of Primitive art in Europe between 1907 and 1918. He was one of the first writers to voice aesthetic appreciation and the first to advocate putting African and Oceanic art in the Louvre.

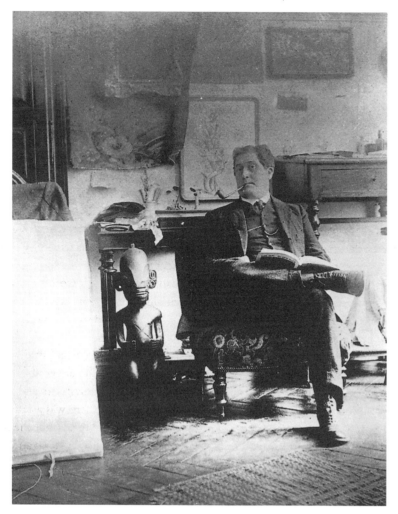

Figure 10. Guillaume Apollinaire in Picasso's studio, Boulevard de Clichy, ca. 1911.

It is not that the Trocadéro Museum isn't large enough; but the collections, instead of increasing in size, are being reduced. The museum itself has become too vast. Visitors are few and far between, and guards even rarer, and the museum is more often closed than open.

The Trocadéro galleries could well accommodate an ethnographic museum of France. The kernel of this museum already exists, but in a lamentable state.

GELETT BURGESS

THE WILD MEN OF PARIS · 1910

I had scarcely entered the Salon des Indépendants when I heard shrieks of
laughter coming from an adjoining wing. I hurried along from room to room
under the huge canvas roof, crunching the gravel underfoot as I went, until I
came upon a party of well-dressed Parisians in a paroxysm of merriment, gaz-
ing, through weeping eyes, at a picture. Even in my haste I had noticed other
spectators lurching hysterically in and out of the galleries; I had caught sight of
paintings that had made me gasp. But here I stopped in amazement. It was a
thing to startle even Paris. I realized for the first time that my views on art
needed a radical reconstruction. Suddenly I had entered a new world, a universe
of ugliness. And, ever since, I have been mentally standing on my head in the
endeavor to get a new point of view on beauty so as to understand and appreci-
ate this new movement in art. . . .

It was an affording quest, analyzing such madness as this. I had studied the
gargoyles of Oxford and Notre Dame, I had mused over the art of the Niger
and of Dahomey, I had gazed at Hindu monstrosities, Aztec mysteries and many
other primitive grotesques; and it had come over me that there was a rationale
of ugliness as there was a rationale of beauty; that, perhaps, one was but the neg-
ative of the other, an image reversed, which might have its own value and eso-
teric meaning. Men had painted and carved grim and obscene things when the
world was young. Was this revival a sign of some second childhood of the race,
or a true rebirth of art? . . .

What wonder Matisse shakes his head and does not smile! He chats thought-
fully of the "harmony of volume" and "architectural values," and wild Braque
climbs to his attic and builds an architectural monster which he names Woman,
with balanced masses and parts, with openings and columnar legs and cornices.
Matisse praises the direct appeal to instinct of the African wood images, and
even sober Derain, a co-experimenter, loses his head, moulds a neolithic man
into a solid cube, creates a woman of spheres, stretches a cat out into a cylinder,
and paints it red and yellow! . . .

Why, here's Derain, now, across the street, with his model, a dead-white girl
with black hair, dressed in purple and green. Derain leaves her pouting, and we

Excerpts from *Architectural Record* (May 1910): 401–3, 406–8, 410.
 The American artist and writer Gelett Burgess (1866–1951) did the interviews for this
article in the spring of 1908.

walk through a strange, crowded bourgeois neighborhood with Derain, who is a tall, serious-looking young man, with kind brown eyes and a shrill blue tie. We plunge down a narrow lane like passage, with casts amidst the shrubbery, into a big open studio, with a gallery at the end.

Look at his biggest picture, first, and have your breath taken away! He has been working two years on it. I could do it in two days. So could you, I'm sure. A group of squirmy bathers, some green and some flamingo pink, all, apparently, modeled out of dough, permeate a smoky, vague background. In front sprawls a burly negro, eight feet long. Now notice his African carvings, horrid little black gods and horrid goddesses with conical breasts, deformed, hideous. Then, at Derain's imitations of them in wood and plaster. Here's the cubical man himself, compressed into geometric proportions, his head between his legs. Beautiful! Derain's own cat, elongated into a cylinder. Burned and painted wooden cabinets, statues with heads lolling on shoulders, arms anywhere but where they ought to be. A wild place, fit for dreams. But no place for mother.

Derain, being a quiet man, doesn't care to talk, but he sits obediently for his photograph, holding the cylindrical cat in his arms, as I instruct him. He shows us portfolios of experiments in pure color, geometrical arrangements such as you did yourself in the second grade of the grammar school, tile patterns, sausage rosettes, and such.

But who am I, to laugh at Derain? Have I not wondered at the Gobelin designs, at the Tibetan goddess of destruction, and sought for occult meanings in the primitive figures of the Mound Builders? Let Derain talk, if he will be persuaded. What has he learned from the negroes of the Niger? Why does he so affect ugly women?

"Why, what, after all, *is* a pretty woman?" Derain answers, kindly. "It's a mere subjective impression—what you yourself think of her. That's what I paint, another kind of beauty of my own. There is often more psychic appeal in a so-called ugly woman than there is in a pretty one; and, in my ideal, I reconstruct her to bring that beauty forth in terms of line or volume. A homely woman may please by her grace, by her motion in dancing, for instance. So she may please me by her harmonies of volume. If I paint a girl in the sunlight, it's the sunlight I'm painting, not the real girl; and even for that I should have the sun itself on my palette. I don't care for an accidental effect of light and shade, a thing of 'mere charm.'

"The Japanese see things that way. They don't paint sunlight, they don't cast shadows that perplex one and falsify the true shape of things. The Egyptian figures have simplicity, dignity, directness, unity; they express emotion almost as if by a conventional formula, like writing itself, so direct it is. So I seek a logical method of rendering my idea. These Africans being primitive, uncomplex, uncultured, can express their thought by a direct appeal to the instinct. Their carvings are informed with emotion. So Nature gives me the material with which

to construct a world of my own, governed not by literal limitations, but by instinct and sentiment." . . .

Picasso is a devil. I use the term in the most complimentary sense, for he's young, fresh, olive-skinned, black eyes and black hair, a Spanish type, with an exhuberant, superfluous ounce of blood in him. I thought of a Yale sophomore who had been out stealing signs, and was on the point of expulsion. When, to this, I add that he is the only one of the crowd with a sense of humor, you will surely fall in love with him at first sight, as I did.

But his studio! If you turn your eyes away from the incredible jumble of junk and dust—from the bottles, rags, paints, palettes, sketches, clothes and food, from the pile of ashes in front of the stove, from the chairs and tables and couches littered with a pell-mell of rubbish and valuables—they alight upon pictures that raise your hair. Picasso is colossal in his audacity. Picasso is the doubly distilled ultimate. His canvases fairly reek with the insolence of youth; they outrage nature, tradition, decency. They are abominable. You ask him if he uses models, and he turns to you a dancing eye. "Where would I get them?" grins Picasso, as he winks at his ultramarine ogresses.

The terrible pictures loom through the chaos. Monstrous, monolithic women, creatures like Alaskan totem poles, hacked out of solid, brutal colors, frightful, appalling! How little Picasso, with his sense of humor, with his youth and deviltry, seems to glory in his crimes! How he lights up like a torch when he speaks of his work!

I doubt if Picasso ever finishes his paintings. The nightmares are too barbarous to last; to carry out such profanities would be impossible. So we gaze at his pyramidal women, his sub-African caricatures, figures with eyes askew, with contorted legs, and—things unmentionably worse, and patch together whatever idea we may. . . .

But Friesz is a man we must take seriously, for Friesz is a serious person, and, if he would, could paint. . . .

His studio is long and wide and high, with ecclesiastical-looking Gothic doors, and out of it another room with many beautiful things. Amongst them, of course, are African-carved gods and devils of sorts. Since Matisse pointed out their "volumes" all the Fauves have been ransacking the curio shops for negro art.

ROGER FRY

THE ART OF THE BUSHMEN · 1910

In the history of mankind drawing has at different times and among different races expressed so many different conceptions, and has used such various means, that it would seem to be not one art, but many. It would seem, indeed, that it has its origins in several quite distinct instincts of the human race, and it may not be altogether unimportant even for the modern draughtsman to investigate these instincts in their simpler manifestations in order to check and control his own methods. The primitive drawing of our own race is singularly like that of children. Its most striking peculiarity is the extent to which it is dominated by the concepts of language. In a child's drawing we find a number of forms which have scarcely any reference to actual appearances, but which directly symbolise the most significant concepts of the thing represented. For a child, a man is the sum of the concept's head (which in turn consists of eyes, nose, mouth), of his arms, his hands (five fingers), his legs and his feet. Torso is not a concept which interests him, and it is, therefore, usually reduced to a single line which serves to link the concept-symbol head with those of the legs. The child does, of course, know that the figure thus drawn is not like a man, but it is a kind of hieroglyphic script for a man, and satisfies his desire for expression. Precisely the same phenomenon occurs in primitive art; the symbols for concepts gradually take on more and more of the likeness to appearances, but the mode of approach remains even in comparatively advanced periods the same. The artist does not seek to transfer a visual sensation to paper, but to express a mental image which is coloured by his conceptual habits.

Prof. Loewy[1] has investigated the laws which govern representation in early art, and has shown that the influence of the early artist's ideas of conceptual symbolism persist in Greek sculpture down to the time of Lysippus. He enumerates seven peculiarities of early drawing, of which the most important are that the figures are shown with each of their parts in its broadest aspect, and that

Excerpts from *Burlington Magazine* (1910): 334ff.

The prominent British art critic and artist Roger Fry (1866–1934) wrote widely about modern art and organized the influential "Manet and the Post-Impressionists" exhibition at the Grafton Galleries in November 1910. His attempt here to link Primitive man with modern children would become a common theme among other writers on the subject. From 1905 to 1910, Fry was director of the Metropolitan Museum of Art in New York.

the forms are stylised—i.e., present linear formations that are regular or tend to regularity.

Of the first of these peculiarities Egyptian and Assyrian sculpture, even of the latest and most developed periods, afford constant examples. We see there the head in profile, the eye full face, the shoulders and breast full face, and by a sudden twist in the body the legs and feet again in profile. In this way each part is presented in that aspect which most clearly expresses its corresponding visual concepts. Thus a foot is much more clearly denoted by its profile view than by the rendering of its frontal appearance—while no one who was asked to think of an eye would visualise it to himself in any other than a full-face view. In such art, then, the body is twisted about so that each part may be represented by that aspect which the mental image aroused by the name of the part would have, and the figure becomes an ingenious compound of typical conceptual images. In the case of the head two aspects are accepted as symbolic of the concept "head," the profile and the full-face; but it is very late in the development of art before men are willing to accept any intermediate position as intelligible or satisfactory. It is generally supposed that early art avoids foreshortening because of its difficulty. One may suppose rather that it is because the foreshortened view of a member corresponds so ill with the normal conceptual image, and is therefore not accepted as sufficiently expressive of the idea. Yet another of the peculiarities named by Prof. Loewy must be mentioned, namely, that the "conformation and movement of the figures and their parts are limited to a few typical shapes." And these movements are always of the simplest kinds, since they are governed by the necessity of displaying each member in its broadest and most explicit aspect. In particular the crossing of one limb over another is avoided as confusing.

Such, in brief outline, are some of the main principles of drawing both among primitive peoples and among our own children. It is not a little surprising then to find, when we turn to Miss Tongue's careful copies of the drawings executed by the Bushmen of South Africa,[2] that the principles are more often contradicted than exemplified. We find, it is true, a certain barbaric crudity and simplicity which give these drawings a superficial resemblance to children's drawings or those of primitive times, but a careful examination will show how different they are. The drawings are of different periods, though none of them probably are of any considerable antiquity, since the habit of painting over an artist's work when once he was forgotten obtained among the bushmen no less than with more civilised people. These drawings are also of very different degrees of skill. They represent for the most part scenes of the chase and war, dances and festivals, and in one case there is an illustration to a bushman story and one figure is supposed to represent a ghost. There is no evidence of deliberate decorative purpose in these paintings. The figures are cast upon the walls of the cave in such a way as to represent, roughly, the actual scenes.[3] Nothing could be more unlike

primitive art than some of these scenes. For instance, the battle fought between two tribes over the possession of some cattle, is entirely unlike battle scenes such as we find in early Assyrian reliefs. There the battle is schematic, all the soldiers of one side are in profile to right, all the soldiers of the opposing side are in profile to left. The whole scene is perfectly clear to the intelligence, it follows the mental image of what a battle ought to be, but is entirely unlike what a battle ever is. Now, in the Bushman drawing there is nothing truly schematic; it is difficult to find out the soldiers of the two sides; they are all mixed up in a confused hurly-burly, some charging, others flying, and here and there single combats going on at a distance from the main battle. But more than this, the men are in every conceivable attitude, running, standing, kneeling, crouching, or turning sharply round in the middle of flight to face the enemy once more.

In fact we have, in all its confusion, all its indeterminate variety and accident, a rough silhouette of the actual appearance of such a scene as viewed from above, for the Bushman makes this sacrifice of actual appearance to lucidity of statement—that he represents the figures as spread out over the ground, and not as seen one behind another. . . .

Another point to be noticed is that in primitive and in children's art such features as eyes, ears, horns, tails, since they correspond to well-marked concepts, always tend to be drawn disproportionately large and prominent. Now, in the Bushman drawings, the eye, the most significant of all, is frequently omitted, and when represented bears its true proportion to the head. Similarly, horns, ears, and tails are never exaggerated. Indeed, however faulty these drawings might be, they have one great quality, namely that each figure is seen as a single entity, and the general character of the silhouette is aimed at rather than a sum of the parts. Those who have taught drawing to children will know with what infinite pains civilised man arrives at this power. . . .

Since, then, Bushman drawing has little analogy to the primitive art of our own races, to what can we relate it? The Bushmen of Australia have apparently something of the same power of transcribing pure visual images, but the most striking case is that of Palæolithic man. In the caves of the Dordogne and of Altamira in Spain, Palæolithic man has left paintings which date from about 10,000 B.C., in which, as far as mere naturalism of representation of animals goes, he has surpassed anything that not only our own primitive peoples, but even the most accomplished animal draughtsmen have ever achieved. Figure 11 shows in outline a bison from Altamira. The certainty and completeness of the pose, the perfect rhythm and the astonishing verisimilitude of the movement are evident even in this. The Altamira drawings show a much higher level of accomplishment than those of the Bushmen, but the general likeness is so great as to have suggested the idea that the Bushmen are descendants of Palæolithic man who have remained at the same rudimentary stage as regards the other arts of life, and have retained something of their unique power of visual transcription.

Figure 11. Altamira cave drawing. Published by Roger Fry in *Burlington Magazine* (1910).

Whether this be so or not, it is to be noted that all the peoples whose draw-
ing shows this peculiar power of visualization belong to what we call the lowest
of savages; they are certainly the least civilisable, and the South African Bushmen
are regarded by other native races in much the same way that we look upon ne-
groes. It would seem not impossible that the very perfection of vision, and pre-
sumably of the other senses[4] with which the Bushmen and Palæolithic man
were endowed, fitted them so perfectly to their surroundings that there was no
necessity to develop the mechanical arts beyond the elementary instruments of
the chase. We must suppose that Neolithic man, on the other hand, was less per-
fectly adapted to his surroundings, but that his sensual defects were more than
compensated for by increased intellectual power. This greater intellectual power
manifested itself in his desire to classify phenomena, and the conceptual view of
nature began to predominate. And it was this habit of thinking of things in
terms of concepts which deprived him for ages of the power to see what they
looked like. With Neolithic man drawing came to express man's thought about
things rather than his sensations of them, or rather, when he tried to reproduce
his sensations, his habits of thought intervened, and dictated to his hand orderly,
lucid, but entirely non-naturalistic forms.

How deeply these visual-conceptual habits of Neolithic man have sunk into our natures may be seen by their effects upon hysterical patients, a statement which I owe to the kindness of Dr. Henry Head, F.R.S. If the word "chest" is mentioned most people see a vague image of a flat surface on which are marked the sternum and the pectoral muscles; when the word "back" is given, they see another flat or almost flat surface with markings of the spine and the shoulder-blades; but scarcely any one, having these two mental images called up, thinks of them as parts of a continuous cylindrical body. Now, in the case of some hysterical patients anæsthesia is found just over some part of the body which has been isolated from the rest in thought by means of the conceptual image. It will occur, for instance, in the chest, but will not go beyond the limits which the conceptualised visual image of a chest defines. Or it will be associated with the concept hand, and will stop short at the wrists. It is not surprising, then, that a mode of handling the continuum of natural appearance, which dictates even the behaviour of disease, should have profoundly modified all artistic representations of nature since the conceptual habit first became strongly marked in Neolithic man. An actual definition of drawing given by a child may be quoted in this connection, "First I think, and then I draw a line around my think."

It would be an exaggeration to suppose that Palæolithic and Bushman drawings are entirely uninfluenced by the concepts which even the most primitive people must form. Indeed, the preference for the profile view of animals—though as we have seen other aspects are frequent—would alone indicate this, but they appear to have been at a stage of intellectual development where the concepts were not so clearly grasped as to have begun to interfere with perception, and where therefore the retinal image passed into a clear memory picture with scarcely any intervening mental process. In the art of even civilised man we may, I think, find great variations in the extent to which the conceptualising of visual images has proceeded. Egyptian and Assyrian art remained intensely conceptual throughout, no serious attempt was made to give greater verisimilitude to the symbols employed. The Mycenæan artists, on the other hand, seem to have been appreciably more perceptual, but the Greeks returned to an intensely conceptualised symbolism in which some of their greatest works of art were expressed, and only very gradually did they modify their formulæ so as to admit of some approach to verisimilitude, and even so the appeal to vision was rather by way of correcting and revising accepted conceptual images than as the foundation of a work of art. The art of China, and still more of Japan, has been distinctly more perceptual. Indeed, the Japanese drawings of birds and animals approach more nearly than those of any other civilised people to the immediacy and rapidity of transcription of Bushman and Palæolithic art. The Bushman silhouettes of cranes might almost have come from a Japanese screen. Like Japanese drawings, they show an alertness to accept the silhouette as a single whole instead of reconstructing it from separately apprehended parts. It is partly due to

Japanese influence that our own Impressionists have made an attempt to get back to that ultra-primitive directness of vision. Indeed they deliberately sought to deconceptualise art. The artist of to-day has therefore to some extent a choice before him of whether he will *think* form like the early artists of European races or merely *see* it like the Bushmen. Whichever his choice, the study of these drawings can hardly fail to be of profound interest. The Bushmen paintings on the walls of caves and sheltered rocks are fast disappearing; the race itself, of which Miss Bleek gives a fascinating account, is now nothing but a remnant. The treatment that they have received at the hands of the white settlers does not seem to have been conspicuously more sympathetic or intelligent than that meted out to them by negro conquerors, and thus the opportunity of solving some of the most interesting problems of human development has been for ever lost.

NOTES

1. "The Rendering of Nature in Early Greek Art." By Emmanuel Loewy. Translated by J. Fothergill. Duckworth, 1907.

2. "Bushman Drawings," copied by M. Helen Tongue, with a preface by Henry Balfour. Oxford: Clarendon Press. 1909. £3 3s. net.

3. This absence of decorative feeling may be due to the irregular and vague outlines of the picture space. It is when the picture must be fitted within determined limits that decoration begins. I have noticed that children's drawings are never decorative when they have the whole surface of a sheet of paper to draw on, but they will design a frieze with well-marked rhythm when they have only a narrow strip.

4. This is certainly the case with Australian Bushmen.

FRANZ MARC

LETTER TO AUGUST MACKE · 1911

I spent some very productive time in the Ethnographic Museum in order to study the artistic methods of "primitive peoples." . . . I was finally caught up, astonished and shocked, by the carvings of the Cameroon people, carvings which can perhaps be surpassed only by the sublime works of the Incas. I find it so self-evident that we should seek the rebirth of our artistic feeling in this cold dawn of artistic intelligence, rather than in cultures that have already gone through a thousand-year cycle like the Japanese or the Italian Renaissance. In this short winter I have already become a completely different person. I think I am gradually really coming to understand what matters for us if we are to call ourselves artists at all: we must become ascetics. Don't be frightened; I mean this only in intellectual matters. We must be brave and give up almost everything which until now was dear and indispensable for us good Central Europeans. Our ideas and ideals must wear a hairshirt. We must nourish them with locusts and wild honey, and not with history, if we are to issue forth from the exhaustion of our European bad taste. . . . The goal "to be wished most ardently" is, naturally, . . . to be brought about by a healthy instinct for color, like that possessed by all primitive peoples. That from this we wish to make "pictures," and not only colorful columns and capitals and straw huts and clay pots, is our advantage, our "Europeanness."

Excerpts from letter of January 14, 1911, *Briefwechsel* (1964), 39–41.

 The German painter Franz Marc (1880–1916) also considered himself a philosopher and theologian and was keenly aware of the new directions that were being taken by European artists. In 1911 he was a cofounder of the Blaue Reiter group in Munich, and in 1912 Marc and Wassily Kandinsky edited *Der Blaue Reiter,* a collection of essays and images that promoted modern art generally and urged artists to be guided by free expression and natural law rather than by academies or schools.

AUGUST MACKE

MASKS · 1912

To create forms means: to live. Are not children more creative in drawing directly from the secret of their sensations than the imitator of Greek forms? Are not savages artists who have forms of their own powerful as the form of thunder? . . .

In our complicated and confused era we have forms that absolutely enthrall everyone in exactly the same way as the fire dance enthralls the African or the mysterious drumming of the fakirs enthralls the Indian. As a soldier, the independent scholar stands beside the farmer's son. They both march in review similarly through the ranks, whether they like it or not. At the movies the professor marvels alongside the servant girl. In the vaudeville theater the butterfly-colored dancer enchants the most amorous couples as intensely as the solemn sound of the organ in a Gothic cathedral seizes both believer and unbeliever.

Forms are powerful expressions of powerful life. Differences in expression come from the material, word, color, sound, stone, wood, metal. One need not understand each form. One also need not read each language.

The contemptuous gesture with which connoisseurs and artists have to this day banished all artistic form of primitive cultures to the fields of ethnology or applied art is amazing at the very least.

What we hang on the wall as a painting is basically similar to the carved and painted pillars in an African hut. The African considers his idol the comprehensible form for an incomprehensible idea, the personification of an abstract concept. For us the painting is the comprehensible form for the obscure, incomprehensible conception of a deceased person, of an animal, of a plant, of the whole magic of nature, of the rhythmical.

Does Van Gogh's portrait of Dr. Gachet not originate from a spiritual life similar to the amazed grimace of a Japanese juggler cut in a wood block? The mask of the disease demon from Ceylon is the gesture of horror of a primitive

Excerpts from *Der Blaue Reiter* (1912), 22, 24, 26. From *The* Blaue Reiter *Almanac*, ed. Wassily Kandinsky and Franz Marc, trans. Henning Falkenstein. Translation © 1974 by Thames and Hudson Ltd., London. *Der Blaue Reiter* © 1965 by R. Piper & Co. Verlag, Munich. Used by permission of Viking Penguin, a division of Penguin Books USA, Inc.

The German artist August Macke (1887–1914), a member of the Blaue Reiter group, was especially critical of connoisseurs and artists who considered objects from Primitive cultures to be only of ethnological interest rather than works of art.

Figure 12. Bella Coola Indians performing a dance in Berlin, 1885. © Kunsthistorisches Museum mit MVK u. ÖTM.

race by which their priests conjure sickness. The grotesque embellishments found on a mask have their analogies in Gothic monuments and in the almost unknown buildings and inscriptions in the primeval forests of Mexico. What the withered flowers are for the portrait of the European doctor, so are the withered corpses for the mask of the conjurer of disease. The cast bronzes of the Negroes from Benin in West Africa (discovered in 1889), the idols from the Easter Islands in the remotest Pacific, the cape of a chieftain from Alaska, and the wooden masks from New Caledonia speak the same powerful language as the chimeras of Notre-Dame and the tombstones in Frankfurt Cathedral.

Everywhere, forms speak in a sublime language right in the face of European aesthetics. Even in the games of children, in the hat of a cocotte, in the joy of a sunny day, invisible ideas materialize quietly.

The joys, the sorrows of man, of nations, lie behind the inscriptions, paintings, temples, cathedrals, and masks, behind the musical compositions, stage spectacles, and dances. If they are not there, if form becomes empty and groundless, then there is no art.

EMIL NOLDE

THE ARTISTIC EXPRESSIONS OF PRIMITIVE PEOPLES · 1912

I was working on a book on the artistic expressions of primitive peoples (*Kunst-aeusserungen der Naturvoelker*). I jotted down some sentences intended to be used as introduction. 1912.

1. The most perfect art is found in classic Greece. Raphael is the greatest of all painters. This is what every art teacher told us twenty or thirty years ago.

2. Many things have changed since that time. We do not care for Raphael, and the sculptures of the so-called classic periods leave us cool. The ideals of our predecessors are no longer ours. We are less fond of works which for centuries have been identified with the names of great masters. Artists wise in the ways of their times created sculptures and paintings for palaces and Popes. Today, we admire and love the simple, monumental sculptures in the cathedrals of Naumburg, Magdeburg, or Bamberg, carved by self-sufficient people working in their own stone yards, people of whose lives we know little, whose very names have not survived.

3. Our museums are becoming larger and fuller, and they are growing fast. I am no friend of these vast agglomerations, which suffocate us with their size. I expect soon to see a reaction against such excessive collections.

4. Not too long ago, the art of only a few periods was deemed worthy of representation in museums. Then others were added. Coptic and Early Christian art, Greek terra cotta and vases, Persian and Islamic art swelled the ranks. Why then are Indian, Chinese, and Javanese art still considered the province of science and ethnology? And why does the art of primitive peoples as such receive no appreciation at all?

Excerpt from *Jahre der Kämpfe, 1902–1914* (1934), 176–77. From *Theories of Modern Art,* by Herschel B. Chipp, Peter Selz, and Joshua Taylor. Translation © University of California Press, 1968.

The German painter Emil Nolde (1867–1956) planned to write a book, *The Artistic Expressions of Primitive Peoples,* for which he wrote these introductory notes. In 1914 Nolde went to New Guinea. He subsequently wrote about his admiration for the natives and his criticism of the white colonists. Although Nolde later became an early member of the Nazi party, he was nonetheless condemned by the Kampfbund für deutsche Kultur (Fighting League for German Culture) for deriving inspiration from Primitive art and for creating "degenerate," distorted images of human figures.

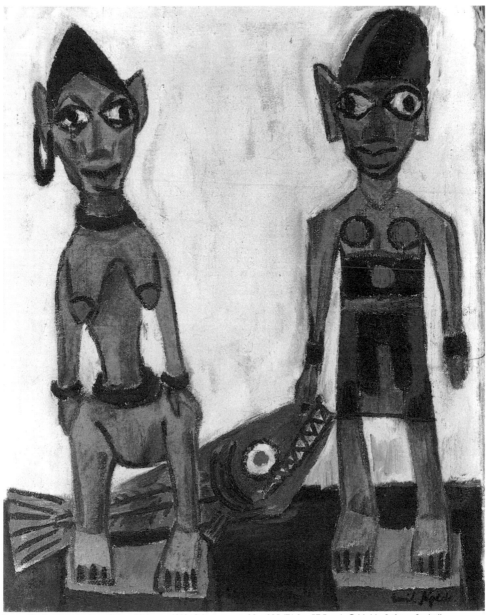

Figure 13. Emil Nolde, *Man, Fish and Woman*, 1912. Oil on canvas, 28 × 23″ (71.3 × 57.5 cm). © Nolde-Stiftung Seebüll.

5. Why is it that we artists love to see the unsophisticated artifacts of the primitives?

6. It is a sign of our times that every piece of pottery or dress or jewelry, every tool for living has to start with a blueprint.—Primitive people begin making things with their fingers, with material in their hands. Their work expresses the pleasure of making. What we enjoy, probably, is the intense and often grotesque expression of energy, of life.

These sentences reach into the present, and perhaps even beyond it.

The fundamental sense of identity, the plastic—colorful—ornamental pleasure shown by "primitives" for their weapons and their objects of sacred or daily uses are surely often more beautiful than the saccharinely tasteful decorations on the objects displayed in the show cases of our salons and in the museums of arts and crafts.

There is enough art around that is over-bred, pale, and decadent. This may be why young artists have taken their cues from the aborigines.

We "educated" people have not moved so wondrously far ahead, as is often said. Our actions cut two ways. For centuries, we Europeans have treated the primitive peoples with irresponsible voraciousness. We have annihilated people and races—and always under the hypocritical pretext of the best of intentions.

Animals of prey know little pity. We whites often show even less.

The first introductory sentences concerning Greek art and the art of Raphael may appear to be tossed off with a lack of responsibility. This is not the case. The painter openly states his opinions. The Assyrians, the Egyptians had a powerful plastic sense, and so did the Archaic Greeks. But then followed a period of pleasing poses, of many limbs, of males and females needing the signs of sex to show whether they were men or women. These were times of frightening decay. Even if all the aesthetes down to this day have maintained the opposite.

ELIE FAURE

THE TROPICS · 1912

Now all the races, even the most primitive, possess the faculty of decorating pots, carving wooden figurines, making furniture, weaving stuffs, and carving metal. That is to say that any people in Europe which has not, in the general on-ward sweep of Occidental culture, known how to utilize the stammerings of these rudimentary arts, to make up a language of its own, a living language that expresses it in its highest desires, must seek to realize them otherwise than by images, which it does not know how to use because it does not love them. Be-sides, as civilization becomes universal, it perverts the needs of the people's soul, and the manifestations of that soul take on more and more of a mongrel charac-ter. To find a primitive art that retains its sap and can impart new and strong emotions to sensibilities that have preserved or regained their first ingenuous-ness, we must go to those peoples who have remained primitives.

It is in the tropics or near the polar regions that men, in the heart of modern times, have preserved practically intact the spirit of their most distant ancestors. It is only there that they have not passed beyond the stage of naturistic fetishism and the grouping by tribes. In one region the heat is too intense; in the other region the cold is too severe. Here the seasons are too distinct and too heavy; there they are too torpid and of too slow a rhythm. Among the peoples of the tropics, even the most rudimentary effort to get food and shelter is practically unnecessary, the effort to rise is too hard, and with the polar peoples the only use of effort is to secure an existence, which is vegetative and precarious, the nature of the country being too ungrateful for the inhabitant to imagine that he could modify his surroundings to his profit. Finally, neither in the one region nor in the other have any great human migrations passed, to renew the race, to bring it the breath of the world outside, because the course of these migrations has been turned aside by the ice, the deserts, the overdense forests, and the too-vast oceans.

The black race is perhaps that one among the backward peoples which has manifested the least aptitude for raising itself above the elementary human

Excerpts from *Histoire de l'art: L'Art médiéval* (1912), 154–60, 163–68.

The French critic and art historian Elie Faure (1873–1937) wrote a four-volume *Histoire de l'art,* which long remained a standard text on the subject. The inclusion of a chapter on "The Tropics," in the second volume, in which "Medieval Art" is broadly construed to in-clude several non-Western cultures, constituted the first inclusion of the arts of Africa and Oceania in a general history of art.

instincts that result in the formation of language, the first social crystallizations, and the industries indispensable to them. Even when transplanted in great numbers to places like North America that have reached the most original, even if not the highest, degree of civilization that we find in modern times, the black man remains, after centuries, what he was—an impulsive child, ingenuously good, and ingenuously cruel; as in the case of other children, all of his acts spring from immediate sensation. And yet his was the only one of the great primitive races which, inhabiting a massive continent in large numbers, lacked neither arms nor heads to modify its surroundings, discover new relationships, and create new ideas. But this continent is divided into twenty sections by the sands, the mountains, the brush, and the virgin forests; it is infested with wild beasts, it is feverish and torrid, and is cut in two by the equator. Its northern shores, those on the Mediterranean, are habitable for white men, and only these regions have, from the beginnings of history, participated in man's great movements toward the future.

However, if we revert to the earliest times we discover an Africa that was probably identical with what it is at this hour, and consequently on the same level with that of the tribes that peopled the north and the west of Europe—perhaps on a higher level. War and commerce created constant relationships between ancient Egypt and the Sudan, and Central Africa participated in the development of the civilization of the Nile. From that period on, iron was worked in Nigritia, while the old world hardly knew yet how to work in bronze, and the African jewelry that is still made by the Somalis of East Africa, the Pahouins, the Ashantis, and the Haoussas of West Africa, was brought by caravans from the confines of Upper Egypt to the markets of Thebes and Memphis. The jewelry is heavy, of a thick and compact material, with incrustations of blue and red stones whose opaque glow spots the circles of mat gold or of somber silver. Geometrical figures are dear to all primitive peoples, whether they paint their pots, decorate their huts, weave their clothing, or stripe the skin of their faces or their bodies; and cutting into the African jewelry in every direction we find again these geometrical forms—short, fat, dense, and pressed closely together. As mathematics, the science of inert forms, preceded biology, so geometrical ornament preceded living ornament, and certain child peoples, incapable of interpreting life, have arrived, in ornamental art, at the highest degree of power. The human mind proceeds always from the simple to the complex, but when the great artist appears to unite the most differentiated living forms through a single arabesque, or when modern science tries to express all its conquests in mathematical symbols, the mind is invariably brought back to primitive sources, the very ones at which instinct slaked its thirst. The result is always the impressive agreement between the most obscure feeling and the highest form of reason.

In general, we need not seek, in the art of the Negroes, anything more than

that still unreasoned feeling which merely obeys the most elementary demands of rhythm and of symmetry. When the youthful peoples follow the instinct which urges them to impose on the living forms that come from their hands a vaguely architectural appearance, an awkward, rough symmetry, they unquestionably obey an imperious desire for synthesis, but this synthesis is of the kind that precedes experience and not the kind that follows it. The sculpture in wood of the Negroes is still very far from the great Egyptian sculpture, for example, whose advent coincides with that of a social and religious edifice of the most powerful architecture. Perhaps it is a first sketch or presentiment of Egyptian art that we see in Negro sculpture—one which may carry us back almost as far as the appearance of man in Africa. From such a beginning may well have come the sudden start for the ascent, through the long centuries in the great fertile valley where the black and white races fuse. Then, after the slowest, the loftiest, the most conscious stylization, after the art of the Nile has sunk into the sands, the Negro again prolongs the immobile inspiration of Africa until our own time. But to him we must not look for metaphysical abstractions, for he gives us only his sensations, as short-lived as they are violent—an attempt to satisfy the most immediate needs that spring from a rudimentary fetishism. And perhaps it is even because of his fearful candor in showing us rough surfaces, short limbs, bestial heads, and drooping breasts that he reaches his great expressiveness. These sculptures in wood—black wood on which the pure blues, the raw greens, the brown reds take on a violence so naïve that it becomes terrifying—have a simplicity in their ferocity, an innocence in their mood of murder, that command a kind of respect. Brute nature circulates in them, and burning sap and black blood. Although man is afraid of them, he cannot help recognizing and loving his impulses—rendered concrete in the crawling crocodiles and the crouching gorillas which are sketched by long strokes in the wood and which decorate the doors and beams of his hut or the sides of his tomtoms. . . .

Polynesian art, like Oriental art in general, would seem to tend more especially toward decoration, whereas the character of the art of Africa, like European art, shows itself in a more marked tendency to isolate form in order to examine the activity it possesses within its own limits and within its individual characteristics.

It is true that the climate and landscape of Oceanica offer to the sensibility of the Polynesians resources that are not found in Africa. The dispersal of the race among the thousands of large and small islands, separated by vast expanses of sea, is perhaps the only thing which, preventing the necessary cohesion among the peoples, prevented also a great civilization from being born in the Pacific and from spreading round about. And now it is too late; the conquest of these regions by Europe, the diseases, the alcohol, the morality, and the religion that it brought them have made the Polynesians anæmic, have decimated them and overcome them. The time has already arrived when they are beginning no

longer to feel in themselves the poetry of nature which surrounds them and which formed them. . . .

The gods that the Polynesians carved in the soft material of their wood, to be erected on their shores or at the doors of their cabins, are in general more animated than the symmetrical silhouettes cut by the Africans. Perhaps their art is less ingenuously conceived and less severe. There is more tendency to style, it seems, but more skill, and at the same time less strength. The eye sockets, the lips, the nostrils, and the ears become, in the most interesting of these images, the point of departure for long parallel lines, sustained and deeply cut, for spirals and volutes which are the result of the effort to demonstrate religious ideas or to terrify an enemy in war; we find in them a profound and pure agreement between the spirit of the myth and its concrete expression. These are no longer dolls which are terrible only in their candor. They are violently and consciously expressive, with their attributes of killing, with their cruel visages; and the colors that cover them are the symbols of their ferocity in combat and their ardor in love. Whether we consider the grimacing faces on the prows of the long curved boats, or the colossuses sheltered under the branches of the odorous forests— men or monsters daubed with vermilion or with emerald green—we find that all these works have passed the archaic stage represented by the statues of Easter Island, which is to Polynesia what an Egypt still plunged in the original mud would be to a lazy Greece, too much enslaved by the flesh. All are monstrous and alive, all have sprung from the bestial energy unchained by the wild loves and the excited senses of a country drunk with its bursting fruits, its multicolored bays, and the multicolored plumes that rain on it like the sunlight. Long ago, before the white man came to force his somber clothing on the people and to dry up their poetic spirit, the great wooden idols were sisters to the enormous flowers and the birds and the naked men who roamed the woods, tattooed from their feet to their foreheads, painted with red, green, and blue, and covered with great undulating lines that were arranged to bring out the forms, to accompany with their flashes the rhythm of the runners, and to accentuate the muscles of the face in their terrifying play of expression during moments of debauchery and cruelty.

Their purpose was to captivate women, to terrify the enemy, and, through an instinct even more obscure and vast, to play, in the symphony of nature, the role dictated by the great corollas hanging from the tangled vines which bind the giant trees, by the glossy coats of the animals, by the fiery wings, and by the sinking of the stars into the sea. All the primitive peoples of the tropics who go naked in the freedom of the light have, in this way and at all times, loved to paint or tattoo their skins with color—the Negroes of Africa and the Indians of America, as well as the Polynesians. But with the Polynesians, the tattooing takes on a brilliancy, and evinces a care for rhythm and life, that we find nowhere else, save among the peoples that derive from the nations of Oceanica or who have

been in touch with them for a long time. For their geometrical ornament, the Japanese substituted figures of birds, dragons, chimeras, women—which are really pictures, through their movement and composition. The New Zealanders, if they preserved in their tattooing the geometrical ornament of their Oceanic ancestors, brought to it a precision, a violence, a will to style that would almost suffice to define them as artists if their plastic genius had not revealed itself by other manifestations.

ANDRÉ WARNOD

DECORATIVE ARTS AND
ARTISTIC CURIOSITIES · 1912

It is quite possible that someday, maybe even before the end of this year, Negro statuary will come to be discovered. And perhaps future generations will consider a work of art from the ancient Sudan an indisputable masterpiece, somewhat as the Venus de Milo, the Victory of Samothrace or the Mona Lisa are for us.

We should also add that this archaic Negro art accords very well with the works of "contemporary" artists, those of the avant-garde—possibly the classics of the future!

When that time comes and possibly even before, Negro art may well be looked upon as a model for beginning artists. Greek art will be a thing of the past and will be considered a mistake that lasted for a few centuries. But we are not there yet, you may rest assured!

Nevertheless, we must now recognize that these Negro statues possess great character and suggest a very refined and sincere aesthetic sensibility. For example, consider this head with its long hair, and the simplicity with which it has been executed; a bit of drawing and a few lines are enough to impart something definitive and impressive. The eyes are close together and the chin is simply drawn as the point made by intersecting lines; the face has sharp angles; and it all works together to give this head a strange appearance. The hair is stylized with the same authority, with a few locks falling to the right, in a single thrust. Undoubtedly, this head was created with a feeling of absolute love and faith and yet in accordance with a very savage, brutal, and violent law, which is perhaps what gives this figure its character and expression.

You will be struck by how a Greek head would seem, by contrast, almost limp in execution and nearly insignificant in expression beside the rude vigor and directness of Negro Art. Of course the Greek head would continue to offer its admirable harmony and its superhuman beauty, but you would perhaps find it a little tame, especially if you weren't too outraged and shocked by the pungency and violence of the other. Today, it seems that we are especially fond of spicy things. We are a little tired of the offerings of the official Salons. We are looking for something different, although we are not exactly sure what. The new cubist

Comoedia (January 2, 1912).

The French art critic André Warnod (1885–1960) was probably the first writer to use the French phrase *"art nègre"* to refer to African and Oceanic art.

and other movements are far from satisfying those who have begun to tire of the art of the Rue Bonaparte. Many people find the art that they would once have admired now too "pompous." Nevertheless, it may still be a great leap for them to become enthusiastic about cubes and new inventions.

Sick of the vulgarity and conventionality of so many works of art, one welcomes a very different conception of art, and that is why one is tempted to pay attention to these primitive and frankly executed works. This might be compared to a need one might have, after over-indulging in candy and sweets, to taste something sharp, brutal, and especially simple. In looking for this kind of sensation, we may end up admiring these Negro statues for their qualities of reality, originality, and power, which provide a relief from the usual vulgarity. Perhaps artists will take these works as a new point of departure—even if we assume that Negro art hasn't already inspired many works today.

Furthermore, there are people who are passionately fond of this art and collect all they can find of it. Currently, these pieces of art are quite rare, and now it is next to impossible to find new ones. They are fetishes and idols, and the Negroes are vigilant in keeping them; while the ones that are being produced today are poor imitations of the older works. The most enthusiastic collectors of Negro sculpture are those who are fondest of avant-garde arts, often the artists themselves. It is not unusual to find one or more of these wooden statues with triangular faces and carved limbs in the studios of artists with the most sophisticated and advanced sense of design. Resting on the corner of a shelf or on some old sideboard, the Negro statue seems to gaze approvingly at the cubist painting or the contemporary statue as it takes shape through the artist's inspired hand.

VLADIMIR MARKOV

NEGRO ART · 1913

FROM SECTION I

Up to the present time, there has persisted a stubborn opinion that Africa, with the exception of Egypt, was poor in the area of artistic antiquities; that it was a land without a history, without legends, without enigmas, poorer, even, than fantasy could conceive; that if we made our way through its deep forests, we would nowhere find monumental ruins of palaces; that if we penetrated its canals, we would not happen upon burials or other monuments. Crude fetishism, rituals, idols—everything was repulsive, tasteless, and banal. It was believed that Negroes were completely devoid of esthetic conceptions and that the lowest instincts controlled their artistic creation; that Africa did not possess the wealth of archaeological monuments found in Mexico, Asia Minor, or Greece; that it had no past and was therefore lacking in poetic excellence; that only the arrival of Islam brought to this wild people a certain culture—religion, crafts, a governmental organization.

Now we need not ascribe any truth to this opinion. Western Africa is rich both in history and, as we shall see below, in art. It occupies a place of honor in the creation of the world's storehouse of beauty. When we acquaint ourselves with the work of various expeditions, we become amazed at the legends, monuments, and antiquities that come to light among the tribes of Africa. It turns out that even here there was a past—rich, strong, and fabulous. Let us remember how many monumental bronzes, how many finely-worked figures came from Benin alone. When the English conquered that country in 1897, they brought a measureless fortune to Europe, the quantity of which could rival the production of any other country.

Much, of course, has disappeared, but by tirelessly listening, endlessly seeking among extremely secretive tribes, then doing excavations where old legends circulate, it is possible to bring astonishing treasure troves to the light of day, along with the secrets of prehistoric and more recent periods.

Excerpts from *Iskusstvo negrov* (1919), 17–18, 35–40.

The Russian artist and theorist Vladimir Markov (pseudonym of Vladimir Ivanovich Matvei, 1877–1914) wrote this text—one of the first in-depth examinations of aesthetics and symbolism in African art—in 1913, but it was not published until 1919. In preparation for writing the book, Markov had systematically photographed the collections of major ethnographic museums throughout Europe. Markov was also the author of *The Principles of the New Art* (1912) and *The Art of Easter Island* (1914).

Until now, conventional wisdom has held that Central Africa is devoid of stone sculpture—it had not been found. But where many failed to find it, L. Frobenius,[1] the leader of one of the most recent expeditions, succeeded. Succeeded, it must be said, with great effort, for the Negro is secretive and always prepared to deny, to conceal the existence of antiquities of his clan or tribe. It is possible to learn a little only from the Negroes who, by some chance, are separated from their native lands.

The incident of these stone sculptures is so typical that it is worth our while to pause and recount it.

For a respectable reward, one Negro sailor, who had turned up in Hamburg, told Frobenius that in his country every person in ancient times was made of stone, and he even supplied the names of several towns in his homeland. These words proved to be true among the ruins of the towns he named, almost inaccessible to Europeans, where Frobenius found the first stone sculptures.

SECTION IV

Now let us turn to our photographs.[2]

Can we say that all this has beauty?

As I said before, I do not intend to prove this for the present. The reader can find a more detailed analysis of these sculptures in my work on the principles of artistic plasticity, which will appear in the near future.[3] Here I shall limit myself to a short, general characterization. I chose among the innumerable quantities of sculpture primarily those which display folk art the most vividly. Since only a few of such sculptures have turned up in Europe, I relied on those in which it was possible to catch at least the remnants of the original principles of creativity and to bring them to light in one way or another. It was necessary to dismiss the arts that showed the influence of Greece, Byzantium, etc., as well as the numerous realistic sculptures brought into Europe in great quantities but lacking any aesthetic value. I do not believe that such derivative sculptures were predominant in Africa. It soon becomes very clear that each museum, each expedition collects sculptures in its own manner, and I am sure that the most interesting, in the artistic sense, have not found their way into museums but have remained at their original sites. Perhaps the latter present no religious or archeological interest, or it may be that they were produced from fresh material of recent origin, or for whatever reason stimulated no interest in the collector. Send a variety of persons—archaeologists, realistic artists, and contemporary artists—to collect icons all over Russia, and you will see what each one collects and how far they are from understanding each other. The idols I have chosen thus represent only various peaks or oases of great art, distant echoes of the original language that satisfied the plastic needs of the people. Thus it must be admitted that in the domain of art, Africa remains a dark continent to us.

Externally, this art astonishes many with its unusual forms, but rarely does

one encounter an art so rich in materials as this. One observes a striking originality in the object of art, a richness and variety in combination of form and line, and along with this a strictness of style. This art has no equivalent in the world. Nowhere else can art be found in which plasticity plays a similar role. It is strange, but no matter how many various foreign influences have passed through Africa—among them the European for four centuries, with its realism—all this has not annihilated Negro art, and even the most recent of objects has preserved the ancient traditions and the old feelings and understanding of beauty almost without any sign of outside contact. The new generation of artists thanks Africa for helping it emerge from the blind alley and stagnation that characterized European art. Both Picasso and Matisse, as it were, gained an education from African sculpture.

One would wish that ethnographers, who have the opportunity to collect art objects of the Negroes and other primitives, sought to understand this art and evaluate it. True, it is difficult for the eye and the emotions to adapt themselves to a new type of artistic contemplation and to a creative language that is foreign to us. It is neither easy nor pleasant to change one's way of looking, to plunge into the essence of something, to liberate oneself from prejudices.[4]

The Negro loves free and independent masses; when these are linked, a symbol he achieves is a symbol of a human being. He does not pursue realism; his true language consists in the play of masses, and he has developed this language to perfection. The masses with which he works are elementary, characterized by weightiness.

The Negro artist's play of weights and masses is truly varied, endlessly rich in ideas, and as self-sufficient as music.

He combines the parts of the body into one mass and receives in this manner an inspiring heaviness; juxtaposing it by contrast with other weighty masses, he achieves mighty rhythms, planes, and lines.

I must emphasize the basic feature in this play of massiveness and weight: the masses that represent the parts of the body are linked arbitrarily, with no connection to the articulations of the actual human organism. These works give the sense of being architectural constructions with only a mechanical linkage. We notice a piling on of masses, an application to or surrounding of one mass by another in which each mass retains its autonomy.

We will find no echo of organic life, of organic connections, directions of bones or muscles in these masses. The head, for example, has no organic bond with the neck but only a mechanical attachment, since the head is an independent mass. If, however, the size and volume of these independent masses do not imitate nature, they nonetheless follow the laws of ornament, and this ornamental arrangement and the play of masses deserve our attention. The plasticity of these masses is elementary, at times geometrical. "When I was in Picasso's studio

and saw the black idols from the Congo," Tugenhold wrote, "I asked the artist if he was interested in the mystical aspect of these sculptures." "Not a bit," he answered, "I am captivated by their geometric simplicity" (*Apollon, 1914*).

It is possible to discern two tendencies in this art: the graphic element and the play of masses. The first creates fine, sharp contours, outlines, ornaments. I can imagine the ancient folk art of Africa, primarily consisting of the play and conceptualizing of masses. The Pygmies, considered to be the oldest inhabitants of Africa, live scattered in the deep forests of the Congo among the tall tribes of the Bantu. One is tempted to attribute some sculptures to the art of the Pygmies. These idols have dense proportions, weight and mass, as if they were the very sources of Negro folk art. Already, moreover, an original feature comes to light—the attempt to convey a human being with absolute, symbolic masses.

Although L. Frobenius supposed that primeval culture arose in Africa due to the influence of the Etruscans, we can treat this opinion with some skepticism. The art of Etruria, which we know thus far from excavations, differs entirely from the examples of sculpture that are appended to this volume. The primitive art of the Iberian peninsula, however, where is it? Perhaps it existed and developed parallel to the art of Sardinia and Alicante and then disappeared, preserved only in the debris of the Congo's forests. For the present, I am forced to consider the art presented in this volume, with its love of mass, to be the art characteristic only of Africa from ancient times, all the more so because it flourished and was preserved only there—it is difficult to find examples with even the slightest quantitative or qualitative similarities in other parts of the world.

In addition to the play of masses, we find something else. We notice that these sculptures have expressions that are very forthcoming, strong, clear, and simple. Even if we take into account only a few masses, we see that they are worked out very cleverly. The symbolism of the real is conveyed convincingly, the features of people and gods are sharply expressed. A certain emphasis on, as it were, crude, realistic sensuality may at first repel us; but this impression disappears when we observe the pieces with more concentration. One will become convinced that the sculpture is pure and free of any sensuality, in contrast to some of the arts of Asia. I also do not see anything laughable or humorous in them, since burlesque and caricature can be conveyed only within the boundaries of realism. Here all parts of the human body are conveyed symbolically.

I would like to emphasize, in order to avoid any misunderstanding, that I am speaking here of plastic, and not literary, symbolism.[5]

Look at any detail, the eye, for example; this is not an eye, but often a slit, a shell, or something else taking its place, yet all the while this fictive form is beautiful, plastic—we shall call this the plastic symbolism of the eye. The art of the Negroes commands an inexhaustible richness of plastic symbols; nowhere is there realism of form, for the forms are completely arbitrary, they serve real functions but with a plastic language. By these means the Negro conveys his en-

tire world of representations and sensations. This type of symbolism is at times intuitive and at times speculative, but always creative, and we Europeans can only envy the capacity of thought that creates such a richness of forms. Having such a language, the Negro did not have to know the laws of the organism, its proportions, anatomy, features, movements—even without these he found a more expedient means of conveying his spiritual convictions. Artists of the new direction highly value this language, which is difficult to attain and all but lost to contemporary culture. To this day, the Negroes have preserved this gift of thinking in terms of plasticity and command a striking talent and inventiveness in the creation of increasingly splendid plastic symbols that we find astonishing. If ethnographers and other collectors looked at Negro art from this perspective, they would understand that the Negroes are a deeply-thinking people and, once having collected all that relates to their art, would be convinced that it possesses monumentalism of concept and execution.

The third characteristic of these sculptures, one that cannot be ignored even if we can only devote a small space to it, is the technique of manufacture.

We could not call the technique applied here "pure," as it is among the people of Northern Asia. Only in rare cases do we get a hint of mastery over one material or proficiency in the use of a certain tool, e.g., wood and axe. In one and the same Negro sculpture it is possible to find traces of both clay technique and use of the axe, as well as of bronze and other materials and implements.

The art of making and the familiarity with their forms resulted in the translation of this technique's entire timbre and effects to wood, then to other materials, to the degree that the artist, in the final analysis, created not an animal or a god, but rather a mask of that being.

In general, the artists used a selection of raw materials, rarely limiting themselves to one medium.[6] They employed nails for the portrayal of hair; one can observe this even in heads of an archaic character. As a consequence of the attraction to new materials, new forms appeared spontaneously; such symbolic means almost always produced the desired effects. A special shell or a nail with a large head conveys the form, gleam, and life of an eye; and the form itself, alien to that of a real eye, was in and of itself originally beautiful because it was plastically connected with the surrounding materials and forms. In wooden sculpture the artist repeated a given form, in which an unrealistic eye—either a shell or a nail—served as a prototype. Thus, the selection of materials left a durable trace on the technique and forms that must have symbolized eyes or other parts of the human body.

This means that the development of this type of technique was quite simple. At first there was no ability to create and convey the human eye, so the Negro sought out something of equal value in surrounding nature, whether it be a nail or a shell; later on, he would not imitate the eye itself but rather its symbolic replacement, justifying the aspirations of the artist and plastically recreating

the form once it was found, and in time deviating further and further from the prototype.

There are idols that are made of many materials: metallic discs, rings, shells, cords, hair, etc., where great taste and understanding in the choice and combination of materials can be noticed, since all material gladdened the eye of primitive man and became valuable to him—be it iron, bronze, or shell. Of course, the abundance of a substance such as iron diminishes the loving and careful human relationship to it.

Thus, we do not find a single pure technique among the Negroes, but rather a play of many techniques.

The imitation of one material by another can be observed in the following example. In early times, people placed elephant tusks at the fronts and sides of the thrones of their leaders, and did the same to the portals of their homes. Since this valuable material gradually sailed off to Europe, however, Africans set up wooden tusks where they once used authentic ones; although the form of a tusk is difficult to produce in other materials, nonetheless it was imitated in wood and in stone. (Let us recall the stone monoliths of Africa and the obelisks of Egypt.)

Many idols, even those of the most recent manufacture, are of value to us since technique and tradition are preserved in them. We clearly perceive in wood the form and technique that were used in clay and we hear the echoes and murmurings of ancient beauties.

As regards the external preparation of the surfaces, it is exceedingly various. We encounter statues polished to an exceptionally fine degree and, generally speaking, finished very carefully with regard to technique.

NOTES

1. [Leo Frobenius (1873–1938), German explorer and ethnologist, one of the originators of culture-historical ethnology, and a leading authority on prehistoric art. His important 3-volume work, *Und Afrika sprach* (*The Voice of Africa*), was published in 1912–13. Eds.]

2. [In the original work, 123 photographs follow Markov's text. Trans.]

3. *Principles of Weight* and *The Plastic Symbol* will appear soon if we are able to complete the editing and indexing that was interrupted by Markov's death.

4. There exists a prejudice against everything pertaining to the Negro that is absolutely without foundation, but so great that many travelers who go to Africa are squeamish about staying in the homes of Negroes and whenever possible stay with Moslems.

5. For details about this symbolism see the entry "Plastic symbol" in *Principles of Plastic Art*.

6. See V. Markov, *Faktura* (1914).

KARL SCHEFFLER

PICASSO AND AFRICAN SCULPTURE
EXHIBITION, BERLIN · 1913

Lessing's *Emilia Galotti* is now playing at the German Theater. Actually, the artists involved in the latest trends should assemble at the theater to applaud loudly when Conti says: "Art must depict in accordance with how the Plastic Force of Nature[1] conceives the image." Parenthetically, the actor who plays Conti would then perhaps try to speak these important words less quickly because, in reference to the latest trends, these words have a programmatic value. In certain ways painters are returning to the magistrate of Wolfenbuettel. The works of art that Lessing had in mind when he formulated this thesis were not the most recent ones. He was thinking about the Laocoon and perhaps of Raffael Mengs, while today's painters think of Negro sculptures and cubism. But that does not affect the thesis. Lessing was wonderfully clever in gracefully interlacing the proof of his statement with doubt: "Art must depict in accordance with how the Plastic Force of Nature—if there is such a thing—conceives the image." Picasso does not speak in the elegantly conditional terms of "if there is such a thing." He has as little doubt as did the Negroes when they carved their old fetishes. In recent weeks, both Negro sculptures and Picasso's latest paintings were exhibited side by side at the Neue Galerie. With both there is little to see, since only in a few of the Negro sculptures—and in them only in a few places—is a truly creative instinct for form expressed; and in Picasso's work form is totally lacking. In the three or four more worthwhile Negro sculptures one at least recognizes that the primitive carvers carried within themselves a sense of the Plastic Force of Nature. They felt the concave as concave, the convex as convex; they felt everything to be unequivocal and strict. They carved without a model in front of them, guided toward their objectives by the Plastic Force of Nature and their own rigid conventions. As a painter, Picasso would like to do the same thing, even though the whole history of art lies between him and the Negroes. Isolated in his studio with his models, he has to think up his own con-

Excerpt from *Kunst und Künstler* (January 1914): 229.

Karl Scheffler (1869–1951) was a prominent German art critic and the editor of *Kunst und Künstler* from 1906 to 1933. This is a review of an exhibition of Picasso's recent works along with African sculpture, held at the Neue Galerie, Berlin, in December 1913.

ventions; in other words, he is like Münchhausen, who has to extricate himself from the morass by his own hair. The effect created is that one sees only the hair of the artist sticking out of the morass with a pair of hands desperately pulling on it.

NOTE

1. ["Plastische Natur" in the original. The German philosopher, critic and playwright Gotthold Ephraim Lessing (1729–81) was influenced by the English philosopher Ralph Cudworth (1659–1708), who proposed the hypothesis of the "Plastick Life of Nature." Plastic Nature according to Cudworth is a formative principle which acts as an intermediary between the divine and the natural world. Eds.]

EMIL WALDMANN

PICASSO AND AFRICAN SCULPTURE EXHIBITION, DRESDEN · 1914

The exhibition of Pablo Picasso, together with the exhibition of Negro sculpture, leaves the impression of a catastrophe. If one arranges an exhibition of Picasso in a city like Dresden, where Picasso is hardly known, then in my opinion one would have to show the early Picasso with his major works. It is not necessary to overestimate the early works, but they are important in their fashion—in as far as they are a revival of the line that had stopped with Puvis de Chavannes and Maurice Denis—and they are impressive and very tasteful. One could have added a few examples of his Cubism. But not the other way around, not so that the visitors stand in front of half a dozen only partially good early works before they take in an endless series of Cubist works. That Picasso went awry with his Cubism is vividly denied. But I certainly believe that he is now on the wrong track. When Negro sculpture, that generally miserable product of some Egyptian provincial art that got stuck somewhere in the jungle, became known to Picasso it made his concept collapse and it became his predominant aspiration to use those primitive artistic principles that derived from awful sculptures in his paintings. By forcing the style of sculpture and pictorial elements together, he could only fail.

Excerpt from *Kunst und Künstler* (March 1914): 344–45.

Emil Waldmann (1880–1945) was a German art critic. After it was shown in Berlin, the dual exhibition of Picasso and African sculpture was shown at the Kunstsalon E. Richter in Dresden, in January 1914.

MARIUS DE ZAYAS

STATUARY IN WOOD BY AFRICAN SAVAGES: THE ROOT OF MODERN ART · 1914

Modern art is not individualistic and esoteric and even less an expression of spontaneous generation. It shows itself more and more frankly as an art of discoveries.

Modern art is not based on direct plastic phenomena, but on epiphenomena, on transpositions and on existing evolutions. In its plastic researches modern art discovered Negro Art. Picasso was the discoverer. He introduced into European art, through his own work, the plastic principles of negro art—the point of departure for our abstract representation.

Negro art has had thus a direct influence on our comprehension of form, teaching us to see and feel its purely expressive side and opening our eyes to a new world of plastic sensations. Negro art has re-awakened in us a sensibility obliterated by an education, which makes us always connect what we see with what we know—our visualization with our knowledge, and makes us in regard to form, use our intellect more than our senses.

If through European art we have acquired the comprehension of form, from the naturalistic point of view, arriving at mechanical representation (by mechanical representation I meant photography), Negro art has made us discover the possibility of giving plastic expression to the sensation produced by the outer life, and consequently also, the possibility of finding new forms to express our inner life.

Negro art, product of the "Land of Fright," created by a mentality full of fear, and completely devoid of the faculties of observation and analysis, is the pure expression of the emotion of a savage race—victims of nature—who see the outer world only under its most intensely expressive aspect and not under its natural one.

Statuary in Wood by African Savages: The Root of Modern Art, exh. cat. (New York: "291" Gallery, 1914).

Marius de Zayas (1880–1961), an associate of Alfred Stieglitz at the gallery of the Photo-Secession group, wrote this text to accompany the exhibition he organized at the "291" Gallery, although it is not certain that it was actually published. The exhibition, which ran from November 3 to December 8, was the first in the United States in which African art was "shown solely from the point of view of art." The objects came from Paul Guillaume in Paris. De Zayas, a Mexican-born American caricaturist, art critic, and collector, was in his own words "a propagandist for modern art."

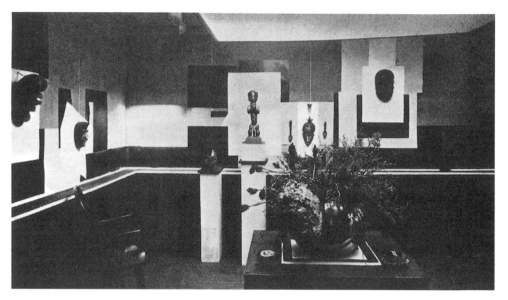

Figure 14. African sculpture exhibition at Stieglitz's "291" Gallery, New York, 1914.

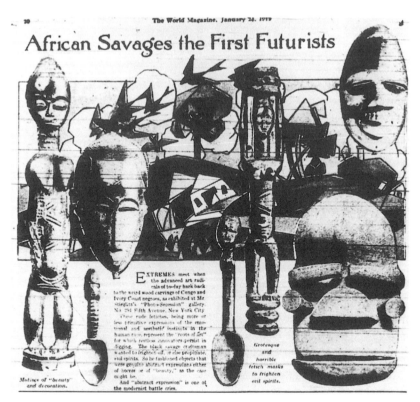

Figure 15. Magazine notice for the African sculpture exhibition at "291" Gallery (1915).

The introduction of the plastic principles of African art into our European art does not constitute a retrogradation or a decadence, for through them we have realized the possibility of expressing ourselves plastically without the recurrence of direct imitation or fanciful symbolism.

CHARLES H. CAFFIN

ROOT OF ART IN NEGRO CARVINGS · 1914

The tenth season at the Little Gallery of "291" Fifth Avenue opens with an exhibition of statuary in wood by African savages. Hitherto objects corresponding to such as are shown here have been mostly housed in natural history museums and studied for their ethnological interest. In the Paris Trocadero, however, their artistic significance has been recognized, as it also has been by certain French art collectors and by some of the "modernists" among artists—notably Matisse, Picasso and Brancusi.

It is as the primitive expression of the art instinct, and particularly in relation to modernism in art, that the present exhibition is being held, and it is said that "this is the first time in the history of exhibitions that Negro statuary has been shown from the point of view of art."

These objects have been obtained from the middle-west coast countries of Africa—Guinea, the Ivory Coast, Nigeria and the Congo. Nothing is known of their date or of the races who produced them, the natives in whose possession they were found having come into some sort of contact with white civilization and lost the traditions of the art.

I have talked with Marius de Zayas, the well-known caricaturist, who for many years has been studying ethnology in relation to art with the view of discovering the latter's root idea, and who accumulated these eighteen examples during his recent visit to Paris. He begins by reminding one of the accepted premise in the study of the evolution of civilization, namely, that every stage in the progress of mankind, wherever it may have occurred, has been characterized by a corresponding attitude toward life and a corresponding expression of it in the handiworks.

While hitherto historians of art have looked for its roots in such directions as the lake dwellers and the caves of Dordogne, they have overlooked the fact that the white race in itself represented an evolution in advance of the black. Consequently, to get at the root of art one must dig deeper than the white primordial and look for it in the black.

The objects, however, which are here shown do not go down to the deepest elemental expression of the savage. They represent him at a comparatively advanced stage, by which time he had evolved a very marked feeling for beauty.

These specimens, when once you have got over the first impression of gro-

New York American (November 2, 1914): 9.
 Charles H. Caffin (1854–1918) was a prominent American art critic.

tesqueness, are easily found to be distinguished by qualities of form, including the distribution of planes, texture and skillful craftsmanship that are pregnant with suggestion to one's esthetic sense.

With what motive and under what kind of inspiration did the primitive artist carve these works? Mr. de Zayas explains that the savage looked out upon a world that seemed full of threats; that his imagination involved no idea of good, but only one of fear of mysterious agencies whose evil purposes he must avert.

He had recourse to fetishes; in earliest stages some stone or stock of wood. As he evolved he increased the efficacy of these by fashioning them into forms of his own devising. Such are the objects here shown; they are fetishes.

Characteristic of all is the purely objective way in which the carver approached his subject. He set out to make his public see just what he saw in the object. But the way in which he saw it was entirely opposed to the photographic way. It was not representation, as in the case of white savage art; it was rather what we call today the caricaturist's way.

If he wished to objectivize the fierce bulging of the eyes, he makes them protrude like pegs; if a covert expression of the eye, he parts the closed lids by a decisive slit. Note, again, in one face the power expressed by the massive protuberance of the features and in another the refinement, actually subtle, obtained by varying the surfaces of the planes. And in almost every case it is not representation, but suggestion, that secures the objective reality. Here is the essential difference between this art and that of white savages.

In a word, the main characteristic of these carvings is their vital objectivity, rendered by means that are abstract. This or that objective fact has been, as it were, drawn out into constructive prominence, and has been given such a shape as would most decisively emphasize it.

Another feature of these carvings which must not be overlooked is their decorative character. It was necessity in the first place that prompted the making of these fetishes. They were needed for the preservation of the race. But by this time the instinct to beautify the needful things of life had been evolved. One can discover it in the details, added for no other purpose than that of ornament, as well as in the treatment of the hair, and of the surfaces generally.

It is impossible, for example, to believe otherwise than that the carver was satisfying his instinct of beauty when he sloped down the contours of one face and curved the lips of another. Over and over again there are details of form and surface that are replete with esthetic feeling.

And one other characteristic among many more that could be mentioned distinguishes these objects. To a greater or less degree all are expressive of movement, be it but the opening or shutting of the eyes. A feeling for the static does not belong to the savage. He is ever on the move, encountering the changes of the seasons and weather. To him life is movement, which, by the way, brings his primordial instinct into touch with modern philosophy as well as modern art.

KAZIMIR MALEVICH

THE ART OF THE SAVAGE
AND ITS PRINCIPLES · 1915

The savage was the first to establish the principle of naturalism: in drawing a dot and five little sticks, he attempted to transmit his own image.

This first attempt laid the basis for the conscious imitation of nature's forms.

Hence arose the aim of approaching the face of nature as closely as possible.

And all the artist's efforts were directed toward the transmission of her creative forms.

The first inscription of the savage's primitive depiction gave birth to collective art, or the art of repetition.

Collective, because the real man with his subtle range of feelings, psychology, and anatomy had not been discovered.

The savage saw neither his outward image nor his inward state.

His consciousness could see only the outline of a man, a beast, etc.

And as his consciousness developed, so the outline of his depiction of nature grew more involved.

The more his consciousness embraced nature, the more involved his work became, and the more his experience and skill increased.

His consciousness developed in only one direction, toward nature's creation and not toward new forms of art.

Therefore his primitive depictions cannot be considered creative work.

The distortion of reality in his depictions is the result of weak technique.

Both technique and consciousness were only at the beginning of their development.

And his pictures must not be considered art.

Because unskillfulness is not art.

He merely pointed the way to art.

Consequently, his original outline was a framework on which the generations hung new discovery after new discovery made in nature.

And the outline became more and more involved and achieved its flowering in antiquity and the Renaissance.

Excerpt from *Ot kubizma i futurizma k suprematizmu: Novyi zhivopisnyi realizm* (1916).

The Russian artist Kazimir Malevich (1878–1935) wrote this text to coincide with the first showing of his suprematist work at "0.10," a Futurist exhibition in Petrograd, December 1915.

The masters of these two epochs depicted man in his complete form, both outward and inward.

Man was assembled, and his inward state was expressed.

But despite their enormous skill, they did not, however, perfect the savage's idea:

The reflection of nature on canvas, as in a mirror.

And it is a mistake to suppose that their age was the most brilliant flowering of art and that the younger generation should at all costs aspire toward this ideal.

This idea is false.

It diverts young forces from the contemporary current of life and thereby deforms them.

Their bodies fly in airplanes, but they cover art and life with the old robes of Neros and Titians.

Hence they are unable to observe the new beauty of our modern life.

Because they live by the beauty of past ages.

CARL EINSTEIN

AFRICAN SCULPTURE · 1915

METHODOLOGICAL COMMENTS

There is scarcely an art that Europeans are more suspicious of than African art. At first, they often refuse even to call it art, so that the gap between these works and the European attitude is expressed in a contempt that has led to a negative terminology. This gap and the resulting biases interfere with, indeed prevent, any aesthetic evaluation, for the latter presupposes some kind of rapport. However, from the very start, the African is considered an inferior, who must be ruthlessly improved, and what he has to offer is dismissed *a priori* as deficient. Vague hypotheses about evolution have been frivolously cobbled to fit him. Some observers have forced their misconception of "primitiveness" upon him, while others have decked out the helpless African with erroneous but persuasive claptrap about "eternally prehistoric tribes." Europeans have tried to depict the African as existing in a primeval state from which he can never emerge. Many opinions about Africans are based on such prejudices, which have been exploited to bolster a convenient theory. In his bigotry, the European presumes that he is absolutely, indeed fantastically, superior to the African.

But in fact, our scorn of the African is due simply to our ignorance, which burdens him unfairly.

One may infer from these plates that the African is not an undeveloped person, that a major African civilization has perished, and that today's African may be to a possible "ancient" African as today's fellah is to the ancient Egyptian.

Several problems in recent European art have prompted a less frivolous inquiry into the art of African nations. As always, the inquiry was triggered by a current artistic event, leading Europeans to find a corresponding African his-

Negerplastik (1915). Translated from German by Joachim Neugroschel.

Carl Einstein (1885–1940), German art historian and critic, wrote extensively on both modern and Primitive art. *Negerplastik,* which was written in the beginning of 1914, was the first comprehensive book about African art. The book included 119 illustrations, some of which were misattributed Oceanic works. It is remarkable for its analysis of sculptural language in general as well as for its discussion of the religious and spiritual background from which African art emerged. Einstein was virtually alone among the early writers on African art in questioning a number of the racist assumptions about Africans. The complete text is here translated into English for the first time. Although the word *Neger* was generally employed in a broad sense to mean "Negro" at this time, the text deals solely with African art, and we have acceded to the translator's desire to render *Neger* as "African" rather than as "Negro."

tory—with the art of the African nations at its core. Something that once appeared senseless became meaningful in the latest artistic efforts: Europeans realized that nowhere have certain spatial problems and a special artistic approach been developed in such purity as in Africa—so that previous verdicts on the African and his art tell us more about the judge than about the object of his judgment. The new attitude soon produced a new passion: Europeans started collecting African art as art; in this new activity, they eagerly reinterpreted the old materials, turning them into new objects.

This brief examination of African art cannot avoid the experiences of modern European art, especially since anything that operates in history is always a consequence of the immediate present. However, these relations will be developed later on, so that we can dwell on a single object and not be distracted by comparisons.

Our knowledge of African art is meager and hazy: aside from a few pieces from Benin, nothing is dated. Several types of artworks are classified according to where they were found, but I do not consider such data useful. Not only have tribes shifted and migrated throughout Africa, but presumably here, as elsewhere, they have fought over fetishes, and the winners have appropriated the gods of the losers in order to possess the strength and protection of these deities. Completely diverse styles often come from a single area, and we may offer multiple explanations without settling on the correct one. We can only posit that in such cases there was an earlier and a later art, or that two distinct styles coexisted side by side, or that one style was imported. For the time being, in any case, neither our historical nor our geographic lore permits even the most approximate resolution. Obviously a stylistic critique cannot be inflicted on a historical sequence that runs from simple to complex. We should discard the notion that simple and initial are identical. Europeans all too readily and falsely assume that the premise and method of thinking are also the start and the manner of the events. Rather, each start (by which I mean an individual and relative beginning—for no other can ever be factually pinpointed) is extremely complex, since a human being wants to express a great deal, indeed too much, in a single entity.

That is why the attempt to say anything about African sculpture seems somewhat doomed. Especially since a majority of observers still demands proof that this is truly art. So we must fear that we will remain dependent on describing external data—a process that can never tell us anything but that a loincloth is a loincloth, a process that never reaches a general conclusion about an overall area to which all these loincloths and thick lips belong. (I find it dubious to view art as a guide to anthropological or ethnological insights, since an artistic depiction says little about the facts on which this scholarship relies.)

Nevertheless, we have to start with the fact and not with a surrogate that has been foisted upon us. I believe that the fact of the existence of African sculptures is more certain than any possible ethnographic or other knowledge! We

will exclude the objectiveness, the objects of surrounding associations, and analyze these works as creative entities. We will try to find out whether the formal aspects of the sculptures produce an overall formal conception that is at one with conceptions of artistic forms. However, there is one thing we absolutely have to go by and one thing we absolutely have to shun. We must stick to viewing a piece by its own lights and acting within the specific laws of what we see; we must never force the structure of our own thinking upon what we see or upon the creativity that we track down. We must never interpolate convenient evolutions or equate the process of thinking with the creative process of artistry. We have to toss out the biased assumption that psychological processes can be simply regarded as the same situation in reverse or that reflections on art merely contrast with the creation of art. Rather, such reflections are a generally different process that transcends form and its world in order to pigeonhole an artwork within the overall context.

However, describing sculptures as formal entities does a lot more than merely present their concrete and objective state; an objective itemization goes beyond the given work, reutilizing it not as a creative entity but as a guide to some kind of praxis that is not on its level. On the other hand, the analysis of forms remains with the immediate givens: for only certain forms can be posited, but they are grasped as individual things, since, as forms, they also say something about the visual approaches and the laws of viewing—thereby forcing on us a knowledge that remains in the sphere of the givens.

If we can implement a formal analysis that is based on and circles around certain peculiar unities of spatial creation and of contemplation, then we have implicitly proved that the given works are art. One might counter that a tendency to generalize and a preset determination secretly dictate such a conclusion. But this is wrong, for the individual form includes the valid elements of viewing—and even depicts them, since these elements can be presented only as form. On the other hand, the individual case does not interfere with the peculiarity of the concept; instead, the two are in a dualistic relationship with one another. It is precisely the essential agreement between the process of viewing and the materialization of the elements that constitutes the work of art. And we should also bear in mind that artistic creation is just as "arbitrary" as the necessary tendency to turn individual forms of viewing into laws; for in both cases, a process of organizing is striven for and attained.

THE PAINTERLY

The European's usual failure to appreciate African art parallels its stylistic power; after all, this art constitutes a significant instance of three-dimensional viewing.

We may state that European sculpture is filled with painterly surrogates. In Hildebrand's *Problem der Form* (Problem of Form) we have the ideal balance of painterly and sculptural. Before Rodin, French sculpture, remarkable as it may

be, seems to aim at wiping out the sculptural. Even frontality, normally regarded as a strict "primitive" purification of form, has to be taken as a painterly treatment of the cubic [i.e., solid, three-dimensional]; for frontality sums up the three-dimensional on multiple levels, which suppress the cubic. After all, the parts closest to the viewer are accentuated and arranged in surface planes, while the more distant parts are seen as an incidental modulation of the front surface, which is dynamically weakened. Here, the artist emphasizes the motifs that are concretely placed in front.

In other cases, the artist replaced the cubic with an objective equivalent of motion; or else, using a drawn or modeled motion of form, he whisked away the decisive component, the immediate expression of the third dimension. Even perspective efforts are harmful to the process of sculptural viewing. Thus we easily understand why the necessary and determined borderline between relief and free-standing sculpture has been fading since the Renaissance, and the painterly excitement, playing around the cubic material (the mass), has transcended any three-dimensional formal structure. As a result, it was painters and not sculptors who delved into crucial issues of three-dimensionality.

Given these formal tendencies, it is clear why our art had to undergo a thorough blending of painterly and sculptural (Baroque). This development could end only with the total defeat of sculpture, which, attempting at least to preserve the maker's excitement and convey it to the viewer, had to be entirely impressionistic and painterly. The three-dimensional was eliminated; the personal "script" carried the day. This history of form was necessarily beholden to a psychological process. Artistic conventions seemed paradoxical; harmony was embodied in an utterly intense creator and, accordingly, in an utterly stimulated viewer; the dynamics of individual processes won out; they became essential and were dwelled on and strongly highlighted. The decision was placed in the prelude and afterword, the work turned increasingly into a guide for psychological excitement; the individual flow, cause, and effect were fixated. These sculptures were more like confessions of a genetic development as objectified forms, more like the lightning-fast contact of two individuals; the dramatics of the judgment passed on works was often considered more important than the art itself. Every precise canon of form and viewing had to be resolved.

A more and more intense development of the sculptural was striven for, a later multiplication of the methods. The actual lack of the sculptural could not be made up for by that "realistic" legend of the "palpated" model; instead this very legend confirmed the absence of a thorough and uniform conception of space.

Such action destroys the distance of things and allows only for the functional meaning that they preserve for the individual. This kind of art signifies the potential accumulation of as great a functional effect as possible.

In several recent artistic efforts, we have seen that this potential component, the viewer, was made virtual and visible. A very few European styles diverged from this—especially the Romanesque-Byzantine, but its Oriental origin has been demonstrated; and equally well known is the rather swift transformation into movement (Gothic).

The viewer was woven into the sculpture, becoming an inseparable function (e.g., perspective sculpture); he united with the predominantly psychological reevaluation of the maker's person if he did not contradict that person by judging him. Sculpture was the subject of a conversation between two people. A sculptor oriented along those lines had to be interested mainly in predetermining the effect and the viewer; in order to anticipate and test the effect, he obviously had to turn himself into the viewer (Futurist sculpture), and the sculptures have to be seen as a "transliteration" of the effect. The spiritual and temporal components fully outweighed the spatial determinant. In order to achieve the—albeit often unconscious—goal, the artist would establish the identification of viewer and maker, for this was the only way to obtain an unrestricted effect.

This state of affairs is marked by the fact that the artist usually sees the effect on the viewer as a reversal of the creative process even though the effect is characterized as nonintense. The sculptor submitted to the majority of spiritual processes and transformed himself into the viewer. While working he would always maintain the detachment of the future viewer and he would model the effect; he emphasized the viewer's visual activity and modeled in touches, so that the viewer himself would shape the actual form. Spatial construction was sacrificed to a secondary, indeed alien feature: material motion. Cubic space, the premise of all sculpture, was forgotten.

Just a few years ago we experienced the impact of a new crisis in France. Through a tremendous exertion of consciousness we realized how nonfunctional and dubious this process was. Several painters had enough strength to avoid a handiwork that slid mechanically further: detached from the usual means and methods, they investigated the elements of viewing space, the things that this viewing produces and dictates. The results of this important effort are sufficiently well known. At the same time, Europeans logically discovered African sculpture and realized that this art, in isolation, had cultivated the pure sculptural forms.

Normally the efforts of these painters are described as "abstraction," though we cannot deny that it was only through a rigorous critique of the muddled terminology that Europeans managed to approach a direct grasp of space. Yet we must approach this direct grasp, which powerfully separates African sculpture from the art that it affects and which gives it an awareness: what looks like abstraction in Europe is an immediate and natural given in Africa. In formal terms African sculpture will prove to be the most powerful realism.

Today's artist not only seeks pure form, he also regards it as the opposition to his prehistory, and he weaves extreme reactiveness into his striving; his necessary criticism intensifies the analytical component.

RELIGION AND AFRICAN ART

African Art is, above all, religious. The Africans, like any ancient people, worship their sculptures. The African sculptor treats his work as a deity or as the deity's custodian: from the very outset, he maintains a distance from his work because this work either is or contains a specific god. The sculptor's work is adoration from a distance, so that the work is, *a priori*, autonomous and more powerful than its maker, especially since the latter devotes his utmost intensity to the sculpture; thus, as the weaker being, he sacrifices himself to it. His labor must be described as religious worship. The resulting piece, as a deity, is free and independent of everything else: both worker and worshiper are at an immeasurable distance from the work. The latter will never be involved in human events except as something powerful and distanced. The transcendence of the work is both determined by and presumed in religiosity. It is created in adoration, in terror of the god, and terror is also its effect. Maker and worshiper are *a priori* spiritual, that is, essentially identical: the effect lies not in the artwork but in its presumed and undisputed godliness. The artist will not dare to vie with the god by striving for an effect; the effect is certainly given and predetermined. It makes no sense to treat such an artwork as striving for an effect since the idols are often worshiped in darkness.

The artist produces a work that is autonomous, transcendent, and not interwoven with anything else. This transcendence is manifested in a spatial perception that excludes any possible action by the viewer; a completely drained, total, and unfragmentary space must be given and guaranteed. Spatial self-containment does not signify abstraction here; it is an immediate sensation. This is guaranteed only if the cubic is achieved totally—that is, if nothing can be added to it. Any activity by the viewer is entirely omitted. (To achieve something similar, religious painting is confined to the pictorial surface; thus, it cannot be approached in decorative or ornamental terms, which are secondary consequences.)

I have said that the three-dimensional must be complete and undiminished. The contemplation is determined by religion and fortified by the religious canon. This determination of the viewing leads to a style that, rather than submitting to any arbitrary individualism, is dictated by the canon and may be altered only by religious upheavals. The viewer often worships the works in darkness; while praying he is entirely absorbed in and devoted to the god, so that he can scarcely affect, much less even notice, what sort of artwork this is. The situation is the same when a king or chieftain is depicted; indeed, a divinity is contemplated, even venerated in a common man's artwork; this too determines

the work. An individual model or portrait has no place in such an art—or at most as a profane subsidiary art that can barely elude the religious practice of art, or that contrasts with it as less essential and unprestigious. The work is treasured as the prototypical embodiment of the worshiped power.

A feature of African sculpture is the strong autonomy of its parts; this too is determined by religion. An African sculpture is oriented not toward the viewer but in terms of itself; the parts are perceived in terms of the compact mass, not at a weakening distance. Hence, they and their limits are reinforced.

It also strikes us that most of these works have no pedestal or similar support. This absence might come as a surprise since the statues are, by our norms, extremely decorative. However, the god is never pictured as anything but a self-sufficient being, requiring no aid of any kind. And he has no lack of pious, adoring hands when he is carried about by the worshiper.

Such an art will seldom reify the metaphysical, which is taken for granted here. The metaphysical will have to be manifested entirely in the complete form, concentrated in it with amazing intensity. That is to say, the form is treated thoroughly in terms of extreme self-containment. The result is a great formal realism; for nothing else can release the forces that exist as immediate form rather than becoming form through abstraction or reactive polemics. (The metaphysical in today's European artists still hints at the previous critique of the painterly and is involved in representation as an objective and formal essence; this completely challenged the absoluteness of religion and art and their rigorously staked-off correlation.) Formal realism, not construed as imitative, mimetic naturalism, has an inherent transcendence, for imitation is impossible: whom could a god imitate, to whom could he submit? The result is a consistent realism of transcendent form. The artwork is viewed not as an arbitrary and artificial creation, but rather as a mythical reality, more powerful than natural reality. The artwork is real because of its closed form; since it is autonomous and extremely powerful, the sense of distance is bound to produce an art of enormous intensity.

The European artwork is subject to emotional and even formal interpretation, in that the viewer is required to perform an active visual function, whereas the African artwork has a clear-cut goal, for religious reasons beyond the formal ones. The African artwork signifies nothing, it symbolizes nothing. It is the god, and he maintains his closed mythical reality, taking in the worshiper, transforming him into a mythical being, annulling his human existence.

Formal and religious self-containment correspond to one another—as do formal and religious realism. The European artwork became the metaphor of the effect that challenges the viewer to indulge in casual freedom. The religious artwork in Africa is categorical and has a precise existence that defies restriction.

For the artwork to have a delimited existence, every time-function must be omitted; that is, one cannot move around or touch the artwork. The god has no

genetic evolution; this would contradict his valid existence. Hence, without using relief (which shows a nonpious and nonindividual hand), the African has to find a representation that instantly expresses itself in solid material. The spatial viewing in such an artwork must totally absorb the cubic space and express it as something unified; perspective or normal frontality is prohibited here—they would be impious. The artwork must offer the full spatial equivalent. For it is timeless only if it excludes any time-interpretation based on ideas of movement. The artwork absorbs time by integrating into its form that which we experience as motions.

VIEWING CUBIC SPACE

Any conceptual debate, no matter how deeply rooted in the act of viewing, becomes autonomous and refrains from expressing all divergences of artistic events in order to maintain its specific structure.

First of all, we have to examine the formal visual quality on which African sculpture is based. We can fully ignore the metaphysical correlative since we have pinpointed it as an autonomous factor, and we know that an abstracted form must have resulted from religion.

We then have to clarify the formal viewing process expressed in this art. We will avoid the mistake of ruining African art by unconsciously recalling any European art form, since for formal reasons African art presents itself as a sharply defined area.

African sculpture presents a clear-cut establishment of pure sculptural vision. Sculpture that is meant to render the three-dimensional is taken for granted by the naive viewer, since it operates with a mass that is determined as a mass in three dimensions. This task appears to be difficult, indeed almost impossible, for instance, when we realize that not just any spatiality, but rather the three-dimensional, must be viewed as *form*. When we think about it, we are overwhelmed with almost indescribable excitement; this three-dimensionality, which is not taken in at one glance, is to be formed not as a vague optical suggestion, but rather as a closed, actual expression. European solutions, which seem makeshift when tested on African sculpture, are familiar to the eye, they convince us mechanically, we are accustomed to them. Frontality, multiple views, overall relief, and sculptural silhouette are the most common devices.

Frontality almost cheats us of the third dimension by intensifying all power on one side. The front parts are arranged in terms of a single viewpoint and are given a certain plasticity. The simplest naturalist view is chosen: the side closest to the viewer, orienting him, with the aid of habit, in terms of both the object and the psychological dynamics. The other views, the subordinate ones, with their disrupted rhythms, suggest the sensation that corresponds to the idea of three-dimensional motion. The abrupt movements, tied together mainly by the object, produce a conception of spatial coherence, which is not formally justified.

The same holds true for the silhouette, which, perhaps supported by perspective tricks, hints at the cubic. At closer inspection, we see that the silhouette comes from drawing, which is never a sculptural element.

In all these cases, we find painting or drawing; depth is suggested, but it is seldom given immediate form. These procedures are based on the prejudice that the cubic is more or less guaranteed by the material mass and that an inner excitement circumscribing the material mass or a unilateral indication of form would suffice to produce the cubic as a form. These methods aim at suggesting and signifying the sculptural rather than actually carrying it out. Yet this cannot be accomplished in this way, since the cubic is presented as a mass here and not immediately as a form. Mass, however, is not identical with form; for mass cannot be perceived as a unity; these approaches always involve psychological acts of motion, which dissolve form into something genetically evolved and entirely destroy it. Hence the difficulty of fixing the third dimension in a single act of optical presentation and viewing it as a totality; it has to be grasped in a single process of integration. Which, however, is form in the cubic.

Clearly, form must be grasped at one glance, but not as a suggestion of the objective; anything that is an act of motion must be fixed as absolute. The parts situated in three dimensions must be depicted as simultaneous; that is, the dispersed space must be integrated in a single field of vision. The three-dimensional can be neither interpreted nor simply given as a mass. Instead, it has to be concentrated as specific existence, which is achieved as follows: the thing that lets us see in three-dimensional terms and that is felt normally and naturalistically to be movement is shaped as a formally fixed expression.

Every three-dimensional point in a mass is open to endless interpretation. This alone makes it almost impossible to achieve an unequivocal goal, and any totality seems out of the question. The very continuity of the relationships of that point merely dashes any hopes of a specific solution—even though we may like to think that we can suggest a unified impression in the gradual, slowly guided process of the functioning of that point. No rhythmic arrangement, no relationship based on drawing, no multiplicity—however rich—of movement can delude us into thinking that the cubic is not immediate and not gathered into a unified form here.

The African seems to have found a pure and valid solution to this problem. He has hit on something that may initially strike us as paradoxical: a formal dimension.

The conception of the cubic as a form (sculpture must contend with that alone and not with a material mass) compels us to define just what that is. It is the parts that are not simultaneously visible; they have to be gathered with the visible parts into a total form, which places the viewer in a visual act and corresponds to a fixed three-dimensional contemplation, producing the normally irrational cubic as something visibly formed. The optical naturalism of Western

art is not an imitation of external nature. Nature, passively copied here, is the viewer's standpoint. This is how we understand the genetic evolution, the unusual relativism of most of our art. European art was adjusted to the viewer (frontality, perspective); and the creation of the final optical form was left more and more to the actively participating viewer.

Like our conceptual ability, form is an equation; this equation is considered artistic when it is grasped as absolute, as unrelated to anything outside it. For form is the complete identity of the visual process with individual realization; in terms of their structure, these two fully coincide and do not relate to one another as a general concept and an individual instance. Viewing may cover multiple cases of realization, but it does not have a greater reality than those instances. It therefore follows that art constitutes a special case of unconditional intensity, and that the quality must be created in it as undiminished.

The task of sculpture is to bring forth an equivalent absorbing the naturalist sensations of movement—and thus the mass—in their entirety and transforming their successive differences into a formal order. This equivalent has to be total, so that the artwork may be felt not as an equivalent of human tendencies directed elsewhere, but rather as something unconditionally self-contained and self-sufficient.

The dimensions of usual space are counted as three, whereby the third, a dimension of movement, is merely counted but not investigated as to its nature. Since the artwork gives form to that which has a specific nature, this third dimension is split in two. We think of motion as a continuum that, while changing space, encloses it. Since fine art fixates, this unity is divided, that is, conceived of in opposite directions; it thereby contains two entirely different directions, which, say, in the mathematician's infinite space, remain quite insignificant. In sculpture, the depth direction and the forward tendency are completely separate ways of creating space. Their disparity is not linear; rather, these are excellent formal distinctions, if they are not melded impressionistically—that is, under the influence of naturalistic concepts of movement. It follows from this that sculpture, in a certain sense, is discontinuous, especially since it cannot do without contrasts as an essential device for fully creating space. The cubic should not be veiled as a secondary suggestive relief and therefore should not be introduced as a materialized relationship; instead, it has to be highlighted as intrinsic.

The viewer of a sculpture readily believes that his impression combines viewing with a conception of the deeper-lying parts; because of its ambiguity this effect has nothing to do with art.

We have stressed that sculpture is a matter not of naturalistic mass, but only of formal clarification. Hence, the nonvisible parts, in their formal function, have to be depicted as form; the cubic, the depth quotient (as I would like to call it), has to be depicted on the visible parts as form; to be sure, only as form, never blending with the objective, the mass. Hence, the depiction of the parts

cannot be material or painterly; instead, they must be presented in such a way as to become sculptural—a way that is naturalistically rooted in the act of motion, fixed as a unity and visible simultaneously. That is to say: every part must become sculpturally independent and be deformed in such a way as to absorb depth, because the conception, appearing from the opposite side, is worked into the front, which, however, functions in three dimensions. Thus, every part is a result of the formal presentation, which creates space as a totality and as a complete identity of individual optics and viewing, and also rejects a makeshift surrogate that weakens space, turning it into a mass.

Such a sculpture is firmly centered on one side, since the latter undistortedly offers the cubic as a totality, as a resultant, while frontality sums up only the front plane. This integration of the sculptural is bound to create functional centers, in terms of which it is arranged. These cubic *points centraux* [central points] instantly produce a necessary and powerful subdivision, which may be called a strong autonomy of the parts. This is understandable. For the naturalist, mass plays no part; the famous, unbroken, compact mass of earlier artworks is meaningless; furthermore, the shape is grasped not as an effect, but in its immediate spatiality. The body of the god, as dominant, eludes the restrictive hands of the worker; the body is functionally grasped in its own terms. Europeans often criticize African sculpture for alleged mistakes in proportion. We must realize that the optical discontinuity of the space is translated into clarification of form, into an order of the parts, which, since the goal is plasticity, are evaluated differently, according to their plastic expression. Their size is not crucial; the decisive feature is the cubic expression that is assigned to them and that they must present no matter what.

However, there is one thing that the African eschews, but to which the European is misled by his own compromise: the modeling interpolated as a basic element; for there is one thing this purely sculptural procedure requires: definite subdivisions. The parts are virtually subordinate functions, since the form has to be concentratedly and intensely elicited in order to be form; for the cubic, as a resultant and as an expression, is independent of the mass. And that alone is permissible. Art as a qualitative phenomenon is a matter of intensity; the cubic, in the subordination of views, must be presented as tectonic intensity.

In this context we have to touch on the notion of the monumental. This concept probably belongs to periods that, lacking any contemplation, measured all their works by the same yardstick. Since art deals with intensity, monumentalism is not an issue. There are other things that must also be eliminated. In approaching these sculptural arrangements we can never rely on linear interpolations; they merely show a viewing weakened by conceptual memories—and that is all. But we are sure to understand the African's untwisted realism if we learn to see by looking—see how the restricted space of the artwork can be immediately fixated. The depth function expresses itself not through proportions

but through the directional result of the welded and not objectively added-up spatial contrasts, which can never be viewed as a unity in the dynamic conception of the mass. For the cubic resides not in the variously placed individual parts, but in their three-dimensional resultant, which is always grasped as a unity and which has nothing to do with mass or the geometric line. The latter presents cubic existence as the nongenetic, unconditional outcome, since the motion is absorbed.

After the assessment of the sculptural concentration, the consequences can be easily explained. Many Europeans have condemned African sculptures as disproportionate; others have tried to glean from them the anatomical structures of the various tribes. Both critiques can be dispensed with; for the organic has no special meaning in art since it only indicates the real possibility of movement. By equating reflections on art with the making of art, albeit in a reverse chronology, Europeans constructed with the aid of abrupt notions, as if art were somehow based on and abstracted from a model. It is quite obvious that the premise of such a procedure would already be art. When examining, we must never leave the level of the object; otherwise we will be talking about many things—but not the object before us. Both "abstract" and "organic" are (either conceptual or naturalistic) criteria alien to art and therefore completely extraterritorial. And we can also ignore vitalistic or mechanistic explanations of art forms. Broad feet, for instance, are broad not because they carry, but because our eyes often move down or because the artist seeks an equilibrium that contrasts with the pelvis. Since the form is tied neither to the organic nor to the mass (now and then the so-called organic needs a pedestal as a geometric and compact contrast), most African sculptures have no pedestal. Or if a pedestal is present, it is sculpturally emphasized by points, and so on.

But back to the issue of proportions. These depend on the extent to which depth is to be expressed in terms of the decisive depth quotient, by which I mean the sculptural resultant. The interrelations of the parts hinge purely on the degree of their cubic functions. Important parts require a corresponding cubic resultant. That is also how we should understand the so-called twisted joints or limbs in African sculptures; a rolled twist makes visible and concentrates that which constitutes the cubic nature of two otherwise abrupt directional contrasts. Parts that are set back and normally only guessed at become active and, in a focused uniform expression, they become functional: they thereby become form and are absolutely crucial to the representation of the immediately cubic. In a rare unification the other sides have to be subordinated to these integrated forms, yet they do not remain unprocessed, suggestive material; they become formally active.

On the other hand, depth becomes visible as a totality. This form, identical with unified viewing, is expressed in constants and contrasts. Yet these are no

longer open to infinite interpretations; rather, the twofold depth direction—
the forward and the backward movement—is bound in a cubic expression. Each
cubic point can be interpreted in terms of two directions; here, it is involved and
secured in the cubic product, and it therefore contains both the forward and
the backward movement, but not within a relationship that is interpolated from
the outside.

In African sculpture as in some other so-called primitive art, we are struck by
the fact that some statues are uncommonly long and slender, while the cubic re-
sultants are not especially emphasized. These factors may express an uncontrol-
lable determination to encompass the cubic naked in the lank form. We believe
that we cannot get at these thin, plain, compressed forms by means of the sur-
rounding space.

I would like to add something about the group. The group visibly confirms
the previously stated opinion that the cubic is expressed not in mass but in
form. Otherwise, the group, like any perforated sculpture, would be a paradox
and a monstrosity. The group constitutes the extreme case of what I wish to call
the remote sculptural effect: at closer inspection, two parts of a group relate no
differently to one another than two remote parts of a figure. Their coherence is
expressed in their subordination to sculptural integration—assuming that we are
not dealing simply with a contrasting or additive repetition of the formal
theme. Contrasting repetition has the advantage of reversing directional values
and thus also the meaning of sculptural orientation. On the other hand, juxta-
position shows the variation of a sculptural system within a visual field. Both are
grasped totally, since the given system is unified.

THE MASK AND RELATED THINGS

Controlled and encircled by powers, a people for whom art, religion, and ethics
are immediately operative will make these things visible on their own bodies.
Scarification makes the body the means and the goal of a process of viewing.
The African sacrifices and intensifies his body; his flesh is visibly dedicated to
the universal, which gains a tangible form on his body. A despotic, uncondi-
tional religion and humanity are revealed when husband and wife, by getting
scarified, turn their individual bodies into universal ones; incidentally, this is also
a heightened erotic force. It takes a certain kind of consciousness to grasp one's
own body as an unfinished work and to alter the body directly. Beyond the nat-
uralistic body the scarifier enhances the form sketched by nature, and body
drawing reaches its acme when the natural form is negated and is transcended
by an imagined form.

In that case the body is at best the canvas or the clay; indeed, it becomes a
hindrance that is bound to provoke the strongest application of form. Getting
scarified implies a direct self-awareness and thereby an at least equally strong

consciousness of form practiced on the object. Here too we find what I have called a sense of distance for objectively creating an enormous talent.

A scarification is only part of a self-objectifying process of influencing the entire body, consciously producing it—and not only in a direct expression of movement such as dancing or a fixated expression such as a hairdo. The African determines his type so strongly that he alters it. He intervenes everywhere in order to sign the expression with an unforgeable signature. Understandably, a human being is transformed if he feels like a cat, a river, the weather; he is any one of these, and he implements the consequences on the too-unambiguous body.

The psychologizing and theatrical European is most likely to feel this in a mask. A human being always changes slightly, but he still tries to maintain a certain continuity, an identity. It is particularly the European who has shaped this feeling into an almost hypertrophic cult. The African, however, is less burdened by a subjective selfhood and he honors objective forces: in order to prevail against them he must become those forces, especially when he celebrates them most intensely. With his transformation he establishes the balance with an annihilating adoration; he prays to the god, he dances ecstatically for the tribe, and, by donning the mask, he personally transforms himself into the tribe and the god. This transformation gives him the most powerful understanding of objectivity; he incarnates it in himself and is himself this objectiveness, in which all individuality is destroyed.

Hence the mask has meaning only when it is nonhuman, nonpersonal—that is, constructive, free of individual experience. Perhaps he even venerates the mask as a deity when not wearing it.

I would like to call the mask "fixated ecstasy"; it may also be the ever-ready device for a tremendous stimulation of ecstasy when the fixated face of the adored power of the animal is present.

It may come as a surprise that the religious arts often cling to the human shape. This strikes me as obvious since the mythical existence, independent of the shape, is already in agreement. The god is already invented and existing indestructibly no matter how he reveals himself. It would almost contradict this formally so resolute artistic sense if one devoted all one's energy to objective contents rather than dedicating all forces to, and worshiping, form (the god's existence). For only the artistic form corresponds to the being of the gods. Perhaps the worshiper wishes to chain the god to the human when he depicts him as such, thereby magically transforming him in his piety; for no one is so egotistical as the worshiper, who, though giving everything to the god, unconsciously makes him human.

At this point, we ought to explain the peculiarly rigid expression that is formed on the faces. This rigidity is nothing but the ultimate intensity of expression, freed of any psychology; at the same time, it makes a clarified structure possible.

In order to shed light on the diverse spiritual abilities of these Africans, I have included a series of masks that descend from the tectonic to the uncommonly human.

Now and then it seems almost impossible to tell which type of expression is depicted in an African artwork: the terrified type or the terrifying type. Here we have excellent proof of the ambiguous indifference of the psychological expression. The physiognomical expressions of opposite feelings are already congruent with one another in terms of experience.

I am shaken by the animal masks when the African puts on the face of an animal that he would otherwise kill. The killed animal also contains the god, and perhaps there is also the feeling of a self-sacrifice when, by donning the animal mask, he pays for the killed creature and approaches the god through it; he sees in that creature the power that is greater than he: his tribe. Perhaps he escapes retaliation for the killed animal when he transforms himself into it.

Between the human mask and the animal mask there is the mask that captures the self-transformation. Here we touch on hybrid forms that, despite the grotesque or fantastic contents, reveal the classical African equilibrium. It is the religious for which the visible world no longer suffices in its excessive urge and which creates the world in between; and the disproportion between the gods and the creature looms ominously in the grotesque.

Allow me to dwell briefly on stylistic explications of the African mask. We saw that the African condenses the sculptural forces in visible resultants. The masks reveal the power of cubic viewing, which makes the surfaces collide with one another, gathers the full meaning of the front face in a tiny number of sculptural forms, and develops the minor three-dimensional directional factors in their resultants.

MARIUS DE ZAYAS

AFRICAN NEGRO ART AND MODERN ART · 1916

For some time sociologists have been studying the life of the savage in order to get at the character of the primitive mentality of mankind. They believe it logical that the rudimentary mental and social life of savages, must have, if not an identity, at least a similarity with the mental and social character of the man of the first ages. The psychology of the savage has thus been carefully analyzed; his customs and habits have been carefully observed, and from those observations one can have an almost accurate conception of primitive mentality.

Lately European art has sought in the work of the savage new elements for the development of plastic expression, and through the discoveries made in the art of the savage we have acquired new knowledge concerning difference of representation in relation to the difference of mental states, and concerning the different degrees of development in the evolution of art.

Of all the arts of the primitive races, the art of the African Negro savage is the one which has had a positive influence upon the art of our epoch. From its principles of plastic representation a new art movement has evolved. The point of departure and the resting point of our abstract representation are based on the art of that race, which can be considered as being in the most primitive state of the cerebral evolution of mankind.

The psychology of the African Negro has been defined and classified in the most complete manner. The numerous tribes of that ethnological group, which comprises three quarters of the population of the African Continent have been studied in all their mental manifestations, so that one can have a clear idea of the conditional state of their brain.

Unfortunately, those who have undertaken the study of the life of the African Negro have considered his art from the European point of view, qualifying it as being grotesque and rudimentary.

I believe that to arrive at a satisfactory conclusion upon the intrinsic significance of the art of a race, one must consider the causes of its production and the

Excerpts from *African Negro Art: Its Influence on Modern Art* (1916), 5–7, 9–14, 32–33, 35–36, 39–41.

De Zayas reflects racist attitudes that were commonly held but rarely expressed so outspokenly as in his contradictory contention that although African art is brilliant, the people who produced it were mentally inferior. Despite the title, the essay says virtually nothing about modern art.

Figure 16. African Hall, American Museum of Natural History, New York, 1910.

place it occupies in relation to the significance of the other arts of the human family.

Thus will be established, firstly the psychologic character of the producer as the cause of the production, and secondly, the character of the art itself as the effect of causes that determine the place it occupies in the logical, and not chronological evolution of the idea of representation. For the different states of the development of plastic representation do not follow a progressive order in relation to time. Plastic evolution is the result of intellectual evolution. The savage of to-day, for example, would be incapable of understanding the work of the Greeks done over two thousand years ago.

Analyzing the art of the different human races, one can see that each race has a determined conception of representation, and that the degree of the development of their art toward naturalism is in direct relation to the intellectual development of the race that produces it. One can say the same of the plastic production of the individual: it follows an evolution in relation to the extent of his knowledge and the progression of his education. A comparative study of the art of the different human races shows that the art of the African Negro savage is less representative from the naturalistic point of view and most expressive

from the point of view of pure form. The small amount of direct imitation—the almost abstract form of the plastic representation of the African Negro—is nothing more than the logical result of the conditional state of his brain. . . .

The Negro art of which I make the present study, presented as an hypothesis, is the one which can be considered as the plastic expression of the characteristic mentality of the pure negro and which belongs to the tribes inhabiting Africa from French Guinea to the Bantu Tribes of Eastern Africa. All the negro continent, as it has been said by Cureau, constitutes an homogeneous psychological species, and represents the first step in the evolution of the intellectuality of man. Although the habits and customs of the tribes vary according to the land they inhabit and the contacts they may have had with other races, although there is a difference of culture between the Negro of the forest and the Negro of the plains, at bottom their mentality is identical.

Among the numberless tribes which compose the negro race one finds more or less awakened intelligences, more or less savage sentiments, more or less rude habits, but their psychology is everywhere the same. If they are very capable of mental progress, the conditions of their life determine all their intellectual development. They remain in a mental state very similar to that of the children of the white race. Their life is purely sensorial. Like the white child they are egocentrists. The rigours of all sorts that they suffer from nature, the constant struggles with their fellowmen and with the supernatural beings created by their imagination, cause them to be preoccupied primarily with their material being, and to have no limits to their egoism.

Le Tourneau has observed that "In comparing the European child to the Negro one finds a very similar cerebral formation. Both have an occipital dolichocephaly. In both the circumvolutions are less developed, the cortical grey matter less thick, the nerves more voluminous in relation to the nervous centers. But this formation which in the white child is transitory, persists in the Negro and even gets more pronounced with the growth of the individual. Thus the newborn Negro is not yet prognathous."

It can be said that the cerebral condition of the Negro savage is particularly primitive, and that his brain keeps the conditional state of the first state of the evolution of the human brain.

"There is hardly a traveller," says Burton, "however unobservant, who has not remarked the peculiar and precocious intelligence of the African's childhood, his 'turning stupid,' as the general phrase is, about the age of puberty, and the rapid declension of his mental powers in old age—a process reminding us of the simiad. It is interesting to find anatomically discovered facts harmonizing with and accounting for the provisionary theories of those who register merely what they have observed. M. Gratiolet's Eureka, that in the occipital or lower breeds of mankind, the sutures of the cranium close at an earlier age than amongst the

frontal races, admirably explains the phenomenon which has struck the herd of men, however incurious. It assigns a physical cause for the inferiority of the Negro, whose physical and mental powers become stationary at an age when, in nobler races, the perceptive and reflective principles begin to claim ascendancy."

"It is certain," says H. Ward, "that the African Negroes have in their youth a very alive intelligence and a rare promptness. The atrophy of their intellectual faculties can be attributed to the premature junction and the subsequent ossification of the sutures of the cranium, which stop in that way the natural expansion of the brain."

Cureau makes an interesting comparison between the premature intellectual stand-still of the Negro and the continual development of the white man. He says: "There are two very distinct states in the intellectual life of the Negro." When a child, he is amiable, gentle, graceful. He is ready witted and docile and shows to be very precocious, more precocious indeed than the great majority of European children. He understands and assimilates without any trouble all that is shown to him. He is active; he is not refractory to work. His elders abuse his good disposition by putting their work upon him.

"From puberty, a radical metamorphosis befalls: a sudden arrest of development, and moreover a slight regression. The comparison of the intellectual evolution of the Negro and that of the European is very interesting. To make it more immediately perceptible, I have represented the one and the other [fig. 17] by two curves, related to the same system of the co-ordinate axes. The years of life are carried in abscissas; the ordinates represent the intellectual development, as if it were possible to assign them a numerical value.

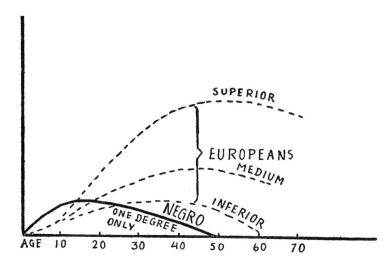

Figure 17. Chart of mental development, from Marius de Zayas, *African Negro Art: Its Influence on Modern Art* (1916).

"The Negro has a rapid intellectual progress during his first ten or twelve years. It diminishes after and becomes stationary; then slowly decreases during the following fifteen years after which follows a rapid decrepitude."

The reason of the stationary state of the mental faculties of the savage Negro is due to his natural and social milieu. The land he inhabits, the rigours of climate and its peculiar diseases, his perpetual war with the natural and the supernatural, make one realize that all intellectual development is impossible under the force of circumstances that compel him to occupy and preoccupy himself exclusively with his material life.

The Negro, besides, does not receive any formal kind of mental education, either from his parents or from society. He grows without care or advice; his character develops by itself; he receives from nature his notions of good and evil without having anybody to guide him in the development of his mental faculties. The Negro is therefore incapable of any intellectual sentiment properly speaking, and he looks but for the satisfaction of the physical needs. Indifferent to the social happenings to which he does not attach any importance, he does not try to commemorate them; he has no history. Nor has he a religion in the proper sense of the word. He has no cult for a divinity nor the sentiment to enter into communion with it. If the Negro creates some divinities, it is to have through them a greater personal power. He does not adore them, he has no cult for them; they are to him but elements for his personal service.

The religious spirit of the savage Negro has not arrived at having a definite form or a doctrine. Since he is incapable of explaining to himself the reason of things, every thing remains for him a mystery. He does not conceive the general cause of natural phenomena; he is unable to establish the notion of cause and effect. His intellectual curiosity is very easily satisfied; he does not try to explain to himself the mechanism of things and refers all happenings, all phenomena to spiritistic conclusions. The only conception he has been able to form of the manifestations of life, is that they come from the spirits. . . .

The two constituent motives of Negro sculpture are: *Fear,* the primitive feeling of the idea of religion, which creates in the Negro the necessity to produce, and *movement,* the primitive sensation of the cognition of form; the visual element on which the Negro bases the actual representation.

It is unquestionable that the negro sees form naturalistically, that the organs of his sight receive the image of form under its natural aspect as does the lens of a camera. But, as it happens in photography that the image transmitted by the lens is modified by the chemical condition of the plate that receives it, so the image transmitted by the eye of man is modified by the conditional state of his brain.

Though the eye of the Negro sees form in its natural aspect, the state of his brain is unable to understand it and retain it in his memory under that aspect. He does not have a concrete remembrance of form; he has only a mental image.

He does not have the idea of form; he has only the sensation of it. His brain cannot carry any further the effect of perception, because he does not co-ordinate his sensations to reach a conclusion. He does not reason; and does not make comparisons to obtain relative values, because he does not possess the faculty of analysis. Unable therefore to represent the form seen by his eye, he represents only the form suggested by his mental condition.

The expressive quality of Negro sculpture is due in great part to the manner in which the artist handles his material. The Negro is naturally identified with the plastic resources of wood. He seems to let his work be guided by the material, and instead of putting his feelings into wood, seems rather to draw them out of it. Negro sculpture is as natural to wood as Mexican sculpture is to stone or Greek sculpture to marble. Ivory, stone and iron are also sculptured by the African Negro, but in those materials he is unable to render his peculiar sense of plasticity and the expression of his sensibility. . . .

I believe that all art, in its idea as well as in its practice, is the result of an intercrossing of social phenomena. I believe with G. Seailles that we do not only take from those who have preceded us, but that we are bound to those who surround us; that in society the volition of one influences that of another, ideas propagate themselves, consciousness is interpenetrating.

Even among the most savage of men, originality and liberty of plastic production do not exist in an absolute manner. The manufacture of the statuette-fetish among the Negroes is a matter which is subject to social influence, in its idea as well as in the actual manufacture. Although by his lack of observation and analysis the Negro is ignorant of the anatomy of the human body, he knows, by having learnt it, the plastic *anatomy* of the feeling he expresses.

In the great majority of Negro statuettes there is a relative amount of direct imitation of the human form, and also certain marks peculiar to each tribe, such as hair-dressings, scars, etc. . . .

It is to be noted that these elements of direct imitation are either the salient points of the human form which strike the primitive visualization of the Negro, or the artificial decorations of the body, decorations which he has the habit of making on himself, and which he knows objectively.

There is no evolution in Negro art. The Negro has not produced plastic states that would be the manifestation of a higher degree of mental development. When he comes into contact with the white man, his art degenerates. Through the introduction of conscious imitation, brought by the white man, the art of the Negro loses its expressive quality.

Symbolism does not exist in the art of the Negro. Though his imagination is awakened by the most insignificant motive, "though he accepts without hesitation the most fantastic theories to explain natural happenings," his brain is in too primitive a condition to attribute to a thing the significance of an idea. He gives form only to a feeling. . . .

In my opinion, the error of those who have undertaken the elucidation of the history of the evolution of art, lies in their considering the methods of civilized man as the only ones for the execution of plastic works, and also in their taking as principal guide the epoch in which the work is done. They forget that art is an effect which has for cause the conditional state of the mental organs which produce it, and that in the history of man it is the development and the evolution of his mental organs, of his brain, which determines the development and evolution of his art. Time, in fact, has nothing to do with the problem. An ethnological group can exist today whose brain is in a very primitive state and which, therefore, produces a very primitive art.

In the plastic arts form is the vehicle in which man couches his feelings or his ideas in order to express himself. The art of the different races of the world, from the lowest class of savages to the most civilized men, shows that for a different state of mental development there is a particular form of representation. This proves that the conception of form is not, and cannot be, arbitrary, but is subjected to previous causal condition; that it is a phenomenon, an effect of an organic cause, and that it goes through its evolution hand in hand with the evolution of the brain. Therefore, in order to identify the primitive conception of represented form, the primitive brain must be determined, it must be discovered that is to say, to what ethnological group belongs the most rudimentary state of mental condition.

All seems to indicate that the African Negro savage has the most rudimentary cerebral condition. His brain can be considered as being in the first state of the evolution of the brain of man. To him, therefore, must belong the first state of the evolution of the conception of form.

Comparing the psychology of the different ethnological groups of the human race from the negro to the white man, and taking as intermediaries the yellow races, one notes that, as soon as there is a mental evolution, there is also an evolution in the representation of form, and that this evolution is toward naturalism.

From the Negro to the white man the representation of form follows an uninterrupted chain, beginning with the geometrical construction of the Negro art and ending in the naturalistic art of the European. A glance at the artistic production of all the human races, starting from the African Negro, and continuing through the Pacific Islanders, the American Indians, the yellow races of Asia and the white races of Europe, would prove my assertion.

I believe that the actual beginnings of the representation of form are those geometrical drawings of which Mr. Deniker denies the existence. They are indeed copies, for nothing is absolutely esoteric or of spontaneous generation; but they are copies not of objects, animals, etc., but of their movement. In all the flat representations of the African Negro only such geometrical drawings are found; they represent movement and have therefore an abstract expression. And the

geometrical structure of these drawings has been maintained in the construction of the statuary. Its plastic spirit is still movement.

It is certain that before the introduction of the plastic principles of Negro art, abstract representations did not exist among Europeans. Negro art has re-awakened in us the feeling for abstract form, it has brought into our art the means to express our purely sensorial feelings in regard to form, or to find new form in our ideas. The abstract representation of modern art is unquestionably the offspring of the Negro Art, which has made us conscious of a subjective state, obliterated by objective education. And, while in science the objective truths are the only ones that can give the reality of the outer world, in art it is the subjective truths that give us the reality of ourselves.

HERMANN BAHR

EXPRESSIONISM · 1916

When at the dawn of time man first awakened, he was startled by the world. To recover himself, to "come to," he had to sever himself from nature; in his later memory this event is echoed and repeated in the impulse to break away from nature. He hates her; he fears her; she is stronger than he; he can only save himself from her by flight, or she will again seize and devour him. He escapes from her into himself. The fact of having the courage to separate from her, and to defy her, shows him that there must be a secret power in himself, and to this power he entrusts himself. From its depths he draws his own God and sets him up against nature. He requires a stronger power than himself, but stronger also than the world; enthroned above him, and above her, it can destroy him, but it can likewise protect him against her. Should his offering find favour, his God will banish the terrors of nature. And thus primeval man draws a magic circle of worship round himself and pricks it out with the signs of his God: Art begins, an attempt of man to break the grip of appearance by making his "innermost" appear also; within the outer world, he has created another world which belongs to him and obeys him. If the former frightens him into mad flight, alarming and confusing all his senses—the eye, the ear, the groping hand, the moving foot— the latter pacifies and encourages him by its calm, by the rhythm and consonance of its rigid, unreal, and unceasing repetition of form. In primitive ornament change is conquered by rest, the appearance to the eye by the picture in the mind, the outer world by the inner man, and when the reality of nature perplexes and disturbs him because he can never fathom her depths, because she always extends further than he can reach, so that beyond the uttermost limit there stretches something beyond, and beyond this extends the threat of yet further vastness—Art frees him by drawing appearance from the depths and by flattening it out on a plane surface. Primeval man sees lines, circles, squares, and he sees them all flat, and he does so owing to the inner need of turning the threat of nature away from himself. His vision is in constant fear of being overpowered and so it is always on the defensive, it offers resistance, is ready to hit back. Every fresh outer stimulus alarms the inner perception, which is always armed and ready, never concedes entrance to nature, but out of the flux of experience he

Excerpts from *Expressionismus* (1916).

Hermann Bahr (1863–1934) was an Austrian playwright and critic.

tears her bit by bit—banishing her from the depth to the surface—makes her unreal and human till her chaos has been conquered by his order.

It is not only primeval man who shows us this determined reaction of repulsion to every stimulus experienced. We recognise this attitude again in one of the highest phases of human development, in the East. There too man, now mature and civilised, has overcome nature. Appearance has been seen through and recognised as illusion, and should the deceiving eye try to entice him into this folly, he is taught by knowledge to withstand. In the East all beholding is tempered by an element of comprehending pity, and wherever the wise man gazes, he sees only that which he knows: the eye takes in the outer stimulus, but only to unmask it instantly. All seeing, for him, is a looking away from nature. We, with our eyes, are still incapable even of imagining this state, for we still see everything, as far as the circle of our civilisation reaches, with the eyes of the Greek. . . .

If Expressionism at the moment behaves in an ungainly, violent manner, its excuse lies in the prevailing conditions it finds. These really are almost the conditions of crude and primitive humanity. People little know how near the truth they are when they jeer at these pictures and say they might be painted by savages. The bourgeois rule has turned us into savages. Barbarians, other than those feared by Rodbertus, threaten; we ourselves have to become barbarians to save the future of humanity from mankind as it now is. As primitive man, driven by fear of nature, sought refuge within himself, so we too have to adopt flight from a "civilisation" which is out to devour our souls. The Savage discovered in himself the courage to become greater than the threat of nature, and in honour of this mysterious inner redeeming power of his, which, through all the alarms and terrors of storm and of ravening beasts and of unknown dangers, never deserted him, never let him give in—in honour of this he drew a circle of guardian signs around him, signs of defiance against the threat of nature, obstinate signs of demarcation to protect his possessions against the intrusion of nature and to safeguard his belief in spirit. So, brought very near the edge of destruction by "civilisation," we discover in ourselves powers which cannot be destroyed. With the fear of death upon us, we muster these and use them as spells against "civilisation." Expressionism is the symbol of the unknown in us in which we confide, hoping that it will save us. It is the token of the imprisoned spirit that endeavours to break out of the dungeon—a tocsin of alarm given out by all panic-stricken souls. This is what Expressionism is.

EDGAR L. HEWETT

AMERICA'S ARCHAEOLOGICAL HERITAGE · 1916

There is an awakening to the place of the native American race in culture history which Americanists are happy to see and encourage. There is a destiny for the American Indians more honorable than to be exploited as material for stirring fiction and spectacular exhibition. They are being recognized as representatives of a race of splendid works and noble characteristics—a people who, in spite of the appalling adversities of the last four centuries, may look forward to a future on the high plane of their ancient traditions.

Masterpieces of art worthy of presentation to the public in museums, galleries, and publications devoted to art and culture; architecture which in design and construction commands the admiration of the master-builders of today; systems of government and religion, ideals of right and practice of justice matching the most exalted that civilization has brought forth—these are achievements of the Indian race and worthy of the consideration of the educated.

Classical archaeology has long had its constituency of scholars, consistently true to the ancient shrines, keeping alive the literature, art, and drama of the people who set standards for the modern world. There has been no lack of capable exponents for every branch of Caucasian culture through its own racial eyes and mind and forms of expression.

The Indian race has had few to maintain its sacred fires. The disposition has been to put them out rather than to preserve them. History affords no parallel to the absolute, relentless subjugation of an entire race inhabiting a whole continent. It has been interpreted to the world almost wholly by its alien conquerors; less and less unsympathetically as years go by, and in some instances with rare understanding, but, nevertheless, by those of other blood.

Between us and the Greeks, only time intervenes, and but a small span of that when we think of it from the biological point of view. Between us and the Indian is the racial chasm which no mind can quite bridge. No Caucasian will ever see with the eyes or think with the brain-cells of the Indian, the Oriental, or the negro. The mind, culture, character, of a branch of the white race may become relatively transparent to us by personal contact or through study of cultural

Art and Archaeology (December 1916): 257–66.

Edgar L. Hewett (1865–1946) was an American archaeologist. This is one of the first publications to recognize American Indian art as art.

products; but the mind of the Indian remains a profound abyss, that of the Oriental an inscrutable mystery, of the negro a portentous force.

It will be necessary to abandon the attitude of the "superior" toward the immature and incompetent, for the Indian is neither a "primitive" nor an "inferior" race. Its culture has the maturity of age (greater probably than our own); has been as long in developing as has the color of the skin; and is about as difficult to modify, for it is the expression of every cell of the organism.

It would do no harm to forget most of the efforts that have been made to explain the Indian race and let its works tell the story. The living Indian is not much inclined to explain through the usual channels. He is uncommunicative about himself—the antithesis of the white man. Literary record is absent and vocal representation not much used. But these can be spared, for the race has, like every other, revealed itself in its art. There was no conscious effort to do it. So the picture is true. What the race actually thought, felt, did, is clear. Words would only obscure it.

The vast archaeological heritage from the unknown America of two or three millenniums furnishes an authentic history of the Indian people. It is their own picture of themselves, their testimony as to how they met and tried to solve the problems that all humanity has confronted.

There has been a singular tendency to think of the ancient masterworks of the race found in Mexico, Central America, and South America as other than Indian art. It is necessary to repeat again and again that all native American remains, whether of plains tribes, mound-builders, cliff-dwellers, Pueblo, Navaho, Toltec, Aztec, Maya, Inca, are just the works of the Indian. Plain fiction and romantic archaeology have a firm hold on the reading public. The most homogeneous of all racial art is that of the American Indian. Chronologically it is without serious gaps, and ethnologically it is unbroken. The unique mentality of the Indian is in the plan and embellishment of every Maya temple; in every Inca monument, Aztec image, Pueblo symbol, Omaha ritual, Navaho dance, Iroquois myth, Chumashan song.

The evidence of the ancient memorials presented in the accompanying illustrations denotes true greatness in the Indian race. Their building operations were on a colossal scale. Only a few peoples of antiquity attempted such gigantic works as did the Incas in Peru, the Mayas in Central America, the Aztecs and their predecessors on the Mexican plateau, the cliff-dwellers of our own Southwest. The monuments of Quiriguá, Tiahuanaco, Teotihuacan, testify to a physical and mental virility of the highest order. The master-works of art, in sculpture, stucco, and mosaic, that have been described in this magazine by Mr. Holmes; the achievements in design and color exhibited in the textile and ceramic arts of the Peruvians, Mayas, Mexicans, and Pueblos ancient and modern, show highly developed and trained esthetic sense.

The ancient government of Pueblo towns was a model of statecraft worthy

of Switzerland. The structures of purely spiritual character expressed in the mythology and ritual of the plains tribes, denote a speculative religion, free from the mysticism of the Orient and the dogmatism of European faiths, based on observation of and reflection on the orderly processes of nature. As described by Miss Fletcher in the article, "Nature and the Indian Tribe," in this number of *Art and Archaeology,* the religion of the Indian measures up well with our own in spiritual character.

The life of the Indian, on the evidence of his cultural remains, was marvelously unified and socialized. Virtually every form of activity, esthetic, industrial, social, was the practice of his religion. In quest of food, sitting in council, taking part as musician or dancer or priest in the ceremony, developing the symbolic design on utensil or garment, building the sanctuary, erecting the monolith, dedicating the temple and embellishing it with statuary, stucco, or mosaic—he was putting his whole spiritual life into it, and always with the thought of "the people," never of the individual or self. The race has left no personal records—only tribal. There are masterpieces of art in great numbers, but signed by no painter, sculptor, or architect.

Solicitude for "the people," exaltation of the tribe, was and still is a constant trait of Indian character. If individuals became prominent as priests, warriors, or builders, they were never personally glorified. Always it was: "The people thought," "the people went out," "the people built," "the old people say." Wisdom was of "the ancients." The ancestor was venerated by not mentioned by name. It is safe to predict that when the Indian hieroglyphic inscriptions are fully understood, there will be found nothing of the boastful tone of individual power which characterizes the records of ancient Babylonians, Egyptians, Romans, as well as those of modern Europeans and Americans.

The native American race exemplifies better than any other the influence of stone in human evolution, for, to the end of its undisturbed epoch, it remained a "Stone Age" people. It fell to it to demonstrate the potentiality of stone unaided by metal. It has shown that the terms "Stone Age," "Bronze Age," "Iron Age," should not be given any chronological significance. They, a Stone Age people, may have been older as a race than the conquering Europeans, an Iron Age people. Likewise, those terms are not to be regarded as denoting progressive efficiency in civilization.

In esthetic, ethical, and social efficiency, the Indians surpassed their conquerors. In material development they fell short of the Europeans, owing to the latter's mastery of metals. In the use of physical forces they were the inferior race, as the ancient Greeks would have been, and the Hebrews. The races that advanced far in material culture because of their conquest of physical forces are not necessarily to be ranked as superior. They were so only in certain respects. Present indications, rather, point to their easy and rapid self-destruction instead

of to the long maturity and slow decay of the races that knew little of metal and placed the emphasis on the spiritual life. It is not certain that high material progress is conducive to racial longevity. That efficiency in civilization is mainly a matter of racial point of view is one of the particular lessons of American archaeology.

The Indian race and its achievements, then, constitute America's archaeological heritage. It has a very intimate and particular interest to us in the United States where we have forcibly intervened in its destiny and where it is being slowly incorporated into our citizenship. We were strong enough to force submission. Had our Indian population been great enough to outweigh the European advantage of arms and equipment for a war, we would probably be still a competitor with Mexico in revolutionary enterprises. In Mexico the submerged race numbers about sixty per cent of the population, and, though thoroughly beaten, inoffensive, and for the greater part submissive, is not capable of being assimilated and cannot take on the imposed culture. So easy to satisfy with its ancient system of universal land-tenure in small holdings, it remains in a state of utter bewilderment over the ways of the small, powerful, ruling class which it cannot understand, the latter being essentially European. The "Strong Man" of Mexico, as Benito Juárez or Porfirio Díaz, comes usually from the native soil, but the population of the country remains so lacking in homogeneity as to preclude the possibility of ever becoming a self-governing nation.

In the United States there is outward submission to the white race, but with lack of understanding on both sides and consequent friction in the administration of Indian affairs. Almost all trouble in dealing with the Indians would disappear if one group of facts could be clearly apprehended, namely, that it is neither through stupidity nor perverseness that peace-loving, order-loving Indians, such as the Pueblos, resist the well-meant efforts for their betterment. It is simply the conflict between age-old ideals of authority, morality, justice— ours seeming as perverted to them as theirs seem to us. If it is their destiny to accept our standards, it can at least be made for them a matter of deliberate selection rather than forcible imposition. The results of the evolutionary forces of the ages in racial color, physiognomy, mentality, culture, cannot be suddenly overthrown. The arbitrary imposition of alien culture upon any subjugated people is an outrage for which the conquerors usually pay a high price.

If the Indian believes that a promise should be inviolable; that authority is the will of all and must be obeyed; that the observance of his own ceremonies is true religion and ours paganism; that obedience to his own social order is morality and some of our customs revolting; that some things that look unholy to us are of the deepest spiritual moment to him; that he has rights with reference to his ancient shrines, ceremonies, sacred places, garb, moral and social canons, it is not to be put down to total depravity. He is simply guilty of belonging to the race

that thinks it came "from the womb of the Earth-Mother" instead of the one that believes its common ancestor to have been fashioned "from the dust of the ground."

Viewed from any standpoint, it is a noble heritage that comes down to us from the long past of America—a heritage of experience, of thought, of expression, recorded in art, religion, social order; results of fervent aspiration and mighty effort; a race pressing its way toward the sun. Its study is the finest aspect of the conservation movement—the conservation of humanity; an attempt to rescue and preserve the life-history of a great division of the human species.

GUILLAUME APOLLINAIRE

CONCERNING THE ART OF THE BLACKS · 1917

In recent years artists, collectors, and museums have thought themselves capable of appreciating the idols of Africa and Oceania from a purely artistic point of view, while disregarding the supernatural quality that was attributed to them by the artists who sculpted them and the believers who worshiped them. No critical approach, however, is yet equal to this new curiosity of ours, and a collection of Negro statues cannot be presented in the same way as a collection of art objects, paintings, or statues executed in Europe, or in the lands of classical civilization of Asia, Egypt, or other Roman regions of North Africa.

In the catalogues it receives, the public is accustomed to seeing clearly defined works, precisely classified, attributable, often with certainty, to specific masters or schools.

An analogous presentation would be impossible in this case. In the current state of anthropology and art studies it would be rash to try to speak with certainty about these Negro idols from an archaeological or an aesthetic perspective. The collector's curiosity is stimulated all the more because information concerning their origin is lacking, and at present no artist's name has yet been identified.

It is therefore impossible at present to assign a definite date to these beautiful wooden fetishes, some of which are of great antiquity (I am speaking here of the African idols). Their characteristic style attests to an unquestionable relation with Egyptian aesthetics, from which they derive; unless, on the contrary, it was the African works that influenced the Egyptian artists—which would also amply justify the current interest in them.

Doubtless, if he had had the occasion to study the African fetishes, Gobineau[1] would have leaned toward the second hypothesis; since, for him, in the history of human progress, the descendants of Ham [Noah's second, "disrespectful" son] played a major role in the birth and development of artistic sentiment. However, as French as he was in spite of the *Gobineauvereine* [German Gobineau clubs], Gobineau would not be in fashion in a civilized country today, and we won't comment any further on this hypothesis, which, indeed, no one else has set forth.

Sculptures nègres: 24 photographies précédées d'un avertissement de Guillaume Apollinaire et d'un exposé de Paul Guillaume (1917).

This is the preface to *Sculptures nègres,* an album of reproductions of African and Oceanic sculptures published by the Parisian dealer Paul Guillaume, which may be considered the first French book on Primitive art.

Figure 18. Two tikis. Marquesas Islands. Formerly collection of Ambroise Vollard.
From Apollinaire and Guillaume, *Sculptures nègres* (1917).

At most, we might be able to classify pieces of Negro art by regions and sometimes by workshops; but in the matter of African art, this classification would often be faulty, and we will not venture any further in this direction.

The evolution of the fetishistic sculpture of the Blacks, as far as we can tell, was effectuated according to rhythms that were infinitely more extended than those which governed the evolution of European or Chinese art. No doubt, the transmission of traditional models can be considered one of the principal rules of this art. To the centuries and parts of centuries of Western art history, Africa and Oceania oppose vast periods that sometimes include the effort of numerous generations. But the inventiveness that has always guided this imitation, an inventiveness whose source was often the use of simple amulets or diverse materials that the artist had on hand, and which stimulated his decorative sense and his religious feelings, makes it difficult to assign these art works to a specific time. Moreover, in the course of years these charms—such as loincloths, large feathers, rosin balls, necklaces, pendants, small iron bells, twigs, handfuls of herbs, shells, boar's teeth, mirrors, nails, bits of iron of all kinds—have been worn down, broken, or lost and have been replaced by other charms that changed the general look of the fetish, making its age difficult to ascertain.

He who would undertake such aesthetic research could not rely on any writing or on any ancient inscription. Aside from a few anthropological indications, or hypotheses about the function of the idols in question, nothing can shed light on the mystery of their anonymity. For a long time we will have to be content with the aesthetic sensations and poetic evocations these Negro idols provide.

To the reports of travelers, the findings of geographers, the classifications of anthropologists, the deductions of ethnographers, might European critics someday be able to add a methodological analysis of styles, the equivalent of what was done for the primitive art in our own country, which was unknown fifty years ago? This is a question that cannot be answered at a time when the rules of war prohibit scholars and collectors from having access to the precious sources of information that are located, for example, in Brussels.

The purpose of this album has been first of all the pleasure it can give, and secondly to gather together a group of examples that are typical from an aesthetic standpoint.

Additionally, contemporary eclecticism found it attractive to exhibit these beautiful, mysterious works of art of the Blacks alongside ancient works and European or exotic curiosities.

Such was the origin of this album, which, although not complete, has the virtue of reproducing the masterpieces of all epochs, all regions, all tendencies, all workshops, of at least being the first to highlight not the ethnic character of the Negro statues, but their beauty—which has already attracted the attention of contemporary artists and collectors.

It is through great audacity in taste that we have come to consider these Ne-

gro idols as real works of art. The present album should help to establish that this audacity was not unjustified and that we are here in the presence of aesthetic realizations whose anonymity takes nothing away from their energy, their grandeur, and their true and simple beauty.

NOTE

1. [Joseph Arthur Gobineau (1816–82), French diplomat and author of *Essai sur l'inégalité des races humaines* (1853–55). Gobineau believed in the superiority of Nordic and Germanic peoples but also held that artistic impulses came primarily from that aspect of humanity represented by primitive peoples. His name was sometimes later associated with various sorts of racism—including National Socialism in Germany. Eds.]

TRISTAN TZARA

NOTE 6 ON AFRICAN ART · 1917

The new art is of the very first order: concentration—angles of the pyramid to-ward the point of the summit, which is a cross; through this purity we have, first of all, deformed and decomposed the object, we have approached its surface and penetrated it. We want a clarity that is direct. The field of art is broken up into camps, with its specialties, its frontiers. Influences of a foreign sort, which mix in, are the shreds of a Renaissance lining, still hanging on the soul of those close to us, for my brother has the soul of autumn's sharp black branches.

My other brother is an innocent; he is good and laughs. He eats in Africa and in the bracelet of the Oceanic Islands: he patiently focuses his sight on the head, carves it in ironwood, and loses the conventional relation between the head and the rest of the body. His idea is: man walks vertically, everything in nature is symmetrical. While working new relationships are formed by their necessity: from this purity expression was born.

Let's draw the light from the dark. Simple-rich. Luminous naïveté. Diverse materials, balance of form. Construct a hierarchy in equilibrium.

Eye: button open wide round pointed to penetrate my bones and my belief. Transform my country into a prayer of joy of anguish. Velvety eye runs in my blood.

Art was at the beginning of time, prayer. Wood and rock were truth. In man I see the moon, the plants, the dark, metal, star, fish. Let the cosmic elements slide, symmetrically. Deform, boil. The hand is strong large. The mouth contains the power of the dark, invisible substance, generosity, fear, wisdom, creation, fire.

No one has seen so clearly as I this evening, to grind out the white.

Sic (September–October 1917): 158.

The Romanian-born French poet Tristan Tzara (1896–1963) was a cofounder of the Dada movement and a collector of Primitive art.

Figure 19. Sculpture with calabash and shells. Luba. Democratic Republic of the Congo.
Wood, 14 1/8" high. Formerly collection of Tristan Tzara. From *African Negro Art,* exhibition catalogue
(New York: Museum of Modern Art, 1935).

JOSEF ČAPEK

NEGRO SCULPTURE · 1918

When discussing Negro art one generally means the native art of people from Africa and Polynesia. However, the nature of artistic expression of "tribes" inhabiting Polynesia is, despite various similarities, in many ways different, crueler, and wilder than that of African tribes.

To some, and especially to those who see their sculpture as ludicrous, preposterous, and overly exotic, it may seem inappropriate that I am now calling attention to the art of people who live in a natural state. But if ethnography is the study of human universals, we should find a live connection even to the art of such native tribes. In the same way that ethnography finds and observes the elementariness of ideas, we can read much that is basic and fundamental to the nature of art in general from the artistic expressions of the so-called savage tribes. Still, I do not mean here that it is correct to view the artistic creation of native tribes as something inadequately elementary or to compare it to the creative experiments, scribbles, and fantasies of children. Especially not in the case of Negro sculpture. A Negro—though we may find in him many childish traits—is not a big child, or an undeveloped, deprived man; rather we have to see here an entirely unique, fulfilled, and perfect form of life.

These sculptures (mainly African) are today the historical traces of a wider culture long gone. They are images of gods and of the dead, idols, fetishes, the demonstrations of religious feelings. As in Egypt, the Middle Ages, India, and elsewhere the spirit of religion was included in all artistic creation, so too is this Negro art fully saturated with the religious element, which is astoundingly, tendentiously, and piercingly displayed in it. But here, religious feeling did not reach (particularly in Africa) the point where larger, cosmological systems are created, as in ancient Mesoamerica, where state-regulated religion led to the creation of monumental architecture seen in temples and other sacred places. A Negro is confused by myths; natural religions are in no way angelic; gods are

Červen 1 (1918): 251–53.

 Josef Čapek (1887–1945), a Czech painter who studied painting in Paris in 1910–1911, was friendly with Apollinaire and other Parisian artists. In 1911, Čapek cofounded the Cubist-oriented Skupina Výtvarných Umělců (Plastic Artists Group) in Prague, which sponsored two exhibitions in 1913–1914 that included African sculpture as well as the work of its members and of foreign artists, including Picasso.

cruel, wicked, they require sacrifices and pain. The Negro mind is frightened by ghosts, spirits, and evil demons. Ideas about the sublime and its world are accompanied by the real savagery of fantasy itself. It is this dreadful and cruel supernatural world that they try to express in their sculptures; they are figures into which a demon enters, in which he lives. It is here that suggestion plays the main role; these images want to be perceived strongly, they should convince and implacably create the impression of supernatural being and activity.

Accordingly, they are equipped with everything that can add to their notion of the supernatural; they are gods, idols, heroes, not people. Correspondingly, a Negro provides them with his imagination, with all the signs and attributes of power and greatness. The heads are excessively large, masked, terrifying; much attention is paid to the eyes: they are composed from shells, mirrors, carefully colored; genitals are generally accented, exaggerated. Everything points to a cruel, urgent effect, to a strong, crushing suggestion, to apprehension and bewilderment.

Many people tend to look freely for primitivism in all that distinguishes the sculpture of native tribes so profoundly from our European conceptions about the plastic representation of a human or godly form. They believe that all those considerable deviations from our verisimilitude—geometry, disproportion, and the incredible fantasy of Negro sculptures—are the result of creative and technical shortcomings, of underdevelopment and impotence. But the Negroes are unusually skilled in their craftsmanship; they work with the simplest tools (in Polynesia, even metal tools are not used), and one glance at their simple everyday equipment—which is almost always remarkably graceful, beautifully formed, and tastefully decorated—is enough for us to remember never again to disparage primitive craftsmanship.

Much can be blamed on the small-minded, wild, and naive ideas of the savage about being and the supernatural. For him, there is no broader-minded notion of religion that could interpose and lend their art a powerful, grand, and uniting characteristic. It would be a mistake, however, to conclude that deficient, small, and absurd religious beliefs would have to result in deficient, small, and absurd artistic expression. Whoever sees these savage creations as only amusing and foolish, whoever is not moved to respect, even to astonishment, that person cannot be helped, and even if I wrote a much more extensive article than this one, I could not convince him that, despite any deficiencies in religious thought, it is an art that is original, mature, and fulfilled.

Here an explanation is in order. Art can roughly be divided into two kinds: art that is representational and art that is creative. Surely you can tell that there is a difference if I say "depicting a person" or "creating a person." Photography and material, veristic art depict; they have no deeper purpose other than to imitate, to simulate a piece of nature. But it was necessary to create a figure: Madonna, Christ, Angel, Animal, Mother, Worker, Earth, Woman; many individuals, even

generations, worked toward this. Let us take for example one of Marold's fig-
urines—it is (even with its graceful lightness and suppleness) art that merely
represents, that never reaches a higher order and bearing. It gives only that
which is seen. Yet there is in art another, deeper effort, which is not based on
mimicry and techniques of imitation, but rather on a more fundamental, more
essential goal—on the need to extract a new thing from the inner soul and mat-
ter, a new being, a new figure, and to place it within the order of this world as
something of special significance. This is a religious need, it has a mystical na-
ture, yet it is so very simple and real.

Surely you will agree with me that when a child builds the figure of a person
from the cubes and arches of his brickbox, and makes himself a "man," he is ar-
riving at something more fundamental, more mysterious, and more organic than
the shepherd in the ancient myth who is said to have discovered painting—for
he, with a piece of coal, outlined the shadow of his lover. The child is starting
from Earth and Thought—from matter and order—from the mysterious com-
patibility and vitality of matter itself. This can make it possible to create a hu-
man figure, from power and from the most beautiful substantiality of thought,
where matter is committed to make thought obedient, to make it come alive
and become human. Of course, there is a big difference: to depict a figure, or to
make a figure. To depict is something passive, whereas to make, to form—that is
competition with creation and at the same time a divine service and prayer to
Creation. Ancient sculpture, Gothic sculpture, Rodin's sculpture, its essence is
not in that it clearly depicts natural forms, but first and foremost because "it is";
it is because a figure was created here, one that intentionally and convincingly
carries within itself all natural truth; the essence is not in the representation but
in the power of substance and thought which gives it life, being, a particular or-
ganic unity.

In the case of the Negro pieces, it is not representation or depiction that is
important; a Negro makes himself a "man," he creates a being from matter. It is
supposed to be a god, one from terrifying and unrestricted ideas. And it really is.
In this kind of art there is no canon or ancient proportionality; here a different
law and measure rule: the relation of formal motives. The Negro does not care
about proportionality and anatomy, yet the whole is organic and alive. Shapes
set themselves in relation to each other vividly, almost paradoxically; they col-
lide dynamically and create strong, striking contrasts. That is why the impression
they give is so vivid, one could almost say that it screams and clamors. Shapes are
simplified so they can function explicitly, some surfaces are turned into a frontal
elevation, the whole is governed by its formal key (cylindrical, segmented, and
lens-like shapes) and creates its own shapely organism; there is much figural in-
vention in Negro sculpture, there is no firmly frozen artistic schema. Anyone
who studies this art more closely would be surprised by the fully unique, ele-
mentary, and refined conception of plastic space that developed here with such

consistency and conviction. It is here, and not in the exotic aspects, that lies the worth and strength of this characteristic and mature sculpture. Inseparably from the ancient and European styles, here arose a perfect one, which, in its own consistent way, realized its unique idea of spatial dimension and substantiality. It was this style with which the new development of European painting, determined by Cézanne, came together. Young French artists began to study the art of native tribes not for its exotic and barbaric side, but because here they found many of their problems realized in a remarkably clean and elementary way. They did not look here for a model to study, but rather for some sort of stimulation; it was only an episode in the development of young French art, which then went its own way, following its own problems. It is from this time, around 1908, that many historically important paintings are dated, mainly those of Picasso and Derain. However, the impulse for the new structure of compositional space came from Cézanne, and it is concealed even in historical styles, in every art that is real. Only stupidity or malevolence can maintain that in new art all the past is vanquished or that it is attracted only to barbarism and exoticism.

PART II

NEW ATTITUDES AND AWARENESSES · 1919–1940

After the first world war, Primitive art began to be gradually accepted into the larger canon of World Art, though cultural and racial prejudice frequently confined it to ethnographic museums. As the relationships between the European nations and their colonies changed, a good deal of effort was given to reevaluating the native cultures of the colonies and their connections to the West. In the meantime, many aspects of the formal vocabulary of Primitive art had been absorbed into modernist art, and many avant-garde artists came to see it as old hat. This is made clear in Jean Cocteau's statement, in the 1920 survey conducted by *Action:* "The Negro crisis has become as boring as Mallarméan Japonisme."

During the 1920s, with the rise of Surrealism, greater emphasis was given to the chthonic qualities of Primitive art. Among the Surrealists, African art was criticized as being too "rational," and greater attention was given to Oceanic art and the art of the American Indians. Collecting and connoisseurship were also on the rise, and a number of the essays consider questions of taste and aesthetic quality. More anthropologically oriented writers sought to understand the relationships between art objects and the religions, philosophies, and social organizations of the cultures that created them. During this period, Primitive art begins for the first time to be exhibited (albeit only occasionally) in art museums and in galleries normally reserved for modern art, and excerpts from catalogue essays and reviews of these exhibitions show how it was presented and received. This period was capped by Robert Goldwater's *Primitivism in Modern Painting* (1938), the first scholarly book-length study of the subject, which was to have great influence on later thinking about it. Regrettably, we were not able to obtain permission to reprint this important text, because we could not accept the changes to our descriptive note required by Professor Goldwater's son, Jean-Louis Bourgeois.

T. S. ELIOT

WAR-PAINT AND FEATHERS · 1919

The Ustumsjiji are a vanishing race. The last repositories of the Monophysite heresy, persecuted and massacred for centuries (on religious grounds) by the Armenians, the remnants of a unique civilization have taken refuge in the remote gorges of the Akim-Baba Range. Here the explorer discovered them, and was privileged to hear their *Shikkamim,* or wandering bards, prophets, and medicine-men, recite or chant, to the music of the *pippin* or one-stringed gourd, the traditional poetry of love, warfare, and theology. The explorer has made a translation or interpretation, in *vers libre,* and the product is declared to be superior, in its subtle and mystical simplicity, to anything that can be bought second-hand on Charing Cross Road.

But suddenly, egged on by New York and Chicago *intelligentsia,* the romantic Chippaway bursts into the drawing-room, and among murmurs of approval declaims his

MAPLE SUGAR SONG.
Maple sugar
is the only thing
that satisfies me.

The approval becomes acclimation. The Chippaway has the last word in subtlety, simplicity, and poeticality. Furthermore, his Continent is backing him. For, says the editor,

> It becomes appropriate and important that this collection of American Indian verse should be brought to public notice at a time when the whole instinctive movement of the American people is for a deeper footing in their native soil.

The Red Man is here: what are we to do with him, except to feed him on maple sugar? And it is not only the Red Men, but the aborigines of every complexion and climate, who have arrived, each tribe pressing upon us its own claims to distinction in art and literature.

The Athenaeum (October 17, 1919): 1036. © T. S. Eliot Estate. Reproduced by permission.

T. S. Eliot (1888–1965) is here reviewing *The Path of the Rainbow: An Anthology of Songs and Chants from the Indians of North America,* edited by George W. Cronyn (New York: Boni & Liveright). That artists are "most competent to understand both civilized and primitive" is perhaps reflected in Eliot's *The Waste Land* (1922), with its references to Frazer's *The Golden Bough.*

Within the time of a brief generation it has become evident that some smattering of anthropology is as essential to culture as Rollin's Universal History. Just as it is necessary to know something about Freud and something about Fabre, so it is necessary to know something about the medicine-man and his works. Not necessary, perhaps not even desirable, to know all the theories about him, to peruse all the works of Miss Harrison, Cooke, Rendel Harris, Lévy-Bruhl or Durkheim. But one ought, surely, to have read at least one book such as those of Spencer and Gillen on the Australians, or Codrington on the Melanesians. And as it is certain that some study of primitive man furthers our understanding of civilized man, so it is certain that primitive art and poetry help our understanding of civilized art and poetry. Primitive art and poetry can even, through the studies and experiments of the artist or poet, revivify the contemporary activities. The maxim, Return to the sources, is a good one. More intelligibly put, it is that the poet should know everything that has been accomplished in poetry (accomplished, not merely produced) since its beginnings—in order to know what he is doing himself. He should be aware of all the metamorphoses of poetry that illustrate the stratifications of history that cover savagery. For the artist is, in an impersonal sense, the most conscious of men; he is therefore the most and the least civilized and civilizable; he is the most competent to understand both civilized and primitive.

Consequently, he is the most ready and the most able of men to learn from the savage; he is the first man to perceive that there are aspects in which the lays of the Dimbovitza or the Arapajos are a more profitable study and a more dignified performance than "Aurora Leigh" or "Kehama." But, as he is the first person to see the merits of the savage, the barbarian and the rustic, he is also the first person to see how the savage, the barbarian and the rustic can be improved upon; he is the last person to see the savage in a romantic light, or to yield to the weak credulity of crediting the savage with any gifts of mystical insight or artistic feeling that he does not possess himself. He will welcome the publication of primitive poetry, because it has more significance, in relation to its own age or culture, than "Kehama" and "Aurora Leigh" have for theirs. But he wants it more carefully documented than the present book; when the translator uses the word "beauty," the contemporary poet wants to know the Navajo equivalent for this word, and how near an equivalent it is. Also, to what extent is an "interpretation" allowed to diverge from a "translation"? The poet and the anthropologist both want to be provided with these data, and they are the only persons whose desires should be consulted. The poet and the artist and the anthropologist will be the last people to tolerate the whooping brave, with his tale of maple sugar, as a drawing-room phenomenon. And the artist, if he gets a chance, in a dinner-table pause, to say something of interest—when he speaks of the Solomon Islanders, it will not be *instead* of whatever he may have to say about Mantegna.

HENRI CLOUZOT AND ANDRÉ LEVEL

SAVAGE ART · 1919

Figures and objects that have been sculpted, generally in wood, by the savage peoples of Oceania and Africa have been admitted into the collections of ethnographic museums for a long time. However, it is only recently that artists and enthusiasts have acknowledged them as works of art. Some prefer the more aristocratic arts of Oceania and Polynesia, which derive distantly from Asia and evoke a mélange of the monstrous and the human. Others show a predilection for the more human and comradely art of Africa, where the ancestral cult has spawned little figures, veritable Lares deities that are practically family portraits.

The moment has come to present to a larger public—for the first time anywhere—an important assemblage of these curious works.

These figures need to be appreciated as religious objects. "Art for art's sake" is a concept that is unknown among the primitives. Their works traditionally serve a ritual and magical utilitarian purpose. The art of savage peoples is defensive, warding off evil spirits more than conciliating good ones. It obeys the same laws as the art of the most remote epochs; its principles and character are thoroughly archaic. Nevertheless, it is the primitive art that is closest to us, almost still alive.

These masks, accessories of dance and cultic or warlike ceremonies, do not seem to provoke the disapproval of the uninitiated. Above all, don't we ask of the mask, whose purpose is to cover and disguise the facial features, for the imaginary, the unexpected? It is astounding that these, in contrast to our own masks and those of the Chinese and Japanese, never "make a face," so to speak. Their expression is a function of their construction, their architecture. The lines and designs are totally plastic.

As to the figures, especially the African ones, which are more human in character, but where the form that the European has inherited from the Greek canon finds itself transformed, recreated by the singular commutation of the

Première Exposition d'art nègre et d'art océanien, exh. cat. (Paris: Galerie Devambez, 1919), 1–4.

This essay by the librarian and art specialist Henri Clouzot (1865–1941) and the collector André Level (1863–1946) was the main text in the catalogue of the first major Parisian exhibition of Primitive art, at the Galerie Devambez, May 10–31, 1919. Apollinaire's preface to the 1917 *Sculptures nègres* exhibition (see p. 107) also appeared in this catalogue. The exhibition, which was organized by the dealer Paul Guillaume, consisted of 147 objects, mainly from the French colonies. Many of the objects belonged to Guillaume and Level.

Negro mind—we need more than just plain good will or a few minutes' effort to adjust to proportions and lines that are so strange to our mentality. Nevertheless the work hangs together; the workmanship in the best periods is clear, firm, and conclusive. The originality is a natural rather than an affected one, while the transformation is involuntary, and so a collective work of the tribe and race. There is a new dialect and grammar to learn here, grinning while we apply ourselves, so to speak, but reserving our definitive judgment till later.

On the other hand, there is no need for preliminaries in order to appreciate the cups, vases and goblets on which the primitives cover all smooth surfaces, like the tattoos on their body, decorated with a richness and invention that the civilized peoples seem to have lost. Even though crowded with decoration, however, the lines stay pure, for no ornament has been added haphazardly. Every decoration is in harmony with the object. We would hesitate to call merely "calabashes" these precious woods that a jeweler might reproduce with dignity in silver or in vermeil, and with which he might create awesome effects that can contribute to the renewal of our own decorative arts, whose simplicity often seems a matter of necessity, and therefore a close cousin to poverty.

If these everyday objects appeal to the visitor, he should then try to accommodate his views to the modes of interpreting the human form that have been common to indigenous sculptors since ancient times.

In effect, their art can claim an ancient lineage. The beautiful Polynesian race is supposedly Caucasian in origin, and, after a period in India, then in Malaya, boldly populated the minuscule archipelagos scattered in the middle of the greatest ocean on the globe. "Nature had prepared a garden of Eden for them, unafflicted by the curse of Adam, which insists that bread be earned by the sweat of one's brow . . . but now they have to pay the price of this beatitude."

As for the Negroes, how can we forget the exchanges of every sort, from the most distant antiquity, between the heart of their continent, the Sudan, and the Pharaoh's empire, or fail to take into account the recent discoveries of a Neolithic civilization at a bend in the Niger, whose regular flooding makes it a brother to the Nile? From the third to the twelfth centuries of our era, and again to the fifteenth century, two great empires ruled there in succession, in the course of which were created, in flourishing schools and workshops, the basic types that have likely inspired all later generations. For, as strange as they seem, the formal perfection of certain works prevents us from imagining that they could have been realized spontaneously with a rough knife by some more or less gifted dabbler. The unexpected conclusion to all of this is doubtless that there is no such thing really as primitive [*sauvage*] art, but that we are confronted here with a sequel that has descended from ancient civilizations, branches from a single source, from which ours evolves as well.

PAUL GUILLAUME

A NEW AESTHETIC · 1919

An exhibition of Negro art is currently on display at the Galerie Devambez. It is therefore interesting to establish the history of the relatively recent taste that has been developed for this curiosity. It was in 1904, at a laundress's shop in Montmartre, that chance first brought me before a Black idol. How to explain the presence in so unlikely a place of so singular an object! The stories that were told to me relating to this subject do not deserve to be repeated. The investigation I undertook led me nevertheless to the discovery of the origin of this mysterious effigy: it came from Bobo-Dioulasso. This is an auriferous region of the Black Sudan. The indigenous people are fetishists and mistrustful of outsiders: the cult belonging to the figurine is at once erotic and mortuary. Whatever the facts, I very much liked what I saw.

About this time, I began to frequent a milieu of writers and painters. I made the acquaintance of Guillaume Apollinaire and he was the first to whom I showed my discovery. I will doubtless never again meet a spirit as enthusiastic, as clairvoyant as was Guillaume Apollinaire before a work of art that revealed something rare and strange. The library of the Trocadéro Ethnographic Museum is quite rich, although uselessly cluttered with works of minuscule importance wherein bluster outweighs exactitude, which travelers more zealous than discriminating or cultured felt obliged to publish. I found it, however, useful to work there, under the kindly guidance of M. Bénazet, and I was especially happy because of the proximity to the museum, where I endlessly surveyed its beautiful and varied displays. I began to publish the fragmentary conclusions I had formed from my studies, in reviews and journals that wanted to show off their liberalism. M. d'Ardenne de Tizac, curator of the Cernuschi Museum, honored me with a request for advice. The importance of this person moved me infinitely, but I contented myself with answering in a few modest vague words. How many letters I have received since! It was even thought that my idols were used by me in the accomplishment of magical operations whose purpose was a subject of much surmise.

Les Arts à Paris (May 15, 1919): 1–4.

Paul Guillaume (1891–1934) was a major dealer in both modern French art and African art. He became one of the greatest promoters of Primitive art in both Europe and the United States, where he was for many years allied with Albert Barnes. Guillaume published a good deal about African sculpture and organized numerous exhibitions and events, including those at the Lyre et Palette (1916) and the Galerie Devambez (1919), and the Fête Nègre (1919).

Meanwhile, I rounded out my knowledge at the Bibliothèque Nationale, where I compared my findings with accounts by credible explorers. I ended up exhuming erudition and documentation so contradictory that I became discouraged and abandoned my studies to focus on the quality of the exhibitions for my gallery. It was at this time that I launched the call for a Society of Negro Archaeology. Whereupon the State, in the form of the Minister for Colonies, jealous of its prerogatives over somnolent traditions, interposed; I mean I was offered official backing. I declined, having an instinctive horror of anything that might threaten my independence; and so, alone, with my own means and out of my own funds, I've assembled the collection, a portion of which I am proud to present to a select public.

When I frequented more painters, it was my great pleasure to find Negro sculptures in many ateliers.

Frank Haviland, who has a dreamy and sensitive nature, and is a proud and talented artist, shyly feminine about his own painting, which will impress people when it is known, had a veritable passion for the idols and was one of the first to notice the architectural quality of the *Tikis* of Oceania. Henri Matisse had a preference for the *Sibitis,* kinds of domestic divinities analagous to the Lares of Greek antiquity; Maurice de Vlaminck, an ardent collector, assembled an important ensemble with which he decorated his house at Chatou, which became for this reason a kind of place of pilgrimage. One could see some very beautiful things there, which have, alas, been scattered since. At Derain's, a mask, a stunning evocation of Fang mysteries, a taboo as moving as a hallucination. This painter, as *disinterested* as could be, had no concern with *collecting* but was motivated by simple pleasure, the simple need for this company, at once raw and reassuring. Picasso owned a certain number of pieces of the most varied provenance; his affectation was to accord absolutely no importance to epochs. I've often argued with him over this dangerous opinion, and I regret to say I am still in total disagreement about this with the painter of the *Saltimbanques.* Other painters, Georges Braque, Dunoyer de Segonzac, Luc-Albert Moreau, André Lhote, Marie Laurencin, were devoted to the new aesthetic as well.

Among writers, the most passionate devotee of Black sculpture was incontestably Guillaume Apollinaire, who prophesied the importance of this discovery in *Mercure de France, Les Soirées de Paris,* and in great foreign reviews that were keen to publish him. We collaborated on the publication of *Sculptures nègres* [in 1917],[1] which was honored by subscriptions from the Ministry of Art, the Library of the City of Paris, the University of Lausanne, the Jacques Doucet Library, etc. Madeleine Le Chevrel wrote a kind and interesting report of her visit to me in the *Gaulois.* Other writers, such as Paulhan, Leblond, André Warnod, André Salmon in France, Marius de Zayas in America, Tristan Tzara in Switzerland, commented in their writing on the role of Negro statuary in the most

recent innovations of avant-garde art. There is a "melanophile" movement in England, and the sculptor Jacob Epstein apparently was its promoter. Young students, composers, painters from the four corners of the world, from China, Japan, Scandinavia, Brazil, and Portugal, are at my door almost daily, asking to be enlightened about this Negro art that they have heard of in their own countries.

Today the most beautiful and rare pieces of Black hieratic art are much sought-after and can be found in the premier collections in Paris and in the entire world. André Level, [Henri] Clouzot, the curator of the Library of the City of Paris, my collaborators for this exhibition; Jacques Doucet, Auguste Pellerin, Jos Hessel, Victor de Goloubew, Georges Menier, Alphonse Kann, the count of Gouy d'Arsy, Bernard d'Hendecourt, Fayet, Bachelier, John S. T. Audley, all have put them on display in their windows. We find them also with women of taste, such as Mmes Tachard, Nicole Groult, and Napierkowska and Mme Tittoni, who often came to the Avenue de Villiers, where I had my collections, when she reigned as Ambassador at the Rue de la Varenne. In Rome, Edouard Keeling, charming dilettante, and Tyrwhitt, who recently became Lord Berners, while remaining a composer of great merit, are active and intelligent champions of the Black cause.

We must not forget that the antiquarian Brummer, the art dealer Kahnweiler, the collectors Hude and Reininghaus all contributed to the popularity of the new movement. During the war, the writer Carl Einstein published a thoroughly documented work on the subject, with many illustrations.

Now that we are arguing about epochs and materials and making subtle classifications, fakes abound, which show just how much it is in favor. Negro art is fashionable! Religious art, sorcerer's art, whether benign or malefic; divine or diabolical specters, you are the enigmatic *cipher* of a civilization which must have been grandiose and terrifying. People will doubtless try to tear your secret from you. For today, I will be satisfied with just savoring the nostalgia you awaken in me for exile and for a distant childhood.

I have often compared the revelation of Negro art and its profound influence on the most brilliant minds of the present epoch to that of the poems of Ossian at the beginning of the last century. MacPherson [their author] was eventually identified; someday it may be possible to lift the veil of anonymity that envelops these works, some of which can be placed advantageously alongside the purest marvels of recognized and acknowledged works of classical antiquity.

P.S.—My observations conclude in agreement with the theories of Gobineau or of Fenellosa on the great antiquity of the Black race and on the anteriority of this statuary to the arts of Antiquity. Artists who sense intuitively the connections of sculptural forms generally share this idea, which is nevertheless contradicted by some. Someday I will publish a scholarly work on this subject, but an

issue of such importance merits the kind of elaboration that would very much delay the appearance of this book, such as I conceive it. Certain Black pieces are, in effect, strikingly similar to the Xoana of the archaic Greeks, or the Bethyles of Chaldea, but I am not sure why we would be authorized to accord more or less respect to Black art based only on simple conjectures.

NOTE

1. [See p. 107 above. Eds.]

FLORENT FELS (EDITOR)

OPINIONS ON NEGRO ART · 1920

GUILLAUME APOLLINAIRE

The evolution of the fetishistic sculpture of the Blacks, as far as we can tell, was effectuated according to rhythms that were infinitely more extended than those which governed the evolution of European or Chinese art. No doubt, the transmission of traditional models can be considered one of the principal rules of this art. To the centuries and parts of centuries of Western art history, Africa and Oceania oppose vast periods that sometimes include the effort of numerous generations. But the inventiveness that has always guided this imitation, an inventiveness whose source was often the use of simple amulets or diverse materials that the artist had on hand, and which stimulated his decorative sense and his religious feelings, makes it difficult to assign these art works to a specific time. Moreover, in the course of years these charms—such as loincloths, large feathers, rosin balls, necklaces, pendants, small iron bells, twigs, handfuls of herbs, shells, boar's teeth, mirrors, nails, bits of iron of all kinds—have been worn down, broken, or lost and have been replaced by other charms that changed the general look of the fetish, making its age difficult to ascertain.

He who would undertake such aesthetic research could not rely on any writing or on any ancient inscription. Aside from a few anthropological indications, or hypotheses about the function of the idols in question, nothing can shed light on the mystery of their anonymity. For a long time we will have to be content with the aesthetic sensations and poetic evocations these Negro idols provide.

JEAN COCTEAU

The Negro crisis has become as boring as Mallarméan Japonisme.

PAUL DERMÉE

Whatever M. Rosenberg says, Picasso had already created his revolution when Negro sculptures came to his attention.

Evidently Negroes are more interesting than the Beaux-Arts students, but that will never last. All the young prodigies of Timbuktu have come today to finish their studies in Paris under the rule of official masters.

Action 1 (April 1920): 23–26.

This survey was edited by Florent Fels (1891–1977), a French art critic who wrote extensively on artists of the School of Paris. *Action* was a short-lived (1920–1922) progressive-anarchist journal run by Fels and Marcel Sauvage.

In seventy centuries the Negroes have not been able to produce a single Picasso. Now it is too late.

JUAN GRIS

Negro sculptures give us flagrant proof of the possibility of an *anti-idealist* art. Animated with a religious spirit, they are the diverse and precise manifestation of great principles and general ideas. How could we not accept an art that, proceeding in this way, succeeds in individualizing what is general and each time in a different way? This is the exact opposite of Greek Art, which was based on the individual, so as to *try to suggest* an ideal type.

PAUL GUILLAUME

Negro art is the life-giving seed of the spiritual twentieth century. The savage who incised into the enormous sequoia an effigy of an Ancestor, sorcerer, or man wasn't worrying about art; he was accomplishing a hieratic sexual act, and not as a paid labor, as it is inevitably conceived of today. His work is fatally disinterested since only natural virtues are involved in its execution: virility, love, fervor, tenderness, ideas of murder, poetry of the river, the forest, of thunder, lightning, sunlight or moon.

This century has had the good fortune to bring out of ancient Africa the splendors of a statuary whose reign is just beginning.

The phony cackle of a skinny old baby, charmer of elderly ladies, will not at all interrupt the unanimous stupefaction [before African art] of insightful men.

Physiognomically, the Negro specter obsesses the intelligent eye and enriches the imagination, and the source of the beautiful creations that it inspires is not about to dry up.

VICTOR GOLOUBEFF

Much has been said and written on Negro art, so it is difficult to add anything. Nevertheless, it seems to me that we haven't insisted enough on an essential point in the study of this art: the perfect harmony between man and matter. Negro art is a pact between man and forest. The forest lends to man its beautiful and durable woods so that he can make gods of them. However, it commands: "Make these gods in my image." And this is why we think we hear in Negro sculptures a kind of call of the tropical forest, with its powerful trees, smooth and hard fruits, resistant roots, solidly fixed in the earth, even the halting cry of the toucan bird. Modern artists, like those of the Middle Ages, love and understand wood. They instruct the oak, the chestnut, and other of our native trees. Negro art is a friend and a guide for them.

JEAN PELLERIN

I think it is impossible for an artist not to love—among many expressions too

remote from our European sensibility—certain of the incontestable beauties of Negro art, and not to be grateful to melanism for the works it has inspired.

I think also that its very special character, its vigor and everything that removes it from facile seduction will protect it from vulgarization. Negro art will not suffer from the banality that afflicts far-eastern art. Its enthusiasts will be able to stay loyal without risking being disgusted by reproductions.

JACQUES LIPCHITZ

Certainly, the art of the Negroes was a wonderful model for us. Their true understanding of proportion, their feeling for drawing, their acute sense of reality have made us perceive, even dare, many things. However, it would be wrong to conclude that our art has become a sort of Mulatto. It is still quite White.

PICASSO

Negro art? Never heard of it! [*Connais pas!*] [1]

ANDRÉ SALMON

The Negro and his Polynesian rival are inspired by human perfection, but they do not subordinate their art to it.

As realists their attentive scruples are those of builders anxious to construct an ensemble of harmonious relationships.

Everything that is incidental in these works can disappear, devoured by time and sacrificed to the taste, the prudery, even the barbarity of the European. The ensemble is not lessened thereby; the premeditated harmony is preserved. . . .

Man taking man for his model, if only to create his gods out of him, cannot be satisfied in imitating man. That is what separates the realist in good health from the naturalist stuck in the web of a vulgar dogma.

What allows the Black image-makers to attain the divine, to approach it in their renditions of the human face, is properly the plastic translation of feelings, and preferably in their most intense moments. It is clear from this that even psychology itself is not lacking in Negro art.

MAURICE VLAMINCK

The only art that you can appreciate without being overwhelmed by the explications, admirations, and praises of a literature which explains the art of the present, the past, and the future. An art still virgin enough to inspire admiration in some and a feeling of horror in others. An evident humanity, a feeling of animality that produces laughter, that sometimes transports us by the feeling of decorative grandeur, like the pillars of a cathedral or the curve of a gothic arch. Through simple means, Negro art succeeds in giving the impression of grandeur and immobility.

NOTE

1. [In 1923, Picasso clarified this denial, saying to Fels: "I already told you that I couldn't say anything more about 'negro art.' You responded for me, 'Negro art, never heard of it.' The fact is that it had become too familiar; the African sculptures that are scattered around my house are more like witnesses than exemplars. I loved circus images, hairdressers' heads and milliners' dummies. I still have a great appetite for curious and delightful objects." Florent Fels, "Chronique artistique. Propos d'artistes. Picasso," *Les Nouvelles littéraires, artistiques et scientifiques* (August 4, 1923): 2. Eds.]

ANDRÉ SALMON

NEGRO ART · 1920

An exhibition of Negro art, held in a Parisian gallery early in the winter of 1919–20 made modern artists' concerns with the productions of the African and Oceanic image-makers suddenly familiar and even popular with the public.

Students of contemporary art are well aware how much patience is necessary in preparing minds to accept new aesthetic conceptions in all their integrity and purity, and in a spirit of disinterestedness. But here the disinterestedness would lie in a moral attitude that would teach us to be wary of fashion.

A Negro festival [*fête nègre*], held on the occasion of this exhibition, that was as pleasant as a charming Russian ballet seems to have greatly favored the fashion but to have done very little for the pure idea.

Because of the limited size of our national collections, many enthusiasts of Negro art have wanted to revisit the incomparably more comprehensive ones at the British Museum, but it can nonetheless not be taken for granted that they will be able to see these arts very objectively; that is, completely free from a fascination with the picturesque and the quaint which had already vitiated their first encounter with this art by preventing them from seeing in these wooden sculptures, as well as in the rarer bronzes, what really matters: the element of essential beauty. We cannot become sensitive to this until we have abandoned the vulgar view, which is of course consistent with the gross barbarity of the civilized, that what is remarkable about these images and even makes them worthy of the Museum is the fact that they are the work of savages.

It would have made more sense, before rushing back to the British Museum collections or to those too rare pieces at the Trocadéro, to have paid more attention to the works of modern artists who insisted on placing Negro art on the same level as Greek, Medieval, or Egyptian art; it was in fact their study of Egyptian art that drew these artists inevitably toward the discovery of the statuary of the African sands and the Polynesian islands.

Before these modern artists had turned their respect for Negro art to such good account in their own works, the known and catalogued pieces of the art of

"L'Art nègre" (1920), in *Propos d'atelier* (1922), 115–33.

André Salmon (1881–1969) was a French poet and art critic closely allied with the Cubists. This article, which was provoked by the 1919 Galerie Devambez exhibition, very likely reflects conversations that Salmon had had with Picasso several years earlier. A somewhat abridged translation of this essay was published in *Burlington Magazine* (April 1920): 164–72.

primitive peoples were of interest only to scholars, for whom they served only as data for various demographic studies; or as toys for explorers, lecturers, and professors of anthropology and geography to play with.

They were not even considered under the woefully inappropriate category of the picturesque. Brought back from sunny climes, these images lacked the kind of "glorifying poet" that the artists of forgotten islands and lost lands had in someone like Pierre Loti.

The first statuettes, the first Dahomean, Nigerian, Senegalese, or Oceanic masks that were so fiercely competed for by Henri Matisse, Picasso, André Derain, Maurice de Vlaminck and M. de Goloubeff—these were in fact fished out of the piles of shields, clubs, spears, arrows, and assegais thrown together haphazardly in old curiosity shops. Such trinkets, as a matter of fact, were usually preferred by collectors over the masks, whose tragic aspect offended European taste—this taste of theirs that seemed so perfect only because it was so extremely limited. This was the situation before 1905.

But there was more to it than that. The only contemporary artist to have been really carried away by the fascination of virgin lands, one who deserves the reputation of a really revolutionary painter, always impatiently looking for novelty (even to the point of naïveté) and whose desire for the new justified and compelled his exile, was totally indifferent to the masterpieces of Maori sculpture that surrounded him. This painter was Paul Gauguin.

Nevertheless, towards the end of the nineteenth century when, tired of reigning at Pont-Aven, Paul Gauguin left Brittany for Tahiti, he had already sculpted the crude and tender images that are among the best of his work in the forests of the Finistère. This apprenticeship in rustic imagery, one that reinvented sculpture, could have prepared him, if not for a great discovery that would renew modern art, at least for some understanding of the austere masters of barbarous antiquity.

Paul Gauguin saw nothing, here and there, except through the lens of the picturesque. As a poet in Tahiti he sang *Noa-Noa* in a poem that is nothing more than Pierre Loti reviewed and corrected by the symbolists.

Paul Gauguin had no part to play in the esteem we have for Negro art today. The concern with order, with constructive values, and with a sense of formal harmony that once again rules our aesthetics was completely lacking in this undisciplined and infuriated impressionist.

On the other hand, those academic artists who are incapable of even suspecting the existence of Negro art, unless to complain that people are impressed by it, are not even worth mentioning. An American sculptor, Mr. Herbert Ward, built himself an African atelier adjacent to the hut of a carver of idols (humble copyist of the traditional images) without it even crossing his mind that that artist, fallen to the rank of artisan, was nonetheless someone far superior to him. Yet Herbert Ward serenely modeled a naturalistic study of this Black sculptor

working on his fetish. But why be so hard on Mr. Ward, when for so long all of Europe, which had long been well-acquainted with Black statuary, regarded it with the same eyes as this American known for being so "sympathetic to negroes." [1]

Sympathy! Picturesque! Taste! Who will be honest about the great damage these words have done, suggesting as they do lukewarm enthusiasm, tepid passion, and condescension. People's minds still haven't been freed from their power.

A public convinced of the excellence of its own culture cannot understand the anguish that drove modern artists to seek lessons from savage image makers. After they had finished touring the world and the ages, modern artists came back to the Negro village, unchanged through the centuries from what it was like on the first day. The more thoughtful of contemporary creators, however, did not go there to plunge themselves naively in some shameful cannibalism. Impressionism and symbolism provided them with savagery enough in Europe. On the contrary, they felt themselves irresistibly drawn toward an art that was no doubt primitive but also very advanced, and without benefit of any Academy or Renaissance! And capable, if you let yourself be affected by its powerful message, of renewing the dried-up sources of Classicism.

Picasso, a passionate hunter of Negro masks in 1906, would arrive at cubism, defined by an anarchistic friend of Bonnard as "a counteroffensive of the Academy"; and the Fauves, with whom Picasso found himself in competition in the curiosity shops, loved and defended with him that admirable innocent the Douanier Rousseau. Now, we do not admire Rousseau for his primitiveness but for his knowledge. Nothing happens by chance in the work of Rousseau; we find no miraculous successes there, since his is an art that owes nothing to the miraculous. For that reason, when we sometimes think of the Douanier in relation to the masters, he makes us more sensitive to the beauties of Giotto and Paolo Ucello.

The Douanier painted his ambitious works in the same way that the Black image-maker carved his sacred fetish. We were just beginning to be disquieted by the latter at the same time that the former was beginning to enjoy his innocent triumph. Rousseau, in sum, was ignorant only of Academism. He did not need to waste his time as did the impressionists with a need for rebellion that would take the edge off his freshness.

African Negroes and Polynesians were not teaching us that monstrous paradox believed by certain misguided Europeans: "the science of ignorance." The artists of the twentieth century, more than their immediate predecessors, were impatient to harmonize their art with a new life, faithful to the museums that they visited with a passion that was governed by reason and the critical spirit. To them the savage image-makers brought plastic examples of a primitive ambition

to base a style, a culture on human sensation of the most profound and virgin sort, one already purified by an exalted feeling capable of expanding this sensation into a conception. To call things by their name, this feeling was that of a religious faith preceding a revelation; there is no need to elaborate on the allegories, the symbols that support this kind of affirmation. Those to whom art means anything at all will be able to find such evidence for themselves.

The carver of idols is doubtless the most scrupulous of realists; he proceeds with as much innocent naïveté as Rousseau, who before doing a full-length portrait of the poet Alfred Jarry, took his measurements with a tape-measure, just like a tailor. Nevertheless, it is dangerous to forget that the Douanier chose his models and that he behaved like that in front of them only *through scrupulosity,* and that before setting to work he had a complete conception of his model.

The Black image-maker, just as scrupulous, does not believe he should omit any detail. It is because of this conscientious approach, consistently applied, with no awkward intervention of the imagination, without any malicious (à la gauloise) or violently sensual intention, that the wooden pieces carved by these savages—especially those of West Africa—are sometimes loaded with scabrous elements; these more "objectionable" pieces are deliberately removed from exhibition in our climates, even by collectors who are among the most understanding, sensitive, and respectful of Negro art and tradition.

These pieces can be suppressed from the ensemble without the harmony suffering as a result. This is because they are nothing but pieces, accessories, and not the essential elements. For the Negro sculptor, as for the great masters of our civilization, the theme, as he has *conceived it,* is what counts.

His application, his fidelity in making human perfection the basis of everything does not derive from the base fetishism of imitation that inclines the White academic to rejoice when he cannot tell the difference between a mirror image of an object and the painting he has made of it. The Negro and his Polynesian rival are inspired by human perfection, but they do not subordinate their art to it.

As realists their attentive scruples are those of builders anxious to construct an ensemble of harmonious relationships.

Everything that is incidental in these works can disappear, devoured by time and sacrificed to the taste, the prudery, even the barbarity of the European. The ensemble is not lessened thereby; the premeditated harmony is preserved.

It is not so rare for the masks associated with festivals or mourning, with weddings or funerals, to come to us stripped of their beards and fleeces of wool, tow, hair, and raffia. Frequently the more or less brilliant coloring of these masks is also modified. But the aesthetic pleasure the savage genius affords us is still very much there. The value of these ornaments is sometimes purely symbolic, and so more religious than aesthetic; or else (since even among primitive peo-

ples there are artists who are not exempt from preciosity), these ornaments are added elements that warn us of the time when over-refinement and false civilization will ruin everything.

It is through the sum of their naked beauties that Negro sculptures are so admirable, and they succeed because of the balance and nobility of their pure form.

We can laugh at the skepticism or the disdain of collectors who are convinced that they are the vigilant guardians of classical order, and who scorn Negro statuettes, or even ridicule them, at the same time as they fill their houses, their galleries, and their museums with gothic images.

Is the distortion that they complain of in these powerful African or Polynesian marvels less pronounced in pieces that have come down to us from the European Middle Ages?

I really do not think so, and I am happy to find confirmation of my view from the prudent critic and jealous defender of tradition, Mr. Camille Enlard, director of the Museum of Comparative Sculpture, an erudite compiler and scholarly expert on the art of the Middle Ages, whose works are authoritative, and who, without intending to, supplied me with a seductive thesis about the constant distortion found in the art of all peoples and of all periods.

It was from an equilibrium that was prodigiously robust yet gracious in its strength that the Egyptians derived the secret of Karnak and of Medinet-Habou.

The example of the Greeks, who began to break up overall equilibrium by employing juxtaposition, no longer satisfies modern artists, who had to go back through the Egyptians to the Negroes to find confirmation of their aesthetic principles.

Although this should be the object of a more sustained study, I want at least to indicate an essential quality of the beauty specific to Dahomean, Nigerian, and Marquesan masks.

This characteristic is in evidence only because there was no need to create any futile naturalistic imitation. Man taking man for his model, if only to create his gods out of him, cannot be satisfied in imitating man. That is what separates the realist in good health from the naturalist stuck in the web of a vulgar dogma.

What allows the Black image-makers to attain the divine, to approach it in their renditions of the human face, is properly the plastic translation of feelings, and preferably in their most intense moments. It is clear from this that even psychology itself is not lacking in Negro art.

We are now just beginning to understand what motivated the artists cited above to look towards Negro art for inspiration. We should add to their number: Othon Friesz, a friend of Henri Matisse at the time; their friend Frank Burty, grandson of Philip Burty—their friendship was the foundation of the Ceret group, where André Derain came to his senses after cubism became something

of a school; Luc-Albert Moreau, André Lhote, Dunoyer de Segonzac, Marie Laurencin, and some talented writers, from my late, unforgettable friend Guillaume Apollinaire to Jean Paulhan, a psychologist and logician, and deeply versed in the languages of East Africa. I myself, who could not even imagine the purity of the Dahomean statuary that Picasso showed me, even if I sensed a kind of savage beauty mixed in with the exotic picturesqueness, I myself kept a very vulgar color illustration from the *Petit Journal illustré,* of the sort that the common people of France cut out in order to decorate their walls: crimes, disasters, and military or civilian acts of derring-do. It represented the first soldiers of Colonel Dood entering Abomey and smiling at the Dahomey idols with their heads of jackals, buffaloes, or unimaginable monsters. I have always wondered when some literate soldier would write an account of the shock that these monuments of a new kind of beauty, and one older than that to which we are accustomed, gave to his "civilized" mind-set. That soldier's book has never been written. The picturesque was too blinding.

What did we finally need to enable the discovery of Negro art?

We needed the desperate patience of Cézanne to yield to us, shortly after his death, after a life of sublime dissatisfaction, the constructive elements whose deliberate acceptance gave new life to the lucid and strict lesson of Ingres; from that pole we needed to come back to Cézanne building as he staggered among the ruins, to meet with El Greco, in whom Maurice Barrès could recognize only the pathetic; we needed to illuminate with new works the subtle and rigorous intention of the least popular of the impressionists, the only one—the great Seurat!—each of whose works confirms the fecundity of the affirmation that captures the spirit of our times: "Conception outweighs vision." It was necessary to visit the Louvre with pure painting in mind, recreating its collection with our own eyes in a proper order—liberating the Venetians and the Florentines finally from the insult of museum curators who have been subjecting them to the tyranny of the Dutch; it was also necessary, for the greater glory of *painting-in-itself,* to confront Delacroix with Courbet, while not avoiding any of the critical work that this entailed; and also to have honestly honored the good Rousseau, as I have said above.

"Living artists" are repelled by the haphazard, which the work that endures rises above; they do not recognize this kind of permanence in the fugitive quality of impressionism; impressionism, which leaves even the best of its acolytes, the freest from bondage to futile anarchy, baffled before the commanding summit: patience. The Academic lies are not even worth denouncing.

If it is purity you are looking for, since 1906 you can find it radiating from the dark foyer of statuettes from the Ivory Coast, Dahomey, Senegambia, and the Pacific Islands.

This lesson will be one for young people, anxious not to reimmerse themselves in some sort of barbarity when they were sincerely fleeing something

worse, but to find a *method:* really a method of decomposition tending toward a renaissance of composition. Composition has been absolutely ignored in Europe since the charming but thoroughly anarchic careers, so grievous for the future, of Bonnard, Vuillard, most of the masters of Pont-Aven, and even Gauguin himself—which no one has ever dared to write about.

In one of his notebooks that are in process of publication—engaging reading, and, in spite of everything, worthy of esteem—Paul Gauguin, the constant witness of the flower of Polynesian art, very calmly made a remark that his biographer Mr. Charles Morice reported with serenity, with the conviction that it would honor his memory: "There does not seem to be any doubt in Europe that both the New Zealand Maoris and the Marquesans had a very advanced art of decoration."

"Decoration" is exactly the word he used. So Gauguin allowed himself to be impressed, but not in the right way; he allowed himself to be enchanted but not to understand. Suddenly he shows us where to look for the weakest point in his work, in spite of its rich surface seductiveness.

Confusion was also rife in minds nourished with the symbolist doctrine (very inferior to the impressionist). Charles Morice, commenting on Gauguin, vaguely finds that Maori art—Negro art—was "real art," something that ties Mexico to Egypt, the Khmer Cambodians of Angkor to the Gothic, the archaic Greeks to the Italian primitives, the Flemish and the French to the Japanese and Chinese, and "Giotto to Puvis de Chavannes."

Allowing Puvis de Chavannes to rest in peace, let us simply note in passing the injustice of treating the Japanese and the Chinese as exactly the same. And let us especially remark the problems in the symbolist mentality if it could perceive in savage art nothing but decoration.

The Fauves of 1905, the Cubists shortly afterward, were calling for something different from a lesson in decoration. And in any case, they would not have been seeking such a lesson from the Negroes.

In a recent study, Mr. Paul Guillaume has given a precious hint as to the true feelings of our contemporary artists who are influenced by Negro art. It is when he writes: "At Derain's, a mask, a stunning evocation of Fang mysteries, a taboo as moving as a hallucination. This painter, as *disinterested*[2] as could be, had no concern with collecting but was motivated by simple pleasure, the simple need for this company, at once raw and reassuring. Picasso owned a certain number of pieces of the most varied provenance; his affectation was to accord absolutely no importance to epochs."

These "epochs" are many and go so far back in time that current research does not prevent us from suggesting that the European sculptors and painters of today, by inclining toward these Black marvels, are only rediscovering the perfect source of classicism.

Not only do some of the most beautiful pieces that have come down to us pre-

date the Christian era, but when the submission of Greece to the Egyptian example is no longer even being debated, we are justified in finding in the Egyptian style the influence of the fetish carvers. Artists, critics, and scholars agree on this.

The artists of our time, these revolutionaries so fundamentally constructors that the anarchic critics of post-impressionism wanted to outrage them by labeling them reactionary; these painters, whose enhanced gaze will respect only a vision under the control of thought; these measurers of space and passionately prudent weighers of form have not been able to create a Museum of Negro Art whose galleries are the Parisian ateliers where the best art students in the world come knocking on the doors, merely because they miss the repudiated picturesque. Nor was this the result of the quest to find something uncomplicated to satisfy the curiosity of a romantic cabinet-maker or upholsterer who subscribes to the *Journal des Voyages*. This was not a matter, as I have said before, of being rejuvenated by plunging into the black lake of a terrible naïveté. No salvation through cannibalism here!

Not at all. But it makes sense to assume that the logic of the noblest artist's life that has ever been led—since the golden age of Italy, even the azure age that Ruskin abused with such ingenious distraction—should lead them to recognize in the grandiose and wild ruins of ancient Negro art the very *principles* of Art.

I will try to prove this.

Among the greatest modern French artists, some go so far as to say that Europe has only been able to reach the tragicomic. Only the image-makers of the African sands and the Polynesian islands were able to attain to the quintessentially dramatic.

If they are right, and I am very much willing to admit that they very nearly are, they would do well—consistent with this idea—to place the Africans above the Oceanians. The further you go from the land of Ham, that cursed ground, the more you have to repay in decadence, as you approach Asia, what you have gained in grace.

It is only recently that we have been able really to look at a Negro mask. We needed to learn more about how to wear these masks, without the help of the traveler or the explorer, whose advice, as I have said, points us in the wrong direction. A mask whose eyelids are drawn flatly in raw white is a mask meant to heighten the power of the gaze. Some other masks that the first collectors presented vertically, as for example a horse's head, need to be looked at horizontally, so that the priest, the sorcerer, or the dancer who dons it offers a spectacle like that of the Egyptian Anubis.

Some masks were painted to sparkle in the fires of the sun; others were made to enchant souls by the light of the African moon. Such were these great black and white masks used by the Gabonese magicians; masks that are veritable magic mirrors, subtly carved mirrors, multifaceted mirrors, constructed in levels unevenly, but nevertheless comprising an ensemble. Works, in a word, that reach

the heights of enchantment only through plastic perfection. Is this not the summit of art?

"It is obvious that certain of these pieces, sculpturally beautiful, have as much character, expression, and humanity as the Hindu, Egyptian, or Assyrian fragments from high antiquity that the Louvre or the British Museum are so honored to have. What is especially interesting is the influence that such an aesthetic has and will have on fashion, on our artists, our literature, and the public; the new confusion and ambiguity that will inevitably surround it."[3]

We are not opposing Negro works to those of classical antiquity. Our purpose rather is to rejuvenate art through the renewal of themes and forms, the artist's observation being linked to the very principles of great art.

I have attempted to indicate what Egypt and Greece could have absorbed from the African image-makers. The collection of Mr. Jacques Doucet is there to persuade me that my imagination has not exceeded the possible. This famous collector believed he could bring together certain masterpieces of Negro statuary and some beautiful samples of European sculpture. Connoisseurs are happy to cite as an example some African head that compares perfectly well with beautiful pieces of Romanesque sculpture.

But the task of the friends of Negro art is not over when it is generally accepted. I am in complete agreement with the scholar Louis Troème's challenge to the serene apathy of the critics and collectors. What we need now is to arrive at a rational classification of these African and Oceanic sculptures. When we know exactly the workshops and the periods in which they were executed we will be in a better position to judge their beauty and to compare them to each other, something we can do only with great difficulty today. At present, uncertain and imprecise points of reference allow only for very timid conjectures.

In two great bourgeois salons that today serve as Picasso's studios, the most beautiful African and Polynesian pieces lie on the floor, mixed randomly with children's puppets, albums, rare books or penny books, a Harlequin's costume, and the most unexpected objects. In addition, Picasso seems to have absorbed from the masters of color all that he needed. We do not suppose he will ever want to study their great works again.

In this connection I hasten to add that if Vlaminck is still collecting new Negro pieces; and if Henri Matisse is still faithful to his Oceanic *sibitis,* types of domestic divinities analogous to the household gods of European antiquity (and to which Frank Haviland prefers the tikis, for their monumentality); if André Derain methodically catalogues his collection, adding to the masks and statuettes some musical instruments whose harmony he has been able to render by repairing them, reconstituting them, making them sing, to the point of having been baptized by his friends the *Lutenist of the Desert*—none of these important artists is obsessed by barbarian fetishes, none believes blindly that in these sublime

works of an innocent humanity is hidden the secret to everything, dressed in some guise or other; which, of course, would have been a very great mistake. None, at times of worry, doubt, and difficult soul-searching, asks of these serene or grimacing idols the definitive "word," the word that would be the entire law, and also the most extreme weakness.

It was in cataloguing his fine Black fellows just yesterday that Derain talked so well and so lucidly with me about Raphael.

But as I have indicated, we all owe to the idol carvers the saving grace that allows us to return to the basic principles of art, at a time when after a brilliant corruption of talents everything is once again found to be in question.

My principal goal has been to demonstrate the intention and the kind of attention that modern artists have been according to Negro art and to stimulate the curiosity of the public about it.

I am sure that young painters will come along who will be able to derive from this naked, innocent art something that their forerunners have not found out about it. A precursor is always somewhat of a primitive.

As for the aestheticians, I will simply leave to them the glory of making profound doctrinal discoveries.

Guillaume Apollinaire brought up the subject frequently in *Mercure de France, Soirées de Paris,* etc. He published, in collaboration with Paul Guillaume, *Le Premier album de sculptures nègres,* which was honored through subscriptions from the Minister of Fine Arts, the Library of the City of Paris, the Jacques Doucet Library, the Library of the University of Lausanne, etc. When death took this great poet, whose war wound left him defenseless against illness, he was working for the Minister of Colonies in the area of logical classification of precious documents. This project, unfortunately interrupted, and which no one has continued, would certainly have assured the admirers of Negro art some official support and would have resulted in both the sponsorship of cultural missions and the funding of voyages, greatly facilitating the clarification of the origins of barbarian statuary.

Just a few months ago there appeared a very well documented work by Maurice Level, the distinguished collector, in collaboration with Mr. Clouzot, who also was one of the first to be interested in our research. It would be impossible to be too grateful to this true friend of the arts, whose title of Director of the Library of the City of Paris has been a kind of shield when the "serious, official" criticism that was so naturally inclined to make fun of us denounced us as weak-minded.

The German writer Carl Einstein published a great work on Negro sculpture, decorated with many plates, during the war, in Berlin. But the precarious state of commercial relations and political problems in "civilized" Europe have hardly favored the diffusion of this Apology for "barbarian" wisdom!

THE ERROR IS ESSENTIALLY OFFICIAL

In one of its June 1919 numbers, the *Journal Officiel*—who would believe it, O Derain, O Matisse—prints the following:

> Père Maurice, doctor of sciences, was the Belgian chargé de mission during the war. He had to find out which places were least affected by sleeping sickness so as to assure relations between the various colonies via railway lines. During his researches he was able to explore the Baluba region, situated between the 5th and 8th degrees of Southern latitude, between Lomani and the Mitomba mountain chain. Père Maurice brought back from this trip a curious collection of figurines, fetishes of Hamitic mien, ivory figurines of a carefully worked Asiatic type, some packets of magical remedies, and a chief's staff decorated with sculptured heads, which presented a remarkable analogy with decorative subjects from ancient Egypt.
>
> This ensemble of pieces has a rather curious character. It contains something of a primitive art where the eye incontestably finds traces of artistic traditions. Egyptian influence appears to be incontestably present; the Asiatic origins remain to be looked into.
>
> The Baluba Negro also paints; he takes his models from nature and creates certain effects from it.
>
> Mr. Dielh thanks Père Maurice for this communication.

Bravo! and all the melanists will be very happy. But the *Journal Officiel* is wrong to announce that they are going to look for Egyptian influence on Negro art. It is the opposite that should be done. Negro art preceded all the other arts. That at least is the opinion of all who have been interested in the question during the past fifteen years. They renewed their assertion of this conviction when I recently contributed a study to the *Burlington Magazine*.

Mr. Picasso responded cruelly to *Action* in its survey about Negro art. I have said this elsewhere.

After this blow, the famous collector Victor Goloubeff consoles the editors of *Action* in responding: "Negro art is a pact between man and forest. The forest lends to man its beautiful and durable woods so that he can make gods of them. However, it commands: 'Make these gods in my image.' And this is why we think we hear in Negro sculptures a kind of call of the tropical forest. . . . Modern artists, like those of the Middle Ages, love and understand wood. They instruct the oak, the chestnut, and other of our native trees. Negro art is a friend and a guide for them."

NOTES

1. This naturalist work by Herbert Ward [sculpture of the African carving his fetish] is certainly interesting from a documentary point of view. Mr. Herbert Ward is a realist closed to all invention, protected against any vulgar excess of imagination; but he is scrupulous, and, in spite of his poor sense of form, limp modeling, and mistakes in drawing, the Negro sculptor's artistic and athletic dignity come through quite clearly. A reproduction of this work appears in the artist's book of travel-memoirs (Plon et Nourrit).

2. This word, I believe, is Guillaume Apollinaire's.

3. [Quotes are in the original publication, source not given. Eds.]

ROGER FRY

NEGRO SCULPTURE AT THE
CHELSEA BOOK CLUB · 1920

What a comfortable mental furniture the generalizations of a century ago must have afforded! What a right little, tight little, round little world it was when Greece was the only source of culture, when Greek art, even in Roman copies, was the only indisputable art, except for some Renaissance repetitions! Philosophy, the love of truth, liberty, architecture, poetry, drama, and for all we knew music—all these were the fruits of a special kind of life, each assisted the development of the other, each was really dependent on all the rest. Consequently if we could only learn the Greek lessons of political freedom and intellectual self-consciousness all the rest would be added unto us.

And now in the last sixty years, knowledge and perception have poured upon us so fast that the whole well-ordered system has been blown away, and we stand naked to the blast, scarcely able to snatch a hasty generalization or two to cover our nakedness for a moment.

Our desperate plight comes home to one at the Chelsea Book Club, where are some thirty chosen specimens of negro sculpture. If to our ancestors the poor Indian had "an untutored mind," the Congolese's ignorance and savagery must have seemed too abject for discussion. One would like to know what Dr. Johnson would have said to anyone who had offered him a negro idol for several hundred pounds. It would have seemed then sheer lunacy to listen to what a negro savage had to tell us of his emotions about the human form. And now one has to go all the way to Chelsea in a chastened spirit and prostrate oneself before his "stocks and stones."

We have the habit of thinking that the power to create expressive plastic form is one of the greatest of human achievements, and the names of great sculptors are handed down from generation to generation, so that it seems unfair to be forced to admit that certain nameless savages have possessed this power not only in a higher degree than we at this moment, but than we as a nation have ever possessed it. And yet that is where I find myself. I have to admit that

The Athenaeum (April 16, 1920): 516. From Roger Fry, *Last Lectures* (London: Cambridge University Press, 1939). By permission of Cambridge University Press.

In Fry's review of this groundbreaking exhibition, he praises African sculpture for being conceived in three dimensions to a greater degree than anything European artists had produced; nonetheless he continues to hold a rather low opinion of the Africans themselves. (See his 1910 essay on the art of the Bushmen, pp. 41–46 above.)

some of these things are great sculpture—greater, I think, than anything we produced even in the Middle Ages. Certainly they have the special qualities of sculpture in a higher degree. They have indeed complete plastic freedom; that is to say, these African artists really conceive form in three dimensions. Now this is rare in sculpture. All archaic European sculpture—Greek and Romanesque, for instance—approaches plasticity from the point of view of bas-reliefs. The statue bears traces of having been conceived as the combination of front, back and side bas-reliefs. And this continues to make itself felt almost until the final development of the tradition. Complete plastic freedom with us seems only to come at the end of a long period, when the art has attained a high degree of representational skill and when it is generally already decadent from the point of view of imaginative significance.

Now the strange thing about these African sculptures is that they bear, as far as I can see, no trace of this process. Without every attaining anything like representational accuracy they have complete freedom. The sculptors seem to have no difficulty in getting away from the two-dimensional plane. The neck and the torso are conceived as cylinders, not as masses with a square section. The head is conceived as a pear-shaped mass. It is conceived as a single whole, not arrived at by approach from the mask, as with almost all primitive European art. The mask itself is conceived as a concave plane cut out of this otherwise perfectly unified mass.

And here we come upon another curious difference between negro sculpture and our own, namely, that the emphasis is utterly different. Our emphasis has always been affected by our preferences for certain forms which appeared to us to mark the nobility of man. Thus we shrink from giving the head its full development; we like to lengthen the legs and generally to force the form into a particular type. These preferences seem to be dictated not by a plastic bias, but by our reading of the physical symbols of certain qualities which we admire in our kind, such, for instance, as agility, a commanding presence, or a pensive brow. The negro, it seems, either has no such preferences, or his preferences happen to coincide more nearly with what his feeling for pure plastic design would dictate. For instance, the length, thinness and isolation of our limbs render them extremely refractory to fine plastic treatment, and the negro scores heavily by his willingness to reduce the limbs to a succession of ovoid masses sometimes scarcely longer than they are broad. Generally speaking, one may say that his plastic sense leads him to give its utmost amplitude and relief to all the protuberant parts of the body, and to get thereby an extraordinarily emphatic and impressive sequence of planes. So far from clinging to two dimensions, as we tend to do, he actually underlines, as it were, the three-dimensionalness of his forms. It is in some such way, I suspect, that he manages to give to his forms their disconcerting vitality, the suggestion that they make of being not mere echoes of actual figures, but of possessing an inner life of their own. If the negro artist

wanted to make people believe in the potency of his idols he certainly set about it in the right way.

Besides the logical comprehension of plastic form which the negro shows, he has also an exquisite taste in his handling of material. No doubt in this matter his endless leisure has something to do with the marvellous finish of these works. An instance of this is seen in the treatment of the tattoo cicatrices. These are always rendered in relief, which means that the artist has cut away the whole surface around them. I fancy most sculptors would have found some less laborious method of interpreting these markings. But this patient elaboration of the surface is characteristic of most of these works. It is seen to perfection in a wooden cup covered all over with a design of faces and objects that look like clubs in very low relief. The *galbe* of this cup shows a subtlety and refinement of taste comparable to that of the finest Oriental craftsmen.

It is curious that a people who produced such great artists did not produce also a culture in our sense of the word. This shows that two factors are necessary to produce the cultures which distinguish civilized peoples. There must be, of course, the creative artist, but there must also be the power of conscious critical appreciation and comparison. If we imagined such an apparatus of critical appreciation as the Chinese have possessed from the earliest times applied to this negro art, we should have no difficulty in recognizing its singular beauty. We should never have been tempted to regard it as savage or unrefined. It is for want of a conscious critical sense and the intellectual powers of comparison and classification that the negro has failed to create one of the great cultures of the world, and not from any lack of the creative aesthetic impulse, nor from lack of the most exquisite sensibility and the finest taste. No doubt also the lack of such a critical standard to support him leaves the artist much more at the mercy of any outside influence. It is likely enough that the negro artist, although capable of such profound imaginative understanding of form, would accept our cheapest illusionist art with humble enthusiasm.

FÉLIX FÉNÉON (EDITOR)

WILL ARTS FROM REMOTE PLACES
BE ADMITTED INTO THE LOUVRE? · 1920

On the art of Black Africa, of American Indians, and of Oceania, we have con-
sulted twenty ethnographers or explorers, artists or aestheticians, collectors or dealers,
submitting to each those questions that seemed most appropriate to them.

The quality of the answers—which we are publishing in the order in which they
were received—shows clearly that our subjects were not chosen at random. An ample
research program would be constituted if such a group were ever to be gathered in a
congress, where many curiosities would be revealed from a world about which we
know little, while the waters around these islands would certainly start to glisten.

F[élix] F[énéon]

ARNOLD VAN GENNEP
Former Professor of Ethnography, University of Neuchâtel

1. I recognize in African Negro, American Indian, and Polynesian or Melane-
sian art, both a past existence and a present one. However, we would not be able
to evaluate these arts only on the basis of our collections in Paris or the
provinces. For the so-called Negro art, we should distinguish between a number
of characteristic styles: that of Benin (bronze, made with the "lost wax" tech-
nique) cannot be studied and appreciated properly except at Oxford (Pitt
Rivers Collection), Leiden, and Berlin (ethnographic museums). Notably at
Berlin there is a life-size head of a Negress, in "lost-wax" bronze, that is as mar-
velous as the Sheik el Beled or the little Egyptian princess. Then there is the art
of the Agni-Baule (Ivory Coast, etc.), examples of which are at the Trocadéro, in
provincial museums, and in special collections. These are mostly statuettes.
Cameroon art is noticeable for its extraordinary canoe prows and masks, and its
decorative art in general. Then we have the style of the Central Congo, which
can be studied in Brussels (Tervueren Museum) and Hamburg (Frobenius Col-

Bulletin de la vie artistique 1 (November 15 and December 1 and 15, 1920): 662–69, 693–703,
726–38.

This survey, organized by the critic and anarchist intellectual Félix Fénéon (1861–1944),
reflects not only the widespread popularity and the surge of interest in Primitive art in the
wake of World War I, but also the way African art was beginning to become absorbed into the
postwar "call to order." Although we print the responses in their entirety, we have abbreviated
most of the lengthy biographical notes that Fénéon wrote about each of his contributors.

lection): sculptures on the tops of boxes, mats made of dyed grasses made to feel like velvet, etc.

We should also distinguish the different styles from the other regions concerned, each with its own technique and history of beginnings, perfection, and evolution. It will be impossible to grasp the richness and the variety of so-called "primitive" arts until there exists a treatise on it such as the one that I started, and that the editor of an art book collection once refused under the pretext that "these savage arts are of no interest."

2. No doubt it would be thoroughly appropriate to exhibit some well-chosen examples of so-called "primitive" art at the Louvre. However, that is not an ideal solution either, since this question would not even be posed in any other colonial power, nor in the United States, where ethnographic museums take up vast buildings that are organized for the study of art as well as technique. As I once explained it, at the inauguration of the Ethnographic Museum of Cologne, this sort of museum fills two sorts of needs, which is why objects are classified there in two categories: firstly, major works, displayed with plenty of space between them, for the general public, with every facility available for artists of all sorts (including industrial designers) to utilize the aesthetic and decorative qualities of the "primitive" arts; and secondly, works that are the subject of serious study and research in rooms reserved for specialists. The Trocadéro currently meets neither of these needs, and we can understand why artists, as well as scientists, would want something better.

Even if the Louvre were to display some "unquestionable masterpieces," it would be necessary to indicate the origin of the objects exactly. Not all Negro tribes are artistic; the problem is to try to understand why in the same country, in the Cameroons or the Belgian Congo, for example, a tribe like the Bakuba (or Baluba) practices sculptural and decorative arts, while none of the neighboring tribes does, at least on the same aesthetic and technical level. Likewise, in the Ivory Coast there are plenty of statuettes, but only a few tribes, and among these only a few individuals, are capable of executing what you might call "a masterpiece."

There are just as many reasons to devote one or more rooms at the Louvre to "primitive art," or, as we ethnographers call it, the art of "half-civilized" peoples, as there were to have Assyrian, Egyptian, etc., galleries there. The dead arts of the Maya, of Mexico, Peru, Easter Island, the Dutch Indies, deserve a place equal to that of the arts of classical or eastern antiquity. However, to avoid crowding we have created the ethnographic museums.

Everywhere except in France ethnography is taught on a university level, and the museum serves as a means of demonstration; but I won't press this point, since it doesn't look as if there is much chance of things changing for the moment.

I would only like to observe that there are "masterpieces" [of Primitive art] gathering dust in forgotten corners in our provincial museums. We might as

well gather them together in Paris rather than lose them without even having the use of them, as they are doomed to rapid disintegration where they are; but, if we do happen to introduce ethnographic sections in the said museums, these beautiful works should have a place there.

3. How would we handle problems of origin and lineage? Just for the arts of Benin there is already an enormous literature, since we have not been able to decide yet whether the "lost-wax" technique was invented by the current inhabitants or imported by their ancestors, or if the latter took it from people that were in their territories before them. We are equally undecided about whether they were influenced aesthetically by the Portuguese; we have found plaques representing sixteenth-century Portuguese soldiers and officers (which we have identified from their uniforms), but this does not prove that all the bronze art from Benin dates from this epoch, or that it was influenced by the Portuguese. In any case, the bronze statuettes and high reliefs representing animals and plants resemble nothing European in workmanship. Likewise, what are the influences that gave birth to, or that have altered, Polynesian or Melanesian sculptural and decorative arts? There has been much discussion on this subject, but it is questionable whether they will resolve such problems, since there are no written documents to help us.

4. Do the "primitive" arts teach us or inspire us? Certainly as much as any European or Asian art that has gained entry into the Louvre, the Museum of Decorative Arts, the Cluny Museum, etc. It is curious that in France we had to wait until 1920 for the question even to be asked. Without saying, exaggeratedly, that everything is useful and suggestive, we should at least remember that what is most useful and suggestive is that which is "other," or different from the usual; and we never know what kind of impact a natural object, or some obscure discovery, some supposedly rude or "savage" work will have on an artistic temperament.

From a practical standpoint, the decorative arts of the Negroes, Oceanians, etc., may be quite useful, through transposition of techniques and motifs, to embroiderers, lacemakers, textile or paper designers, ceramists—as happened with Mycenaean, Greek, and Egyptian works. Adaptations of this sort are common in Germany, England, and the United States, where ethnographic museums (of the modern type I described) have been supported for a long time by an enthusiastic public of designers and commercial painters. If we admit a number of these masterpieces into the Louvre, I think that would inspire a similar development.

In short, the idea you propose in your survey has the great merit of demolishing a number of ridiculous preconceived notions, as well as following in the French tradition of judging people by their character and their works, and not by the color of their skin.

SALOMON REINACH

Member of the Institute, curator of the Museum of National Antiquities (at the Saint-Germain-en-Laye Château)

The ensemble of the precivilization arts includes (1) prehistoric art and (2) the art of backward peoples. The great interest of this double study is to see emerge, for example, analogies between the art of the reindeer hunters of 10,000 years ago and that of the Bushmen of today. This interest is both historical and psychological, while allowing us insight into the essentially magical nature of Primitive art, and so is enormously relevant to the history of the human spirit.

None of the backward arts—in contrast to prehistoric art—has been able to reproduce the image of an animal in a way that is to our taste today, which, for better or worse, was created by fifth-century Greece. As to the human form, neither the primitive [prehistoric] nor the backward peoples have known how to appeal to our sense of sight. The least ineffective, in this respect, is from Mexico, Peru, and Benin; but the Benin bronzes, so remarkable in execution and so expressive, had been exposed to the influence of European models.

As to the Negro wood sculpture, it is really hideous; to pretend otherwise seems to me to be an aberration, if not simply a joke.

The paintings of the primitives have something to teach us, since the animal painters of the Altamira caves were superior, in their way, to the Greeks. Certain backward peoples, notably the Polynesians, are more original in decorative art than were the Greeks; and Polynesian wood sculpture offers lessons that are not to be scorned.

All of this can be studied at the Trocadéro or Saint Germain. The Louvre once had an ethnographic section; but they were right to send it out to Saint Germain and the Trocadéro. To bring it back would not make sense.

LUCIE COUSTURIER

Painter and writer

The biggest complaint against Negro art is its disproportion—which is also its genius.

To be appreciated a sculpture must be seen, which it cannot be if it is fashioned in very banal proportions.

It becomes visible only to the extent that these proportions are changed.

This does not imply that such a work of art has no proportions. It has even stricter ones than those belonging to norms and canons: those that are imposed by their expressive needs.

Negro statuary is admirably proportioned. With large heads so as to accommodate easily the adornment of deeply moving features, they reduce the body to a discrete, though characteristic, architectural support.

We do the same thing, according to our whim, with a landscape.

Certainly we can conceive of an art—that of Michelangelo, among others—that emphasizes the development of the limbs and trunk at the expense of the head, which is reduced to an elegant appendage.

However, that kind of art is less sincerely human, being more like the art of a disengaged landscape painter.

But, as lovers do, Negro statuary starts with the eyes in order to recreate its creatures.

So a Matisse, a Bonnard first depicts flowers and fruits, then adds the rest of the world.

When, following London, the Louvre admits Negro art, it will find not only its complement but its essence. This may be how, even against the grain, a museum is made.

DR. J. C. MARDRUS

Meeting the author of The Queen of Sheba, *of the famous translation of* The Thousand and One Nights, *and of the translation of* The Koran, *we asked for his participation in our survey, using, to simplify things, the word "savages," which we weren't thinking of as pejorative, but which he found objectionable: "After the six delightful years we've just been through [World War I], don't you think Europeans should have the modesty to reserve this word for themselves? But no, they continue to label people with it who have neither the opportunity nor the inclination to reply." "Well, you've said as much, Doctor, perhaps you'd like to answer in their name."*

Of the "three arts" you mentioned to me, the one I prefer, beyond question, is the one that seems inspired, in a very indirect way, by the primitive, prehistoric art of very early Egypt, that which preceded the Divine Dynasties. By this I mean what we today call, so pompously, the "Negro art" of Africa.

In any case the Negroid stammerings that we are currently calling *art* seem infinitely more interesting, in terms of our anguished taste of today—which has changed in so many ways and on so many things—more interesting, I would say, than all the maternal Venus de Milos, all the "mysterious smiles" of Mona Lisas, all the hue and cry over the Opera, the Pont Alexandre, Gambetta Monument, Grand and Petit Palais, and our other marvels of hackneyed and exaggerated fastidiousness that make us sick with disgust.

However, since the topic is Negroes . . . A friend of mine, a blonde, white, rosy-cheeked, sleek young woman, with a face like a fairy's if there ever was one, asked one day, in front of me, of a great hunk of a Negro, who had something of the cannibal about him: "What impression do the blonde, white, rosy-cheeked, sleek young women that Doctor Mardrus is so fond of make on you?" And the Negro responded in his slightly cannibal language: "To me the blonde, white, rosy-cheeked, sleek young women that Doctor Mardrus is so fond of seem like Negresses freshly flayed alive, whose skin has been completely peeled away."

Well, sir, I myself, before a certain kind of European art, I'm just like this Negro. I am transposing, at least, his memorable words, to apply them to the "arts" of today, which—with some exceptions—impress me as having been conceived and realized by and for man-eating Negroes.

Pity your friend, I beg of you, for not feeling the way civilized people do, and please excuse his irremediable love of the "savage."

GASTON MIGEON

Author of a very useful manual on the practice of Oriental ceramics, translator of a book by Fenellosa on Chinese and Japanese art, Curator of the Departments of Medieval and Renaissance Arts at the Louvre.

1. Negro African or Indian arts are only things of the past; the moderns have only been repeating ancient formulas, since neither their minds nor their customs have changed very much.

2. Any artistic manifestation of the human mind, whether of Greece or the Congo, is worthy of our curiosity. The greatest museums have opened their doors; the British Museum, for example, by confusing, it is true, ethnographic works with the very highest art.

3. To my knowledge, the greatest interest of these arts is in their sculptural expression of figures of idols and fetishes.

4. Origins, filiations, influences? Here we're fully in the domain of archaeology, and only at the very beginning. It is sufficient to say for now that Fenellosa talked of an art of the Pacific that in certain ways could have given rise to the great arts of China.

5. Their instructive value? I wouldn't totally deny this aspect, provided the cubists don't insist that these lessons are the only ones of value, which would be a very sad thing indeed, besides being a really negligible opinion.

PAUL GUILLAUME

The artists and collectors who have been favoring Negro art have made a very clear distinction between the productions of Black Africa and those of the Americas or of the Oceanic archipelago. It seems that even the most fervid Melanophiles dismiss the latter because they don't see in them the qualities of initial invention and undeniable purity found in Negro art properly speaking. The natural aesthetic was born in deepest Africa and perfected a canon, which the migrations toward the coast imperceptibly altered. European infiltration seems to have been the cause of a decadence, of an annihilation such that one could regard the great black vein as forever dry.

But the noble works of the African past have enchanted the young generation, painters especially, and their contact with unknown works has unleashed an enthusiasm without which the very existence of French art would be at stake. They have absorbed unconsciously the mysterious sap shut within the

wood for centuries. The hieratic power of these effigies fascinated some observers to the point of frenzy, but for others they constituted a miraculous event that linked them with the great tradition.

Since no art has influenced the art of our epoch more powerfully, Negro art will be admitted to the Louvre, together with the works it inspired, as a necessary explanation; but this process should not be hastened by fear or impatience. For we should not forget that there currently exists no elite with the expertise to pick out those works whose meaning and authenticity make them worthy of permanent consecration.

KEES VAN DONGEN

Painter

It is impossible to respond to your survey on the art of savage peoples. You cannot be at once judge and part of what's being judged.

DR. R. VERNEAU

Professor of Anthropology at the National Museum of Natural History, Director of the review Anthropologie, *Curator of the Trocadéro Ethnographic Museum*

If you visit the galleries of the ethnographic museum [Trocadéro], you will easily notice that in ancient Mexico, the Yucatan, Guatemala, Peru, etc., there certainly once existed artists worthy of the name. In Africa, you will find an equally artistic sensibility among the modern Negroes. Visit our Oceania gallery and you will agree that Polynesians manifest a taste that I would not hesitate to call artistic, notably in the decor of certain objects, and in their tattoos, with which, in the Marquesas Islands, they used to cover their bodies.

And I am only alluding to spontaneous original art, and not to that which has been affected, often unfortunately, by the Europeans. The ancient Mexicans, the Mayans, the ancient inhabitants of Colombia, Ecuador, Peru, or Bolivia, were, from this point of view, quite superior to modern Indians who have undergone European influence.

ANGEL ZARRAGA

Painter

You're asking me to express some of my ideas on Mexican art as a contribution to your survey on the art of savage peoples.

Savages? All right, if you insist.

But this word takes me back to my teenage years when, twenty years ago, I visited the galleries of the museum of Mexico City with my old mentor Don Pedro de la Berreda. My master, tall, skinny, bony, wrapped in his long black cloak, was showing me the enormous monoliths of the people of the past. And he—who was so gentle, so serious, so tender even, when with almost feminine

gestures he taught me the differences between an orthopteran and a lepidopteran—became wild and even violent in talking of the great civilizations that are no more.

"You see, my child, there have been only two civilizations in the world: the Toltec and the Maya! All the rest are *savages!*"

And I did not understand (and still do not, today). Raised in the positivist doctrine that was all the rage at our university, I swore only by "the great pyramid whose base is mathematics, whose essence is ethics, passing by way of natural science." I did not understand, for I heard also the imperious call of my elders, of my grandfather on my mother's side, Pierre Marin, tanner by trade and French, and of my father's family, doctors, men and women of letters and of Romantic and French culture. And so I dared to utter a few vague words on Mediterranean mythology; but my old master was insistent on the matter.

"Your Jupiter? A fraud, nothing else; a thief, a scoundrel. A god, him? With hands like ours, feet like ours? With . . ."

He paused so as not to overly outrage my almost childlike innocence.

"Look."

And he showed me a representation of the sun in an ancient theogony, with concentric deep blue and vermilion disks with golden points cutting through the mass of primary colors.

"Look. That's *a force,* you can't mutilate it, break its finger or pluck out its eye. It's above you, not because its marble ass is larger than yours, but because, big or little, it's Tontiu, the sun! Your Diana? Yes, I know, with her long thighs and her parade bow and her ridiculous little crescent on her curly coil of hair, pretext for Greek or Renaissance pornography, or for Titian or another licentious old codger to pull up some skirts and garner applause in their senile societies. Look, that is Meztli, the Moon; she was born of sacrifice in the old legend, offered up to make light by rushing into the fire, and her flesh of silver and black is no longer flesh, it's the sign of pilgrims, the symbol of women who perpetuate themselves through the miracle of childbearing. She's a symbol of the subterranean work of the Earth!"

He waxed lyrical. "Yes, don't you see? Latin civilization is a false start entirely, your gods think only of orgasms, while the gods of those people thought only of creating, without worrying what would befall their creation. Later on, I want you to reflect on this: that people have the simulacra that they deserve, and that our era of hedonists has hedonists as gods, and our fearful epoch worships the gods of fear! I know that you're going to talk to me about Huitzilopoxtli, god of war, but he is also a god of barbarians and conquerors, a god of decadence, for the Aztec was the European of this continent, and between Mars, with his helmet, his sword and his cuirass, and Huitzilopoxtli dressed in shreds of human flesh, there is only a difference of form . . ."

My old master continued in his lisping speech: "The men of today *imitate* because they are afraid to *represent,* they are afraid of *forces* as they are afraid of

color, as they are afraid of the matter that they claim to have subjugated and that will rule them one day. I'm old, but you will see some great things."

In his great deserted gallery he resembled a prophet or Don Quixote.

"You will see great things, cities that will explode, millions of men who will kill themselves for the gods of your Greece. Savages, I tell you!"

Later, fifteen or twenty years later, I am still thinking about all of that, and in our painters' battles between representation and imitation sometimes I say to myself with anguish: "My God, my God, if my old teacher was right . . . If our Mediterranean civilization was only a vast pornography . . ."

ROBERT DREYFUS

In his Essay on the Inequality of Human Races, *first published in 1853–55, Count Gobineau accords to Negroes, elsewhere so decried by him, the privilege of having initiated humanity into the mysterious pleasures of art. We've invited Robert Dreyfus to interpret this Gobinian thesis, just perfect for annoying Negrophobes. Robert Dreyfus, in fact, is not only a historian of the Roman agrarian question, of the Falloux law and of the revolution of 1848—he is the author of* The Life and Prophecies of Count Gobineau.

Count Gobineau does not need me to interpret him. He can very well explain his Negrophile theorem, for he has already commented on and refined his thought in a brilliant passage in the *Essay on the Inequality of Human Races* (Book 2, Chapter 7).

Here is this eloquent and curious page:

If we admit, with the Greeks and the most competent judges in this matter, that exaltation and enthusiasm are the essence of art, that this essence when it is pure verges on madness, we should not look to the organizing and intelligent faculties of our nature for the cause of creativity, but rather to sensory disturbance, in ambitious thrusts that push the senses into a fusion of mind and appearance, so as to derive something from them that is more pleasant than reality . . . On this basis a rigorous conclusion follows, that the source from which the arts have sprung is foreign to the civilizing instincts. *It is hidden in the blood of the Blacks . . .*

This is, you will say, a very pretty crown that I place on the deformed head of the Negro, and a great honor to him to convoke around him the harmonious choir of the Muses. It is not really such an honor. I have not said that all the Pierides [nine daughters of Pierus, to whom he gave the names of the Muses] were gathered; the noblest ones are missing, those that govern thought, those that prefer beauty to passion . . . If we translate for him [the Negro] the verses of the *Odyssey,* and notably the meeting of Ulysses with Nausicaa, that apex of the sublimity of thoughtful inspiration: he would fall asleep. For sympathy to surface, for all beings, it is necessary first that the intellect has grasped something, and that is the problem with the Negro . . . The artistic sensitivity of this being, powerful in itself beyond all expression, will remain necessarily

limited to the lowest uses . . . Therefore, among all the arts that the Melanian prefers, music is in first place, insofar as it caresses his ear with a succession of sounds and asks nothing of the thinking part of the brain. The Negro adores it, he revels in it excessively; nevertheless, how foreign he is to the delicate conventions through which the European imagination has learned to ennoble sensations!

In the charming air of Paolino of the *Secret Marriage:*

Pria che spunti in ciel' l'aurora, etc.

the sensuality of the enlightened White, guided by science and reflection, is going to compose, from the very first measures, so to speak, a tableau . . . Delicious dream! The senses here sweetly lift the mind and rock it in ideal spheres where taste and memory offer it its most exquisite portion of pleasure.

The Negro sees nothing of all of that, he doesn't grasp the smallest portion; and yet, if you awaken his instincts: enthusiasm, emotion will be very much more intense than our contained trance and our respectable satisfaction.

Let me imagine a Bambara listening to a pleasing melody. His face is ablaze, his eyes shine. He laughs and his large mouth shows, sparkling in the midst of his tenebrous face, his sharp white teeth. Joy arrives . . . Inarticulate sounds strive to emerge from his throat, choked by passion; great tears roll down his prominent cheeks; another instant and he will start to scream. When the music stops he is overcome with fatigue.

In our refined habits, we have made of art something so intimately linked with what the meditations of the mind and the suggestions of science have that is most sublime, that it is only through abstraction, and with a certain effort, that we can extend the notion to include dance. For the Negro, by contrast, dance is, along with music, the most irresistible passion. That is because sensuality is almost everything, if not in fact everything, in dance.

Therefore the Negro possesses in the highest degree the sensual faculty without which no art is possible; and, on the other hand, the absence of intellectual aptitudes render him completely unsuitable for artistic cultivation, even for the appreciation of the most elevated productions of human intelligence. To bring out his talents, he needs to ally himself with a race that is differently endowed . . .

Artistic genius, equally foreign to the three great races, appeared only as a consequence of the fusion of the Whites and the Blacks.

In my book on *The Life and the Prophecies of Count Gobineau,* I cited this text, linking it to the remarks of the late Paul Adam on the musical aptitude of Negroes. In 1904 this insightful observer traveled to the United States and sent *The Times* magnificent letters on the Saint Louis Exhibition.

Now, Paul Adam wrote one day:

Whatever faults belong to the descendants of Uncle Tom, they have a certain talent, which is musical. Almost all Negroes have a good ear. Nothing is more astonishing than to hear an adipose matron sitting at the door of a humble

habitat, singing and peeling vegetables. From this shapeless mass, the color of pitch, rises a delicate, crystalline voice that enchants. Black choruses perform symphonies in perfect unity. And for them it's natural, spontaneous. Booker Washington and his acolytes would do well by their likes if they founded special musical schools in America. Moreover, in cultivating this evident and almost universal gift, adroit pedagogues would quickly inculcate into this people the taste for a subtle art that also educates the mind. The sensualism of the race would be a great help in developing musical taste. . . .

JOS HESSEL

Appraiser with the Court of Appeals, specialist in tropical and contemporary art.

1. Does it exist?—For sure, and powerfully, both from an archeological and a modern point of view.

2. Should it be in the Louvre? Does it have a beneficial effect? Yes, to both questions. It is clear that new painting and sculpture (as has been confirmed again at the Salon d'Automne) is inspired by Negro art. If the latter were represented in the Louvre by some excellent examples, its lessons would be all the clearer.

3. My preferences? Without hesitation, the arts of Black Africa, particularly the ancient Ivory Coast and Gabon (Pahan lands). The pieces from the great creative epoch of these two regions are, in my opinion, as important as the most beautiful antiquities in our museums.

4. Filiation? None. This African art is itself an original source; in my opinion, Asiatic and even Western arts are often derivative of Negro art.

CHARLES VIGNIER

Symbolist writer and Asian art collector.

Could art be temporal, subject to fashion? Your questions suggest that it is even local. You would like to know, it seems, if I think Madagascan, Mexican, or Javanese sculptures are good enough to travel from the Trocadéro to the Louvre. Which implies a ranking with ethnography at the bottom, archaeology in the middle, and our self-conscious arts at the top. All right! However, your question as posed proves that the separations are not so watertight, that many osmotic phenomena are to be expected, and that sneaky collusions are perpetrated, and sometimes even ostentatious, illicit combinations.

In the Louvre itself, the most stable hierarchies only last as long as the career of the curator. A certain gem of the Salon Carré was once casually stuck into a wall, to which it will return. The Lesueur works are displayed haphazardly, and in what humiliating attic are the lofty Van Dycks now moldering?

The implicit message of your question amounts to: "Why has recognition of the art of Dahomey, Congo, Peru, Mexico, Polynesia been so slow in coming?"

And why was Roman art forgotten for so long? Why rediscover the primitives? Why, just thirty years ago, were Vermeers sold in Brussels for 1,500 francs? Why, fifteen years ago, could I purchase a twelfth-century Virgin for 200 francs? A Cézanne for the same price? A Hsia Kuei landscape for a smile? A Behza miniature for a grimace? Why does a work of art flourish, hibernate, then enter an unexpected revival? Why do lowly pebbles change into emeralds, or golden illuminations into dry leaves? Why this magic, sleight of hand, virtuality? Do I know? Do you know?

The curator of a great museum said to me: "We're not buying Sassanian works, *because we have not yet begun this category.*"

No Peruvian, Polynesian, Sudanese, Dahoman category in the Louvre. And this is a sufficient reason to persist in this abstention. On the other hand, these works are welcome in the British Museum, in the Metropolitan in New York, the Fine Arts in Boston, and at the University Museum in Philadelphia. Among others.

COLONEL GROSSIN

Colonial officer. His letter explains the reasons that kept him from participating in our survey, but with a few lines in this same letter he participates anyway.

No, what I've seen among these backward populations, that of Oceania for example, does not merit being admitted to the Louvre; nevertheless, you can't deny that with the Oceanic peoples (who are still in the late Stone Age) you don't find serious attempts at artistic decoration, either in their constructions, or in ornamental objects, or in furnishings, if one could so name a few mats and gourds.

One thing that has especially impressed me has been the Chinese influence in New Caledonia and the New Hebrides. Especially in the last two centuries, the Chinese have much frequented the New Caledonian coasts, where they were prospecting for sandalwood and fishing for sea cucumbers.

JEAN GUIFFREY

Mr. Guiffrey, who organized the Boston Museum and who wrote a life of Delacroix, is, since the death of Mr. Leprieur, Curator of Painting at the Louvre.

I don't think the question of admitting to the Louvre selected works of African, Oceanian, or American provenance would be raised if we had in Paris or in France a spacious and well-organized ethnographic museum. I have seen establishments in America, for instance in New York and Chicago, that could be regarded as models of this kind. There the most special pieces are surrounded by hunting, fishing, and household tools, and there are reconstituted ensembles that add considerably to their meaning and interest. No one there would dream of moving the best pieces to museums of European or ancient art.

No doubt it was Gauguin's example and the ease of distant voyages that have developed in our young artists a taste for the exotic, which is manifested in

some by a justified admiration for certain works that are skillfully made in Guinea, Honolulu, or the Arizona desert. However, works of these artists are not yet in the Louvre. It would seem therefore at least premature to place works there that interested them but have no relation to the others around them.

I will remind you also that an ethnographic museum with an excellent choice of works did exist at the Louvre just fifteen years ago. Some of it was sent to the Trocadéro, some to the Saint Germain Museum, so as to enable comparison with prehistoric objects and monuments from our country or from our neighbors. This may somewhat satisfy those who want to bring together European art and choice objects of African, Oceanic, and American provenance. Civilizations resemble each other at their origin; some have remained in their infancy. It would be paradoxical to place their faltering first efforts, however curious they may be, alongside the most perfect creations of human genius, for which the Louvre is already short of space.

MONSIGNOR A. LE ROY

Author of Primitive Religion.

Do the so-called "primitive" populations of Africa, America, and Oceania offer manifestations worthy of the name of art?

Yes, and of all types, in design, painting, sculpture, architecture, without mentioning music and dance, eloquence and poetry. One of the traits of man, in fact, is to have a sense of beauty and to attempt to idealize it in reproducing it. He has always done this, and everywhere, as the prehistoric cave paintings attest. The animals have never done this, anywhere. And if man has often represented the monkey, the monkey never thought of representing man, any more than of representing himself.

However, just as for literature, art has its periods of childhood, maturity, decadence, renaissance, and evolution. It also has its special qualities, according to countries, races, populations, and individuals. In Africa there are tribes that are especially talented, and among these tribes, as elsewhere, individuals who have a highly developed artistic sense. Some account should be taken also of the material means at the disposal of the artist to realize his idea: wood, stone, metal, ivory, etc., not to mention tools and education. So it is that in our African missions it is not so rare to find children, sons of cannibals, who manifest special artistic talents and create remarkable little works of design and sculpture. They have evolved under our very eyes.

What we may say of African art, the least developed of all, applies with all the more reason to Indian art of the Americas, Oceanic art, not to mention Indian, Chinese, and Japanese art.

This is an original, primitive art, which can have its more or less visible links with a past of great antiquity, but which has evolved and which deserves—for

pedagogy as well as for reasons of curiosity—to be represented in our museum through certain choice works.

These would show, in any case, that man is, naturally, an artist.

PAUL RUPALLEY

Has assembled a vast collection of objects from Africa, Oceania, and Northwest America.

We can't deny that uncivilized peoples, the primitives, have their own art, which is rather in a phase of decadence and tends, if not to disappear, at least to atrophy on contact with civilization; this is in great measure due to the rush to satisfy travelers' demands, whereas previously a good deal of time went into producing these objects.

Almost always Primitive art is inspired by religious ideas, and that is the condition under which its most interesting works are created. Stylization is also a major factor, especially in Oceania, where simple figures that seem geometrical to a European evoke for the natives a particular sacred animal.

However, this art is of a very special sort and has nothing to gain, in my opinion, by being confronted with the arts of civilized peoples. Also, I would find its display in the Louvre, or any similar place, undesirable because of the dilution which would result; I think that works of the same nature should be assembled in the same place, while their scattering interferes with appreciating and studying them.

Negro art is very different from Oceanic art. The former, as Mr. Clouzot and Mr. Level have said so pertinently in *Negro Art and Oceanic Art,* is full of camaraderie and is familiar and human. But Oceanic art, although less varied, is more grandiose, more hieratic, and also more ornamental. As to American art, it is especially represented by pre-Columbian epochs; today it isn't very important, except for the Alaskan peoples and those of the Northwest islands, who have a very special and interesting art. In conclusion, I prefer Oceanic, Polynesian, and particularly Marquesan art, which is possessed of a noble character that it is rarely found elsewhere, and is made with great technical skill.

It is difficult to establish the lineage of these arts; it follows the rule of the emigration of peoples. It is incontestable that Oceanic art owes a lot to Malaysian art, which itself is related to that of Indochina. On the other hand, African art seems to have developed apart from any great external influence, with a few exceptions, such as that of Benin, which during a certain epoch underwent the influence of the Portuguese, and that of Madagascar with its unquestionable Malaysian links.

As to the pedagogical value possessed by Primitive art, I think it is essentially nil, or otherwise harmful, to judge by certain works that claim to be inspired by it. We should not forget that Primitive art, by definition, is one that has not benefited from the progress of civilization and the human mind, and to want to return

to it is to regress and annul abruptly the advantage of centuries of work and study. The only domain where one can find an application for it is that of decoration.

GEORGES MIGOT

Author of Essay for a Musical Aesthetic.

The colossal Easter Island statues flank the entrance of the British Museum.

We are in possession of works that are fitting representatives of Oceanic, Australian, Negro, and South American arts.

Let us dig them out from under ethnographic accumulations that hide them from the scientist as well as the artist.

The arts of Mexico and of Central America, with its "God of Rain," so close to that of the Egyptians; with its "Plumed Serpent," and the admirable stone bas-relief entitled "Offering to an Unknown God," so close to the Gothic; Mogul and Polynesian art with several related divinities—to judge from the writing of their curves and their horizontality, Hindu divinities—deserve a place in the Louvre.

Not at all in a spirit of comparison, which would be absurd in art, but to affirm that the human mind was complete in knowledge each time it expressed in eurythmic beauty what it was feeling. That it was, with its first masterpiece, already perfect.

As to specimens of Negro and Negroid art (Australian, Papuan, Melanesian), it would be good to select the best.

Studying them might allow us to affirm that any race that has not produced masterpieces is incapable also of material and social development.

Which should not exclude from the Louvre examples from certain African races. Even if they only served to show, in the handling of similar subject, their inferiority to prehistoric works.

LÉONCE ROSENBERG

His gallery on the Rue de la Baume is a Cubist emporium. From 1908 to 1913, he assembled a collection of Negro art, which he ceded, before the war, to Jos. Hessel, he tells us.

Since so-called "civilized" European navigators and colonists have flooded the so-called "savage" peoples with their modern junk, Negro art has lost its spiritual as well as material character: so much for the present.

However, in the past and in long-inaccessible regions, it was entirely otherwise. The natives were quite able to conserve faithfully an idealist tradition that dates back to prehistory, producing *some* works of an incontestable artistic interest. To attribute to these latter even an approximate date seems to me to be very risky. If the *intentions* are indubitably ancient, the *productions*—at least the ones we know of—don't seem to me to go back quite as far as the remote epochs to

which we often ascribe them with too much complacency. This does not mean that in ancient times there were not Negro artists of great talent or even genius, which was expressed in some very successful works. The Greeks, the Egyptians, and the Chaldeans attained spiritual summits beyond which man cannot hope to rise, but which nevertheless do not preclude the hope of trying to attain the same heights by a different route. With the Negroes, whose links with the foregoing I will discuss later, the artistic productions always leave us with the feeling that there can or must exist better works of this sort. Now I wonder whether these better works were not already created by prehistoric American civilizations (not to mention the legendary Atlantis), Egypt, Chaldea, the Caucasus, and India—inspirations for the Negro world.

There no doubt emerges from the art that concerns us here a spirit of construction and synthesis, a consequence of work that is neither empirical nor rational, but purely *traditional,* because it perpetuates, in the cult objects, or those connected with war or daily life, *the repertory of previous civilizations,* for clearly practical purposes. The constructive spirit implies the knowledge of geometrical lines as well as of number relations, of which it seems to me savage populations were not knowledgeable and whose importance man could not entirely grasp until contacts had been established with the larger universe. Now, it does not seem that the Negro race of *historical* times has been concerned about things on quite so high a level, not having given any evidence up to now of being a true civilization.

On the other hand, because the savage peoples were so long inaccessible to modern European civilization they were in a position, since they fortunately had no other choice, to conserve the tradition of the great civilizations whose artistic tributaries they were. In that respect they resemble the Merovingians, heirs of the civilization of the eastern basin of the Mediterranean, who, not having been contaminated by the Italian Renaissance, still carry on today the spirit of early Byzantine basilicas, although reflecting a certain decadence in their mentality and works.

The study of *prehistory* reveals to us that there existed at the beginning of humanity two very distinct races, the Sudanese, called the "black race," and the Borean, called the "white race." The first, infinitely more advanced in civilization than the second, undertook a methodical conquest of territories occupied by the Boreans, Celts, or Scythians. These latter, succumbing in an unequal struggle with a numerically superior adversary who was also well armed, fled their burning forests and took refuge in Northern Europe and Asia. The Blacks, who were *builders,* constructed solid walls around their conquests as they advanced, and then pursued the enemy with a perfectly trained and disciplined infantry and an experienced cavalry. They sowed disorder in their ranks with the help of elephants that were armed with towers, after having demolished the Borean defenses with their clever and irresistible war machines. The struggle

lasted a few centuries, in the course of which, through prisoners whom they succeeded in taking in ambush, the Whites, called "Scythians" or "Celts," were, little by little, initiated into the science of the Blacks and so obtained certain advantages, the accumulation of which earned them an honorable peace. But the uniform and pure race represented by the Boreans, once it had emerged from its ignorance and had become morally and materially the equal of its conquerors and its instructors, took its revenge by chasing the invader progressively farther from the occupied territories. The black race included, on its left flank, the Atlanteans, who were red in color, and in the center the Africans, who were brown-black; finally on its right it was composed of Asians, yellow in hue. While returning to where it set out, it left behind the results and the teachings of the great civilization that it had brought with its armies and which it was able to conserve and develop for thousands of years to come, under varied circumstances and in spite of the internecine struggles with rival populations. Mexico, Mesopotamia, Egypt, Persia, the Caucasus, India, and China have left us tangible reminders of this, and Negro art was the reflection of this *historical* civilization of the black race whose origin is lost in the mysterious depths of prehistory. Scythian jewels (Hermitage Museum), Caucasian art (Samarkand), the painted pottery of Susa of the earliest epoch (Morgan mission, Louvre), the geometrically decorated vases of archaic Greece (Campana collection, Louvre), ancient Indian, Chinese, Cambodian, Javanese art, aren't they all present in certain works in wood, for example, by natives of Oceania or New Guinea?

At this time I would like to admit my preference for Oceanic art, since it is there that the tradition seems to have been maintained most purely. Although there is no aspect of Negro art that cannot be related to the art of great past civilizations, nevertheless it deserves a little space in the Louvre, where only the *ten most beautiful* pieces ever seen seem to me to be worthy of being displayed. The others do not go beyond ethnography.

The Negroes were especially skillful in the fashioning of masks, and it is in this form certainly that I would like to see their works in the museum. As to their fetishes and idols, I find almost all of them to be a bit like caricatures, in spite of the undeniable seriousness of their purpose.

A spirit of synthesis and the search for rhythm in a practical discipline; that, it seems to me, is the lesson of this art. But do we not hear this counsel better from the Mycenaean, Cretan, Rhodan artists, etc., formulated during very primitive epochs and by way of marvelous examples?

It belongs to us poor moderns to strip our souls of odious individualism and, following in the footsteps of Negro artisans, to make an effort to glorify in our works the spirit of an entire civilization and not quasi-eternally the hateful "me."

If the fortuitous encounter of Negro wood sculpture, during the height of impressionism, and at a moment when awareness of Primitive art was not so widespread, about fifteen years ago, provoked a considerable revolution in intel-

ligent and enthusiastic artists such as André Derain, Vlaminck, Henri Matisse, especially Pablo Picasso, and put at their disposal a precious source of aesthetic instruction, it nevertheless does not justify the excessive speculation that has been directed to Negro art. Without falling into the ingratitude of a certain notorious artist who owes much to this art and who now—although the very high quality of his work certainly would not risk depreciation if he were to admit it—denies it, all the same, we can affirm that the consequences of the discovery of Negro art are more important than the art itself, which, taken as a whole and *considered in itself,* is surely worthy of regard, but loses some of its interest as soon as it is *compared*.

H. CLOUZOT AND A. LEVEL

André Level played a part in the ingenious artistic experiment of the "Peau de l'Ours." H. Clouzot wrote, in collaboration with Level, Negro Art and Oceanic Art *(Paris: Devambez, 1919).*

A number of works of the less civilized peoples of Africa, America, and Oceania have presented the traits of what we currently call "art." They have maintained, very close to our own epoch—and this is the kernel of what they have to teach us—the elements and traditions of the primitive arts, as a result of a lesser and slower evolution than in Europe or even in Asia.

A choice selection of these works will rightly appear, sooner or later, in a museum like the Louvre, one of whose principal virtues is the number and amplitude of the comparisons it allows. And their admission will be in accord with its rules, since these are more or less recently dead arts, the indigenous peoples having lost the sense of their traditions on contact with Europeans.

The purpose of these productions was utility—religious, magical, martial, hunting, or domestic—an essential condition that is accompanied, with all the primitives, by an innate taste for display and linear ornamentation, painting and tattooing of the body, decoration of weapons and implements. However, this ornamentation never lessens the practical utility of the objects—a good example for us to learn from.

The technique of execution, on unadulterated materials, is indifferent to time. It is honest, conscientious, sometimes perfect, in spite of the rudimentary tools.

Finally, the arts of America and Oceania reveal certain Asiatic connections, just as African Negro art (which distinguished people call Melanism)—the one we prefer, for its variety, audacity, its style even, which often avoids stylization—has been influenced, along the coasts, by Europeans, and also through frequent trade, via the Sudan, with ancient Egypt.

As to the increasing value of these arts, in particular Negro art—which is the most recently recognized and whose name has become lucrative to the point that it is currently applied to many productions that are not the result of

black workmanship—it has been significant even for the general public, interested, sympathetic, above all and always amused by any new manifestation of exoticism.

During the Middle Ages what exchanges, what savory mixtures of all the arts—architecture, statuary, book illumination—were the result in the West of the Crusades and the frequentation of the Byzantine East! Didn't diplomatic missions make orientalism fashionable? Under Louis XIV, didn't the cortege of visiting Siamese ambassadors, welcomed with such fervor and delight by the court, the city, the onlookers, and the artisans, bring a foretaste of the Far East? Indian objects, porcelains, and lacquers were by turns all the rage. The new arrival is utilized, transformed, modified to suit French tastes.

An ethnic art that lives on itself, dies of consumption. It has to be strong enough to assimilate a foreign style and become all the more vigorous thereby. An excess of purity in taste leads to extinction. As with preceding periods, our epoch will know how to extract from these new exotic fruits the nourishing saps that agree with its organism—which has already happened to a greater extent than people realize. It is no surprise that we have seen the opening, in one of our largest department stores, of a Negro art section.

WALTER PACH

THE ART OF THE AMERICAN INDIAN · 1920

For the tragedies of the past we are too late—the individual has been lost; the free people with its ancient culture has been destroyed by the brutality and ignorance of the invader; its story goes into history and literature, and at some distant time the tangible relics of its life are collected and ranged on the shelves of a museum. Usually the sole value they have there is to serve as models for the men of a later age, and it is a questionable value, for they will lead astray the many who see only the externals of the old works and ideas—the insight which permits a crossing of the barriers of time and race being reserved for the few who can penetrate to the spirit of an ancient people and thereby strengthen their own.

But there is another value for history and the museum. If we cannot intercede in the tragedies of the past, we can see in them a warning against needless wrong in present times. Such a wrong may occur in America, in the case of the Indians of our Southwest. For most of us the question of the Indian has seemed a thing of the past. He is on his reservations and should be well treated by the Government, all will agree, but few of us know that in certain localities—very considerable ones—his ancient life and culture still exists under the threat of extinction.

Some people will say that the threat comes from circumstance, from evolution. The West is growing up, and even if the Indians keep their land, the ideas of the white man must enter their territory and drive out the old ideas. It is true that the nomadic tribes that peopled the greater part of America can no longer continue in their ancient state. But the question of the Indians of the Southwest is entirely different. Historically they are a sedentary race, like the Mayas and Aztecs of Mexico and Central America. They are city-builders, and as such could develop forms of culture and art which are impossible to rovers. Of the music, the poetry, and the drama which expressed the ideas of the northern Indians it is not easy to speak, for much has been lost, and there remain the difficulties of language, its rhythm and its allusions, which prevent all save a few from follow-

The Dial 68 (January 1920): 57–65.

Walter Pach (1883–1958) was an American artist, critic, and advocate for modernism (he was one of the organizers of the 1913 Armory Show). This is one of the most eloquent early articles arguing for the importance of recognizing and preserving American Indian art and culture.

ing the ideas as they deserve. And if we ourselves understand them, we do not change the fact that the old conditions for these people have vanished.

In New Mexico and Arizona, on the other hand, we have Indians living in the country very largely according to the customs of their ancestors. Many a person who has admired their work in the Museum of Natural History in New York or the Field Museum in Chicago—to say nothing of the great collections in Europe—has been surprised to learn that these Indians have not degenerated into the tame pensioners of the reservations, but are in the essentials of character, very much what they were in the past. The best proof of this is their art: at its best to-day it is equal to the best they ever produced. All the centuries of contact with white men have not sufficed to blot it out or even to give it the hybrid quality that one finds, for example, with the Hawaiians. The Spaniards conquered the country in the sixteenth and seventeenth centuries and priests from their settlements in Mexico taught their faith to the Indians, who are Catholics to-day. But the Church has been content with such acceptance of its tenets as could easily be given by a people who hold to their ancestral mythology and to the arts which express their beliefs of the sun, the clouds, the earth, and their relationships.

So tolerant and gentle was the mingling of the European and American religions that when the Indians painted certain subjects they had learned to know from the Spanish priests, they made a really important addition to Christian art. The Santa Fé Museum has a number of examples of this imagery; in the Brooklyn Museum is a St. Francis that shows in impressive fashion the capability of the Indians to work with a foreign theme. The idea of the work was derived, doubtless, from some decadent specimen of late Spanish painting, for the religious pictures one finds in the region are characteristic "export articles" of the poor quality that has given the term its meaning. Nothing more different from such a model could be imagined than the Indian painting, for the newly aroused race, direct and vigorous in expression, infuses the work with a purity and an austere beauty quite worthy of a European primitive.

As interesting as one must find this type of picture, it is the autochthonic art of the Indians that is important. It attains the dignity that inheres in national and religious things, for it belongs to the whole of the people and informs every phase of their lives, from the great ceremonies of prayer and thanksgiving to the making of clothing, ornaments, and the objects of daily use. In reality, there is no break in the continuity of the Indian's thought and art when he goes from the sand-painting before his altar to the decoration of a cooking bowl. The "curio" from the Southwest which gives an exotic note to many a room is not, like its neighbor there, the old French helmet, a thing whose reason for existence has long since passed; still less is it like the batik hanging now so much in favor where designs are used of whose meaning the decorator knows little and believes less.

No one having even a slight familiarity with the work of the Indians ever has to trouble in distinguishing the things they make according to their own ideas and those they make for the tourist trade. The loss of beauty which the commercialized work exhibits is of course due to the loss of idea. For instance, in the band of decoration the Indian paints around his bowl there must always be a small opening; this means to him the place where spirits pass from the lower to the upper world. But as the white man has no interest in that, or thinks the break in the design an imperfection, the Indian ceases to follow the idea that was alive for him when he worked for his own people. The Hopi potter will never make a vessel of perfect roundness, for the perfect thing is to him the symbol of a life that is finished.

The life of these Southwestern Indians is not yet finished. But how long can it continue? At first the answer would seem so obvious as to make the question an affront if men were not taking measures to-day to consummate our last great wrong against the Indians. It must be our last, for if we "civilize" the Indians of the Southwest, there will be no more tribes possessing an ancient life of which we might deprive them. It is not a matter of preserving the artistic talent of the Americans who have given the best proof that they possess that quality. This is a precious thing, but I have so far discussed their art merely as the exponent of their life, as indeed art is always the thing that tells one most truly the life of a people. Neither is it the tourist who threatens to rob these Southwestern people of their old ideas. If they could stand three centuries of intercourse with the Spaniards, they need not fear the effect of occasional sight-seers from other parts of this country, even with the increasing facility of travel.

It is the government agents who are at the center of the present-day problem of the Indians. The men of the pueblos are wanted as farm-hands, herdsmen, and laborers, the women as domestic servants. As long as the Indians hold to their "heathenish" beliefs, they will stay in their villages and continue their "useless" manner of life. And so the ideas which the Spanish padres allowed to live until now, must be destroyed by the new missionaries of education and industry. Charges of immorality are trumped up against the ancient ceremonies, and no device that could lead to their suppression and the turning of the Indians into useful citizens is considered too ugly for use—the end justifying the means: the end and the means, in fact, being altogether worthy of each other. In some localities the agents have met with success, the first one of their lives, in many cases, for they are frequently men who have failed in other occupations and are sent out to the Indian country to start life anew. Their attitude toward the people under their care may be judged by the remark made by one of them to a well known archæologist who, like many of his *confrères,* had been advising the Indians against abandoning their old practices. "If it weren't for you damned scientists," said this agent, "we'd soon have the Indians down off the mesas and at work."

This does not accord with the argument that the change in the life of the

pueblos is simply the march of progress, the evolution of history, or whatever other phrase we may use to exalt our actions. Perhaps the ancient life is doomed, perhaps we must see the disappearance of the last of the nations we displaced on this continent. There is justification for our past acts in the higher needs of the white race, but no such excuse can be offered for the stupid course that is now being pursued. The Indians ask only to be let alone. Surely it is time for us to realize that even backward peoples have their rights. Undoubtedly we have progressed in our dealing with the Indians; to-day it is more our intelligence that needs quickening than our sense of justice. The important thing is that our new understanding of the problem come about quickly, for we have only a limited time in which to correct our policy. The life of a people is no more to be given back, once it is destroyed, than the life of an individual.

And the white Americans should realize that a new understanding of the Indians is important, not for their sake only, nor that we may come with a clean conscience to our place in the international council that is to uphold the rights of the weaker peoples. We need to realize that the Indians are not simply our wards, an unfortunate race to whom we owe something, but that there are great things to be learned from them if we save—or permit them to save—their ancient and beautiful culture.

There is more than one voice crying out in the world to-day that in the earlier forms of society values were attained that our present proud condition has lost. One such was noticed lately in these pages, in the review of Dr. Cram's books. If we were forced to a decision that the Mediævalism he asks for is impracticable, especially in view of his lack of understanding of the living and important qualities of our period, we may well accept his reminder of the greatness of the age of faith. The trend of much latter-day thought, indeed, is toward concession that in our struggle for scientific knowledge and material accomplishment we have been overlooking spiritual attainment (one hates to pronounce the words—so generally have they been monopolized by the weaklings of the intellect). But the spiritual thing has been the strong thing again and again in history. And a sign that it may be so once more lies in the evidence that we are coming to realize that in the countries and the periods that are backward in material development there is often a great wealth of intuition as applied to life and the world's relation to it. The Indian is a typical case in point, and his wisdom is not for any "little group of earnest thinkers," as the young lady of the Sunday supplement calls them, but for the whole generation of to-day and of to-morrow. Poets, artists, and those scientists who see that their profession must take heed of æsthetic ideas are naturally the first to become aware of the profound value of the Primitive, but it would be contrary to experience if people in general did not follow the train of thought along which the specialists have led. Once more let us hope that when they have been brought by it, in our own country, to an appreciation of the Indians, they do not find that their study must

be conducted from relics in the museums and libraries, but that they may learn from the living people—the peaceful and contented men and women of the pueblos, whom we may know to-day.

Almost unheard of by the general public, many students are working toward a truer understanding of the Indians. It is a pity that the results of their fascinating researches should go to technical or university publications instead of to the magazines of large circulation. For if the majority of Americans knew the need of the Indians and what they mean to us, the response to their need would be immeasurably better than it is.

The specialists should lay aside the diffidence that is natural to them when there is a question of popularizing their theme, and use every opportunity to bring the present-day problem of the Indian to general attention. Unfortunately not all such means of approach are available. Last year a proposal was made to the Metropolitan Museum in New York to organize a great exhibition of Indian art for that institution, the aid of distinguished authorities and loans from the most important collections being promised. The directors of the Metropolitan received the offer in a sympathetic spirit and agreed that the showing of a folk-art alive in our country to-day was a matter of great interest. Certain agreements entered into with the Museum of Natural History, however, leave Indian matters to the latter institution, and so the project, at least in so far as it concerned the art museum, had to be given up. Those who had conceived the idea of the exhibition felt that it would lose most of its point if it were held in the Natural History Museum, as the ethnological aspect it must have there would be a matter of no new interest to the general public. What should be the outstanding feature for the lay visitor to the exhibition is the fact that the Indian has produced a genuine and valuable art, and that he is continuing to do so. The exhibition will be held in New York in March, with this point in view, laying more emphasis on the work of to-day than had been planned.

After seeing the modern work of the Indians, we shall be better prepared to go to the collections of the older objects. It is hoped to open to the public this spring one of the greatest of these, at the Museum of the American Indian in New York. Familiar to most of us from childhood as the relics of a savage period, the Indian things reveal themselves in a startlingly new light if we think of them as art. To some it will seem at first that only by an extension of the term can it be applied to the work of the Indians.

Let these people begin a new acquaintance with the sculpture and the architecture of ancient Mexico—the greatest art which has yet been produced in the Western Hemisphere. Americans in Italy have often wondered how it is possible for a people with the work of the Renaissance on the walls of its old buildings and its museums to produce the lamentable things one sees in the modern Italian exhibitions. The case is not a parallel one here, since we are considering a different race from that which peoples America to-day. None the less, we may

feel humble enough if we set anything our sculptors have done beside those great heads and figures of the Mayas—art which may be ranked with that of the Egyptians, the Hindus and the Chinese.

Working southward in his new discovery of American, the student finds an overwhelming treasure of art among the people of Central America, and certainly in the northern part of South America. Expeditions sent out by the Museum of the University of Pennsylvania have recently brought back magnificent pottery made to-day in the Upper Amazon country, as pure and as sure in design as the work that was done by the tribes before the time of Columbus. A climax in American art is reached when we come to the work of the Peruvians. Certain of their paintings (so to style them) made of the brilliant feathers of tropical birds carry the use of color to one of the most remarkable points attained by any artists.

I permit myself to wander so far afield because it is well to reassure ourselves, if only by this summary mention of the accepted and tremendous monuments of Indian art, that in them the red man has shown that his race must be accounted one possessing genius for expression in plastics. To-day no more work of a monumental character is being done, unless it be, as I have heard reported, among the Alaskans.

One characteristic, however, runs through all Indian art, ancient and modern, of monumental or of small size: it has the unbounded sincerity of a free people. If the language of art has any meaning whatsoever, then Indian productions of every type say that their makers believed in them and did them naturally, because they liked what they did. With the North Americans, as with other really primitive peoples, there seems to be no question of period of evolution. The prehistoric mounds of Arizona and New Mexico reveal pottery of a type similar to that which is being made to-day. Many of us prefer the recent work of some of the pueblos to that of their distant forbears. An even more encouraging sign of strength in the Southwestern Indians is that they have been able to use new materials, the water colours which they have obtained from the white people. This may seem a small thing, but one very frequently finds that the possession of a different material brings in a change in the whole character of the work done with it. Such Indian paintings as I have seen in the new and more complex medium are indeed different from any of the old designs, but they have lost none of the old quality of genuineness. The decadent work done for commercial purposes which I mentioned previously is rather uncommon, and is found in only the few places where the pressure of the white man has finally caused routine performance and a desire for quantity, in place of that satisfaction of instinct which is the secret of Indian life and art.

What noble designs instinct produced on the pottery of the Hopi! As one goes over a collection of several thousand specimens, one is impressed by their really infinite variety. Here are two pictures of the Sun-God, the feathers used in

the dance to represent his beard (the rays of the sun) being disposed in almost exactly the same position, the same drawing of the face and the same colours being used, as tradition has dictated. But if the two images were produced by the same artist, they were produced at two different moments of time, and that great faculty the Indian has of following his mood has given to the two works a shade of difference, one from the other, so that both are living things. Old Nampeyo, blind to-day in her Hopi village, has handed on her art to her daughter and to other pupils, and their work may be placed beside that of their ancestors—not because it is exactly like the ancient pieces, but because it keeps up their tradition of life. A little habituation permits us to enter, to a surprising extent, into the significance of the Indian designs. We appreciate the humour which so many observers have noted as a characteristic of this people, we understand the quality of fear certain works are meant to inspire, or we follow the homage to the elements, which is one of the most constant themes of their simple and beautiful pantheism.

With such a basis for his art, with a certainty that every one of his people will understand his work (where is the white artist who can say the same?) it is not strange that what the Indian has in mind he says with naturalness and eloquence. There is no appearance of hesitation, or of correcting. The strokes of his brush are quick and sure; they move in rhythms like those of the dancers or those eagles whose flight the dance symbolizes. Or those figures painted on deerskin: the character, the action of the man is rendered with an immediacy for which our painters and poets strive all their lives. The impedimenta of the endlessly complicated art of Europe has, in the later decades, proved such a hindrance to the expression of these simple and powerful ideas that it is small wonder if many men are trying to throw off the load—and if they delight in the work of the Indian, whose swift, sensitive line and grasp of composition yield results near enough to our own for us to understand them,—different enough from our inbred art to give us the special pleasure that comes from things that are new to us. Familiar or strange, the red man's work is beautiful, and in quite the sense of the word that we have always given to it. The black pottery of the Santa Clara pueblo has not the measureless refinement that, in centuries of continuing culture, brought perfection to the Egyptian vases of the later dynasties, but it has the vigour and largeness of design of the very early period of the art of Egypt. And to-day—I come back to the word because what is most important to remember is that this work is still being produced—certain head-dresses, batons, and figures used in the religious ceremonies flame with a magnificence of red and green such as the Hopi country shows in daylight, or glow in pale marvels of white and gray, like the desert under the stars.

MARSDEN HARTLEY

RED MAN CEREMONIALS · 1920

It is significant that all races, and primitive peoples especially, exhibit the wish somehow to inscribe their racial autograph before they depart. It is our redman who permits us to witness the signing of his autograph with the beautiful gesture of his body in the form of the symbolic dance which he and his forefathers have practiced through the centuries, making the name America something to be remembered among the great names of the world and of time. It is the redman who has written down our earliest known history, and it is of his symbolic and esthetic endeavors that we should be most reasonably proud. He is the one man who has shown us the significance of the poetic aspects of our original land. Without him we should still be unrepresented in the cultural development of the world. The wide discrepancies between our earliest history and our present make it an imperative issue for everyone loving the name America to cherish him while he remains among us as the only esthetic representative of our great country up to the present hour. He has indicated for all time the symbolic splendor of our plains, canyons, mountains, lakes, mesas and ravines, our forests and our native skies, with their animal inhabitants, the buffalo, the deer, the eagle, and the various other living presences in their midst. He has learned throughout the centuries the nature of our soil and has symbolized for his own religious and esthetic satisfaction all the various forms that have become benefactors to him.

Americans of this time and of time to come shall know little or nothing of their spacious land until they have sought some degree of intimacy with our first artistic relative. The red man is the one truly indigenous religionist and esthete of America. He knows every form of animal and vegetable life adhering to our earth, and has made for himself a series of striking pageantries in the form of stirring dances to celebrate them, and his relation to them. Throughout the various dances of the Pueblos of the Rio Grande those of San Felipe, Santo Domingo, San Ildefonso, Taos, Tesuque, and all the other tribes of the west and the southwest, the same unified sense of beauty prevails, and in some of the dances to a most remarkable degree. For instance, in a large pueblo like Santo

Excerpts from *Art and Archeology* 9 (January 1920): 7–8, 12–14.

The American artist Marsden Hartley (1877–1943) was a great admirer of American Indian art, and his own works reflect the influence of Indian motifs and symbols. Hartley, who first became familiar with Indian art in the ethnographic museums of Paris and Berlin, later became a strong advocate for the art and for viewing American Indians as "peaceable and unobtrusive" citizens.

Figure 20. Marsden Hartley, *Indian Composition*, ca. 1914–15. Oil on canvas, 47 3/16 x 47". Frances Lehman Loeb Art Center, Vassar College, Poughkeepsie, New York. Gift of Paul Rosenfeld 1950.1.5.

Domingo, you have the dance composed of nearly three hundred people, two hundred of whom form the dance contingent, the other third a chorus, probably the largest singing chorus in the entire redman population of America. In a small pueblo like Tesuque, the theme is beautifully represented by from three to a dozen individuals, all of them excellent performers in various ways. The same quality and the same character, the same sense of beauty, prevails in all of them.

It is the little pueblo of Tesuque which has just finished its series of Christmas dances—a four-day festival celebrating with all but impeccable mastery the various identities which have meant so much to them both physically and spiritually—that I would here cite as an example. It is well known that once gesture is organized, it requires but a handful of people to represent multitude; and this lonely handful of redmen in the pueblo of Tesuque numbering at most but seventy-five or eighty individuals, lessened, as is the case with all the pueblos of the

country to a tragical degree by the recent invasions of the influenza epidemic, showed the interested observer, in groups of five or a dozen dancers and soloists including drummers, through the incomparable pageantry of the buffalo, the eagle, the snowbird, and other varying types of small dances, the mastery of the redman in the art of gesture, the art of symbolized pantomimic expression. It is the buffalo, the eagle, and the deer dances that show you their essential greatness as artists. You find a species of rhythm so perfected in its relation to racial inter-pretation, as hardly to admit of witnessing ever again the copied varieties of dancing such as we whites of the present hour are familiar with. It is nothing short of captivating artistry of first excellence, and we are familiar with nothing that equals it outside of the negro syncopation which we now know so well, and from which we have borrowed all we have of native expression.

If we had the redman sense of time in our system, we would be better able to express ourselves. We are notoriously unorganized in esthetic conception, and what we appreciate most is merely the athletic phase of bodily expression, which is of course attractive enough, but is not in itself a formal mode of ex-pression. The redman would teach us to be ourselves in a still greater degree, as his forefathers have taught him to be himself down the centuries, despite every obstacle. It is now as the last obstacle in the way of his racial expression that we as his host and guardian are pleasing ourselves to figure. It is as inhospitable host we are quietly urging denunciation of his pagan ceremonials. It is an inhos-pitable host that we are, and it is amazing enough, our wanting to suppress him. You will travel over many continents to find a more beautifully synthesized artistry than our redman offers. In times of peace we go about the world seeking out every species of life foreign to ourselves for our own esthetic or intellectual diversion, and yet we neglect on our very doorstep the perhaps most remarkable realization of beauty that can be found anywhere. It is of a perfect piece with the great artistry of all time. We have to go for what we know of these types of expression to books and to fragments of stone, to monuments and to the pre-served bits of pottery we now may see under glass mostly, while here is the liv-ing remnant of a culture so fine in its appreciation of the beauty of things, under our own home eye, so near that we can not even see it. . . .

Inasmuch as we have the evidence of a fine aristocracy among us still, it would seem as if it behooved us as a respectable host to let the redman guest en-tertain himself as he will, as he sublimely does, since as guardians of such excep-tional charges we can not seem to entertain them. There is no logical reason why they should accept an inferior hospitality, other than with the idea of not inflict-ing themselves upon a strange host more than is necessary. The redman in the aggregate is an example of the peaceable and unobtrusive citizen; we would not presume to interfere with the play of children in the sunlight. They are among the beautiful children of the world in their harmlessness. They are among the aristocracy of the world in the matters of ethics, morals, and etiquette. We forget

they are vastly older, and in symbolic ways infinitely more experienced than ourselves. They do not share in tailor-made customs. They do not need imposed culture, which is essentially inferior to their own. Soon we shall see them written on tablets of stone, along with the Egyptians and the others among the races that have perished. The esthetics of the redman have been too particular to permit of universal understanding, and of universal adaptation. It is the same with all primitives, who invent regimes and modes of expression for themselves according to their own specific psychological needs. We encourage every other sign and indication of beauty toward the progress of perfection. Why should not we encourage a race that is beautiful by the proof of centuries to remain the unoffensive guest of the sun and the moon and the stars while they may? As the infant prodigy among races, there is much that we could inherit from these people if we could prove ourselves more worthy and less egotistic.

The artist and the poet of perception come forward with heartiest approval and it is the supplication of the poet and the artist which the redman needs most of all. Science looks upon him as a phenomenon; esthetics look upon him as a giant of masterful expression in our midst. The redman is poet and artist of the very first order among the geniuses of time. We have nothing more native at our disposal than the beautiful creation of this people. It is singular enough that the as yet remote black man contributes the only native representation of rhythm and melody we possess. As an intelligent race, we are not even sure we want to welcome him as completely as we might, if his color were just a shade warmer, a shade nearer our own. We have no qualms about yellow and white and the oriental intermediate hues. We may therefore accept the redman without any of the prejudices peculiar to other types of skin, and we may accept his contribution to our culture as a most significant and important one. We haven't even begun to make use of the beautiful hints in music alone which he has given to us. We need, and abjectly so I may say, an esthetic concept of our own. Other nations of the world have long since accepted Congo originality. The world has yet to learn of the originality of the redman, and we who have him as our guest, knowing little or nothing of his powers and the beauty he confers on us by his remarkable esthetic propensities, should be the first to welcome and to foster him. It is not enough to admit of archaeological curiosity. We need to admit, and speedily, the rare and excellent esthetics in our midst a part of our own intimate scene. The redman is a spiritual expresser of very vital issues. If his pottery and his blankets offer the majority but little, his ceremonials do contribute to the comparative few who can perceive a spectacle we shall not see the equal of in history again. It would help at least a little toward proving to the world around us that we are not so young a country as we might seem, nor yet as diffident as our national attitude would seem to indicate. The smile alone of the redman is the light of our rivers, plains, canyons, and mountains. He has the calm of all our native earth. It is from the earth all things rise. It is our geogra-

phy that makes us Americans of the present, children. We are the product of a day. The redman is the product of withered ages. He has written and is still writing a very impressive autograph on the waste places of history. It would seem to me to be a sign of modernism in us to preserve the living esthetic splendors in our midst. Every other nation has preserved its inheritances. We need likewise to do the same. It is not enough to put the redman as a specimen under glass along with the auk and the dinosaur. He is still alive and longing to live. We have lost the buffalo and the beaver and we are losing the redman, also, and all these are fine symbols of our own native richness and austerity. The redman will perpetuate himself only by the survival of his own customs for he will never be able to accept customs that are as foreign to him as ours are and must always be; he will never be able to accept a culture which is inferior to his own.

In the esthetic sense alone, then, we have the redman as a gift. As Americans we should accept the one American genius we possess, with genuine alacrity. We have upon our own soil something to show the world as our own, while it lives. To restrict the redman now would send him to an unrighteous oblivion. He has at least two contributions to confer, a very aristocratic notion of religion, and a superb gift for stylistic expression. He is the living artist in our midst, and we need not think of him as merely the anthropological variation or as an archaeological diversion merely. He proves the importance of synthetic registration in peoples. He has created his system for himself from substance on through outline down to every convincing detail. We are in a position always of selecting details in the hope of constructing something usable for ourselves. It is the superficial approach. We are imitators because we have by nature or force of circumstance to follow, and improve upon, if we can. We merely "impose" something. We can not improve upon what the redman offers us in his own way. To "impose" something—that is the modern culture. The interval of imposition is our imaginary interval of creation. The primitives created a complete cosmos for themselves, an entire principle. I want merely, then, esthetic recognition in full of the contribution of the red man as artist, as one of the finest artists of time; the poetic redman ceremonialist, celebrant of the universe as he sees it, and master among masters of the art of symbolic gesture. It is pitiable to dismiss him from our midst. He needs rather royal invitation to remain and to persist, and he can persist only by expressing himself in his own natural and distinguished way, as is the case with all peoples, and all individuals, indeed.

A national esthetic consciousness is a sadly needed element in American life. We are not nearly as original as we fool ourselves into thinking. We imbibe superficially, and discard without proper digestion the food that we are ignorant of. We have the excellent encouragement of redman esthetics to establish ourselves firmly with an esthetic consciousness of our own. It is with us in possibility at least, as it is with all peoples. It is time to begin now, for the exceptional American that is to represent us a hundred years hence will want far finer exam-

ple to build upon than we have with us now. The indication as the outcome of the war, of the American that is to come is as disconcerting as it is flattering. We shall need something to offer him in the way of an arrived culture. The redman proves to us what native soil will do. Our soil is as beautiful and as distinguished as any in the world. We must therefore be the discoverers of our own wealth as an esthetic factor, and it's the redman that offers us the way to go.

CARLO ANTI

THE SCULPTURE OF THE AFRICAN NEGROES · 1923

In the recent past the sculpture of the African negroes achieved entrance into one of the most important temples dedicated to contemporary art, the Thirteenth International Exposition of Art at Venice, 1921, and was exhibited on equal terms with the work of the greatest living artists of the world. The wooden figures from the Congo basin were given a separate room like those assigned, among others, to Maurice Denis, Kokoschka, Ettore Tito, and Albin Egger-Lienz.

Did this circumstance perhaps mark the apogee of the estimation accorded negro-sculpture? It seems to me that it was, rather, symptomatic of its decline. At this International Exposition it became evident that futurism in art is a lost cause: in the years past it has had a wide destructive effect, and at the present moment, our artists, recovering from the crisis, are preparing to pursue other methods in the work of reconstruction. For this reason the exhibit of negro sculpture at Venice was certainly not meant to point out new paths to artists; its organizers were rather prompted by a subtle spirit of mischief. Those modest figurines in wood and ivory seemed to say: "Here we are, who yesterday embodied the ideals of artists vainly striving to realize mistaken fancies of art-regeneration; behold us now what we used to be, mere fetishes of ingenuous savages."

Nevertheless, it cannot be said that the cult of negro-sculpture has been without reason and without effect.

About 1905, when impressionism in painting, in its manipulation of colour, had suppressed all "form" in the objects reproduced, there arose by way of reaction the insistence on seeing and feeling the forms in their third dimension and planes. The negro sculptures were without question examples of true hypersensitiveness to mass, in whose expression, full and violent, there is no attempt to retain the forms and proportions of nature. They had besides that synthesis or idealization of forms which frees them from unessential details of purely illus-

Excerpts from *Art in America* (December 1923). By permission of **ART IN AMERICA,** Brant Publications, Inc.

Carlo Anti (1889–1961), an Italian writer on art and archaeology, was one of the first to recognize that since no writers on African art had adequate knowledge of Africa, the art of the continent had been "judged from a European and twentieth-century point of view." This text was written the same year the Brooklyn Museum mounted the first exhibition of African art in an American art museum.

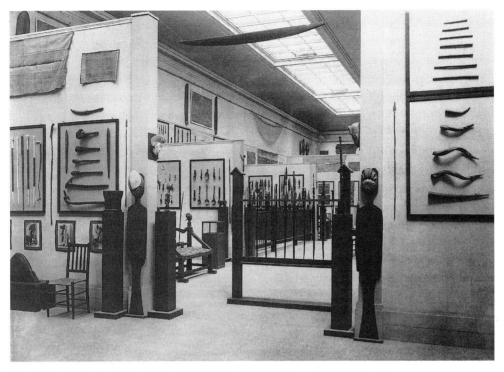

Figure 21. Installation view of the exhibition "Primitive Negro Art, Chiefly from the Belgian Congo," Brooklyn Museum, New York, April 11, 1923, through May 20, 1923.

trative force, a quality which made them responsive to the increasing demand for formal abstraction in art, reacting against the precision of the photographic reproductions now flooding the world.

It is true that one does not need to go to the center of Africa to find an art that is strongly sensitive to mass and that idealizes form; Ancient Egypt and some schools of classic Greece exhibit both qualities in a manner which is more clear and organic, but Egypt could not fail to appear conventional to the modern artist, who certainly is not over-cultured (and, for the good of art, it is better so), while his knowledge of classic Greece was obtained only from the plaster casts of works for the most part Hellenistic, and from the quantity of ugly Roman copies which provide the characteristic aspect of the great museums. On the other hand, the passion for the primitive and the exotic, so widely diffused at the present day, attracted the artist inevitably toward negro-sculpture, which, because it was imperfectly understood, and also because it was the product of a primitivism unbridled by any conscious artistic purpose, provided exactly what the artists were in search of, not in spite of, but because of the rudeness of its products.

In fact it is clearly evident that artists, and by natural consequence also the students who interested themselves in negro-sculpture, saw in it not what really

Figure 22. Female figure. Teke. Republic of the Congo. From *Art in America and Elsewhere* (1923). Courtesy of Museo Nazionale Preistorico ed Etnografico "L. Pigorini," Rome.

existed, but what they wished to see—reflections therein of their own mental state and aesthetic longings.

To comprehend completely a negro work of art one would need to reconstruct the negro soul, and this—if indeed it be possible—would require an effort of ethnographic learning of which no one has felt himself capable. Up to the present time, therefore, negro-sculpture has been judged from a European and a twentieth-century point-of-view. This point is important in interpreting the subjects, which are not without influence on the aesthetic judgment, and also in analyzing the expression, since it is quite possible that where we see a tragic face the negro beheld a comic grimace. Above all it is necessary to keep this in mind in any aesthetic analysis of the negro-sculpture, since aesthetic purpose was certainly not in the mind of the negro, who was guided by criteria wholly utilitarian, while to us it is the main object of attention. . . .

The female fetish of the Bateke [fig. 22] is remarkable in another respect. It is one of the very rare cases in which the negro artist, instead of trying to obliterate the traces of his wood technique—a strange phenomenon deserving particular study, since it must have a reason all its own—allows the technique to reveal itself in all its particulars, and even avails himself thereof in order to obtain a special decorative effect. To be noted especially is the peculiar cutting of the eyes and mouth, contrasted with the vertical incisions that line the face, while by a strange inversion the hairy part of the cranium is left smooth. The statuette is also a capital example of the vaunted "cubism" of the negroes. In this piece, in fact, the artist has carried his simplification to an extreme, succeeding in reducing the figure to a rigid cylindrical scheme, enlarging to this end the lower portion of the legs; the arms and breasts are mere indications, and the thickened neck, with the emphasis placed upon the so-called "collar of Venus" peculiar to female anatomy, has enabled the artist to more easily incorporate the head in his cylindrical system.

This illustrates the peculiarity which is without doubt the most characteristic of the negroes, and as was pointed out before, of their purest stock, the Bantu; tending toward artistic manifestations based upon an abstraction of nature and the most pronounced synthesis of form, they arrived spontaneously and unconsciously at that cubism which the cerebrations of modern artists believed was their own discovery of recent years. This cubism, if it merited being stigmatized as an illogical outrage to our aesthetic sense, or a sort of barbaric mimicry without meaning, is nevertheless capable of being a lofty ideal even within the boundaries of our own art, provided it be kept within certain limits and especially if it be interpreted with genius. Such it was in fact in the hands of the great practitioners of Greek art, which now is ignorantly disparaged as the quintessence of the academic, and considered the negation of the process above described.

FLORENT FELS

MELANIAN ART AT THE PAVILLON DE MARSAN · 1923

Did Gobineau, who was, with Nietzsche and Montaigne, the comrade-in-arms of some of us, do more for Negro art than the "syncopated orchestra" jazz bands? His centenary coincides with the exhibition at the Museum of Decorative Arts, where the art of the Blacks has been admitted. "Admitted" is the right word. The Trocadéro Museum certainly has some important works, but its collections don't even approach the depth of those at the British Museum or at Tervueren. Negro style is a little passé today, in spite of weavers who have been inspired by African material; and only couturiers would now want to confuse art with fashion. Although specialists are just starting to dare to take seriously the aesthetic of the Blacks, nevertheless it seems that great civilizations located along the Tropic of Capricorn, by way of contacts that were more frequent than today's geography would imply, transmitted the canons of its highly idealist art. If we allow the possibility of sunken islands and even continents, it will not surprise us to recognize the same aesthetic constants on a line of influence which, passing by way of Touamotou and Madagascar, starts from Peru to end in the great lakes and headwaters of the Nile. Africa surely had its civilization. Under the Fourth Dynasty of Egypt the extent of mercantile exchange proves the parity of the two cultures [Black Africa and Egypt]. Pharaohs had no reservations at all about marrying Black women. Perhaps the Egyptians wanted to mix their blood with one that was more idealistic and sensual, as is the thesis of Gobineau, who said that Black blood is the source of the artistic and lyrical impulse. During the Twelfth Dynasty, the Egyptians reduced the Negroid populations to slavery; a new factor emerges here, however, and anthropology can be more helpful than intuition in taking account of this. We have discovered, right here in France, in fossil deposits of the later Pleistocene epoch, ancient vestiges of Melanian art which have been dated to the Aurignacian period. These Melanian works include carved stone blocks, strangely close to Egyptian black rock, that represent whole figures.

You will not see anything like this at the Marsan Pavilion Exposition. Aside

Nouvelles littéraires (October 27, 1923): 4.

This is a preview of the "Exposition de l'art indigène des colonies françaises" at the Pavillon de Marsan. One of the purposes of this popular exhibition was to present French designers and craftsmen with works that they might be able to use for models.

from some large Madagascan figures and Papuan sculptures, reproduced here, there are just a few mediocre pieces labeled "of great antiquity."

Melanian art is not, properly speaking, idealistic. Their religion would prevent this, since the Negro believes in a supreme, inaccessible, abstract, unique Being, which is indifferent to human affairs, and is not subject to *concrete representation*.

God delegates his powers to messengers on earth who have the power to transmit the divine to men and things, and who are beneficent. Evil comes from the water, like the inexplicable. Whites are *the men of the waters*.

Fetishes do not represent the cult of the gods but rather are the symbol of general ideas. Any object or being can become a fetish. The stones themselves have a soul. Through incantation power is summoned [from fetishes], but it is also quite limited. There are fetishes for stomachaches, war wounds, sterility, etc. If the fetish fails to rid one of the malady, if it fails in its mission and does not obey, it is abandoned for a few days to the terror of the bush, where it is beaten, while nails are sunk into its stomach or eye to bring about better results. And sometimes, in serious cases, they even cut off its sexual parts. But these mutilations, like the total destruction of numerous fetishes, were rather owing to early Catholic and Protestant missionaries. Currently, religious missions, particularly French and German Protestant missions, are making major contributions to the documentation on Blacks, collecting not only fetishes but also religious and poetic texts.

Especially characteristic of Melanian art is the respect for natural forms and for the qualities of specific materials. Madagascan objects are based on the curves of the horns that are used in their fashioning: a few incisions easily allow a crocodile, a bird, or a fish to emerge. Consequently a stylization is obtained, through the readiest means, which can result in effects of great power. If Melanian art is enjoying a vogue today that situates it with the products of advanced civilizations such as the Greek and the Egyptian, we believe that it is due to a spirit of synthesis that is expressed through a pristine economy of line. This is equally true for the art of Benin, a land permeated by a Gothic influence through the incursions of Portuguese navigators, and whose fetishes are finely detailed; though decorated, tormented by an ornamental obsession with details, their forms are clear and simple.

Every notable race has its qualities: in Dahomean objects, on the masks and the faces of little men dressed in leopard skins with cruel mouths and carnivorous teeth, is visible the ferocity of men who are inured to murder and to ordeals. In the Congo the attitude is at once meeker and more simian, while with the Pahans it becomes quasi-hieratic. The works of the Ivory Coast and the Cameroons are powerful, whereas in Yoruba and Benin they are of a rare technical refinement. In these latter places you even come across little objects of gold, horn, and ivory which remind one of Japanese dolls.

As is the case with Negro people themselves, it seems to the superficial observer that there is little difference between the diverse expressions of their

sculptures. It is easier to specify the origin of one of these works than it is for a primitive painting. Nuances nevertheless convey the particularity of each race.

Melanian art had some impact for a while on the plastic creations of our painters and sculptures. This seems to be over, and from now on Melanian objects will only serve the purpose of inspiration. It has nevertheless suggested a new technique, discernible in certain Picassos and most of the figures of Modigliani. For the erudite, it is the subject of studies of great interest, while to the public it offers insights into a new facet of human creativity. Negro sculptures surprise and amuse first of all through their caricatural appearance, but one soon discerns infinitely more profound qualities.

Be warned about pieces copied and manufactured in quantity by contemporary natives. There exist in Dakar (and Montmartre) workshops for the manufacture of Melanian objects "of great antiquity." Three years ago, at a Parisian show, a famous collector acquired a magnificent bust that combined the purest qualities of Benin, Michel Pacher, and Bartholomé. Purchasing an expensive piece displayed by a reputable dealer is no guarantee either. Nor is there any security in buying in some corner of the provinces a Negro object left "on consignment" by a Parisian dealer. Under the galleries of the Palais Royal there is a little store that belongs to the Colonial ministry and is placed under official control. There you find very few pieces of any real value, but at least what you find there is reasonably priced and authentically Melanian. The exhibition of indigenous arts will open at the beginning of November. It will be my pleasure to return and to examine this show in greater detail, if I am invited to do so.

ALAIN LOCKE

NOTE ON AFRICAN ART · 1924

The significance of African art is incontestable; at this stage it needs no *apologia*. Indeed no genuine art ever does, except when it has become incumbered with false interpretations. Having passed, however, through a period of neglect and disesteem during which it was regarded as crude, bizarre, and primitive, African art is now in danger of another sort of misconstruction, that of being taken up as an exotic fad and a fashionable amateurish interest. Its chief need is to be allowed to speak for itself, to be studied and interpreted rather than to be praised or exploited. It is high time that it was understood, and not taken as a matter of oddness and curiosity, or of quaint primitiveness and fantastic charm.

This so-called "primitive" Negro art in the judgment of those who know it best is really a classic expression of its kind, entitled to be considered on a par with all other classic expressions of plastic art. It must be remembered that African art has two aspects which, for the present at least, must be kept rigidly apart. It has an aesthetic meaning and a cultural significance. What it is as a thing of beauty ranges it with the absolute standards of art and makes it a pure art form capable of universal appreciation and comparison; what it is as an expression of African life and thought makes it an equally precious cultural document, perhaps the ultimate key for the interpretation of the African mind. But no confusing of these values as is so prevalent in current discussions will contribute to a finally accurate or correct understanding of either of these. As Guillaume Apollinaire aptly says in *Apropos de l'Art des Noirs* (Paris 1917), "In the present condition of anthropology one cannot without unwarranted temerity advance definite and final assertions, either from the point of view of archeology or that of aesthetics, concerning these African images that have aroused enthusiastic appreciation from their admirers in spite of a lack of definite information as to their origin and use and as to their definite authorship."

It follows that this art must first be evaluated as a pure form of art and in terms of the marked influences upon modern art which it has already exerted, and then that it must be finally interpreted historically to explain its cultural meaning and derivation. What the cubists and post-expressionists have seen in it

Excerpts from *Opportunity, Journal of Negro Life* (May 1924): 134–38.

The African-American philosopher Alain Locke (1886–1954), writing during the Harlem Renaissance, or New Negro Movement, was one of the first writers to identify the way in which African art could provide American Blacks with a sense of a cultural past. *Opportunity* was published by the National Urban League.

intuitively must be reinterpreted in scientific terms, for we realize now that the study of exotic art holds for us a serious and important message in aesthetics. Many problems, not only of the origin of art but of the function of art, wait for their final solution on the broad comparative study of the arts of diverse cultures. Comparative aesthetics is in its infancy, but the interpretation of exotic art is its scientific beginning. And we now realize at last that, scientifically speaking, European art can no more be self-explanatory than one organic species intensively known and studied could have evolved in the field of biology the doctrine of evolution.

The most influential exotic art of our era has been the African. The article of M. Paul Guillaume, its ardent pioneer and champion, is in itself sufficient witness and acknowledgment of this. But apart from its stimulating influence on the technique of many acknowledged modern masters, there is another service which it has yet to perform. It is one of the purposes and definite projects of the Barnes Foundation, which contains by far the most selected art-collection of Negro art in the world, to study this art organically, and to correlate it with the general body of human art. Thus African art will serve not merely the purpose of a strange new artistic ferment, but will also have its share in the construction of a new broadly comparative and scientific aesthetics.

Thus the African art object, a half a generation ago the most neglected of curios, has now become the corner-stone of a new and more universal aesthetic that has all but revolutionized the theory of art and considerably modified its practice. The movement has a history. Our museums were full of inferior and relatively late native copies of this material before we began to realize its art significance. Dumb, dusty trophies of imperialism, they had been assembled from the colonially exploited corners of Africa, first as curios then as prizes of comparative ethnology. Then suddenly there came to a few sensitive artistic minds realization that here was an art object, intrinsically interesting and fine. The pioneer of this art interest was Paul Guillaume, and there radiated from him into the circles of post-impressionist art in Paris that serious interest which subsequently became an important movement and in the success of which the art of African peoples has taken on fresh significance. This interest was first technical, then substantive, and finally, theoretical. "What formerly appeared meaningless took on meaning in the latest experimental strivings of plastic art. One came to realize that hardly anywhere else had certain problems of form and a certain manner of their technical solution presented itself in greater clarity than in the art of the Negro. It then became apparent that prior judgments about the Negro and his arts characterized the critic more than the object of criticism. The new appreciation developed instantly a new passion, we began to collect Negro art as art, became passionately interested in corrective re-appraisal of it, and made out of the old material a newly evaluated thing."

There is a curious reason why this meeting of the primitive with the most

sophisticated has been so stimulating and productive. The discovery of African art happened to come at a time when there was a marked sterility in certain forms of expression in European plastic art, due to generations of the inbreeding of idiom and style. Restless experimentation was dominant. African images had been previously dismissed as crude attempts at realistic representation. Then out of the desperate exhaustion of the exploiting of all the technical possibilities of color by the Impressionists, the problem of form and decorative design became emphasized in one of those natural reactions which occur so repeatedly in art. And suddenly with the substitution in European art of a new emphasis and technical interest, the African representation of form, previously regarded as ridiculously crude, suddenly appeared cunningly sophisticated. Strong stylistic associations had stood between us and its correct interpretation, and their breaking down had the effect of a great discovery, a fresh revelation. Negro art was instantly seen as a "notable instance of plastic representation." "For western art the problem of representation of form had become a secondary and even mishandled problem, sacrificed to the effect of movement. The three-dimensional interpretation of space, the ground basis of all plastic art, was itself a lost art, and when, with considerable pains, artists began to explore afresh the elements of form perception, fortunately at that time African plastic art was discovered and it was recognized that it had successfully cultivated and mastered the expression of pure plastic form."

It was by such a series of discoveries and revaluations that African art came into its present prominence and significance. Other articles in this issue trace more authoritatively than the present writer can the attested influence of Negro art upon the work of Matisse, Picasso, Modigliani, and Soutine among the French painters, upon Max Pechstein, Elaine Stern among German painters, upon Modigliani, Archipenko, Epstein, Lipchitz and Lembruch among sculptors. This much may be regarded, on the best authority, as incontestable. The less direct influence in music and poetry must be considered separately, for it rests upon a different line both of influence and of evidence. But in plastic art the influence is evident upon direct comparison of the work of these artists with the African sculptures, though in almost every one of the above mentioned cases there is additionally available information as to a direct contact with Negro art and the acknowledgment of its inspiration.

The verdict of criticism was bound to follow the verdict of the creative artists. A whole literature of comment and interpretation of "exotic art" in general, and Negro art in particular has sprung up, especially in Germany. Most diverse interpretations, from both the ethnographic and the aesthetic points of view, have been given. On good authority much of this is considered premature and fantastic, but this much at least has definitely developed as a result—that the problems raised by African art are now recognized as at the very core of art theory and art history. . . .

Equally important with this newer aesthetic appreciation is the newer arche-
ological revaluation. Negro art is no longer taken as the expression of a uniformly
primitive and prematurely arrested stage of culture. It is now seen as having
passed through many diverse phases, as having undergone several classical devel-
opments, and as illustrating several divergent types of art evolution. The theory
of evolution has put art into a scientific straight-jacket, and African art has had
to fit in with its rigid preconceptions. It is most encouraging therefore to see an
emancipated type of scientific treatment appearing, with Torday and Joyce's his-
torical interpretation of art in terms of its corresponding culture values, and in
Goldenweiser's rejection of the evolutionary formula which would make all
African art originate from crude representationalism, that is to say, naïve and
non-aesthetic realism. For Goldenweiser, primitive art has in it both the decora-
tive and the realistic motives, and often as not it is the abstract principles of de-
sign and aesthetic form which are the determinants of its stylistic technique and
conventions.[1] Of course this is only another way of saying that art is after all art,
but such scientific vindication of the efficacy of pure art motives in primitive art
is welcome, especially as it frees the interpretation of African art from the pre-
vailing scientific formulae. Thus both the latest aesthetic and scientific interpre-
tations agree on a new value and complexity in the art we are considering.

Perhaps the most important effect of interpretations like these is to break
down the invidious distinction between art with a capital A for European forms
of expression and "exotic" and "primitive" art for the art expressions of other
peoples. Technically speaking an art is primitive in any phase before it has mas-
tered its idiom of expression, and classic when it has arrived at maturity and be-
fore it has begun to decline. Similarly art is exotic with relation only to its
relative incommensurability with other cultures, in influencing them at all vitally
it ceases to be exotic. From this we can see what misnomers these terms really
are when applied to all phases of African art. Eventually we will come to realize
that art is universally organic, and then for the first time scientifically absolute
principles of art appreciation will have been achieved.

Meanwhile as a product of African civilization, Negro art is a peculiarly pre-
cious thing, not only for the foregoing reasons, but for the additional reason that
it is one of the few common elements between such highly divergent types of
culture as the African and the European, and offers a rare medium for their fair
comparison. Culture and civilization are regarded too synonymously: a high-
grade civilization may have a low-grade culture, and a relatively feeble civiliza-
tion may have disproportionately high culture elements. We should not judge
art too rigidly by civilization, or vice versa. Certainly African peoples have had
the serious disadvantage of an environment in which the results of civilization
do not accumulatively survive, so that their non-material culture elements are in
many instances very much more mature and advanced than the material civi-
lization which surrounds them. It follows then that the evidence of such ele-

ments ought to be seriously taken as factors for fair and proper interpretation.

Indeed the comparative study of such culture elements as art, folk-lore and language will eventually supply the most reliable clues and tests for African values. And also, we may warrantably claim, for the tracing of historical contacts and influences, since the archeological accuracy of art is admitted. Comparative art and design have much to add therefore in clearing up the riddles of African periods and movements. Although there are at present no reliable conclusions or even hypotheses, one can judge of the possibilities of this method by a glance at studies like Flinders-Petrie's "Africa in Egypt" (Ancient Egypt, 1916) or G. A. Wainwright's "Ancient Survivals in Modern Africa" (*Bulletin de la Société de Géographie,* Cairo, 1919–20). Stated more popularly, but with the intuition of the artist, we have the gist of such important art clues in the statement of Guillaume Apollinaire to the effect that African sculptures "attest through their characteristic style an incontestable relationship to Egyptian art, and contrary to current opinion, it seems rather more true that instead of being a derivative of Egyptian art, they" (or rather we would prefer to say, their prototypes) "have on the contrary exerted on the artists of Egypt an influence which amply justifies the interest with which we today regard them."

But for the present all this is merest conjecture, though we do know that in many cases the tradition of style of these African sculptures is much older than the actual age of the exemplars we possess. Paul Guillaume, who has been the first to attempt period classification of this art, has conjecturally traced an Early Sudan art as far back as the Vth or VIth century, and has placed what seems to be its classic periods of expression as between the XIIth and the XIVth centuries for Gabon and Ivory Coast art, the XIth and XIIth for one phase of Sudan art, with another high period of the same between the XIVth and the XVth centuries. There are yet many problems to be worked out in this line—more definite period classification, more exact ethnic classification, especially with reference to the grouping of the arts of related tribes, and perhaps most important of all the determination of their various *genres.*

A new movement in one of the arts in most cases communicates itself to the others, and after the influence in plastic art, the flare for things African began shortly to express itself in poety and music. . . .

Since African art has had such a vitalizing influence in modern European painting, sculpture, poetry and music, it becomes finally a natural and important question as to what artistic and cultural effect it can or will have upon the life of the American Negro. It does not necessarily follow that it should have any such influence. Today even in its own homeland it is a stagnant and decadent tradition, almost a lost art, certainly as far as technical mastery goes. The sensitive artistic minds among us have just begun to be attracted toward it, but with an intimate and ardent concern. Because of our Europeanized conventions, the key to the proper understanding and appreciation of it will in all probability first

come from an appreciation of its influence upon contemporary French art, but we must believe that there still slumbers in the blood something which once stirred will react with peculiar emotional intensity toward it. If by nothing more mystical than the sense of being ethnically related, some of us will feel its influence at least as keenly as those who have already made it recognized and famous. Nothing is more galvanizing than the sense of a cultural past. This at least the intelligent presentation of African art will supply to us. Without other more direct influence even, a great cultural impetus would thus be given. But surely also in the struggle for a racial idiom of expression, there would come to some creative minds among us, from a closer knowledge of it, hints of a new technique, enlightening and interpretative revelations of the mysterious substrata of feeling under our characteristically intense emotionality, or at the very least, incentives toward fresher and bolder forms of artistic expression and a lessening of that timid imitativeness which at present hampers all but our very best artists.

NOTE

1. See Goldenweiser, *Early Civilization*, pp. 25, 172–173, 180–183.

HENRI CLOUZOT AND ANDRÉ LEVEL

THE LESSON OF AN EXHIBITION · 1925

The Exposition of Indigenous Art of the French Colonies of Africa and Ocea-nia and of the Belgian Congo, organized in October 1923 at the Marsan Pavil-ion by the Central Union of Decorative Arts, was meaningful and diverse.

The loans by the Trocadéro Ethnographic Museum, the government offices, colonial officials, artists, and enthusiasts brought together for the first time ever an ample collection of works, and especially of ancient pieces of sculpture, offer-ing the public extensive information about Black and Oceanic Art.

It would be unfair at this point not to recall the 1919 exhibition at the De-vambez Gallery, which began, with necessarily limited means, to call atten-tion to arts that were for too long limited to the confines of ethnographic mu-seums and to the display windows of certain specialty dealers (whose number since then has greatly increased). Interesting for the initiated, that exhibition pleased visitors and critics and was a prelude to the beautiful presentation at the Museum of Decorative Arts, where objects are no longer grouped by collection but rather according to a geographical classification that allows for fruitful comparisons.

This time, numerous articles published in newspapers or magazines and the curiosity shown by ordinary visitors have affirmed that the public was ripe to appreciate this new kind of art. The first impression of visitors was surprise at the great character and beautiful style of these works. Too accustomed to think-ing of industrial progress as the standard by which to judge the importance of a people, the public was astounded to realize that the great interest of the Blacks in the plastic arts lay precisely in their backwardness, one might even say their complete lack of industrial organization, that had enabled them to maintain for so long the purity of their traditions and the skills they needed to practice them. No division of labor, no withering mechanical processes. Art was brought to life by beliefs and by nature as seen through the eyes of a child, for whom nothing is

Excerpts from "La Leçon d'une exposition," in *Sculptures africaines et océaniennes: Colonies françaises et Congo belge* (1925), 3–8, 18.

This essay, written to introduce an album of photographic reproductions, provides the most detailed description and analysis of the "Exposition de l'art indigène des colonies françaises" at the Pavillon de Marsan in Paris, for which no official exhibition catalogue was published. The same authors' catalogue for the Galerie Devambez exhibition in 1919 (see p. 123) had helped, along with the growing number of fine Primitive art collections in Paris, to provide the context for the organization of the 1923 exhibition.

inanimate. Thus each artisan approaches his tradition with personal fervor, and time was not a limiting factor for him.

Does this mean, however, that visitors and critics have entirely accepted the varied expressive modes of indigenous artists and artisans? Although seduced by the unexpectedness, the beauty, the perfect craft of the masks and practical objects, some have continued to consider the idols repulsive, without bothering to examine them. The idols—let's say the word: fetishes—are less accessible but often nobler and more meaningful in conception. Let's grant them a new credit. Such works will certainly be better received at the next International Colonial Exposition.

Others, confronted by these successfully executed works, believed they had discovered an instinctive art. An attentive examination of the works on display allows us, however, to determine exactly the respective roles of tradition and individual gifts. Numerous examples are presented of the principal types of masks and idols used in each area. Apparently none of the artists had invented the model that he copied, which must have been established in an ancient epoch favorable to creative energies, possibly during the great Black empires, whose splendors have gone down in history, from the third to the seventeenth centuries in the vast delta of the Niger. But that model, owing to the rites that kept it in use, continued to be followed, while the greater or lesser degree of variation in the examples on display give evidence of the personal character, and sometimes incomparable talents, of the artists. Each artisan, in his guild, had faith in his religious traditions or rituals and brought to his work his particular technical gifts. The creation of masterpieces in all great epochs of art is due to this alliance of the collective and the individual.

As might be expected, the most ancient sculptures in each region are also the most meaningful, the richest in individual quality, and the most exempt from Western influence. The art of the Black is above all sculptural, and its favorite material is wood. Diverse woods, more or less hard or resistant, were worked on when they were still green and easier to manipulate (hence the cracks that often appeared later on) and then blackened and polished by the natives, and by the passage of time, to simulate the highest shine on bronze.

Let us admit in any case that to this day the exact age of these sculptures has been almost impossible to determine. Some of them, through their expression of grandeur, evoke a kind of similarity with Gothic or Romanesque works, or even Classical ones. Others, through a kind of diffuse grace, make us think of works of the Renaissance or eighteenth century. But it should be understood that these coincidences are completely relative, notions that exist only in our minds and on whose basis we may not ascribe a date corresponding to a specific epoch of our Western art. Besides, how could we establish general points of view for the art of the Blacks that newly discovered works would not force us to modify incessantly, since the scope and complexity of this art are so unsus-

pected? At most, concerning time periods, we might be able to establish, notably for the works of Benin—which are not part of our study, since it was an English colony—that certain works go back to the sixteenth century, for they represent Europeans in the costume of that period. Likewise, in the Belgian Congo, we have been able to collect details indicating that the effigies of certain chiefs go back to the eighteenth century.

Nevertheless, the archaic character and aged look of the woods should not deceive us, since, though the model might come from early antiquity, the specimen of worked wood that has come down to us has certainly aged quickly in Africa, and the possibility of long conservation seems so hypothetical that it is hard to ascribe to it even a few centuries of existence. A few score of years, 100 or 150 years at most, seems most likely.

It would certainly be very interesting to accompany the objects with a concomitant explication of the morals, religion, legends, and mentality of the natives and to try to understand what these traditional sculptures meant to them. But in the current state of ethnographic knowledge, it is almost impossible to establish a correlation between legendary traditions and specific sculptural works, which moreover were usually acquired without any precise indication of provenance. Even if we could be surer about the dates of the works, how could we in any case establish their meaning, other than ritual, to the present-day natives, whose profound decadence from an artistic viewpoint can be attributed mostly to the coming of the colonizers, who did not as in the past simply establish a few trading stations but brought with them a whole organization, which had the effect of more or less completely breaking the chain of indigenous traditions? We are therefore usually reduced to examining the works that were made before the arrival of Occidental administrators, and to seek out the reasons why we are interested in their insights and successes—we and not those by whom, and for whom, they were made. Isn't this furthermore how critics have often proceeded with regard to ancient art objects? Certainly it is unfortunate not to know what their creators and contemporaries thought. But it is possibly no less interesting to know what we feel before these sculptures, whose distance in time and space conveys a mystery that usually cannot be penetrated. Additionally, the existence of beautiful works lasts longer than a generation. The next generation, by reason of the amplitude of the problems that they pose and of the very life that animates them, frequently finds other things to admire in them than the preceding one. A similar situation holds for many of the famous pieces that fill our museums and that have known the alternating favor and indifference of the public. If we strive to define the current feelings and preferences of our artists and enthusiasts regarding these works, which constitute an almost virgin territory for criticism, we do so only in the spirit of preparing the way for those who will later on revise these notions and who will possibly be curious about what we thought about these things in 1925.

It appears that the Ivory Coast masks, an impressive number of beautiful examples of which are on display at the Marsan Pavilion, have united connoisseurs and the public in a common admiration. In fact, no Black country has fashioned any that are more varied, striking, or human. Some among them represent animal effigies, for example the powerfully rendered baboons, which are admirably stylized. For the art of the Blacks, while being more realistic than is commonly supposed, is not trivially so. It does not imitate or copy a model servilely and minutely, but only renders its essential lines and basic design, as if from memory. Certain masks modeled on the human face topped with horns succeed, furthermore, in compressing a being entirely through an astonishing shorthand by presenting jowls into which short curved legs are inserted. But the most moving masks of this privileged region remain, it seems, those that resemble most nearly the normal human physiognomy. Some present a sweet and serious face, with a thin nose and with a mouth whose moving prognathous lines are so supple it ceases to be unpleasant, with a pile of hair mounted on the forehead and crowned by a decorative motif, which does not lessen the sculptural value of the ensemble. Others show a naked face, whose more or less bulbous forehead opposes its mass to that of the mouth and chin, thereby creating a constant equilibrium. They vary in their simplicity, since each example is different; the balancing projections are softened or marked in extraordinary relief, and the expressions range from an almost serene seriousness to the most ferocious intensity. In certain pieces, the lines are all geometrically arranged and their surprising success from a cubist standpoint sheds light on the influence that Black art has exerted on our own contemporary art. . . .

As different as the arts of Africa and Oceania are in their manifestations, the religious underpinnings of terror and the traditions that arose and were preserved for protection from supernatural dangers remain the common ground from which these peoples have drawn their inspiration. But races and climates are not at all the same, and it is not difficult to distinguish the sculpture and decorative style of the Oceanians from those of African natives. Oceanian art is more distant, less human, sometimes of a perfection that is a little cold, but often full of grandeur. It is less varied too, for as numerous and varied as the particular insular groups are, the earthly surface they inhabit occupies very little space in the Pacific Ocean, and we cannot compare the shrinking number of their natives with the multitude of Black tribes that populate, however thinly, the compact mass of the African continent.

If we possess in fetishist Africa a colonial domain whose importance is surely second to none, that is far from true for Oceania—the final reason for the lesser number of specimens of Oceanic art that we have at our disposal.

ALAIN LOCKE

LEGACY OF THE ANCESTRAL ARTS · 1925

Music and poetry, and to an extent the dance, have been the predominant arts of the American Negro. This is an emphasis quite different from that of the African cultures, where the plastic and craft arts predominate; Africa being one of the great fountain sources of the arts of decoration and design. Except then in his remarkable carry-over of the rhythmic gift, there is little evidence of any direct connection of the American Negro with his ancestral arts. But even with the rude transplanting of slavery, that uprooted the technical elements of his former culture, the American Negro brought over as an emotional inheritance a deep-seated æsthetic endowment. And with a versatility of a very high order, this off-shoot of the African spirit blended itself in with entirely different culture elements and blossomed in strange new forms.

There was in this more than a change of art-forms and an exchange of cultural patterns; there was a curious reversal of emotional temper and attitude. The characteristic African art expressions are rigid, controlled, disciplined, abstract, heavily conventionalized; those of the Aframerican, free, exuberant, emotional, sentimental and human. Only by the misinterpretation of the African spirit, can one claim any emotional kinship between them—for the spirit of African expression, by and large, is disciplined, sophisticated, laconic and fatalistic. The emotional temper of the American Negro is exactly opposite. What we have thought primitive in the American Negro—his naïveté, his sentimentalism, his exuberance and his improvizing spontaneity are then neither characteristically African nor to be explained as an ancestral heritage. They are the result of his peculiar experience in America and the emotional upheaval of its trials and ordeals. True, these are now very characteristic traits, and they have their artistic, and perhaps even their moral compensations; but they represent essentially the working of environmental forces rather than the outcropping of a race psychology; they are really the acquired and not the original artistic temperament.

Excerpt from *The New Negro: An Interpretation* (1925), 254–67.

This essay, which calls for Blacks to reclaim their ancestral heritage by using African art as an inspiration and influence for their own art, had a powerful impact on many African-American artists. *The New Negro,* which was edited by Alain Locke, contains an anthology of writings, mostly by African-American writers, reflecting on the many contributions made by Blacks in every facet of American culture. This book is the closest the Harlem school came to issuing a manifesto.

A further proof of this is the fact that the American Negro, even when he confronts the various forms of African art expression with a sense of its ethnic claims upon him, meets them in as alienated and misunderstanding an attitude as the average European Westerner. Christianity and all the other European conventions operate to make this inevitable. So there would be little hope of an influence of African art upon the western African descendants if there were not at present a growing influence of African art upon European art in general. But led by these tendencies, there is the possibility that the sensitive artistic mind of the American Negro, stimulated by a cultural pride and interest, will receive from African art a profound and galvanizing influence. The legacy is there at least, with prospects of a rich yield. In the first place, there is in the mere knowledge of the skill and unique mastery of the arts of the ancestors the valuable and stimulating realization that the Negro is not a cultural foundling without his own inheritance. Our timid and apologetic imitativeness and overburdening sense of cultural indebtedness have, let us hope, their natural end in such knowledge and realization.

Then possibly from a closer knowledge and proper appreciation of the African arts must come increased effort to develop our artistic talents in the discontinued and lagging channels of sculpture, painting and the decorative arts. If the forefathers could so adroitly master these mediums, why not we? And there may also come to some creative minds among us, hints of a new technique to be taken as the basis of a characteristic expression in the plastic and pictorial arts; incentives to new artistic idioms as well as to a renewed mastery of these older arts. African sculpture has been for contemporary European painting and sculpture just such a mine of fresh *motifs,* just such a lesson in simplicity and originality of expression, and surely, once known and appreciated, this art can scarcely have less influence upon the blood descendants, bound to it by a sense of direct cultural kinship, than upon those who inherit by tradition only, and through the channels of an exotic curiosity and interest.

But what the Negro artist of to-day has most to gain from the arts of the forefathers is perhaps not cultural inspiration or technical innovation, but the lesson of a classic background, the lesson of discipline, of style, of technical control pushed to the limits of technical mastery. A more highly stylized art does not exist than the African. If after absorbing the new content of American life and experience, and after assimilating new patterns of art, the original artistic endowment can be sufficiently augmented to express itself with equal power in more complex patterns and substance, then the Negro may well become what some have predicted, the artist of American life. . . .

There is a vital connection between this new artistic respect for African idiom and the natural ambition of Negro artists for a racial idiom in their art expression. To a certain extent contemporary art has pronounced in advance upon this objective of the younger Negro artists, musicians and writers. Only the

most reactionary conventions of art, then, stand between the Negro artist and the frank experimental development of these fresh idioms. This movement would, we think, be well under way in more avenues of advance at present but for the timid conventionalism which racial disparagement has forced upon the Negro mind in America. Let us take as a comparative instance, the painting of the Negro subject and notice the retarding effect of social prejudice. The Negro is a far more familiar figure in American life than in European, but American art, barring caricature and *genre,* reflects him scarcely at all. An occasional type sketch of Henri, or local color sketch of Winslow Homer represents all of a generation of painters. Whereas in Europe, with the Negro subject rarely accessible, we have as far back as the French romanticists a strong interest in the theme, an interest that in contemporary French, Belgian, German and even English painting has brought forth work of singular novelty and beauty. This work is almost all above the plane of *genre,* and in many cases represents sustained and lifelong study of the painting of the particularly difficult values of the Negro subject. To mention but a few, there is the work of Julius Hüther, Max Slevogt, Max Pechstein, Elaine Stern, von Reuckterschell among German painters; of Dinet, Lucie Cousturier, Bonnard, Georges Rouault, among the French; Kees van Dongen, the Dutch painter; most notably among the Belgians, Auguste Mambour; and among English painters, Neville Lewis, F. C. Gadell, John A. Wells, and Frank Potter. All these artists have looked upon the African scene and the African countenance, and discovered there a beauty that calls for a distinctive idiom both of color and modeling. The Negro physiognomy must be freshly and objectively conceived on its own patterns if it is ever to be seriously and importantly interpreted. Art must discover and reveal the beauty which prejudice and caricature have overlaid. And all vital art discovers beauty and opens our eyes to that which previously we could not see. While American art, including the work of our own Negro artists, has produced nothing above the level of the *genre* study or more penetrating than a Nordicized transcription, European art has gone on experimenting until the technique of the Negro subject has reached the dignity and skill of virtuoso treatment and a distinctive style. No great art will impose alien canons upon its subject matter. The work of Mambour especially suggests this forceful new stylization; he has brought to the Negro subject a modeling of masses that is truly sculptural and particularly suited to the broad massive features and subtle value shadings of the Negro countenance. After seeing his masterful handling of mass and light and shade in bold solid planes, one has quite the conviction that mere line and contour treatment can never be the classical technique for the portrayal of Negro types.

The work of these European artists should even now be the inspiration and guide-posts of a younger school of American Negro artists. They have too long been the victims of the academy tradition and shared the conventional blindness of the Caucasian eye with respect to the racial material at their immediate dis-

posal. Thus there have been notably successful Negro artists, but no development of a school of Negro art. Our Negro American painter of outstanding success is Henry O. Tanner. His career is a case in point. Though a professed painter of types, he has devoted his art talent mainly to the portrayal of Jewish Biblical types and subjects, and has never maturely touched the portrayal of the Negro subject. Warrantable enough—for to the individual talent in art one must never dictate—who can be certain what field the next Negro artist of note will choose to command, or whether he will not be a landscapist or a master of still life or of purely decorative painting? But from the point of view of our artistic talent in bulk—it is a different matter. We ought to and must have a school of Negro art, a local and a racially representative tradition. And that we have not, explains why the generation of Negro artists succeeding Mr. Tanner had only the inspiration of his great success to fire their ambitions, but not the guidance of a distinctive tradition to focus and direct their talents. Consequently they fumbled and fell short of his international stride and reach. The work of Henri Scott, Edwin A. Harleson, Laura Wheeler, in painting, and of Meta Warrick Fuller and May Howard Jackson in sculpture, competent as it has been, has nevertheless felt this handicap and has wavered between abstract expression which was imitative and not highly original, and racial expression which was only experimental. Lacking group leadership and concentration, they were wandering amateurs in the very field that might have given them concerted mastery.

A younger group of Negro artists is beginning to move in the direction of a racial school of art. The strengthened tendency toward representative group expression is shared even by the later work of the artists previously mentioned, as in Meta Warrick Fuller's "Ethiopia Awakening," to mention an outstanding example. But the work of young artists like Archibald Motley, Otto Farrill, Cecil Gaylord, John Urquhart, Samuel Blount, and especially that of Charles Keene and Aaron Douglas shows the promising beginning of an art movement instead of just the cropping out of isolated talent. The work of Winold Reiss, fellow-countryman of Slevogt and von Reuckterschell, which has supplied the main illustrative material for this volume has been deliberately conceived and executed as a path-breaking guide and encouragement to this new foray of the younger Negro artists. In idiom, technical treatment and objective social angle, it is a bold iconoclastic break with the current traditions that have grown up about the Negro subject in American art. It is not meant to dictate a style to the young Negro artist, but to point the lesson that contemporary European art has already learned—that any vital artistic expression of the Negro theme and subject in art must break through the stereotypes to a new style, a distinctive fresh technique, and some sort of characteristic idiom.

While we are speaking of the resources of racial art, it is well to take into account that the richest vein of it is not that of portraitistic idiom after all, but its almost limitless wealth of decorative and purely symbolic material. It is for the

development of this latter aspect of a racial art that the study and example of African art material is so important. The African spirit, as we said at the outset, is at its best in abstract decorative forms. Design, and to a lesser degree, color, are its original *fortes*. It is this aspect of the folk tradition, this slumbering gift of the folk temperament that most needs reachievement and reexpression. And if African art is capable of producing the ferment in modern art that it has, surely this is not too much to expect of its influence upon the culturally awakened Negro artist of the present generation. So that if even the present vogue of African art should pass, and the bronzes of Benin and the fine sculptures of Gabon and Baoulé, and the superb designs of the Bushongo should again become mere items of exotic curiosity, for the Negro artist they ought still to have the import and influence of classics in whatever art expression is consciously and representatively racial.

GEORGES SALLES

REFLECTIONS ON NEGRO ART · 1927

What do we find in studies published on Negro art? A little geography, even more ethnography, philosophy in abundance, but no history at all. To qualify the objects we place in that category, we have none of our usual methods of aesthetic numeration. Neither twelfth nor eighteenth century; neither Louis XV nor the Later Roman Empire. All is ageless; the only clue is the place of origin or the tribe.

Among the other arts, Negro art occupies a singular position. After being taken from the domain of ethnography, as has happened with many others—the arts of Asia, for example—it has not been able, like them, to penetrate and find shelter in the field of archaeology.

Our judgment on it is thereby distorted. Not being able to interpret as historians, we are forced to evaluate as artists. And nothing is more limiting for our sense of taste, which today rather inclines us to see in a work of art more of a choice document than something for which beauty alone is sufficient.

May we hope that this situation will soon change? I am afraid that the absence of buried objects will not allow this to happen very soon. The custom of burying objects was not practiced among the Negroes; and we cannot imagine that we will find under African sands, as under those of Asia, many levels of civilization waiting for the learned or avaricious pickax.

Most of the Negro works are, furthermore, made of wood, a very perishable substance in these regions where insects destroy it quickly. As for other materials: stone, bronze, and terracotta were used much less often or only recently. The markers are missing that would allow us to return very far on the road of the past.

Consider, in contrast, the situation for the arts of pre-Columbian America. Because of the attention paid to them by some artists who have noticed the beauty of these works, which were as neglected as those of the Negroes, an interest was awakened in the civilizations that produced them. The archaeologist comes into the picture. He assembles the materials gathered by the ethnographer and organizes them, instead of letting everything remain confusingly in

Excerpt from *Cahiers d'art* 7 (1927): 247–49.

Georges Salles (1889–1966) was then an assistant curator at the Louvre. He later became Director of the French Museums (1944–59) and was named President of the Artistic Council for the National Museums in 1961.

the same category. To help him complete his task, he has monuments to unearth, tombs to open, texts to read—all of which are missing from the Negro past.

We have thought of remedying this lacuna by supposing, as is generally agreed, that Negro civilizations evolved more slowly than those of other races. In calling them "primitive" we are saying as much. From the study of the present we might obtain knowledge of the past. But is this primitiveness a continuity or a return? Was there not a higher point in their civilization, followed by a descending curve? Paul Guillaume alludes to a great empire, that of Ghana, which covered a vast area, and which included Moslems who arrived there during the Middle Ages, following the Crusades. To the north and east of the Sudan, in certain regions of the Congo, there remains evidence of these incursions.

I will put aside the question of influence from modern Europe, which from a pictorial point of view has been so damaging, and which has resulted only in a "colonial art," which it is better to leave unmentioned. An exception should nevertheless be made for the art of Benin, an enclave where the Portuguese influence developed a type of art so different from what we meet on the rest of the Dark Continent. This is not without analogy with what happened in the isles of the Pacific, a closed field where encapsulated influences fermented and produced such a diverse flowering.

In our current state of ignorance the most practical way of classifying our Negro collections is by country and tribe. Still we need to be clear at the beginning that the Negro tribes were often seminomadic and that an identical art can be perceived sometimes in very different regions and populations, without our being able to establish to which of these populations or regions we should attribute it. Whatever the case, this classification is still more reliable than one based on epoch, on the supposed signification of the objects, or on other considerations, and it should be of some minimal help at least in rounding out our comprehension of Negro art through other means of investigation: comparative study of civilizations, aesthetic or psychoanalytic interpretations.

A recent visit to the Tervueren Museum allowed us to note that this sort of classification does not lessen appreciation of the beautiful pieces. Among the twelve series of masks that are presented in the vitrines of this museum of the Belgian Congo, I chose, with the help of Georges-Henry Rivière, the few specimens that this issue of *Cahiers d'Art* is publishing. The sculptural imagination of the Negroes is manifested in them in a truly surprising way through the renewal of each type of these masks. Although these objects were grouped by scholars for a uniquely scientific purpose, I would be astounded if they did not attract the admiration of artists.

It is superfluous to recall that it was the painters who discovered Negro art. Are not artists today the great discoverers of unknown forms? They speak the plastic language and explain to us what, for others, is still a mystery. Their aid is helpful to all who are trying to understand the arts of the past. But it is even

more important in this case, because of the scarcity of historical evidence. Let us hope that the Trocadéro Museum, which will soon begin a new life, will be the theater of a fruitful collaboration between artists and men of science.

Since I am closing this article of question marks with some wishes, I will add that of seeing some pieces of these primitive arts take their place in the great conservatory of the arts of the past, which is our Louvre Museum. Just because an art presents itself without papers and certificates is no reason to exclude it from the company of those that carry with them the guarantee of numbered archives. What should be enough is that it is a gripping and novel expression of the oldest human concerns. If it did not have this quality, Negro art would not have been able to renew our artistic world and refresh our sense of mystery during the past decade.

CHRISTIAN ZERVOS

OCEANIC WORKS OF ART AND TODAY'S PROBLEMS · 1929

In dedicating an entire issue of *Cahiers d'Art* to the art and culture of Oceanian peoples we have not simply sought to satisfy the curiosity of our readers.

In presenting works of Oceanian art we have especially sought to confront our readers with problems that our epoch willingly shrinks from.

It cannot be denied that at present the mind is undergoing a more and more complete mechanization that is removing us ever farther from any interior life. Numerous hindrances rise to block every intention of liberating our consciousness, and tormenting fetters surround our soul to the point of suffocation.

Nothing is more natural therefore than to see art itself reduced in our time to the narrow limits of form, to the detriment of feeling and imagination, which illuminate the forms with their poetry.

Only a few artists, who moreover are endlessly reproached for their imaginative liberty and the risky character of their works, now allow serious spiritual concerns to affect their plastic needs. With them the unconscious factor is more intense than the conscious one and brings them back, at least for a while and in some of their works, to that state of activity which seems to thwart any calculation.

These artists have felt that the invisible and intangible things that constantly touch their souls are no less real than other things. There are in effect myriad things that man does not see but which surround him and enrich his life, objects without the slightest physical consistency but whose outlines can nonetheless be felt, events that arise from the depths of dreams, reflected in the mirrors of perception. These figures and sounds sometimes affect all the senses and may establish mastery over vast spaces of the unknown. Often these energies even take over the personality, disturbing and provoking unexpected changes in it.

In extending life beyond the phenomenal world, we end up convincing ourselves that it does not disappear entirely. Become impalpable, life continues to persist through invisible faculties.

Cahiers d'art 2 (March–April 1929): 57–58.

Christian Zervos (1889–1970) was editor of the avant-garde journal *Cahiers d'art,* which was closely associated with the Surrealists. This entire issue of the journal was dedicated to Oceanic art and culture and provided the most comprehensive information to date about the arts of the Pacific.

In the Oceanian primitive, these intuitions that surge up from our being in the rare moments when it touches on the extreme limits of sensory perception form the very substance of his spiritual life. He is the poet who believes in the reality of his fictions, for in his heart the treasures of sensibility are locked.

We always expect that from an Oceanian work of art visions as marvelous as the soul can conjure will spring forth, which our art is incapable of attaining. The reader might be shocked to see this journal, which is relentless in according a higher reality to certain abstractions than it grants to the concrete objects from which they were derived, be so taken with the art of the natives of Oceania, which is so minutely realistic. But to do so would be to forget that feelings and imagination play an essential part in the composition of Oceanian works of art. Furthermore, that which you may mistake at first glance for realism is steeped in the subtle atmosphere of their mystico-magical conception of life. The Oceanian primitive applies himself to representing faithfully the image of his ancestor in his works for reasons that are purely cultic, for he is convinced that the model lives again in this image. But at the same time that he is determined to fix the dead in the most astounding likeness to his earthly appearance, he involuntarily adds his own passions, which lift the realistic image to an abstract level of feeling. In modeling a mask, the Oceanian seeks to materialize the spiritual energies of the ancestor and, through the magic of the image, to conciliate the mysterious power that he apprehends.

For although the theories of Spencer on the religion of natural man have been generally contested, and wrongly so, with the Oceanians, as with all primitive peoples, one must unquestionably understand the adoration of objects as a form of spirit-worship; and the spirits are almost always those of the ancestors.

For the primitive, not all the energies that constitute the brilliant game of life disappear with their separation from the body. He believes that the deceased continues to make his activity felt among the living. He is conceived as being willful and full of violent passions. Is not the primitive often sure that he sees against the wall of his house the shadow of someone who has just escaped from reality? Is he not at times surprised to hear the voice that once expressed affection or anger? In the silence of the night, has he not often felt the ancestor come to share his vigil? Accordingly he thinks of himself as dependent on circumstances created by the dead person, which he tries to render favorable so as to create prosperity and happiness for himself. Thus the living and the dead draw close to one another. The living yields to the dead his share of desires, ambitions, courage, friendship. He strives to become attached to him through the bonds of duty and concludes a pact of fidelity with him. In return, the dead owe the living who have known how to gain their favor a beneficent, faithful, indefatigable assistance.

The play of imagination at this level of intensity involves the need to revivify the dead through the device of the image and to protect this image under a sacred and sheltering roof.

This ancestor cult, joined with human sacrifice, brings us back to the dim past of primitive humanity. It was only in a later cultural phase, when association through ideas become more important and the violence of primal passions become attenuated, that the powerful ancestor cult weakened to the point of refusing the dead the right to partake in life. In the pre-Homeric epoch, the dead continued to influence the destinies of the living in a direct and durable way. With Homeric civilization, the dead were deprived of their previous prerogatives and became "vain and insubstantial faces," whose shadows sadly walk beneath the earth.

The little that we know of Oceanian civilization allows us to confirm that they never attained that stage of culture where corrupt elements and adjunctions would attenuate the ancestor cult.

This cult is completed by the adoration of other spirits, since it seems that the Oceanian feels the constant desire to invent special divinities that are always new. His emotion makes him conceive of an intangible world, entirely peopled with beneficent or ominous spirits. And although he himself may be the creator of these spirits, he regards them with no less terror and respect. Born from his own inner consciousness, they become independent entities that transcend the subtlest distinctions that his reason is able to make.

The powerful spirits that the primitive thus imagines to be behind every object, most of whom were human beings lifted to the rank of spirits, made him regard death with a certain degree of equanimity. A future life separated from the body was not at all uncertain for him. This future life being very much like present reality, it would follow that a man's situation on earth would determine that in the afterlife. In order to establish a suitable posthumous destiny, he needed to develop his faculties during his material existence.

This faith in a future life that continues one's present life is shared by the Oceanian with the Chinese, as with the Greeks of the pre-Homeric age and the Hindus, insofar as we can conclude from their religious legends and ritual practices.

Therefore, in order to evaluate Oceanian works of art, it is necessary to take special account of movements that have arisen from the depths of their souls. We should not look at these works in the same way that we regard classical works. The products of Oceanian art emit their powerful effect through the poetic invention that created them. The visionary imagination, conditioned by the spiritual aspirations of populations that have kept intact the primal passions of the individual, places us in the presence of imaginative and emotive human faculties that are inaccessible to reason but which allow us to move beyond the limits that have been so carefully constituted by prudence.

We have thus used Oceanian art and the states of mind that constitute its essential elements to criticize once more the works of artists who insist on slavishly copying the appearance of objects, and to encourage the work of all those who still believe in the marvelous and who lighten the burden of our con-

sciousness. Through their hard-won mastery over nature and countless successive experiments, the latter have reached the point where they can do without strict formal limitations. The strange whisper of poetry that has penetrated deeply into their spirits impels them towards the unprecedented. If they do not share the faith of primitive men, they nevertheless experience no less intensely the presentiments that bubble in the soul only to disappear as soon as they surface in the consciousness of our long-established civilization. They enter thereby into closer rapport with the spirit of things than with their material aspects and so touch on the very essence of art, as well as on what most intimately inspires it.

PAUL ÉLUARD

SAVAGE ART · 1929

Totally self-sufficient, always so profoundly expressive, ceaselessly exploring this mysterious domain of the silent caves of the heart, blood, eyes, head coupling the forms of passion, despair, indifference, and anger, human forms that die give themselves over to death only to take leave of an impotent world.

You annihilate the savages through love of logic, and also by shame, and by charity, a charity that proceeds by analogies and that makes you give half an overcoat to someone who will die from being half naked. You are saints. It shatters you like glass to hear them make love and dream, without eyes, in broad daylight!

If the savage affirms that he is a man, it is to distinguish himself not from the animals, but from the spirits. If he is quiet they are quiet, if he sings they sing, if he dances they dance. He wears them on his face; he sacrifices their own kind to them, his own kind.

EATING A FLOWER[1]

or

CANNIBALISM

in New Guinea

The magical laws of moral life. How sometimes it is impossible (and I would like to say materially impossible rather than morally impossible) to love a bird, a blade of grass, or the morning star.

In the sense that we understand the word "artificial," we say that the savage lives an absolutely artificial life.

To create men denotes only lack of imagination. But to create spirits, invisible ones—so as not to be tempted to look at them. To act with such detachment. If an invisible spirit somehow imposes itself on your sight, then just break it!

With us the statue is just part of the decor. For the savage, the statue eliminates the decor, even his own decor: his body. The statue reveals to the savage his dumbness, blindness, paralysis, the wind blowing through the dust of his bones. It reveals to him that they are equal, after all appearances have been seen through.

Variétés (June 1929): 36–37.

The poet Paul Éluard (1895–1952) was also an avid collector of Primitive art. This issue of *Variétés* was devoted to Surrealism.

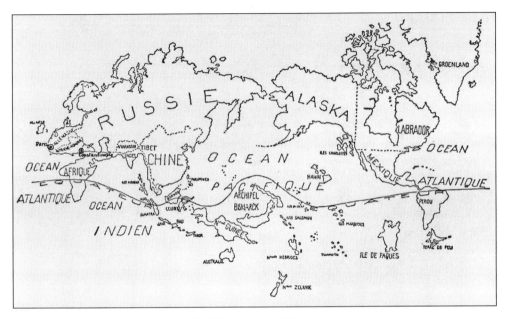

Figure 23. "Surrealist Map of the World," from *Variétés* (1929).

Fetishism is the opposite of religion. The savage opposes the spirits to each other, takes revenge on some, uses others, replaces those that are used up, changes his beliefs according to the spirits he is dealing with, and he laughs or he cries according to the kind of show they give him.

If the savage had gods, he would quickly get the better of them. As for divine power, it is enough to circumscribe it, to oppose it a little. It is there for everybody. Or else, at the beginning of everything, be a deicide as one is an infanticide. Otherwise, it's war: the sun against the moon, the sea against the land. And the victims don't get up by themselves.

Fetishes cannot be separated from their creator, the savage of whom we speak. And the idea is born in this creator that his creatures have created him. Subjectivity creates an objectivity which gradually returns from its creation to creative subjectivity. When the savage first saw a mirror, he smashed it and made eyes for his dolls out of it, fathers for his children. Imagine a pane of glass silvered on both sides and in which a man dreams that his eyes, on the outside, prove that he is on the inside.

Others than myself have tried to explain totemism in a way that conforms to your taste.

Here is the Fish of the Floods, the Birds of the Thunder, here between the four cardinal points are set the head of an ancestor, an eagle, a dragonfly or a man, here are the Great Phantoms, here reality becomes the very image of the unconscious, here we allow language to exist, for forms to become fixed so as to

bear witness to the origin of delirious gestures. The savage has made an image, see how reality resembles this image and how it becomes sacred. Creation is thereby inscribed into an uncreated world. The phenomena of nature are phenomena of the mind. They will be consulted, meditated, provoked, seduced, threatened, fought, divided. Natural powers, if we have to, we will cut off your head,

<p style="text-align:center">THE WIND WILL BE WHIPPED</p>

We will ascribe to the natural omnipotence of ideas all the responsibility for this world. And it will always be so, even when our memory fails us.

NOTE

1. [In English in the French text. Eds.]

WALDEMAR GEORGE

THE TWILIGHT OF THE IDOLS · 1930

The clerks of cubism, retired from active duty, who sadly evoke the heroic epoch of the Place Ravignan and of the Bateau Lavoir, make me retch. At that time, "They were in on things." They saw this miracle with their own eyes, this supreme gift from heaven: the first cubist canvas. They took part in the unforgettable banquet that the poets and their equals, the painters, gave to the Douanier Rousseau. They remember having rubbed shoulders with great men when those soothsayers were obscure and poor. They have forgotten nothing. Their memory is fresh and when they are old they will tell their grandchildren about the legendary existence of the artists who lived in Montmartre at the beginning of the century. While awaiting that day, they write the anecdotal history of contemporary art. These men, these war veterans crowned with laurel, have perogatives over us. First of all they have the privilege of age—these decorated grumblers recall the disabled veterans of the Franco-Prussian War, the last survivors of the charge at Reichshoffen, whose unvarying story we used to hear as children: "Such as into himself at last eternity changes him."[1] They recall the Mark Twain hero who brags about having approached a famous person and cleaned up after his dog or picked up his cane. "I saw the queen," he says to his neighbor, "just as I'm seeing you." The fortune, the glory, the renown of the heroes of the Place Ravignan springs from the humble accounts of their early exploits.

There is a spirit of the Place Ravignan. This spirit leaves an oil stain. Hasn't Mr. M———,[2] a Catholic writer, admitted that before finding his center of gravity, he asked himself, not without a certain anxiety, if he had "done well" to have distanced himself from the path then traced by Guillaume Kostrowitzki [Apollinaire]. This spirit is the spirit of mystification, the necessary adjunct to an essentially baroque poetic genius. Guillaume Apollinaire, who was its living incarnation, broke with it at the end of his life. This Pico della Mirandola was able to escape from the circle within which he had enclosed his epoch. The "Calligrammes," which were his testament, bore witness to the classical orientation of his thought. Apollinaire could only reach his goal with Universalism.

Les Arts à Paris 17 (May 1930): 7–13.

Waldemar George (1893–1970) was a prolific if sometimes reactionary critic. He was the editor of *Les Arts à Paris* and a friend of the journal's founder, Paul Guillaume, to whom this piece was addressed as an open letter.

The rapports between nascent Cubism and the discovery of African sculptures that had been gathering dust for years in obscure ethnographic museums remain rather mysterious. African sculpture was not envisioned then, that is to say at the time of the Fauves, as a direct message from the Barbarian World. Painters, and you yourself, dear friend, found therein constructive principles that were adequate to your own needs and concerns. Negro art erupted in France because it corresponded to a preexisting expressive desire. Doubtless, Derain needed to undergo the enchantment, the magical power of the ritual dance masks. But Picasso, that rationalist painter who opposes spirit with reason, was interested in exploiting only its plastic quality, only the geometry of African statues. Negro art acted like a call from the dark continent, like a reaction against classical norms, after the conclusion of the Treaty of Versailles. Ten years later, however, this tonic has become a solvent. To what kind of collective psychosis may we attribute this new attitude of a whole society before a form of artistic expression? Regression, displacement? Poets, dealers, and Surrealist painters speak of Negro sculpture the way Paul Gauguin spoke of Maori art. They ask these strange objects of sorcery to satisfy their "thirst for mystery." Their "will to hallucinate" is excited upon contact with these idols that were torn from the very heart of darkness.

This second wave of Negro art entirely falsified the sense of a style that was removed to a certain degree from scientific control and put into the service of fugitive passions. The fascinating attraction that the study of problems relating to Negro art exercised on the profane recalls in a way the excessive interest shown by the public in the doctrines of Bergson in the years before the war. Negro art (and Oceanian art) signify for the majority a mystery that is within the reach of all. The exclusive fascination of our generation for archaic and barbarian forms is not an effect of fashion. Rather, pessimism based on masochism, a secret desire to humiliate the human being and to degrade him to the level of a reptile, a taste for escape, a latent search for a diversion from and compensation for Taylorized[3] and rationalized "positive" life find a normal outlet, an opening up in all these manifestations of primitive thought. (For Taine, the art of an epoch is the immediate reflection of the milieu and the moment. For Freud, art expresses all the organic aspirations of an epoch even when it seems to controvert them. Therefore, a purely materialist epoch severed from the ideal can generate an idealist art.) I no more blame than praise this frame of mind. I remark it and try to explain it. I know that it would be puerile to confuse Negro art with Oceanian art, to deny the contribution of Pre-Columbian art, to question the intrinsic value of prehistoric art, to relegate the drawings of the insane merely to clinical evidence, to smile, as did our fathers, at the summary graffiti of children. I realize that it would occur to no one to place the "Hell" of the old Royal Library of Paris (now the Bibliothèque Nationale) and the Gallery of Monsters of the Dupuytren Museum on the same level. Nevertheless, in certain periodicals I

come across a conscious and premeditated juxtaposition of "phenomena," "freaks of nature," classical works, and contemporary works, presented as irradiations, as secrets too long repressed, as Freudian complexes, translated into a verbal or pictorial language composed of negatives and multiple exposures. Pathology and archaeology become allies, it seems, to preach to a public entirely won over to their cause. Men find that which they seek. Exploration is not a mechanical and disinterested enterprise. If so many unknown idols have been dug up in recent years, it is because the diggers themselves are idolaters. Now this cult sworn to barbarity, this return to a primal age of civilization, has become a pedagogical exercise. The "Modern Fantastic," dear to our sweet Aragon, is a leper, an excrescence of flesh. I vomit up your mysteries. My aspiration is toward clarity. Negro art and Oceanian art have become the prey of "avant-garde" poets, married, sterilized, and converted into collector-specialists. The mission of these arts seems to have come full circle, so that the exhibition at the Galerie Pigalle will not exercise any stronger influence on current painting than the retrospective of French porcelain at the Marsan Pavilion.

Does this mean that Negro art is going into a period of eclipse? It seems to us, on the contrary, that this art has acquired a new meaning. Negro art is ready for a museum of comparative sculpture. It is ready for the Louvre. But Negro art must be envisaged from the point of view of formal perfection. If the Gabonese mark its apogee, it is because they mark its highest degree of mastery, of civilization. Let's sum things up: young people who have put works by Prinzhorn behind them, who have transcended the intermediary phase of Freudian conformism (dixit Em. Berl),[4] those who have absorbed innumerable works on the indigenous arts of Africa, including those of Leo Frobenius, are asking the Negroes for a lesson in the science of sculpture and not at all a lesson in imbecility. Those young people will love African art to the degree that it represents a superior state of civilization, a state of universality, and not to the degree that it is exotic and "savage."

There are three attitudes and three positions to take before the "problem of modern painting." There are those who are still in the process of getting past snobbery. The people associated with the rue de la Boetie[5] (God willing, they'll recognize themselves here) have not really lived out the drama raised by the works of Picasso. They never really believed in him. They crossed a wild river while their hearts and their feet remain dry. The mediocrities, those prudent moderates who dare think of themselves as the grandsons of Homais and Prudhomme, are living cadavers, so little . . . alive. They defend the imprescriptable rights of Latinity against the Jewish-German spirit, just as Mr. de Waleffe defends short trousers against the masculine fashions that have been imported from England. They love the Greek. They always loved it and treated it as a model. These fossils have understood only the letter of contemporary art and of Greek art.

There are those who occupy a middle position, who are *up to date,*[6] as Jacques-Émile Blanche says—that despiser of primitive intelligence, that French satirist of vintage quality whose precise sense of ridicule at times approaches divination. These middle people approve of, on the one hand, the barbarous arts, and on the other, all the current forms that accord a primordial value to "occult" factors in the subconscious. They make their own all the imperatives of modern aesthetics. Their heads are stuffed with art criticism. They know that a painted work is only a "surface covered with colors" and that a sculpture is an "artistic fact."

Dealers, patrons, or dilettantes, they roar with laughter when their friends ask them "what a statue or canvas is supposed to represent." They know, from birth, that a work of art is an end in itself, a plastic organism, a microcosm of the world. They believe in the great genius of the Master, the King of Kings, of "the greatest painter that Europe has known since the Renaissance" (authentic). They are slaves to his renown. They love art and cannot do without the "modern." They have won in battle the right to be called revolutionaries and pass for the same. They set up house in the revolution. Sometimes they take a little nap there. But at the slightest alarm, they leap up to wave their flag and their incendiary torches, those toys that impress no one. These retired veterans of bloody battle have used up all their power to shock. In their publications they vainly associate "the most modern work" with those of the most elegant epochs of the past.

Vainly they call Han art stubborn, decadent, which they then oppose to Zhou art, and pre-Zhou. The sensibility of our contemporaries is far too jaded for any form, however extreme it may be, to scandalize them or to seem subversive.

Then there are those who have rounded the cape of avant-garde snobbery. We'll get to them later.

When does modern art start? Or more exactly: *When starts the modernism?*[7] This question returns incessantly in the Anglo-American reviews. Some date modern art from Goya y Lucientes, others from Edouard Manet. Others think it was really born with the Master of Aix, or even with "Fauvism."

I reply: What is the date of this chimera that is the simplistic concept of a "modern" plastic art as distinct from an "ancient" one? I reply: Modern art, never heard of it [*connais pas*].[8] There is no modern art. There is no break in continuity between past, present, and future. Painters, critics, and collectors are the only ones who feel an irresistible need to believe in the myth of the revolution carried out by our era.

History repeats itself. But our contemporaries who hear themselves repeating for a half-century that you have to be of your time have lost, by way of "modernism," the sense of eternity, of the harmonious continuity of facts.

Enough of middling Cubism, or Cubist exegesis. A German professor one day suggested to us the following research subject. Analyze the plastic concep-

tion of angels, archangels, and heavenly messengers in the art of Northern countries in the fifteenth century. Our modern aristarchs tackle more difficult notions and thornier problems. They research, among other peccadilloes, the problem of the dissociation of color, matter, and form in Cubist painting between 1910 and 1914. While the University, under the impetus of Henri Focillon, that unquestionable master of Art History, is throwing off the yoke of the academic and university mind, pedantry invades "modern" criticism and aesthetics. André Salmon, who is supposed to be anticonformist, congratulates one of his grave colleagues for speaking of living art just as savants speak of art of the past; that is, with the intention of instructing (read: boring) his peers.

A tenth-rate poet and improvised critic comments on a little exhibition and discovers the source of the difference between the "collages" of Braque and those of Joan Miró. The young man forgets to identify the mistresses of these Misters!

The question of precedence plays a capital role in the history of Cubism. Everyone claims to have discovered the polyhedral form before anyone else. While X likes to brag: "Y was still working completely in Impressionism, but I was already handling my volumes like diamond facets."

Contemporary French painting has grown and ripened in a hostile ambiance. This ambiance is henceforth a myth. The "moderns" currently dispose of a technical and aesthetic toolbox, of means of moral and material pressure and penetration so powerful, so active, that they win out easily over their sworn enemies. But who are these moderns, where are they going, where are they coming from? What is their reason for being? What goal are they striving for? The geometric style that was pilloried by the defenders of an obsolete tradition has died a beautiful death after having disfigured Paris and the French provinces—that oasis. This style spared only the United Kingdom. The style of notation and recording of dreams, of the "immediate data of consciousness," whose supreme expression is micrography and radiography, *subverted from their necessity,* has aged more rapidly than Rops and Moreau. An export commodity, the art called Surrealist finds a last refuge on foreign soil, notably in Belgium. The return to the object, *Neue Sachlichkeit,* that is to say the film close-up transposed into painting, the utilization of documentary films, the blind worship of technology, the constructive spirit of Dessau's Bauhaus, the modern Academy that in Germany defends a hygienic, puritan, fearless, remorseless aesthetics, have all come to nothing. The new painting and architecture, which have evolved under the malevolent sign of geometry, have been emptied of all metaphysical substance. Mass hysteria, on the other hand, is doing very well.

Touring Greece, Drieu la Rochelle's characters go straight to Delphi, bypassing the Acropolis. The Parthenon represents for these men, in the same sense as Versailles does, a dead civilization. The Greece of Pericles and the French Great Century inspire no respect in them.

"What difference does it make to me," says one of their number, "not to have

seen the Parthenon? It is the masterpiece of another one of those Great Centuries. The fifth century before Christ is just like the seventeenth century: the Parthenon is Versailles. Today, what lesson does Versailles have to teach us? We are becoming Barbarians again, addicted to new and unknown forms; so, what attracts us in History are its first stirrings."

Consciously or perhaps quite unconsciously, Drieu la Rochelle puts his finger in the wound. We are barbarians, proud above all of our barbarity. Such is the maxim of most of my contemporaries. (Those who defend "civilization" are mere robots who recite formulas.)

Nevertheless, the attitude of the young generation that is rediscovering Greece and Italy bears witness to a will, on one hand, to react against the devotional cult of savage arts, of the instinctive, subterranean life of primitiveness; and on the other hand, to cause a profound revision of the great classical values, that is to say to tear Raphael and Poussin, Phidias and Praxitiles, from under the shameful and degrading wing of the schools and academies.

To the arbitrary cult of distortion the young men of today are opposing the cult of abstract beauty. These young people are turning their backs on the Abbé Jousse. They doubt the efficiency of an exclusively sensorial, visual civilization. They have lost faith in salvation through the return to infantile Dada. They tend more and more to lean toward the epochs of high, grand culture. They scorn the puerile fetishism of avant-garde aesthetes for whom no work of art is archaic, rudimentary, bizarre, and awkward enough. The effigies of cruel Aztec gods, collections of Oceanian idols, popular images, and the drawings of the insane have yielded in young ateliers to the *Defeat of Chosroes,* by Piero della Francesca. This insignificant fact—at least apparently it is—says a lot about the taste of the artists who represent the future.

But it would be a mistake to think that the return to Rome and Greece, those strongholds of humanism, corresponds to a vague nostalgia for equilibrium and serenity. Athens and Italy mean, not the canon, the rule, the norm, the law, and the spirit of moderation, beautiful proportion, and *joie de vivre,* but the triumph of human intelligence, of the mystery in the full light of day, of the dream the wakeful dreamer has, a purely metaphysical hallucination. The professors at the École des Beaux-Arts will never understand what kind of resonance the *Venus de Milo* wakens in us. If we venerate this decried statue more than the Afghan gods described in *Documents* (Number 2, February 1930), it is because she is more abstract and more universal. The architecture of the divine Palladio affords us the same order of emotion. We find therein an exacting will to speak to the spirit, to transcend the stage of physical beauty or ugliness, to create a fiction, an active and intellectual illumination, to know how to sacrifice chaos and the infinite to the module proportion, to a preconceived rhythm, to know how to choose, to understand everything and to be understood, to impose a limit, to put a brake on one's passions. René Huyghe finds in this tendency a triumph of

the creative essence: quality of the creative essence, its intensity, ecstasy, and diffused force. The young French generation is restoring to the king of creation his sense of dignity. It cannot resign itself to putting man on the same level as the animal, even if this animal is a totemic emblem. It humanizes beasts and objects. It gives man back his rights and his sovereignty. Such a generation—isn't it so, my dear Paul Guillaume—can turn only toward the world of Antiquity.

NOTES

1. [The first line of Mallarmé's *Tombeau d'Edgar Poe.* Eds.]

2. [Probably François Mauriac. Eds.]

3. [Frederick W. Taylor (1856–1915), the inventor and engineer known as the father of scientific management, who introduced time and efficiency studies into modern industrial production, which greatly affected assembly-line techniques. Eds.]

4. [Emanuel Berl (1892–1976) wrote about the spiritual decadence of the bourgeoisie. Eds.]

5. [*Boeotians* in the original; also skeptics. Eds.]

6. [In English in the original. Eds.]

7. [In English in the original. Eds.]

8. [An echo of Picasso's 1920 disavowal of African art; see p. 131 above. Eds.]

G. H. LUQUET

PRIMITIVE ART · 1930

FROM INTRODUCTION

Having defined in what sense we understand the word *art* and its different modalities, let us be clear about what we understand by the concept of primitive art. In current usage this term is equivalent to the art of primitives. The word *primitive* itself has been given two meanings, which have only their pejorative connotation in common. In ethnography it vaguely indicates "savages," with whom we also associate prehistoric men, which is simply to say that one makes an abstraction out of the instinctive prejudice that inclines us to consider civilizations different from our own, human collectivities that are extremely far from us in space or time, as inferior. The meaning that the word *primitive* has acquired in the history of European art is already a little more objective, for it expresses not *only* the notion that artists we apply the label to are not as good as their successors, but also that they prepared the way for them. But even here "primitive" corresponds only to a chronological anteriority that is purely relative. For us, the expression "primitive art" must suggest something positive, incontestable, purely chronological, applying to a kind of art that in fact appeared before the others.

Now there is one domain where we may notice a chronological succession of art forms; that is, in the individual development of the civilized person of today. Any individual, whether or not he later acquires either an amateur or professional artistic development, will conceive figurative drawing successively in two ways. These two ways are not only different but even opposites, which we will characterize by the names *intellectual realism* and *visual realism*. In today's civilized individual, intellectual realism is the primitive form of art.

We cannot compare this very limited evolution of a present-day individual to the evolution of humanity through the ages and around the globe, which obviously does not represent a unique and continuous progress. All the same, in milieus more or less tightly circumscribed in space and time, and which constitute to a certain extent closed systems, we may remark a succession of conceptions of figurative art like that which is produced in a civilized contemporary in the course of his individual existence. Diverse authors, in particular K. Lamprecht,

Excerpt from *L'Art primitif* (1930), 4–7, 9, 10–12, 66–67, 252.

The philosopher and psychologist G. H. Luquet (1876–1965) wrote extensively on prehistoric art, Primitive art, and children's art. At the time he wrote this book, he had already published *L'Art et la religion des hommes fossiles* (1926), *L'Art néo-calédonien* (1926), and *Le Dessin enfantin* (1927).

have thought themselves capable of transposing to art, and especially to drawing, the *biogenetic principle* of Fr. Müller, according to which the development of the individual recapitulates the evolution of the species; and which A. Comte in his *law of three states* also applied to mental and, in particular, intellectual evolution. It is not for me to judge this notion, which seems to me to have been challenged by progress in biology, from a morphological point of view; but as concerns its application to figurative art, I will present my ideas about how it should be understood if we insist on holding on to it. It is by no means sure, it is even very improbable, that figurative art exists in all human milieus or is practiced by all individuals even in the milieus that have it. But in all individuals where it exists, it seems that its development has followed an identical course. This development includes a series of successive phases. One person may stop sooner than another in the series, and not attain the highest levels, if only because of a premature death; but no individual arrives at a later stage without having gone through the earlier ones.

This being the case, since the conception of figurative art that a present-day civilized individual has in his childhood and the forms that result from it represent, in a purely objective and chronological sense, the primitive form of art for this individual, it is legitimate to call all art "primitive," at whatever point in time or space it is found, to the extent that it presents the same traits as children's drawing. Conversely, it is legitimate to consider children's drawing as simply a particular example of primitive art as we have defined it.

You should not be surprised therefore to see us assemble under the same concept of primitive art works that emanate from artists as dissimilar as, for example, Stone Age Europeans, Greek ceramists of the sixth century before Christ, the painters of the Quattrocento, the Melanesians, the Redskins, the Eskimos, etc. In classing things in this way we are taking account of two factors. The first is that these artists, whatever the differences in their milieus and in their technical skill from a purely artistic point of view, obey, as far as figurative art is concerned, a conception that is common to them and is opposed to that of present-day civilized adults; in the same way that a physicist gathers materials as different as copper, acidulous water, and humid air under the same concept of an electrical conductor. The second factor is that for the civilized individual of today this conception of drawing and of figurative art generally, which characterizes the age of childhood, chronologically precedes the idea that the same individual will have of it as an adult and is gradually replaced by it in the course of his existence.

The preceding considerations apply exclusively to figurative art. In fact, to obtain an objective definition of primitive art, we have had to resort to the spontaneous drawing of the child (we would like to state once and for all, in the interest of brevity, that we mean the civilized child of today). Now, spontaneously, the child has no taste for geometric art and is even resistant to sugges-

tions that try to interest him in it. Likewise, it is only after childhood proper, and as a result of instruction, often even a specialized instruction for professional purposes, that our contemporaries apply themselves to decorative art. The criterion that we have called upon to define primitive art is consequently inapplicable to geometric art and to ornamental art. We will limit ourselves therefore in this book to the study of figurative art, which furthermore can easily furnish us enough matter by itself. Borrowing our materials not only from independent art—the only kind children create—but also from decorative art when it uses figurative motifs, we will attempt to isolate those tendencies which guide the primitive artist in his efforts to attain the goal of figurative art, that is to say, to create images of real beings or objects that he considers to be good likenesses.

FROM CHAPTER I: THE ORIGINS OF FIGURATIVE ART

Art exists only through works of art, and works of art exist only through artists. The birth of figurative art for a given individual is the voluntary production by this individual of his very first figurative work; the birth of art for humanity merges with the production of the first figurative work of art of the most ancient artist.

[A brief consideration of prehistoric art is omitted.]

It is the same for the ethnographic documents on which we depended, because no better sources of information were available, when attempts were first made to substitute an objective study of the question for *a priori* speculations about it. In effect, these art works, which travelers can acquire and on occasion can watch being created, are made by adults, who in all likelihood have already made others; which accordingly do not represent an initiation into art for these artists. All the more reason that they do not represent a beginning for the population to which they belong. Even when we are confronted by works that are of a certain antiquity, their age, even in simply relative terms, is generally indeterminable, and it is possible, even probable, that they were preceded by other works which have disappeared.

Once the appearance of figurative art is noted, in the development either of an individual or of humanity, a question arises as to its origin. This question can be formulated as: How could an individual who has never executed any figurative work have formed an intention to produce one?

This question can be answered objectively in respect to children's drawings. In fact, directly observing a child allows us not only to witness the execution of his first figurative drawing, but also to take account of what occurred in his life before that drawing was done and to note how it originated.

Obviously, it is impossible to obtain such reliable results for the origins of figurative art with regard to humanity in general. The first artist cannot be observed; we possess only a limited number of works, whose creators are un-

known, and it is not possible, as it is for the child, to reconstruct their psychic process on the basis of overt or implied statements. Furthermore, it is not permissible to transfer to the first hypothetical artist, by analogy, conclusions that seem legitimate for a real child. The child is in a situation not only different from but even contrary to the ancient one that interests us; notably, the child has come from a long line of forebears, many of whom must have done drawings; his parents might have started him off and shown him how to draw.

But it just so happens that by a lucky chance the observation of children of today seems to establish, as we shall see, that heredity, suggestion, and example exert no appreciable influence on them, and that each child reinvents figurative drawing on his own, as if he were the first draftsman. Furthermore, concrete evidence supports the conjecture that art began with the people of the Aurignacian period in the same manner as with our children. It is therefore reasonable, at least as a working hypothesis, to study first of all the origins of figurative art in children's drawings and afterward to pursue research into whether the beginnings of Aurignacian art reveal an analogous genesis.

We can first of all establish that for a given individual, whether that person be the first artist or today's child, figurative art proper or the voluntary execution of images of real objects necessarily had to be preceded by a phase in which images were produced, certainly, but by chance and not intentionally.

The intentional execution of a figurative work, like any voluntary act, supposes two preconditions. One is affective: the desire to execute the work—in other words, the expectation of an advantage and in the end the pleasure resulting directly or indirectly from its accomplishment. The other is intellectual: the very idea of the accomplishment, the representation of the act as purely within the realm of possibility (for we surely need to represent what we want if we want something).

FROM CHAPTER II: INTELLECTUAL REALISM

In attempting a definition of primitive art that maintains its chronological meaning, which alone is exempt from subjective judgments, we have decided on the following: *Primitive art is that which, whatever the age and milieu of the artist, is guided in the rendering of forms by the same conception of figurative art and thus of resemblance that guides our children's art, insofar as they draw in their own way, which is different from the style of the adults they will become.*

Once this abstract definition of primitive art has been stated, it should be stressed that this is no arbitrary construction, but corresponds to reality. The clearest and most convincing procedure seemed to us to be the following. After isolating the common features that link the characteristics of figurative art, and especially of drawing by civilized adults, we will examine the features that are different. Then we will take account of the presence of these new features, sometimes in representations of the same object or of the same scenes, in the

drawings of our children and in the works of adults that come from the most diverse milieus in time and space.

The characteristics that distinguish primitive art from the art of civilized adults can be seen in the representation either of static tableaux, of objects or groups of objects at a unique moment, or of moving scenes, those that include a succession of moments. First of all, let us examine the representation of static tableaux; the representation of moving scenes will occupy us in the following chapter.

Among even the most diverse artists, figurative art intends to be realistic, since its goal is to create images that resemble real objects, or, secondarily, objects imagined on the basis of real ones. The figurative art of the child and of the primitive has the same realist purpose as that of the civilized adult, differing only in its conception of realism, or in other words of resemblance. An image is a resemblance for an adult when it reproduces *what his eye sees of [the object];* for a primitive, when it translates *what his mind knows of it.* We can express both the common and the distinctive characteristics of these two sorts of figurative art by calling the first a *visual realism* and the second an *intellectual realism.*

For reasons that we will explain later, in sculpture or three-dimensional art these two kinds of realism most often produce similar effects, so that it is usually impossible to decide if a sculpture derives from one or the other. Therefore we will apply these concepts mainly to drawing, understood in the larger sense that has been described in the introduction, meaning art of only two dimensions or, according to the German expression, flat art. For intellectual realism, the purpose of a drawing is to describe in lines the figured object, just as language would describe it in words. The representation in the drawing of a specific aspect of the model is a sort of graphic proposition that could be enunciated verbally: that object possesses this character. . . .

In conclusion, the facts have brought us face-to-face with two antithetical conceptions of figurative art. One bases its representations of things on visual realism, and its representations of narratives on its corollary, the symbolic type of graphic narration; this is the classical art of civilized adults. The other conception, which is manifested both in our children and in adults from various milieus, bases its representation of things on intellectual realism, and for narrative it uses a successive type, as in Epinal images.[1] Because this second type of figurative art is what our children start with, tending to replace it gradually with the first type as they grow older, and because many adults have not gone beyond it, it well deserves the name of primitive art.

NOTE

1. [Inexpensive woodcut prints, colored by hand or stencil. These prints were popular in French provincial towns and take their name from the French city Epinal, where prints are still made. Eds.]

GEORGES BATAILLE

PRIMITIVE ART · 1930

"The classical art of civilized adults," G. H. Luquet writes in the conclusion of the volume that he has just devoted to "primitive art," "is not at all as aesthetics has long conceived it to be, the only possible form of figurative art. In fact, there is another kind, characterized by differing and opposing tendencies. We encounter it at the same time in children and adults, even among professionals, and in the numerous and varied human milieus that prehistory, history, and ethnography have informed us about. It is legitimate to assemble in the same genre these artistic productions, which share a common quality of opposition to the art of civilized adults, under the name of primitive art. Taking into consideration the age of the artists, we can distinguish within this genre between two categories, child art and the primitive art of adults, but these two types are in every way identical." It is unquestionably difficult today to assent to such bold propositions on first hearing them. A separation of art forms into two basic categories set in opposition to each other risks seeming all the more arbitrary because the parallel between children and savages belongs today to the detective novel. The times are past when a formula like "ontogeny recapitulates phylogeny" seemed to solve all the problems presented by the study of evolution. We must admit nevertheless that the affirmations of Mr. Luquet do not proceed from an arbitrarily placed confidence in a formula that is scorned today, but from the analysis of a great many facts.

Mr. Luquet has based his reconstitution of the "origins of figurative art" in the distant Aurignacian epoch on the minute observation of children. "Observation of children of today," he writes, "seems to establish . . . that heredity, suggestion, and example exert no appreciable influence on them, and that each child reinvents figurative drawing on his own as if he were the first draftsman." But the author has to admit that the child finds himself from the beginning in the presence of figurative representations, to which he generally attributes the same degree of reality as he does to the real objects around him. However, a

Documents 7 (1930): 389–97. © Gallimard, 1970.

The French librarian, writer, and poet Georges Bataille (1897–1962) here reviews Luquet's *L'Art primitif* (p. 219 above). Bataille was the founder, editor, and publisher of *Documents,* and until his falling-out with André Breton had been loosely associated with the Surrealists. He was especially fascinated by eroticism, mysticism, and the irrational. The reader will note that Bataille's essay discusses some aspects of Luquet's book that are not included in the excerpt from it given above.

factor independent of the will to figuration can easily be identified: children in particular (but here I suppose we must also interject certain cases concerning grownups as well) go so far as to dip their fingers purposely into coloring substances, such as cans of paint, in order to leave traces of themselves by wiping their fingers on walls, doors, etc. Such markings do not seem to me, as they do to Mr. Luquet, to be fully "capable of explanation as mechanical affirmations of the personality of their authors." In so arguing, Mr. Luquet relates such actions to one of the rare means children have of asserting their personalities, along with the destruction of objects, and the exploits of "smash-everything kids," a relationship whose validity will be further insisted on later.

Mr. Luquet's analysis is unquestionably very satisfying. The drawings of children, considered in their most elementary form, have nothing to do with the figurative representations that they are already acquainted with and that they suppose only adults are capable of creating. But the scribblings they are eager to cover blank paper with (when they begin these exercises, without any premeditation) can by chance suggest resemblances to them, mostly quite arbitrary ones. Three crossed sticks are seen as a windmill, a broken line as a whip with its lash, etc. The resemblance is sometimes slightly accentuated by a few very simple additions, such as an eye for a bear, or a beak for a bird. Afterwards these "fortuitous images" can be repeated at will.

Mr. Luquet then cites the rather formless drawings of the early Aurignacian period which seemed to be the result of "finger painting, sometimes confused, crossing every which way, sometimes forming quite regular patterns of straight parallel lines, either horizontal or vertical"; in addition, "analogous marks but with longer, more sinuous and complicated lines . . . more likely to give rise to a figurative interpretation. We end up eventually with animal drawing, still done in a very rough manner, but already recognizable, from those of Clotilde de Santa Isabel, Quintanal, and Hornos, to those of Gargas, a little finer, all of them drawn on clay, but with a single finger, with resemblances that it seems difficult to regard as merely accidental and unpremeditated."

All the same, the author of *Primitive Art* feels it necessary to add a hypothesis that is complementary to this interpretation: "It is quite possible," he says, "that for the Aurignacians, as with our children, artistic creation might have consisted from the beginning not of the execution of a complete figure on an entirely blank surface, but rather of the substantially easier and psychologically simpler operation of improving a resemblance in images done by others. The child perfects, in this way, not only his own fortuitous drawings, but also the productions of others, and even of natural accidents."

Mr. Luquet cites a certain number of representations dating from the Aurignacian period that must have resulted from processes of the same kind.

Up to this point, the argument focuses on the origins and not on the constituent elements of "primitive art." Hence it is with the intention of applying

his analysis to these elements that Mr. Luquet proposes the following general definition, which he italicizes: "*Primitive art,*" we are supposed to believe, "*is that which, whatever the age and milieu of the artist, is guided in the rendering of forms by the same conception of figurative art and thus of resemblance that guides our children's art, insofar as they draw in their own way, which is different from the style of the adults they will become.*"

"An image is a resemblance for an adult when it reproduces *what his eye sees of [the object];* for a primitive, when it translates *what his mind knows of it.* We can express both the common and the distinctive characteristics of these two sorts of figurative art by calling the first a *visual realism* and the second an *intellectual realism.*" In *intellectual realism,* "the drawing contains elements of the model that are invisible, but which the artist thinks indispensable; conversely, he ignores aspects of the model that are clearly visible but of no interest to the artist."

In close to two hundred pages Mr. Luquet accumulates a considerable number of examples, borrowed from children's art or that of savage peoples, from so-called popular arts (Epinal images, graffiti, etc.), sometimes even from prehistoric arts. He shows thereby that these different kinds of art have in common traits such as the representation of two eyes or two ears in profile; the distortion of the size of the paws, horns, or ears; transparency of the sea or of a house or an egg, allowing us to see within it the fish, the inhabitants, or the bird; or the dynamic arrangement in a figurative representation of elements that create the impression of the passage of time.

It seems to me difficult to deny that this conception of *intellectual realism* is far less interesting than the analysis of origins. Mr. Luquet deals only summarily with the difficulties for his theory that would result from an examination of sculpted objects: "In sculpture or three-dimensional art these two kinds of realism [intellectual and visual] most often produce similar effects, so that it is usually impossible to decide if a sculpture derives from one or the other." It might make more sense to recognize that a category such as Mr. Luquet's *intellectual realism* may be of use in classifying different works of graphic art but that it is *essentially* inapplicable to sculpture. On a sculpted object there can be no occasion for representing two eyes on the same profile of a figure! Transparency is impossible, and the arrangements of elements that would suggest successive moments in time would be a factor only in very rare instances. And we hardly need mention that a general conception of figurative art is devoid of all interest unless it can be applied to all types.

I will add that the author has regrettably omitted another important issue.

Mr. Luquet has himself acknowledged in *The Art and Religion of Fossil Man* (1926) that the art of the epoch of the reindeer, although it presents certain characteristics that correspond to *intellectual realism,* is a matter incontestably of *visual realism.* Animal representations from this epoch are so well known that it is necessary to insist on this point. It seems therefore that the Aurignacians had

passed practically without transition from the phase of origins to the phase represented by the art of civilized peoples. Therefore primitive art would have been unknown to the first men who made what we today call a *work of art*.

This at least seems to be the case if we follow Mr. Luquet's theory. Besides these knowledgeably elaborated conceptions, a much coarser point of view is possible, namely that art that is pejoratively called *primitive* should rather be described in terms of the *transformation*[1] of the forms presented. Such an art has existed, with easily identifiable characteristics, from the very beginning, *but that gross and deforming art was one reserved for the representation of the human form*. To tell the truth, I am astonished that anyone who is attempting to define a kind of art which is different from that which is traditional in Europe would not have been struck at once by the obvious and even shocking duality at the very origins of figurative representation. Reindeer, bison, or horses are represented with such precise detail that if we had equally careful images of the men themselves, the strangest period of human avatars would no longer be the most inaccessible. But the drawings and sculptures which were supposed to represent the Aurignacians are almost all very unformed and *much less human* than those that represent animals; others such as the Hottentot Venus are ignoble caricatures of the human form. This contradiction persists into the Magdalenian period.

It is regrettable that this *willed* alteration of forms is unaccounted for in Mr. Luquet's definitions.

I do not claim to account for this categorical duality entirely, from the beginning. I do not think it is much more mysterious than many others, but for the moment I will limit myself to indicating how this problem might be dealt with.

Whatever the impasse into which Mr. Luquet seems to have fallen, in my opinion his work supplies important data, at least concerning the origin of figurative representation. The dirty hands wiped across walls, or the scribblings in which he sees the origin of children's drawing, are not only "mechanical affirmations of the personality of their authors." Without being insistent enough about it, Mr. Luquet has linked these actions to the destruction of objects by children. It is very interesting to note that in these different cases it is always a matter of the *transformation* of objects, whether the object be a wall, a sheet of paper, or a toy. Personally, I remember having practiced such scrawls: I spent a whole school year smearing the suit of the student in front of me with ink from my inkwell. I can have no illusions today about the feeling that led me to do this. The resulting fuss ended a state of bliss of the most dubious sort. Later I practiced a finer kind of drawing, ceaselessly inventing more or less comical profiles, but it was not just anytime and on any paper. Sometimes I was supposed to compose an assignment on a sheet of paper, sometimes I was supposed to copy the teacher's dictation into a notebook. I have no doubt but that I thereby recreated the normal conditions of graphic art. It is a matter above all of *transforming* what is at hand. During early childhood the first sheet of paper that

Figure 24. Abyssinian children's graffiti collected by Marcel Griaule from the churches of Godjam.

comes along, which you fill with dirty scribbling, does just fine. But it is possible to become more demanding as you grow older. I can think of no better example than that of the Abyssinian children, some of whose graffiti are published here. Abyssinian children who manifest this drawing mania do it only on columns or church doors. They are punished whenever they are caught red handed; nevertheless, the lower parts of the churches are covered with their bizarre lucubrations.[2]

It is true that the principal *transformation* is not on the surface on which the drawing is made. The drawing itself develops and is repeated in different versions, as the representation of the object becomes more and more deformed. This evolution is easy to follow, starting with some scribbles. Chance isolates a visual resemblance from a few strange lines that can be fixed through repetition. This phase represents a kind of second degree of the *transformation*; that is to say, that the altered object (paper or wall) is transformed to the point where it be-

comes a new object, a horse, a head, a man. Finally, by dint of repetition, this new object is itself altered by a series of deformations. Art, since that is incontestably what it is, proceeds in this sense through successive destructions. Therefore, insofar as art liberates *libidinous* instincts, these instincts are sadistic.

All the same, another outlet is offered for figurative representation from the moment when imagination substitutes a new object for the one that has been destroyed. Instead of behaving towards the new object in the same way as towards the preceding one, it is possible, in the course of repetition, to subject it to a progressive appropriation compared to the represented original. By this means we pass, for example, quite rapidly from an approximate figuration to an image that looks increasingly like an animal. What is at stake here is then a true change of meaning from the beginning of the evolution of the image. We will limit ourselves to remarking for the moment that this is the kind of change in meaning that occurred starting with the Aurignacian, as far as the representation of animals is concerned, but not the representation of humans. This does not happen in the drawings of most children, where you have to allow for their desire to alter the forms to the point of making them laughable; nor does it occur in the art of many of the savages of today. On the other hand, a change in the opposite direction has taken place in our time in the figurative arts: they have quite suddenly undergone a process of decomposition and destruction that was almost as painful to many people as the sight of the decomposition and destruction of a cadaver would be. But of course the conception of Mr. Luquet can no more explain this modern form of representation than it can account for sculpture in general; for although this putrefied painting transforms objects with an unprecedented violence, it does not manifest the qualities of intellectual realism to any significant degree.

However that may be, we have seen how the work of Mr. Luquet, collected in the volume that he has just devoted to Primitive art, makes a considerable contribution to our notions about the origin and even the meaning of figuration. On this issue, the opinions of Mr. Luquet represent a positive resource, difficult to discount, whatever doubt may be attached to the conceptions that relate individual to historical evolution. These opinions need to be developed only in the sense that they do not allow a sufficient role for psychological factors. These factors are very readily observed in children, whereas our information on prehistoric man remains quite limited. But it is not at all helpful to claim that the development could have occurred prehistorically in the same way that it now occurs in children. It should be enough, for the present, to observe in both cases the result of the psychological factor that has been isolated, meaning the transformation of forms. Only the different treatment of men and animals will be able to supply psychological indications concerning prehistory; but I doubt that the analysis of this difference will afford sufficient results.

NOTES

1. The term *transformation* is doubly pertinent in expressing a partial decomposition analogous to that of cadavers and at the same time the passage to a completely heterogeneous state of being corresponding to what the German Protestant Professor Otto calls the *completely other,* that is to say, the sacred, as manifested for example in a ghost (cf. R. Otto, *Le Sacré,* trans. A. Jundt, Paris: Payot, 1929 [*The Idea of the Holy,* trans. John W. Harvey, London and New York, 1923]).

2. These admirable *graffiti* were collected by Marcel Griaule, from the churches of Godjam, during his recent sojourn there. Mr. Griaule has collected not less than 500, which he plans to publish in the near future. Children draw them during services and seem to prefer forms that are susceptible to several interpretations, like a pun.

JOHN SLOAN AND OLIVER LAFARGE

INTRODUCTION TO
AMERICAN INDIAN ART · 1931

The American Indian race possesses an innate talent in the fine and applied arts. The Indian is a born artist; possessing a capacity for discipline and careful work, and a fine sense of line and rhythm, which seems to be inherent in the Mongoloid peoples. He has evolved for himself during many thousand years a form and content peculiarly his own. We white Americans have been painfully slow to realize the Indian's value to us and to the world as an independent artist, although his work has already won recognition abroad.

Our museums have collected Indian manufactures with scientific intent, placing as it were, the choice vase and the homely cooking pot side by side. Bound by the necessity of giving a whole picture they have not been able to set forth their many beautiful specimens in an advantageous manner.

The casual tourist who goes out to the Indian country likes to bring back some knickknack as a souvenir and proudly displays it as a "genuine Indian" article. Unhappily, Americans know the art of the Indian chiefly through such cheap curios made for the gullible white man. Looking upon the Indian himself as a curio, and with this cast of mind failing to recognize the high artistic value of the best Indian products, if indeed he ever sees them, the tourist will not pay the price which any craftsman must ask for the mere time, labour and materials involved in his work. Thus the whites have forced the Indians, often extremely poor and in need of money, to meet their demand for little, sweet-grass baskets, absurd bows and arrows, teapots, candlesticks, and any number of wretched souvenirs which they never made until white men decided that these, and these only, were "genuine Indian souvenirs."

It is a far cry, indeed, from such miserable knickknacks to the watercolours of young Pueblo Indian artists, reproduced in this book. To any sensitive person, it is obvious that on the basis of these alone, our "curio concept" of the American

Excerpt from *Introduction to American Indian Art to Accompany the First Exhibition of American Indian Art Selected Entirely with Consideration of Esthetic Value,* exh. cat. (Exposition of Indian Tribal Arts, 1931), 5, 7.

The American painter John Sloan (1871–1951) and the anthropologist Oliver LaFarge (1901–1963) organized this exhibition, which traveled throughout the United States for two years and was the first major U.S. exhibition to show Indian arts in an aesthetic context. This introduction seems to have been a collaboration, although Sloan apparently wrote the section on painting and the conclusion, while LaFarge wrote the section about Indian arts and crafts.

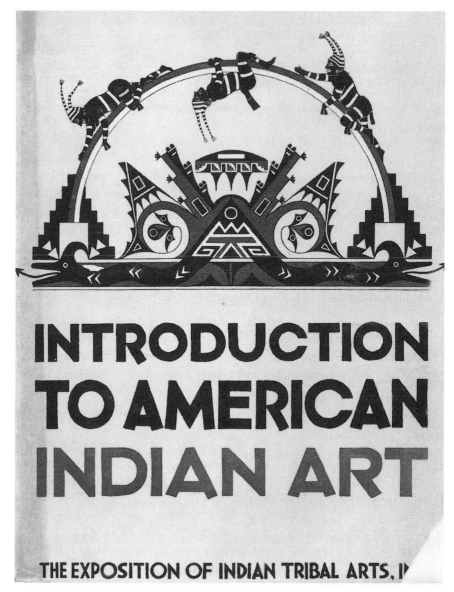

INTRODUCTION TO AMERICAN INDIAN ART

THE EXPOSITION OF INDIAN TRIBAL ARTS, I

Figure 25. Cover of *Introduction to American Indian Art*, exhibition catalogue (New York, 1931).

Indian must be revised. Here are young men steeped in an ancient tradition and discipline who, coming into contact with our pictorial art, have not copied it, but evolved for themselves from their own background new forms—different for each tribal or cultural group—as satisfactorily Indian as the beadwork or the silverwork which Sioux and Navajo evolved from similar contacts, a new force coming directly into our world of art.

In these pictures we see the object combined with the artist's subjective re-

232

sponse to it—a union of material and technique both symbolic and intelligible. These young Indians have applied to the painting of their pictures the discipline of line and colour developed through many centuries of decorating every imaginable object of daily or sacred use with designs innately suited to the objects decorated and charged with traditional cultural concepts. Simplicity, balance, rhythm, abstraction, an unequalled range of design elements, and virility, characterize the work of the Indian today.

The Indian artist deserves to be classed as a Modernist, his art is old, yet alive and dynamic; but his modernism is an expression of a continuing vigour seeking new outlets and not, like ours, a search for release from exhaustion. A realist, he does not confine his art to mere photographic impression, nor does he resort to meaningless geometric design. In his decorative realism he combines the elements of esthetic and intellectual appeal. He is a natural symbolist. He is bold and versatile in the use of line and colour. His work has a primitive directness and strength, yet at the same time it possesses sophistication and subtlety. Indian painting is at once classic and modern.

ECKART VON SYDOW

THE MEANING OF PRIMITIVE ART · 1932

When the art of the primitive peoples entered the sphere of scientific research, a tendency towards an inclusive interpretation prevailed. The reason might have been that the discovery occurred within the realm of German culture—e.g., within the realm of ideas where the tendency for vastly extensive, often purely speculative summary approaches was deeply rooted. There might have also been a wish to tone down that which was alien, at the beginning of this appearance of an almost incomprehensible art form. Be that as it may, Primitive art was—by and large—understood as a homogeneous whole and put in the context of the various other important intellectual, spiritual, and material factors that played a role in the lives of primitive peoples. Although this wide-ranging approach is appealing and interesting, it also creates difficulties.

In order to find a visible way to make sense of the chaos of Primitive art and to present a useful and persuasive explanation for both its peculiarity and the difference of its appearance, three major trends appeared consecutively. One of these explanations holds that it is possible to find an analogy between the art form and the economic system of a particular area. The second sees a parallel between the principles that underlie religious expressions and artistic forms. The third points to the predominance of sexuality in primitive cultures and believes to have found there the key to understanding.

The first theory, which related certain economic systems to certain art forms, is the oldest one. When Ernst Grosse, one of the very first researchers, began to deal with Primitive art and wrote his *Anfänge der Kunst* (*The Beginnings of Art,* 1894), the parallels between certain economic systems and art forms appeared to him so obvious that he believed he would be able to establish categorically that the art forms derived from the economic systems. The relationship would be set forth as follows: naturalism prevailed among hunting nomads, abstract art forms among crop farmers and cattle breeders. Grosse had one reason for this state-

"Sinndeutung der primitiven Kunst," in *Die Kunst der Naturvölker und der Vorzeit* (Berlin: Im Propyläen, 1932), 20–23.

The German art critic Eckart von Sydow (1885–1942) was one of the major German writers on prehistoric and Primitive art. This book was part of the prestigious Propyläen-Kunstgeschichte, a comprehensive series of scholarly books on the history of world art. It was first published in 1923 and dedicated to the German expressionist artist Karl Schmidt-Rottluff. The book went through several revisions (1927, 1932, 1938); this chapter was added in 1932.

ment, which convinced city dwellers: "A keen eye and dexterity are necessary for the naturalistic primitive sculptor, and a keen eye and dexterity are also indispensable for the life of the primitive hunter." Both of these skills, however, are of little importance for the crop farmer and the cattle breeder. This reasoning actually is incorrect, since anyone who has grown up in the countryside knows how well a shepherd or cowherd knows his animals. But the basic premise for this analysis is itself incorrect—as I have shown at length in my book *Primitive Kunst und Psychoanalyse* (*Primitive Art and Psychoanalysis,* 1927). The Eskimos took from the hunters and fishermen very expressive masks; the Bushmen took mostly imaginative coloring as well as very abstract portrayals of people; the Australians make often lavish petroglyphs with merely symbolic "representations" of natural forms; the Golds, a Siberian tribe of fishermen and cattle breeders, create extremely abstract symbols. On the other hand, so many instances of naturalistic style have been documented from farming societies that there cannot be any valid claim for anything close to a rule. However, there might be some truth to Grosse's thesis, which Herbert Kuhn dealt with in his *Kunst der Primitiven* (*The Art of Primitives,* 1923) at length. It may apply especially to architecture, whereas the fine arts don't have any fixed tie to the economy.

The unsolved problems of the materialistic theory of art history raise other issues. The close links between religion and artistic work, and the intensive impetus that artistic work often receives from religion, justifies the question: what kind of religiosity presents a parallel to artistic expression? In his book *Kunst und Religion der Naturvölker* (*Art and Religion of the Primitive Peoples,* 1926), Eckart von Sydow looked into the possible connections between these two areas. Here too, however, it becomes obvious that it is possible to talk about a parallelism between religious and artistic forms of expression only in a very limited way—even though one can see, for example, that the predominantly static character of African mythology, ancestor worship, the demonic, and sorcery are in keeping with the generally static character of African sculpture. Furthermore, the picturesque and dynamic art works of the South Seas are characterized by fluid and intensely decorative styles in areas that have mythologies. And finally, in North America myths and the demonic are formed analogously to the artistic production of the tribes. Nevertheless, one cannot deny that there are certain difficulties, which are analyzed in the above-mentioned book—for example, the contrast between the forcefulness of Indonesian myths and the weakness of the representations of their ancestors. Still, one may adhere to the basic idea that there is often an analogy of a general kind.

A third method of explanation is connected with the culture and philosophy of the time, where "life" is considered more important than moments that exist only in ideas and material things. Sexuality, the productive source of organic life, is the realm where the strongest contradiction to all logic and materialism is to be found. There are two studies that trace Primitive art back to human sexu-

ality. On the basis of his long missionary work in New Pomerania (Melanesia, South Seas), Peter Winthius tried to prove that primitive thinking is concerned most of all with sex. In his artistic work, the primitive person is mostly interested in expressing the sexual, the connection between the masculine and the feminine. Whatever is straight, stands for the male sexual organ; whatever is round, or sickle-shaped, stands for the female one. The final goal is to produce and depict two sexualities. Even in the ornaments of certain tribes of the South Seas and other regions, the basic thought is repeatedly to depict the *actus generationis,* preferably in permanency, so that the living being would be clearly formed in its dual sexuality. In the course of this train of thought, Winthius arrives at the point where he finds the *actus generationis* "in almost all" works of the primitive tribes. This interpretation of the psyche of primitive peoples and their art touched off passionate opposition, and one can hardly escape the impression that the missionary's propositions had succumbed to his subjective intuition. In the light of his tendency to transfer his experiences in New Pomerania—apparently with no good reason—onto absolutely different religions of the earth, one will have to take his opinion for now as just an isolated finding.

While Winthius relies on his sporadic experiences in an isolated area of the South Seas, others have tried to use the results of psychoanalytic research when explaining primitive works of art, among them E. von Sydow's *Primitive Kunst und Psychoanalyse* (*Primitive Art and Psychoanalysis,* 1927). The basic understanding of this work conforms with Winthius in so far as sexuality is recognized as a basic principle of the primitive nature. It follows a systematic outline of the fine arts of the primitive tribes, covering architecture, sculpture, and drawing only in the context of their various forms. As to architecture and its three characteristics—the spatially enclosed area, the attempt to create a single open space, and the excessive weight of the roofing—the result leads back to the mother's womb. With regard to sculpture and its three characteristics—the unity of the block-like form, the excessive weight of the head vis-à-vis the body, and the preference for single figures—the result points to the phallus. And for drawing and its characteristics—two-dimensionality and unity of the flat surface—the result points to the surface of the human body. However, this study does not maintain that only those elements that they can be psychoanalytically established are valid, but rather that cultural characteristics are also of great importance. In addition, that work also acknowledges the importance of intellectual freedom within the development of art, its contribution to primitive buildings and to more complicated forms.

To sum up, it can be said that neither the materialistic nor the religious nor the psychoanalytic explanations suffice in exploring the appearance of Primitive art. It is necessary to combine these major kinds of analysis. However, in order to employ such a combination in a fruitful manner it seems to be necessary to construct a cultural-historical outline. Only then will it be possible to describe

the influence of the one or the other element with convincing clarity—which cannot be done on the basis of the more intuitive work methods that we have briefly described. Two ethnological movements have set the goal of working out such an outline in historical order: evolutionism and the cultural-historical method.

ROMARE BEARDEN

THE NEGRO ARTIST AND MODERN ART · 1934

For the moment, let us look back into the beginnings of modern art. It is really nothing new, merely an expression projected through new forms, more akin to the spirit of the times. Fundamentally the artist is influenced by the age in which he lives. Then for the artist to express an age that is characterized by machinery, skyscrapers, radios, and the generally quickened cadences of modern life, it follows naturally that he will break from many of the outmoded academic practices of the past. In fact every great movement that has changed the ideals and customs of life, has occasioned a change in the accepted expression of that age.

Modern art has passed through many different stages. There have been the periods of the Impressionists, the Post Impressionists, the Cubists, the Futurists, and hosts of other movements of lesser importance. Even though the use of these forms is on the decline, the impression they made in art circles is still evident. They are commendable in the fact that they substituted for mere photographic realism, a search for inner truths.

Modern art has borrowed heavily from Negro sculpture. This form of African art had been done hundreds of years ago by primitive people. It was unearthed by archaeologists and brought to the continent. During the past twenty-five years it has enjoyed a deserved recognition among art lovers. Artists have been amazed at the fine surface qualities of the sculpture, the vitality of the work, and the unsurpassed ability of the artists to create such significant forms. Of great importance has been the fact that the African would distort his figures, if by so doing he could achieve a more expressive form. This is one of the cardinal principles of the modern artist.

It is interesting to contrast the bold way in which the African sculptor approached his work, with the timidity of the Negro artist of today. His work is at best hackneyed and uninspired, and only mere rehashings from the work of any artist that might have influenced him. They have looked at nothing with their own eyes—seemingly content to use borrowed forms. They have evolved nothing original or native like the spiritual, or jazz music.

Many of the Negro artists argue that it is almost impossible for them to evolve such a sculpture. They say that since the Negro is becoming so amalgamated

Opportunity: Journal of Negro Life (December 1934): 371–72.

The eminent African-American artist Romare Howard Bearden (1911–1988) wrote this essay when he was still an art student.

with the white race, and has accepted the white man's civilization he must progress along those lines. Even if this is true, they are certainly not taking advantage of the Negro scene. The Negro in his various environments in America, holds a great variety of rich experiences for the genuine artists. One can imagine what men like Daumier, Grosz, and Cruickshanks might have done with a locale like Harlem, with all its vitality and tempo. Instead the Negro artist will proudly exhibit his "Scandinavian Landscape," a locale that is entirely alien to him. This will of course impress the uninitiated, who through some feeling of inferiority toward their own subject matter, only require that a work of art have some sort of foreign stamp to make it acceptable.

I admit that at the present time it is almost impossible for the Negro artist not to be influenced by the work of other men. Practically all the great artists have accepted the influence of others. But the difference lies in the fact that the artist with vision, sees his material, chooses, changes, and by integrating what he has learned with his own experiences, finally molds something distinctly personal. Two of the foremost artists of today are the Mexicans, Rivera and Orozco. If we study the work of these two men, it is evident that they were influenced by the continental masters. Nevertheless their art is highly original, and steeped in the tradition and environment of Mexico. It might be noted here that the best work of these men was done in Mexico, of Mexican subject matter. It is not necessary for the artist to go to foreign surroundings in order to secure material for his artistic expression. Rembrandt painted the ordinary Dutch people about him, but he presented human emotions in such a way that their appeal was universal.

Several other factors hinder the development of the Negro artist. First, we have no valid standard of criticism; secondly, foundations and societies which supposedly encourage Negro artists really hinder them; thirdly, the Negro artist has no definite ideology or social philosophy.

Art should be understood and loved by the people. It should arouse and stimulate their creative impulses. Such is the role of art, and this in itself constitutes one of the Negro artist's chief problems. The best art has been produced in those countries where the public most loved and cherished it. In the days of the Renaissance the towns-folk would often hold huge parades to celebrate an artist's successful completion of a painting. We need some standard of criticism then, not only to stimulate the artist, but also to raise the cultural level of the people. It is well known that the critical writings of men like Herder, Schlegel, Taine, and the system of Marxian dialectics, were as important to the development of literature as any writer.

I am not sure just what form this system of criticism will take, but I am sure that the Negro artist will have to revise his conception of art. No one can doubt that the Negro is possessed of remarkable gifts of imagination and intuition. When he has learned to harness his great gifts of rhythm and pours it into his

art—his chance of creating something individual will be heightened. At present it seems that by a slow study of rules and formulas the Negro artist is attempting to do something with his intellect, which he has not felt emotionally. In consequence he has given us poor echoes of the work of white artists—and nothing of himself.

It is gratifying to note that many of the white critics have realized the deficiencies of the Negro artists. I quote from a review of the last Harmon exhibition, by Malcolm Vaughan, in the New York *American:* "But in the field of painting and sculpture, they appear peculiarly backward, indeed so inept as to suggest that painting and sculpture are to them alien channels of expression." I quote from another review of the same exhibition, that appeared in the *New York Times:*

> Such racial aspects as may once have figured have virtually disappeared, so far as some of the work is concerned. Some of the artists, accomplished technicians, are seen to have slipped into grooves of one sort or another. There is the painter of the Cezannesque still life, there is the painter of the Gauguinesque nudes, and there are those who have learned various "dated" modernist tricks.

There are quite a few foundations that sponsor exhibitions of the work of Negro artists. However praise-worthy may have been the spirit of the founders the effect upon the Negro artist has been disastrous. Take for instance the Harmon Foundation.[1] Its attitude from the beginning has been of a coddling and patronizing nature. It has encouraged the artist to exhibit long before he has mastered the technical equipment of his medium. By its choice of the type of work it favors, it has allowed the Negro artist to accept standards that are both artificial and corrupt.

It is time for the Negro artist to stop making excuses for his work. If he must exhibit let it be in exhibitions of the caliber of "The Carnegie Exposition." Here among the best artists of the world his work will stand or fall according to its merits. A concrete example of the accepted attitude towards the Negro artist recently occurred in California where an exhibition coupled the work of Negro artists with that of the blind. It is obvious that in this case there is definitely created a dual standard of appraisal.

The other day I ran into a fellow with whom I had studied under George Grosz, at the "Art Students' League." I asked him how his work was coming. He told me that he had done no real work for about six months.

"You know, Howard," he said, "I sort of ran into a blind alley with my work; I felt that it definitely lacked something. This is because I didn't have anything worthwhile to say. So I stopped drawing. Now I go down to the meetings of The Marine and Industrial Workers' Union. I have entered whole-heartedly in their movement."

We talked about Orozco, who had lost his arm in the revolutionary struggle

in Mexico. No wonder he depicted the persecution of the underclass Mexicans so vividly—it had all been a harrowing reality for him.

So it must be with the Negro artist—he must not be content with merely recording a scene as a machine. He must enter wholeheartedly into the situation which he wishes to convey. The artist must be the medium though which humanity expresses itself. In this sense the greatest artists have faced the realities of life, and have been profoundly social.

I don't mean by this that the Negro artist should confine himself only to such scenes as lynchings, or policemen clubbing workers. From an ordinary still life painting by such a master as Chardin we can get as penetrating an insight into eighteenth century life, as from a drawing by Hogarth of a street-walker. If it is the race question, the social struggle, or whatever else that needs expression, it is to that the artist must surrender himself. An intense, eager devotion to present day life, to study it, to help relieve it, this is the calling of the Negro artist.

NOTE

1. [The Harmon Foundation, organized and supported by the wealthy businessman William Elmer Harmon (1862–1928), presented financial awards for distinguished achievement among African-Americans in business, industry, music, literature, and art. Started in 1922 in New York City, the philanthropic organization is best known for its awards to visual artists and exhibitions during the 1920s and the early 1930s. Eds.]

JAMES JOHNSON SWEENEY

THE ART OF NEGRO AFRICA · 1935

Today the art of Negro Africa has its place of respect among the esthetic traditions of the world. We recognize in it the mature plastic idiom of a people whose social, psychological and religious outlook, as well as history and environment, differ widely from ours. We can never hope to plumb its expression fully. Nevertheless, it no longer represents for us the mere untutored fumblings of the savage. Nor, on the other hand, do its picturesque or exotic characteristics blind us any longer to its essential plastic seriousness, moving dramatic qualities, eminent craftsmanship and sensibility to material, as well as to the relationship of material with form and expression.

Today, the art of Negro Africa stands in the position accorded it on genuine merits that are purely its own. For us its psychological content must always remain in greater part obscure. But, because its qualities have a basic plastic integrity and because we have learned to look at Negro art from this viewpoint, it has finally come within the scope of our enjoyment, even as the art expressions of such other alien cultures as the Mayan, the Chaldaean, and the Chinese.

Whether or not African Negro art has made any fundamental contribution to the general European tradition through the interest shown in it by artists during the last thirty years is a broadly debatable point. In the early work of Picasso and his French contemporaries, as well as in that of the German "Brücke" group, frank pastiches are frequently to be found. But these, like the adoption of characteristically negroid form-motifs by Modigliani and certain sculptors, appear today as having been more in the nature of attempts at interpretation, or expressions of critical appreciation, than true assimilations. When we occasionally come across something in contemporary work that looks as if it might have grown out of a genuine plastic assimilation of the Negro approach, on closer examination we almost invariably find that it can as fairly be attributed to another influence nearer home. Cézanne's researches in the analysis of form, to

Excerpts from *African Negro Art,* exh. cat. (Museum of Modern Art, 1935), 11–13, 21. © Museum of Modern Art, 1935.

James Johnson Sweeney (1900–1986) was curator of the influential first exhibition of African art mounted at a museum of modern art and wrote a brief introductory essay for the catalogue. Although the exhibition implied a strong relationship between African art and modern Western art, Sweeney's essay stressed Western artists' independence from African art and emphasized that African art should be recognized in its own right, not just because of its influence on modern art.

take an obvious example, not only laid the foundation for subsequent developments in European art but also played an important part in opening European eyes to the qualities of African art.

In any case, it remains a fact that, about the year 1905, European artists began to realize the quality and distinction of the Negro plastic tradition to which their predecessors had been totally blind, and that the conditions which had prepared them for this realization had been at the same time laying the foundations for a freshened European plastic outlook.

In those first years there had been practically nothing yet written on the subject. This fact in itself had an appeal for the younger painters of the time, tired of traditions so overlaid with literature that an approach on purely plastic grounds was difficult. Anthropologists and ethnologists in their works had completely overlooked (or at best had only mentioned perfunctorily) the esthetic qualities in artifacts of primitive peoples. Frobenius was the first to call attention to African art. But his articles *Die Kunst der Naturvölker* in Westermann's *Monatshefte* (Jahrgang XI, 1895–6); and *Die Bildende Kunst der Afrikaner* in *Mitteilungen der anthropologischen Gesellschaft in Wien,* 1897–1900, treated the subject primarily from non-esthetic viewpoints. It was not the scholars who discovered Negro art to European taste but the artists. And the artists did so with little more knowledge of the object's provenance or former history than in what junk shop they had been lucky enough to find it and whether the dealer had a dependable source of supply.

Of course many examples were to be found in ethnographical museums but usually lost in a clutter of other exhibits, since their esthetic character was of no interest to their discoverers or possessors at the time. One has only to look over the priced catalogs of W. D. Webster, an auctioneer of ethnographical specimens located in Biecester, Oxford, to realize how little regarded during the years between 1897 and 1904 were those pieces we recognize today as among the most important in collections such as that of the Museum für Völkerkunde, Berlin. Travellers, traders, and soldiers brought objects back to Europe as curiosities. And when the material of which they were made had no value of its own, they eventually fell into the hands of dealers in ethnographical specimens or, as more often occurred, those of curiosity dealers.[1] And it was in those curiosity shops that the first amateurs in France and Belgium made their acquaintance with Negro art.

At first no one heeded the vogue commercially. But gradually as it began to spread and the supply, which was always extremely limited, dwindled, dealers began to take steps to assure themselves of importations. At first the liquidation of estates of old soldiers who had taken part in punitive expeditions against the natives (particularly in England whose African forces had reaped a harvest of Benin bronzes) helped to keep the demand satisfied. Traders then took steps to ship to Europe whatever they could prevail on the natives to part with. How-

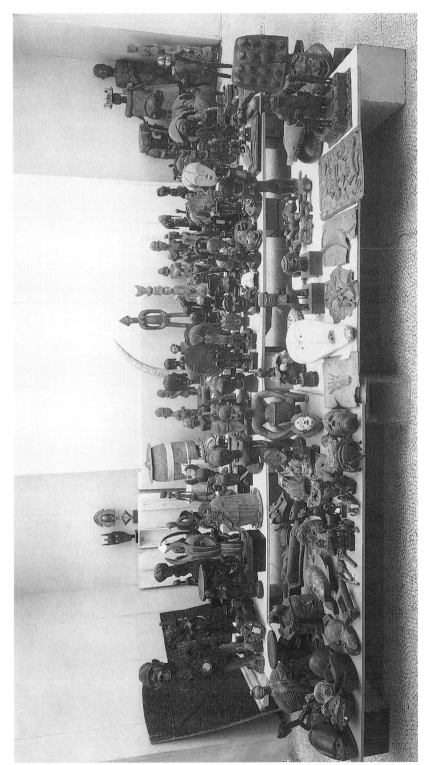

Figure 26. An assemblage of objects included in the exhibition "African Negro Art," Museum of Modern Art, New York, March 18, 1935, through May 19, 1935. Photograph © 2001 The Museum of Modern Art, New York.

ever, even in Africa the supply was small: fine pieces were no longer being pro-
duced due to the decadence of the natives following their exploitation by the
whites. Soon the traders were reduced to employing natives to manufacture
copies for the market. And when this in turn failed to satisfy the demand, white
forgeries that soon outdistanced the native copies in "character" began to be
turned out on a quantity production scale in Brussels and Paris.

Today save for some rare, hitherto unexploited regions,[2] art as we have known
it in its purest expression no longer comes out of Africa. So while African art on
one hand may be considered modern since very few of the examples we possess,
due to the highly perishable character of their material in a tropical climate,
could have survived more than a century and a half (excepting of course the
Benin bronzes and the terra cotta heads dug up in the neighborhood of Ifa), on
another, we may say, the art of Africa is already an art of the past. . . .

In the end, however, it is not the tribal characteristics of Negro art nor its
strangeness that are interesting. It is its plastic qualities. Picturesque or exotic
features as well as historical and ethnographic considerations have a tendency to
blind us to its true worth. This was realized at once by its earliest amateurs. To-
day with the advances we have made during the last thirty years in our knowl-
edge of Africa it has become an even graver danger. Our approach must be held
conscientiously in quite another direction. It is the vitality of the forms of Ne-
gro art, that should speak to us, the simplification without impoverishment, the
unerring emphasis on the essential, the consistent, three-dimensional organiza-
tion of structural planes in architectonic sequences, the uncompromising truth
to material with a seemingly intuitive adaptation of it, and the tension achieved
between the idea or emotion to be expressed through representation and the
abstract principles of sculpture.

The art of Negro Africa is a sculptor's art. As a sculptural tradition in the last
century it has had no rival. It is as sculpture we should approach it.

NOTES

1. Unfortunately, gold objects of wooden figures covered with gold leaf (as were most
 of the wooden statuettes in the gold-bearing regions originally) were melted down
 or stripped for their metal. In No. 144 we have an example of a wooden statuette
 covered with thin leaf gold which was recently brought back from the Aitutu tribe
 of Ivory Coast. Most of the finest small Ivory Coast figures were probably adorned
 in this fashion before they fell into European hands.

2. Last year Dr. Himmelheber of Karlsruhe brought back several extremely fine objects
 from the Ivory Coast, mainly from the Aitutu and Guro tribes. Among these objects
 are the masks, and the gold objects lent by the Forschungsinstitut of Frankfort (Nos.
 144–160).

ALAIN LOCKE

AFRICAN ART · 1935

Even to those who have known and appreciated it, African art has been seen through a glass darkly—either as exotic and alien or as the inspiration and source of contemporary modernism. The current exhibition of the Museum of Modern Art, aside from being the finest American showing of African art, reveals it for the first time in its own right as a mature and classic expression. The obvious intent has been to show African art in its own context, and to document its great variety of styles by showing a few pure and classic specimens of each. The whole wide range of extant collections, European as well as American, has been combed for the best examples; of the well-known collections only those of Corail-Stop and the Barnes Foundation are missing, and this wide and highly selective culling has resulted in an exhibit which is a revelation even to the experts. Something like that change in evaluation which was made necessary when the art world first saw the Greek originals of the already familiar Roman copies, or discovered the firm strength and austerity of archaic and pure Greek art in contrast with the subtle delicacy of this art in its period of maturity and approaching decadence, must be the result of a showing such as this. Among other things, our notion of the exceptionally small scale of African sculpture must be abandoned since item after item proves the existence of a "grand style," with corresponding heroic proportion and simplicity. Seventy-two collections have been the vast reservoir from which a selection of six hundred items has been chosen, and these range from small private collections of art amateurs to the great state collections at Leipzig, Munich, Berlin, Tervueren, the Paris Trocadéro Museum and our own collections at Chicago, Brooklyn, the University of Pennsylvania, and even Harlem. Mr. James Johnson Sweeney is the presiding genius who has gleaned this vast territory and pressed out the essence, giving America not only its greatest show of African art among the seven that have been held here since the memorable first one of 1914 at "Gallery 291," but a master lesson in the classic idioms of at least fourteen of the great regional art styles of the African continent. Our title, then, is no exaggeration: this is a definitive exhibition of African classics.

Excerpt from *American Magazine of Art* 28 (May 1935): 271–78.

This essay was written in response to the 1935 Museum of Modern Art exhibition.

Only such a weeding out could have revealed the classical maturity of this native art. As it stands out in a few specimens of pure style rather than the usual jumble of hybrids and second-rate examples, it is only too obvious that, instead of a heightened expression of this plastic idiom, we have in modernist art a dilution of its primitive strength and its classic simplicity. Mr. Sweeney goes further in his preface and argues that the new idiom of modern painting and sculpture was an independent development of European aesthetic that merely happened to be in the direction of the African idioms, and the adoption of their characteristic Negroid form motives "appears today as having been more in the nature of attempts at interpretation, or expressions of critical appreciation, than true assimilation." Out of this novel thesis that these two movements—the new appreciation of African art and of the Negro plastic tradition, and the working out of the new aesthetic in European art—were coincidental rather than cause and effect, Mr. Sweeney draws deductions leading to the glorification rather than the belittlement of African art. He believes that African art is best understood directly, and in terms of its own historical development and background, and that it should be recognized in its own idiom and right, rather than in terms of its correlation with modern art or its admitted influence upon modern art. The exhibition vindicates this thesis and the claim that "today the art of Negro Africa has its place of respect among the aesthetic traditions of the world."

Having learned the similarities of African art and modernist art, we are at last prepared to see their differences. The secret of this difference would seem to be a simple but seldom recognized fact. The modern artist, as a sophisticate, was always working with the idea of authorship and a technically formal idea of expressing an aesthetic. The native African sculptor, forgetful of self and fully projected into the idea, was always working in a complete fusion with the art object. Sheldon Cheney is exactly right when he says: "These little idols, fetishes and masks are direct expressions of religious emotions. The sculptor approaches his work in humility, always feeling that he is less important than the figure he is carving. His carving is for itself, out of his emotion." Although its vitality, its powerful simplification, "its unerring emphasis on the essential and its timelessness" were appreciated by the European modernist, and were technically and ideally inspiring, few or no modern artists could be at one and the same time naïve and masterful, primitive and mature. And so the enviable combination of naïveté and sophistication, of subtlety and strength could not be reachieved but only echoed. Few may be expected to agree until they have seen the exhibit, but few who have seen it may be expected to dissent.

JOHN D. GRAHAM

PRIMITIVE ART AND PICASSO · 1937

Plastically and aesthetically there are only two basic traditions operating up to our day: the Greco-African and the Perso-Indo-Chinese.

The Greco-African culture is based on geometric design; it is centripetal and synthetic in principle; it has an evolutionist conception of the human figure, stylization, and symbolism; it is evocative and full of implications; it has a spontaneous technique; it uses earth colors; and the helmet form it evolved is rooster-like. This aesthetic culture was probably evolved by a dark skinned race and has roots in Africa or South Europe. It prevailed in Africa, Greece, Spain, Italy and all around the Mediterranean Sea. Examples of this art are the prehistoric paintings in the Altamira caves of Spain, and in Bechuanaland, South Africa; the sculpture of equatorial Africa, the pre-Archaic painting and sculpture of Greece and Etruria, early Byzantine and Spanish Art, Pompeian wall paintings, and the embroidery and weaving of Spain, Morocco, and the Balkans. The influence of this civilization travelled in fragmentary forms as far North as Scandinavia and Russia. The so-called Greek border can be observed in the lace and the carvings of these lands, the same geometric design and the same earth colors.

The second basic tradition, the Perso-Indo-Chinese culture, on the other hand, is based upon florid design; it is analytic and centrifugal in principle; it is based on decorative stylization, on literary content; it has a deliberate, machine-like technique; and yellow and green are its predominant colors. Its helmet is conoid. This civilization is essentially Asiatic and is best typified by Chinese, Indian, Assyro-Babylonian, Minoan, and Scythian art. It is well exemplified in the Germano-Gallic and in the Barbaric art of the fifth to the eighth century. The Assyro-Babylonian, the Germano-Gallic, and the Barbaric art experienced a certain degree of Greco-African influence in color and design, while Egyptian art, being the farthest to the east in Africa felt some Asiatic influence.

The Central European countries, France, Germany, and Russia, in various degrees felt the impact of both civilizations. In Russia the Perso-Indo-Chinese was diluted by the Byzantine influence of the Greek church while in France the

Magazine of Art 30 (April 1937): 236–39, 260.

John D. Graham (pseudonym of Ivan Dambrowsky, 1881–1961) was a Russian-born American painter, collector, and aesthetician. He was extremely influential among the New York avant-garde, especially the Abstract Expressionists.

Hispano-Moresque influence largely superseded the Barbaric of Perso-Indo-Chinese. The Germanic or brachycephalic people, coming from Asia, preserved the Perso-Indo-Chinese aesthetic tradition, tempered only with a degree of Roman influence brought back from their Italian invasions. The history of costume shows this clearly. While the Mediterranean races dress in earth colors—mostly black, brown, and red—the Central European races dress in bright rainbow colors, with yellow and green predominant. The Mediterranean races wear a rooster helmet or departures from it such as the Morion or the Bourguignone. The Central European races wear a derivative from the spiked Persian helmet. The Central European helmet of the present day comes from the Schellern of the fifteenth century which in turn became the peasant slouch hat of Breughel or the spiked helmet of Mongolia.

In modern times we can trace the two different approaches in the work of various painters. The Perso-Indo-Chinese tradition has influenced the Impressionists; its florid designs and its yellow and green color schemes are found in the paintings of van Gogh, Renoir, Kandinsky, Soutine, Chagal; the Greco-African is exemplified by Ingres, Picasso, Mondrian.

Primitive races and primitive genius have readier access to their unconscious mind than so-called civilized people. It should be understood that the unconscious mind is the creative factor and the source and the storehouse of power and of all knowledge, past and future. The conscious mind is but a critical factor and clearing house. Most people lose access to their unconscious at about the age of seven. By this age all repressions, ancestral and individual, have been established and free access to the source of all power has been closed. This closure is sometimes temporarily relaxed by such expedients as danger or nervous strain, alcohol, insanity, and inspiration. Among primitive people, children, and geniuses this free access to the power of the unconscious still exists in a greater or lesser degree. Children, the intoxicated and the insane cannot make proper use of this ability since their critical powers are impaired or under-developed. This access to the Unconscious permitted primitive people to comprehend the origin of species and the evolution of forms eons of years ago. The pre-Archaic Greeks with their painted warriors and maidens with duck-like heads, the Maori's green jade Tiki in the form of the human foetus. The Eskimo and the North American Indian masks with features shifted around or multiplied, and the Tlingit, Kwakiutl, and Haida carvings in ivory and wood of human beings and animals, these all satisfied their particular totemism and exteriorized their prohibitions (taboos) in order to understand them better and consequently to deal with them successfully.

Therefore the art of primitive races has a highly evocative quality which allows it to bring to our consciousness the clarities of the unconscious mind, stored with all the individual and collective wisdom of past generations and

forms. In other words, an evocative art is the means and the result of getting in touch with the powers of our unconscious. It stimulates us to move and act along the intuitional line in our life procedure.

Two formative factors apply to primitive art: first, the degree of freedom of access to one's unconscious mind in regard to observed phenomenon, and second, an understanding of the possibilities of the plain operating space.

The first allows an imaginary journey into the primordial past for the purpose of bringing out some relevant information, the second permits a persistent and *spontaneous* exercise of design and composition as opposed to the *deliberate* which is valueless. These capacities allow the artist, in the first place, to operate in *pure relevating form* which means the most elemental components of form. In this process such superfluous components as details and irrelevant obstructing frills and adornments are dispensed with, not used as by other civilizations to conceal the artist's ignorance and distress and to obscure the public's vision. In the second place these capacities permit the artist to work freely *within* the pure form, shifting at will, assembling and disassembling the character-features of form. For example, in treating a face the artist assembles the features in order to bring out the character or plastic meaning of the face, grouping the eyes and nose close together in a poignant form or dispersing them or rearranging them at will in order to fit a preconceived composition.

Picasso's painting has the same ease of access to the unconscious as have primitive artists—plus a conscious intelligence. Greek painting of the eighth century B.C. has been always with us yet we never really saw it until Picasso discovered it to us. Compare Picasso's 1928 "Period de Dinard" painting: in this period he painted romping horses on the beach with small baby horses inserted between the legs of the big horses just as the Greeks of the eighth century B.C. did, achieving an arbitrary perspective, an imaginary perspective (as all perspective is, in fact). He thus explained the true nature of painting which due to its operating space is two-dimensional, and refuted modeling or three-dimensional painting as a make-believe art or a false art. Three-dimensional treatment of form belongs justly to sculpture and architecture alone. In his 1928–29 period Picasso painted faces circular with three dots, two for the eyes and one for the nose, a counterpart to which we find among New Caledonian jade axes, asymmetrically circular with two eloquent round, eye-like holes. Picasso's treatment of the human figure in this period is reminiscent of Mediaeval wrought iron sculpture. In his 1929–30 period we find in his painting, his drawing and, especially in his sculpture an interpretation of the embryonic development of the brow as a predominant part of the head-form which was similarly treated by the Pre-Archaic Greeks, by Ucello, and, with the greatest clarity, by the African tribes of the Gabun region. No artist ever had greater vision or insight into the origins of plastic forms and their ultimate logical destination than Picasso. In 1934 we find him painting women in interlocking figures of eight just as did the

thirteenth-century masters who created the mosaics of St. Mark's in Venice. Other artists observed the beautiful prehistoric painting and primitive sculpture, but Picasso alone graphically penetrated and brought out the real meaning of this art. He delved into the deepest recesses of the Unconscious, where lies a full record of all past racial wisdom. The primitive artists, on the road to the elucidation of their plastic problems, similarly reached deep into their primordial memories. All Picasso's work from 1927 on, discloses the most profound insight into the problems of space and matter, into the origins of forms and their ultimate, logical destination.

JAMES A. PORTER

THE NEGRO ARTIST AND RACIAL BIAS · 1937

The relatively late prominence of the Negro artist in American artistic events has stimulated curiosity about his origins, his heritage, and his future. Most of the curiosity has been directed upon his future. Arguments have ensued, and champions have risen to defend one side or the other of the central question concerned in the Negro artist's future. For example, the value of African Negro art to the American Negro artist has now, as an argument, almost reached the proportions of a *cause célèbre*. A number of critics, artists, and laymen have stated their opinions about it in print; and the discussion still goes on more or less warmly in the studios, exhibition and lecture halls.

Dr. Alain Leroy Locke's recent pamphlet, *Negro Art: Past and Present,*[1] is intended to bolster his already wide reputation as a champion of Africanism in Negro art. This little pamphlet, just off the press, is one of the greatest dangers to the Negro artist to arise in recent years. It contains a narrow racialist point of view, presented in seductive language, and with all the presumption that is characteristic of the American "gate-crasher." Dr. Locke supports the defeatist philosophy of the "Segregationist." A segregated mind, he implies, is only the natural accompaniment of a segregated body. Weakly, he has yielded to the insistence of the white segregationist that there are inescapable internal differences between white and black, so general that they cannot be defined, so particular that they cannot be reduced through rational investigation.

The fundamental question in this controversy is of a two-fold character: What may constitute a distinctive contribution by the American Negro artist to American culture? And could it have been made prior to the advent of the so-called Negro Renaissance? Those who have taken the racialist point of view maintain that no truly distinctive contribution was made by the Negro to world culture prior to the rediscovery of African Negro art by certain European artists and critics of art. Secondly, they insist that by distinctiveness is meant the resemblance of painting or sculpture by Negroes to African art forms or to the more

Art Front 3 (July–August 1937): 8–9.

Artist and art historian James A. Porter (1905–1970) wrote this text in response to Alain Locke's pamphlet *Negro Art: Past and Present* (1936), in which Locke discusses similar ideas that he developed in his 1924 and 1925 publications. Porter also wrote *Modern Negro Art* (1943), one of the first books to examine the relationship between African art and African-American visual arts.

or less abstract patterns made by the Cubists and their successors. The Negro artist, they declare, should bear in mind his "inherent dependency" upon African art forms.

It is possible to understand how a critic who has chosen to place the genesis of the Negro's cultural contribution in the first twenty-five years of this century could ignore all that had been accomplished by the Negro on American soil in the Eighteenth and Nineteenth centuries. It is possible to understand his indifference to the small but genuine achievement of the many early American Negroes whose legacy extends the blackman's cultural history back into the Eighteenth century. There were, for example, Negro craftsmen and artists who, had they white skins, would have been received by the irascible John Trumbull into the First National Academy of Design. Freed of his racial prejudice, William Dunlap would have written something concerning the early black as well as the early white craftsmen and artists. What does it mean to the racialist that Gilbert Stuart received his first lesson in drawing from a Negro slave? Or that Nelson A. Primus painted white subjects as successfully as he did black? Does he know that Governor DeWitt Clinton of New York sat to a black man for his portrait? Voluntarily wearing "blinkers," he shuts out from view the long procession of artists and writers whose work in sum represents a brilliant introduction to the Negro Renaissance—artists like Reason, Smith, Douglass, Duncanson, Simpson, Chaplin, Dorsey, Bowser, Edmonia Lewis, Harper, Tanner, Brown and many others. The writers we have not space to mention.

We shall not have gained a true perspective of the position of the early Negro artist until we have realized how closely bound up were his activities with the great social questions that racked the American conscience in the Nineteenth century. The question of slavery with its corollaries, colonization and abolition, employed the talents of Negro artists as well as writers. Indeed, Negro historians have not canvassed the question thoroughly until they show this among other dynamic elements that motivated the anti-slavery movement. Furthermore, it is a mistake on the part of the racialists to look back upon the cultural aspirations of the first free Negroes as evidence of class privilege. On the contrary, such aspirations amounted to a bold assertion of freedom, a protest against the shackles of slavery or the opprobrium attaching to membership in a despised race. Even though their art and literature were surcharged with propaganda they represented the conviction of truth over against a hell of prejudice.

Another serious error of the segregationists is their disbelief in the native (nonprofessional) craft arts or in the Negro spirituals as aspects of culture. In other words, we have here a perpetuation of the idea of spiritual separatism to an absurd degree. If the Negro spirituals are true only of a slave society they must be true of any similar group of people, similarly conditioned anywhere in the world. There are many reasons why these two categories of early production can be counted on the credit side of Negro cultural achievement. Assessed for

aesthetic, social, and intrinsic racial values, they are found to contain generous proportions of each. Moreover, they contain these qualities in forms that are useful and inspirational to other races. Evidently the segregationalists wish to deny the historical fact of incipient cultural movements among enslaved peoples. They forget that in ancient Rome the art of writing was the special province of the slave. They do not know that countless slaves have won in many periods and places, and under the most trying conditions of persecution, freedom, honor and respect through cultural achievement alone.

Another serious error which is made by the racialists is to urge the Negro artist to adopt the forms used by the African artist. The Negro artist who "adopts" such forms or imposes them upon his ideas and the objects that embody them gives birth to sterile art which will not have the crucial exigency that we associate with the arts of the African tribes. The "primitive" artist, whether African or Polynesian, is at one with the forms he uses because these are dictated by the society in which he finds himself, which in turn is modified by surrounding climatic and geographical conditions. To learn the truth of this one need only seek to establish the style history of a given section of African art. It is then that the questions of material culture and of cultural necessity arise.

It has been clearly shown by reputable anthropologists that the belief that one race is fundamentally different in mind from another is baseless. If this is true, the special qualities of tribal art must result not from any unique racial character, but from influential phases within the particular culture from which it comes. Thus, Cubism is not merely the result of the impact of African forms upon European art practice. Could Cubist art have been produced in Dahomey? From this evident impossibility it is clear that no common denominator exists within racial or territorial cultural activities unless it be that of common social, economic and political concerns upon a more or less uniform level of civilization.

Negro artists who have received the inspiration of African art in a purely formal way have failed to convince us that the resulting work is any better than American or European adaptations of Greek or Roman form-language. When they point indiscriminately to European artists who have been influenced by the African "discovery" they betray their lack of information. For by now it should be known that the most significant primitivistic artists made of their conduct toward problems of form an analogue of the creative process of which they postulated African art the result. So that Modigliani, Picasso, Brancusi and others sought to identify their emotional experience with objects of aesthetic character or objects amenable to a pervading conception of aesthetic surface. They did not merely imitate African forms. It is with genuine disappointment that the segregationist should observe that in each case the "primitivizing" artist had to rely upon academic techniques to define his objects clearly. The principle to be deduced from the foregoing is that the immobility of African forms

cannot again become mobilized until it is identified with the very stuff of our existence.

In his book, *The New Negro,* Dr. Locke has asked that young Negro artists take as their model the American Taos group of artists of whom Walter Ufer was the leader. Their painting of the American Indian, he thought, represented the proper point of departure for the Negro. But he promptly turned to a Swedish draftsman who had a fair facility of hand at drawing romanticized versions of Mexicans, Laplanders and Norwegians, as the ideal person to adorn *The New Negro* with portraits of Negro leaders. Such an action represents an unfortunate inconsistency of policy; and it is not difficult to reconcile it with such a piece of self-effacement as the following excerpts from the pamphlet above-mentioned: "A real and vital racialism in art is a sign of artistic objectivity and independence and gives evidence of a double emancipation from apologetic timidity and academic imitativeness." Which is followed by the unexplained contradiction: "In fact, except for closer psychological contact and understanding, the relation of the Negro artist to racial subject matter is not so very different from that of his white fellow artist to the same material."

To dispose of the dependent question: what makes for a distinctive contribution of the Negro artist to American culture, we must note first of all that reasoning like the foregoing requires it to be socially exclusive, racially self-conscious, formal in style and content, and politically neutral. We have only to examine the work of the most sincere Negro artists now at work to find the refutation of these conclusions. For example, among the sculptors, the best are those who have been open-minded with regard to choice of subject-matter. They have insisted, at the same time, upon making up their own minds, and in so doing they have been able to learn a great deal more about their *métier.* Elizabeth Prophet and Augusta Savage have, like Meta Warrick Fuller and May Howard Jackson before them, studied the psychological as well as the formal aspects of Negro illustration and interpretation. In addition to this they have tried to make their interpretations universal in value. It is as if in reply to suspicious questioning they had said, "Hath not a Negro senses? affections? passions?" Is he not subject to the same diseases, hurt with the same weapons and warmed and cooled by the same winter and summer as his Anglo-Saxon brother? The presence among the Negro artists of such versatile as well as socially-minded individuals as Hale Woodruff, W. E. Scott, Charles Alston, Aaron Douglass, Henry Bannarn, Sargent Johnson, Lois M. Jones and James A. Porter is an indication of an anti-racialist front. These young people are impressed with the richness and the variety of life and the urgency of the material problems that they must solve. They will not cringe or be driven into a tight and unworthy little compartment of aesthetic production.

Finally, it is with hope that one contemplates the variety of the present interest manifested in Negro art. It is good that the artist is not totally preoccupied

with the expression of vapid abstractions, or the imposing of a specious "Africanism" upon his art. One does not find a strictly "racial" artist anywhere. In the great cosmopolitan centers like New York he is more than a studio artist. There, one finds him making social cartoons, decorative sculpture; anecdotal subjects of wide commentary fall from his pen. He is a portrait painter and a sculptor of animals. He experiments with styles, and works conscientiously to found a style. In rural districts or in small ingrown communities like Charlston, South Carolina, one may find him preoccupied with landscapes, the suburban atmosphere. There he may be characteristically a painter of still life and in type a formalist painter with naive technical traits. A self-taught Negro sculptor in Richmond, Virginia, has attracted considerable notice through his direct and vivid carvings in wood, whose subjects are almost invariably stoutish women whom he has observed in the street. Without ever having seen the work of Gaston Lachaise he had hit upon precisely the same conception of form for which Lachaise had won wide acclaim. We may rely very largely upon individual and environmental factors to determine the nature of real contributions to American culture.

NOTE

1. *Bronze Booklet No. 3.* Published by the Associates in Negro Folk Education. P.O. Box 636; Ben Franklin Station; Washington, D.C.

PART III

THE ASCENDANCE OF PRIMITIVISM · 1941–1983

Around 1940, the approach to Primitivism by both artists and art historians again began to change. Partly as a result of World War II, the most innovative thinking about Primitive art shifted to the United States. New attention was given to American Indian art, and American artists in particular found in it a native source that had the virtue of not having come to them via European culture. The 1941 "Indian Art of the United States" exhibition at the Museum of Modern Art played an important role in changing the perception of Native American art among both artists and the general public. (This was followed in 1946 by the Museum of Modern Art's "Arts of the South Seas" exhibition, which reflected both the attention that had been given to Oceanic art by the Surrealists and the increased awareness of the Pacific Basin that had been inculcated by the war in the Pacific.) Because Native American art included a good deal of painting and surface decoration, unlike the more purely sculptural forms that were associated with Africa, it was also more directly accessible to abstract painters. Thus a new phase in the formal response to Primitive art was initiated. For American artists eager to create an art that could lay claim to a mythic and philosophical content, in contrast to American Scene painting, Primitive art became an important paradigm for artistic ambition as well as a stimulus for new forms. This is seen for example in the 1943 statement by Adolph Gottlieb and Mark Rothko, in which they asserted that "only that subject-matter is valid which is tragic and timeless. That is why we profess spiritual kinship with primitive and archaic art."

At the same time, among critics and scholars a good deal of attention was beginning to be given to the historigraphical questions raised by the relationship of Primitivism to modern art. For the most part, Primitivism was generally studied in terms of looking for ways in which Western artists had been affected by the formal qualities of Primitive art, and increasing attention was given to questions of specific influences and sources. During this same period, the study of Primitive art itself also began to expand. From the late 1930s on, it was dominated by what might be characterized as a scientifically oriented anthropological approach, and studies of the aesthetics of Primitive peoples also began to proliferate. As studies of Primitive arts and societies multiplied, attention also began to be given to the relationship of Primitive societies to the industrialized West, and to the effect of Western values on traditional societies, although there was still a tendency to treat Primitive art itself somewhat ahistorically. This phase of study reached a kind of culmination in the Museum of Modern Art's 1984 exhibition, " 'Primitivism' in 20th Century Art."

FREDERIC H. DOUGLAS AND RENÉ D'HARNONCOURT

INDIAN ART OF THE UNITED STATES · 1941

For centuries the white man has taken advantage of the practical contributions made by the American Indian to civilization. Corn, one of the food staples most widely used today, was developed thousands of years ago through the diligence and patience of Indian agriculturists. Tomatoes, squash, potatoes and tobacco were cultivated on this continent long before the white man's arrival. In fact, the white invader was only too glad to learn from the Indian how to utilize the material resources of this country and adopted many of the native methods for his own use.

In spite of this ready recognition of the material achievements of the various Indian tribes, we have hardly ever stopped to ask what values there may be in Indian thought and art. An almost childish fascination with our own mechanical advancement has made us scorn the cultural achievements of all people who seem unable or unwilling to follow our rapid strides in the direction of what we believe to be the only worth-while form of progress.

For four centuries the Indians of the United States were exposed to the onslaught of the white invader, and military conquest was followed everywhere by civilian domination. As war never encourages objective appreciation of cultural values in the enemy camp, it is not surprising that in the days of the Indian wars tribal traditions were regarded as contemptibly backward. But it is deplorable that the advent of civilian domination added actual suppression to scorn. This destructive attitude of the civil authorities was rarely due to hostility. In many cases it was simply the result of their complete lack of understanding of Indian life, and sometimes it was even a manifestation of misguided good will. Indian tradition was seen as an obstacle to progress and every available means was employed to destroy it thoroughly and forever. Dances and ceremonials were outlawed, arts and crafts were decried as shameful survivals of a barbaric age and even the use of Indian languages was prohibited in many schools.

Excerpt from "Introduction: Tribal Traditions and Progress," *Indian Art of the United States,* exh. cat. (Museum of Modern Art, 1941), 9–13. © Museum of Modern Art, 1941.

Frederic H. Douglas (1897–1956) was Curator of Indian Art at the Denver Art Museum. René d'Harnoncourt (1901–1968) was General Manager of the U.S. Department of the Interior's Indian Arts and Crafts Board, established in 1936. D'Harnoncourt, who probably wrote most of the catalogue, later became director of the Museum of Modern Art (1949–1968). This exhibition played an important role in changing the public perception of Native American art and had a profound impact on many of the artists who would later be associated with Abstract Expressionism.

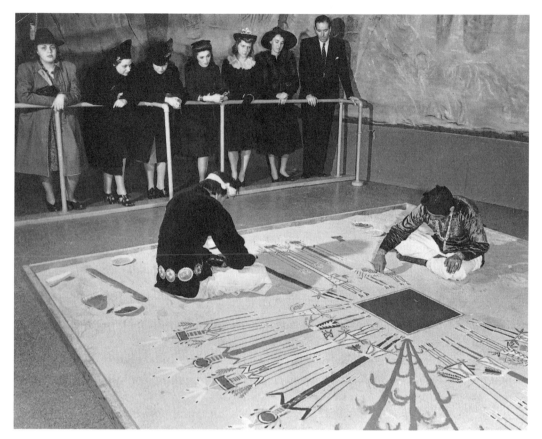

Figure 27. Navajo Indians executing sand painting, March 26, 1941, during exhibition "Indian Art of the United States," Museum of Modern Art, New York, January 22, 1941, through April 27, 1941. Photograph © 2001 The Museum of Modern Art, New York.

Only in recent years has it been realized that such a policy was not merely a violation of intrinsic human rights but was actually destroying values which could never be replaced, values so deeply rooted in tribal life that they are a source of strength for future generations. In recognition of these facts, the present administration is now cooperating with the various tribes in their efforts to preserve and develop those spiritual and artistic values in Indian tradition that the tribes consider essential. At the same time, the administration makes every effort to help them realize their desire to adopt from the white man such achievements as will make it possible for them to live successfully in a modern age. This attitude led to the promulgation of the Indian Reorganization Act of 1934, which created a legal basis for the rehabilitation of Indian economic and cultural life. By this Act we are taking into consideration for the first time the validity of Indian tradition as well as the need for progress.

It is impossible to generalize on the present status of tribal tradition in the various groups. Some of them are still guided by tradition in all their activities

and regard it as the basis of their entire economic, social and ceremonial life. Others have adopted some of the white man's ways, and some preserve tradition only in such subtle aspects of their culture that its existence is often imperceptible to the casual observer. It is also frequently true that factions within a tribe represent various attitudes ranging from strict adherence to open defiance of it. However, it must be said that Indian tradition still permeates in varying degrees every tribal unit that has not been completely absorbed by its white neighbors.

The survival of tribal cultures through generations of persecution and suppression is in itself a testimony to their strength and vitality. It is natural that a new appreciation of these values by the authorities and by part of the American public is now bringing to light in many places traditional customs and traditional thinking that have lived for years carefully shielded from unsympathetic eyes.

But our new willingness to recognize the value of Indian traditional achievement is unfortunately sometimes fostered by sentimentality rather than by true appreciation. There are people who have created for themselves a romantic picture of a glorious past that is often far from accurate. They wish to see the living Indian return to an age that has long since passed and they resent any change in his art. But these people forget that any culture that is satisfied to copy the life of former generations has given up hope as well as life itself. The fact that we think of Navaho silversmithing as a typical Indian art and of the horsemanship of the Plains tribes as a typical Indian characteristic proves sufficiently that those tribes were strong enough to make such foreign contributions entirely their own by adapting them to the pattern of their own traditions. Why should it be wrong for the Indian people of today to do what they have done with great success in the past? Invention or adaptation of new forms does not necessarily mean repudiation of tradition but is often a source of its enrichment.

To rob a people of tradition is to rob it of inborn strength and identity. To rob a people of opportunity to grow through invention or through acquisition of values from other races is to rob it of its future.

This publication, as well as the exhibition upon which it is based, aims to show that the Indian artist of today, drawing on the strength of his tribal tradition and utilizing the resources of the present, offers a contribution that should become an important factor in building the America of the future.

The Indian art of the United States is part of the larger body of native art produced in all the Americas. Indian culture reached its climax in the densely settled sections of Mexico and Central America, and in the Andean regions of South America. Large numbers of specialists provided the complex and highly developed native society of these regions with an infinite variety of decorated artifacts created to meet the demand of all classes from nobility to peasantry.

Compared with the art of these countries, that north of the Rio Grande could be described as provincial. It was produced on a relatively small scale and

it never included such complicated processes of manufacture as metal casting or welding, which were perfectly mastered in the cultural centers south of the Rio Grande. At its best, however, it equals these arts in aesthetic refinement and often excels in freshness and power.

In theory, it should be possible to arrive at a satisfactory aesthetic evaluation of the art of any group without being much concerned with its cultural background. A satisfactory organization of lines, spaces, forms, shades and colors should be self-evident wherever we find it. Yet we know that increased familiarity with the background of an object not only satisfies intellectual curiosity but actually heightens appreciation of its aesthetic values.

This may be partly due to the fact that the eye, trained to see only familiar elements of form and color, actually fails to see in a work of foreign origin certain elements that may be of great importance to its maker. But surely it is also the result of a human inability to isolate aesthetic enjoyment, to separate it from habitually emotional or intellectual associations with specific forms or subjects. Only with knowledge of the background of a work of art are we able to synchronize, in effect, our pattern of associations with those of the culture that produced it and thus see it clearly enough to judge its merit. In looking at Indian objects it is essential to realize, for instance, how few of the frequent distortions or exaggerations of human or animal likenesses are meant to be grotesque. Most of them are the result of a consistent use of stylized tribal designs in the portrayal of living creatures. The Tlinkit mask, for example, is a representation of a hawk that appears to us grotesque because it combines human features with a hawk's beak, an accepted practice in Northwest Coast art. The seemingly sinister expression of the eyes is due to a typical regional form of conventionalization. The Seneca mask, on the other hand, was actually intended to create fear. It was made to represent the bodiless, floating head of a malevolent spirit.

Another example of misinterpretation of the Indian artist's motives for choosing certain forms is the popular belief that the strange double animals seen so frequently in Northwest Coast art were made to represent mythical monsters. Actually they are just a representation of the two sides of one and the same animal, and illustrate a tendency toward realism, not a desire to express mystic powers. The Northwest Coast people always considered all aspects of their model, and used this device to give a complete rendering of their subject when they portrayed it on a two-dimensional plane.

Our tendency to deal with unfamiliar manifestations of other cultures by describing them with one ambiguous and usually somewhat derogatory term is quite unfortunate. It is very misleading to refer to Indian art as primitive art. The word *primitive,* in either its literal sense, describing an early stage of development, or its popular sense, implying lack of refinement, only fits certain of the rudimentary and archaic forms of Indian art which can hardly be considered representative. Most Indian art is the result of a long period of development in

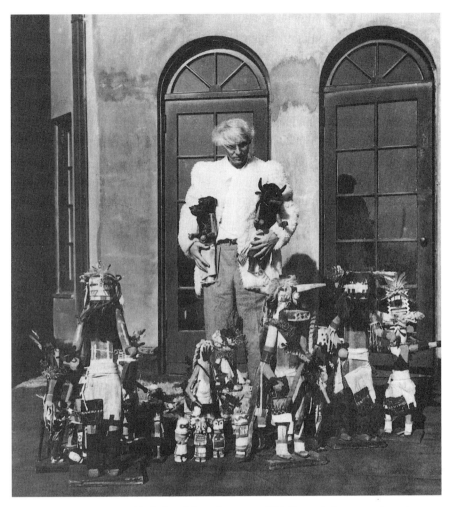

Figure 28. Max Ernst, surrounded by kachina dolls on the terrace of Hale House, the brownstone located at Beekman Place at East 51st Street in Manhattan that he shared with Peggy Guggenheim, ca. 1942. The Museum of Modern Art Archives, New York: James Thrall Soby Papers, I.17(5). Photograph courtesy of The Museum of Modern Art, New York.

which capable craftsmen devoted all their inventive skill to perfecting specialized techniques and styles. Some of it reaches a level that compares favorably with the products of any of the great pre-mechanic civilizations.

Traditional Indian art can best be considered as *folk art* because it is always an inextricable part of all social, economic and ceremonial activities of a given society. It creates within a collectively established scope of forms and patterns, and always serves a definite utilitarian or spiritual purpose that is accepted by the entire group.

Among certain groups, such as the Pueblo, centuries of rigidly organized collective activities have produced sharply defined collective concepts and art styles. Most subjects have prescribed conventionalized forms, and the same com-

binations of form elements occur over and over again with minor variations. In this type of culture the contribution of the individual artist is almost entirely limited to arrangement of patterns and to sensitive execution.

Such limitations are not, of course, considered a hardship by the traditional Pueblo artist, who is himself part of the group and whose concepts are therefore identical with those held by his tribe. The variety in quality found in Pueblo art is convincing evidence that even the most rigidly established tribal patterns allow for individual achievement of the highest degree.

Among other Indian cultures the established scope of tribal art forms is considerably wider and allows in some cases for a variety of renderings and arrangements that is astonishing. How important it is for the Indian artist to stay within the scope of his traditional arts, no matter how wide or narrow that may be, can be learned from his own judgment of tribal work, frequently rendered in the terms of "right" or "wrong" instead of our customary "good" or "bad."

Fine art in the sense of art for art's sake is a concept that is almost unknown in Indian cultures. There are very few aboriginal art forms that have no established function in tribal life. Some of the miniature ivory carvings of the Eskimo may be an exception to the rule since there is no evidence that they serve any specific purpose, but by and large every product made by an Indian artist has a function and is created by him primarily to serve a given end. Artistic merit is simply considered a necessary by-product of good workmanship.

The close relationship between aesthetic and technical perfection gives the work of most Indian artists a basic unity rarely found in the products of an urban civilization. The perfection of manufacturing processes in our own world has made it possible for us to force almost any raw material into any given shape—an achievement that has turned out to be of doubtful value in the hands of many ambitious but undiscriminating contemporaries. The Indian artist, whose simple tools have always forced him to study his raw material in order to discover just what treatment will best utilize its inherent characteristics, has developed a sense of the fitness of form and material that gives distinction to all his work.

HENRY MOORE

PRIMITIVE ART · 1941

The term "Primitive Art" is generally used to include the products of a great variety of races and periods in history, many different social and religious systems. In its widest sense it seems to cover most of those cultures which are outside European and the great Oriental civilizations. This is the sense in which I shall use it here, though I do not much like the application of the word "primitive" to art, since, through its associations, it suggests to many people an idea of crudeness and incompetence, ignorant gropings rather than finished achievements. Primitive art means far more than that; it makes a straightforward statement, its primary concern is with the elemental, and its simplicity comes from direct and strong feeling, which is a very different thing from that fashionable simplicity-for-its-own-sake which is emptiness. Like beauty, true simplicity is an unselfconscious virtue; it comes by the way and can never be an end in itself.

The most striking quality common to all primitive art is its intense vitality. It is something made by people with a direct and immediate response to life. Sculpture and painting for them was not an activity of calculation or academism, but a channel for expressing powerful beliefs, hopes, and fears. It is art before it got smothered in trimmings and surface decorations, before inspiration had flagged into technical tricks and intellectual conceits. But apart from its own enduring value, a knowledge of it conditions a fuller and truer appreciation of the later developments of the so-called great periods, and shows art to be a universal continuous activity with no separation between past and present.

All art has its roots in the "primitive," or else it becomes decadent, which explains why the "great" periods, Pericles' Greece and the Renaissance for example, flower and follow quickly on primitive periods, and then slowly fade out. The fundamental sculptural principles of the Archaic Greeks were near enough to Phidias' day to carry through into his carvings a true quality, although his conscious aim was so naturalistic; and the tradition of early Italian art was sufficiently in the blood of Massacio for him to strive for realism and yet retain a primitive grandeur and simplicity. The steadily growing appreciation of primitive art among artists and the public today is therefore a very hopeful and important sign.

The Listener (April 24, 1941): 598–99. Reproduced by permission of the Henry Moore Foundation.

The work of the English sculptor Henry Moore (1898–1986) reflects his deep interest in African, Oceanic, Northwest Coast, and Eskimo art, which he also collected.

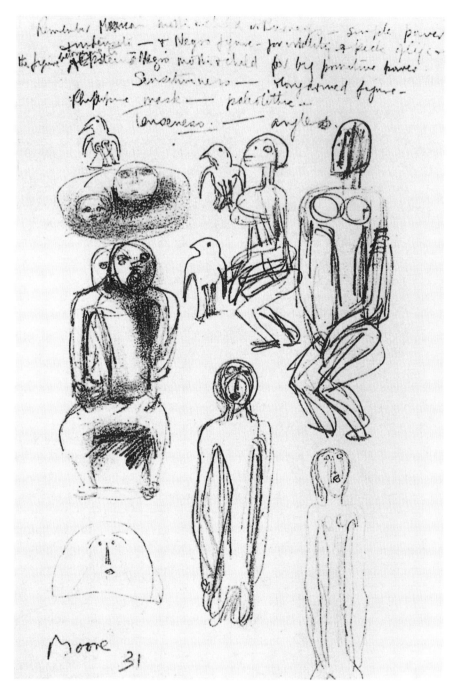

Figure 29. Henry Moore, *Studies of African and Eskimo Sculpture*, 1931. Reproduced by permission of the Henry Moore Foundation.

Excepting some collections of primitive art in France, Italy and Spain, my own knowledge of it has come entirely from continual visits to the British Museum during the past twenty years. Now that the Museum has been closed, one realizes all the more what one has temporarily lost—the richness and comprehensiveness of its collection of past art, particularly of primitive sculpture, and perhaps by taking a memory-journey through a few of the Museum's galleries I can explain what I believe to be the great significance of primitive periods.

At first my visits were mainly and naturally to the Egyptian galleries, for the monumental impressiveness of Egyptian sculpture was nearest to the familiar Greek and Renaissance ideals one had been born to. After a time, however, the appeal of these galleries lessened; excepting the earlier dynasties. I felt that much of Egyptian sculpture was too stylized and hieratic, with a tendency in its later periods to academic obviousness and a rather stupid love of the colossal.

The galleries running alongside the Egyptian contained the Assyrian reliefs—journalistic commentaries and records of royal lion hunts and battles, but beyond was the Archaic Greek room with its lifesize female figures, seated in easy, still naturalness, grand and full like Handel's music; and then near them, downstairs in the badly lit basement, were the magnificent Etruscan Sarcophagus figures—which, when the Museum reopens, should certainly be better shown.

At the end of the upstairs Egyptian galleries were the Sumerian sculptures, some with a contained bull-like grandeur and held-in energy, very different from the liveliness of much of the early Greek and Etruscan art in the terracotta and vase rooms. In the prehistoric and Stone Age room an iron staircase led to gallery wall-cases where there were originals and casts of Palæolithic sculptures made 20,000 years ago—a lovely tender carving of a girl's head, no bigger than one's thumbnail, and beside it female figures of very human but not copyist realism with a full richness of form, in great contrast with the more symbolic two-dimensional and inventive designs of Neolithic art.

And eventually to the Ethnographical room, which contained an inexhaustible wealth and variety of sculptural achievement (Negro, Oceanic Islands, and North and South America), but overcrowded and jumbled together like junk in a marine store, so that after hundreds of visits I would still find carvings I had not discovered before. Negro art formed one of the largest sections of the room. Except for the Benin bronzes it was mostly woodcarving. One of the first principles of art so clearly seen in primitive work is truth to material; the artist shows an instinctive understanding of his material, its right use and possibilities. Wood has a stringy fibrous consistency and can be carved into thin forms without breaking, and the Negro sculptor was able to free arms from the body, to have a space between the legs, and to give his figures long necks when he wished. This complete realization of the component parts of the figure gives to Negro carving a more three-dimensional quality than many primitive periods where stone is the main material used. For the Negro, as for other primitive

peoples, sex and religion were the two main interacting springs of life. Much Negro carving, like modern Negro spirituals but without their sentimentality, has pathos, a static patience and resignation to unknown mysterious powers; it is religious and, in movement, upward and vertical like the tree it was made from, but in its heavy bent legs is rooted in the earth.

Of works from the Americas, Mexican art was exceptionally well represented in the Museum. Mexican sculpture, as soon as I found it, seemed to me true and right, perhaps because I at once hit on similarities in it with some eleventh-century carvings I had seen as a boy on Yorkshire churches. Its "stoniness," by which I mean its truth to material, its tremendous power without loss of sensitiveness, its astonishing variety and fertility of form-invention and its approach to a full three-dimensional conception of form, make it unsurpassed in my opinion by any other period of stone sculpture.

The many islands of the Oceanic groups all produced their schools of sculpture with big differences in form-vision. New Guinea carvings, with drawn-out spider-like extensions and bird-beak elongations, made a direct contrast with the featureless heads and plain surfaces of the Nukuoro carvings; or the stolid stone figures of the Marquesas Islands against the emasculated ribbed wooden figures of Easter Island. Comparing Oceanic art generally with Negro art, it has a livelier thin flicker, but much of it is more two-dimensional and concerned with pattern making. Yet the carvings of New Ireland have, besides their vicious kind of vitality, a unique spatial sense, a bird-in-a-cage form.

But underlying these individual characteristics, these featural peculiarities in the primitive schools, a common world-language of form is apparent in them all; through the working of instinctive sculptural sensibility, the same shapes and form relationships are used to express similar ideas at widely different places and periods in history, so that the same form-vision may be seen in a Negro and a Viking carving, a Cycladic stone figure and a Nukuoro wooden statuette. And on further familiarity with the British Museum's whole collection it eventually became clear to me that the realist ideal of physical beauty in art which sprang from fifth-century Greece was only a digression from the main world tradition of sculpture, whilst, for instance, our own equally European Romanesque and Early Gothic are in the main line.

Primitive art is a mine of information for the historian and the anthropologist, but to understand and appreciate it, it is more important to look at it than to learn the history of primitive peoples, their religions and social customs. Some such knowledge may be useful and help us to look more sympathetically, and the interesting tit-bits of information on the labels attached to the carvings in the Museum can serve a useful purpose by giving the mind a needful rest from the concentration of intense looking. But all that is really needed is response to the carvings themselves, which have a constant life of their own, independent of whenever and however they came to be made, and they remain as full of sculp-

tural meaning to-day to those open and sensitive enough to perceive it as on the day they were finished.

But until the British Museum opens again books and photographs must be a substitute, so far as they can, for the works we are unable to see in the round; and the above reflections have been prompted by an excellent, solid little book called *Primitive Art,* by L. Adam, which has just appeared, with 36 photogravure reproductions and numerous line drawings in the text. It is within everyone's reach in the sixpenny Pelican series, and if it receives the attention it deserves, it should bring a great many extra visitors to the British Museum when its Galleries reopen. Dr. Adam does not regard primitive art in the condescending way in which it used to be regarded, *i.e.,* as if the real aim of the artist had been naturalistic representation, and that though he hadn't yet learned how to do the job convincingly, he could be praised every now and then for making some pretty good shots at it. Even so, in spite of Dr. Adams' general sensibility to his subject, the very high praise he gives to the portrait heads from Ite may perhaps be regarded as an indication that this prejudice still lingers, and it is no doubt as a further concession to it that the reproduction of one of these heads has been chosen for the cover of the book.

ADOLPH GOTTLIEB AND MARK ROTHKO

THE PORTRAIT AND THE MODERN ARTIST · 1943

MR. GOTTLIEB: What seems odd to me, is that our subject matter should be questioned, since there is so much precedent for it. Everyone knows that Grecian myths were frequently used by such diverse painters as Rubens, Titian, Veronese and Velasquez, as well as by Renoir and Picasso more recently.

It may be said that these fabulous tales and fantastic legends are unintelligible and meaningless today, except to an anthropologist or student of myths. By the same token the use of any subject matter which is not perfectly explicit either in past or contemporary art might be considered obscure. Obviously this is not the case since the artistically literate person has no difficulty in grasping the meaning of Chinese, Egyptian, African, Eskimo, Early Christian, Archaic Greek or even pre-historic art, even though he has but a slight acquaintance with the religious or superstitious beliefs of any of these peoples.

The reason for this is simply, that all genuine art forms utilize images that can be readily apprehended by anyone acquainted with the global language of art. That is why we use images that are directly communicable to all who accept art as the language of the spirit, but which appear as private symbols to those who wish to be provided with information or commentary.

And now Mr. Rothko you may take the next question. Are not these pictures really abstract paintings with literary titles?

MR. ROTHKO: Neither Mr. Gottlieb's painting nor mine should be considered abstract paintings. It is not their intention either to create or to emphasize a formal color–space arrangement. They depart from natural representation only to intensify the expression of the subject implied in the title—not to dilute or efface it.

If our titles recall the known myths of antiquity, we have used them again because they are the eternal symbols upon which we must fall back to express basic psychological ideas. They are the symbols of man's primitive fears and motivations, no matter in which land or what time, changing only in detail but never

Excerpt from typescript of a radio interview by Hugh Stix, broadcast on "Art in New York," WNYC, October 13, 1943. © Adolph and Esther Gottlieb Foundation/Licensed by VAGA, New York.

The Abstract Expressionist painters Adolph Gottlieb (1903–1974) and Mark Rothko (1903–1970) had published a letter in the *New York Times* only a few months earlier (June 13, 1943), in which they discussed similar ideas. According to Hugh Stix, the two artists came to him with the idea for the interview.

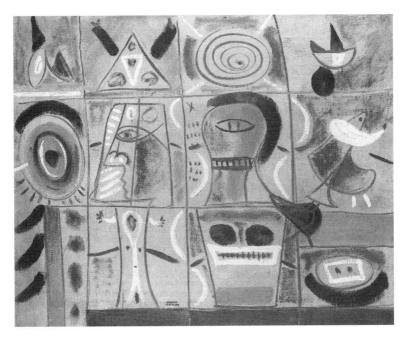

Figure 30. Adolph Gottlieb, *Nostalgia for Atlantis,* 1944. Oil on canvas, 20 x 25".
© Adolph and Esther Gottlieb Foundation / Licensed by VAGA, New York.

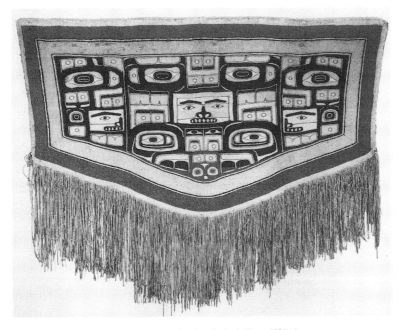

Figure 31. Blanket. Tlingit. Alaska. Dyed wool and cedar-bark fibers, 69" high.
Acquired by Adolph Gottlieb in 1946. Brooklyn Museum of Art.

in substance, be they Greek, Aztec, Icelandic, or Egyptian. And modern psychology finds them persisting still in our dreams, our vernacular, and our art, for all the changes in the outward conditions of life.

Our presentation of these myths, however, must be in our own terms, which are at once more primitive and more modern than the myths themselves—more primitive because we seek the primeval and atavistic roots of the idea rather than their graceful classical version; more modern than the myths themselves because we must redescribe their implications through our own experience. Those who think that the world of today is more gentle and graceful than the primeval and predatory passions from which these myths spring, are either not aware of reality or do not wish to see it in art. The myth holds us, therefore, not thru its romantic flavor, not thru the remembrance of the beauty of some by-gone age, not thru the possibilities of fantasy, but because it expresses to us something real and existing in ourselves, as it was to those who first stumbled upon the symbols to give them life. And now Mr. Gottlieb, will you take the final question? Are you not denying modern art when you put so much emphasis on subject matter?

MR. GOTTLIEB: It is true that modern art has severely limited subject matter in order to exploit the technical aspects of painting. This has been done with great brilliance by a number of painters, but it is generally felt today that this emphasis on the mechanics of picture making has been carried far enough. The surrealists have asserted their belief in subject matter but to us it is not enough to illustrate dreams.

While modern art got its first impetus thru discovering the forms of primitive art, we feel that its true significance lies not merely in formal arrangements, but in the spiritual meaning underlying all archaic works.

That these demonic and brutal images fascinate us today, is not because they are exotic, nor do they make us nostalgic for a past which seems enchanting because of its remoteness. On the contrary, it is the immediacy of their images that draws us irresistibly to the fancies, the superstitions, the fables of savages and the strange beliefs that were so vividly articulated by primitive man.

If we profess a kinship to the art of primitive men, it is because the feelings they expressed have a particular pertinence today. In times of violence, personal predilections for niceties of color and form seem irrelevant. All primitive expression reveals the constant awareness of powerful forces, the immediate presence of terror and fear, a recognition and acceptance of the brutality of the natural world as well as the eternal insecurity of life.

That these feelings are being experienced by many people thruout the world today is an unfortunate fact, and to us an art that glosses over or evades these feelings, is superficial or meaningless. That is why we insist on subject matter, a subject matter that embraces these feelings and permits them to be expressed.

RALPH LINTON AND PAUL S. WINGERT

ARTS OF THE SOUTH SEAS · 1946

In spite of its variety and beauty, Oceanic art is still relatively unknown. Anthropologists have of course dealt with many of its regional and local manifestations but have treated them chiefly as a source of useful evidence in their studies of other aspects of native life. Only a few artists and art lovers, most of them associated with advanced movements, have recognized its full esthetic value.

The appreciation of foreign art forms by such a group is always connected with the group's own preoccupation. It is significant, therefore, that Oceanic art was among the last of the primitive arts to be "discovered." The Cubists, in their search for the basic geometric forms underlying the complex shapes of nature, turned to African Negro art. The reviving interest of modern sculptors in direct carving and their emphasis on actual volume without recourse to "painting" with light and shade, led to a new appreciation of the ancient sculptures of Mexico and Asia Minor. More recently, the interest in the dream world and the subconscious that first developed during the later phases of Expressionism, made us aware of the Magic art from Oceania. The affinity of this Magic art with certain contemporary movements is not limited to concept and style but can be observed also in the choice of materials and in technique.

Each of these "discoveries" of foreign art styles called for a new method of approach. The solution of formal problems admired in African Negro art can be appreciated in terms of pure esthetics. Yet an understanding of the relationship between content and form in Melanesian sculpture calls for some knowledge of the cultural background of the native artist. The growing realization in our art world that a work of art can best be appreciated in the context of its own civilization, together with the increasing interest in art shown by many scientists, holds a great promise. The collaboration among these groups should contribute greatly to our knowledge and understanding of the creative potentialities of mankind.

Excerpt from Introduction to *Arts of the South Seas,* exh. cat. (Museum of Modern Art, 1946), 7–8. © Museum of Modern Art, 1946.

Ralph Linton (1893–1953) was an American anthropologist influential in the development of cultural anthropology; the American art historian Paul S. Wingert (1900–1974) was a pioneer in the study of Primitive art as an academic discipline. The Surrealists' emphasis on Oceanic art, as well as the American exposure to the South Seas during World War II, helped to give impetus to this exhibition.

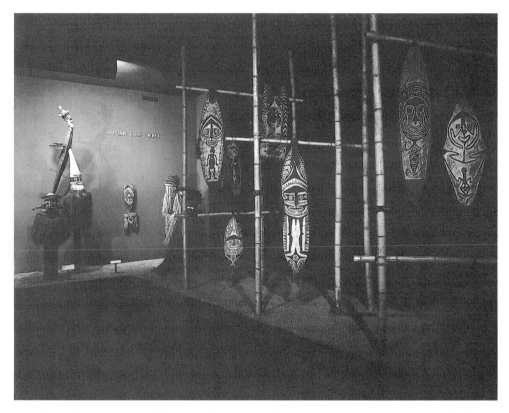

Figure 32. Installation view of the exhibition "Arts of the South Seas," Museum of Modern Art, New York, January 29, 1946, through May 19, 1946. Photograph © 2001 The Museum of Modern Art, New York.

BARNETT NEWMAN

ART OF THE SOUTH SEAS · 1946

Primitive art has become for artists the romantic dream of our time. Each art epoch, like each historic age, has its romantic dream of the past, since artists, no less than historians, yearn for the great works of some other time, never for the achievements of their own time. The Impressionists, it is well known, had their dream in the Japanese print. They doted over this art of the Orient just as, centuries earlier, the Byzantines, anxious to create a sacred art around the Christ legend, had their romance in the religious grandeur of India and China. Until the Impressionists broke the spell, Europe's emotional life had been dominated, for centuries, by that grandiose dream, the Renaissance.[1] The Renaissance itself, found its dream in Classical Greece. And for the Greeks, the Egyptian pyramid stood as a standard of absolute beauty, the symbol of all their aesthetic hopes.

In our time Picasso may have dreamed of a half dozen Utopias but his primary dream—the one that gave him his voice—was Negro sculpture. This does not mean that his art arose from it. But Picasso did try to achieve the artistic ideals he thought he understood to exist in this primitive art tradition. Likewise Matisse found his nostalgic world in the great decorative traditions of primitive Persia. The non-objectivists from Kandinsky to Mondrian yearned for the purism of primitive design. The Expressionists seized the idiom of modern art, rooted as this idiom is in an interpretation of the meaning of primitive art, to express a personal art, from within, just as El Greco used the then existing Venetian dream to express his own personal vision. Modern sculpture likewise has its romance in primitive traditions; Brancusi in the pre-historic and the Negro, Henry Moore in Pre-Columbian Mexican sculpture, Lipchitz in a succession of primitive styles.

The Museum of Modern Art in New York has brought this inter-relationship between modern art and the art of primitive peoples up to date with its recent exhibition of art objects from the Oceanic Islands of the South Pacific. With this

Ambos Mundos 1 (June 1946): 51–55. By permission of the Barnett Newman Foundation.

The abstract painter Barnett Newman (1905–1970) wrote this essay in response to the "Arts of the South Seas" exhibition at the Museum of Modern Art. It was originally published in Spanish as "Las formas plásticas del Pacífico" and was not published in English until 1970, when it appeared as "Art of the South Seas" in *Studio International* (February 1970): 70–71.

exhibition, it is now clear that even Surrealism, which has always given the impression of being on the periphery if not outside the curve of the modern plastic revolutionary wave, is no exception to the romanticism of our time, that it had its romance in the art of the South Seas.

This has been the most comprehensive display of this art ever assembled and is perhaps the first aesthetic presentation of this material, making it an event of international importance.[2] It is interesting that except for the pieces brought from Australia to represent the art of its aborigines, the four hundred items collected have all come from American science museums. It has taken a war to make the American people tragically aware of this region as a cultural realm, until now known as some exotic paradise mortgaged to the travel agencies.

The scope of South Sea art is so vast (the label Oceanic compresses twenty cultures) that it would be incomplete to try a detailed analysis of it here, just as it would be insufficient to treat the history of Western European art in a phrase. South Sea art ranges from the ornate, rococo decorative styles of the New Zealand Maoris, to the functional simplicity of the Islands of Micronesia; from the expressionistic, semi-realistic art of Easter Island to the imaginative symbolism of New Ireland carvings; from the metaphysical drawings of the Australian Bushmen to the abstract art of the New Guinea Papuans.

Yet if it is permissible to isolate the distinguishing character of an art tradition, if it is permissible, for example, to describe Western European art as an art of the voluptuous; if it can be said that the distinguishing character of Negro African art is that it is an art of terror, terror before nature as the idea of nature made itself manifest to them in terms of the jungle; if Mexican art can be said to contain a terror of power,[3] then it can be said that despite its wide range, the distinguishing character of Oceanic art, the quality that gives us a clue to its difference from all other art traditions, is its sense of magic. It is magic based on terror, but unlike the African terror before nature this is a terror before nature's meaning, the terror involved in a search for answers to nature's mysterious forces.

All life is full of terror. The reason primitive art is so close to the modern mind is that we, living in times of the greatest terror the world has known, are in a position to appreciate the acute sensibility primitive man had for it. Yet though all men live in terror, it is the objects of terror that contain within themselves those elements of cultural interpretation that permit the differentiation of its various subjective expressions. Modern man is his own terror. To the African and to the Mexican, it was the jungle. To the South Sea Islander, it could not have been a like terror before an immobile nature, but a terror before forces, the mysterious forces of nature, the unpredictable sea and the whirlwind. In Oceania, terror is indefinable flux rather than tangible image. The sea and the wind, unlike the static forest and the jungle, approach metaphysical acts. Whether benign or catastrophic, they arise out of the mystery of space. The terror they

engender is not, then, a terror before an inscrutable nature but one that arises before abstract forces. The Oceanic artist, in his attempt at an explanation of his world, found himself involved in an epistemology of Intangibles. By coping with them, he developed a pictorial art that contained an extravagant drama, one might say a theatre, of magic.[4]

The exhibition in New York was so arranged that each grouping showed a fraternity with the several facets of our modern art movements. The functionalism of Micronesian objects mirror our own modern functional architecture and objects. It is very close to present constructivist concepts. The distortions of the Papuan shields and figures touch our abstract painters. Some of the distortions recall our Expressionists. But the overwhelming evidence emphasizes that the main point of contact is with our Surrealists.

We now know that for the Surrealists and for those movements now arising out of Surrealism the Utopian dream was not what so many supposed, the Renaissance, but the art of the South Seas. The link, of course, is only one of emotional attachment. We know that, historically, the Surrealists arrived at their statement through Freud. He was the catalyst who freed their unconscious selves to give them the hope that they might arrive through the free association of ideas and symbols at a magical world. They derived from him. Yet the relationship between South Sea art and Surrealism makes clear that the modern painter, no matter of what school, is emotionally tied to primitive art. The Oceanic artist and the Surrealist form a fraternity under a common fatherhood of aesthetic purpose.

Just as the exhibition clarified this fraternity, it also sharply exposed the fundamental cleavage between them which explains why the Surrealists failed to achieve this common purpose. It was almost as if the object lesson of this important exhibition was to demonstrate the failure of the Surrealists correctly to interpret the meaning of magic—that they comprehended only its superficial aspects. By insisting on a materialistic presentation of it rather than a plastic one, by attempting to present a transcendental world in terms of realism, in terms of Renaissance plasticity and Renaissance space, by so to speak, mixing the prevailing dream of the modern artist with the outworn dream of academic Europe, they hoped to make *acceptable* (the Surrealists prefer the term sur-real) what they consciously knew was unreal. This realistic insistence, this attempt to make the unreal more real by an over-emphasis on illusion ultimately fails to penetrate beyond illusion, for having reached the point where we see through the illusion, we must come to the conclusion that it must have been illusion for the artists themselves, that they practised illusion because they did not themselves feel the magic. For realism, even of the imaginative, is in the last analysis a deception. Realistic fantasy inevitably must become phantasmagoria so that instead of creating a magical world, the Surrealists succeeded only in illustrating it.

Here is the dividing line between the Surrealist and the Oceanic artist. We

Figure 33. Barnett Newman, *Pagan Void,* 1946. Oil on canvas, 33 x 38″ (83.8 x 96.5 cm).
© 2002 Barnett Newman Foundation /Artists Rights Society (ARS), New York.

know the primitive artist attempted no deception. He believed his magic. We feel it too, because we can see that it came from deep convictions, that it was an expression of the artist's being rather than his beliefs. Without any attempts at illusion, working directly, using the plastic means *per se,* the primitive artist gives us his vision, complete and with candour.

There is a new movement that has arisen here in America which shows through its works that it has, in effect, reinterpreted Oceanic art, that it has also set out on an art of magic, but that this time it is a visionary art, a subjective art without illusionary trappings. Their techniques are the techniques of modern abstract art but their roots lie in the same mythological subject matter that motivated the South Sea artist. They are thereby closer to him than the traditional Surrealists. However, an analysis of the work of this group is the subject of another article.

NOTES

1. David and Ingres, the French neo-classicists, had their dream in the Florentine Renaissance; Delacroix, leader of the French Romantics, in the Renaissance through the flamboyant Rubens from Flanders; Manet, the French Realist, found the Renaissance through the majestic, the baroque dream of Velázquez and Goya; while the Spanish Realists, seeking to glorify the reality of their times in terms of an earlier idealism, went to the Renaissance directly. The list can be amplified to cover every major figure and school of European art, yet it would be dangerous to value it more seriously than as an interesting phenomenon in the history of artist psychology. There should be no dialectical insistence of an "historic process" lest some *Kunstwissenschaftsmann* more interested in the "grand" conception than in truth choose to indulge in it to build a dialectic of purpose to the delight of our Hegel-intoxicated generation. The significance of this romantic urge among artists is that it makes clear the psychological need they had and have for emotional security in an Utopian dream based on the past. It is a search for a sense of fraternity. No more.

2. Europe and America have seen many grand exhibitions of African and Mexican art, but it is doubtful if South Sea art on such a scale has ever been shown anywhere.

3. The Mexicans carved the hardest stone without the benefit of metal tools and this victory over nature, this transcendental pride is visible in the heroic monumentality of their work.

4. In many of the islands, art objects were made in religious exercises by a special elite class in special ceremonies depicting a specific mystery and the objects then made were shown and destroyed immediately after the ceremony. Here religion was art and art was a religion.

BARNETT NEWMAN

NORTHWEST COAST
INDIAN PAINTING · 1946

It is becoming more and more apparent that to understand modern art, one must have an appreciation of the primitive arts, for just as modern art stands as an island of revolt in the stream of Western European aesthetics, the many primitive art traditions stand apart as authentic aesthetic accomplishments that flourished without benefit of European history.

On the American continent, along the Pacific coastline of Canada and southern Alaska, there emerged such an art, a valid tradition that is one of the richest of human expressions. Yet the art of the Northwest Coast Indian, if known at all, is invariably understood in terms of the totem pole. In assembling this exhibition of Northwest Coast painting, in honor of the opening of the new Betty Parsons Gallery (Mrs. Parsons must be congratulated for her long devotion to both modern and primitive art), I have been eager to shift the focus to this little-known work, which many anthropologists claim antedated the totem pole sculpture. Whether it did or not, it constitutes one of the most extensive, certainly the most impressive, treasuries of primitive painting that has come down to us from any part of the globe.

It is our hope that these great works of art, whether on house walls, ceremonial shaman frocks and aprons, or as ceremonial blankets, will be enjoyed for their own sake, but it is not inappropriate to emphasize that it would be a mistake to consider these paintings as mere decorative devices; that they constitute a kind of heightened design. Design was a separate function carried on by the women and took the form of geometric, nonobjective pattern. These paintings are ritualistic. They are an expression of the mythological beliefs of these peoples and take place on ceremonial objects only because these peoples did not practice a formal art of easel painting on canvas.

Foreword to *Northwest Coast Indian Painting,* exh. cat. (New York: Betty Parsons Gallery, 1946). By permission of the Barnett Newman Foundation.

This essay was written for the catalogue of the exhibition organized by Barnett Newman with the cooperation of the American Museum of Natural History. John Graham and Max Ernst also lent objects to the show. In 1944, Newman had organized a "Pre-Columbian Stone Sculpture" exhibition for the Wakefield Gallery in New York. The presence of Primitive art at Betty Parsons, a gallery that represented a number of leading abstract artists, reflects the deep interest of many New York School artists in Primitive art.

Here, then, among a group of several peoples the dominant aesthetic tradition was abstract. They depicted their mythological gods and totemic monsters in abstract symbols, using organic shapes, without regard to the contours of appearance. So strict was this concept that all living things were shown "internally" by means of bisection. It is this bisection of the animal, showing both parts of it, that gives the illusion of symmetrical pattern. Their concern, however, was not with the symmetry but with the nature of organism, the metaphysical pattern of life.

There is an answer in these works to all those who assume that modern abstract art is the esoteric exercise of a snobbish elite, for among these simple peoples, abstract art was the normal, well-understood, dominant tradition. Shall we say that modern man has lost the ability to think on so high a level? Does not this work rather illuminate the work of those of our modern American abstract artists who, working with the pure plastic language we call abstract, are infusing it with intellectual and emotional content, and who, without any imitation of primitive symbols, are creating a living myth for us in our own time?

D. H. KAHNWEILER

NEGRO ART AND CUBISM · 1948

About the year 1907, a few painters with their friends began to form haphazard collections of African Negro and Oceanic sculptures. I will not refer here to the actual details of this historical event: I have elaborated them in my *Juan Gris*.[1] The important fact is that we bought these sculptures as works of art, and not as objects of interest. It seems obvious that works so utterly different from those formerly admitted to the official aesthetic hierarchy should have some connexion with the aims the painters who attributed an artistic value to these sculptures had set themselves. Certainly, some of these painters were solely concerned with pure aesthetic enjoyment; others merely imitated the visual aspect of these sculptures.

Public opinion immediately connected *Cubism* with Negro art by styling the years between 1907 and 1909 as the "Negro period" in Picasso's work. This was its method of proclaiming that Picasso's paintings (the only Cubist painter known to a wider public at this time, thanks to his "Blue" and "Rose" periods) resembled African sculptures. However naïve this way of considering the question may be, it is correct in establishing a connexion between the *Cubist* painters and Negro art.

In fact, the same relationship does not exist between Negro art and that of the *other* painters who had begun to acquire African sculptures. Matisse, with his intelligence and acute sensibility, was capable of appreciating these sculptures at their true value; but neither his painting nor his sculpture shows any signs of this admiration. His works explain themselves without recourse to anything outside the European tradition. By their "primitive" appearance some of Derain's works are connected to Gauguin—or somewhat later to Gothic art—but not to the Negro artists. As for Vlaminck, the "barbaric" aspect of a few of his pictures—such as the "Baigneuses" of 1909—certainly shows the influence of the appearance of the African sculptures, but not the slightest understanding of their spirit.

Présence africaine 3 (1948): 367–77.

Daniel Henry Kahnweiler (1884–1979) was an important dealer in modern art, notably for the Cubists, and a prominent collector. Kahnweiler, who was an intimate of the artists at the time, makes a substantial connection between African art and Cubism. Especially noteworthy is Kahnweiler's notion that certain elements of Picasso's 1912 *Guitar*, which radically influenced the history of Western sculpture, were inspired by a Grebo mask, and that such masks allowed the painter to create invented signs that were removed from imitation, freed sculpture from mass, and led to the principle of transparent sculpture.

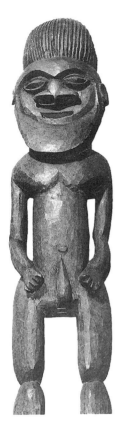
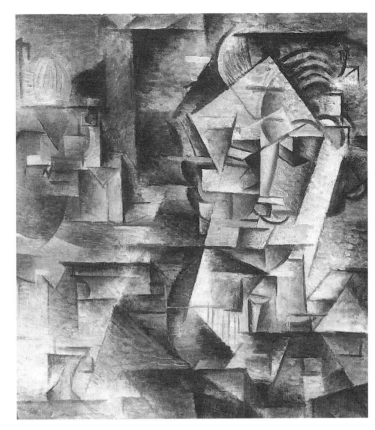

Figure 34. *Right:* Detail from Pablo Picasso, *Daniel-Henry Kahnweiler,* 1910, oil on canvas, 40 x 29″ (101.1 x 73.3 cm). Gift of Mrs. Gilbert W. Chapman in memory of Charles B. Goodspeed, 1948.561. Art Institute of Chicago. All rights reserved. © 2002 Estate of Pablo Picasso/Artists Rights Society (ARS), New York. Shown with detail of roof finial figure (which appears in the background of Picasso's painting), New Caledonia. Wood, 49⅝″ (126 cm) high overall. Musée Picasso, Paris. Formerly collection of Pablo Picasso.

If we admit public opinion was not mistaken in connecting Cubist painters and African sculptures, we must try to assess their true relationships. I have already said that we had begun to collect these sculptures as well as the objects of Oceanic art.[2] However, our interest was to concentrate itself more and more on the productions of Negro Africa. Nearly twenty years later, the Surrealists developed a passionate enthusiasm for Oceanic art. Nevertheless, I must, once more, dispute the validity of the thesis of a direct influence of African art on Picasso and Braque, the two Cubist painters of that time. The real question was one of convergence. European tradition and, in particular, the Cubist discovery of Cézanne's true intentions enable us to understand the *trends* which made their appearance in Picasso's "Demoiselles d'Avignon" (1907) and in Braque's landscapes of Estaque (1908). Their *appearance* (if an exterior cause is insisted on) is easily explained by the example of the painting, and, even more, by the sculpture of Gauguin during his stay in Oceania, both of which show the

285

Polynesian influence on this painter. This is not a question of an influence of Negro art on the Cubists, but rather of a phenomenon usual at the beginning of a break with the existing tradition. We try to reassure ourselves by finding elsewhere, in time and space, confirmation of the new trends we adopt. Other examples of this are the "Renaissance" rediscovering Greco-Roman art and the Impressionists' great enthusiasm for Japanese art.

How did African art corroborate the thought of the Cubist painters? What was its lesson? Once again, I must emphasize that these painters were aiming at as precise, as *absolute* as possible a *representation*, as well as at the creation of works with an *autonomous existence*. Such an art is essentially *conceptual*. Also years of work were needed in order to achieve a true conceptual art. The coloured artist always shows us what he *knows* and *not* what he *sees*. For example, he represents all the parts of the human body, carefully enumerating them. One day, Matisse, showing me a "seated woman" in his collection, drew my attention to the fact that the posterior of this woman, hidden by the seat of the chair, appeared *underneath* the chair. Negro sculpture displays things with the minimum of means. Its relief is simplified in the extreme, it suppresses everything which is not essential. The *unity* of every sculpture is complete, each component strictly subjected to the whole. What is more, in Negro art the Cubists rediscovered their own conception of the work of art as *object*. Impressionism, the extreme climax of an evolution which had begun with the Renaissance, had reduced the work of art to the role of a reflection of a momentary aspect of the exterior world, retained by the artist's imagination. Now, the plastic work of art differing, in this respect, from the literary work of art has an *objective* existence in the real world, and it is only by safeguarding this existence that the artist can be sure of transmitting to everyone, present and future, the lived experience which he means to snatch from the destructive action of time. The African artist creates real *objects* which, with their possibility of being put anywhere, demanding neither base nor plinth, and with no connexion to any pre-existing architecture, are pre-eminently real *sculpture*.[3]

At the outset, Cubist art was *static* to the point of appearing almost frozen. In Negro art it rediscovered another static art. What is still more important is that Cubist art was aiming at the creation of *plastic realities*. It repudiated the imitation of the consequences of merely a unique visual perception. Later, it was to lead to the invention of plastic signs meaning fairly obviously a "reality" of the exterior world, in order to "be" that reality. Now, an African sculpture *is a sign, an emblem,* in its entirety as it is in each of its details; it leads to the creation of the "reality" signified in the spectator's imagination. This arm, this leg, this chest, this sex—all of them are signs. The statue as a whole is a sign. By "reading" these signs we understand that it is a man, or a woman, who are even recognizable to the connoisseur as originally from a certain district, members of a certain tribe, or of some clan. The bare essential is intimated. The individual alone is

represented; often even the "terrasse," the usual plinth in European sculpture is missing.

In a very muddled way this is what we were discovering in Negro art. The Cubist painters felt themselves encouraged in their work by the existence of an art which they guessed to be closely related. We can see that the *appearance* of the Negro sculptures, which the people of that time thought they rediscovered in the Picasso figures of 1907 to 1909, did not play any part in the cult professed by the Cubist painters for African art. This appearance, which still struck most people at that date as *primitive,* had ceased to be primitive for them and appeared to be just the result of a correct and valid conception of sculpture which ought to become their own. A few years before, Aloys Riegl had published his *Spätrö-mische Kunstindustrie,*[4] and had been the first to demonstrate that all art is the perfect expression of its cultural milieu and that its "style" is never falsified by an *incapacity* (such as imitating the exterior world, for instance). This proposition robs the term "primitive" of all meaning, at any rate in so far as it is used in the pejorative sense which still persists to the present day. For us, Negro art was an art like all the others, an art which we rated very highly but which we were only just beginning to be acquainted with. I myself had hardly yet thought about it, and I did not know that it was an essentially *religious* art, an art which the need to represent mythological beings—gods, ancestors—in an invariable way deflected from the imitation of the variable, leading it to the representation of type. We know that this is equally true of Christian art, but the Judaic prohi-bitions against making idols has diverted it towards painting, whereas the African spirit finds its expression in sculpture.

Slowly we were learning to know more about African works of art. Only a few years later, the Cubist painters, having made a study of them, were to find in them a lesson whose results would be fundamental for *European sculpture.* The Cubists, we imagine, were chiefly interested in the problems of painting. Never-theless, after a certain time, they were prevented by what was at stake from limit-ing their researches in this way. The upheaval which they started communicated itself into sculpture. From then on, without knowing the exact reason for it, their efforts tended towards a *liberation* of the plastic arts by the affirmation of their real nature, which is that of *handwriting.* Plastic art is nothing but a hand-writing, although more or less irrational pre-occupations often divert an art to-wards aims which deny it the unequivocal manifestation of its nature as handwriting. It attains its freedom by admitting, by proclaiming this fact. No longer forced to attach itself to the imitation of the visible world whose frag-ments compressed in the mass of the statue or in the rectangle of the painting or bas-relief, knock into each other, injure each other, threatening to break the unity of the work of art, it can, in the interior of the work of art, build up signs which have come from its own essence, and which, in another respect, signify the exterior world. This is roughly what the Cubist painters felt. Negro sculp-

ture encouraged them in this direction. Imitation embarrassed them more and more. It was in opposition to the austere architecture they aimed at in their pictures. For this reason they revolted against the *means of illusion*. Of these, they were particularly shocked by chiaroscuro both because of its imitative character, and also by the falsification of local tone it required. Since 1909, Picasso had tried to introduce *real* relief—a very light relief—into a picture to avoid the *simulated* shadow; but this subterfuge could not satisfy the two Cubist painters. However, it led them to make a further study of sculpture and its means. On various occasions, Picasso had himself already made sculpture, but only one mask of 1907 showed an attempt at innovation in this art (a nose, represented in a non-imitative manner is "folded back" on to the side). A "head of a woman" from early 1910 appears to be an attempt to reproduce a "head and shoulders" independent of the surrounding light, by giving it its own light, which is achieved by means of an extremely indented and perforated surface, in such a way as to multiply the shadows. However, in spite of the truly novel appearance of this bust, this does not mark a real break with the tendencies of European sculpture, in particular with those of Rodin.

It took a long time for the Cubist painters to realize that European sculpture had completely degenerated, and that by the end of the nineteenth century it was in reality not even real sculpture any more, that is to say, sculpture with authentic three-dimensional validity. Ever since it began, European sculpture had been threatened by this danger. Born towards the end of the Christian Middle Ages, at its inception, it was forced to reckon with the iconoclastic tendencies of Christianity, link itself to architecture, and style itself as ornament, attaching itself to the wall, from which it breaks away in the Renaissance. The nineteenth century sees its decline and Impressionism completes its downfall. With Medardo Rosso and with Rodin, who was himself influenced by this forgotten Italian sculptor, it tries to envelop itself with its own atmosphere, and in this way loses, so to speak, its own limits, and what is more, its cubic *existence in space*.[5] Now this constitutes the very essence of sculpture. Like painting, bas-relief is forced to seek the support of a wall, carves an imaginary space out of the wall, unless it makes this imaginary space appear to exist between the spectator and the wall (as was the case both with the first Cubist paintings and the frescoes of Giotto and his contemporaries). It should be said here that this creation of space is the criterion of belonging to the figurative plastic arts other than sculpture in round relief. Decoration remains a flat ornamentation on the level surface; it creates absolutely no space for the spectator.

Negro sculpture itself pre-eminently possessed the *cubic existence* in real space, by which genuine sculpture can be recognized.[6] On the other hand, its very marked character as a "sign" preserved it from any confusion with human beings living in the same space. There is a danger of this when sculpture is imitative. It protects itself from this by various means: by dimensions smaller or larger

than life-size, by monochrome, or by a base which raises it above the people walking around. Picasso and Braque, discovering in Negro sculpture the qualities of *real sculpture*, had nevertheless not yet found a remedy for what embarrassed them so much in *painting*, that is to say, the need to use the means of illusion to depict volume. It is true that no one had yet really penetrated the character of the *signs* belonging to this sculpture. As a matter of fact, they were always trying to define the objects in the pictures by various figurations showing them from several sides. They placed these figurations *side by side* without succeeding in combining them, as Picasso did later on, into a single sign.

The beginning of synthetic Cubism is the crucial moment. From that time, the Cubist painters—Gris and Léger had just joined Braque and Picasso—resolutely dispensed with all imitation in order to create real *signs*. In so doing, they rediscovered the true direction of the figurative plastic arts. *Negro sculpture* permitted these painters to see clearly into the problems which had been confused by the evolution of European art, and to find a solution which, by avoiding every art of illusion, resulted in the liberty to which they aspired.

European sculpture, together with that of all the civilizations which had up till that moment entered the museums, preserves on itself an *uninterrupted surface* similar to that of all living entities, animals, plants, etc. In a sense, this "skin" is without any solution of continuity, and defines the limits of the person depicted. To put it briefly, it is possible to visualize these sculptures as mouldings on nature, mouldings which are sometimes deformed, drawn-out or compressed, but which always preserve a *compact structure,* without a crack, and whose surface constitutes the diagram of the person "read" by the spectator. *Now, in certain Ivory Coast masks, the Cubist painters discovered marks which, without recourse to imitation, compelled the spectator to imagine the face whose "real" shape these masks did not imitate. That, I am sure, was the decisive discovery which allowed painting to create invented signs, freed sculpture from the mass, and led it to transparency.* I do not affirm this without careful consideration. People will say that these painters could have found still more significant examples of open-work sculpture in certain Sudanese masks and in the sculptures of New Zealand. I am not so sure about this, for it seems to me that the solution found by the Ivory Coast sculptors goes much further than the simple transparent sculpture which still preserves an aspect of imitation. However, the fact is that Picasso had a wobé mask in his possession, and it is the study of this mask which originated the upheaval which took place at that time. Wobé masks, as is perhaps known, show, underneath a very high forehead slightly bent backwards, the lower half of the face as a flat surface from which *project* the triangular nose, the parallelepiped mouth and the *cylindrical eyes.* These cylinders are five centimetres wide and about ten centimetres high. All these signs, which have absolutely nothing imitative about them—notice particularly the representation of the eyes by cylinders in relief—create a face of compelling grandeur in the spectator's imagination.

289

We should carefully consider this: the wobé mask does not offer the spectator a ready-made diagram of this face in relief—however deformed it may be—as do Romanesque sculpture, Sumerian or Egyptian art. The boundaries of this face are only defined by the contour of the mask, not by its volume. The real "shape" of the face represented as it is seen forms itself in front of the mask, at the end of the cylinder eyes. In this way the eyes are seen in concave.

Now, let us consider the works of Picasso and Braque around 1912. Their paintings, with their "superimposed planes," are often only the transposition—I will even say the imitation—into *painting* of a *sculptural* means which found its legitimate use in Braque's paper reliefs which have been destroyed, and in Picasso's reliefs in various materials of which a few survive. By examining these (dating from 1913 and 1914) it is impossible to doubt my proposition that it was the wobé masks which opened these painters' eyes. For example, the hollow of the guitar in some of Picasso's reliefs is marked by a projecting lead cylinder, in others by a plastilene cone. How can we fail to recognise in these the means (identical in the first case) by which the Ivory Coast artists create a volume whose limits they only indicate by the height of the cylinders representing the eyes?

The kind of "transparency" which is thus achieved for the first time in *relief,* appears in *three-dimensional* European sculpture in Picasso's 1914 "Verre d'absinthe" of painted bronze. In this, the interior of the glass is simultaneously shown with its exterior shape. Perhaps someone will raise the objection that it is the transparency of the glass which is imitated in this way. Very likely. It is possible that Picasso needed this excuse to reassure himself, but it is no less true that the discovery of transparent sculpture is established by this glass and by the reliefs which seem to me considerably more important. Thus, in European art, *emblem sculpture replaces sculpture derived from mouldings on nature*, opening up the way to all that has been achieved since: "drawing in space," sculptures in iron wire, in string, in wicker, constructions in wood, iron, etc. Like architecture, such a sculpture creates *spaces* as well as volumes, thereby superbly increasing its scope.

It is quite useless for someone or other to boast of having been the first to make use of one of these new *techniques.* The works of the pre–1914 Cubist painters contained them all, implicitly. I will prove this. I am neither creator nor prophet. I have only conscientiously observed the efforts of my friends. Now, in my essay "Das Wesen der Bildhauerei," [7] written in 1915 and published in 1919, I said: "We feel that a *real* sculpture must be born. Many signs foretell it. What will it be like? By breaking the surface of bodies, will it show us them perforated, open? Probably. . . ."

It is certain that the *principle* of transparent sculpture had been found, since I was able to predict its advent. The Cubist painters had discovered this principle in the Ivory Coast masks, a principle which has played an important part in their liberating and constructive action. They also had made use of the same

means employed by the makers of wobé masks in order to create form. What is more, in doing this, they had understood the power of "plastic signs," and of "emblems," far removed from all imitation. The admirable liberty of the art of our time, which opens it up to unbelievable possibilities, we owe to the example of Negro art.

NOTES

1. *Juan Gris: His Life and Work,* by D. H. Kahnweiler. Lund Humphries, 1947.

2. *Negerplastik,* by Carl Einstein, the first book to appear on Negro art as art, makes no distinction between African and Oceanic art. It would be wrong to criticize it for this. It was concerned with the *plastic* discovery of these arts, not with ethnography. Their classification could wait.

3. Obviously, I am talking of the spirit which animates the whole of Negro sculpture. I know that decorative works exist, forming part of a whole; such as the bas-reliefs of Abomey.

4. At that time none of us knew about this book.

5. Of course, I realize how this destructive action contained simultaneously both the desire for and the possibility of liberation.

6. I only mean here Negro *statues.* The masks are *reliefs* and it is perhaps for this reason that they have been so instructive to the Cubist *painters.*

7. *Feuer,* Sarrebrück, Jahrgang I, Heft 2–3, November–December, 1919.

JEAN DUBUFFET

ANTICULTURAL POSITIONS · 1951

I think, not only in the arts, but also in many other fields, an important change is taking place, now, in our time, in the frame of mind of many persons.

It seems to me that certain values, which had been considered for a long time as very certain and beyond discussion, begin now to appear doubtful, and even quite false to many persons. And that, on the other hand, other values which were neglected, or held in contempt, or even quite unknown, begin to appear of great worth.

I have the impression that a complete liquidation of all the ways of thinking whose sum constituted what has been called Humanism and has been fundamental for our culture since the Renaissance, is now taking place, or, at least, going to take place soon.

I think the increasing knowledge of the thinking of so-called primitive peoples, during the past fifty years, has contributed a great deal to this change, especially the acquaintance with works of art made by these peoples, which have much surprised and interested the Occidental public.

It seems to me especially that many persons begin to ask themselves if the Occident has not many very important things to learn from these savages. It may be in many cases that their solutions and their ways of doing, which first appeared to us very rough, are more clever than ours. It may be that ours are the rough ones. It may be that refinement, cerebrations, depth of mind are on their side and not on ours.

Personally I believe very much in the values of savagery. I mean instinct, passion, mood, violence, madness.

Now I must say I don't mean that the Occident lacks savage values.

Even I think that the values held up by our culture don't correspond to the real frame of mind of the Occident. I think that the culture of the Occident is a coat which doesn't fit. Which, in any case, doesn't fit any more. I think this culture is very much like a dead language, without anything in common with the language spoken in the street. This culture drifts further and further from daily

Lecture at the Arts Club of Chicago, December 20, 1951, published as "Anticultural Positions," in *Arts Magazine* 53 (April 1979): 156–57. © Gallimard, 1967.

The French painter Jean Dubuffet (1901–1985), one of the leading artists of the postwar School of Paris, was associated with *art brut* ("raw art"), which was derived from his studies of Primitive art and the art of children and the mentally ill. Dubuffet gave this lecture in English.

Figure 35. Jean Dubuffet, *The Fine-Nosed Magus*, 1952. Oil on canvas, 24 x 20". © 2002 Artists Rights Society (ARS), New York/ADAGP, Paris.

life. It is confined to certain small and dead circles as a culture of mandarins. It no longer has real and living roots.

For myself, I aim for an art which would be in immediate connection with daily life, an art which would start from the daily life, and which would be a very direct and very sincere expression of our real life and our real moods.

I am going to enumerate several points concerning the Occidental culture with which I don't agree.

One of the principal characteristics of Western culture is the belief that the nature of man is very different from the nature of other beings of the world.

Custom has it that man cannot be identified, or compared in the least, with elements such as wind, trees, rivers—except humorously, as for poetic rhetorical figures. The Western man has, at least, a great contempt for trees and rivers, and hates to be like them.

On the contrary, the so-called primitive man loves and admires trees and rivers. He has a great pleasure to be like them. The primitive man believes the blossoming of the man is to be found by developing what, in the man, is like trees and rivers, and becoming something as a super-tree, a super-river.

He believes in a real similitude between man and trees and rivers. He has a very strong sense of continuity of all things, and especially between man and the rest of the world. Those primitive societies have surely much more respect than Western man for every being of the world; they have a feeling that a man is not at all the owner of the beings but only one of them among the others.

My second point of disagreement with Occidental culture is the following one. Western man believes that the things he thinks exist outside exactly in the same way he thinks of them. He is convinced that the shape of the world is the same shape as his reason. He believes very strongly the basis of his reason is well founded and especially the basis of his logic.

But the primitive man has rather an idea of weakness of reason and logic; he believes rather in other ways of thinking. That is why he has so much esteem and so much admiration for the states of mind which are called by us delirium and madness. I must declare I have a great interest in madness. I am convinced art has much to do with madness and aberrations.

I think this disposition of mind is also fairly characteristic of the so-called primitive societies.

Now, third point. I want to talk about the great respect Occidental culture has for elaborated ideas. I don't regard elaborated ideas as the best part of human function. I think ideas are rather a weakened rung in the ladder of mental function, something like a landing where the mental processes become impoverished, like an outside crust caused by cooling.

Ideas are like steam condensed into water by the contact with the level of reason and logic.

I don't think the greatest value of mental function is to be found at this landing of ideas and it is not at this landing that they interest me. I aim rather to capture the thought at a point in its development prior to this landing of elaborated ideas.

The whole art, the whole literature, and the whole philosophy of the Occident rest on the landing of elaborated ideas. But my own art and my own philosophy lean entirely on stages more underground. I try always to catch the mental process at a deeper point of its roots, where, I am sure, the sap is much richer.

Now, fourth. Occidental culture is very fond of analysis and I have no taste for analysis and no confidence in it. One thinks everything can be known by way of dismantling it, of dissecting it into all its parts, and studying separately each of these parts.

My own feeling is quite different. I am more disposed on the contrary to always recompose things. As soon as an object has been cut only in two parts, I have the impression it is lost for my study; I am further removed from this object instead of being nearer to it.

I have a very strong feeling that the sum of the parts does not equal the whole.

My inclination leads me, when I want to see something really well, to regard it with its surroundings, whole. If I want to know this glass on the table, I don't look straight at this glass, I look at the middle of the room, trying to include in my glance as many objects as possible.

If there is a tree in the country, I don't bring it into my laboratory to look at it under my microscope, because I think the wind which blows through its leaves is necessary for the knowledge of the tree and cannot be separated from it. Also the birds which are in the branches, and even the song of these birds. My turn of mind is to join with the tree always more things surrounding the tree, and further, always more of the things which surround the things which surround the tree.

I have been a long time on this point, because I think this turn of mind is an important factor of the aspect of my art.

The fifth point, now, is that our culture is based on an enormous confidence in the language—and especially the written language—and on a belief in its ability to translate and elaborate thought. That appears to me to be a misapprehension. I have the impression that language is a rough, very rough stenography, a system of algebraic signs, very rudimentary, which impairs thought instead of helping it. Speech is more concrete, animated by the sound of the voice, intonations, a cough, and even making a face and mimicry, and it seems to me more effective. Written language seems to me a bad instrument. As an instrument of expression, it seems to deliver only a dead remnant of thought, more or less as clinkers from the fire. As an instrument of elaboration, it seems to overload thought and falsify it.

I believe (and here I am in accord with the so-called primitive civilizations) that painting is more concrete than the written word, and is a much more rich and varied instrument for the expression and elaboration of thought.

I have just said, what interests me, in thought, is not the instant of transformation into formal ideas, but the moments preceding that.

My painting can be regarded as a tentative language fitting for these areas of thought.

I have come to my sixth and last point, and I intend now to speak of the notion of beauty adopted by Occidental culture.

I want to begin by telling you the ways in which my own conception differs from the usual one.

The latter believes that there are beautiful objects and ugly objects, beautiful persons and ugly persons, beautiful places and ugly places, and so forth.

Not I. I believe beauty is nowhere. I consider this notion of beauty as completely false. I refuse absolutely to assent to this idea that there are ugly persons and ugly objects. This idea is for me stifling and revolting.

I think the Greeks were the ones who first made this invention to purport that certain objects are more beautiful than others.

The so-called savage nations don't believe in that at all and they don't understand when you speak to them of beauty.

This is the reason one calls them savage. The Western man gives the name of savage to one who doesn't understand that beautiful things and ugly things exist and who doesn't care for that at all.

What is strange is that, for centuries and centuries, and still now more than ever, the men of the Occident dispute which are the beautiful things and which are the ugly ones. All are certain that beauty exists without doubt but one cannot find two who agree about the objects which are endowed. And from one century to the next it changes. The Occidental culture declares beautiful, in each century, what it declared ugly in the preceding one.

The rationalization of this is that beauty exists but it is hidden from view for many persons. To perceive beauty requires a certain special sense, and most people do not have this sense.

One also believes it is possible to develop this sense, by doing exercises, and even to make it appear in persons who are not gifted with this sense. There are schools for that.

The teacher in these schools states to his pupils that there is without doubt a beauty of things, but he has to add that people dispute which things are thus endowed, and that people have so far never succeeded in establishing it firmly. He invites his pupils to examine the question in their turn and so, from generation to generation, the dispute continues.

This idea of beauty is however one of the things our culture prizes most; it is customary to consider this belief in beauty and the respect for this beauty as the ultimate justification of Western civilization—the principle of civilization itself is involved with this notion of beauty.

I find this idea of beauty a meager and not very ingenious invention, and especially not very encouraging for man. It is distressing to think about people being deprived of beauty because they are too corpulent or too old. This idea that the world we live in is made up of ninety per cent ugly things and ugly places, while things and places endowed with beauty are very rare and very dif-

ficult to meet—I must say, I find this idea not very exciting. It seems to me that the Occident will not suffer a great loss if it loses this idea.

On the contrary, if he becomes aware that there is no ugly object or ugly person in the world and that beauty does not exist anywhere, but that any object is able to become for any man a way of fascination and illumination, he will have made a good catch. I think such an idea will enrich life more than the common idea of beauty.

And now what happens with art? Art has been considered, since the Greeks, to have as its goal the creation of beautiful lines and beautiful color harmonies. If one abolishes this notion, what becomes of art?

I am going to tell you. Art, then, returns to its real function which is much more significant than creating shapes and colors agreeable for a so-called pleasure of the eyes.

I don't find this function, assembling colors in pleasing arrangements, very noble. If painting were only that, I should not lose one hour of my time in this activity.

Art addresses itself to the mind, and not to the eyes. It has always been considered in this way by primitive peoples, and they are right. Art is a language, an instrument of knowledge, an instrument of expression.

I think this enthusiasm about the language of the words, which I mentioned before, has been the reason our culture started to regard painting as a rough, rudimentary, and even contemptible language, good only for illiterate people. From that, culture invented, as a rationalization for art, this myth of plastic beauty, which, in my opinion, is an imposture.

I just said, and I now repeat, that painting is, in my opinion, a language much richer than that of words. So it is quite useless to look for rationalizations in art.

Painting is a language much more immediate and at the same time much more charged with meaning. Painting operates through signs which are not abstract and incorporeal like words. The signs of painting are much closer to the objects themselves. Further, painting manipulates materials which are themselves living substances. That is why painting allows one to go much further than words do in approaching things and conjuring them.

Painting can also—and it is very remarkable—conjure things more or less as wanted. I mean: with more or less presence; that is to say: at different stages between being and not being.

At last painting can conjure things, not isolated, but linked to all that surrounds them; a great many things simultaneously.

On the other hand, painting is a much more immediate and much more direct way than the language of words, much closer to the cry or to the dance; that is why painting as a way of expression of our inner voices is much more effective than that of words.

I just said that painting, especially much better than words, allows one to express the various stages of thought, including the deeper levels, the underground stages of mental processes.

Painting has a double advantage over the language of words. First, painting conjures objects with greater strength and comes much closer to them. Second, painting opens to the inner dance of the painter's mind a larger door to the outside. These two qualities of painting make it an extraordinary instrument of thought, or if you will, an extraordinary instrument of clairvoyance, and also an extraordinary instrument to exteriorize this clairvoyance and permit us to get it ourselves along with the painter.

Painting now can illuminate the world with wonderful discoveries, can endow man with new myths and new mystics, and reveal, in infinite number, unsuspected aspects of things and new values not yet perceived.

Here is, I think, for artists, a much more worthy job than creating assemblages of shapes and colors pleasing for the eyes.

JEAN LAUDE

FRENCH PAINTING AND NEGRO ART · 1968

INTRODUCTION: THE PROBLEM

"About the year 1907, a few painters with their friends began to form haphazard collections of African Negro and Oceanic sculptures. . . . It seems obvious that works so utterly different from those formerly admitted to the official aesthetic hierarchy should have some connexion with the aims the painters who attributed an artistic value to these sculptures had set themselves. Certainly, some of these painters were solely concerned with pure aesthetic enjoyment; others merely imitated the visual aspect of these sculptures."[1] D. H. Kahnweiler's thoughts pose a series of problems that can be distinguished only theoretically: *historical problems* concerning the artists' new acquisitions, beginning with the first years of the twentieth century; and *aesthetic problems* concerning issues of borrowing and influence. Together with these problems, we must articulate others posed by the meanings of these events and borrowings; it is no longer possible today to isolate an area of human activity and abstract it from its relative situation within a complex set of circumstances that form the character of civilization.

CIRCUMSTANCES OF DISCOVERY

The meaning of a fact lies not so much within itself as in the system of relations that it maintains within a specific historical milieu. The discovery of the art of Benin by the Portuguese at the end of the fifteenth century does not have the same meaning, and did not have the same effects, as the rediscovery of this art by the whole of Europe after the English punitive expedition of 1898. And when the painters in Paris or Dresden were collecting masks and statuettes from Black Africa a little less than ten years after the dispersal of the war booty that was brought back to England, this fact meant something different again.

The discovery of what was then called "colonial art," which included Oceanian as well as African sculptures, seemed to be part of a general movement of return to beginnings, of which this was merely a particular aspect. This movement had begun well before the first decade of the century, and it was not limited to art alone. It coincided with the circling of the planet by the European coloniz-

Excerpt from Introduction to *La Peinture française (1905–1914) et "l'art nègre"* (1968), 9–19.

This book by the French art historian Jean Laude (1922–1984), who wrote extensively on both modern art and African art, was only the second major scholarly book on Primitivism and modern art.

ing powers. It expressed itself in literature by accentuating the exotic trends and, almost immediately, by provoking a critical reflection on exoticism. Finally, this was the time when ethnographic museums were established, with the purpose of gathering and displaying products created in the countries visited by travelers, subdued by soldiers, and occupied by colonists. Since this time, ethnology has attempted to constitute itself as an original science, defining the methods that are distinct to it and establishing the kinds of problems it will take up.

Discovering new continents that it attempts to control, Europe discovers at the same time some new problems. Paradoxically, at the very moment when it affirms itself materially by way of the civilizing mission it attributes to itself as a matter of course, it can no longer think of itself as being so special. Its universalism—in whose name it brought civilization to *savage* and *primitive* peoples, and which was supposed to legitimize its enterprises intellectually and morally—turns against it. More exactly, it forces a revision and a modification of certain values and calls into question its ethnocentric prejudices; through the labors of its ethnologists the notion of the relativism of cultures progressively develops.

Furthermore, in its very heart, Europe is swept by obscure forces. It is no coincidence that interest in the *savage* and the *primitive* grows along with industrialization and urbanization. But we should be careful to qualify this observation: sometimes this interest seems to signal the refusal of modern life; at other times it is a positive sign, indicating affiliation with the modernist movement.

FASHION AND NEGROPHILIA

The arts of Black Africa were discovered at or about the same time as other nonclassical and non-European arts. But we tend to think of them when we speak of an impact on contemporary painting and of the crucial influence in the orientation of this painting after their discovery. To quote Mr. D. H. Kahnweiler again, "The admirable liberty of the art of our time, which opens it up to unbelievable possibilities, we owe to the example of *Negro art*."[2] Japanese prints, Egyptian sculpture, Tahitian and Marquesan tikis and tapas, Islamic arabesque script—these all played a part in the art of the end of the nineteenth century and in some works of Matisse or Picasso. Their role was a limited one, however, and they did not give rise to a movement, at least in the same sense as the African arts did.

In 1920, J. Cocteau replied to a questionnaire of the review *Action:* "The Negro crisis has become as boring as Mallarméan Japonisme."[3] Was this a joke, a fit of bad temper, or the tactical skill of a man who, always thinking in terms of fashion, was trying to anticipate it? If he had some such scheme in mind, it wasn't exactly crowned with success; it was premature, as witnessed by a letter addressed by J. Cocteau to "Paul Guillaume, Slavetrader": "Your little Negro fetishes protect our generation, whose task it is to build on the ruins of impres-

sionism. Youth is turning toward more robust models. This is the only way that the universe can become the pretext for a new architecture of sensibility instead of ever glistening between the sun's distant lashes. . . . Negro art therefore is not just a deceptive lightning bolt from childhood or madness, but rather it arises from the noblest stages of civilization." [4] This letter is dated 1923.

Possibly J. Cocteau didn't really believe his prognostication of 1920 and was only trying to be a little provocative. Or else, by 1923 he had reconsidered: what he was in a hurry to store in the warehouse of obsolete accessories had much more life in it than he had supposed. The events that followed must have proved this beyond a shadow of a doubt. In fact, we need only think of the increase in interest in African arts, which culminated in about 1931, with the Colonial Exhibition at Vincennes; the great exhibition organized by Philippe de Rothschild at the Pigalle Gallery; and the sale, at the Hotel Drouot, of the collection of G. de Miré and those of Paul Éluard and André Breton. Not only did the exhibitions multiply, in France and abroad, but numerous works were published, new private collections were assembled, and, in particular, an international market for Negro sculpture was created.

Starting in 1919, African art progressively moved into public awareness and into the commercial circuit, becoming an integral part of the aesthetic pantheon and of imaginary museums. All of this is significant in ways that, in spite of appearances, are difficult to pinpoint.

APPRECIATION AND INFLUENCE OF THE ART

If we wish to analyze this phenomenon more closely so as to isolate its meaning, we find ourselves confronted with two categories of notions: those that concern the *presumed* influence of Negro art on painting and sculpture at the beginning of the twentieth century; and those that relate to scientific ideas on the subject of the *primitive arts* and to the development of museums. Neither the scientific ideas nor the establishment of specialized museums impinged, at least immediately, on the tastes and reflections of enthusiasts and artists. But the interest that artists showed for it sensitized a more and more widespread public towards *Negro art*. We may opine even farther: scientific investigation was enormously stimulated by the artistic movement that preceded it, even if later on the scientists needed to nuance, qualify, and criticize some hasty or premature generalizations and risky propositions that were too absolute or were simply badly stated.

These two categories of notions define only one aspect of the problem regarding the atmosphere in which Negro art came to be known. The introduction of African Negro sculpture into the aesthetic pantheon and commercial circuits is another circumstance, of limited though noticeable importance; it does not establish very much regarding the eventual influence of this sculpture on modern art; it does not allow us to decide whether this influence was real,

apparent, illusory, or sporadic, whether it was a phenomenon of great significance characterizing a great tangent of contemporary art, or whether it was purely and simply a fad.[5]

We are dealing here with two kinds of factors that really constitute separate domains, with no necessary connection between them. An interest in an archaic or exotic nonclassical art does not deeply impinge, *ipso facto,* on efforts that are contemporaneous with its discovery. In this way pre-Columbian arts were known (and appreciated) from the end of the nineteenth century: We may cite the great Central American exhibition in Madrid in 1893, which was followed, in 1920, by that of the Burlington Fine Arts Gallery in London. In 1928, in Paris, the Museum of Decorative Arts (Marsan Pavilion) presented "The Ancient Arts of America," and the G. van Oest publications began, under the direction of Paul Rivet, a collection of monographs, Ars Americana, whose purpose was to acquaint the public with Ecuadorian ceramics and sculpture, Columbian metalwork, Mexican art, etc. Certainly these arts—displayed, collected, traded, and commented on, and also associated with a style of novel, of which D. H. Lawrence's *The Plumed Serpent* is the premier example—had practically no impact on modern art, except one that was very sporadic (a few works by Paul Klee) or delayed (in a few of Bissière's works, inspired by Peruvian fabrics). They cannot be considered as having stamped their characteristics on the great current of contemporary art.

THE PROBLEM OF BORROWINGS

These remarks introduce us to an important problem. Even if it was sporadic and did not initiate a transformation of received values, an influence cannot be absorbed (or welcomed) except under certain conditions, which singularly limit its effectiveness.

But, for a start, what do we understand by *influence?* More exactly, confronted by what facts, and based on what observations, are we entitled to speak of influence?

We should not limit this inquiry to a report on the resemblances between the forms in a particular painting and a particular mask or sculpture. The establishing of two parallel series would result in an inventory, a not very significant one, of the directly borrowed forms. Besides, it would be quite illusory; on a certain level of abstraction, a form or a sign is in no way characteristic of a style or even of an art. We can easily confuse the elements borrowed from two kinds of statuary that have no connection either in time or in space. The fact is that these elements, at least in archaic or *primitive* arts, are not particularized to the point that they would reveal to the questioner their true origin, their identity. If some pertinent trait is sometimes attributed to them, it is not because of their appearance (because of a stylistic particularity) but rather their meaning within a framework of groups into which they are integrated.

Facial concavity appeared on certain figures that Picasso created in the course of the winter of 1907–8. We also find it in a certain number of African styles: in the statuary of the Senufo (Ivory Coast Republic), the Fang (Gabonese Republic), and Warega (Republic of the Congo, Leopoldville), but also in non-African works; for instance, on the great sculpted ferns of the New Hebrides.

The source of a borrowing can be identified only if we find it in the group of which it is a part, and not in isolation; only if there is proof of the existence of a work in the artist's immediate surroundings that could have commanded his attention. There are, in art, fortuitous encounters that can orient work in an imaginative vein. Certain works by Alberto Giacometti seem to have been directly inspired by Tellem statuettes (Republic of Mali). Now, these statuettes, covered with a clotted sacrificial coating, and erected in space according to the delicate rules that govern their vertical structure, arrived in Europe only in 1954, at a time when the sculptor had already created most of his figurines. No doubt Giacometti was already interested in archaic and African arts, and the encounter could have been something that was anticipated long before.[6] But in fact the Tellem statuettes have a unique, characteristic physiognomy that sets them apart from other African productions. Furthermore, the preoccupations of Giacometti—when he did his small sculptures—were not in any way concerned with an exploration of an archaic or primitivistic connection.

It is important not to allow ourselves to be misled by appearances but to try to see beyond them, to determine to just what extent it will be legitimate to deal with them on a different level. There are, in fact, works where no artificial resemblance alerts the eye, works from which all direct reference has been abolished, and yet we still are able to discern in them an influence, as secret and almost invisible as it may be. In 1913, Picasso composed a collage, *Guitar and Flask,* which no longer exists today. It had no apparent connection to African sculpture, whereas the great nudes of 1908 prominently proclaimed their affiliation with a system of forms borrowed from Senufo sculpture. Nevertheless, the collage is possibly the work where we find the most manifest integration—or, if you prefer, assimilation—of a plastic lesson derived from African sculpture. This is the work that, through an element directly borrowed from a Wobé mask (Republic of the Ivory Coast), acquired a quality whose significance would be immense, especially for sculpture, and would certainly be recalled by such artists as Henri Laurens.[7]

All the same, it would be tendentious to locate the problem only between two poles, one constituted by the presence of formal analogies that are immediately noticeable, and the other by the complete integration of a solution to plastic problems as defined by works for which an original model no longer exists.

Few works of Vlaminck show any evidence, in their formal structure, of the stupendous emotion that the painter says he experienced when he discovered *Negro art,* and that he insists on recalling in numerous writings and testimonies.

Must we then assume that the African sculptures that he collected until the end of his life had no impact on his art? Our appreciation of such factors would indeed be very defective if we were to pay attention only to those that relate to formal analogies, at the expense of those that define, in some way, a psychological orientation, through an ambiance or an environment. It is quite clear that Vlaminck understood *Negro art* through his own subjectivity. Nevertheless, even from the strict point of view we are following here, Vlaminck's interpretations of African statuary cannot and should not be rejected on the pretext that they are incorrect and even absolutely untenable.

On the other hand, some artists—and Juan Gris is among them—have taken from their experience of Black sculpture a set of general aesthetic principles which reinforced those that they were already developing in their own works. But it would be profoundly unjust toward a body of a work that, in spite of the efforts of some great critics and writers, is not yet getting the respect it deserves, to limit it to the application of theoretical principles derived from intellectual reflection. Just as in the work of Vlaminck, but for diametrically opposed reasons, African art is at once present and absent in the painting of Juan Gris. Absent, for you would look in vain for formal analogies, be they limited to details or not. Present, since Juan Gris had perhaps the best sense of the profound originality of the African aesthetic, an aesthetic that he personally felt very close to.

DIVERSE INTERPRETATIONS OF AFRICAN ART

You may guess from what we have said that the influence of African art at the beginning of the century was not uniform and that it was exerted in as many ways as there were painters to receive and accept it. This is only a superficial appearance, which certainly has to be taken into account in order to distinguish differences and nuances in interpretation. But behind it, we quickly find affinities and connections, even if they were provisional, or seemed so at the moment, though not over time.

In other words, what first seemed like individual styles of interpretation of African art belongs in fact to a more general tendency, shared by many different personalities. This community of tendencies should be understood for what it was in itself, but equally in regard to what it became afterwards. The work of Picasso and Braque, between 1910 and 1914, was guided by the same hypotheses. In a sense, in spite of the differences in the way they were produced, the works of these painters are part of the same movement, so much so that it is difficult, at first glance, even to distinguish them. But after 1914, the art of Braque and that of Picasso recover their autonomy; they each, according to the bent of their personality, develop aspects of their work that they had shared for a while.

Events must be understood both according to their immediate value and significance (what they mean when they occur) and to their value and meaning

relative to what preceded and followed them. As soon as we start being more rigorous in our analysis and interpretation of African art, we become aware that there were—beyond immediate differences and independently of later divergences—common tendencies, not limited to a single individual. Quite rapidly, divisions between schools of thought and geographical borders disappear. Before 1914, Vlaminck and Derain were closer to the Dresden painters than to Matisse. Similarly, the official names of the schools that have succeeded each other since Impressionism should be either entirely abandoned or at least very much altered. To begin with, they compartmentalize dynamic phenomena too strictly while masking external liaisons. Then they enclose under the same rubric undertakings that are sometimes divergent and that we could not confuse. Finally, they imply that art develops according to a process that is linear and nearly ineluctable. This, as we shall see, contradicts the facts and seriously distorts our viewpoint; it also implies, through the notion of an organic evolution, the idea that the artists of today would be somehow the "primitives" of a future art, that of the twentieth century.

The great creators of the beginning of the century worked simultaneously with many hypotheses, which they deepened or abandoned, and to which they returned sometimes after having deserted them; their perspective always remained open. A solution can lead to another that continues it; on the other hand, it can just as well lead to nothing at all.

Art history today cannot be seen as developing according to a unilateral, linear, logical, and quasiorganic process. A threshold that has been passed does not determine one that will follow. The field of possibilities does not shrink with each new addition but, on the contrary, spreads out like a fan. From each victory in the plastic and aesthetic order—a victory that is always threatened, in the sense that the artists and their demons of doubt and investigation ceaselessly call it into question[8]—the painter can create a series of works in which he exploits the results of an experiment, developing and deepening it. But he can also find himself confronted, sooner or later, with different options which push that series into the past. Or instead of exploiting new findings, the series may simply be a process of investigation.

We may see here the risks and dangers of the retrospective view: it connects in a necessary, even predetermined order empirical activities whose purpose is rather to break or violate limits, to widen the field of inquiry through hesitations, investigations, and changes in orientation. But it is impossible to fragment the unity of creation of a great artist without fragmenting his unity of consciousness. And that is the rub. You cannot establish a succession of plastic events as if they led from one to the other, when they are actually attempts at abandonment or renewal, in fact, *experiments*. But these attempts and these experiments are an integral part of the unity of a painter's work overall, of the consciousness of that painter, which they constitute. Additionally, they are meaningful in them-

selves and relative to the groups of each of the painters and of all contemporary painters participating in the same tendencies.

The notion of "investigation" should not be understood as expressing the pursuit of a more or less clear purpose the artist would aim at directly; rather, it describes a series of experiments—sometimes very divergent—meant to widen the range of possibilities that are offered for creative activity at a given moment.

This is the problem: to appreciate the novelty and the meaning of an event in relation to what preceded or surrounded it at the moment it was produced, without being prejudiced by its consequences; then to resituate this event, with its differential factor thus defined, within the body of work that followed it, to try to evaluate its consequences and their real import.

THE SIGNIFICANCE OF A DISCOVERY

To discover *Negro art,* to place it in the aesthetic pantheon, to effect limited borrowings, or to accept influences that are more than merely formal—this is to break with a past, to innovate and more or less commit the future to a quest. This is also to become committed to the meaning of this quest, whether it be situated in immediate and visible applications of a borrowing that is recognized as such, or whether it slides, like a thread through the warp, into a more extensive current.

There are indeed discoveries—and rediscoveries—that have no future; but there are others which seem like a privileged and exemplary manifestation of a change of orientation, of which they are somehow the sign or symptom.

As we have established, the discovery of *Negro art* is part of a general movement which tends to qualify or requalify in the aesthetic order works belonging neither to classical occidental art nor to the Greek or Roman tradition. The interest now being shown in archaic, exotic, *primitive,* or even popular arts of all countries and times is possibly only an extension of the interest in that which was called *colonial art* around 1908. This interest has not ceased or even lessened with the presumed influence of this colonial art on contemporary art; it continues to expand, as evidenced by the multiplication of private collections, as well as exhibitions, scientific or popularizing works devoted to African sculpture in general or to one or another of its aspects, and the increase of commercial activity involving Black art.

On the other hand, numerous painters or sculptors (Lapicque, Magnelli, Jacobsen, Soulages, et al.) possess in their homes and studios masks and statues that have no impact on their own productions. And, in numerous private collections, these masks and statuettes are displayed next to works (paintings and sculptures) of very different aesthetic tendencies: with Rouault, Soutine, or even Renoir and Maillol, with Braque, Picasso, and Léger, with Pevsner, Magnelli, Kupka, Herbin, Giacometti, Dubuffet. In other words, African art is associated, in the same groups, with practically all trends in modern European art since impressionism.[9]

As there was not always any influence, it would not make sense here to establish a direct connection between the two types of art. On the other hand, it is possible to see in the association of the two arts the expression of both a meaning and a direction which underlies the interest that has been shown in African Negro sculpture. This interest has been extended to all the archaic arts, from ancient to so-called primitive ones, but it crystallized around productions of the Dark Continent that thereby came to exemplify a tendency in taste that has been affirmed and accentuated since the beginning of this century. Two categories of facts have been distinguished, in the preceding discussion; namely, phenomena of borrowing (or of influence) that exclusively concern the producers, and phenomena of interest (or of taste) that concern the consumers. A connection can be established, provisionally and as a simple hypothesis. What the enthusiast is looking for in modern art (independently of his aesthetic allegiance) and in Negro art (or more generally in archaic and "primitive" art)—would it not be one and the same thing?

A borrowing may become decisive not at the moment when it is effectuated but within the framework of a later development, in the chronological whole where it has taken its place. The utilization of two Congolese masks on the right side of the *Demoiselles d'Avignon* should be understood in relation to the painting and to the consequences they had for Picasso in terms of the character of his future work. Would a borrowing then be only a kind of chemical agent that precipitates a solution? Or does it really cause the mutation of a system or its conversion into another system?

Without minimizing the "phenomena of artistic inspiration or creation by way of ancient or exotic works," writes Mr. R. Passeron, we should remark that these works, already known or lying dormant in curiosity shops, "suddenly took on their status as sources only for an epoch and for artists whose problems and investigations had evolved in a certain direction and so were corroborated and catalyzed by this 'revelation.' And this evolution, which makes of the borrowing a choice, and of the influence a revolution, implies, for the painter, an underlying intention of tearing himself away from all possible repetition, in general quite comfortable, of what his most immediate masters have taught him."[10] The last sentence perhaps tends to overestimate the psychological aspect of the problem at the expense of its meaning in a historically situated whole. But it is quite true that a revolution is sudden only if we judge it by its explosion. In fact, there is no such thing as an overnight conversion. And any "revelation" is less about the object that provoked it or occasioned it than about that deep content which the object brought to the surface. It is possibly not Negro art that modern artists discovered at the beginning of the century, but more likely modern art that they discovered by discovering Negro art. Far from being a revelation, *Negro art* would seem to have been more of a *revealer.*

NOTES

1. D. H. Kahnweiler, "Negro Art and Cubism," *Présence africaine* 3 (1948), p. 367; reprinted in *Confessions esthétiques* (Paris: Gallimard, 1961). [Kahnweiler's complete text is given on p. 284, above. Eds.]

2. Ibid, p. 377.

3. "Opinions on Negro Art," *Action* 3 (April 1920), p. 24.

4. J. Cocteau, "Letter to Paul Guillaume, Slavetrader," *Das Querschnittbuch* (Frankfurt am Main, 1923), p. 64. The following lines are excerpted from a letter that Jean Cocteau wrote us, dated January 10, 1954: "Yes, we've all passed by way of Negro art, and recently I've seen in a Resnais film (censored by the Colonial Ministry) that Negro art surpassed Greek art and went back much farther in time than the fetishes and masks that I have been acquainted with."

5. This was the opinion of Mr. P. Francastel, who wrote in 1944: "Let's consider Negro art, for example. If you think of its immediate repercussions, we must admit that they were mediocre, having produced more in the way of trial works than really finished ones. . . . Negro art therefore seems to have been, at least for the moment, a manifestation of fashion and not really a major current of contemporary art." P. Francastel, *Nouveau dessin, nouvelle peinture* (Paris, 1944), p. 148.

6. Principally in certain sculptures in his "surrealist" period (1925–35). The *Woman* (sometimes called the *Spoon-Woman*) of 1926 can be likened to certain sculpted spoons of the Ivory Coast Dan people, with a head sculpted on their handle. Cf. J. Dupin, *Alberto Giacometti* (Paris: Maeght, 1963), p. 193. J. Dupin notes that at the time when Giacometti was working on this sculpture, "he welcomed and benefited from numerous influences, through curiosity and the desire to see and experience: the archaic and primitive arts; and the arts of the moderns, particularly that of the cubists, Laurens and Lipchitz" (op. cit., p. 391). On the nature of his interest in archaic or exotic sculpture, Giacometti explained, during a radio interview with G. Charbonnier: "The sculpture of the New Hebrides is true and truer than true, because it looks. This is not just the imitation of the eye, this is really a gaze. Everything else is only support for the looking. . . . If the gaze, that is to say life, becomes the essential thing, then there can be no question but that the head is the most important part. The rest of the body is reduced to the role of antennae that make life possible for the figures—a life which is located in the cranial cavity." G. Charbonnier, *Le Monologue du peintre* (Paris: Julliard, 1959), pp. 166–67. On this matter, we would like to refer the reader also to our study "The Solitary Struggle of Alberto Giacometti," *Critique* 199 (December 1963).

7. The mask and the collage are reproduced in Kahnweiler, "Negro Art and Cubism," pp. 374–75. (The reproductions are of very bad quality.) Picasso has confirmed Kahnweiler's interpretation, and the correctness of the borrowing, to M. Leiris.

8. On the hesitating and investigative structure of this phenomenon, cf. R. Passeron, *Pictorial Work and the Functions of Appearance* (Paris: Vrin, 1962). The author, who is a painter, also speaks of experiments: "Each production of the investigator, acquiring its status as work through an ensemble at once personal (taking into account partial ensembles, called phases of the painter) and shared (role of schools and movements) into which it has been integrated, is at once incomplete as such, or incomplete in terms of the ongoing investigation, and complete as an experiment, an attempt, or a stage. The failure of a drawing, an abandoned sketch, are, from this perspective, completed experiments, if it has been possible to form conclusions on that basis, to

learn something and pass on. This structure of abandonment is worthy of some special attention here, in any case: in this often very painful stage of the process the different drafts that were produced maintain temporarily a kind of equality in failure or success. All are indications. None is decisive. The whole series will pass, as one block, into the past, when the problems that were confronted with such hesitation are posed more clearly, or perhaps suddenly resolved."

9. I will allow myself here to refer to the first part of our film *Negro Art* (made with M. R. Berue and produced by Caravelle Films), where we studied the different ways in which the West has understood African sculpture. In the film, this sculpture is presented in its setting in various Parisian collections.

10. Passeron, *Pictorial Work,* p. 239.

PART IV

THE MUSEUM OF MODERN ART'S 1984
PRIMITIVISM EXHIBITION AND ITS AFTERMATH

The Museum of Modern Art's " 'Primitivism' in 20th Century Art" exhibition, and the controversy that surrounded it, precipitated great changes in thinking about the subject. It revealed a shift in cultural values marked by a new relativism and a concomitant rejection of Eurocentric thinking. The texts presented in this part of the book discuss those changes. They show how attitudes toward Primitive art and Primitive cultures underwent a distinct transformation, suggesting that the idea of Primitivism had not been fully historicized but was still very much part of an ongoing cultural debate.

WILLIAM RUBIN

MODERNIST PRIMITIVISM · 1984

No pivotal topic in twentieth-century art has received less serious attention than primitivism—the interest of modern artists in tribal[1] art and culture, as revealed in their thought and work. The immense bibliography of modern art lists only two instructive books on the subject: the pioneering text by Robert Goldwater, first published almost half a century ago, and that of Jean Laude, written two decades ago, considerably more limited in scope, never translated from the French, and long out of print. Neither author had access to certain important collections, that of Picasso among them, or to much significant documentation now available. The need for a scholarly literature consistent with the historical importance of the subject is reflected in the unusual scope of the present undertaking—though, at best, this book is but a beginning.

Upon reflection, it is perhaps not surprising that primitivism has received so little searching consideration, for intelligent discourse on the subject requires some familiarity with both of the arts whose intersection in modern Western culture accounts for the phenomenon. The studies of the two have traditionally remained separate. Until fairly recently, tribal objects were largely the preserve, at least in scholarly and museological terms, of ethnologists. Only since World War II has the discipline of art history turned its attention to this material, however, graduate-level programs in Primitive art are still comparatively rare, and few of their students are also involved in modern studies. It should come as no surprise, therefore, that much of what historians of twentieth-century art have said about the intervention of tribal art in the unfolding of modernism is wrong. Not familiar with the chronology of the arrival and diffusion of Primitive objects in the West, they have characteristically made unwarranted assumptions of influence. As an example, I cite the fact that none of the four types of masks proposed by eminent scholars as possible sources for *Les Demoiselles d'Avignon*

Excerpts from "Modernist Primitivism: An Introduction," in *"Primitivism" in 20th Century Art: Affinity of the Tribal and the Modern,* exh. cat. (Museum of Modern Art, 1984), 1–7, 17–18, 20–28, 71, 73.

The then Director of Painting and Sculpture at the Museum of Modern Art, William Rubin (b. 1927), was the organizer, with Kirk Varnedoe, of the 1984 exhibition " 'Primitivism' in 20th Century Art." He also edited its elaborate catalogue, for which this text served as the introduction. In order to save space, most of Rubin's footnotes have been omitted; although they are of great interest in themselves, many are not essential to the central argument of the excerpt that we reproduce. Readers are referred to the original publication for the full scholarly documentation.

315

could have been seen by Picasso in Paris as early as 1907 when he painted the picture. On the other hand, few experts in the arts of the Primitive peoples have more than a glancing knowledge of modern art, and their occasional allusions to it sometimes betray a startling naïveté.[2]

The quite different kinds of illumination cast upon tribal objects by anthropologists and by art historians of African and Oceanic cultures are ultimately more complementary than contradictory. Both naturally focus on understanding tribal sculptures in the contexts in which they were created. Engaged with the history of primitivism, I have quite different aims; I want to understand the Primitive sculptures in terms of the Western context in which modern artists "discovered" them. The ethnologists' primary concern—the specific function and significance of each of these objects—is irrelevant to my topic, except insofar as these facts might have been known to the modern artists in question. Prior to the 1920s, however, at which time some Surrealists became *amateurs* of ethnology, artists did not generally know—nor evidently much care—about such matters. This is not to imply that they were uninterested in "meanings," but rather that the meanings which concerned them were the ones that could be apprehended through the objects themselves.[3] If I therefore accept as given a modernist perspective on these sculptures (which like any other perspective is by definition a bias), I shall nevertheless try to make a virtue of it, hoping that despite the necessarily fragmentary character of our approach—whose primary purpose is the further illumination of modern art—it may nevertheless shed some new light even on the Primitive objects.

Discourse on our subject has suffered from some confusion as to the definition of primitivism. The word was first used in France in the nineteenth century, and formally entered French as a strictly art-historical term in the seven-volume *Nouveau Larousse illustré* published between 1897 and 1904: "*n.m. B.-arts Imitation des primitifs.*" Though the Larousse reference to "imitation" was both too extreme and too narrow, the sense of this definition as describing painting and sculpture influenced by earlier artists called "primitives" has since been accepted by art history; only the identity of the "primitives" has changed. The Larousse definition reflected a mid-nineteenth-century use of the term insofar as the "primitives" in question were primarily fourteenth- and fifteenth-century Italians and Flemings. But even before the appearance of the *Nouveau Larousse illustré*, artists had expanded the connotations of "primitive" to include not only the Romanesque and Byzantine, but a host of non-Western arts ranging from the Peruvian to the Javanese—with the sense of "primitivism" altering accordingly. Neither word, however, as yet evoked the tribal arts of Africa or Oceania. They would enter the definitions in question only in the twentieth century.

While primitivism began its life as a specifically art-historical term, some American dictionaries subsequently broadened its definition. It appears for the

first time in Webster in 1934 as a "belief in the superiority of primitive life," which implies a "return to nature." Within this expanded framework, Webster's art-related definition is simply "the adherence to or reaction to that which is primitive." This sense of the word was evidently firmly entrenched by 1938 when Goldwater used it in the title of *Primitivism in Modern Painting.* The general consistency of all these definitions of primitivism has not, however, prevented certain writers from confusing primitivism (a Western phenomenon) with the arts of Primitive peoples. In view of this, we have drawn attention to the former's very particular art-historical meaning by enclosing it within quotation marks in the title of our book.

Nineteenth-century primitivist painters had appreciated pre-Renaissance Western styles for their "simplicity" and "sincerity"—which they saw in the absence of complex devices of illusionist lighting and perspective—and for their vigor and expressive power, qualities these artists missed in the official art of their own day, which was based on Classical and academic models. The more that bourgeois society prized the virtuosity and finesse of the salon styles, the more certain painters began to value the simple and naïve, and even the rude and the raw—to the point that by the end of the nineteenth century, some primitivist artists had come to vaunt those non-Western arts they called "savage." Using this word admiringly, they employed it to describe virtually any art alien to the Greco-Roman line of Western realism that had been reaffirmed and systematized in the Renaissance. Given the present-day connotations of "primitive" and "savage," we may be surprised to discover what art these adjectives identified for late nineteenth-century artists. Van Gogh, for example, referred to the high court and theocratic styles of the ancient Egyptians and the Aztecs of Mexico as "primitive," and characterized even the Japanese masters he revered as "savage" artists. Gauguin used the words "primitive" and "savage" for styles as different as those of Persia, Egypt, India, Java, Cambodia, and Peru. A self-proclaimed "savage" himself, Gauguin later annexed the Polynesians to his already long list of "primitives," but he was less drawn to their art than to their religion and what remained of their life-style. Decades before African or Oceanic sculpture would become an issue for artists, the exotic arts defined as "primitive" by Gauguin's generation were being admired for many qualities that twentieth-century artists would prize in tribal art—above all, an expressive force deemed missing from the final phases of Western realism, which late nineteenth-century vanguard artists considered overattenuated and bloodless. With the exception of Gauguin's interest in Marquesan and Easter Island sculpture, however, no nineteenth-century artist demonstrated any serious artistic interest in tribal art, either Oceanic or African. Our contemporary sense of Primitive art, largely synonymous with tribal objects, is a strictly twentieth-century definition.

The first decades of the twentieth century saw both a change in meaning and a shrinkage in the scope of what was considered Primitive art. With the "dis-

covery" of African and Oceanic masks and figure sculptures by Matisse, Derain, Vlaminck, and Picasso in the years 1906–07, a strictly modernist interpretation of the term began. As the fulcrum of meaning shifted toward tribal art, the older usages did not fall away immediately. "Primitive art" simply became increasingly identified, during the following quarter-century, with tribal objects. As far as vanguard artists of the beginning of the century were concerned, this meant largely African and Oceanic art, with a smattering (in Germany) of that of American Indians and Eskimos (which would become better known among Paris artists only in the twenties and thirties).

In Paris, the term "art nègre" (Negro art) began to be used interchangeably with "primitive art." This seemingly narrowed the scope of meaning to something like tribal art. But as a term that should have been reserved for African art alone, it was in fact so loosely employed that it universally identified Oceanic art as well. It was not until the 1920s that Japanese, Egyptian, Persian, Cambodian, and most other non-Western court styles ceased to be called Primitive, and the word came to be applied primarily to tribal art, for which it became the standard generic term. In Goldwater's book, written the following decade, the "primitive" is synonymous with African and Oceanic art. To be sure, pre-Columbian court styles such as the Aztec, Olmec, and Incan continued to be called Primitive (and artists did not always distinguish between them and tribal art). But this was an inconsistency, and should now be recognized as such. In their style, character, and implications, the pre-Columbian court and theocratic arts of Mesoamerica and South America should be grouped with the Egyptian, Javanese, Persian, and other styles that together with them had constituted the definition of the Primitive during the later nineteenth century.[4] The progressive change in the meaning of the word after 1906 was a function of a change in taste. Consistent with it, pre-Columbian court art enjoyed—except for Moore, the Mexican muralists, and, to a lesser extent, Giacometti—a relatively limited interest among early twentieth-century vanguard artists. Picasso was not unique in finding it too monumental, hieratic, and seemingly repetitious. The perceived inventiveness and variety of tribal art was much more in the spirit of the modernists' enterprise.[5]

The inventiveness just mentioned, which led in some African and Oceanic societies to an often astonishing artistic multiformity, constitutes one of the most important common denominators of tribal and modern art. Few remaining sculptures of the Dan people, to take perhaps the most startling example, are much more than a century old, yet the range of invention found in their work far outdistances that of court arts produced over much longer periods—even millennia of Ancient Egypt after the Old Kingdom. And unlike Egyptian society, which placed a positive value upon the static as regards its imagery, the Dan not only explicitly appreciated diversity but recognized the value of a certain originality. As the fascinating study by the ethnologist P. J. L. Vandenhoute

showed, the Dan were even willing "to recognize a superior social efficacity in [such originality]." Although tribal sculptors were guided by established traditional types, the surviving works themselves attest that individual carvers had far more freedom in varying and developing these types than many commentators have assumed. This relative variety and flexibility, along with the concomitant incidence of change, distinguish their art from the more static, hieratic—and often monumental—styles of the court cultures in question (which for the sake of convenience I shall refer to generically as Archaic, in what amounts to but a slight broadening of that term's usual art-historical application).[6]

During the last two decades, the words "Primitive" and "primitivism" have been criticized by some commentators as ethnocentric and pejorative, but no other generic term proposed as a replacement for "primitive" has been found acceptable to such critics; none has even been proposed for "primitivism." That the derived term primitivism is ethnocentric is surely true—and logically so, for it refers not to the tribal arts in themselves, but to the Western interest in and reactions to them. Primitivism is thus an aspect of the history of modern art, not of tribal art. In this sense, the word is comparable to the French "japonisme," which refers not directly to the art and culture of Japan, but to the European fascination with it. The notion that "primitivism" is pejorative, however, can only result from a misunderstanding of the origin and use of the term, whose implications have been entirely affirmative.

Objections to the adjective "primitive," on the other hand, focus not unfairly on the pejorative implications of certain of its many meanings.[7] These have had no place, however, in its definition or use as an art-historical term. When Picasso, in the ultimate compliment, asserted that "primitive sculpture has never been surpassed,"[8] he saw nothing contradictory—and certainly nothing pejorative—in using the familiar if now-contested adjective "primitive" to identify the art. It is precisely the admiring sense with which he and his colleagues invested the word that has characterized its use in art writing. Employed in this restricted way, the word has a sense no less positive than that of any other aesthetic designations (including Gothic and Baroque, which were both coined as terms of opprobrium).[9] The "effective connotations" of "primitive" when "coupled with the word art," as Robert Goldwater concluded, are of "a term of praise."[10] As we are using the term "Primitive" essentially in an art-historical spirit, we have decided to insist upon this sense of its meaning by capitalizing its initial letter (except within quotation marks). All this does not mean that one would not happily use another generic term if a satisfactory one could be found. And, to be sure, William Fagg, dean of British ethnologists of Africa, proposed that "tribal" be universally substituted for "primitive."[11] But the critics who object to "primitive" object with equal if not greater vehemence to "tribal."

It is clear that art history is not the only discipline that has sought and failed

to find a generic term for the Primitive that would satisfy critics. After struggling with the problem for some time, Claude Lévi-Strauss noted that "despite all its imperfections, and the deserved criticism it has received, it seems that *primitive,* in the absence of a better term, has definitely taken hold in the contemporary anthropological and sociological vocabulary." "The term *primitive,*" he continued, "now seems safe from the confusion inherent in its etymological meaning and reinforced by an obsolete evolutionism." Lévi-Strauss then added a reminder hardly necessary for those who admire tribal art. "A primitive people," he insisted, "is not a backward or retarded people, indeed, it may possess, in one realm or another, a genius for invention or action that leaves the achievements of other peoples far behind."[12] This last was recognized by modern artists at the beginning of this century, well before the attitudes summarized by Lévi-Strauss were to characterize anthropological or art-historical thinking.

For the bourgeois public of the nineteenth century, however, if not for the art lovers of the twentieth, the adjective "primitive" certainly had a pejorative meaning. Indeed, that public considered any culture outside Europe, or any art outside the parameters of Beaux-Arts and salon styles—which meant all non-Western and some Western art—inherently inferior. (Even Ruskin opined that there was "no art in the whole of Africa, Asia or America.") To the extent that the "fetishes" of the tribal peoples were known at all, they were considered the untutored extravagances of barbarians. In fact, tribal objects were not then considered art at all. Gathered first in *cabinets de curiosités,* the masks and figure sculptures (along with other material) were increasingly preserved during the later nineteenth century in ethnographic museums, where no distinctions were made between art and artifact. As artifacts were considered indices of cultural progress, the increasing hold of Darwinian theories could only reinforce prejudices about tribal creations, whose makers were assigned the bottom rung of the cultural evolutionary ladder.

We shall explore in depth in our chapter on Gauguin a quite opposite Western view of the Primitive that had already begun to form in the eighteenth century, especially in France. But this affirmative attitude, of which Jean-Jacques Rousseau's Noble Savage is the best-known embodiment, involved only a segment of the small educated public. It remained, moreover, literary and philosophical in character—never comprehending the plastic arts. Antipodal to the popular view, it tended to idealize Primitive life, building upon it the image of an earthly paradise, inspired primarily by visions of Polynesia, especially Tahiti. If we trace this attitude to its source in Montaigne's essay "On Cannibals," we see that from the start the writers in question were primarily interested in the Primitive as an instrument for criticizing their own societies, which they saw as deforming the innately admirable spirit of humankind that they assumed was still preserved in the island paradises.

Needless to say, most of these writers knew little of life in Polynesia or other distant lands, and the body of ideas they generated may be justly characterized as "the myth of the primitive." Indeed, even among those having firsthand contact with tribal peoples, the fantasy of the Primitive often overrode reality. The French explorer Bougainville, for example, one of the discoverers of Tahiti, saw evidence there of cannibalistic practices. But all of this is forgotten in this classic description of the island as "la Nouvelle Cythère," the New Cythera. By identifying Tahiti with the island of Greek mythology where, under the reign of Venus, humans lived in perpetual harmony, beauty, and love, Bougainville was equating the "myth of the primitive" with the already long-established but almost equally unreal "myth of the antique." It mattered little, however, that the affirmative view of the Primitive we have been describing had almost as little relation to reality as the negative one. The myth was from the start the operative factor, and until the third decade of the twentieth century, it had far more influence on artists and writers than did any facts of tribal life, of which, in any case, the first social scientists themselves knew but little.

This interest in the Primitive as a critical instrument—as a countercultural battering ram, in effect—persisted in a different form when early twentieth-century vanguard artists engendered a shift of focus from Primitive life to Primitive art. Modernism is unique as compared to the artistic attitudes of past societies in its essentially critical posture, and its primitivism was to be consistent with this. Unlike earlier artists, whose work celebrated the collective, institutional values of their cultures, the pioneer modern artists criticized—at least implicitly—even when they celebrated. Renoir's *Boating Party*, for example, affirmed the importance of gaiety, pleasure, and informality, in short, the life of the senses. But by that very fact, it criticized the repressive and highly class-conscious conventions of contemporary Victorian morality. The Cubist artist's notion that there was something important to be learned from the sculpture of tribal peoples—an art whose appearance and assumptions were diametrically opposed to prevailing aesthetic canons—could only be taken by bourgeois culture as an attack upon its values.

That the modern artists' admiration for these tribal objects was widespread in the years 1907–14 is sufficiently (if not very well) documented in studio photographs, writings, reported remarks, and, of course, in their work itself. Artists such as Picasso, Matisse, Braque, and Brancusi were aware of the conceptual complexity and aesthetic subtlety of the best tribal art, which is only simple in the sense of its reductiveness—and not, as was popularly believed, in the sense of simple-mindedness. That many today consider tribal sculpture to represent a major aspect of world art, that Fine Arts museums are increasingly devoting galleries, even entire wings to it, is a function of the triumph of vanguard art itself. We owe to the voyagers, colonials, and ethnologists the arrival of these objects

in the West. But we owe primarily to the conviction of the pioneer modern artists their promotion from the rank of curiosities and artifacts to that of major art, indeed, to the status of art at all. . . .

That tribal art influenced Picasso and many of his colleagues in significant ways is beyond question. But that it caused no fundamental change in the direction of modern art is equally true. Picasso himself put it succinctly when he said: "The African sculptures that hang around . . . my studios are *more witnesses than models*."[13] That is, they more bore witness to his enterprise than served as starting points for his imagery. Like the Japanese prints that fascinated Manet and Degas, Primitive objects had less to do with redirecting the history of modern painting than with reinforcing and sanctioning developments already under way. Nevertheless, Picasso—who had an instinct for the *mot juste*—chose his words carefully, and his "more . . . than" construction must be looked at with care. Though more "witnesses" than "models," the sculptures were admittedly thus models to some extent. Hence, while first elected for their affinity to the artist's aims, once in the studio, the tribal objects took on a dual role, and exerted some influence.

Just how much and what kind of influence these objects exerted is, as noted, extremely difficult to gauge. In his classic text, Goldwater took a very conservative position on this question, to which Laude's book largely adhered. While arguing a "very considerable influence of the primitive on the modern"[14] in very general terms ("allusion and suggestion"), Goldwater insisted on the "extreme scarcity of the direct influence of primitive art forms" on twentieth-century art.[15] As our study will show, Goldwater substantially underestimated that aspect of the issue. Moreover, he considered most of the influence of tribal art to be poetic, philosophical, and psychological, granting it only a "very limited direct formal influence."[16] It was his view that Brancusi, for example, never adapted "specific forms of Negro sculpture, and . . . his work is never related to any particular tribal style." Yet the attitude, shape, and convex-concave structure of the head and the elongated form of the neck (as well as the obliquely projecting coiffure or "comb") of Brancusi's *Madame L. R.* (1914–18) seem to me unquestionably derived from Hongwe reliquary figures. Moreover, as Geist has shown, the peculiarly shaped mouth in the head that remains from the otherwise destroyed *First Step*, 1913, was almost certainly derived from a Bambara sculpture in the Trocadéro Museum. Comparable examples can be adduced in the work of many artists whose primitivism was discussed by Goldwater only in general terms.

In the examples mentioned above, the juxtapositions of the modern and African works speak for themselves. But I am firmly of the opinion that there exists a whole body of other influences, *no less dependent on particular forms in individual*

tribal objects, where a simple comparison of the modern and tribal works involved would not signal the relationship between them. Indeed, I consider it axiomatic that among modern artists who admired and collected tribal works, many of the most important and profound influences of "art nègre" on their work are those that we do not recognize and will never know about. While artists of all periods have taken the shape of a head, the position of a body, or a particular pattern from the work of other artists, their assimilation of their colleagues' work often takes a more complicated, less recognizable form—all the more so in the twentieth century, given the degree of metamorphosis of visual raw materials in most modern styles. By the time the plastic idea—borrowed knowingly or unconsciously—is fully digested and reemerges in the context of the borrower's very different style, it is often "invisible." The influence of tribal art is no exception to this principle. . . .

It is still sometimes said that traditional tribal art was a collective rather than an individual creation involving constant repetition of established formulae, to which the individual carver brought little beyond artisanal skill. My own experience with this art, on the contrary, has confirmed for me the assumption that good art is made only by gifted individuals. I am, in fact, struck by the differences rather than the similarities between tribal pieces of the same style (at least in types not standardized for European tastes), and especially by the uniqueness of those works I would call masterpieces. For example, of the dozen or so Grebo masks I have seen, no two are alike, though all include the basic constituents. And the Metropolitan's, the finest of the group, is the least typical. The differences between these masks are just as marked as those between works by anonymous Western artists of the Medieval schools in given regions—any particular school of Romanesque sculptors, for example. And the best work of both is distinguished by unique qualities of expressiveness and invention. That sculptures as fine as the Metropolitan's Grebo mask are, indeed, rare among Primitive objects, that the overwhelming bulk of tribal art is not very good, says nothing about it that would not be true of the production of any period, including—if not especially—our own.

While the birth of a very gifted artist is a rare thing in any civilization, only certain cultures provide a context for his or her flourishing. The fact, for example, that all African sculpture, good as well as bad, comes from but a portion of the tribally inhabited areas does not mean that individuals with great artistic potential were not born in the other regions. Rather, the social and religious traditions there did not demand, or even permit, sculptural activity (although a high order of artistic realization was reached in some of those regions in other visual arts such as architecture and body painting).

The generally low quality level of most tribal art—at least that preserved in

the West—has many explanations. In some traditions, for example, masks were made by all males, at least for certain rites, rather than being executed by trained artists. More important, perhaps, is the fact that tribal art has not only suffered a much higher rate of extinction than Western art, but that its transportation to and preservation in the West have been largely haphazard. The loss begins with the limited durability of wood sculpture in a tropical climate; add to this the fact that many Primitive cultures jettisoned objects when they were desacralized—sometimes after being used only once. Such facts mean that most of the wooden tribal art preserved in Africa or the West is less than a century or so old, and therefore represents only the tail end of long and (since the colonial period) dissolving—or at least profoundly changing—traditions. A certain number of African wood pieces are in fact much older; they remain either because they were preserved, like Egyptian wood sculpture, by being stored in dry, sub-Sahara regions (the Dogon figures attributed to the "Tellem"), or because reasons of religion or state ensured their conservation and protection.

While certain older pieces are very fine, the selection process that preserved even these was *not determined by aesthetic quality.* Indeed, it has been argued that many of the earliest African sculptures to arrive in Europe were "replacement pieces," hastily made by sculptors for a European, so that the community could avoid giving up a sacred object.[17] There was in operation, in fact, a kind of "negative selection," insofar as many important older pieces were destroyed as sacrilegious by the early missionaries. The great bulk of the art made in Europe since the beginning of the Renaissance has also disappeared. But what remains has been preserved largely (though by no means entirely) on the basis of an ongoing collective judgment as to artistic value, which consensus functions as a winnowing process. For this process, a society seems to need not only gifted artists, but a concept of Fine Arts supported by an ongoing critical tradition which, in turn, requires a written language. Such discourse about sculpture as existed in African and other preliterate tribal societies fell short of this.

Until the 1950s, the selection of such tribal art as has been preserved in the West was *primarily accidental* insofar as artistic quality is concerned. There are some masterpieces among the early Primitive objects brought back by seamen, travelers, and missionaries as curiosities. And here and there, they may have been chosen from among the myriad possibilities by individuals of developed artistic taste, though this was surely not generally the case. Nor is there any reason to imagine the operation of such taste in the choice of objects brought back as souvenirs by colonials (even though a few became students of the art of their regions). The situation improved somewhat in the case of the early ethnologists. But as ethnologists did not generally distinguish between art and artifact—indeed, some still reject aesthetic considerations as unscientific and thus alien to their discipline—the majority of objects they brought back have little or no artistic interest. These ethnologists were obliged to make choices, nonetheless,

and because they were individuals of greater experience and sometimes evidently greater taste than the voyagers or colonials, the quality of what they sent back tended to be somewhat better. Certain ethnologists of recent generations possess considerable artistic culture, but in Africa and Oceania these men and women have been working with tribal cultures increasingly altered in varying degrees by colonialism and modern technology, with the result that the traditional art forms as practiced in recent decades tend to be exaggerated and base or to become academically frozen. While fine older pieces can occasionally still be obtained in tribal regions, ethnological museums are generally in no financial position to compete for them.

One might imagine that the major dealers in tribal art who emerged in the years just before and after World War I, men of great taste such as Guillaume and Ratton, would have reversed the fundamentally accidental determination of those objects that would make their way to Western markets by traveling to tribal areas to buy work. But this was not the case. So far as I know, no dealer of Picasso's generation or the one that followed ever set foot in Africa. Dealers exercised their taste by choosing for their stock from the best of what travelers, missionaries, colonials, and the "runners" they financed happened to bring back. It is true that a number of dealers who matured after World War II traveled widely in tribal areas and brought to Europe some extraordinary work, including types of Primitive sculpture previously rare or unknown. But by the 1970s, any long-term role they could have played was much diminished or rendered moot as the indigenous authorities themselves became conscious of the artistic value of older objects the collectivities possessed, and as the new-born nations in Africa and Oceania began to treat such art as national treasures.

If the "invisible" interventions of tribal objects in the history of modern art illustrated by Picasso's Grebo masks must remain largely hypotheses, there are more than enough quite recognizable ones to flesh out our definition of primitivism. The range of these may be illustrated by two early paintings of Max Weber [fig. 36]. In the first, Weber's 1910 Matissean still life, *Congo Statuette,* a small Yaka figure is quite realistically represented—which we can confirm by reference to the sculpture itself. As with the many outright depictions of tribal objects in German Expressionist paintings, this image tells us of Weber's interest in the Primitive, but does not testify to any influence of tribal art on his style—at least directly. In this sense, the Primitive sculpture functions like any other still-life object. In Weber's Synthetic Cubist *Interior with Women,* c. 1917, however, African material is less depicted than absorbed into his now Cubist style, itself enriched by his recollections of Picasso's 1907–08 "African" paintings. The face of the woman seated in the center, to take but one example, is a synthesis of elements drawn from elongated concave Fang masks and from Kuba masks with conical eyes.

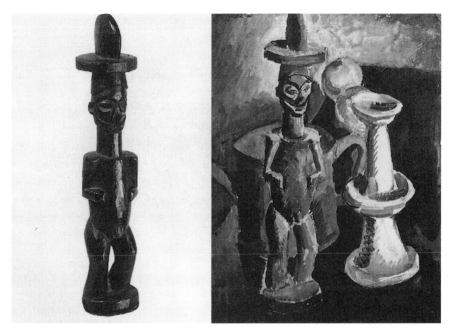

Figure 36. Figure. Yaka. Democratic Republic of the Congo. Wood, 10¼" (26 cm) high. Formerly collection of Max Weber. Max Weber, *Congo Statuette*, 1910. Gouache on board, 13½ x 10½" (34.2 x 26.7 cm).

The two paintings by Weber testify alternately to an interest in tribal art on the part of the painter and to an influence of it upon him. However, many suggestions of such direct influence made up to now, whether in texts or exhibitions (such as the ambitious one held in Munich at the time of the Olympic games), are misleading simply because of the unlikelihood that the modern artist in question could have seen the particular tribal work proposed, even in reproduction. These examples involve, for the most part, presumed influences on modernist works of the earlier decades of the century, when many of the now-familiar types of tribal objects were not visible in the cities where the artists worked or traveled nor were reproduced (except, in some cases, in very rare and expensive ethnological publications that the pre-Surrealist generations—save for a few German artists—did not consult).

When such ahistorical juxtapositions are visually convincing, they illustrate *affinities* rather than *influences*. Affinities are far from unimportant, however, and in the long run, the multiplicity of them may tell us something more essential about twentieth-century art than do the far rarer instances of direct influence (which might be thought of as confirming the propinquity involved). The third section of the exhibition this book accompanies is entirely devoted to exploring the broad underlying affinity that relates much modern and tribal art. This may be said to parallel, as Picasso himself observed, the affinity of Italian Renaissance painting for the art of Classical antiquity—even though (as was the case with

the Cubists and tribal sculpture) the Renaissance painters actually were ac-
quainted with little of that art. A proper distinction between influences and
affinities is nonetheless as crucial to the study of modern art as it is to that of the
Renaissance. But because tribal art has not until lately been treated as part of art
history, modernist scholars have repeatedly fallen into the kind of error that
their counterparts in Renaissance art history would never make.

In order to dramatize the distinction between affinities and influences, I
would like to juxtapose some works by Max Ernst with tribal objects to which
they bear a striking resemblance. When we compare Ernst's *Bird-Head* to an
African mask of the Tusyan people, for example, we find among their common
characteristics—apart from a general sense of the apparitional—such particulars
as a flat rectangular head, straight horizontal mouth, small round eyes, and a
bird's head projecting from the forehead. Let us also take Ernst's engraved stone
sculpture, *Oval Bird,* of that same year (1934), comparing it to the Bird-Man re-
lief from Easter Island in the British Museum. Both *Oval Bird* and the Easter Is-
land image are egglike in contour and depict a syncretistic birdman whose
rounded forms echo the contour of the sculptural field. The upper arm of both
figures descends in a curve and the forearms project forward; both birdmen have
a large round eye. Though the oversized hand of the Easter Island figure gives
way in the Ernst stone to a second bird's head (birdmen with large hands are,
however, found in other works by Ernst), and while the head of Ernst's *person-
nage* projects forward like that of the Easter Island relief, it is much less beaklike
in form. Nevertheless, that form is almost exactly matched in another Ernst bird
head, also in an oval field, in the painting *Inside the Sight: The Egg.*

One of the most celebrated of Polynesian objects, the Easter Island Bird-Man
relief was collected in 1915 and acquired by the British Museum in 1920; it was
reproduced in a number of publications beginning in 1919. Unlike his Cubist
predecessors—and even more than most of his Surrealist colleagues—Ernst was
a great *amateur* of ethnology and possessed a considerable library on the subject,
probably including, both Maurer and Spies believe,[18] one or more of the early
publications in which the Easter Island relief was reproduced. Hence we would
be on reasonably solid ground in speaking here of an influence of the Bird-
Man relief on his work. On the other hand, the resemblance between Ernst's
Bird-Head and the Tusyan mask, striking as it is, is fortuitous, and must therefore
be accounted a simple affinity. *Bird-Head* was sculpted in 1934, and no Tusyan
masks appear to have arrived in Europe (nor were any reproduced) prior to
World War II.

That such striking affinities can be found is partly accounted for by the fact
that both modern and tribal artists work in a conceptual, ideographic manner,
thus sharing certain problems and possibilities. In our own day it is easy to con-
ceive of art-making in terms of problem-solving. But this was also substantially
true for tribal artists, though their solutions were arrived at incrementally—as in

much Western art—over a period of generations. Ethnologists might argue that I am falsely attributing to the tribal artists a sense of Western art-making, that the tribal sculptor creating ritual objects for a cult had no consciousness whatever of aesthetic solutions. (The latter is simply their assumption, of course, based on the fact that many tribal cultures had no word for "art.")[19] Even if this could be proven true, however, it would not contradict my contention insofar as the finding of artistic solutions is ultimately an intuitive rather than an intellectual activity. The art-making process everywhere has certain common denominators, and as the great ethnologist Robert Lowie quite rightly observed, "the aesthetic impulse is one of the irreducible components" of mankind.[20] The "artness" of the best tribal objects alone demonstrates that great artists were at work and that a variety of aesthetic solutions were arrived at, however little the artists themselves might have agreed with our description of the process. Now these solutions, insofar as they were to problems held in common—a sign for "nose," for example—were certainly likely to bear a resemblance to one another in ways that are independent of influences and traditions. Hence the similarity of tribal works from entirely unrelated regions, as in the head of a New Hebrides (Melanesia) fern sculpture and an African Lwalwa mask. Is it so surprising, then, that Picasso's solution for the head of the upper right maiden in the *Demoiselles* should resemble a mask from the Etoumbi region of Africa of a type he could not have seen at the time?

To say that Picasso's solution and that of the Etoumbi artist resemble each other is not, of course, to equate them. Quite apart from the fact that the Picasso head is painted and the Etoumbi mask carved—so that a different set of artistic conventions apply—there are many aspects of the Picasso image that presuppose ontogenetically the whole phylogeny of Western art. Moreover, the aesthetic affinities between signifiers, such as they are, do not permit us to assume comparable relationships on the level of the signified. Thus Herbert Read was rightly criticized for attributing Expressionist anxiety (*angst*)—a peculiarly modern state of mind—to African sculpture.[21] And Picasso's reference to the exorcistic character of African art, which he said was created to make man "free," turned on a definition of freedom in terms of private psychological emancipation of a kind that would make no sense to a member of a tribal society. . . .

An undertaking such as this book, and the exhibition to which it is ancillary, must inevitably raise questions in the curator's mind as to its necessity—if for no other reason than its cost in time, effort, and money. Nor can the curator, though he has seen the works individually over the years in differing contexts, truly foresee the effect of bringing them together—the revelation, or lack thereof, that their confrontation may engender. Indeed, in a sense he organizes the exhibition to see what will happen. It would be disingenuous, nevertheless, to pretend that in proposing our exhibition I did not feel fairly certain that it

would result in a significant correction of the received history of modern art, and draw to the attention of that art's very large public some unfamiliar but particularly relevant masterpieces from other cultures. There was also the thought that some modern works we know quite well might seem all the richer for being seen from a new perspective. However presumptuous it may seem, all this lies within the realm of my expectations.

In the realm of my hopes, however, there is something less explicit, more difficult to verbalize. It is that the particular confrontation involved in our exhibition will not only help us better to understand our art, but in a very unique way, our humanity—if that is not saying the same thing. The vestiges of a discredited evolutionary myth still live in the recesses of our psyches. The vanguard modernists told us decades ago that the tribal peoples produced an art that often distilled great complexity into seemingly simple solutions. We should not therefore be surprised that anthropology has revealed a comparable complexity in their cultures.[22] I hope our effort will demonstrate that at least insofar as it pertains to works of the human spirit, the evolutionary prejudice is clearly absurd. The various metamorphoses of Picasso's *Demoiselles d'Avignon* were but the visible symbols of the artist's search within his own psyche. This self-analysis, this peeling away of layers of consciousness, became associated with a search into the origins of man's way of picturing himself. Having retraced those steps through the Archaic in his Iberian studies, Picasso was prepared for the "revelation" of Primitive art at the Trocadéro Museum, which led him to the deeper, more primordial solution for which he was searching. At the Trocadéro, Picasso apprehended something of profound psychological significance that Gauguin had failed to discover in the South Seas.

That Picasso would call the *Demoiselles* his "first exorcism picture" suggests that he understood the very making of it as analogous to the kind of psychospiritual experiences of rites of passage for which he assumed the works in the Trocadéro were used. The particular kind of personal freedom he experienced in realizing the *Demoiselles*, a liberating power that he associated with the original function of the tribal objects he saw, would have been meaningless—as the anthropologists would be the first to insist—to tribal man. Yet there *is* a link, for what Picasso recognized in those sculptures was ultimately a part of himself, of his own psyche, and therefore a witness to the humanity he shared with their carvers. He also realized that the Western artistic tradition had lost much of the power either to address or to change the inner man revealed in those sculptures.

Like all great art, the finest tribal sculptures show images of man that transcend the particular lives and times of their makers. Nevertheless, the head of the African figure illustrated opposite this page has for us at first an almost shocking sense of psychological otherness, while the New Guinea carving reproduced here has a comparable otherness in terms of the way we understand our bodies. Nothing in Western (or Eastern) art prepares us for them. Yet they

move us precisely because we *do* see something of ourselves in them—a part of ourselves that Western culture had been unwilling to admit, not to say image, before the twentieth century. If the otherness of the tribal images can broaden our humanity, it is because we have learned to recognize that otherness in ourselves. "Je," as Rimbaud realized, "est un autre."

I spoke earlier about Picasso's notion of the affinity of modern and tribal art as paralleling, in certain respects, the relationship between the arts of the Renaissance and Classical Greece. The analogy does not, however, capture the furthest reaches of implication in the affinity this book explores. For while the Italians of the fifteenth century were not in many significant ways, material or spiritual, advanced over the Greeks of the fifth century B.C., we, technologically speaking, are far beyond both, and with our consciousness of this we think of ourselves as having progressed light years beyond the tribal peoples. But insofar as art is a concrete index to the spiritual accomplishments of civilizations, the affinity of the tribal and the modern should give us pause.

NOTES

1. During the past twenty years, the word "tribal" has been frequently used in preference to "primitive" in characterizing a wide variety of arts of more or less noncentralized societies with simple technologies. Both words are profoundly problematic; we use them reluctantly (and interchangeably) in this book to answer the need for a generalizing collective term for the art we are addressing. No adequate or generally agreed-upon substitutes for "tribal" and "primitive" have been proposed. Among some specialists, "tribal" has been used in preference to "primitive" because the latter is felt to contain too many negative Darwinian connotations (see discussion pp. 319–20). Others prefer "primitive" to "tribal" because many of the cultures commonly referred to as tribal (in Africa especially) are not tribal in the ethnological sense of the term.

Our use of "tribal" is obviously not anthropological in spirit. It corresponds roughly to Webster's (*New International Dictionary*, 2d ed.) third definition of "tribe"—as the word is used "more loosely": "Any aggregation of peoples, especially in a primitive or nomadic state, believed to be of common stock and acting under a more or less central authority, like that of a headman or chief." The word "tribal" should thus be understood as simply a conventional counter. The Africanist Leon Siroto observes:

> "Tribal" in this connection would have to be no more than an arbitrary convention chosen to avoid the pitfalls of the term "primitive" as an expedient minimal designation in general discourse. It has been used so long and so widely that it seems to have gained significant acceptance.
>
> Caution is indicated: many, if not most, of the peoples intended by the term do not form tribes in the stricter sense of the concept. They may speak the same languages and observe more or less the same customs, *but* they are not politically

coordinated and have no pragmatic recognition or corporate identity. More-over, a number of them, for these reasons, have disparate iconographies and practice markedly contrastive styles, tendencies that should caution against the notion that their art is *tribal* (i.e., ethnically unitary and distinctive). . . . Anthro-pologists tend to agree that tribal groups are more of a European creation than a fact of life. (Letter to W. R. of November 1983.)

Until the 1960s, "tribal" was still widely used by anthropologists to fill the need for a general term cutting across cultures and continents. Hence, for example, the collection of essays edited by Daniel Biebuyck for the University of California Press in 1969 was called *Tradition and Creativity in Tribal Art.* Today it might be titled dif-ferently, but the problem of nomenclature has not been solved. William Fagg has been the most eloquent proponent of the concept of "tribality in African art." This art, he insists, "is a product and a function of the tribal system," though he observes that "tribal is not a static concept, but a dynamic one" and that "tribal styles are sub-ject to constant change" ("The African Artist" in Biebuyck, ed., p. 45).

African scholars (among others) have criticized "tribal" as "Eurocentric" (Ekpo Eyo, cited in the *New York Times,* October 12, 1980, p. 70), and their point is well taken, although the anathema cast on the word in Africa (it has literally been banned by one African parliament) probably responds in part to the political prob-lem of melding unified nations and a national consciousness from ethnically diverse populations. That the "Eurocentrism" in question still exists—despite efforts to overcome it—is hardly surprising considering that the disciplines of art history and anthropology are themselves European inventions.

When addressing individual cultures, art historians can easily avoid such prob-lematic terms as "tribal." But the need for a general term arises from the wish to al-lude to characteristics that appear (to some Western eyes, at least) similar in a variety of cultures in different parts of the world. The most up-to-date histories of world art still employ, if somewhat gingerly, the words "tribal" and "primitive" (e.g., Hugh Honour and John Fleming, *The Visual Arts: A History* [Englewood Cliffs, N.J., 1982], p. 547). Some anthropologists would argue that any perceived common characteris-tics implied in such use of the word "tribal" are fictions—which explains why the word has largely disappeared from anthropological literature. Even if true, however, this does not mean that it is inappropriate in the study of modernist primitivism. On the contrary, precisely because we are *not* directly addressing the cultures in question, but investigating *the ideas formed of them in the West* over the last hundred years, the use of the word "tribal"—which is a function of such ideas and the context in which they were formed—is not misleading. The word's ethnocentric drawbacks become, in effect, illuminating, for they characterize the nature of the primitivist perspective.

We have retained the term "primitive" but have decided to capitalize it (except within quotation marks) in order to underline that aspect of its many meanings having to do with art-historical designation (as opposed to using it as a strictly de-scriptive term).

2. Symptomatic of this is the tendency of one of the leading authors on African art to characterize masks as "cubist" simply because they have rectilinear geometrical structures.

3. Anthropologists, especially those who consider the characterization of tribal objects *as art* irrelevant to their concerns, often write as if only the scientifically verifiable and verbalizable anthropological constituents of these objects have meaning. Art

historians' interests naturally include the aesthetic and expressive potential of many of these objects. In general, artists usually consider only the direct apprehension of the latter as truly meaningful. This is exemplified in a remark made to me by Picasso to this effect: "Everything I need to know about Africa is in those objects."

4. Pre-Columbian civilization was (and still is) popularly identified by artists and others primarily with art from large-scale, complex, later-period theocratic societies of the Maya, Toltec, and Aztec in Mesoamerica and the Inca in Peru. These societies were characterized by a high degree of both specialization and social, economic, and political hierarchization, which are reflected in their monumental architecture and sculpture, which I would classify as more Archaic than Primitive in nature. Less known, but certainly not unknown to some artists, were many simpler pre-Columbian socio-cultural entities that did not have state-level government, monumental public works, written languages (which were, in any case, confined to the Maya), and other features of more complex societies. Notable among these were the Chrotega, Chiriqui, Chibcha, and many other chiefdoms that occupied the area between Mesoamerica and the northern Andes.

 If, in terms of their art, the Maya, Toltec, Aztec, and Inca should be grouped with such cultures as the Cambodian or Egyptian, they present an exception insofar as the social and religious fabric of all the pre-Columbian cultures was marked by certain characteristics otherwise generally associated with Primitive rather than court cultures. Since, however, modern artists knew little or nothing of this, and approached pre-Columbian cultures entirely through works of art (or their reproductions), these works entered modernism in the late nineteenth century not in the company of the tribal arts of Africa and Oceania (which were overlooked by artists at that time) but as Archaic arts, like those of the other court cultures such as the Egyptian that had passed for "primitive" to Gauguin and van Gogh. The "primitive" aspects of pre-Columbian technology, sociology, and communications account for the cultures' still being sometimes classified as Primitive in terms of their art (which, at the Metropolitan Museum and most others, is in the same department as African and Oceanic art).

 Monumental Mesoamerican architecture and sculpture were visible in museums and world's fairs (the 1889 Paris Exposition Universelle had a reconstruction of an "Aztec House") and were of interest to artists generations before "art nègre" was known. Museum collections also contained a certain amount of material from the more remote, less centralized pre-Columbian regions, which art had somewhat more in common with tribal art. Yet how much of the latter was seen by artists, at least before the 1920s and 1930s, is open to question.

 Pre-Columbian art unquestionably had an influence on modern art, but most of that influence was from the Archaic sculpture of the Aztec, Maya, Toltec, and Olmec cultures. After Gauguin and van Gogh, interest in it is largely associated with the generation of the 1930s (although, on a conceptual more than an aesthetic level, pre-Columbian civilizations have been of interest to recent artists). The measure of how deep or widespread this influence was will require a study that can satisfactorily distinguish demonstrable influences from simple affinities. Barbara Braun, with whom I have consulted on the organization of *"Primitivism" in Twentieth Century Art,* is presently at work on a book about pre-Columbian sources of modern art.

 In addition to pre-Columbian objects, most natural history museums also possessed some specimens of the tribal arts of Mesoamerica and South America. Exam-

ples of these more recent objects are the Mundurucú trophy head that Nolde included in his painting *Masks* and the Witoto mask. . . .

5. Picasso seems to have had conflicting emotions about what he called "l'art aztèque," by which he meant the whole of pre-Columbian art as he knew it. My notes of conversations with him contain a reference to this art which I set down from memory as "boring, inflexible, too big . . . figures without invention." However, he praised the beauty of an "Aztec head" in a conversation with Brassaï (*Picasso and Company,* trans. Francis Price from the French *Conversations avec Picasso* [Garden City, N.Y.: Doubleday, 1966], p. 242). As recorded by Brassaï (for May 18, 1960), Picasso and he were looking at an album of his photographs. The chapter in the album entitled "Primitive Images," an "Aztec head," Brassaï tells us, "makes Picasso pause abruptly, and then he cries: 'That is as rich as the façade of a cathedral.'"

 Picasso's feeling for the inventiveness of tribal art was a response to a reality—African and Oceanic art *is* more variegated and inventive than pre-Columbian art—as is evident if one compares visits to Mexico City's Museo Nacional de Antropología and the Oceanic wing of Berlin's Museum für Völkerkunde, the two most beautiful and elaborate presentations of these respective arts that I know. But Picasso's attitude was also partly a matter of his perspective; hence my phrase "perceived inventiveness." What Picasso saw in the Trocadéro and the curio shops as the art of "les nègres" was thought of by him as issuing, broadly speaking, from a single cultural entity, Africa, when in fact the variety of African styles is in part a function of an immense number of ethnic groups of different religions, languages, and traditions covering an area far more vast than Western Europe.

6. Goldwater (*Primitivism in Modern Art,* [New York: Vintage, 1967], p. 150) quite rightly used "Archaic" to characterize the Iberian sculpture that interested Picasso and that subsequently "leads into the 'Negro' paintings." Picasso's interest in that sculpture was continuous with his even earlier interest in Egyptian art. The latter shares sufficient common denominators with certain non-Western court arts—at least as perceived by artists in the late nineteenth and early twentieth centuries—to warrant a global term; "Archaic," I believe, serves this purpose better than does any other adjective.

7. In the 1897–1904 *Nouveau Larousse illustré* (in which the word "primitivisme" made its first appearance), "primitive" was given (as both adjective and noun) sixteen different definitions, ranging from the algebraic and geological to the historical and ecclesiastical. Two of the sixteen were pejorative in connotation, notably the one marked "ethnological": "Les peuples qui sont encore au degré le moins avancé de civilisation." The fine-arts definition, given as a noun, was simply: "Artistes, peintres ou sculpteurs qui ont précédé les maîtres de la grande époque."

8. In conversation with Sabartés in his studio at villa Les Voiliers, Royan, 1940. (See Jaime Sabartés, *Picasso, An Intimate Portrait,* trans. Angel Flores from the Spanish *Picasso, Retratos y Recuerdos* [New York, 1949], p. 213.)

9. "Gothic" was traditionally paired with "barbaric" in the classicist critique of Western art. Only in the nineteenth century did the word begin to attain respectability. The speed at which pejorative connotations can drop away from art-historical terms may be measured by the rapidity with which the designation "Impressionist" was accepted by the pubic and even the painters themselves, despite the fact, as Meyer Schapiro has observed, that it had pejorative connotations relating to artisanal house decoration ("peinture d'impression").

10. Robert Goldwater, "Judgments of Primitive Art, 1905–1965," in *Tradition and Creativity in Tribal Art,* ed. Biebuyck, p. 25.

11. "The Dilemma Which Faces African Art," *The Listener,* September 13, 1951, pp. 413–15.

12. *Structural Anthology,* trans. C. Jacobsen and B. G. Schoepf (London, 1963), pp. 101–02.

13. Statement made to Florent Fels, in the course of successive conversations that led to the "interview" published by Fels (*in Les Nouvelles littéraires, artistiques et scientifiques,* no. 42, August 4, 1923, p. 2): "Je vous ai déjà dit que je ne pouvais plus rien dire de 'l'art nègre.'... C'est qu'il m'est devenu trop familier, les statues africaines qui traînent un peu partout chez moi, sont plus des témoins que des exemples."

14. Goldwater, *Primitivism in Modern Art,* p. xvi.

15. Ibid, p. xxi.

16. Ibid, p. 254.

17. Cf. Jacques Kerchache, *Chefs-d'oeuvre de l'art africain,* exhibition catalog (Grenoble: Musée de Peinture et de Sculpture, November–December 1982), n.p.

18. From Maurer and Spies in conversation with the author. The first association of the Easter Island stone and work of Max Ernst that I know is in Lucy Lippard's introductory essay "The Sculpture" for the exhibition catalog *Max Ernst: Sculpture and Recent Painting,* ed. Sam Hunter (New York: The Jewish Museum, March 3–April 17, 1966), pp. 38–39, where Ernst's untitled painted granite sculpture of 1934 and the Easter Island stone carving of a bird-headed man are reproduced across from each other without commentary in the text.

19. As noted above, there is—and no doubt was—discourse among tribal peoples regarding at least certain aesthetic aspects of cult objects. The proof, however, that tribal artists solved aesthetic problems is in the objects themselves. That the majority of artists merely imitated received ideas is true for all cultures, though this fact is ably "masked" by many recent Western artists. What certainly differs is the degree of consciousness of the artists that they are, in fact, solving aesthetic problems. But the solutions of genius in the plastic arts are all essentially instinctual, regardless of such intellectual superstructures as might be built around them after the fact by the artists themselves, other artists, or critics and art historians.

20. *Primitive Religion* (New York, 1924), p. 260.

21. "Tribal Art and Modern Man" in *The Tenth Muse: Essays in Criticism* (London: Routledge and Kegan Paul, 1957). This essay originally appeared in *The New Republic,* September 1953.

22. This is the burden of Lévi-Strauss's sructuralist analysis of Primitive language, kinship patterns, and myth (see *Structural Anthropology:* the comparison of the workings of the "primitive" and modern mind on p. 230).

THOMAS McEVILLEY

DOCTOR, LAWYER, INDIAN CHIEF · 1984

Something, clearly, is afoot. Richard Oldenburg, director of the institution here, describes one of its publications and the exhibition it accompanies, both titled " 'Primitivism' in 20th Century Art: Affinity of the Tribal and the Modern," as "among the most ambitious ever prepared by The Museum of Modern Art." "Over the years," he continues, "this Museum has produced several exhibitions and catalogues which have proved historically important and influential, changing the ways we view the works presented, answering some prior questions and posing new ones."[1] Indeed, this *is* an important event. It focuses on materials that bring with them the most deeply consequential issues of our time. And it illustrates, without consciously intending to, the parochial limitations of our world view and the almost autistic reflexivity of Western civilization's modes of relating to the culturally Other.

The exhibition, displaying 150 or so Modern artworks with over 200 tribal objects, is thrilling in a number of ways. It is a tour de force of connoisseurship. Some say it is the best primitive show they have seen, some the best Eskimo show, the best Zairean show, the best Gauguin show, even in a sense the best Picasso show. The brilliant installation makes the vast display seem almost intimate and cozy, like a series of early Modernist galleries; it feels curiously and deceptively unlike the blockbuster it is. Still, the museum's claim that the exhibition is "the first ever to juxtapose modern and tribal objects in the light of informed art history"[2] is strangely strident. Only the ambiguous word "informed" keeps it from being ahistorical. It is true that the original research associated with this exhibition has come up with enormous amounts of detailed information, yet since at least 1938, when Robert Goldwater published his seminal book *Primitivism in Modern Painting,* the interested public has been "informed" on the general ideas involved.[3] For a generation at least, many sophisticated collectors of Modern art have bought primitive works too, and have displayed them together. For five or so years after its opening in 1977, the Centre Pompidou in Paris exhibited, in the vicinity of its Modern collections, about 100 tribal objects from

Artforum 23 (November 1984): 54–60.

 At the time he wrote this article, art critic and cultural philosopher Thomas McEvilley (b. 1939) was a contributing editor of *Artforum* and a professor of art history at Rice University. This review precipitated a long, acrimonious exchange of letters between Rubin, McEvilley, and Varnedoe in subsequent issues of *Artforum* (see the bibliography).

the Musée de l'Homme. Though not actually intermingled with Modern works, these were intended to illustrate relationships with them, and included, as does the present show, primitive objects owned by Picasso, Braque, and other early Modernists. More recently, the exhibition of the Menil Collections in Paris' Grand Palais, in April, 1984, juxtaposed primitive and Modern works (a Max Ernst with an African piece, Cézanne with Cycladic), and sometimes, as in the present exhibition, showed a Modern artist's work in conjunction with primitive objects in his collection. The premise of this show, then, is not new or startling in the least. That is why we must ask why MoMA gives us primitivism now—and with such intense promotion and overwhelming mass of information. For the answer one must introduce the director of the exhibition, and, incidentally, of the museum's Department of Painting and Sculpture, William Rubin.

One suspects that for Rubin the Museum of Modern Art has something of the appeal of church and country. It is a temple to be promoted and defended with a passionate devotion—the temple of formalist Modernism. Rubin's great shows of Cézanne, in 1977, and Picasso, in 1980, were loving and brilliant paeans to a Modernism that was like a transcendent Platonic ideal, self-validating, and in turn validating and invalidating other things. But like a lover who becomes overbearing or possessive, Rubin's love has a darker side. Consider what he did to Giorgio de Chirico: a major retrospective of the artist's work, in 1982, included virtually no works made after 1917—though the artist lived and worked for another half century. Only through 1917, in his earliest years as an artist, did Chirico practice what Rubin regards as worth looking at. This was a case of the curator's will absolutely overriding the will of the artist and the found nature of the oeuvre. (It sure made the late work chic.) A less obvious but similar exercise occurs in Rubin's massive book *Dada and Surrealist Art* [4]—a book not so much about Dada and Surrealism as against them. The Dadaists of course, and following them the Surrealists, rejected any idea of objective esthetic value and of formally self-validating art. They understood themselves as parts of another tradition which emphasized content, intellect, and social criticism. Yet Rubin treats the Dada and Surrealist works primarily as esthetic objects, and uses them to demonstrate the opposite of what their makers intended. While trying to make antiart, he argues, they made art. Writing in 1968, at a time when the residual influence of the two movements was threatening formalist hegemony, Rubin attempted to demonstrate the universality of esthetic values by showing that you can't get away from them even if you try. Dada and Surrealism were, in effect, tamed.

By the late '70s the dogma of universal esthetic feeling was again threatened. Under the influence of the Frankfurt thinkers, and of post-Modern relativism, the absolutist view of formalist Modernism was losing ground. Whereas its esthetics had been seen as higher criteria by which other styles were to be judged, now, in quite respectable quarters, they began to appear as just another style. For

a while, like Pre-Raphaelitism or the Ash-can School, they had served certain needs and exercised hegemony; those needs passing, their hegemony was passing also. But the collection of the Museum of Modern Art is predominantly based on the idea that formalist Modernism will never pass, will never lose its self-validating power. Not a relative, conditioned thing, subject to transient causes and effects, it is to be above the web of natural and cultural change; this is its supposed essence. After several years of sustained attack, such a credo needs a defender and a new defense. How brilliant to attempt to revalidate classical Modernist esthetics by stepping outside their usual realm of discourse and bringing to bear upon them a vast, foreign sector of the world. By demonstrating that the "innocent" creativity of primitives naturally expresses a Modernist esthetic feeling, one may seem to have demonstrated once again that Modernism itself is both innocent and universal.

"'Primitivism' in 20th Century Art" is accompanied by a two-volume, 700-page catalogue, edited by Rubin, containing over 1,000 illustrations and 19 essays by 15 eminent scholars.[5] It is here that the immense ideological web is woven. On the whole, Goldwater's book still reads better, but many of the essays here are beautiful scholarship, worked out in exquisite detail. Jack Flam's essay on the Fauves and Rubin's own 100-page chapter on Picasso exemplify this strength. The investigation and reconstruction of events in the years from 1905 to 1908 recur in several of the essays; these years constitute a classic chronological problem for our culture, like the dating of the Linear B tablets. At the least, the catalogue refines and extends Goldwater's research (which clearly it is intended to supplant), while tilling the soil for a generation of doctoral theses on who saw what when. Its research has the value that all properly conducted scientific research has, and will be with us for a long time. In addition to this factual level, however, the catalogue has an ideological, value-saturated, and interpretive aspect. The long introductory essay by Rubin establishes a framework within which the other texts are all seen, perhaps unfortunately. (Some do take, at moments, an independent line.) Other ideologically activated areas are Rubin's preface, and the preface and closing chapter ("Contemporary Explorations") by Kirk Varnedoe, listed as "codirector" of the exhibition after "director" Rubin.

A quick way into the problems of the exhibition is in fact through Varnedoe's "Contemporary Explorations" section. The question of what is really contemporary is the least of the possible points of contention here, but the inclusion of great artists long dead, like Robert Smithson and Eva Hesse, does suggest inadequate sensitivity to the fact that art-making is going on right now. One cannot help noting that none of the types of work that have emerged into the light during the last eight years or so is represented. Even the marvelous pieces included from the '80s, such as Richard Long's *River Avon Mud Circle,* are characteristic of late '60s and '70s work.

A more significant question is the unusual attention to women artists—

Hesse, Jackie Winsor, Michelle Stuart, and above all Nancy Graves. Though welcome and justified, this focus accords oddly with the very low proportion of women in the show that preceded " 'Primitivism' " at the new MoMA, "An International Survey of Recent Painting and Sculpture." That show had a different curator, yet in general it seems that curators need a special reason to include a lot of women in a show—here, perhaps the association of women with primitivism, unconsciousness, and the earth, a gender cliché which may have seemed liberating ten years ago but may seem constricting ten years hence.

In the context of Modern art, "primitivism" is a specific technical term: the word, placed in quotation marks in the show's title, designates Modern work that alludes to tribal objects or in some way incorporates or expresses their influence. Primitivism, in other words, is a quality of some Modern artworks, not a quality of primitive works themselves. "Primitive," in turn, designates the actual tribal objects, and can also be used of any work sharing the intentionality proper to those objects, which is not that of art but of shamanic vocation and its attendant psychology. Some contemporary primitivist work may also be called primitive; yet the works selected by Varnedoe are conspicuously nonprimitive primitivism. The works of Smithson and Hesse, for example, may involve allusion to primitive information, but they express a consciousness highly attuned to each move of Western civilization. Rubin and Varnedoe make it clear that they are concerned not with the primitive but with the primitivist—which is to say they ask only half the question.

There are in fact contemporary artists whose intentionalities involve falling away from Western civilization and literally forgetting its values. These are the primitive primitivists; they are edited out of the show and the book altogether. The farthest the museum is willing to go is Joseph Beuys. Varnedoe explicitly expresses a dread of the primitive, referring darkly to a certain body of recent primitivist work as "sinister," and noting that "the ideal of regression closer to nature is dangerously loaded," that such works bring up "uncomfortable questions about the ultimate content of all ideals that propose escape from the Western tradition into a Primitive state." [6] The primitive, in other words, is to be censored out for the sake of Western civilization. The museum has evidently taken up a subject that it lacks the stomach to present in its raw realness or its real rawness. Where is the balance that would have been achieved by some attention to work like Eric Orr's quasishamanic objects involving human blood, hair, bone, and tooth, or Michael Tracy's fetishes of blood, hair, semen, and other taboo materials? The same exorcising spirit dominates the schedule of live performances associated with the exhibition: Meredith Monk, Joan Jonas, and Steve Reich, for all their excellences, have little to do with the primitivist, and less with the primitive. Where are the performances of Hermann Nitsch, Paul McCarthy, Kim Jones, and Gina Pane? Varnedoe's dread of the primitive, of the dangerous beauty that attracted Matisse and Picasso and that continues to attract

Which is "primitive"?
Which is "modern"?

And the real question, of course, is "How do they relate
to each other—and we to them?"
Now, for the first time, we can fully explore those fascinating
questions in an exciting and enlightening new exhibition,
" 'Primitivism' in 20th Century Art: Affinity of the Tribal and the Modern."
In over 350 works—150 modern and 200 tribal—we can now
get a definitive view of the similarities and differences, the
influences and affinities, which have intrigued us for nearly
a hundred years. It is a show which sheds new light on, and
challenges much of our "received wisdom" about, both "primitive"
and "modern" and their relation to each other. It may be the
first exhibition you've ever seen which asks and answers so many
questions about our art—and ourselves. And you'll find it at...

The Museum of Modern Art, 11 West 53rd Street
September 27, 1984 to January 15, 1985
Daily and Weekends 11-6 pm, Thursday 11-9 pm, Closed Wednesday

Philip Morris Incorporated
It takes art to make a company great.

Makers of Marlboro, Benson & Hedges 100's,
Merit, Parliament Lights, Virginia Slims
and Players; Miller High Life Beer, Lite Beer,
Löwenbräu Special and Dark Special Beers,
Meister Bräu and Milwaukee's Best; 7UP,
Diet 7UP, LIKE Cola and Sugar Free LIKE Cola.

© Philip Morris Inc. 1984

(top left) LES DEMOISELLES D'AVIGNON, Pablo Picasso, 1907 (detail). Collection: The Museum of Modern Art, New York. Acquired through the Lillie P. Bliss Bequest. (top right) MBUYA (SICKNESS) MASK, Pende, Zaire. Collection: Musée Royal de l'Afrique Centrale, Tervuren, Belgium.

Figure 37. Advertisement for the exhibition " 'Primitivism' in 20th Century Art: Affinity of the Tribal and the Modern" at the Museum of Modern Art, New York. *New York Times* (October 5, 1984). Offset on newsprint, printed in black, 11¼ x 7" (28.6 x 17.8 cm). Museum of Modern Art Archives, New York. Records of the Department of Public Information, II. Photograph © 2001 The Museum of Modern Art, New York.

some contemporary artists today, results in an attempt to exorcise them, and to deny the presence, or anyway the appropriateness, of such feeling in Western humans.

Our closeness to the so-called contemporary work renders the incompleteness of the selection obvious. Is it possible that the classical Modern works are chosen with a similarly sterilizing eye? Was primitive primitivist work made in the first third of this century, and might it have entered this exhibition if the Western dread of the primitive had not already excluded it from the art-history books? Georges Bataille, who was on the scene when primitive styles were being incorporated into European art as Modern, described this trend already in 1928, as Rosalind Krauss points out in the catalogue's chapter on Giacometti. He saw the estheticizing of primitive religious objects as a way for "the civilized Westerner . . . to maintain himself in a state of ignorance about the presence of violence within ancient religious practice."[7] Such a resistance, still dominant in this exhibition almost 60 years later, has led not only to a timid selection of contemporary works but to the exorcising of the primitive works themselves, which, isolated from one another in the vitrines and under the great lights, seem tame and harmless. The blood is wiped off them. The darkness of the unconscious has fled. Their power, which is threatening and untamed when it is present, is far away. This in turn affects the more radical Modern and contemporary works. If the primitive works are not seen in their full primitiveness, then any primitive feeling in Modernist allusions to them is bleached out also. The reason for this difficulty with the truly contemporary and the truly primitive is that this exhibition is not concerned with either: the show is about classical Modernism.

The fact that the primitive "looks like" the Modern is interpreted as validating the Modern by showing that its values are universal, while at the same time projecting it—and with it MoMA—into the future as a permanent canon. A counterview is possible: that primitivism on the contrary invalidates Modernism by showing it to be derivative and subject to external causation. At one level this show undertakes precisely to coopt that question by answering it before it has really been asked, and by burying it under a mass of information. The first task Rubin and his colleagues attempt, then, is a chronological one. They devote obsessive attention to the rhetorical question, Did primitive influence precede the birth of Modernism, or did it ingress afterward, as a confirmatory witness? It is hard to avoid the impression that this research was undertaken with the conclusion already in mind. The question is already begged in the title of the exhibition, which states not a hypothesis but a conclusion: " 'Primitivism' in 20th Century Art: Affinity of the Tribal and the Modern."

The central chronological argument, stated repeatedly in the book, is that although the Trocadéro Museum (later the Musée de l'Homme) opened in Paris in 1878, primitive influences did not appear in Parisian art till some time in the period 1905 to 1908. This thirty-year lag is held to show that the process of dif-

fusion was not random or mechanical, but was based on a quasideliberate exercise of will or spirit on the part of early Modern artists—in Rubin's words, an "elective affinity." [8] It was not enough, in other words, for the primitive images to be available; the European receptacle had to be ready to receive them. As far as chronology goes the argument is sound, but there is more involved than that. What is in question is the idea of what constitutes readiness. Rubin suggests that the European artists were on the verge of producing forms similar to primitive ones on their own account—so positively ready to do so, in fact, that the influx of primitive objects was redundant. For obvious reasons Rubin does not spell this claim out in so many words, yet he implies it continually. For example, he writes that "the changes in modern art at issue were already under way when vanguard artists first became aware of tribal art." [9] The changes at issue were of course the appearance of primitivelike forms. The claim is strangely improbable. If one thinks of Greco-Roman art, Renaissance art, and European art through the 19th century, there is nowhere any indication that this tradition could spawn such forms; at least, it never came close in its thousands of years. A countermodel to Rubin's might see readiness as comprising no more than a weariness with Western canons of representation and esthetics, combined with the gradual advance, since the 18th century, of awareness of Oceanic and African culture. The phenomena of art nouveau (with its Egyptianizing tendencies) and *japonisme* filled the thirty-year gap and demonstrate the eagerness for non-Western input that was finally fulfilled with the primitive works. Readiness, in other words, may have been more passive than active.

Clearly the organizers of this exhibition want to present Modernism not as an appropriative act but as a creative one. They reasonably fear that their powerful show may have demonstrated the opposite—which is why the viewer's responses are so closely controlled, both by the book and, in the show itself, by the wall plaques. The ultimate reason behind the exhibition is to revalidate Modernist esthetic canons by suggesting that their freedom, innocence, universality, and objective value are proven by their "affinity" to the primitive. This theme has become a standard in dealing with primitivism; Goldwater also featured the terms "affinities," rather than a more neutral one like "similarities."

A wall plaque within the exhibition informs us that there are three kinds of relations between modern and primitive objects: first, "direct influence"; second, "coincidental resemblances"; third, "basic shared characteristics." This last category, referred to throughout the book as "affinities," is particularly presumptuous. In general, proofs of affinity are based on the argument that the kind of primitive work that seems to be echoed in the Modern work is not recorded to have been in Europe at the time. Ernst's *Bird Head,* for example, bears a striking resemblance to a type of Tusyan mask from the upper Volta. But the resemblance, writes Rubin, "striking as it is, is fortuitous, and must therefore be accounted a simple affinity. *Bird Head* was sculpted in 1934, and no Tusyan masks

appear to have arrived in Europe (nor were any reproduced) prior to World War II."[10] The fact that the resemblance is fortuitous would seem to put it in the category of coincidental resemblances. It is not evidence but desire that puts it in the "affinities" class, which is governed as a whole by selection through similarly wishful thinking. In fact, the Ernst piece cannot with certainty be excluded from the "direct influences" category either. The argument that no Tusyan masks were seen in Europe in 1934 has serious weaknesses. First of all, it is an attempt to prove a negative; it is what is called, among logical fallacies, an *argumentum ex silentio*, or argument from silence. All it establishes is that Rubin's researchers have not heard of any Tusyan masks in Europe at that time. The reverse argument, that the Ernst piece shows there were probably some around, is about as strong.

A similar argument attempts to establish "affinity" between Picasso and Kwakiutl craftspeople on the basis of a Kwakiutl split mask and the vertically divided face in *Girl Before a Mirror*, 1932. For, says Rubin, "Picasso could almost certainly never have seen a 'sliced' mask like the one we reproduce, but it nonetheless points up the affinity of his poetic thought to the mythic universals that the tribal objects illustrate."[11] The argument is weak on many grounds. First, Picasso had long been familiar with primitive art by 1932, and that general familiarity, more than any "universals," may account for his coming up with a primitivelike thing on his own. The same is true for Ernst and the *Bird Head*. Modern artists don't necessarily have to have seen an object exactly similar to one of their own for influence to exist. Anyway, the similarity between *Girl Before a Mirror* and the "sliced" Kwakiutl mask is not really that strong. The mask shows a half head; the girl has a whole head with a line down the middle and different colors on each side. Rubin attempts to correct this weakness in the argument by noting that "Northwest coast and Eskimo masks often divide integrally frontal faces more conventionally into dark and light halves."[12] But most of the world's mythological iconographies have the image of the face with the dark and light halves. Picasso had surely encountered this common motif in a variety of forms—as the alchemical Androgyne, for example. There is, in other words, no particular reason to connect his *Girl Before a Mirror* with Kwakiutl masks, except for the sake of the exhibition.

In addition to Rubin's reliance on the notoriously weak argument from silence, his "affinities" approach breaches the Principle of Economy, on which all science is based: that explanatory principles are to be kept to the smallest possible number (*entia non multiplicanda sunt praeter necessitatem*). The Principle of Economy does not of course mean keeping information to a minimum, but keeping to a minimum the number of interpretive ideas that one brings to bear on information. The point is that unnecessary principles will usually reflect the wishful thinking of the speaker, and amount to deceptive persuasive mechanisms. In the present case, ideas like "elective affinity," "mythic universals," and "affinity

of poetic thought" are all *entia praeter necessitatem*, unnecessary explanatory principles. They enter the discourse from the wishful thinking of the speaker. An account lacking the ghost in the machine would be preferred. The question of influence or affinity involves much broader questions, such as the nature of diffusion processes and the relationship of Modernist esthetics to the Greco-Roman and Renaissance tradition. In cultural history in general, diffusion processes are random and impersonal semiotic transactions. Images flow sideways, backwards, upside down. Cultural elements are appropriated from one context to another not only through spiritual affinities and creative selections, but through any kind of connection at all, no matter how left-handed or trivial.

The museum's decision to give us virtually no information about the tribal objects on display, to wrench them out of context, calling them to heel in the defense of formalist Modernism, reflects the exclusion of the anthropological point of view. Unfortunately, art historians and anthropologists have not often worked well together; MoMA handles this problem by simply neglecting the anthropological side of things. No attempt is made to recover an emic, or inside, sense of what primitive esthetics really were or are. The problem of the difference between the emic viewpoint—that of the tribal participant—and the etic one—that of the outside observer—is never really faced by these art historians, engrossed as they seem to be in the exercise of their particular expertise, the tracing of stylistic relationships and chronologies. The anthropologist Marvin Harris explains the distinction:

> Emic operations have as their hallmark the elevation of the native informant to the status of ultimate judge of the adequacy of the observer's descriptions and analyses. The test of the adequacy of emic analyses is their ability to generate statements the native accepts as real, meaningful, or appropriate. . . .
> Etic operations have as their hallmark the elevation of observers to the status of ultimate judges of the categories and concepts used in descriptions and analyses. The test of the adequacy of etic accounts is simply their ability to generate scientifically productive theories about the causes of sociocultural differences and similarities. Rather than employ concepts that are necessarily real, meaningful, and appropriate from the native point of view, the observer is free to use alien categories and rules derived from the data language of science.[13]

The point is that accurate or objective accounts can be given from either an emic or an etic point of view, but the distinction must be kept clear. If etic pretends to be emic, or emic to be etic, the account becomes confused, troubled, and misleading.

MoMA makes a plain and simple declaration that their approach will be etic. Materials in the press kit which paraphrase a passage of Rubin's introduction argue, "As our focus is on the modernists' experience of tribal art, and not on

ethnological study, we have not included anthropological hypotheses regarding the religious or social purposes that originally surrounded these objects." Rubin similarly argues in his own voice that "the ethnologists' primary concern—the specific function and significance of each of these objects—is irrelevant to my topic, except insofar as these facts might have been known to the modern artists in question."[14] The point of view of Picasso and others, then, is to stand as an etic point of view, and is to be the only focus of MoMA's interest; emic information, such as attributions of motives to the tribal artists, is to be irrelevant.

This position is consistent in itself, but is not consistently acted on. In effect, it is violated constantly. It must be stressed that if the emic/etic question is to be neglected, then the intentions of the tribal craftsmen must be left neutral and undefined. But Rubin's argument constantly attributes intentions to the tribal craftsmen, intentions associated with Modernist types of esthetic feeling and problem-solving attitudes. The very concept of "affinity" rather than mere "similarity" attributes to the tribal craftsmen feelings like those of the Modernist artists, for what else does the distinction between affinities and accidental similarities mean? The claim that there is an "affinity of poetic spirit" between Picasso and the Kwakiutl who made the "sliced" mask attributes to the Kwakiutl poetic feelings like those of Picasso. The assertion that their use of "parallelisms and symmetries" demonstrates a "propinquity in spirit"[15] between Jacques Lipchitz and a Dogon sculptor attributes to the Dogon a sensibility in general like that of Lipchitz. And so on. Rubin says that the "specific function and significance of each of these objects is irrelevant—for example, what ceremony the object was used in, how it was used in the ceremony, and so on. The use of the word "each" here is tricky. It is true that Rubin ignores the specific function of each object, but it is also true that he attributes a general function to all the objects together, namely, the esthetic function, the function of giving esthetic satisfaction. In other words, the function of the Modernist works is tacitly but constantly attributed to the primitive works. It is easy to see why no anthropologist was included in the team. Rubin has made highly inappropriate claims about the intentions of tribal cultures without letting them have their say, except through the mute presence of their unexplained religious objects, which are misleadingly presented as art objects. This attitude toward primitive objects is so habitual in our culture that one hardly notices the hidden assumptions until they are pointed out. Rubin follows Goldwater in holding that the objects themselves are proof of the formal decisions made, and that the formal decisions made are proof of the esthetic sensibility involved. That this argument seems plausible, even attractive, to us is because we have the same emic view as Rubin and MoMA. But connections based merely on form can lead to skewed perceptions indeed. Consider from the following anthropological example what absurdities one can be led into by assuming that the look of things, without their meaning, is enough to go on:

In New Guinea, in a remote native school taught by a local teacher, I watched a class carefully copy an arithmetic lesson from the blackboard. The teacher had written:

$$4 + 1 = 7$$
$$3 - 5 = 6$$
$$2 + 5 = 9$$

The students copied both his beautifully formed numerals and his errors.[16]

The idea that tribal craftsmen had esthetic problem-solving ambitions comparable to those of Modernist artists involves an attribution to them of a value like that which we put on individual creative originality. An anthropologist would warn us away from this presumption: "in preliterate cultures . . . culture is presented to its members as clichés, repeated over and over with only slight variation." "Such art isn't personal. It doesn't reflect the private point of view of an innovator. It's a corporate statement by a group."[17] Yet Rubin declares, again relying only on his sense of the objects, without ethnological support, that "the surviving works themselves attest that individual carvers had far more freedom in varying and developing these types than many commentators have assumed."[18] Surely Rubin knows that the lack of a history of primitive cultures rules out any judgment about how quickly they have changed or how long they took to develop their diversity. The inventiveness Rubin attributes to primitive craftsmen was probably a slow, communal inventiveness, not a matter of individual innovation. In prehistoric traditions, for example, several thousand years may be needed for the degree of innovation and change seen in a single decade of Modernism. Rubin asserts formalist concerns for the tribal craftspeople "even though they had no concept for what such words mean."[19] Consider the particular value judgment underlying the conviction that the only thing primitives were doing that is worth our attention, their proof of "propinquity of spirit" with the white man, was something they weren't even aware of doing.

From a purely academic point of view Rubin's project would be acceptable if its declared etic stance had been honestly and consistently acted out. What is at issue here, however, is more than a set of academic flaws in an argument, for in other than academic senses the etic stance is unacceptable anyway. Goldwater had made the formalist argument for tribal objects in the '30s; it was a reasonable enough case to make at the time. But why should it be replayed fifty years later, only with more information? The sacrifice of the wholeness of things to the cult of pure form is a dangerous habit of our culture. It amounts to a rejection of the wholeness of life. After fifty years of living with the dynamic relationship between primitive and Modern objects, are we not ready yet to begin to understand the real intentions of the native traditions, to let those silenced cultures speak to us at last? An investigation that really did so would show us immensely more about the possibilities of life that Picasso and others vaguely

sensed and were attracted to than does this endless discussion of the spiritual propinquity of usages of parallel lines. It would show us more about the "world-historical" importance of the relationship between primitive and Modern and their ability to relate to one another without autistic self-absorption.

The complete omission of dates from the primitive works is perhaps one of the most troubling decisions. Are we looking at works from the '50s? (If so, are they modern art?) How do we know that some of these artists have not seen works by Picasso? One can foresee a doctoral thesis on Picasso postcards seen by Zairean artists before 1930. The museum dates the Western works, but leaves the primitive works childlike and Edenic in their lack of history. It is true that many of these objects cannot be dated precisely, but even knowing the century would help. I have no doubt that those responsible for this exhibition and book feel that it is a radical act to show how equal are the primitives to us, how civilized, how sensitive, how "inventive." Indeed, both Rubin and Varnedoe passionately declare this. But by their absolute repression of primitive context, meaning, content, and intention (the dates of the works, their functions, their religious or mythological connections, their environments), they have treated the primitives as less than human, less than cultural—as shadows of a culture, their selfhood, their Otherness, wrung out of them. All the curators want us to know about these tribal objects is where they came from, what they look like, who owns them, and how they fit the needs of the exhibition.

In their native contexts these objects were invested with feelings of awe and dread, not of esthetic ennoblement. They were seen usually in motion, at night, in closed dark spaces, by flickering torchlight. Their viewers were under the influence of ritual, communal identification feelings, and often alcohol or drugs; above all, they were activated by the presence within or among the objects themselves of the shaman, acting out the usually terrifying power represented by the mask or icon. What was at stake for the viewers was not esthetic appreciation but loss of self in identification with and support of the shamanic performance. The Modernist works in this show serve completely different functions, and were made to be perceived from a completely different stance. If you or I were a native tribal artisan or spectator walking through the halls of MoMA we would see an entirely different show from the one we see as 20th-century New Yorkers. We would see primarily not form, but content, and not art, but religion or magic.

Consider a reverse example, in which Western cultural objects were systematically assimilated by primitives into quite a new functional role. In New Guinea in the '30s, Western food containers were highly prized as clothing ornaments—a Kellogg's cereal box became a hat, a tin can ornamented a belt, and so on. Passed down to us in photographs, the practice looks not only absurd but pathetic. We know that the tribal people have done something so inappropriate as to be absurd, and without even beginning to realize it. Our sense of the

smallness and quirkiness of their world view encourages our sense of the larger scope and grater clarity of ours. Yet the way Westerners have related to the primitive objects that have floated through their consciousness would look to the tribal peoples much the way their use of our food containers looks to us: they would perceive at once that we had done something childishly inappropriate and ignorant, and without even realizing it. Many primitive groups, when they have used an object ritually (sometimes only once), desacralize it and discard it as garbage. We then show it in our museums. In other words: our garbage is their art, their garbage is our art. Need I say more about the emic/etic distinction?

The need to coopt difference into one's own dream of order, in which one reigns supreme, is a tragic failing. Only fear of the Other forces one to deny its Otherness. What we are talking about is a tribal superstition of Western civilization: the Hegel-based conviction that one's own culture is riding the crucial time-line of history's self-realization. Rubin declares that tribal masterpieces "transcend the particular lives and times of their makers." [20] Varnedoe similarly refers to "the capacity of tribal art to transcend the intentions and conditions that first shaped it." [21] The phrase might be restated: "the capacity of tribal art to be appropriated out of its own intentionality into mine."

As the crowning element of this misappropriation of other values comes the subject of representation. Rubin distinguishes between European canons of representation, which are held to represent by actual objective resemblance, and the various primitive canons of representation, which are held to represent not by resemblance but by ideographic convention. Our representation, in other words, corresponds to external reality, theirs is only in their minds. But the belief that an objective representational system can be defined (and that that system happens to be ours) is naive and inherently contradictory. It is worth noting that tribal peoples tend to feel that it is they who depict and we who symbolize. Representation involves a beholder and thus has a subjective element. If someone says that A doesn't look like B to him or her, no counterargument can prove that it does. All conventions of representation are acculturated and relative; what a certain culture regards as representation is, for that culture, representation.

Rubin's love of Modernism is based on the fact that it at last took Western art beyond mere illustration. When he says that the tribal artisans are not illustrating but conceptualizing, he evidently feels he is praising them for their modernity. In doing so, however, he altogether undercuts their reality system. By denying that tribal canons of representation actually represent anything, he is in effect denying that their view of the world is real. By doing them the favor of making them into Modern artists, Rubin cuts reality from under their feet.

The myth of the continuity of Western art history is constructed out of acts of appropriation like those Rubin duplicates. The rediscovery of Greco-Roman works in the Renaissance is an important instance of this, for the way we relate to such art is also in a sense like wearing a cereal-box hat. The charioteer of

Delphi, ca. 470 B.C., for example, was seen totally differently in classical Greece from the way we now see him. He was not alone in that noble, self-sufficient serenity of transcendental angelic whiteness that we see. He was part of what to us would appear a grotesquely large sculptural group—the chariot, the four horses before it, the god Apollo in the chariot box, and whatever other attendants were around. All was painted realistically and must have looked more like a still from a movie than like what we call sculpture. Both Greco-Roman and primitive works, though fragmented and misunderstood, have been appropriated into our art history in order to validate the myth of its continuity and make it seem inevitable.

It is a belief in the linear continuity of the Western tradition that necessitates the claim that Western artists would have come up with primitivelike forms on their own, as a natural development. The purpose of such theorizing is to preclude major breaks in Western art history; its tradition is to remain intact, not pierced and violated by influence from outside the West. The desire to believe in the wholeness, integrity, and independence of the Western tradition has at its root the Hegelian art-historical myth (constructed by the critical historians like Karl Schnaase, Alois Riegl, and Heinrich Wölfflin) that Western art history expresses the self-realizing tendency of Universal Spirit. (This is Rubin's vocabulary. He once declared, for example, that Pollock's paintings were " 'world historical' in the Hegelian sense.")[22] When brought down to earth—that is, to recorded history—this view involves not only the conclusion that the shape and direction of Modern art were not really affected by the discovery of primitive objects, but another conclusion equally unlikely, that the shape and direction of European art were not really influenced by the discovery of Greco-Roman works in the Renaissance.

In fact, Western art history shows three great breaks: one when the population of Europe was changed by the so-called barbarian invasions in the late Roman Empire, which led to the transition from Greco-Roman to Christian art; the second with the Renaissance, the transition from Christian art to European art; the third at the beginning of the 20th century, with the transition from European to Modern art. Each of these breaks in tradition was associated with a deep infusion of foreign influence—respectively Germanic, Byzantine, and African/Oceanic. To minimize these influences is to hold the Western tradition to be a kind of absolute, isolated in its purity. From that point of view the adoption of primitive elements by early Modernists is seen as a natural, indeed inevitable, inner development of the Western tradition. But the context of the time suggests otherwise. In the 19th century the Western tradition in the arts (including literature) seemed to many to be inwardly exhausted. In 1873 Arthur Rimbaud proclaimed his barbarous Gallic ancestors who buttered their hair,[23] and called for a disorientation of the patterns of sensibility. The feeling was not uncommon; many artists awaited a way of seeing that would amount simultane-

ously to an escape from habit and a discovery of fresh, vitalizing content. For there is no question that the turn-of-the-century fascination with archaic and primitive cultures was laden with content: Baudelaire, Rimbaud, Picasso, and Matisse were attracted, for example, by the open acknowledgment of the natural status of sex and death in these cultures. By repressing the aspect of content, the Other is tamed into mere pretty stuff to dress us up.

Of course, you can find lots of little things wrong with any big project if you just feel argumentative. But I am motivated by the feeling that something important is at issue here, something deeply, even tragically wrong. In depressing starkness, "'Primitivism'" lays bare the way our cultural institutions relate to foreign cultures, revealing it as an ethnocentric subjectivity inflated to coopt such cultures and their objects into itself. I am not complaining, as the Zuni Indians have, about having tribal objects in our museums. Nor am I complaining about the performing of valuable and impressive art-historical research on the travels of those objects through ateliers (though I am worried that it buries the real issues in an ocean of information). My real concern is that this exhibition shows Western egotism still as unbridled as in the centuries of colonialism and souvenirism. The Museum pretends to confront the Third World while really coopting it and using it to consolidate Western notions of quality and feelings of superiority.

Hamish Maxwell, chairman of Philip Morris, one of the sponsors of the exhibition, writes in the catalogue that his company operates in 170 "countries and territories," suggesting a purview comparable to that of the show. He continues, "We at Philip Morris have benefited from the contemporary art we have acquired and the exhibitions we have sponsored over the past quarter-century. . . . They have stirred creative approaches throughout our company."[24] In the advertisement in the Sunday *New York Times* preceding the "'Primitivism'" opening, the Philip Morris logo is accompanied by the words, "It takes art to make a company great."

Well, it takes more than connoisseurship to make an exhibition great.

NOTES

1. Richard E. Oldenburg, Foreword, in William Rubin, ed., *"Primitivism" in 20th Century Art: Affinity of the Tribal and the Modern,* New York: The Museum of Modern Art, 1984, p. viii.

2. The Museum of Modern Art, New York, press release no. 17, August 1984, for the exhibition "'Primitivism' in 20th Century Art: Affinity of the Tribal and the Modern," p. 1.

3. Revised and republished as Robert Goldwater, *Primitivism in Modern Art,* New York:

Vintage Books, 1967. In 1933, 1935, 1941, and 1946, the Modern itself had exhibitions of archaic and primitive objects separately from its Modern collections. René D'Harnoncourt, director of the Museum for 19 years, was an authority on the subject.

4. William Rubin, *Dada and Surrealist Art,* New York: Harry N. Abrams, 1968.

5. Two by Rubin, two by Kirk Varnedoe, two by Alan G. Wilkinson, and one each by Ezio Bassani, Christian F. Feest, Jack Flam, Sidney Geist, Donald E. Gordon, Rosalind Krauss, Jean Laude, Gail Levin, Evan Maurer, Jean-Louis Paudrat, Philippe Peltier, and Laura Rosenstock.

6. Kirk Varnedoe, "Contemporary Explorations," in Rubin, *"Primitivism,"* pp. 662, 681, 679.

7. Rosalind Krauss, "Giacometti," in Rubin, *"Primitivism,"* p. 510.

8. William Rubin, "Modernist Primitivism: An Introduction," in Rubin, *"Primitivism,"* p. 11.

9. Ibid.

10. Ibid., p. 25.

11. Rubin, "Picasso," in Rubin, *"Primitivism,"* pp. 328–330.

12. Ibid., p. 328.

13. Marvin Harris, *Cultural Materialism: The Struggle for a Science of Culture,* New York: Vintage Books, 1980, p. 32.

14. Rubin, "Modernist Primitivism," in Rubin, *"Primitivism,"* p. 1.

15. Ibid., p. 51.

16. Edmund Carpenter, *Oh, What a Blow That Phantom Gave Me!,* New York: Holt, Rinehart and Winston, 1973, p. 54.

17. Ibid., pp. 53, 56.

18. Rubin, "Modernist Primitivism," in Rubin, *"Primitivism,"* p. 5.

19. Ibid., p. 19.

20. Ibid., p. 73.

21. Kirk Varnedoe, preface, in Rubin, *"Primitivism,"* p. x.

22. Cited in Peter Fuller, *Beyond the Crisis in Art,* London: Writers and Readers Publishing Cooperative Ltd., 1980, p. 98.

23. Arthur Rimbaud, *Une saison en enfer* (A season in hell), 1873, trans. Louise Varèse, New York: New Directions, 1961, p. 7.

24. Hamish Maxwell, in Rubin, *"Primitivism,"* p. vi.

JAMES CLIFFORD

HISTORIES OF THE TRIBAL AND
THE MODERN · 1985

You do not stand in one place to watch a masquerade.

—an Igbo saying

The "tribal" objects gathered last fall on West 53rd Street in New York have been around. They are travelers—some arriving from folklore and ethnographic museums in Europe, others from art galleries and private collections. They have traveled first class to the Museum of Modern Art, elaborately crated and insured for important sums. Previous accommodations have been less luxurious. Some were stolen, others "purchased" for a song by colonial administrators, travelers, anthropologists, missionaries, sailors in African ports. These non-Western objects have been, by turns, curiosities, ethnographic specimens, major art creations. After 1900 they turned up in European flea markets, thereafter moving between avant-garde studios and collectors' apartments. Some came to rest in the unheated basements or "laboratories" of anthropology museums, surrounded by objects made in the same region of the world. Others would encounter odd fellow travelers, lit and labeled in strange display cases. Now on West 53rd Street they are interspersed with works by European masters, Picasso, Giacometti, Brancusi and others. A three-dimensional Eskimo mask with twelve arms and a number of holes hangs beside a canvas on which Joan Miró has painted colored shapes. The people in New York look at the two objects and see that they are alike.

Travelers tell different stories in different places. During the winter of 1984–85 one could encounter tribal objects in an unusual number of locations around New York. This essay surveys a half dozen of them (describing all in an "ethno-

Art in America (April 1985): 164–77, 215. By permission of ART IN AMERICA, Brant Publications, Inc.

The American anthropologist James Clifford (b. 1945) teaches at the University of California, Santa Cruz, and is well known for his widely influential book *The Predicament of Culture: Twentieth-Century Ethnography, Literature, and Art* (1988). As Clifford notes, the MoMA show was one of six major exhibitions of Primitive art in New York in the fall and winter of 1984. The new Center for African Art opened in September, with an exhibition of masterpieces from the Musée de l'Homme, Paris; "Asante: Kingdom of God" opened at the American Museum of Natural History in October, and the Margaret Mead Hall of Pacific Peoples opened as a permanent installation at that museum in December; "Te Maori" opened at the Rockefeller Wing of the Metropolitan Museum of Art in September; and an exhibition of Northwest Coast Indian art opened at the IBM Gallery in October.

graphic present" of late December 1984) while dwelling on the prominent
MoMA show. This exhibition recounts an important history and establishes a
dominant esthetic that is confirmed, refined and sometimes questioned by the
other collections.

On West 53rd Street an origin story of modernism is told. Around 1910, Pi-
casso and his cohort suddenly, intuitively, recognize that "primitive" objects are
in fact powerful "art." They collect, imitate and are affected by these objects.
Their own work, even when not directly influenced, seems oddly reminiscent of
non-Western forms. The modern and the primitive converse across the cen-
turies and continents. At the Museum of Modern Art an exact history is told,
featuring individual artists and objects, their encounters in specific studios at
precise moments. Photographs document the crucial influences of non-Western
artifacts on the pioneer modernists. This focused story is surrounded and infused
with another—a loose allegory of relationship centering on the word "affinity."
The word is a kinship term, suggesting a deeper or more natural relationship
than mere resemblance or juxtaposition. It connotes a common quality or
essence joining the tribal to the modern. A Family of Art is brought together,
global, diverse, richly inventive and miraculously unified: for every object dis-
played on West 53rd Street looks modern.

The exhibition at MoMA is historical and didactic. It is complemented by a
comprehensive, scholarly catalogue which includes divergent views of its topic
and in which the show's organizers, William Rubin and Kirk Varnedoe, argue at
length its underlying premises. One of the virtues of an exhibition that blatantly
makes a case or tells a story is that it encourages debate and makes possible the
suggestion of other stories. Thus, in what follows different histories of the tribal
and the Modern will be proposed in response to the sharply focused history on
display at the Museum of Modern Art. But before that history can be seen for
what it is—a specific story that excludes other stories—the universalizing alle-
gory of "affinity" must be cleared away.

This allegory, the story of the Modernist Family of Art, is not rigorously ar-
gued at MoMA. (That would require some explicit form of either an archetypal
or structural analysis.) The allegory is, rather, built into the exhibition's form,
featured suggestively in its publicity, left uncontradicted, repetitiously asserted—
"Affinity of the Tribal and the Modern." The allegory has a hero. His virtuoso
work, an exhibit caption tells us, contains more affinities with the tribal than
that of any other pioneer modernist. These affinities "measure the depth of Pi-
casso's grasp of the informing principles of tribal sculpture, and reflect his pro-
found identity of spirit with the tribal peoples." Modernism is thus presented as
a search for "informing principles" that transcend culture, politics and history.
Beneath this generous umbrella the tribal is modern and the modern more
richly, diversely human.

Some Affinities Not Included in MoMA's "Primitivism" show:

Collections: Left, Georges Braque in his studio, Paris, 1911. Right, interior of Chief Shake's house (Kwakiutl), Wrangel, Alaska, 1909.

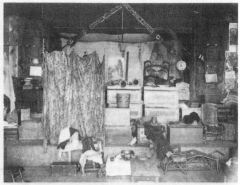

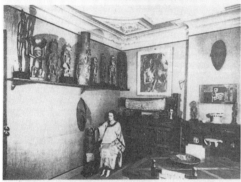

Appropriations: Left, Mrs. Pierre Loeb in family apartment with modern and tribal works, Rue Desbordes-Valmore, Paris, 1929. Right, New Guinea girl with photographer's flash bulbs (included in the "Culture Contact" display at the Hall of Pacific Peoples).

Bodies: Far left, Josephine Baker in a famous pose, Paris, ca. 1929. Center, Figure (Chokwe, Angola), wood, 16½ inches. Left, Costume design by Fernand Léger for *The Creation of the world*, 1922–23, gouache and ink, 12 by 8 inches.

FERNAND LÉGER

Figure 38. "Affinities not included in the Museum of Modern Art's 'Primitivism' show," from *Art in America* (1985). The top right photo is Tlingit, not Kwakiutl (as its caption indicates). Center right photo courtesy the American Museum of Natural History Library; lower left photo courtesy Stanley B. Burns, M.D., and the Burns Archive; lower right photo © 2002 Artists Rights Society (ARS), New York/ADAGP, Paris.

The power of the affinity idea is such (it becomes almost self-evident in the MoMA juxtapositions) that it is worth reviewing the major objections to it. Anthropologists, long familiar with the issue of cultural diffusion versus independent invention, are not likely to find anything special in the similarities of selected tribal and modern objects. An established principle of anthropological comparative method asserts that the greater the range of cultures the more likely one is to find similar traits. MoMA's sample is very large, embracing African, Oceanic, North American and Arctic "tribal" groups.[1] A second principle, that of the "limitation of possibilities," recognizes that invention, while highly diverse, is not infinite. The human body, for example, with its two eyes, four limbs, bilateral arrangement of features, front and back, etc., will be represented and stylized in a limited number of ways.[2] There is thus, *a priori,* no reason to claim evidence for affinity (rather than mere resemblance or coincidence) because an exhibition of tribal works that seem impressively "modern" in style can be gathered. An equally striking collection could be made demonstrating sharp dissimilarities of tribal and modern objects.

The qualities most often said to link these objects are their "conceptualism" and "abstraction" (but a very long and ultimately incoherent list, including "magic," "ritualism," "environmentalism," use of "natural" materials, etc., can be derived from the show and especially from its catalogue). Actually, the tribal and modern artifacts are similar only in that they do *not* feature the pictorial illusionism or sculptural naturalism that came to dominate Western European art after the Renaissance. Abstraction and conceptualism are, of course, pervasive in the arts of the non-Western world. To say that they share with modernism a rejection of certain naturalist projects is not to show anything like an affinity.[3] And indeed, the "tribalism" selected in the exhibition to resemble modernism is itself a construction designed to accomplish the task of resemblance. Ife and Benin sculptures, highly naturalistic in style, are excluded from the "tribal" and placed in a somewhat arbitrary category of "court" society (which does not, however, include large chieftainships). Moreover, Pre-Columbian works, though they have a place in the catalogue, are largely omitted from the exhibition. One can question other selections and exclusions which result in a collection of only "modern"-looking tribal objects. Why, for example, are there relatively few "impure" objects, constructed from the debris of colonial culture contacts? And is there not an overall bias toward clean, abstract forms as against rough or crude work?

The "Affinities" room of the exhibition is an intriguing but entirely problematic exercise in formal mix and match. The room's short introductory text begins well: "AFFINITIES presents a group of tribal objects notable for their appeal to modern taste." Indeed, this is all that can rigorously be said of the room. But the text continues: "Selected pairings of modern and tribal objects demonstrate common denominators of these arts that are independent of direct influ-

ence." The phrase "common denominators" implies something more systematic than intriguing resemblance. What can it possibly mean? This introductory text, cited in its entirety, is emblematic of the MoMA undertaking as a whole. Statements carefully limiting its purview (specifying a concern only with modernist primitivism and not with tribal life) coexist with frequent implications of something more. The "affinity" idea itself is wide-ranging and promiscuous, as are allusions to universal human capacities retrieved in the encounter of modern and tribal, or invocations of the expansive human mind—the healthy capacity of modernist consciousness to question its limits and engage otherness.[4]

Nowhere, however, does the exhibition or catalogue underline a more disquieting quality of modernism: its taste for appropriating or redeeming otherness, for constituting non-Western arts in its own image, for discovering universal, ahistorical "human" capacities. The search for similarity itself requires justification. For even if one accepts the limited task of exploring "modernist primitivism," why could one not learn as much about Picasso's or Ernst's creative processes by analyzing the *differences* separating their art from tribal models or by following out the ways their art moved *away* from, gave new twists to, non-Western forms?[5] This side of the process is unexplored in the exhibition. The prevailing viewpoint is made all too clear in one of the "affinities" featured on the catalogue covers, a juxtaposition of Picasso's *Girl Before a Mirror,* 1932, with a Kwakiutl half-mask, a type of mask quite rare among Northwest coast creations. Its task here is simply to produce an effect of resemblance (an effect actually created by the camera angle). In this exhibition a universal message, "Affinity of the Tribal and the Modern," is produced by careful selection and the maintenance of a specific angle of vision.

The notion of affinity, an allegory of kinship, has an expansive, celebratory task to perform. The affinities shown at MoMA are all on modernist terms. The great modernist "pioneers" (and their museum) are shown promoting formerly despised tribal "fetishes" or mere ethnographic "specimens" to the status of high art and in the process discovering new dimensions of their ("our") creative potential. The capacity of art to transcend its cultural and historical context is asserted repeatedly.[6] In the catalogue Rubin tends to be more interested in a recovery of elemental expressive modes, whereas Varnedoe stresses the rational, forward-looking intellect (which he opposes to an unhealthy primitivism—irrational and escapist). Both celebrate the expansive spirit of modernism, pitched now at a global scale but excluding—as we will see—Third World modernisms.

At West 53rd Street, modernist primitivism is a going Western concern. It is, Varnedoe tells us, summing up in the last sentence of the catalogue's second volume, "a process of revolution that begins and ends in modern culture, and because of that—not in spite of it—can continually expand and deepen our contact with that which is remote and different from us, and continually threaten, challenge, and reform our sense of self" (p. 682). A skeptic may doubt the ability of

the modernist primitivism exhibited at MoMA to threaten or challenge what is by now a thoroughly institutionalized system of esthetic (and market) value. But it is appropriate, and in a sense rigorous, that this massive collection spanning the globe should end with the word "self."

Indeed, an unintended effect of the exhibition's comprehensive catalogue is to show, once and for all, the incoherence of the modern Rorschach of "the primitive." From Robert Goldwater's formalism to the transforming "magic" of Picasso (according to Rubin); from Lévy-Bruhl's mystical *mentalité primitive* (influencing a generation of modern artists and writers) to Lévi-Strauss's *pensée sauvage* (resonating with "systems art" and the cybernetic binarism of the Minimalists); from Dubuffet's fascination with insanity and the childish to the enlightened rational sense of a Gauguin, the playful experimentalism of a Picasso or the new "scientific" spirit of a James Turrell (the last three approved by Varnedoe but challenged by Rosalind Krauss, who is more attached to decapitation, *bassesse* and bodily deformations);[7] from fetish to icon and back again; from Aboriginal bark paintings (Klee) to massive Pre-Columbian monuments (Moore); from weightless Eskimo masks to Stonehenge—the catalogue succeeds in demonstrating, not any essential affinity between the tribal and modern or even a coherent modernist attitude toward the primitive, but rather the restless desire and power of the modern West to collect the world.

Setting aside the allegory of affinity, we are left with a "factual," narrowly focused history—that of the "discovery" of primitive art by Picasso and his generation. It is commonly said that this (the "History" section) is, after all, the rigorous part of the exhibition, and the rest merely suggestive association. Undeniably a great deal of scholarly research in the best *Kunstgeschichte* tradition has been brought to bear on this specific history. Numerous myths are usefully questioned; important facts are specified (what mask was in whose studio when); and the pervasiveness of tribal influences on early modernist art—European, English and American—is shown more amply than ever before. The catalogue has the merit of including a number of articles that dampen the celebratory mood of the exhibition: notably the essay by Krauss and useful contributions by Christian Feest, Philippe Peltier and Jean-Louis Paudrat detailing the arrival of non-Western artifacts in Europe. These historical articles exhibit the less edifying imperialist contexts that surrounded the "discovery" of tribal objects by modernist artists at the moment of high colonialism.

But if we ignore the "Affinities" room at MoMA and focus on the "serious" historical part of the exhibition, new critical questions emerge. What is excluded by the specific focus of the history? And isn't this factual narration still infused with the affinity allegory, since it is cast as a story of creative genius recognizing the greatness of tribal works, discovering common artistic "informing principles"? Could the story of this intercultural encounter be told differently?

It is worth making the effort to extract another story from the materials in the exhibition—not a history of redemption or of discovery, but of reclassification. This other history assumes that "art" is not universal, but a changing Western cultural category. The fact that rather abruptly, in the space of a few decades, a large class of non-Western artifacts came to be redefined as art is a taxonomic shift that requires critical historical discussion, not celebration. That this construction of a generous category of art pitched at a global scale occurs just as the planet's tribal peoples come massively under European political, economic and evangelical dominion cannot be irrelevant. But there is room for no such complexities at the MoMA show. Obviously the modernist appropriation of tribal productions as art is not simply "imperialist." The project involves too many strong critiques of colonialist, evolutionist assumptions. But, as we shall see, the scope and underlying logic of the "discovery" of tribal art reproduces hegemonic Western assumptions rooted in the colonial and neo-colonial epoch.

Picasso, Léger, Apollinaire and many others came to recognize the elemental, "magical" power of African sculptures in a period of growing *négrophilie*, a context that would see the irruption on the European scene of other evocative black figures: the jazzman, the boxer (Al Brown), the *sauvage* Josephine Baker.[8] To tell the history of modernism's recognition of African "art" in this broader context would raise ambiguous and disturbing questions about esthetic appropriation of non-Western others, issues of race, gender and power. This other story is largely invisible at MoMA, given the exhibition's narrow focus. It can be glimpsed only in the small section devoted to "La Création du Monde," the African cosmogony staged in 1923 by Léger, Cendrars and Milhaud, and in the broadly pitched, if still largely uncritical, catalogue article by Laura Rosenstock devoted to it. But overall, one would be hard pressed to deduce from the exhibition that all the enthusiasm for things *nègre,* for the "magic" of African art, had anything to do with race. Art in this focused history has no essential link with coded perceptions of black bodies—their vitalism, rhythm, magic, erotic power, etc.—seen by whites. The modernism represented here is concerned only with artistic invention, a positive category separable from a negative primitivism of the irrational, the savage, the base, the flight from civilization.

A different historical focus might have brought a photograph of Josephine Baker into the vicinity of the African statues that were exciting the avant-garde in the teens and '20s. But such a juxtaposition would be unthinkable in the MoMA history, for it evokes different affinities than those contributing to a category of great art. The black body in '20s Paris was an ideological artifact. Archaic Africa (which came to Paris by way of the future, i.e., America) was sexed, gendered and invested with "magic" in specific ways. Standard poses adopted by "La Baker," like Léger's designs and costumes, evoked a recognizable "Africanity"—the naked form emphasizing pelvis and buttocks, a segmented stylization suggesting a strangely mechanical vitality. The inclusion of so ideologically

loaded a form as the body of Josephine Baker among the figures classed as art on West 53rd Street would suggest a different account of modernist primitivism, an analysis of the category *nègre* in *l'art nègre,* and an exploration of the "taste" that was something more than just a backdrop for the discovery of tribal art in the opening decades of this century.

Such a focus would treat art as a category defined and redefined in specific historical contexts and relations of power. Seen from this angle and read somewhat against the grain, the MoMA exhibition documents a *taxonomic* moment: the status of non-Western objects and "high" art are importantly redefined, but there is nothing permanent or transcendent about the categories at stake. The appreciation and interpretation of tribal objects takes place within a modern "system of objects," in Baudrillard's phrase, which confers value on certain things and withholds it from others.[9] Modernist primitivism, with its claims to deeper humanist sympathies and a wider esthetic sense, goes hand in hand with a developed market in tribal art and with definitions of artistic and cultural authenticity that are now widely contested.

Since 1900, non-Western objects have generally been classed as either primitive art *or* ethnographic specimens. Before the modernist revolution associated with Picasso and the simultaneous rise of cultural anthropology associated with Boas and Malinowski, these objects were differently classified—as antiquities, exotic curiosities, Orientalia, the remains of Early Man, etc. With the emergence of 20th-century modernism and anthropology, figures formerly called "fetishes" (to take just one class of object) became works either of "sculpture" or of "material culture." The distinction between the esthetic and the anthropological was soon institutionally reinforced. In art galleries, non-Western objects were displayed for their formal and esthetic qualities; in ethnographic museums they were represented in a "cultural" context. In the latter, an African statue was a ritual object, belonging to a distinct group; it was displayed in ways that elucidated its use, symbolism and function.

The institutionalized distinction between esthetic and anthropological discourses took form in the years documented at MoMA, years that saw the complementary discovery of primitive "art" and of an anthropological concept of "culture."[10] Though there was from the start (and continues to be) a regular traffic between the two domains, this distinction is unchallenged in the exhibition. At MoMA treating tribal objects as art means excluding the original cultural context. Consideration of context, we are firmly told at the exhibition's entrance, is the business of anthropologists. Cultural background is not essential to correct esthetic appreciation and analysis: good art, the masterpiece, is universally recognizable.[11] The pioneer modernists themselves knew little or nothing of these objects' ethnographic meaning. What was good enough for Picasso is good enough for MoMA. Indeed, an ignorance of cultural context seems almost

a precondition for artistic appreciation. In this object system, a tribal piece is detached from one milieu in order to circulate freely in another, a world of art— of museums, markets and connoisseurship.

Since the early years of modernism and cultural anthropology, non-Western objects have found a "home" either within the discourses and institutions of art or within those of anthropology. The two domains have excluded and con- firmed each other, inventively disputing the right to contextualize, to represent these objects. As we shall see, the esthetic/anthropological opposition is system- atic, presupposing an underlying set of attitudes toward the "tribal." For both discourses assume a primitive world in need of preservation, redemption and representation. The present concrete existence of tribal cultures and artists is suppressed in the name either of constituting authentic, "traditional" worlds or of appreciating their products in the timeless category of "art."

Nothing on West 53rd Street suggests that good tribal art is being produced in the 1980s. The non-Western artifacts on display are located either in a vague past (reminiscent of the label, "nineteenth–twentieth century," that accompanies African and Oceanian pieces in the Metropolitan Museum's Rockefeller Wing) or in a purely conceptual space defined by "primitive" qualities: magic, ritual- ism, closeness to nature, mythic or cosmological aims, etc.[12] In this relegation of the tribal or primitive either to a vanishing past or to an ahistorical, conceptual present, modernist appreciation reproduces common ethnographic categories. The same structure can be seen in the recently opened Hall of Pacific Peoples dedicated to Margaret Mead at the American Museum of Natural History.

This new permanent hall is a superbly refurbished anthropological stopping place for non-Western objects. In *Rotunda,* the Museum's publication, an article announcing the installation contains the following paragraph:

> Margaret Mead once referred to the cultures of Pacific peoples as "a world that once was and now is no more." Prior to her death in 1978 she approved the basic plans for the new *Hall of Pacific Peoples.*

We are offered treasures saved from a destructive history, relics of a vanishing world. Visitors to the installation (and especially members of *present* Pacific cul- tures) may find a "world that is no more" more appropriately evoked in two charming display cases just out by the hall. It is the world of a certain anthropol- ogy. Here one finds a neatly typed page of notes from Mead's much-disputed Samoan research, a picture of the field-worker interacting "closely" with Melanesians—she is carrying a child on her back, a box of brightly colored discs and triangles once used for psychological testing, a copy of Mead's column in *Redbook,* etc. In the Hall of Pacific Peoples, artifacts suggesting change and syn- cretism are set apart in a small display called "Culture Contact." It is noted that Western influence and indigenous response have been active in the Pacific since

the 18th century. Yet few signs of this involvement appear anywhere else in the large hall, despite the fact that many of the objects displayed were made in the past 150 years in situations of contact and that the museum's ethnographic explanations reflect recent research done in the cultures of the Pacific. The historical contacts and impurities that are part of ethnographic research—that may signal the life, not death, of societies—are systematically excluded.

The tenses of the hall's explanatory captions are revealing. A recent color photograph of a Samoan kava ceremony is accompanied by the words: "STATUS and RANK were [sic] important features of Samoan society"—a statement that will seem strange to anyone who knows how important they remain in Samoa today. But elsewhere in the hall a black-and-white photograph of an Australian Arunta woman and child, taken around 1900 by the pioneer ethnographers Spencer and Gillen, is captioned in the *present* tense. Aboriginals, apparently, must always inhabit a mythic time. Many other examples of temporal incoherence could be cited—old Sepik objects described in the present, recent Trobriand photos labeled in the past, and so forth.

The point is not simply that the image of Samoan kava drinking and status society presented here is a distortion, or that in most of the Hall of Pacific Peoples history has been airbrushed out. (No Samoan men at the kava ceremony are wearing wristwatches; Trobriand face painting is shown without noting that it is worn for cricket matches.) Beyond such questions of accuracy is an issue of systematic ideological coding. To locate "tribal" peoples in a nonhistorical time and ourselves in a different, historical time is clearly tendentious and no longer credible.[13] This recognition throws doubt on the perception of a vanishing tribal world—rescued, made valuable and meaningful either as ethnographic "culture" or as primitive/modern "art." For in this temporal ordering the real or genuine life of tribal works always precedes their collection, an act of salvage which repeats an all too familiar story of death and redemption. In this pervasive allegory, the non-Western world is always vanishing and modernizing. (As in Walter Benjamin's allegory of modernity, the tribal world is conceived as a ruin.)[14] At the Hall of Pacific Peoples or at the Rockefeller Wing, the actual, ongoing life and "impure" inventions of tribal peoples are erased in the name of cultural or artistic "authenticity." And similarly, at MoMA, the production of tribal "art" is entirely in the past. Turning up in the flea markets and museums of late 19th-century Europe, these objects' destiny is to be esthetically redeemed, given new value in the object system of a generous modernism.

The story retold at MoMA, the struggle to gain recognition for tribal art (for its capacity "like all great art . . . to show images of man that transcend the particular lives and times of their creators"),[15] is taken for granted at another stopping place for tribal travelers in Manhattan, the new Center for African Art on East 68th Street. Executive Director Susan Vogel proclaims in her introduction to the

catalogue of its inaugural exhibition, "African Masterpieces from the Musée de l'Homme," that the "aesthetic-anthropological debate" has been resolved. It is now widely accepted that "ethnographic specimens" can be distinguished from "works of art" and that within the latter category a limited number of "masterpieces" are to be found. Vogel correctly notes that the esthetic recognition of tribal objects depends on changes in Western taste. For example, it took the work of Francis Bacon, Lucas Samaras and others to make it possible to exhibit as art "rough and horrifying [African] works as well as refined and lyrical ones."[16] But once recognized, art is apparently art. Thus the selection at the Center is made on esthetic criteria alone. Its opening placard affirms that these objects' "ability to transcend the limitations of time and place, to speak to us across time and culture . . . places them among the highest points of human achievement. It is as works of art that we regard them here and as a testament to the greatness of their creators."

There could be no clearer statement of one side of the esthetic-anthropological "debate" (or, better, *system*). On the other, anthropological side, across town, the Hall of Pacific Peoples presents collective rather than individual productions—the work of "cultures." But within an institutionalized polarity, interpenetration of discourses becomes possible. Science can be estheticized, art made anthropological. At the American Museum of Natural History, ethnographic exhibits have come increasingly to resemble art shows. Indeed, the Pacific Peoples Hall represents the latest in estheticized scientism. Objects are displayed in ways that highlight their formal properties. They are suspended in light, held in space by the ingenious use of plexiglass. (One is suddenly astonished by the sheer weirdness of a small Oceanic figurine perched atop a three-foot transparent rod.) These artistically displayed artifacts are scientifically contextualized. But an older functionalist attempt to present an integrated picture of specific societies or culture areas is no longer seriously pursued. There is an almost Dadaist quality to the labels on eight cases devoted to Australian Aboriginal society (I cite the complete series in order): "CEREMONY, SPIRIT FIGURE, MAGICIANS AND SORCERERS, SACRED ART, SPEAR THROWERS, STONE AXES AND KNIVES, WOMEN, BOOMERANGS." Moreover, the hall's pieces of culture have been recontextualized within a new cybernetic, anthropological discourse. For instance, flutes and stringed instruments are captioned: "MUSIC is a system of organized sound in man's [*sic*] aural environment" or nearby: "COMMUNICATION is an important function of organized sound."

In the anthropological Hall of Pacific Peoples, non-Western objects still have primarily scientific value. They are, in addition, beautiful.[17] Conversely, at the Center for African Art, artifacts are essentially defined as "masterpieces," their makers great artists. The discourse of connoisseurship reigns. Yet once the story of art told at MoMA becomes dogma, it is possible to reintroduce, and coopt, the discourse of ethnography. At the Center, tribal contexts, and functions are

described, along with individual histories of the objects on display. Now firmly classified as masterpieces, African objects escape the vague, ahistorical location of the "tribal" or the "primitive." The catalogue, a sort of *catalogue raisonné*, discusses each work intensively. The category of the masterpiece individuates: the pieces on display are not typical; some are one of a kind. The famous Fon "God of War" or the Abomey shark-man lend themselves to precise histories of individual creation and appropriation in visible colonial situations. Captions specify *which* Griaule expedition to West Africa in the '30s acquired each Dogon statue.[18] We learn in the catalogue that a superb Bamileke mother and child was carved by an artist named Kwayep, that the statue was bought by the colonial administrator and anthropologist Henri Labouret from King N'Jike. While tribal names predominate at MoMA, the Rockefeller Wing and the American Museum of Natural History, here proper names make their appearance.

In the "African Masterpieces" catalogue we learn of an ethnographer's excitement on finding a Dogon hermaphrodite figure that would later become famous. The letter recording this excitement, written by Denise Paulme in 1935, serves as evidence of the esthetic concerns of many early ethnographic collectors.[19] These individuals, we are told, could intuitively distinguish masterpieces from mere art or ethnographic specimens. (Actually, many of the individual ethnographers behind the Musée de l'Homme collection, such as Paulme, Michel Leiris, Marcel Griaule and André Schaeffner, were personal friends and collaborators of the same "pioneer modernist" artists who, in the story told at MoMA, constructed the category of primitive art. Thus the intuitive, esthetic sense in question is the product of a historically specific milieu.)[20] The "African Masterpieces" catalogue insists that the founders of the Musée de l'Homme were art connoisseurs, that this great anthropological museum never treated all its contents as "ethnographic specimens." The Musée de l'Homme was and is secretly an art museum.[21] The taxonomic split between art and artifact is thus healed, at least for self-evident "masterpieces," entirely in terms of the esthetic code. Art is art, in any museum.

In this exhibition, as opposed to the others in New York, information can be provided about each individual masterpiece's history. We learn that a Kiwarani antelope mask studded with mirrors was acquired at a dance given for the colonial administration in Mali on Bastille Day, 1931. A rabbit mask was purchased from Dogon dancers at a *gala soirée* in Paris during the Colonial Exhibition of the same year. These are no longer the dateless "authentic," tribal forms seen at MoMA. At the Center for African Art a different history documents both the art work's uniqueness and the achievement of the discerning collector. By featuring rarity, genius and connoisseurship, the Center constitutes autonomous art works able to circulate, to be bought and sold, in the same way as works by Picasso or Giacometti. The Center traces its lineage, appropriately, to the former Rockefeller Museum of Primitive Art, with its close ties to collectors and the art market.

In its inaugural exhibition the Center confirms the predominant esthetic/ethnographic view of tribal art as something located in the past, good to be collected and given esthetic value. Its second show, which opened on March 12, is devoted to "Igbo Arts: Community and Cosmos."[22] It tells another story, locating art forms, ritual life and cosmology in a specific, changing African society—a past *and* present heritage. Photographs show "traditional" masks worn in danced masquerades around 1983. (These include satiric figures of white colonists.) A detailed history of cultural change, struggle and revival is provided. In the catalogue Chike C. Aniakor, an Igbo scholar, writes along with co-editor Herbert M. Cole of "the continually evolving Igbo aesthetic."

> It is illusory to think that which we comfortably label "traditional" art was in an earlier time immune to changes in style and form; it is thus unproductive to lament changes that reflect current realities. Continuity with earlier forms will always be found; the present-day persistence of family and community values ensures that the arts will thrive. And as always, the Igbo will create new art forms out of their inventive spirit, reflecting their dynamic interactions with the environment and their neighbors and expressing cultural ideals. (P. 14)

Aniakor and Cole provide a quite different history of "the tribal" and "the modern" than that told at the Museum of Modern Art, a story of invention, not of redemption. In his Foreword to the catalogue, Chinua Achebe's vision of culture and of objects sharply challenges the ideology of the art collection and the masterpiece. Igbo, he tells us, do not like collections.

> The purposeful neglect of the painstakingly and devoutly accomplished *mbari* houses with all the art objects in them as soon as the primary mandate of their creation has been served, provides a significant insight into the Igbo aesthetic value as *process* rather than *product*. Process is motion while product is rest. When the product is preserved or venerated, the impulse to repeat the process is compromised. Therefore the Igbo choose to eliminate the product and retain the process so that every occasion and every generation will receive its own impulse and experience of creation. Interestingly this aesthetic disposition receives powerful endorsement from the tropical climate which provides an abundance of materials for making art, such as wood, as well as formidable agencies of dissolution, such as humidity and the termite. Visitors to Igboland are shocked to see that artifacts are rarely accorded any particular value on the basis of age alone. (P. ix)

Achebe's image of a "ruin" suggests, not the modernist allegory of redemption (a yearning to make things whole, to think archeologically), but an acceptance of endless seriality, a desire to keep things apart, dynamic and historical.

The esthetic/anthropological object systems of the West are currently under challenge, and the politics of collecting and exhibiting occasionally become vis-

ible. Even at MoMA, evidence of living tribal peoples has not been entirely excluded. One small text breaks the spell. A special label explains the absence of a Zuni War God figure, currently housed in the Berlin Museum für Völkerkunde. We learn that late in the show's preparations MoMA "was informed by knowledgeable authorities that Zuni people consider any public exhibition of their war gods to be sacrilegious." Thus, the label continues, although such figures are routinely displayed elsewhere, the museum decided not to bring the War God (an influence on Paul Klee) from Berlin. The terse note raises more questions than it answers, but it does at least establish that the objects on display may, in fact, "belong" somewhere else than in an art or an ethnographic museum. Living traditions have claims on them, contesting (with a distant but increasingly palpable power) their present home in the institutional systems of the modern West.[23]

Elsewhere in New York this power has been made even more visible. The recent Maori show at the Metropolitan clearly established that the "art" on display was still sacred, on loan not merely from certain New Zealand museums but also from the Maori People. Indeed, tribal art is political through and through. The Maori have allowed their tradition to be exploited as "art" by major Western cultural institutions and their corporate sponsors (in this case, Mobil Oil) in order to enhance their own international prestige and thus contribute to their current resurgence in New Zealand society.[24] Tribal authorities gave permission for the exhibition to travel, and they participated in its opening ceremonies in a visible, distinctive manner. So did Asante leaders at the exhibition of their art and culture at the Museum of Natural History. Although this display centers on 18th- and 19th-century artifacts, evidence of the 20th-century colonial suppression and recent renewal of Asante culture is included, along with color photos of modern ceremonies and newly made "traditional" objects brought to New York as gifts for the museum. In this exhibition the *location* of the art on display—the sense of where, to whom and in what time(s) it belongs—is quite different from the location of the African objects at MoMA or in the Rockefeller Wing. The tribal is fully historical.

Still another representation of tribal life and art can be encountered at the Northwest Coast collection at the IBM Gallery, whose objects have traveled downtown from the Museum of the American Indian. They are displayed in pools of intense light (the beautifying "boutique" decor that seems to be modernism's gift to museum displays, both ethnographic and artistic). But this exhibition of traditional masterpieces ends with works by living Northwest Coast artists. And outside the gallery, in the IBM atrium, two large totem poles have been installed. One is a weathered specimen from the Museum of the American Indian, the other has been specially carved for the show by the Kwakiutl Calvin Hunt. The artist put the finishing touches on his creation where it stands in the atrium; fresh wood chips are left scattered around the base. Nothing like this is possible or even thinkable at West 53rd Street.

The organizers of the MoMA exhibition have been clear about its limitations, and they have repeatedly specified what they do not claim to show. It is thus, in a sense, unfair to ask why they did not construct a differently focused history of relations between "the tribal" and "the modern." Yet the exclusions built into any collection or narration are legitimate objects of critique, and the insistent, didactic tone of the MoMA show only makes its focus more debatable. If the non-Western objects on West 53rd Street never really question but continually confirm established esthetic values, this raises questions about "modernist primitivism's" purportedly revolutionary potential. And the absence of any examples of Third World modernism or of recent tribal work reflects a pervasive, "self-evident" allegory of redemption.

The final room of the MoMA exhibition, "Contemporary Explorations," which might have been used to refocus the historical story of modernism and the tribal, instead strains to find contemporary Western artists whose work has a "primitivist" feel.[25] Diverse criteria are asserted: a use of rough or "natural" materials, a ritualistic attitude, ecological concern, archeological inspiration, certain techniques of assemblage, a conception of the artist as shaman, or some familiarity with "the mind of primitive man in his [sic] science and mythology" (derived perhaps from reading Lévi-Strauss). Such criteria, added to all the other "primitivist" qualities invoked in the exhibition and catalogue, unravel for good the category of the primitive, exposing it as an incoherent cluster of qualities that, at different times, have been used to construct a source, origin or alter-ego confirming some new "discovery" within the territory of the Western self. The exhibition is at best a historical account of a certain moment in this relentless process. The feeling created, by the end, is claustrophobia.

The non-Western objects that excited Picasso, Derain and Léger broke into the realm of official Western art from outside. They were quickly integrated, recognized as masterpieces, given homes within an anthropological/esthetic object system. By now, this process has been sufficiently celebrated. We need exhibitions that question the boundaries of art and of the art world, an influx of truly undigestible "outside" artifacts. The relations of power whereby one portion of humanity can select, value and collect the pure products of others need to be criticized and transformed. This is no small task. In the meantime, one can at least imagine shows that feature the impure, "inauthentic" productions of past and present tribal life; exhibitions radically heterogeneous in their global mix of styles; exhibitions that locate themselves in specific multicultural junctures; exhibitions with nature in them that remains "unnatural"; exhibitions whose principles of incorporation are openly questionable. The following is my contribution to a different show, on "affinities of the tribal and the postmodern"; I offer just the first paragraph from Barbara Tedlock's superb recent description of the Zuni Shalako ceremony, a festival that is only part of a complex, living tradition:[26]

Imagine a small western New Mexican village, its snow-lit streets lined with white Mercedes, quarter-ton pickups and Dodge vans. Villagers wrapped in black blankets and flowered shawls are standing next to visitors in blue velveteen blouses with rows of dime buttons and voluminous satin skirts. Their men are in black Stetson silver-banded hats, pressed jeans, Tony Lama boots and multicolored Pendleton blankets. Strangers dressed in dayglo orange, pink and green ski jackets, stocking caps, hiking boots and mittens. All crowded together they are looking into newly constructed houses illuminated by bare light bulbs dangling from raw rafters edged with Woolworth's red fabric and flowered blue print calico. Cinderblock and plasterboard white walls are layered with striped serapes, Chimayó blankets, Navajo rugs, flowered fringed embroidered shawls, black silk from Mexico and purple, red and blue rayon from Czechoslovakia. Rows of Hopi cotton dance kilts and rain sashes; Isleta woven red and green belts; Navajo and Zuni silver concha belts and black mantas covered with silver brooches set with carved lapidary, rainbow mosaic, channel inlay, turquoise needlepoint, pink agate, alabaster, black cannel coal and bakelite from old '78s, coral, abalone shell, mother-of-pearl and horned oyster hang from poles suspended from the ceiling. Mule and white-tailed deer trophy-heads wearing squash-blossom, coral and chunk-turquoise necklaces are hammered up around the room over rearing buckskins above Arabian tapestries of Martin Luther King and the Kennedy brothers, The Last Supper, a herd of sheep with a haloed herder, horses, peacocks.

NOTES

1. The term "tribal" is used here with considerable reluctance. It denotes a kind of society (and art) which cannot be coherently specified. A catchall, the concept of tribe has its source in Western projection and administrative necessity rather than in any essential quality or group of traits. The term is now commonly used instead of "primitive" in phrases like "tribal art." The category thus denoted, as this essay will argue, is a product of historically limited Western taxonomies. But while the term was originally an imposition, certain non-Western groups have embraced it. Tribal status is in many cases a crucial strategic ground for identity. In this essay my use of "tribe" and "tribal" reflects common usage while suggesting ways the concept is systematically distorting. See Morton Fried, *The Notion of Tribe,* Menlo Park, Ca., Cummings Pub. Co, 1975.

2. These points were made by William Sturtevant at the symposium of anthropologists and art historians held at the Museum of Modern Art on Nov. 3, 1984.

3. A more rigorous formulation than that of affinity is suggested in Michel Leiris's essay of 1953, "The African Negroes and the Arts of Carving and Sculpture," U.N.E.S.C.O. *Interrelations of Cultures,* Westport, Conn., 1971, pp. 316–351. How, Leiris asks, can we speak of African sculpture as a single category? He warns of "a danger that we may underestimate the variety of African sculpture; as we are less

able to appreciate the respects in which cultures or things unfamiliar to us differ from one another than the respects in which they differ from those to which we are used, we tend to see a certain resemblance between them, which lies, in point of fact, merely in their common differentness." Thus, to speak of African sculpture one inevitably shuts one's eyes "to the rich diversity actually to be found in this sculpture in order to concentrate on the respects in which it is *not* what our own sculpture generally is." The affinity of the tribal and the modern is, in this logic, an important optical illusion—the measure of a *common differentness* from artistic modes that dominated in the West from the Renaissance to the late 19th century.

4. See, for example, Rubin's discussion of the mythic universals purportedly shared by Picasso's painting *Girl Before a Mirror,* 1932, and a Northwest Coast half-mask, one of the affinities (not influences) featured on the catalogue covers and the exhibition's publicity, in *"Primitivism" in 20th Century Art: Affinity of the Tribal and the Modern,* pp. 328–330. See, also, Kirk Varnedoe's association of modernist primitivism with rational, scientific exploration, in *"Primitivism,"* pp. 201–203, 652–653.

5. This point was made by Clifford Geertz at the November 3rd symposium.

6. See *"Primitivism,"* pp. x, 73.

7. The clash between Krauss's and Varnedoe's dark and light versions of primitivism is the most striking incongruity within the catalogue. For Krauss the crucial task is to shatter predominant European forms of power and subjectivity; for Varnedoe the task is to expand their purview, to question and to innovate.

8. On *négrophilie* see Jean Laude, *La Peinture française (1905–1914) et "L'art nègre,"* Paris, Klincksieck Editions, 1968; for parallel trends in literature see (for France) Jean-Claude Blachère, *Le Modèle nègre,* Nouvelles Editions Africaines, Dakar, 1981, and (for America) Gail Levin, " 'Primitivism' in American Art: Some Literary Parallels of the 1910s and 1920s," *Arts,* Nov. 1984, 101–105. The following sketch of the ideological "body" of Josephine Baker owes a good deal to discussions with Robert Coleman and other members of my seminar on cultural description, U.C. Santa Cruz, fall 1984.

9. See Jean Baudrillard, *Le Système des objets,* Paris, Gallimard, 1968.

10. On the complementary ideas "art" and "culture," see the historical account by Raymond Williams, *Culture and Society: 1750–1950,* New York, Harper, 1966. The 20th-century developments traced in the present essay redeploy these ideas in an intercultural domain while preserving their older ethical and political charge.

11. On the recognition of masterpieces, see Rubin's confident claims in *"Primitivism,"* pp. 20–21. He is given to statements like the following on tribal and modern art: "the solutions of genius in the plastic arts are all essentially instinctual . . ." (p. 78, note 80). A stubborn rejection of the supposed views of anthropologists (who believe things like collective production of works of tribal art) characterizes Rubin's attempts to clear out an autonomous space for esthetic judgment. Suggestions that he may be projecting Western esthetic categories onto traditions with different definitions of "art" are made to seem simplistic (see, for example, p. 28).

12. On "conceptual" primitivism see the "Contemporary Explorations" room in the exhibition, also *"Primitivism,"* pp. 10, 661–689.

13. The most trenchant critique of this pervasive temporal setup is Johannes Fabian's *Time and the Other: How Anthropology Makes its Object,* New York, Columbia University Press, 1983.

14. Walter Benjamin, *The Origin of German Tragic Drama,* London, New Left Books, 1977.

15. *"Primitivism,"* p. 73.

16. Susan Vogel, "Introduction," *African Masterpieces from the Musée de l'Homme,* eds. Susan Vogel and Francine N'Diaye, New York, Harry Abrams, Inc., 1985, p. 11.

17. At the November 3rd symposium Christian Feest pointed out that the recent tendency to reclassify objects in ethnographic collections as "art" was in part a response to the much greater amount of funding available for art (rather than anthropological) exhibitions.

18. For the colonial context of Marcel Griaule's museum-collecting expeditions see James Clifford, "Power and Dialogue in Ethnography: Marcel Griaule's Initiation," in *History of Anthropology* 1 (1983), pp. 121–156. See also Michel Leiris, *L'Afrique fantôme,* Paris, Gallimard (1934, 1981).

19. *African Masterpieces,* p. 122

20. For more details, see James Clifford, "On Ethnographic Surrealism," *Comparative Studies in Society and History,* Vol. 23, No. 4 (1981), pp. 539–564.

21. *African Masterpieces,* p. 11.

22. Herbert M. Cole and Chike C. Aniakor, eds. *Igbo Arts: Community and Cosmos,* Museum of Cultural History, UCLA, Los Angeles, 1984.

23. The shifting balance of power is evident in the case of the Zuni war gods or *Ahauuta.* Zuni vehemently object to the display of these figures (terrifying, and of great sacred force) as "art." They are the only traditional objects singled out for this objection. After passage of the Native American Freedom of Religion Act of 1978, Zuni initiated three formal legal actions claiming return of the *Ahauuta* (which as communal property are, in Zuni eyes, by definition stolen goods). A sale at Sotheby Park-Bernet in 1978 was interrupted and the figure eventually returned to the Zuni. The Denver Art Museum was forced to repatriate its *Ahauutas* in 1981. A claim against the Smithsonian is unresolved. Other pressures have been applied elsewhere in an ongoing campaign. In these new conditions, Zuni *Ahauuta* can no longer be routinely displayed. Indeed, the figure Paul Klee saw in Berlin ran the risk of being seized as contraband had it been shipped to New York for the MoMA show. For general background, see Steven Talbot, "Desecration and American Indian Religious Freedom," *Journal of Ethnic Studies,* Vol. 12, No. 4 (1985), pp. 1–18.

24. Sidney Moka Mead, ed., *Te Maori: Maori Art from New Zealand Collections,* New York, Harry Abrams, Inc., 1984. In an article on corporate funding of the arts (Feb. 5, 1985, p. 27) *The New York Times* reported that Mobil sponsored the Maori show in large part to please the New Zealand Government, with which it is collaborating on the construction of a natural gas conversion plant.

25. In places the search becomes self-parodic, as in the caption for works by Jackie Winsor: "Winsor's work has a primitivist feel, not only in the raw physical presence of her materials, but also in the way she fabricates. Her labor—driving nails, binding twine—moves beyond simple systematic repetition to take on the expressive character of ritualized action."

26. Barbara Tedlock, "The Beautiful and the Dangerous: Zuni Ritual and Cosmology as an Aesthetic System," *Conjunctions* 6, 1984, pp. 246–265.

KIRK VARNEDOE

ON THE CLAIMS AND CRITICS OF THE "PRIMITIVISM" SHOW · 1985

" 'Primitivism' in 20th-Century Art: Affinity of the Tribal and the Modern" sought not only to present art of exceptional quality, but through that art to address intellectual issues of great density and importance. Even beyond the popular and critical acclaim the show enjoyed, another index of its impact is the serious debate surrounding those issues that has been established in several recent reviews—especially those of Thomas McEvilley, Hilton Kramer, James Clifford, and Yve-Alain Bois [for the last two, see *A.i.A.*, April '85].[1] Of course the show was hardly flawless, as its own organizers would readily concur; and these critics have been correct to cite lapses and uneven aspects within it. But in considering the more basic criticisms voiced in these commentaries (and parallel critiques that were aired at the Museum's two-day symposium for anthropologists and art historians last November) I want to suggest how they may reveal, not so much putative flaws in the exhibition and its accompanying publication, but problems in critical positions, and broader dilemmas in contemporary intellectual life.

The prime purpose of the show was to illuminate an aspect of Western modernism: its contact with and inspiration from tribal art of Africa, Oceania and North America. Nonetheless, the disclaimer that the show was not about tribal art *per se*—only about modern artists' responses to it—did not ward off accusations of a "formalist," "decontextualizing" and thereby deforming ethnocentrism. In some instances the objections seemed directed as much against the way history happened (since ethnocentrism is endemic to modernist primitivism by any account) as against the way the show represented it. But on the whole critics claimed to indict actions taken by the curators rather than those reported by the exhibition, and blame not the limitations of the modern artist's viewpoint but the curators' violation of those limits. Thus they pointed out that the majority of tribal objects were *not* selected on strict documentary principles, but according to contemporary standards of quality. And, they asserted, we *did*

"On the Claims and Critics of the 'Primitivism' Show," *Art in America* (May 1985): 11–21. By permission of ART IN AMERICA, Brant Publications, Inc.

Art historian Kirk Varnedoe (b. 1946) was the coorganizer of the Museum of Modern Art's Primitivism exhibition. He later became Chief Curator of Painting and Sculpture at the museum.

make claims about the tribal objects *per se,* by imputing formal concerns to their makers in order to suggest elements that linked modern and tribal creation.

Now admittedly, high standards of quality weren't licensed by the show's documentary premises (which were amply fulfilled all the while). But even hostile visitors concurred that the show's presentation of tribal art was powerful precisely because it was discriminating; and no one has seriously argued that it would have been more virtuous to have shown shoddier pieces.

It is instead the other accusations, about allegedly imposing our values on tribesmen, that are the real sticking points. They were at the heart of Thomas McEvilley's objections to the show, as well as of James Clifford's attack on the "Affinities" section (the part of the show where comparisons sought to illuminate "common denominators" shared by modern and tribal objects which were historically unconnected). These objections are crucial because they open onto broader critical positions against "formalism" and "decontextualization"; and because they provide the launch zone from which charges of cultural imperialism and autistic reflexiveness have been flung not just at the show, but through it at the Museum of Modern Art, modernism, and Western society in general.

Such reactions confirm what was a given before the outset: that the show treads on highly sensitive territory, especially in regard to cross-cultural comparisons. Certainly from a curatorial point of view it would have been safer to have stuck to documenting specific influences of tribal art, and to have left the whole area of "Affinities" out of the project. Safer, but far less interesting and provocative. Similarly, it would be judicious now to beg off the attacks, either by wearily reinsisting that the show was not really about tribal art or by saying (as is true) that the idea of "Affinity" was initially conceived in the narrower sense of the one-way kinship modern artists felt with tribal art, imputing nothing about reciprocity. Judicious, but less interesting or useful. Whatever the local weakness in our particular presentation, I think there remains more value in the basic notions of "Affinities" and "common denominators" than James Clifford would allow; and that there are sound reasons to allow the accompanying "formalism"—and, yes, even "decontextualization"—that he and others have rejected. Let me thus be the devil's advocate (or MOMA's, which for many will be the same) and stand up a bit for these much-maligned ideas.

We allegedly "decontextualized" the tribal objects in the show by dealing with them outside the context of their original use. But in fact we simultaneously "recontextualized"—shifted the focus of inquiry to see the pieces not just in some emptied-out void, but as part of a separate set of considerations. We wanted to deal with the questions raised by the forms of the objects, rather than with the other kinds of questions that could only be answered by supporting texts about their origins or functions. This way of looking at things is the stan-

dard condition under which all museums show Western art, but it is held by many to be more problematic with regard to tribal art; and by our critics to be especially unfair with regard to the tribal objects shown in "Primitivism." The show should have been more informative, critics insisted, as to the original purpose and societal context of those works—by adding labels with anthropological information, for example.

In a sense this is just an argument about one kind of exhibition as opposed to another—a full-dress ethnographically oriented display, which we were not out to do, versus the show about primitivism we did do. But in fact the critics' call for context suggests some more basic disagreements about the ways art can be understood. The little argument about label texts opens into something fundamental about the way art works, and about the way we get knowledge. At issue are a constellation of basic intellectual positions—contextualism, holism, and relativism—that are dominant credos in much of contemporary thought.

The contextualist position here, as elsewhere, starts from the basic laudable premise that the things people make or do should be understood in terms of their circumstances of origin. The problem arises when this position hardens, as it seems to have for some of the critics of "Primitivism," into the insistence that all valid meanings of a work of art are delimited by those founding contingencies. You can't know anything true or meaningful about an Igbo yam mask, such a contextualist would say, unless you know all about the Igbo rituals for which it was made. The idea that circumstances shape art leads in this fashion fatally to the conclusion that it is circumstances, not art, that finally most merit our attention. This hard version of contextualism then dovetails with the larger belief in holism.

Holism also begins impeccably, with the sympathetic ecological plea that all activities are interrelated; but it can then lead inexorably to the noxious conclusion that you really can't know any one thing unless you know everything. Under this light all divisions are artificial, therefore harmful: to wit, not only is the notion of tribal *art* wrong because it isolates one activity from others, but also the idea of the tribe itself is just a jury-rigged grouping for our convenience; and furthermore the focus of the "Primitivism" show on three cultures is invalidated because it leaves out the other interrelated aspects of modern primitivism's taste for the Pre-Columbian, the infantile, the naive, perhaps eventually the Egyptian, the archaic Greek, etc. In larger terms, the holist credo inevitably favors general over specific modes of investigation, since in its view the truths that count can only be snared by maximum extension of the widest nets of intellectual abstraction. You can't know anything true or meaningful about the Igbo yam mask, this view would hold, unless you comprehend everything about the Igbo worldview. From this position, one arrives at the logic of the larger label, in a corollary devotion to historical texts at the expense of historical objects. Here, too, lie the roots of the ever-more-familiar imperative to discuss the

work of art in terms of what's not there rather than what is. In the politics of professions as well as in these methodological concepts, one consequence of the holist revulsion against divisions is disavowal of the separateness of disciplines, and thence the urge to merge: the study of tribal art must be dissolved into anthropology, the study of art history into history. More on this anon.

Now we can begin to understand what the critics mean when they accuse us of "formalism." Evidently they don't mean simply that we adhere to some theory associated with Clement Greenberg or Viktor Šklovskij; the objection is more basic. For them, real and useful knowledge apparently can only proceed from examining whole contexts through texts, while knowledge gained from visual analysis of the way representations are made is assumed to be devoid of guiding ideas and doomed to yield only falsehoods. The implication is that all we care about is the way things look—as if looking were the opposite of thinking, and the evidence of form were evidence for nothing.

Specifically, the anti-formalist critics hold that the comparisons we set up between modern and tribal objects were mere "look-alikes": trivial resemblances based on morphology without regard to meaning, and therefore empty. Now obviously there *were* some instances of banal resemblance, but these were among the comparisons that demonstrated provable influences. This common, lesser strain of primitivism we felt obliged to present, but not to defend against charges of superficiality. The more speculative juxtapositions we made of historically unconnected works were however (like the more arresting instances of influence) based *not* on mere surface resemblance but on concordances of structure and apparent strategy. The concern was precisely *not* with the self-sufficiency of appearances, but with the idea that visible isomorphisms—in the structuring of volumes, in the sequence and variety of parts, in strategies of transposing natural orders—might suggest that underlying approaches to the construction of ideographic, non-naturalistic systems of representation (usually of the human face or form) were in some instances parallel in tribal and modern Western art.[2] In that sense, we did focus on form, not because it excludes meaning but because it points to, or more simply *is* meaning. It is a kind of meaning—one very consequential significance among many to be found in the objects, separately or together—which an exhibition is especially good at making vivid and immediate. The way our exhibition proceeded to isolate this meaning was not by any conspiratorial denial of other possible truths, but simply by an act of comparative focusing, of the kind anthropologists frequently use when they study the organizational forms of a range of tribal dance patterns, or barter systems, or kinship myths. Indeed, this kind of selective matching is an essential aspect of human thought on all levels from the scientific to the everyday.

It might help, for example, to think of the basic notion of the useful analogy. Any worthwhile analogy contains a gap of difference and a leap of similarity,

and perforce involves accepting a selective focus. Saying "an orange is like a tangerine" is fine but doesn't get us terribly far. Saying "the universe is like a gas bubble" is outrageous but may be immensely helpful even though—or because—there are millions of obvious differences between the two terms. Similarly, if we say an Igbo yam mask is like a Picasso painting of a head, we focus on the modular repetition that both use to denote facial features—not finally to deny or suppress the objects' countless differing particularities visible or invisible, but operationally in order to understand something about them, and possibly about a larger system to which they may both belong.[3] The problem addressed is anything but trivial. It concerns parallel ways humans may construct separate visual languages to say different things; and in order to focus on it we allow for the kind of comparative thinking that involves strategic departure from both works' separate integrities (for not only the Igbo mask but also the Picasso is denatured in the process; both connect to a world of complexities held provisorily aside).

Perhaps some of the "Affinities" have *only* the force of an analogy, without bespeaking deeper linkages. Perhaps on the other hand they may indicate congruities on the level of shared cognitive structures in human representational systems; or they may say something about the rulebound nature of image-making as a human game. Almost certainly they vary in implication, since some of the concordances are more subtle than others. We did not pretend to provide final answers that explain whey these parallel representational structures appear in these particular situations. And clearly one thing we were not arguing for was some Jungian notion of "esthetic universals." To the contrary, written into the selection of the comparisons is the idea that they are relatively rare and specific, that they illuminate structures especially pertinent to tribal and 20th-century Western art and not to the art of other periods or cultures. The tribal-modern relationship is not a hypothesis that emerges from thin air, but one obviously suggested by the special, pervasive and consequential importance these particular forms of tribal art have had for 20th-century Western artists.[4]

We have not reached, however, the roots of the critics' disagreement; for they have objected not just to the methods used in "Affinities" but to the basic validity of the inquiry itself, to the premise that underlies everything we have just discussed. The premise in question, which our critics seem to find highly suspect, is that there exist real things worth knowing about human beings as culture-makers, beyond the local facts of their particular and various cultures. The corollary notion is that there is value in studying the ways people may be alike, rather than just emphasizing the ways they're different.

These curatorial heresies seem to run directly against the grain of further credos, of pluralism and relativism, that are also found hypertrophied in contemporary though. As with contextualism and holism, these lines of thought

start out unimpeachably well. They begin with premises liberating and morally sound, honoring the Other-ness of different cultures or epochs, and abstaining from any hierarchies of dominance in which our limited viewpoint might claim power over theirs. Alas, when yoked with a certain brand of holism, these ideas do a very different kind of work. The separate integrity of the age or the culture becomes conceived in terms of abstractions variously labeled as epistemes, paradigms, et al., which are held to be all-pervasive and all-powerful in their local dominance, and wholly incommensurable with the worldviews of other cultures and ages.

A part of this kind of *zeitgeist* determinism is the ostensibly liberating vision that everything we know—ourselves, our institutions, our ideas—is only a set of artificial constructs built into us by the systems of our society. And if it's true for us—who at least have some glimmer of despairing awareness of this—it's triply true for tribesmen, who are seen by critics like McEvilley as deeply blinkered into an inability to do anything that isn't inscribed in the "texts" of their economic-religious structure and their language. On this account, it is a grave error for us to pretend to know anything about them in terms like "art," which are fit for our local use only, made only to adorn the wall of conventions that imprison and isolate us.

Of course, respect for human pluralism deservedly commands moral and intellectual force. However, the evidence is not clear that we should congeal it into a rigid doctrine of the inescapable, atomized separatism of all human experience in separate cultures. When stated in these harsh exclusionary terms, the credo tends to blur the line between opinion and fact, and to disallow the contradictions it generates internally. That is to say, the argument is open-ended as an empirical question and faulty as a logical position. Empirically, on the evidence of field reports, psychological studies, etc., ironclad cultural relativism certainly does not stand as the only legitimate way in which to think about human production and communication. For each of the authorities one might marshal in its defense—as for example the dubious Whorf-Sapir hypothesis on the total constraints languages allegedly impose—there are other respected sources of evidence and interpretation that point to different conclusions: that there can be significant common denominators among the different ways humans perceive and represent; that cultural frameworks aren't as wholly binding as they may appear; and that the way meanings derive from context is the motor nerve of communication rather than its Achilles heel.

It would be pointless, though, to reduce the debate over "Primitivism" to a battle of bibliographies on language acquisition, perceptual psychology, and so on—not least because the court is still out on these matters, lots of new findings are as yet unevaluated, and there will likely never be any crisp, one-sided permanent consensus. It can be suggested, though, that the evidence of the critics' own arguments shows that their positions don't hold logically, just on the level of

common sense and personal practice; and that their results tend to go against the grain of their own initial strengths.

If there's really *no* commensurability between epistemes, and no way to know the Other in our own language, then that is that, and we close the book and hunker down at home. But it seems that no one believes this, and least of all those who urge more anthropology—more scientific anthropology, the quintessentially modern-Western construct based in all our contingent myths of evidence and objectivity—as is the remedy for MOMA's allegedly deforming vision of tribal objects as art. Our critics not only believe that it *is* possible to have knowledge of the Other; they sometimes allow that it is possible for artists as well as ethnologists to have it. At that point we are in a position of deciding among contending anthropological viewpoints (which is precisely what we did not feel obliged or qualified to do in "Primitivism"); and we find ourselves tussling about which artist's vision is more compelling. These are evidently disagreements on particulars, not principles; but it seems the former (matters of taste and opinion) travel under guise of the latter (issue of science and philosophy) in some of the attacks on "Primitivism."

Clearly McEvilley, for example, thinks it *is* possible for the Western mind to understand meaning in tribal representations, and to have that understanding in various ways. Thus he defends both the science of anthropology and the possibility of shared worldviews among tribal and modern artists. He just doesn't think I have the *correct* understanding, or that the artists I focused on in the exhibition have the *true* community of spirit. Clearly, too, he knows that what people do may be different, in effect and substance, from what they think they're doing; and thus accepts that an outside observer may read meaning, or even impute motivation, from appearances without regard to documented indigenous expressions of context or purpose. On this principle he, like Bois, insists that in itself the very fact of my selection of several contemporary women artists for "Primitivism" *shows* I subscribe to an earth-mother cliché—even though I explicitly reject this idea in my catalogue essay, and offer wholly different reasons for my choices. But he won't allow this familiar practice of outside judgment and analysis to extend to assessments of artistic aspects in tribal objects, because he knows in advance that this is a *wrong* meaning.

For those who subscribe to these critics' basic principles, such distances from practice and conflations with preference may seem irrelevant. But I find disturbing the progress from the theoretical high ground of cautionary admonitions against hegemony, toward practicing claims of exclusive access to indisputable truths. It suggests a familiar recent pattern in which, by the assertion that all knowledge is but the masquerade of Power, fervent attitude is licensed to parade as firm authority.

On a far more general level, these disparities between principles and practices

also bring to mind one of the tales that the history of primitivism has to tell, in which ideals of respect for the Other have been fatefully interwoven with an urge to the authoritarian. This latter tale is worth sketching, for it not only suggests how modernist primitivism might connect to other parts of intellectual history, but also "contextualizes" our current debate. The history of primitivist thought in the West since the 18th century has seen a recurrent oscillation between (in rough-cut terms) Rationalism and Romanticism. The Rationalist current of the Enlightenment posited some faculty of reason that was held to be a human birthright regardless of race or society. The belief that this birthright only got smothered by civilization tended theoretically to favor the Noble Savage; but in practice it was used to justify imposing the Enlightenment's brand of "universal" Reason over all the "contingent" differences of non-Enlightened civilizations. The notion of universal mental structures came to be seen both as a tyrannical political premise and as an impediment to genuinely scientific investigation of the rich variety of appearances, customs, languages and beliefs that flourished in the world.

Enter Romanticism, with its empirical devotion to variety and its regard for the significance of differences—and with it, new ethnologies of folk song and folk art, and systematic philology. The problem arose when this "primitivism," too, with its investment in the separate organic integrity of cultures and in comparative thinking, led to an equally sinister form of tyranny equating culture with nature (especially race), and ranking peoples on rigid ladders of destiny. The proliferation of useful differences became confused with the fetishization of categories and fed the intolerance it seemed destined to banish. At this point a partial return of the despised "universalism"—the notion that humans share something important regardless of differences—could have salutary and innovative consequences.

There's a great deal to be said—far too much for here—about the way these two inheritances interact in modern views of the primitive, from Gauguin and Franz Boas right on through. But for the moment it's worth underlining the particular way in which the Romantic Rebellion has been replayed in recent years, in the reaction against structuralist thinking which has conditioned some of the negative views of our exhibition. Claude Lévi-Strauss's view of tribal society, so influential in the 1960s, linked up with an essentially rationalist current that looked for common or comparable mental structures beneath heterogeneous appearances. Now this once-provocative slant of thought, regarded in its day as an assault on Western humanism, is lately painted as the established seat of all that tradition's logocentric evils. It is the recoil from the lofty structuralist brand of analysis that has brought a sharp corrective pendulum-swing back toward a professedly empirical insistence on individual cultures as incomparable singularities, impervious to Western constructs of rationality. It is easy to see

how this flows into the larger current of epistemes and paradigms we examined earlier, and not too hard to find some familiar landmarks in the new intellectual landscapes they jointly nourish.

One of the most salient of these features is a twin investment: belief in the impenetrable separateness of cultural worldviews, paired with a veneration of the irrational or anti-rational current in Western thought. The idea is roughly that, if culture is both artificial and all-constraining, then the only way to achieve access to the true Other, or to truth of any kind, is by a radical rejection of, and escape from, one's cultural prison. In the Western tradition this squares with the idea that the energy of great art, from Romanticism through Surrealism and beyond, is to be measured in its distance of escape from the shackling conventions of an ever-more rationalized worldview. (The recent wrinkle is that the mantle of the true fugitive has passed from the artist, child and madman to the theorizing critic—who deconstructs the entrapments of Power, and attains Ideas while all others have only ideology. Art thus approaches correctness as it aspires to the condition of criticism, but that is a subject for another day.)

Of course this story of flight from Western civilization has been the foundation narrative of modernist primitivism, beginning with Gauguin in Tahiti as its archetype. It should stand to reason that those who are enchanted by this romance of escape would extol the history of artistic primitivism as one of the nobler episodes in modern art's noble struggle to abandon or destroy Western values. But in fact what has happened to modernist primitivism follows roughly the pattern of what happened to structuralism: once seen as the *bête noire* of the Western tradition, it is now recognized as a lap dog. In this holist view, Picasso's revolution was merely of the palace kind, and the *big* picture shows that there's little to choose between him and the colonialists who fired the guns in Africa, except styles of imperialism. And if that isn't bad enough, to present a *history* of primitivism is worse, for it compounds the initial ethnocentrism with still another overlay of logocentrism, in the benighted desire to organize and clarify a record.

Leave aside yet again the internal contradictions in such arguments (in this case the plea—by those who scorn the idea of history—that fuller history would improve the situation). Focus instead again on what I think is the crux of most of the debates, the difference between the hypothetical exhibition that some critics desired, or would have done themselves, and the one that was in fact presented.

In detail the missing dream-shows don't always come together; they may even be self-cancelling. For example, Bois feels that a conceptually based involvement with the primitive, like Robert Smithson's should have been more to the fore; while Clifford, though he shares a mistrust of the merely visible, finds the diffuse conceptual linkages of recent primitivism unworthily incoherent. Some, like

McEvilley, want more documentation of the origin-history of the tribal objects themselves (not the record of their coming to Europe, which we fully covered); while Clifford wants more post-facto Western cultural history, such as a picture of Josephine Baker on the walls to speak for *négrophilie* (I suppose that for the confirmed holist there's something inherently false and incomplete in anything we can understand about the primitivism of, say, the *Demoiselles d'Avignon,* without reference to this vogue for American black culture, which got going about a decade behind artists' first involvement with African objects). In the main, though, those who have most disliked MOMA's exhibition do share one reasonably similar vision, of a truly radical primitivism that MOMA's show and book allegedly conspired to exclude.

Let's sketch it caricaturally as follows: MOMA's version of primitivism is allegedly false consciousness, enslaved to the market for tribal objects and to the myths of individual creativity that support same; and, in its urge to validate modernist esthetics, is blind to the solipsism of its own attempts to "know" (an evil word obviously synonymous with "collect") the Other. The true primitivism is something else again. It isn't superficial because it can't be seen, and can't be bought because it doesn't depend on objects (theirs or ours). It's not Eurocentric because it relies on anthropology, and it can't be implicated in the crimes of the West because it states right out loud that it doesn't like Western values. It believes the Other is irrevocably Other, and it knows this is so because it can wholly identify with and understand what that Other is all about. What the Other is all about is an enthralled submersion in darkly anti-Cartesian "intentionalities" that free tribespeople from such Western fallacies as self-consciousness, doubt, cynicism, humor, and (god forbid) esthetic appraisals—and that remove from their individual consciousness any distracting decisions about form or materials, so as not to pollute their object-making in its "collective" formation, or in its singular focus on the shadowy violence of blood religion.

Now I am instantly ready to admit that this caricature may lump too many people's ideas into a monolithic construction, and that it dismissively fails to do justice to the intellectual integrity, evidential bases, and honorable purposes of the arguments most critics have advanced. I am equally quick to note that I model these overstatements on the similar excesses of those reviews that posit "Primitivism" as the whole-cloth emblem of some conspiratorial plot, authorial and institutional; and try to convince their readers that the only real story of the exhibition and book is a negative one, to be unmasked in terms of the truths it concealed, repressed, censored, denied, etc. To call a spade a spade, this latter way of arguing is just a paranoid style, usually involving a set of predisposed feelings about the Museum of Modern Art so complex and deep-seated as to preclude reasonable debate on the issues at hand.

If we look at the exhibition that took place instead of the ones that didn't, I believe we will find that it neither concealed nor censored the conflicting points

of view I've previously outlined. Instead it did something positive, and stronger: it offered an alternative vision that speaks on the same matters in very different terms. On the matter of individual creativity within tribal traditions, for example, it offered not only individual objects of tremendous power and sophistication, but also the opportunity to compare objects of identical format from the same traditions—as for example the two Grebo masks in the first vitrine. For the hard contextualists the differences between these objects—between Picasso's Grebo mask and the one from the Metropolitan Museum—cannot exist in any meaningful way, as both were conceived to have the same function within the same society. For the hard cultural relativist the whole comparison is a sham, since to call these objects "art" and to see quality distinctions between them is only to mount a masquerade based on arbitrary Western conventions. Yet there *is* a difference between them, which is not a figment of anyone's imagination, but present and demonstrable; and that difference suggests to me that in these objects is vested evidence of a variety of dialogue between individual decision and traditional tribal model—an aspect of the makers' existence (or of the Grebo worldview, if you will) that may well escape any other form of record.

Is it hopelessly superficial and ethnocentric to recognize this, and find it worth reflecting on? Or should we rule this evidence of our experience out of court, and—as the critics would have us doing with their points—"repress" it and "deny its existence"? I think the show did in the end tell us something about tribal art itself; and furthermore that what it told us—about the differences and similarities in the way three tribal cultures made representations, about the range of sophistication and achievement possible within those representational systems—was true, valuable to know, and now knowable except through this kind of examination of the art.

The primary focus of the exhibition was not on the Primitive, however, but on primitivism; and here, too, positive positions were taken that seem to me as valuable as they are unfashionable. Modernist primitivism is obviously a complex human phenomenon, partaking of several different and even contradictory strands that interweave boldness and fear, wit and anger, creativity and destructiveness. It is replete with aspects trivial, mediocre and sinister as well as with high achievements and positive power (a heterogeneity brought into relief by the differing viewpoints of the book's numerous authors). But among the most powerful lessons it has to offer are some I believe the exhibition and book amply illuminate; and these are lessons that cannot easily be assimilated by the credos of contextualism and relativism I mentioned earlier. Among the lessons are the following: The things people make can communicate powerfully far beyond the confines of their original purposes and cultural contexts (we might have already guessed this from, say, Shakespeare's popularity in China). Acknowledging the interdependence of meaning and context entails not just insisting on the

subservience of human creations to their original purposes; but also respecting their hidden strengths, and multifaceted capacity to reveal different powers in different places. Furthermore, in likening representational systems to languages, we need not only use Saussure nihilistically, to posit an arbitrary hollowness and solipsism of words as analogues for images. We can look as well, and more tellingly, at all there is to learn about the rogue generative power of such systems from the creative "misunderstandings," the hybrid "dialects," and the neologistic inventiveness that arise in the modernist encounter with the tribal.

Modern artistic primitivism has, in its broadest implications, a lot to say about the way humans can use their cultural conventions to change themselves and to understand new things—how Giotto and Daumier prepared Gauguin to value Marquesan carving, or how Gauguin's art in turn joined with the very different lessons of Cézanne to help prepare Picasso for his encounter with African and Oceanic sculpture. And it has more to say, too, about how this process works in reverse, so that African sculpture became not a simple "source" for Picasso, but a catalytic agent that allowed him to re-imagine the possibilities of what he had at hand, in such a way that Rousseau and Cézanne could be pulled together on one canvas across a gap that might have seemed unbridgeable.

Picasso, like most pioneer modernists, encountered tribal art not just "out of context," but embedded in a context of general ignorance or misunderstanding about the objects' original functions or societal meanings. This necessitated a willful forgetting or setting-aside. What took place was an aggressive recontextualization of tribal objects, out of the (by now largely discredited) web of contextual "knowledge" that had held them distant and in significant senses invisible, into the volatile taxonomic category of art, then in upheaval. The eventual shift in Western frameworks for tribal art was from the natural history museum to the art museum; but the crucial way station was the artist's studio, where not only the constraints of the ethnological context but also the constraints of the inherited artistic tradition were tactically set aside for a new kind of thinking to emerge, which would challenge the parameters of both. It's too simple to say Picasso suddenly saw tribal objects as art. A changing definition of art readied him to see how something formerly excluded could be included—and would further transform the category in the process. The resources and limits of Western art weren't inert and closed boundaries that had to be broken, but varied and malleable things that he realized he could use to build a window to the outside, and with that action also see the house he lived in by a whole new light.

This creative use of existing forms as a way of gaining knowledge about the new and unfamiliar, and this way of then using that knowledge to reorder one's own tradition so as to make new meanings expressible, are central to the compelling character of 20th-century Western art—as central as is its uncommon openness to the art of radically different societies, or to change in general. Some of our critics read the gains from primitive art only as sycophantic "appropria-

tions," and assimilate into European colonialism the openness to unfamiliar modes of seeing and feeling that characterize modernism. But this openness so obviously contradicts the one-sidedness of colonial exploitation that the critics' acts of selective focus—comparable to their willful blindness before the Grebo vitrine—evidence a simplifying partiality more extreme than any of which we've been accused. They tend not only to obscure the local facts of the way primitivism worked, but also to preclude reflection on some of the things the history may have to tell us about the way communication and innovation happen across and within cultural frontiers.

Both the history of modernist primitivism and the way it was presented at MOMA converge on some broader lessons about knowing things, and about knowing art in particular. Contextualism notwithstanding, there's a serious need for fields of inquiry that study representations in the trans-cultural context of other representations. And holism notwithstanding, circumscribing these fields of inquiry can bring into relief as much truth as it suppresses. The general and rather simple proposition touched on above—that cultural conventions can be not just chains of confinement but also tools of discovery—has a particular relevance to the debate at hand, as it relates to other current disputes between artificial polarized notions of "formalism" and "contextualism" in the study of art.

The study of the history of art is felt to be in crisis, and lament is heard for the eras when thinkers such as Riegl or Wölfflin radiated influence outward from art's study to other fields of inquiry. Yet is a remedy to be found, as is commonly now argued, only in breaking down the "arbitrary cultural conventions" that have isolated art history, and thereby dissolving this field and others into one holistic interdisciplinary conception of historico-sociology? Or should we hold, to the contrary, that the term "art," in however imperfect and changing a way (indeed, *because* of its flexibility and lack of closure), is a useful convention rather than merely an onerous one—that it helps us understand a set of human activities and aspirations that merit study as phenomena related across the barriers of time and cultures?

If to do so is considered proper only for a "mere connoisseur," a superficial "formalist," and an enemy of history, then we have a crisis that is not to be solved by dissolving the discipline. For it is powerful questions about how and why art has a history that have characterized the admired thinkers; and to respond only that art is an epiphenomenal pawn of other histories is inadequate to their measure. Not less distinct, but sharper and more challenging boundaries, which define better, more on-point questions about art and its history—might these not be an alternative way to change art history from a discipline of patchwork borrowing into one of greater generative value to human inquiry writ large?

As an art historian I am more than aware of what can be gained from con-

textualism, holism, and cultural pluralism; I frequently defend one or the other approach. Can I then ask the critics of "Primitivism" to take a hard look—as they should be predisposed to do—at the other side, at the limitations that these contingent, culturally derived paradigms of thought can, when rigidified, impose on seeing and understanding important things that do not fit their rule?

NOTES

1. See Thomas McEvilley, "Doctor Lawyer Indian Chief: '"Primitivism" in 20th Century Art' at the Museum of Modern Art in 1984," *Artforum*, Nov. '84; Hilton Kramer, "The 'Primitivism' Conundrum," *The New Criterion,* Dec. '84; Yve-Alain Bois, "La Pensée Sauvage," *Art in America,* April '85; James Clifford "Histories of the Tribal and the Modern," *Art in America,* April '85. See also the exchange between myself, William Rubin and Thomas McEvilley in *Artforum,* Feb. '85; and William Rubin's further response in the latter dialogue, scheduled to appear in *Artforum,* May '85.

2. Yve-Alain Bois seems to have misunderstood, for instance, the point of the comparison between a Giacometti figure and the elongated body of a Nyamwezi dance baton. The comparison was shown in the "Concepts" section of the show, immediately adjacent to two Fang masks, one highly attenuated and the other very squat. The point being made here was not just that the Giacometti looked like the dance baton, or that he was influenced by such a piece (in fact, in both the book and on the label other possible models for Giacometti's stylization were stressed). The point of the whole vitrine—for which the pieces were demonstrative evidence—was that the radical reformulations of body proportions one finds in 20th-century art are parallel to similarly drastic compressions and elongations in certain areas of tribal art. In thinking back over the show, it would seem that a great many of the comparisons made—between a Henry Moore and a New Ireland Malanggan, between an Alexander Calder and a New Guinea Imunu, between a Baranoff-Rossiné and a Baga headdress, and so on—were demonstrating not surface similarities but just the kind of structural parallels in conception that Bois believes valuable, and claims are missing. Of course there may also exist important structural parallels which are not so accessible; the linkage of Picasso's Guitar to the Grebo mask he owned is just such a "conceptual" match, as Bois correctly notes. But one of the points of that comparison (made clear in the label) was that some of the most telling influences and connections in this field are doubtless "invisible"—covert and subtle in such a way that they are retrievable only through the kind of guiding affirmation Picasso provided in this case. In 20th-century primitivism there are lots of obvious connections that finally aren't worth looking at; and there are undoubtedly countless instances of rapport which are profound but unknown, "invisible," and/or undemonstrable. The show generally tried to find a middle ground: connections that were telling and could be demonstrated to the public through the objects.

3. My thanks to Leo Steinberg for his suggestion of the analogy as analogous model for the "Affinities" comparisons. I am also grateful to Adam Gopnik for suggestions both substantive and structural that helped shape this essay as a whole.

4. A word about the pool from which we drew the "Affinities" comparisons: James Clifford feels that if one takes any three cultures and cross-references them with the limited possibilities for stylistic encoding of human features, resemblances are predictably inevitable. Thus he concludes that those we find have no special status and boil down to similarities only of exclusion—shared departures from naturalism common to many other styles as well. I have some very basic disagreements. The concentration on these three groups follows not our whim but the lead of modern artists, who consistently picked these kinds of objects, in preference to other non-naturalistic styles, because they felt these were more specially relevant to what they were doing.

I take it that by Clifford's "nothing-new-under-the-sun" account, it's spurious to see anything really innovative in modern Western art, and doubly spurious to believe the latter has anything credibly special to do with tribal art in particular. He would seem thus to feel that there's no substantive distinction to be made between Japonism and modernist primitivism; and that Buddhist or Egyptian art would hold just as many telling match-ups with innovative works of 20th-century modernism as do Oceanic and American Indian art. I doubt that many artists or art historians would subscribe to those views, or for that matter buy the proposition that the options for representing human form constitute as narrow and as dormantly closed a set as he contends.

The possibilities humans invent and will continue to invent for representation are vastly diverse, and the point of our juxtapositions was precisely not to promote the vague notion of some universal "family of art," but to zero in on exceptional cases—specific parallelisms shared by these particular objects from these particular cultures and not shared to anything near the same degree with other traditions. Admittedly there were degrees of success in what we attempted. The Kenneth Noland tondo painting, as Bois correctly pointed out, was a weak moment—since the similarity was too broadly shared with too many other art forms to be specially meaningful in our context.

A final point about Clifford's notion of a connection between imperialist hegemony and primitivist influence. Primitivism is not a natural result if imperialism. This cause-and-effect linkage is weaker in its explanatory power than the frailest of our match-ups; for there have been numerous cultures colonized by the West that have had virtually no effect on Western art—and, one might add, countless conquests that have brought together vastly different cultures throughout history and around the globe, without the phenomenon we observe in modernist response to the three tribal cultures we cite.

HAL FOSTER

THE "PRIMITIVE" UNCONSCIOUS
OF MODERN ART · 1985

Historically, the primitive is articulated by the West in deprivative or supple-
mental terms: as a spectacle of savagery or as a state of grace, as a socius without
writing or the Word, without history or cultural complexity; or as a site of orig-
inary unity, symbolic plenitude, natural vitality. There is nothing odd about this
Eurocentric construction: the primitive has served as a coded other at least since
the Enlightenment, usually as a subordinate term in its imaginary set of opposi-
tions (light/dark, rational/irrational, civilized/savage). This domesticated primi-
tive is thus constructive, not disruptive, of the binary *ratio* of the West; fixed as a
structural opposite or a dialectical other to be incorporated, it assists in the estab-
lishment of a Western identity, center, norm, and name. In its modernist version
the primitive may appear transgressive, it is true, but it still serves as a limit: pro-
jected within and without, the primitive becomes a figure of our unconscious
and outside (a figure constructed in modern art as well as in psychoanalysis and
anthropology in the privileged triad of the primitive, the child, and the insane).

If Rubin presented the art-historical code of the primitive, Varnedoe offered
a philosophical reading of primitivism. In doing so, he reproduced within it the
very Enlightenment logic by which the primitive was first seized, then (re)con-
structed. There are two primitivisms, Varnedoe argues, a good rational one and a
dark, sinister one.[1] In the first, the primitive is reconciled with the scientific in a
search for fundamental laws and universal language (the putative cases are Gau-
guin and certain abstract expressionists). This progressive primitivism seeks en-
lightenment, not regressive escape into unreason, and thinks the primitive as a
"spiritual regeneration" (in which "the Primitive is held to be spiritually akin to
that of the new man"),[2] not as a social transgression. Thus recouped philosophi-
cally, the primitive becomes part of the internal reformation of the West, a mo-
ment within *its* reason: and the West, culturally prepared, escapes the radical
interrogation which it otherwise poses.

But more is at stake here, for the reason that is at issue is none other than the
Enlightenment, which to the humanist Varnedoe remains knightlike; indeed,
he cites the sanguine Gauguin on the "luminous spread of science, which today

Excerpt from *October* 34 (Fall 1985): 58–70.
Art historian Hal Foster (b. 1955) teaches at Princeton University.

from West to East lights up all the modern world."[3] Yet in the dialectic of the Enlightenment, as Adorno and Horkheimer argued, the liberation of the other can issue in its liquidation; the enlightenment of "affinity" may indeed eradicate difference.[4] (And if this seems extreme, think of those who draw a direct line from the Enlightenment to the Gulag.) Western man and his primitive other are no more equal partners in the march of reason than they were in the spread of the word, than they are in the marketing of capitalism. The Enlightenment cannot be protected from its other legacy, the "bad-irrational" primitivism (Varnedoe's dramatic example is Nazi Blood and Soil, the swastika ur-sign), any more than the "good-rational" primitivism (e.g., the ideographic explorations of Picasso) can be redeemed from colonial exploitation. Dialectically, the progressivity of the one is the regression of the other.

Varnedoe argues, via Gauguin, that "modern artistic primitivism" is not "antithetical to scientific knowledge."[5] One can only agree, but not as he intends it, for primitivism is indeed instrumental to such power-knowledge, to the "luminous spread" of Western domination. On the other hand, the primitivist incorporation of the other is another form of conquest (if a more subtle one than the imperialist extraction of labor and materials); on the other, it serves as its displacement, its disguise, even its excuse. Thus, to pose the relation of the primitive and the scientific as a benign dialogue is cruelly euphemistic: it obscures the real affiliations between science and conquest, enlightenment and eradication, primitivist art and imperialist power. (This can be pardoned of a romantic artist at the end of the last century who, immersed in the ideology of a scientistic avant-garde, could not know the effectivity of these ideas, but not of an art historian at the end of this century.)

Apart from the violence done to the other in the occlusion of the imperialist connection of primitivism and in the mystification of the Enlightenment as a universal good, this good/bad typology tends to mistake the disruption posed by the primitive and to cast any embrace of this disruption—any resistance to an instrumental, reificatory reason, any reclamation of cognitive modes repressed in its regime—as "nihilistic," regressive, "pessimistic."[6] (It is thus that the transgressive primitivism of such artists as Smithson is dismissed.) We are left where we began, locked in our old specular code of ethical oppositions. But then we were told all along that the issue was "human creativity wherever found":

> This is the extreme of liberal thought and the most beautiful way of preserving the initiative and priority of Western thought within "dialogue" and under the sign of the universality of the human mind (as always for Enlightenment anthropology). Here is the beautiful soul! Is it possible to be more impartial in the sensitive and intellectual knowledge of the other? This harmonious vision of two thought processes renders their *confrontation* perfectly inoffensive, by denying the difference of the primitives as an element of rupture with and subversion of (our) "objectified thought and its mechanisms."[7]

There is a counterreading of the primitive precisely as subversive, to which we must return, but it is important to consider here what cultural function primitivism generally performs. As a fetishistic recognition–and–disavowal of difference, primitivism involves a (mis)construction of the other. That much is clear. But it also involves a (mis)recognition of the same. "If the West has produced anthropologists," Lévi-Strauss writes in *Tristes Tropiques*, "it is because it was tormented by remorse."[8] Certainly primitivism is touched by this remorse, too; as the "elevation" of the artifact to art, of the tribal to humanity, it is a compensatory form. It is not simply that this compensation is false, that the artifact is evacuated even as it is elevated (the ritual work becomes an exhibition form, the ambivalent object reduced to commodity equivalence), that finally no white skin fond of black masks can ever recompense the colonialist subjection detailed in Fanon's *Black Skin White Masks.* To value as art what is now a ruin; to locate what one lacks in what one has destroyed: more is at work here than compensation. Like fetishism, primitivism is a system of multiple beliefs; an imaginary resolution of a real contradiction:[9] a repression of the fact that a breakthrough in our art, indeed a regeneration of our culture, is based in part on the breakup and decay of other societies, that the modernist discovery of the primitive is not only in part its oblivion but its death. And the final contradiction or aporia is this: no anthropological remorse, aesthetic elevation, or redemptive exhibition can correct or compensate this loss *because they are all implicated in it.*

Primitivism, then, not only absorbs the potential disruption of the tribal objects into Western forms, ideas, and commodities, it also symptomatically manages the ideological nightmare of a great art inspired by spoils. More, as an artistic coup founded on military conquest, primitivism camouflages this historical event, disguises the problem of imperialism in terms of art, affinity, dialogue, to the point (the point of the MOMA show) where the problem appears "resolved."

A counterdiscourse to primitivism is posed differently at different moments: the destruction of racial or evolutionist myths, the critique of functionalist models of the primitive socius, the questioning of constructs of the tribal, and so forth. Lévi-Strauss has argued most publicly against these models and myths in a culturalist reading that the "savage mind" is equally complex as the Western, that primitive society is indeed based on a nature/culture opposition just as our own is. Other ethnologists like Marshall Sahlins and Pierre Clastres have also countered the negative conception of the primitive as a people without god, law, or language. Where Lévi-Strauss argues that the primitive socius is not without history but thinks it as form, Sahlins writes that paleolithic hunters and gatherers, far from a subsistence society, constitute the "first affluent" one, and Clastres (a student of Lévi-Strauss) contended that the lack of a state in the primitive socius is a sign not of a prehistorical status, as it may be thought in a

Western teleology, but of an active exorcism of external force or hierarchical power: a society not without but *against* the state.[10]

Such a theoretical displacement is not simply an event internal to ethnology: it is partly incited by anticolonial movements of the postwar period and by third world resistance in our own; and it is partly affirmed by a politicization of other disciplines. For if primitivism is denial of difference, then the countermeasure is precisely its insistence, "opening the culture to experiences of the Other," as Edward Said writes, "the recovery of a history hitherto either misrepresented or rendered invisible."[11] Finally, no doubt, a counterdiscourse can only come through a countermemory, an account of the modern/primitive encounter from the "other" side.[12] But lest this recovery of the other be a recuperation into a Western narrative, a political genealogy of primitivism is also necessary, one which would trace the affiliations between primitivist art and colonial practice. It is precisely this genealogy that the MOMA show does not (cannot?) attempt; indeed, the issue of colonialism, when raised at all, was raised in colonialist terms, as a question of the accessibility of certain tribal objects in the West.

As for a cultural counterpractice, one is suggested by the "primitive" operation of *bricolage* and by the surrealist reception of the primitive as a rupture. Indeed, the dissident surrealists (Bataille chief among them) present, if not a "counterprimitivism" as such, then at least a model of how the otherness of the primitive might be thought disruptively, not recuperated abstractly. It is well known that several of these surrealists, some of whom were amateur anthropologists, were not as oblivious as most fauves and cubists to the contexts and codes of the primitive, that some politicized rather than aestheticized the primitivist-imperialist connection (in 1931, Aragon and others organized an anticolonial exhibition to counter the official *Exposition coloniale* in the new Musée des Colonies). And when these "ethnographic surrealists" did aestheticize, it tended to be in the interests of "cultural impurities and disturbing syncretisms." Which is to say that they prized in the tribal object not its *raisonnable* form but its *bricolé* heterogeneity, not its mediatory possibilities but its transgressive value. In short, the primitive appeared less as a solution to Western aesthetic problems than as a disruption of Western solutions. Rather than seek to master the primitive—or, alternatively, to fetishize its difference into opposition or identity—these primitivists welcomed "the unclassified, unsought Other."[13]

It is most likely excessive (and worse, dualistic!) to oppose these two readings of the primitive—the one concerned to incorporate the primitive, the other eager to transgress with it—and to extrapolate the latter into a counterpractice to the former. (Again, such a counterpractice is not for the West to supply.) However, *bricolage*—which Lévi-Strauss, influenced by the surrealists, did after all define as a "primitive" mode—is today posed in the Third World (and in its name) as such a resistant operation, by which the other might appropriate the forms of the modern capitalist West and fragment them with indigenous ones in

a reflexive, critical montage of synthetic contradictions.[14] Such *bricolage* might in turn reveal that Western culture is hardly the integral "engineered" whole that it seems to be but that it too is *bricolé* (indeed, Derrida has deconstructed the Lévi-Strauss opposition *bricoleur*/engineer to the effect that the latter is the product, the myth of the former).[15]

One tactical problem is that *bricolage,* as the inversion of the appropriative abstraction of primitivism, might seem retroactively to excuse it. Indeed, the famous Lévi-Strauss formula for *bricolage* is uncannily close to the Barthes definition of appropriation (or "myth"). In his definition (1962) Lévi-Strauss cites Franz Boas on mythical systems: "'It would seem that mythological worlds have been build up, only to be shattered again, and that new worlds were built from the fragments'"; and adds: "In the continual reconstruction from the same materials, it is always earlier ends which are called upon to play the part of means: the signified changes into the signifying and vice versa."[16] Compare Barthes on myth (1957): "It is constructed from a semiological chain which existed before it: it *is a second-order semiological system.* That which is a sign . . . in the first system becomes a mere signifier in the second."[17] The difference is that myth is a one-way appropriation, an act of power; *bricolage* is a process of textual play, of loss and gain: whereas myth abstracts and pretends to the natural, *bricolage* cuts up, makes concrete, delights in the artificial—it knows no identity, stands for no pretense of presence or universal guise for relative truths. Thus, if it is by a "mythical" reduction of content to form that the primitive becomes primitivist, by a mythical abstraction of signified into signifier that African ritual objects, customs, *people* become "Africanity"—if it is by myth that one arrives at affinity and universality—then *bricolage* may well constitute a counterpractice. For in *bricolage* not only may the primitive signified be reclaimed but the Western signified may be mythified in return, which is to say that primitivism (the myths of the African, the Oceanic, that still circulate among us) may possibly be deconstructed and other models of intercultural exchange posed. However compromised by *its* appropriation as an artistic device in the West (superficially understood, *bricolage* has become the "inspiration" of much primitivist art), *bricolage* remains a strategic practice, for just as the concept of myth demystifies "natural" modes of expression and "neutral" uses of other-cultural forms, so too the device of *bricolage* deconstructs such notions as a modern/tribal "affinity" or modernist "universality" and such constructs as a fixed primitive "essence" or a stable Western "identity."

THE OTHER IS BECOMING THE SAME; THE SAME IS BECOMING DIFFERENT

Below, I want briefly to pose, to collide, two readings of the primitive encounter with the West: that of its progressive eclipse in modern history and that of its disruptive return (in displaced form) in contemporary theory. The first history, as we have seen, positions the primitive as a moment in the "luminous" spread

of Western reason; the second, a genealogy, traces how the primitive, taken into this order, returns to disrupt it. The difficulty is to think these contrary readings simultaneously, the first aggressively historicist, the second historically enigmatic.

If the identity of the West is defined dialectically by its other, what happens to this identity when its limit is crossed, its outside eclipsed? (This eclipse may not be entirely hypothetical given a multinational capitalism that seems to know no limits, to destructure all oppositions, to occupy its field all but totally.) One effect is that the logic that thinks the primitive in terms of opposition or as an outside is threatened (as Derrida noted in the work of Lévi-Strauss or as Foucault came to see within his own thought, such structural terms can no longer be supported even as methodological devices).[18] In the second narrative, this "eclipsed" or sublated primitive reemerges in Western culture as its scandal—where it links up genealogically with poststructuralist deconstruction and politically with feminist theory and practice. In this passage the primitive other is transformed utterly, and here in particular its real world history must be thought. For the historical incorporation of the outside might well be the condition that compels its eruption into the field of the same as difference. Indeed, the eclipse of otherness, posed as a metaphysical structure of opposites or as an outside to be recovered dialectically, is the beginning of difference—and of a potential break with the phallocentric order of the West.

This genealogy is not as conjectural as it may seem: connections between certain "ethnographic surrealists" and poststructuralists are there to be traced. The intermediary figures are Lacan, Lévi-Strauss, and, above all, Bataille, whose notions of *dépense* and *la part maudite,* developed out of Mauss's theory of the gift, have influenced Baudrillard, and whose notion of transgression has influenced Foucault and Derrida. On this reading, if the early moderns sublated the primitive into reason, the dissident surrealists thought it transgressively; but it was left to poststructuralism and feminism to theorize it, however transformed in position and effectivity. As Rosalind Krauss has suggested, the poststructuralist and feminist deconstruction of phallocentric oppositions is related to the "collapse of differences"—i.e., of *oppositions* between natural and unnatural forms, conscious and unconscious states, reality and representation, politics and art—that is at the heart of surrealist scandal.[19] It is this transgressive enterprise that is dismissed as "arbitrary" and "trivial" in postwar American formalism in which, in a neomodernist moment, crisis is once more recouped for continuity. Indeed, this collapse or rupture is not thought deeply again till the art of the generation of Smithson, in which formalist criteria give way to a concern with "structure, sign, and play," in which, with such devices as the site-nonsite, the form of the exhibition work with expressive origin and centered meaning is displaced by a serial or textual mode "with a concept of limits that could never be located.[20]

On the one hand, then, the primitive is a modern problem, a crisis in cultural identity, which the West moves to resolve: hence the modernist construction

"primitivism," the fetishistic recognition-and-disavowal of the primitive differ-ence. This ideological resolution renders it a "nonproblem" for us. On the other hand, this resolution is only a repression: delayed in our political unconscious, the primitive returns uncannily at the moment of its potential eclipse. The rup-ture of the primitive, managed by the moderns, becomes our postmodern event.[21]

The first history of the primitive encounter with the West is familiar enough, the fatalistic narrative of domination. In this narrative 1492 is an inaugural date, for it marks the period not only of the discovery of America (and the rounding of the Cape of Good Hope) but also of the renaissance of antiquity. These two events—an encounter with the other and a return to the same—allow for the incorporation of the modern West and the instauration of its dialectical history. (Significantly, in Spain, 1492 also marks the banishment of the Jews and Arabs and the publication of the first modern European grammar; in other words, the expulsion of the other within and the encoding of the other without.)[22] This, too, is the period of the first museums in Europe and of "the first works on the 'life and manners' of remote peoples"—a collection of the ancients and "sav-ages," of the historically and spatially distant.[23] This collection only expands, as the West develops with capitalism and colonialism into a world-system. By the eighteenth century, with the Enlightenment, the West is able to reflect on itself "as a culture *in the universal,* and thus all other cultures were entered into its mu-seum as vestiges of its own image."[24]

There is no need to rehearse this "dialectic" here, the progressive domination of external and internal nature (the colonization of the outside and the uncon-scious), but it is important to note that this history is not without its representa-tions and contestations in modern theory. Indeed, in 1946 Merleau-Ponty could write:

> All the great philosophical ideas of the past century—the philosophies of Marx and Nietzsche, phenomenology, German existentialism and psycho-analysis—had their beginnings in Hegel; it was he who started the attempt to explore the irrational and integrate it into an expanded reason, which remains the task of our century.[25]

There is, however, an obvious paradox here: the Western *ratio* is defined against the very unreason that it integrates; its dialectical identity requires the very other that it absorbs, disavows, or otherwise reduces to the same. It is this para-dox that the notion of transgression, as elaborated by Bataille amidst discussions of both "the end of history" and the otherness of the primitive, addresses. (Bataille attended the lectures on Hegel given by Alexandre Kojève in the '30s; he was also, of course, the principal theorist of the primitive as transgressive.) In his essay on Bataille—an essay in which the surrealist concern with the other

may be linked to the poststructuralist concern with difference—Foucault opposes the transgressive to the dialectical as a way to think through the logic of contradiction, as a "form of thought in which the interrogation of the limit replaces the search for totality."[26] Yet if transgression challenges the dialectic, the end of history, and the incorporation of the primitive other, it also presupposes (or at least foreshadows) them. Which is to say that the transgressive appears as a stopgap of the dialectical; it recomposes an outside, an other, a sacred, if only in its absence: "All our actions are addressed to this absence in a profanation which at once identifies it, dissipates it, exhausts itself in it, and restores it in the empty purity of its transgression."[27] Transgression is thus bound by a paradox of its own: it remarks limits even as it violates them, it restores an outside even as it testifies to its loss. It is on the borderline between dialectical thought and the becoming of difference, just as the structuralism of Lévi-Strauss is on the borderline between metaphysical oppositions and deconstruction.

There is no question that today we are beyond this border, that we live in a time of cancelled limits, destructured oppositions, "dissipated scandals"[28] (which is not to say that they are not recoded all the time). Clearly, the modern structures in which the Western subject and socius were articulated (the nuclear family, the industrial city, the nation-state) are today remapped in the movement of capital. In this movement the opposition nature/culture has become not only theoretically suspect but practically obsolete: there are now few zones of "savage thought" to oppose to the Western *ratio*, few primitive others not threatened by incorporation. But in this displacement of the other there is also a decentering of the same, as signalled in the '60s when Foucault abandoned the logic of structural or dialectical oppositions (e.g., reason/unreason) in favor of a field of immanent relations, or when Derrida proclaimed the absence of any fixed center or origin, of any "original or transcendental signified . . . outside a system of differences."[29] It was this that led Foucault to announce, grandly enough, the dissolution of man in language. More provocative, however, was his suggestion, made at the same moment (1966), that "modern thought is advancing towards that region where man's Other must become the Same as himself."[30] In the modern episteme, Foucault argued, the transparent, sovereign *cogito* has broken down, and Western man is compelled to think the unthought. Indeed, his very truth is articulated in relation to the unconscious and the other; thus the privilege granted psychoanalysis and ethnology among the modern human sciences. The question returns then: What happens to this man, his truth, when the unconscious and the other are penetrated—integrated into reason, colonized by capital, commodified by mass culture?

Tellingly, it was in the '30s and '40s, after the high stage of imperialism and before the anticolonial wars of liberation, that the discourse of the other was most thoroughly theorized—by Lacan, of course, and Lévi-Strauss (who, in

Tristes Tropiques, pondered "the ethnological equivalent of the mirror stage")[31] but also by Sartre, who argued that the other was necessary to the "fusion" of any group, and Adorno and Horkheimer, who elaborated the role of otherness in Nazism. I mention these latter here to suggest that, however decentered by the other, the (Western) subject continues to encroach mercilessly upon it. Indeed by 1962 (when Lévi-Strauss wrote that "there are still zones in which savage thought, like savage species, is relatively protected"),[32] Paul Ricoeur could foresee a "universal world civilization." To Ricoeur, this moment was less one of the imperialist "shock of conquest and domination" than one of the shock of disorientation: for the other a moment when, with the wars of liberation, the "politics of otherness" had reached its limit, and for the West a moment when it became "possible that there are just *others,* that we ourselves are an 'other' among others."[33]

This disorientation of a world civilization is hardly new to us today. In 1962 Ricoeur argued that to survive in it each culture must be grounded in its own indigenous tradition; otherwise this "civilization" would be domination pure and simple. Similarly, in our own time Jürgen Habermas has argued that the modern West, to restore its identity, must critically appropriate its tradition—the very project of Enlightenment that led to this "universal civilization" in the first place.[34] Allegories of hope, these two readings seem early and late symptoms of our own postmodern present, a moment when the West, its limit apparently broached by an all but global capital, has begun to recycle its own historical episodes as styles together with its appropriated images of exotica (of domesticated otherness) in a culture of nostalgia and pastiche—in a culture of implosion, "the internal violence of a saturated whole."[35]

Ricoeur wrote presciently of a moment when "the whole of mankind becomes a kind of imaginary museum."[36] It may be this sense of closure, of claustrophobia that has provoked a new "primitivism" and "Orientalism" in recent theory: e.g., the Baudrillardian notion of a primitive order of symbolic exchange that "haunts" our own system of sign exchange, or the Deleuzian idea of a "savage territoriality" now deterritorialized by capital; Barthes's Japan cast as the "possibility of a difference, of a mutation, of a revolution in the propriety of symbolic systems," or Derrida's or Foucault's China seen as an order of things that "interrupts" Western logocentrism.[37] But rather than seek or resuscitate a lost or dead other, why not turn to vital others within and without—to affirm *their* resistance to the white, patriarchal order of Western culture? For feminists, for "minorities," for "tribal" peoples, there are other ways to narrate this history of enlightenment/eradication—ways which reject the narcissistic pathos that identifies the death of the Hegelian dialectic with the end of Western history and the end of that history with the death of man, which also reject the reductive reading that the other can be so "colonized" (as if it were a zone simply to occupy, as if it did not emerge imbricated in other spaces, to trouble other dis-

courses)—or even that Western sciences of the other, psychoanalysis and ethnology, can be fixed so dogmatically. On this reading the other remains—indeed, as the very field of difference in which the subject emerges—to challenge Western pretenses of sovereignty, supremacy, and self-creation.

NOTES

1. See Varnedoe, "Gauguin," pp. 201–203, and "Contemporary Explorations," pp. 652–653, in *"Primitivism" in 20th Century Art,* ed. William Rubin, New York, Museum of Modern Art, 1984.

2. Ibid., p. 202.

3. Ibid.

4. Max Horkheimer and Theodor W. Adorno, *Dialectic of Enlightenment,* trans. John Cumming, New York, Seabury Press, 1972.

5. Varnedoe, "Gauguin," p. 203.

6. See, for example, Varnedoe, "Contemporary Explorations," pp. 665, 679.

7. Jean Baudrillard, *The Mirror of Production,* trans. Mark Poster, St. Louis, Telos Press, 1975, p. 90. The reference is to Lévi-Strauss's claim, in *The Raw and the Cooked* (trans. J. and D. Weightman, New York, Harper and Row, 1969, pp. 13–14), that "it is in the last resort immaterial whether in this book the thought processes of the South American Indians take place through the medium of my thoughts, or whether mine take place through the medium of theirs. What matters is that the human mind, regardless of the identity of those who happen to be giving it expression, should display an increasingly intelligible structure. . . ."

8. Lévi-Strauss, *Tristes Tropiques,* trans. J. and D. Weightman, New York, Atheneum, 1978, p. 389.

9. This definition of art . . . was developed by Lévi-Strauss in relation to a tribal form, Caduveo face painting; see *Tristes Tropiques,* pp. 196–197.

10. See, in general, Marshall Sahlins, *Culture and Practical Reason,* Chicago, University of Chicago Press, 1976; and Pierre Clastres, *Society Against the State,* trans. Robert Hurley, New York, Urizen Books, 1974.

11. Edward W. Said, "Opponents, Audiences, Constituencies, and Community," in *The Anti-Aesthetic,* ed. Hal Foster, Port Townsend (WA), Bay Press, 1983, p. 158.

12. As for a Western text that involves this "other" account, an example is provided by the Jean Rouch film *Les Maîtres Fous,* a documentary of the trauma of imperialist subjection ritually worked through by an African tribe. In a trance the tribesmen are one by one "possessed" by the white colonial figures, the Crazy Masters—an exorcism that inverts the one in the *Demoiselles.* Here, though, the image of the other is used to purge the other, and the objectification is reversed: it is the white man who appears as the other, the savage, the grotesque. At the end the tribesmen return to the colonial city and once again assume subject-positions—in the army, in road crews, in the "native population."

13. Clifford, "On Ethnographic Surrealism," *Comparative Studies in Society and History* 23 (Oct. 1981), p. 564.

14. This strategy was posed by Abdellah Hammoudi at the symposium (Nov. 3–4, 1984) held at MOMA in conjunction with the show.

15. Jacques Derrida, "Structure, Sign, and Play in the Discourse of the Human Sciences," in *Writing and Difference*, trans. Alan Bass, Chicago, University of Chicago Press, 1978, p. 285. In *Of Grammatology* (trans. Gayatri Chakravorty Spivak, Baltimore, The Johns Hopkins University Press, 1976, p. 105), Derrida writes of Lévi-Strauss: "At once conserving and annulling inherited conceptual oppositions, this thought, like Saussure's, stands on a borderline: sometimes within an uncriticized conceptuality, sometimes putting a strain on the boundaries, and working toward deconstruction."

16. Lévi-Strauss, *The Savage Mind,* Chicago, University of Chicago Press, 1966, p. 21

17. Roland Barthes, "Myth Today," in *Mythologies,* trans. Annette Lavers, New York, Hill and Wang, 1972, p. 114. In *For a Critique of the Political Economy of the Sign* (trans. Charles Levin, St. Louis, Telos Press, 1981, p. 96), Jean Baudrillard writes: "This semiological reduction of the symbolic property constitutes the ideological process."

18. See Derrida, "Structure, Sign, and Play," and Foucault, "History, Discourse, and Discontinuity, *Salmagundi,* Summer–Fall 1972, pp. 225–248." Fredric Jameson has suggested in this regard that one "referent" of French deconstruction may well be American capital. See his "Pleasure: A Political Issue," in *Formations,* ed. Victor Burgin et al., London, Routledge & Kegan Paul, 1983.

19. Rosalind Krauss, "Preying on 'Primitivism,'" *Art and Text,* no. 17 (April 1985).

20. Ibid.

21. Such "delays" are common enough: for example, the critique of representation, initially undertaken in cubism and collage, that returns in a different register in postmodernist art.

22. See Tzvetan Todorov, *The Conquest of America,* trans. Richard Howard, New York, Harper and Row, 1984, p. 123. Todorov argues that the conquest of America was from one perspective a "linguistic" one.

23. Todorov, p. 109.

24. Baudrillard, *The Mirror of Production,* pp. 88–89.

25. Maurice Merleau-Ponty, *Sense and Nonsense,* trans. Hubert and Patricia Dreyfus, Evanston, Northwestern University Press, 1964, pp. 109–110.

26. Foucault, "A Preface to Transgression," in *Language, Counter-Memory, Practice,* ed. Donald F. Bouchard, Ithaca, Cornell University Press, 1977, p. 50.

27. Ibid., p. 31.

28. The phrase is Robert Smithson's; see *Robert Smithson: The Collected Writings,* ed. Jack Flam, Berkeley, University of California Press, 1996, p. 329.

29. Derrida, "Structure, Sign, and Play," p. 280.

30. Foucault, *The Order of Things,* New York, Vintage Books, 1970, p. 238.

31. Catherine Clément, *The Lives and Legends of Jacques Lacan,* trans. Arthur Goldhammer, New York, Columbia University Press, 1983, p. 76.

32. Lévi-Strauss, *The Savage Mind,* p. 219.

33. Paul Ricoeur, "Universal Civilization and National Cultures," in *History and Truth*, trans. Charles A. Kelbley, Evanston, Northwestern University Press, 1965, p. 278. Also see Fredric Jameson, "Periodizing the Sixties," in *The Sixties Without Apology*, ed. Sayres, Stephanson, et al., Minneapolis, University of Minnesota Press, 1984, pp. 186–188.

34. See Jürgen Habermas, "Modernity—An Incomplete Project," in *The Anti-Aesthetic*, pp. 3–15.

35. Baudrillard, "The Beaubourg Effect," trans. Rosalind Krauss and Annette Michelson, *October*, no. 20 (Spring 1982), p. 10.

36. Ricoeur, p. 278. What clearer sign of this implosion—when mankind is treated as a museum of the West—can there be than the "Primitivism" show? If the "universality" of the Enlightenment positioned the West in a transcendental relation to the primitive, then the "globality" of multinational capital (as represented by Philip Morris) may put us in a transcendental relation to our own modernity.

37. See Baudrillard, *For a Critique of the Political Economy of the Sign*, passim; Gilles Deleuze and Felix Guattari, *Anti-Oedipus*, trans. Hurley, Seem, and Lane, New York, Viking Press, 1977, pp. 139–271; Barthes, *The Empire of Signs*, trans. Richard Howard, New York, Hill and Wang, 1982, pp. 3–4; and Derrida, *Of Grammatology*, pp. 77–93.

THOMAS McEVILLEY

THE GLOBAL ISSUE · 1990

> When asked why he wished to be buried upside down, Diogenes replied, "Down will soon be up."

"Writing before the exhibition," I remarked in the catalogue of the Centre Pompidou's *"Magiciens de la terre"* show in Paris last summer, "I do not know (nor may I after) how well or badly it will fulfill its post-Modern agenda." My essay was written three years ago. Now the exhibition has happened, occasioning a hail of mostly negative criticism rather similar in premise to the attacks (including my own) on the Museum of Modern Art's "'Primitivism' in 20th Century Art" show in New York in 1984. One has to be sympathetic to the antihegemonic impulse behind this criticism of *"Magiciens de la terre."* Still, in the end, I feel, it misses the point.

Like many viewers, I did have problems with the show. There were many distressing signs of residual colonialist attitudes. As various reviewers pointed out, for example, the title showed a romantic tilt toward the idea of the "native artist" as not only a magician (with the term's suggestion of the prerational) but also as somehow close to the earth (not *magiciens du monde,* of the world, but *de la terre*), as if in some precivilized state of nature. The curators were understandably motivated by a desire not to use the word "artists," in deference to the ongoing anthropological debate about whether so-called "primitive" peoples have the ideology (essentially, in our terms, Kantian) that makes objects "art" in our sense of the word. Still, an aura of Rousseau and of the Noble Savage clings round their title. And the word *magician* really does not express very precisely what Hans Haacke does, or Lawrence Weiner, or Barbara Kruger, or Chéri Samba, or many others in the show, both Eastern and Western—or Northern or Southern.

The tilt toward the cliché of the earthy native was also visible in the selection and installation of the works. Despite the fact that a number of artists in India

Artforum 28 (March 1990): 19–21.

In the spring of 1990, the Centre Pompidou in Paris opened a large exhibition, "Magiciens de la Terre" (Magicians of the Earth), meant to serve as a postmodern corrective to the 1984 MoMA "Primitivism" exhibition. "Magiciens" was an ambitious international exhibition, billed as the first to bring together art from the entire world and to mix artists of the "centers" with artists from the "margins." McEvilley's discussion of why this exhibition was so badly received draws attention to the continuing thorniness of some of the issues involved.

are currently attempting to work out a thoughtful conflation of Indian and Western styles and themes, for example, the curators chose to exhibit primarily traditional, craftlike work from that country. Actually, most of the artists in *"Magiciens"* who might be described as cool, intellectual, and conceptual were Westerners (Weiner, Kruger, Haacke, Daniel Buren, and so on); and in general (though not without exception), the artists whose work seemed most earthy and ritualistic were non-Western (Esther Mahlangu of South Africa, Cyprien Tokoudagba of Benin, Nuche Kaji Bajracharya of Nepal, Joe Ben Jr., a Native American sand painter, and so on). It would not have been hard to reverse, or to balance, those categories, perhaps by placing more emphasis on work that attempts to bridge the gap. (But maybe that is another show, and the next stage in the postcolonialist process.) Indeed, the curators may have intended a gesture at such a balance through the huge Richard Long mud painting in the portion of the show at La Villette—the "earthiest" piece in the exhibition, literally, and by a European artist. But as many seem to have felt, the overriding presence of the Long circle, which dominated everything at La Villette, smacked of hierarchy. Even more unfortunate was the aboriginal sand painting lying on the floor beneath it, as if conquered or raped.

More could be said, and has been said by others, to indicate how the curators failed to arrive at a fully postcolonialist show. Not least would be the atrocious catalogue statements by the curators themselves, with their talk of spirituality implying universals they may not have intended, and their rather clumsy, gung ho enthusiasms. But for all this, it nevertheless seems to me that the generally negative press reaction to *"Magiciens de la terre"* was mistaken. (Though I wrote what the curators called the keynote statement in the catalogue, I made no curatorial contribution to the exhibition, and have no ongoing connection with the Pompidou. My defense of the show is based on my belief in its premises, not in the details of the curation.)

Part of the reason for the often hostile reaction to *"Magiciens"* may have been the fact that it was not seen in the United States and the " 'Primitivism' " show was not seen in Europe. One cannot really understand *"Magiciens"* without thinking of what the " 'Primitivism' " show meant in terms of history and society.

A sensitive exhibition defines a certain moment, embodying attitudes and, often, changes of attitude that reveal, if only by the anxieties they create, the direction in which culture is moving. The distance from " 'Primitivism' " to *"Magiciens"* suggests how much things have changed in the five years between them. Western culture as it enters the 1990s is somewhat inchoately seeking a new definition of history that will not involve ideas of hierarchy, or of mainstream and periphery, and a new, global sense of civilization to replace the linear Eurocentric model that lay at the heart of Modernism. These issues rose into the foreground in the art world with the " 'Primitivism' " show, which was widely perceived—here, in Europe, and indeed around the world—as an amaz-

ingly unconsidered display of neocolonialist mentality. It seemed to want to turn back the clock of history, anachronistically reaffirming the ideology of classical Modernism.

That ideology involved the Kantian esthetic theory—which made claims for pure form, the absolute value judgment, and the universality of esthetic canons—with the Hegelian myth of history, which held that history had an inherent goal. These two ideas worked together to justify European colonialist hegemony. The idea that history has a goal makes it plausible to imagine that some cultures may be farther along toward that goal than others. These, of course, would be the colonizing cultures of the West, since this was a Western myth. And if we were closer to the goal, the right to make the supposedly universal value judgment was ours. History, in this view, gave us the right to judge other cultures on our terms (never judging ourselves on theirs). It seemed to follow logically that it was the responsibility of Western civilization to drag the rest of the world, for its own good, into history and toward the goal. Thus the Work (as Hegel called it) of history was the white man's burden, in Rudyard Kipling's phrase. Of course the white man was also burdened with the task of carrying back into Western coffers what an earlier English poet, John Milton, called "barbaric pearl and gold."

Increasingly since the late '60s, this ideology has lost credibility. As post-Modernism (or post-History, meaning post–the Hegelian view of history) dawned, it came to seem that in fact history had no inherent goal. It might go wherever circumstances drew it, and circumstances were too manifold, complex, and subtle to be susceptible to extensive control. The distinction we had drawn between nature and culture seemed to be breaking down. That division, when it was first bruited (by the Greek Sophists, from whom Hegel took the idea), was based on the notion that we can't control nature but we can control culture. Nowadays the opposite seems true: it is culture that is out of control, nature all too vulnerable to human direction.

It was at this moment of attitudinal change that the "'Primitivism'" show appeared, like a holding action for classical Modernism. There was the Kantian doctrine of universal quality again; there was the Hegelian view that history is a story of Europeans leading dark-skinned peoples toward spiritual realization; there was the sense of mainstream and periphery. The fact that so-called primitive art resembled Western advanced art seemed to be attributed primarily not to the incontestable fact that the Western artists had imitated "primitive" works, but to the idea of an underlying affinity between Western artists and "primitives" that demonstrated the universality of the Modernist canon. The colonized nations were called upon to testify to the superiority of the colonizers. It was a kind of police action.

"Magiciens" was conceived in the midst of the widespread controversy over

the " 'Primitivism' " show. The hope it embodied was to find a postcolonialist way to exhibit the works of first- and third-world artists together, a way that would involve no projections about hierarchy, or about mainstream and periphery, or about history having a goal. Works by 50 Western and 50 non-Western artists would be exhibited in a neutral, loose, unsystematic way that would not imply transcultural value judgments. The exhibition would be superficially similar to " 'Primitivism' " in that it too would exhibit first- and third-world objects side by side in a major Western museum. But where " 'Primitivism' " had dealt with universals, *"Magiciens"* would deal with particulars. Where " 'Primitivism' " had left the "primitive" works anonymous and undated, *"Magiciens"* would treat them exactly as it treated the Western pieces. Where " 'Primitivism' " had been Eurocentric and hierarchic, *"Magiciens"* would level all hierarchies, letting the artworks appear without any fixed ideological framework around them. Where " 'Primitivism' " presented "primitive" works as footnotes to their Western Modernist imitations, *"Magiciens"* would choose each work by what appeared to its curators to be its interest as itself, not by its value of illustrating something other than itself. (The curators' taste, it seemed to me, functioned in the selection process as a kind of random element.) Where " 'Primitivism' " came equipped with a huge, hectoring catalogue enforcing the curators' view of virtually everything in the show, *"Magiciens"* just put the stuff out there unexplained, or, rather, untamed by explanation. As for the idea of a center, *"Magiciens,"* at least in the catalogue, would make a gesture toward dismissing it. Each artist was given two pages in the volume; on each spread was a small map that showed the artist's home as the center of the globe.

Perhaps the key fact is that the two exhibitions embodied radically different ideas of history. " 'Primitivism' " was still based on the Hegelian myth of Western cultures leading the rest of the world forward. *"Magiciens"* was the epitaph of this view, and of the Kantian idea of the universal value judgment. If history has no goal, then there can be no basis on which to claim that one culture is more advanced toward the goal than any other. Suddenly each culture is simply the most advanced example of its type. Each culture has an equal claim to be just where it is.

The " 'Primitivism' " show was based on a belief in universally valid quality judgments, particularly those made by the curators. The *"Magiciens"* show hoped to be able to acknowledge that value judgments are not innate or universal but conditioned by social context, and hence that they only really fit works emerging from the same context. This thought does not mark the end of the idea of quality, only it relativization. When one walked through *"Magiciens,"* instead of automatically thinking, This is good or this is bad, one might be provoked to attend to the limitations of one's ideas of good and bad—to confront the fact that often one was looking at objects for which one had no criteria except some

taken from a completely different, and possibly completely irrelevant, arena. The absence of a scholarly catalogue left the viewer confronted simply with the works and the bewilderment they might produce.

Criticism of *"Magiciens"* came from both the right and the left. To rightist critics, the show seemed a destroyer of Modernism. The curators had given up the Western claim to being a more advanced civilization; they had given up our long-claimed right to judge other cultures by our own standards, and to treat these judgments as somehow objective. This anxiety must underlie the unpublished remark of a prominent British critic that *"Magiciens"* marked the end of Western civilization—as if Western civilization were constituted precisely by the claim to hegemony; as if yielding that claim, one yielded all.

Critics approaching from the left expressed unhappiness at how depoliticized the show was. They questioned the motives of the institution, suspecting it, among other things, of attempting to recapture French cultural claims to global relevance. They brought up the tradition of French colonialism, sometimes implying that the show might better have transpired in Kinshasa or Djibouti—places where, unfortunately, it probably would not have affected much the way the Western art world operates. They questioned the idea of introducing these artists into the Western market system, like innocent lambs being led to the slaughter. They questioned the imposition of bourgeois individualist values on these artists from supposedly communal societies. They spoke of *"Magiciens"* as if it were " 'Primitivism.' "

The bone everyone has been picking—right, left, or centrist—is the lame curation. The show didn't add up in so many ways, despite the good sense of its underlying premises. I don't argue that point. (In fact, I feel that the show's inconsistencies saved it from the rigidity of a single framework of value.) What I am defending is an idea that I think was never really in question and that I doubt anyone wants directly to attack. All the criticism of the show that I have seen fails to confront the monumental fact that this was the first major exhibition consciously to attempt to discover a postcolonialist way to exhibit first- and third-world objects together. It was a major event in the social history of art, not in its esthetic history. *"Magiciens"* opened the door of the long-insular and hermetic Western art world to third-world artists. The question is not really whether the people who opened the door had gravy on their jackets, or slipped and fell as they were opening it. The question is this and this only: as we enter the global village of the '90s, would any of us *really* rather that that door remain closed?

Some of the criticism of the show was honorably motivated by a compassionate concern for the third-world artists. This concern arises understandably from a skepticism about whether the door is really open, how far it's open, and how long it'll stay open. It has happened before that the Western art market, seeking new goods, has elevated a previously peripheral group to the main-

stream and, when it didn't work out financially, ejected them again. (One thinks, for example, of the Mexican muralists of the '30s and of the graffiti artists of the early '80s.) The composition of such international exhibitions as the forthcoming Venice Biennale and of the Documenta two years hence will be most revealing about the question of whether the door is really open. Meanwhile, I've heard that African artists from *"Magiciens"* are having one-person shows in Paris and New York galleries. The Center for African Art in New York is preparing a show of contemporary art from Africa. Down will be up. It may be that the deck of cards of Western art history has been thrown into the air—that there are unknown elements in the game now, elements not yet under any particular control.

LUCY LIPPARD

NAMING · 1990

The most pervasive and arguably most insidious term artists of color must challenge is "primitivism." It has been used historically to separate the supposedly sophisticated civilized "high" art of the West from the equally sophisticated art it has pillaged from other cultures. The term locates the latter in the past—usually the distant past—and in an early stage of "development," implying simplicity on the positive side and crudity or barbarism on the negative. As James Clifford has written, the notion of the primitive in Western culture is "an incoherent cluster of qualities that at different times have been used to construct a source, origin, or alter ego confirming some new 'discovery' within the territory of the Western self," assuming a "primitive world in need of preservation, redemption and representation."[1]

I should not even have to touch upon this anthropological problem in a book devoted to the contemporary art of my peers, but the Western concept of primitivism denigrates traditions with which many contemporary artists identify and fortify themselves. The term "primitive" is also used to separate by class, as in "minor," "low," "folk," or "amateur" art—distinguished from the "fine," "high," or "professional" art that may in fact be imitating it. There is an inference that such work is "crude" or "uncooked," the product of "outsiders."[2] "Primitives" are those who "naively" disregard the dictates of the market and make art for the pure joy of doing so. In fact, much "primitive" art is either religious or political, whether it is from Africa or from today's rural or urban ghettos. It is not always the quaint and harmless genre, the ideological captive, pictured in the artworld.

And yet, as Jerome Rothenberg has pointed out, "primitive means complex."[3] The West has historically turned to the Third World for transfusions of energy and belief. In less than a century, the avant-garde has run through some five centuries of Western art history and millennia of other cultures with such a strip-mining approach that it has begun to look as though there were no "new" veins to tap. Where the Cubists appropriated the *forms* of traditional cultures and the Surrealists used their dreamlike *images* to fantasize from, many artists in the

Excerpt from *Mixed Blessings: New Art in a Multicultural America* (1990), 24–29. © 1990 by Lucy R. Lippard. Reprinted by permisssion of Pantheon Books division of Random House, Inc.

Lucy Lippard (b. 1937) is an activist American art critic known for her provocative writing on issues relating to identity and culture.

'70s became educated about and fascinated with the *meanings* of unfamiliar religions and cultures. The very existence of the international mini-movement called "primitivism" constituted an admission that Western modernism once again needed "new blood." In the '80s the overt rampage through other cultures was replaced by postmodernist "appropriation" (reemploying and rearranging borrowed or stolen "readymade" images from art and media sources)—a strategy warmed over from '60s Conceptual Art and often provocatively retheorized. Some of this work is intended to expose as well as to revise the social mechanisms of image cannibalism. The "appropriation" of anything from anywhere is condoned as a "critical" strategy. Yet as Lowery Stokes Sims has pointed out, such "visual plagiarism" has its limits, especially when it reaches out into other cultures "in which this intellectual preciosity has no frame of reference. . . . Appropriation may be, when all is said and done, voyeurism at its most blatant."[4]

There are more constructive ways of seeing the "primitive." Cuban art critic Gerardo Mosquera has pointed out that "for Latin Americans, the 'primitive' is as much *ours* as the 'contemporary,' since *our* 'primitivism' . . . is not archeological material, but an active presence capable of contributing to *our* contemporary world."[5] Judith McWillie, a white scholar of black Atlantic art, has pointed out that the art of self-educated black artists closely paralleled the works of early modernists; that

> even before Derain, Matisse, and Picasso began to unfix the classical boundaries of Western imagination and form, blacks in the Americas were synthesizing African, European, and Native American idioms to create non-objective assemblages and narrative improvisations that prefigured the aesthetic revolutions to come; and that African consciousness, in spite of history's most profound shocks and disassociations, is able to sustain itself independently, flavoring and transforming, without exception, every culture that comes into contact with it.[6]

African American writer Michele Wallace identifies another contemporary response as "a process of imitation and critical reversal":

> For instance, my mother, Faith Ringgold, saw in Picasso a place where she, as a black artist produced by the West, could think about her African heritage. I mean you could sort of run it backward: black artists looking at white Europeans appropriating African artifacts for modernism and Cubism. If you came as, say, a black person in the '50s studying art, the way to translate the tradition that exists in African sculpture was to look at a painter who had already traveled that route of appropriation, and then reinterpret his appropriation.[7]

When other cultures appropriate from Western modernism they are called derivative. When new information is brought into the isolated art world through

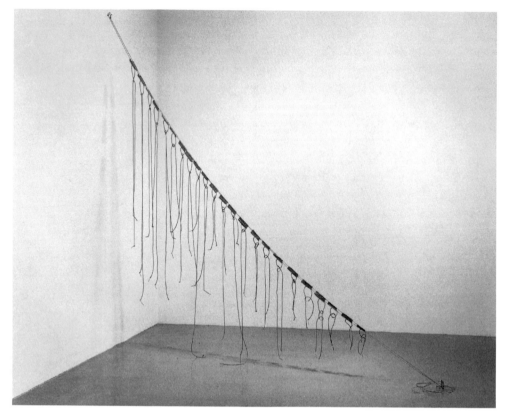

Figure 39. Eva Hesse, *Vinculum, II,* 1969. Twenty-three rubberized wire-mesh plaques stapled to shielded wire, 19′5″ x 3″ (591.7 x 7.6 cm), with twenty-three hanging extruded rubber wires, knotted, ranging in size from 7″ (17.9 cm) to 62″ (157.6 cm). Size installed, 9′9″ x 2½″ x 9′7½″ (297.2 x 5.8 x 293.5 cm). Reproduced with the permission of The Estate of Eva Hesse. Galerie Hauser & Wirth, Zurich. Museum of Modern Art, New York. The Gilman Foundation Fund. Photograph © 2001 The Museum of Modern Art, New York.

new images and interests, its welcome is qualified. The dominant culture prefers to make over its sources into its own image, filtering them through the sieve of recent local art history, seeing only that which is familiar or currently marketable and rejecting that which cannot be squeezed into "our" framework. Art from ethnic groups is still seen as though it were made for export to the "real" U.S.A. It wasn't until the mid-'80s that exhibitions organized *by subjects* rather than *of objects* began to attract attention.

Ironically, and sadly, access to information about global art is more available to the educated and well-traveled Western artist than to most of the heirs of those dehistoricized cultures. This constitutes a dilemma for the nonwhite or non-Western artist whose work may even be called derivative just because its authentic sources have already been skimmed off by white artists. The artworld's assumption of its centrality, and its massive absorption of Native imagery through "neo-primitivist" art, made Flathead/Shoshone painter Jaune Quick-To-See Smith

404

feel sad, because it's material we could be using. White artists can be "objective" about it, where Indians are "subjective" and not exactly sure how to draw on their backgrounds, because they are so much closer. When Native Americans refer to Indian art, it is automatically assumed to be "traditional" by white critics, even when it transcends tradition and is mixed with Euro-American styles.[8]

There are two sides to the boundary-crossing between the Third and First Worlds: the one-way trip in which TV, Donald Duck, Coca-Cola, Nestlé's baby formula, pesticides, and drugs outlawed in the United States replace traditional products and customs, contributing to the complex and not necessarily negative "creolization" of the Third World; and the return trip where remnants of ancient customs are abducted and carried triumphantly home to the West, to rest in splendor in elaborate museum installations—or to be buried in museum basements inaccessible to the public.[9] (This too is not as simple as I'm making it sound here; these objects, however deracinated, do constitute the base for cultural identifications that might otherwise have no material focus.) An enlightened attitude on the part of the West would convey a heightened awareness of the *contemporary* arts being made within those cultures whose pasts now appear to be common property, an acceptance not only of a culture's artifacts, but of its living creators as well.

In the United States, Native America is the place to start learning these lessons. The loss of the original communal name as well as individual names inevitably threatens the loss of culture and identity itself. (Most original names for Native peoples mean "the people," or "ourselves": the Navajo are Dineh; the Cheyenne, as artist Edgar Heap of Birds often points out in his work, are Tsistsista; the Salish are Sle'ligu, "We the Human Beings.") Modernist Indian artists are often caught between cultures, attacked by their own traditionalists for not being Indian enough and attacked by the white mainstream for being "derivative," as though white artists hadn't helped themselves to things Indian for centuries and as though Indians did not live (for better and worse) in the dominant culture along with the rest of us. Seneca artist Peter Jemison has demanded: "What about all of the white people who have taken things from Indians and reflected off us as though they were their own ideas, i.e. Jackson Pollock, Max Ernst. . . . You know, it's ok for Picasso to take African masks, so it's ok for us too."[10]

A classic example of one-sided "universalism" was the Museum of Modern Art's controversial 1984 exhibition "'Primitivism' in Twentieth-Century Art: Affinity of the Tribal and the Modern." Curator William Rubin, hiding behind quotation marks, declared that the term "primitivism" is simply part of modern art, owned by those who name its components, and was not meant to reflect on the original cultures from which the West borrows. His exhibition included no current art by "high artists" from Africa, Melanesia, or Native America, who

were presumably not "primitive" enough. A single African American mod-
ernist—Martin Puryear—appeared in the contemporary section. Romare Bear-
den, the dean of African American modernists and then at the height of his
career, was in the show but excluded from the "contemporary" section. (There
were no Latinos or Asians represented at all, since Pre-Columbian art was desig-
nated "court" rather than "tribal" art and omitted entirely, as was Asian art.) But
with classic ethnocentrism, the curators did include in another section such ut-
ter irrelevancies as a Kenneth Noland target painting of 1961, absurdly juxta-
posed against a New Guinea sculpture that incidentally bears concentric circles.
Cross-cultural or "transitional" objects bearing witness to the effects (often
powerfully integrated) of "contact" with the invaders were almost entirely ab-
sent from the Museum of Modern Art's show; they were considered "impure."
Jaune Quick-To-See Smith adamantly denies the notion, found in parts of the
Indian community as well, that Native peoples who incorporate modernism
into their art become, in the process, "inauthentic." She says they are simply ac-
knowledging the reality that they live in two cultures: "Dying cultures do not
make art. Cultures that do not change with the times will die." [11]

The very different exhibition "Magiciens de la terre," an extravaganza of cur-
rent "global" art held at the Centre Pompidou in Paris in 1989, displayed its bi-
ases from another angle. Although focused on the present, and on one level far
less elitist and arrogantly ethnocentric than the MoMA show, it featured
shamans, popular artists, sign painters, ritual ground painters, and what-have-
you from all over the Third World, while all but one of the U.S. participants
were white. Of the one hundred artists in the show, only ten were women and
only five of them came from the Third World. [12] No credit whatsoever was given
to a preceding global exhibition, the Second Bienal of Habana in 1986—a mot-
ley, yet amazing conglomeration of art from the Third World chosen not by the
Cubans, but by people from the countries where it was made. [13] The French cu-
rators, sometimes accompanied by Western artists, made "field trips" all over the
Third World, but seem to have visited only the "high art" centers of the West.

One of the functions of "Magiciens de la terre" was to "extract" or "bring
out" Third World art and artists from the mostly non-art contexts they inhabit.
The act of decontextualization transformed them into exotica, as Pakistani/
British artist Rasheed Araeen has pointed out, raising broader political questions:

> If the relationship between the "center" and the "periphery" is one of in-
> equality, is it possible for an equal exchange to take place within a framework
> which does not challenge this relationship? [Marginality in these postcolonial
> conditions] has little to do with the nature of their cultures but with the
> extremity of their exploitation and derivation resulting from Western imperi-
> alism. . . . If other peoples are now aspiring to [the West's] material achieve-
> ments and want to claim their own share, why are they constantly reminded

of its harmful effects on their own traditional cultures? If aspiration to modernity and modernism is detrimental to the creativity of other cultures, why is this concern confined only to the production of art? . . . Modernism for the "other" remains a basic issue. . . . But it seems that the Emperor does not want to be reminded of his nakedness, not when he is actually wearing so many colorful clothes imported from all over the world.[14]

The Pompidou show drew some perceptive criticism from Western progressives of the way the work was presented and even of the fact that it was presented at all. But little attention was paid to (or information given about) the reasons the non-Western artists chose to participate and how it affected their art. Did the abrupt displacement of rooted images and actions damage their functional effectiveness? Did it fulfill agendas "we" are not aware of? How did it fit, or not fit, into the "strategy of self-concealment"[15] that has been one of Native peoples' best defenses against colonial oppression? Curator Jean-Hubert Martin, refusing to take the blame for exploitation, cited a countermotive: the Australian aboriginal artists, he said, acknowledge "the problem of their decontextualization. . . . But they go on to argue that they commit their 'treason' for a particular purpose: to prove to the white world that their society is still alive and functioning."[16]

A name less obviously irritating than "primitive" for the creations of people of color and "foreign" whites is "ethnic art." Although it was originally coined with good intentions and some internal impetus, it has since been more coldly scrutinized as a form of social control that limits people's creative abilities to their culture's traditional accomplishments; both Left and Right have been accused of harboring this "separate but equal" agenda of "ethnic determinism."[17] There are categories and contexts where "ethnic" artists are supposed to go and stay, such as folk art and agitprop, community arts centers, ghetto galleries and alternative spaces. The Los Angeles artist Gronk, whose zany expressionist paintings and performances fit no Chicano stereotypes, says, "If [well-known white artist] Jon Borofsky makes a wall painting it's called an installation. If I do one, it's called a mural, because I'm *supposed to be* making murals in an economically deprived neighborhood."[18]

NOTES

1. James Clifford, "Histories of the Tribal and the Modern," *Art in America* (April 1985), pp. 164–77. See also Lucy R. Lippard, "Give and Takeout," in *The Eloquent Object,* ed. Marcia Manhart and Tom Manhart (Tulsa: Philbrook Museum of Art, 1987), pp. 202–27.

2. See John Berger, "Primitive Experience," *Seven Days* (March 13, 1977), pp. 50–51.

3. Jerome Rothenberg, "Pre-Face," in *Technicians of the Sacred* (Garden City, N.Y.: Doubleday, 1968), p. xix ff. Rothenberg suggests the term "archaic" as "a cover-all term for 'primitive,' 'early high,' and 'remnant,'" which also encompasses "mixed" cultural situations and a vast variety of cultures.

4. Lowery Stokes Sims, "Race, Representation, and Appropriation," in *Race and Representation,* ed. Maurice Berger and Johnnetta B. Cole (New York: Hunter College Art Gallery, 1987), p. 17.

5. Gerardo Mosquera, *Contracandela* [collected essays] (Havana: Editorial José Martí, forthcoming).

6. Judith McWillie, in *Another Face of the Diamond,* ed. Inverna Lockpez and Judith McWillie (New York: INTAR Hispanic Arts Center), p. 7.

7. Michele Wallace, "The Global Issue," *Art in America* (July 1989), p. 89. However, as Judith Wilson pointed out to me, black artists were buying African art in the '20s, as advised by Alain Locke in his important 1925 essay, "The Legacy of the Ancestral Arts" [in *The New Negro: An Interpretation* (New York: Albert and Charles Boni, 1925)]. By the '50s, many black artists based their forms directly on these objects and traveled to Africa.

8. Jaune Quick-To-See Smith, in conversation with the author, Santa Fe, Jan. 1985.

9. See Barbara Braun, "Cowboys and Indians: The History and Fate of the Museum of the American Indian," *Village Voice* (April 8, 1986), pp. 31–40.

10. Peter Jemison, "Out of Sight, Out of Mind I," *Upfront* no. 6–7 (Summer 1983), p. 20.

11. Quick-To-See Smith, conversation, Jan. 1985.

12. The U.S. representation in "Magiciens de la terre" was all Euro-American, except for Navajo artist Joe Ben. Nam June Paik, a Korean living part-time in New York, and Alfredo Jaar, a Chilean living in New York, were also included. Two Native Canadians were represented.

13. See "Report from Havana: Cuba Conversation," *Art in America* (March 1987), pp. 21–29. Extensive catalogs exist for the 1986 and 1989 Third World Bienals in Havana.

14. Rasheed Araeen, "Our Bauhaus, Others' Mudhouse," *Third Text* no. 6 (1989) pp. 4, 6, 12, 8.

15. Tony Fry and Anne-Marie Willis, "Aboriginal Art: Symptom or Success?" *Art in America* (July 1989), pp. 114–15.

16. Jean-Hubert Martin, "The Whole Earth Show: An Interview with Jean-Hubert Martin," by Benjamin H. D. Buchloh, *Art in America* (May 1989), p. 156.

17. Rasheed Araeen, "From Primitivism to Ethnic Arts," *Third Text* no. 1 (Autumn 1987), p. 10.

18. Gronk, in conversation with the author, Dec. 8, 1988.

SIEGLINDE LEMKE

PRIMITIVIST MODERNISM · 1998

The primary concern of *Primitivist Modernism* has been for art works in which black and white cultures are mutually constitutive. To describe this cultural relation as an "affinity between the modern and the tribal"—as William Rubin, director of the MOMA exhibit, did—is a misleading gloss, not only because the term "tribal" is inaccurate, but also because "affinity" suggests that Western and non-Western art are parallel structures that can never be integrated. Instead of fearing that any closer relation might be disruptive, we should think of this relation as a vital hybrid in which white and black cultures have formed something entirely new. It is an example of what Françoise Lionnet called a "métissage"; yet structurally this hybrid is not completely equivalent to creolization because the original, culturally specific identities are no longer discernible.[1]

This book argues that the First World owes much of its symbolic cultural capital to sources found throughout the Third World. We have seen that there is no modernism without primitivism. By this I do not mean that all of modernism was informed by African art—Mondrian's and Charles Sheeler's works, for example, bear no obvious traces. Nor do I offer a monocausal account of the shaping of modernism. I suggest, however, that black cultures played a seminal role in the emergence of a new aesthetic paradigm; modernism includes the presence of the so-called primitive at its heart.

I have explored some of the ramifications of a movement that began in the first decade of this century when Pablo Picasso and his colleagues became interested in *l'art primitif* and *l'art nègre*. Those young artists discovered in black art a symbolic weapon to attack postromanticist aesthetics. The repercussions of what they accomplished are still not fully discernible. Since modernism's black antecedents were officially denied, especially during the racially troubled 1920s and 1930s, only now have we begun to comprehend Virgil Thomson's assertion that "Africa has made profound alterations in our European inheritance."[2] Only recently have scholars begun to evaluate the artistic and social implications of Alain Locke's observation that "in being modernistic, they are indirectly being African."

Excerpt from *Primitivist Modernism: Black Culture and the Origins of Transatlantic Modernism* (1998), 144–50. © 1998 by Sieglinde Lemke. Used by permission of Oxford University Press, Inc.

Sieglinde Lemke (b. 1963) is a professor at the John F. Kennedy Institute for North American Studies at the Free University of Berlin.

One consequence of our discussion of the cross-cultural interplay at the core of modernism is that we need to reconfigure our critical map to include what we have called primitivist modernism. It is finally time for the role that the primitive has played to come front and center and take its place in the accepted ranks of contributors to modernism's innovation. Critics and historians of modernism have long held that the movement developed along a number of aesthetic lines or trends. One is the highly experimental, iconoclastic avant-gardism that implicitly followed Ezra Pound's dictum to "make it new." This course, which is primarily concerned with formalistic innovation, encompasses diverse trends in painting, such as futurism or dadaism, and poetry by Pound or Stevens.

A second trend is to minimalism, the Bauhaus ethos that "less is more." This includes, for example, abstraction and precision in the visual arts but also literary techniques such as those used by Ernest Hemingway or Gertrude Stein.

A third trend is a realist aesthetic. This includes portrait paintings or social realist works in the visual arts. In literature, it manifests itself as an attempt to convey moral messages, as a psychological realism that deals with personal conflicts, or an ethnic literature that attempts to represent the life of immigrants "accurately." Moreover, it includes a politicized aesthetic that criticizes bourgeois attitudes, speaks on behalf of the proletariat, and envisions the liberation of the working class.

The ignored fourth trend, namely that of a primitivist modernist aesthetic, is composed of art works in which formal and cultural difference are interrelated. While this investigation has focused on the influx of African or African American expressions, one could also posit a study that accounted for the influence of, say, Japanese culture on the shaping of modern art. It is crucial, however, that this influence manifest itself not in terms of subject matter but rather in a fusion of forms. This trend in modernism, in which cultural difference is incorporated formally, is a harbinger of an increasingly integrated multiculturalism in the arts. While art historians (particularly scholars of cubism) might agree with this four-part model, this reconfiguration, which accounts for the seminal role black expressions have played, is certainly not commonly accepted in other art forms.

What, ultimately, will have been the effect of the African artistic influx? One way of getting at this question is to think of how this "cross-over" aesthetic distinguishes modernism from its artistic predecessors. In premodern art, say in *Jugendstil* or *art nouveau,* the European classicist tradition dominated. When a black element was introduced, as in Manet's *Olympia*, it remained marginalized literally and thematically—as the black maid in *Olympia* is shunted to the periphery. If nonwhites played a role in premodern works of art, they were only significant as objects of representation, or misrepresentation.

In modernist works, by contrast, there emerged a new way of dealing with black elements: in some, black elements were formalistically constitutive; in others, they were thematically integrated. In modernism's early phase, the Africanist

presence asserted itself to the world. In modernism's more advanced phases, however, the traces of the black African catalyst were, consciously or unconsciously, effaced. While Picasso moved on to create an increasingly abstract art in the 1930s, Josephine Baker downplayed the Africanist elements in her stage performances and transformed her primitivist stage persona into that of a glamorous and dignified modern diva.

Meanwhile, cross-over aesthetics in America existed only as popular culture—as black performers playing in front of white audiences. On the level of high art, there was no equivalent in America to *Les Demoiselles* or the *revue nègre*. The American public was appalled when European modernist art was imported to New York and exhibited in the Armory Show. This collective rejection of modernism was paralleled by a national disapproval of Baker's performance in the Ziegfeld Follies in 1936. While it is a well-known fact that the American public was hesitant to accept formal artistic innovations, it is not commonly discussed that this rejection was related to an unwillingness to accept African or African American cultures and the people who made it. . . .

Concomitant with the white appropriation of black art was a move by blacks to reappropriate European primitivist modernism. Black intellectuals and artists of the New Negro movement relied on artistic and ideological impulses derived from European cultures. The Harlem Renaissance is highly indebted to its cultural other. Since some European avant-garde artists tried to keep the Negro element incognito, it is not surprising that Alain Locke urgently sought to unveil this role and use it as a starting point to construct a New Negro and, in the process, a "New White" as well.

If black primitivist modernism generated Locke's New Negro movement, primitivism was also a starting point for Du Bois and helped him to initiate a Pan-African movement. If Locke and Du Bois had not appropriated and modified Euro-American primitivism, black modernism and Negritude (the ideology of the liberation movement of postcolonial Africa) could not have assumed the forms they did. Although Europe's valorization of Africa was generated by dubious motives, it had a fermenting effect on African cultures. This was a crucial step toward a process in which the "primitive" would gain cultural autonomy. . . .

Between 1906 and 1938, this cross-cultural dynamic of interracial collaboration, borrowing, reappropriation, and outright parody influenced the making of European and American modernism. As a consequence, the fixed binary oppositions, which had been apparently absolute and noncontingent until the nineteenth century, started to merge or dissolve in the curious dynamism of race in European and, to a lesser degree, American art and cultural history. What had been thought of in the West as unalterable opposites began to drift into one another. The color line became more permeable, even if only symbolically or at the level of popular culture. The socioeconomic inequality between African

Americans and Anglo-Americans persisted, of course; Jim Crow reality was affected by this process only slightly, if at all. Even in Cunard's socialist discourse, the primitive was still essentialized as the sensual authentic, utilized primarily as a means of ideological critique. But in spite of these structures, a dynamic interplay undermined racial divisions between black and white cultures. This cultural mixing was, by and large, a critique of binary divisions that was neither complete nor conscious but had wide-ranging effects.

In this cross-cultural interplay, we might find the seed of a method to reconsider black modernism and postmodernism. Thomas Docherty has called the exigency of postmodernism "the demand for a just relating to alterity, and for a cognition of the event of heterogeneity." According to Docherty, we are faced with two choices: "the search for a just politics, or the search for just politics."[3] To him, there is only one option: we need to find an ethical basis for an ethical demand, and therein lies "the real political burden and trajectory of the postmodern."

This investigation did not set out to discover grounds for "a just politics." But in disclosing a cross-cultural dialectic in which the socially marginalized have contributed to shaping the center of modernism, we may have taken a step toward interrelating race, modernism, and ethics. Of course, the acceptance of "the primitive" was not ethically motivated—it was at best ethnocentric, and at worst racist—and it had very little to do with a genuine concern for people of African descent or for their art. But given the social context (a racist definition of civilization that had assumed an absolute opposition between African and European cultures), cross-over aesthetics proved revolutionary in undermining this essentialist presupposition.

My assessment of primitivism differs from that of Hal Foster, who feels that primitivism is "a metonym of imperialism, which served to disavow these [imperialist] preconditions."[4] While imperialism, economic exploitation, and political oppression are responsible for primitive art's making its way to Europe in the first place, the fact that European artists used African art as a source of inspiration can hardly be dismissed as mere cultural imperialism. Foster's precondition for dismissing primitivism as an "unjust politics" is based on his equating economic and artistic practices. But equating colonizers and artists is inadequate. It was only in the sphere of the arts that a dialectical process could safely germinate. Instead of dismissing primitivism as racism, it is more instructive to consider its potential in subverting the antagonism between the races. Primitivist modernism opened a space comparable to what Homi K. Bhabha called the third space of enunciation, an ambiguous space that undermined the opposition that the colonialist enterprise was predicated upon.

On the other hand, the overly enthusiastic response to primitivism that celebrates the European appreciation of "primitive expressiveness" (as William Rubin did when he exalted: "We [Westerners] respond to them [African art

objects] with our total humanity.") is equally inept. To discover in primitivism evidence of a "universal" or "trans-historical essence" is to disavow important cultural differences. Moreover, Rubin downplays the contributions black cultures have made to shaping transatlantic modernism—and it is this that is most crucial about primitivist modernism. . . .

Ten years ago, Daniel J. Singal asserted in "Towards a Definition of American Modernism" that a "modernist embrace of natural instinct and primitivism" was the key to understanding modernism. I have focused on the formalistic "embrace" of the other of color. Given the significance of this cross-cultural embrace, one wonders if the very term "the other"—a term so fashionable in contemporary debates on multiculturalism and postmodernism—is even helpful. In fact, what we have seen is that the term quickly becomes obsolete as the "other" and the "self" are thoroughly interwoven. On the symbolic level at least, white and black cultures have been intertwined; they are mutually constitutive.

If cultural hybridity is at the core of early modernism, we might start to speculate on the effects this could have on late postmodernism. Maybe black expressions will once again yield new (white) art forms. Or perhaps the knowledge of cultural hybridity within modernism will function as a harbinger for an integrated multiculturalism in American society. Or maybe postcolonial studies will continue to explore incidents that transcend binary logic. Maybe we will come to the understanding that hybridity can not be limited to colonized cultures, that it is constitutive of white cultures as well. Even the most cursory glance at pop culture attests that this fascination with the cultural other continues America's dialectical dance of avowal and disavowal, even as it heads into the twenty-first century.

NOTES

1. Françoise Lionnet, *Autobiographical Voices: Race, Gender, Self-Portraiture* (Ithaca: Cornell University, 1989).

2. Virgil Thomson, "The Future of American Music," *Vanity Fair* (September 1925): 62.

3. Thomas Docherty, introduction to *Postmodernism: A Reader* (London: Harvester Wheatsheaf, 1993), pp. 26, 27.

4. Hal Foster, "The 'Primitive' Unconscious of Modern Art," *October* 34 (1985): p. 47.

CODA: QUOTATIONS FROM ARTISTS AND WRITERS

JEAN-JACQUES ROUSSEAU, 1755

The savage and the civilised man differ so much in the bottom of their hearts and in their inclinations, that what constitutes the supreme happiness of one would reduce the other to despair. The former breathes only peace and liberty; he desires only to live and be free from labour; even the *ataraxia* of the Stoic falls far short of his profound indifference to every other object. Civilised man, on the other hand, is always moving, sweating, toiling and racking his brains to find still more laborious occupations. . . . In reality, the source of all these differences is, that the savage lives within himself, while social man lives constantly outside himself, and only knows how to live in the opinion of others.

EUGÈNE DELACROIX, 1832

We notice a thousand things which are lacking with these people [Moroccans]. Their ignorance produces their calm and their happiness; but we ourselves, are we at the summit of what a more advanced civilization can produce?

They are closer to nature in a thousand ways: their dress, the form of their shoes. And so beauty has a share in everything they make. As for us, in our corsets, our tight shoes, our ridiculous pinching clothes, we are pitiful. The graces exact vengeance for our knowledge.

CHARLES BAUDELAIRE, 1846

The origin of sculpture is lost in the mists of time; thus it is a *Carib* art. We find, in fact, that all races bring real skill to the carving of fetishes long before they embark upon the art of painting, which is an art involving profound thought and one whose very enjoyment demands a particular initiation.

GUSTAVE COURBET, 1850

In our oh-so-civilized society it is necessary for me to lead the life of a savage; I must free myself even from governments.

EUGÈNE DELACROIX, 1855

I am becoming more and more captivated by the *naive painters [naïfs]*. . . . I feel that by studying these models of a period that was generally supposed to be barbarous, most especially by myself, and finding that they are full of the qualities that mark great works of art, I am striking off the last of the chains that bound me and confirming my idea that the *beautiful* is everywhere, and that each man not only sees it in his own way but is absolutely bound to render it in his own manner.

Sources for the quotations in the Coda begin on page 436.

JOHN RUSKIN, 1857

Pure and precious art exists [in Europe] . . . there is none in America, none in Asia, none in Africa.

OWEN JONES, 1868

If we would return to a more healthy condition, we must even be as little children or as savages.

PAUL GAUGUIN, 1889

You will always find nourishing milk in the primitive arts, but I doubt if you will find it in the arts of ripe civilizations.

PAUL GAUGUIN, 1895

I felt your revulsion: a clash between your civilization and my barbarism. . . . A civilization from which you are suffering: a barbarism which spells rejuvenation for me.

PAUL KLEE, 1902

I want to be as though newborn, knowing nothing absolutely about Europe; ignoring poets and fashions, to be almost primitive.

MAURICE DENIS, 1904

The primitive prefers reality to the appearance of reality. He conforms to the image of things, the notion he has of them.

GUILLAUME APOLLINAIRE, c. 1908

The elementary laws that govern the existence of the world give away their role when an artist creates dangerously according to the serpentine formula: You are created in the image of God. For a long time, artists had no conscience of and no concern for their proper divinity. Today, the pride of men finally manifests itself. The painters (and the poets), after having consciously admitted their ignorance, took the reasonable decision to create. We are puzzled by the thought that this grave moral lesson was given to Europe by Africa and Oceania. Nothing is truer. The contemplation of the Negroes and the Kanaka gave birth to irregular creations, so passionate and so harmonious, which inspired many thoughtful reflections.

PAUL KLEE, 1909

Will and discipline are everything. Discipline as regards the work as a whole, will as regards its parts. . . .

If my works sometimes produce a primitive impression, this "primitiveness" is explained by my discipline, which consists in reducing everything to a few steps. It is no more than economy; that is, the ultimate professional awareness, which is to say, the opposite of real primitiveness.

SIGMUND FREUD, 1911

And I am of opinion that the time will soon be ripe for us to make an extension of a thesis which has long been asserted by psycho-analysts, and to com-

plete that which has hitherto had only an individual and ontogenetic application by the addition of its anthropological counterpart, which is to be conceived phylogenetically. "In dreams and in neuroses," so our thesis has run, "we come more upon the *child* and the peculiarities which characterize his modes of thought and his emotional life." "And we come upon the *savage* too," we may now add, "upon the *primitive* man, as he stands revealed to us in the light of the researches of archaeology and of ethnology."

WILHELM WORRINGER, 1911

This modern primitivism should not be a final goal. The pendulum never remains fixed at the broadest sweep. This primitivism should be seen much more as a means of passage, as a great long drawing of breath, before the new and decisive language of the future is pronounced.

SIGMUND FREUD, 1912

Neurotics are above all *inhibited* in their actions: with them the thought is a complete substitute for the deed. Primitive men, on the other hand, are *uninhibited:* thought passes directly into action. With them it is rather the deed that is substitute for the thought.

PAUL KLEE, 1912

Limiting myself to the idea, not to the momentary, accidental nature and the merely superficial appurtenance of a number of works, I should like to reassure people who found themselves unable to connect the offerings here with some favorite painting in the museums, were it even a Greco. For these are primitive beginnings in art, such as one usually finds in ethnographic collections or at home in one's nursery. Do not laugh, reader! Children also have artistic ability, and there is wisdom in their having it! The more helpless they are, the more instructive are the examples they furnish us; and they must be preserved free of corruption from an early age.

WASSILY KANDINSKY, 1912

Our souls, which are only now beginning to awaken after the long reign of materialism, harbor seeds of desperation, unbelief, lack of purpose. . . . This doubt, and the still-oppressive suffering caused by a materialistic philosophy create a sharp distinction between our souls and those of the "primitives." Our souls, when one succeeds in touching them, give out a hollow ring, like a beautiful vase discovered cracked in the depths of the earth. For this reason the movement toward the primitive, which we are experiencing at this moment, can only be, with its present borrowed forms, of short duration.

MAX BECKMANN, 1912

. . . this dependence on ancient primitive styles which in their own times grew organically out of a common religion and mystic awareness. [I find it] weak because Gauguin and the like weren't able to create types out of their own confused and fragmented times which could serve us in the way that the gods and heroes served the peoples of old. Matisse is an even sadder representative of this ethnography museum art—from the Asian department.

JACOB EPSTEIN ON AMEDEO MODIGLIANI'S STUDIO, 1912

His studio at that time [1912] was a miserable hole within a courtyard, and here he lived and worked. It was then filled with nine or ten of those long heads which were suggested by African masks, and one figure. They were carved in stone, at night he would place candles on the top of each one and the effect was that of a primitive temple.

GUILLAUME APOLLINAIRE, 1913

Finally, I must point out that the fourth dimension—this utopian expression should be analyzed and explained, so that nothing more than historical interest may be attached to it—has come to stand for the aspirations and premonitions of the many young artists who contemplate Egyptian, Negro, and Oceanic sculptures, meditate on various scientific works, and live in the anticipation of a sublime art.

VINCENC BENEŠ, 1913

The new artists enjoy all those arts of the past which are concerned with substantiality, movement, flatness, geometric synthesis of form; which nonoptically glance at nature not because of identity of feeling, but rather for the interest of formal connections. They are the arts of the whole Orient, Romanesque, Gothic, in part Baroque, all those that are naive, that is native arts and the arts of primitive nations, Negro, Mexican, etc.

OTTO GUTFREUND, 1913

In sculpture, Negro figurines are a type of elementary understanding of plasticity. The physical, substantial representation with its expressive potential is equally strong as oriental dance. Today's sculptor goes further, he himself substitutes volume with illusional volume—surface.

ALEKSANDR SHEVCHENKO, 1913

We are striving to seek new paths for our art, but we do not reject the old completely, and of its previous forms we recognize above all—the primitive, the magic fable of the old East.

The simple, unsophisticated beauty of the lubok, the severity of the primitive, the mechanical precision of construction, nobility of style, and good color brought together by the creative hand of the artist-ruler—that is our password and our slogan.

Life without movement is nothing—and therefore we always aspire not to enslave the forms of objects on one plane, but to impart their movement to them by means of the depiction of intermediate forms.

Beauty is only in the harmony of simple combinations of forms and colors. Recherché beauty is very close to the tawdry affectation of the market—the product of the mob's corrupted tastes.

MAX WEBER, c. 1913

Definition of modernism: An eclecticism peculiar to modern civilization produced this modern-art child which happened to be born in the city of Paris. Its

genealogy is Italian, Spanish, Oriental, primitive. . . . [Its] simplification of form is derived from African, Mexican, and other primitive sculpture.

UMBERTO BOCCIONI, 1913

Gauguin's journey to Tahiti, and the appearance of Central African fetishes in the ateliers of our Montmartre friends, are a historical inevitability in the destiny of the European sensibility, much like the invasion of a barbaric race into the organism of a people in decadence.

HENRI GAUDIER-BRZESKA, 1914

The modern sculptor, is a man who works with instinct as his inspiring force. His work is emotional. The shape of a leg, or the curve of an eyebrow, etc., etc., have to him no significance whatsoever; light voluptuous modeling is to him insipid—what he feels he does so intensely and his work is nothing more nor less than the abstraction of this intense feeling. . . . This sculpture . . . is continuing the tradition of the barbaric peoples of the earth (for whom we have sympathy and admiration).

TRISTAN TZARA, 1916

Soco Bgai Affahou/ zoumba zoumbai zoumbai zoum.

PABLO PICASSO, c. 1917

My greatest artistic emotions were aroused when the sublime beauty of the sculptures created by the anonymous artists of Africa was suddenly revealed to me. These works of religious art, which are both impassioned and rigorously logical, are the most powerful and the most beautiful of all the products of the human imagination.

I hasten to add, however, that I detest exoticism. I have never liked the art of China, Japan or Persia.

What I respond to in antique art, is the restraint that is synonymous with beauty, but I admit that the somewhat mechanical rhythm that destroys the proportions of all Greek works of art I have always found extremely unpleasant.

CARL GUSTAV JUNG, 1918

The unconscious, in so far as it is activated in any way by small amounts of energy, is projected upon certain more or less suitable objects. . . .

If it is inanimate objects that have the "magical" quality, often their mere statistical incidence is sufficient to prove that their significance is due to the projection of a mythological content from the collective unconscious. . . .

We find this phenomenon beautifully developed in primitive man. . . . Thus does primitive man dwell in his land and at the same time in the land of his unconscious. Everywhere his unconscious jumps out at him, alive and real. How different is our relationship to the land we dwell in! Feelings totally strange to us accompany the primitive at every step. Who knows what the cry of a bird means to him, or the sight of that old tree! A whole world of feeling is closed to us and is replaced by a pale aestheticism. Nevertheless, the world of primitive feeling is not entirely lost to us; it lives on in the unconscious. The further we

remove ourselves from it with our enlightenment and our rational superiority, the more it fades into the distance, but is made all the more potent by everything that falls into it, thrust out by our one-sided rationalism. This lost bit of nature seeks revenge and returns in faked, distorted form, for instance as a tango epidemic, as Futurism, Dadaism, and all the other crazes and crudities in which our age abounds.

CARLO CARRÀ, 1921

All of this so-called "Negrism" that has been introduced into painting in the last few years is of no aesthetic importance whatsoever. Like other idiotic aberrations of our times such as Dadaism, "Negrism" is a passing lie invented by snobs. "Negrism," like "Fauvism,"shows its origins to be literary, and like the earlier movement, it will inevitably last but a short time.

CARL EINSTEIN, 1921

With the inception of Cubism, we examined the African works of art and found perfect examples. From this standpoint, the highly valued arts of Yoruba-land and Benin have no decisive meaning for us when it comes to African art—despite their technical refinement. In order to form a judgment, one's attitude towards technical skillfulness and the assessment of their so-called vivid impressions are not sufficient. But the artists of those regions teach us that one must not look at African art according to predetermined formulas. People often talk about the differentiation of European culture and art. The fragmentary overview of African art is no less nuanced; it is not permissible to be led into some wrong and narrow attitude by the catchphrase, "the primitive art of primitive tribes." The fact that African art is differentiated is a sign of protracted formative processes whose origin and course are still unknown.

CONSTANTIN BRANCUSI, c. 1923

The African negro savages also preserved the life of matter in their sculpture. They worked with the wood. They did not wound it, they knew how to eliminate the unnecessary parts of it to make it become a fetish sculpture. And the African wood sculpture remains a living and expressive wood under a form given by a human feeling.

Christian primitives and negro savages proceeded only by faith and instinct. The modern artist proceeds by instinct guided by reason.

HENRY VARNUM POOR, 1926

The carvings and tools and pottery and things of the Greeks, Egyptians, Persians, Chinese—all peoples remote and romantic—are in our Metropolitan, and shown to the public as "Art." There is nothing of American Indian art. There is obviously some reasonableness in the omission since the American Museum of Natural History and the Museum of the American Indian do show so much American Indian work. Still it is a pity and something which should be changed. They go very well with meteorites and stuffed animals but they should also be shown as "Art." Whatever authority as such the Metropolitan Museum could give to these things they richly deserve and should have.

MAX JACOB, 1927

Cubism was born of negro sculpture.

ANDRÉ BRETON, 1928

But beyond this aspect of emotion for emotion's sake, let us not forget that for us, in this era, it is reality itself that is involved. How can anyone expect us to be satisfied with the fleeting sense of uneasiness that some particular work of art may bring us? There is not a single work of art that can hold its own before what one can only call, in this sense, our integral *primitivism*. When I know what will be the outcome of the terrible struggle within me between actual experience and possible experience, when I have finally lost all hope of enlarging to huge proportions the hitherto strictly limited field of action of the campaigns I have initiated, when my imagination recoils upon itself and serves only to coincide with my memory, then I will willingly imitate the others and grant myself a few relative satisfactions. I shall then join the ranks of the embroiderers. I shall have forgiven them. But not before!

ADOLPHE BASLER AND CHARLES KUNSTLER, 1929

If the plastic sense of the art of savages is accessible to us, we remain refractory to their spirit of simplification, to their exaggerated or abbreviated sense of proportion, to the rhythm of their monstrous deformations, which can be understood only within the context of the hallucinating visions of African or Oceanian peoples. "We have never ourselves believed," as we have written elsewhere, "that an art which is the expression of savage animism could support the speculations that have emanated from certain hypercivilized brains among our contemporaries. But in any case it was absolutely inevitable that the studies of ethnographers of Africa and Oceania, and that the research amassed by them, would be a much-needed tonic for an art which had doubtless become anemic." For the artistic activity of the savage relates rather to techniques of magic from which, "through the hysterical frenzy of its ritual there erupt tormented forms in an onslaught that is at once teratological and decorative." This is not visual realism but instead a symbolic conception of a reality that is less optical than tactile. Conventional forms, with the primitives, are not genetic ones, as all artists since Gauguin have imagined them to be. But they contain an original truth which is the soul of all religious art, and so of the magical symbolism of the Africans or Oceanians. No exasperated aestheticism, no intentional naïveté can simulate this state of mind. The barbarous cubism and rudimentary geometry of the Africans or the Papuans emerge from mythical reveries, as missing in Gauguin as they are in Picasso.

JACOB EPSTEIN, 1929–1931

I am influenced by African sculpture in the same manner that all primitive work must influence the artist. African work has certain important lessons to teach that go to the root of all sculpture. I have tried to absorb those lessons without working in the African idiom. It would indeed be absurd for a European artist in these days to produce African idols, and like all imitation it would be insincere.

TRISTAN TZARA, 1929

Nowhere else did man's pride carry him to more crystalline heights than on these spots of ground, these archipelagos named in the ink of luxuriating multitudes: *Melanesia* and *Polynesia*. . . . A logical function of a superior order rules the Oceanian world. In search of this we spend the clearest product of our nights. Through what sumptuous arrangement of unknown laws, what ferocious cerebral mimetics, can a mysterious Masonry of the mind succeed in ascending to such glorious entanglements from so little substance? No one has as yet understood the implications of such an expansiveness.

PIET MONDRIAN, 1931

The phenomenon that art was at first not only closely bound to subject matter, but arose from it, is explained by observing that man by his very nature has an instinctive need not only to create but to establish, to describe, to explain, to express what he sees, feels, and thinks. He wants to create, but his conception of reality remains primitive and too closely tied to his natural instinct. Nevertheless, where intuition is still pure, true art can arise—but in a primitive way—for purely plastic expression is preponderant in the work. We find this in the art of "savages" and of children. The same phenomenon occurs when a superior force influences a more or less primitive period: kings, saints, and initiates have elevated the intuition of peoples. Egyptian, Greek, and primitive art show numerous examples of this.

ARTHUR MILLIER, 1935

Last Tuesday evening a gentleman of African lineage demonstrated his skill in one of the oldest and most difficult of arts. Today I respectfully submit the proposition that the ancestors of Joe Louis brought the equally difficult art of wood sculpture to at least an equally high state of development. There is nothing difficult about the appreciation of African Negro sculpture today. Since the Renaissance Western man, bowing to philosophy and science, valued the non-religious arts of Greece and Rome above all others. Even in the eighteenth century Gothic art and architecture were still considered barbarous. Had Negro sculpture been known before our time it would have been considered beyond the pale of art. Today our best sculptors treasure examples of it, not because it is a highly developed art in the Western mode of elaborate counterpoint, but because no sculpture anywhere excels the best Negro carving in the fundamentals of that medium.

WILLIAM H. JOHNSON, c. 1935

I feel myself both a primitive man and a cultured painter.

JOAN MIRÓ, 1936

Each grain of dust possesses a marvelous soul. But to understand this it is necessary to rediscover the religious and magic sense of things—that of primitive peoples.

MEYER SCHAPIRO, 1936

The differences between the cultures of primitive and civilized peoples today

are more adequately explained by differences in natural environment, by historical circumstances, by the effects of favorable and limiting conditions. Psychological tests have revealed no significant inherited inferiority of the so-called backward peoples.

JOHN GRAHAM, 1936

African art is by no means a primitive art, in the sense that a peasant art (whether ancient or contemporary) is a primitive art. It is an art that, like Egyptian, Greek, Chinese, and Gothic art, it has taken thousands of years of fastidious civilization to evolve and set. It is, furthermore, an art resulting from a highly developed aesthetic viewpoint; from logical "argumentation" and consummate craftsmanship. "Primitive" art, on the contrary, is any art that derives—whatever the date of its creation—from a low state of civilization; an art making its first faulty and undetermined steps toward the formulation, by its artists, of an aesthetic viewpoint.

An art that has finally formulated and realized its plastic aspirations, an art, in short, that is definitely poised, is a classical art. The art of Africa is classic, in the same sense that the Egyptian, Greek, Chinese and Gothic arts are classic.

The art of Africa has served as a liberator for sculptors and painters. It has shown them that, in the plastic arts, proportions can be rearranged, so long as the aesthetic impulse involved in their rearrangement is inspired and noble. African sculptures have unshackled the modern artist from the tyranny of the camera—the slavery of the seven-heads-to-the-figure rule. Without that liberation, Picasso, Matisse, Braque, Modigliani, Brancusi, Epstein and other modern masters would not have reached their goals.

CHRISTIAN ZERVOS, 1936

The races that are considered inferior have taught us that in combining instinct with reason one's art acquires more power. This is why we have attempted to establish lines of communication between the people of today and all those dreamers who have been marginalized until now, so as to become acquainted with the resources of instinct before reason was imposed on art, as well as to the extent to which it has been possible to preserve the authenticity of their plastic values.

How can we in good faith deny that we owe to the sculptors of Black Africa and Polynesia, those late outgrowths of the forces of the past, our insight into the earliest stages of humanity, about which we knew so little? Since we have understood this secret we have developed a taste for instinct. When the profane call primitive works caricaturing idols, when they level scornful criticism at the artistic creativity of our time, this is because they have become so myopic that they no longer see that our supposed violation of hallowed canons, as well as the "deformations" of the primitives, come directly from the conditions of instinct.

ARISTIDE MAILLOL, 1937

You have to be synthetic. When we were young we were naturally so, as were the Negro sculptures which reduced 20 forms into one.

But it is necessary to be modern, to adapt oneself to one's time. Gauguin was wrong to imitate Negro sculpture. He should have sculpted as he painted, keeping to nature, instead of making women with big heads and tiny legs. He had two ideas, one in painting and one in sculpture; he was thus an *homme double*. . . .

Negro art contains more ideas than Greek art. What is astonishing in it is the strange invention of objects, an imaginative side and an extraordinary decorative sense, difficult to explain. We don't know how to take these liberties that the Negroes have succeeded in taking. We are too subservient to the past. Those among us who do Negro art are making a mistake.

JACOB EPSTEIN, 1940

My sculpture (apart from a short period, in 1912–1913 when cubism was in the air, and abstraction an interesting experiment) has remained in the European tradition of my early training. Most advanced painters and sculptors have been influenced by primitive work. This includes Matisse, Gauguin, Picasso, Modigliani, Brancusi, Henry Moore, Lipchitz, and many lesser artists. When I say that my work is not African, I do not rebut what I would be ashamed to admit, but simply state a fact. Brancusi, some of whose early work was influenced by African art, now declares categorically that one must not be influenced by African art, and he even went so far as to destroy work of his that he thought had African influence in it.

ANDRÉ BRETON, 1941

The long nostalgia of poets, from the nineteenth century onwards, and the more concrete and insistent flattery of the painters of the twentieth century could not fail, eventually, to seduce the soul of Africa—the Africa that Baudelaire called "superb"—into responding. It is nearly forty years now since the great Guinean goddess of Fecundity could first be admired in Paris, at the Musée de l'Homme, taking its rightful place in art alongside figures which are accepted as expressing ideally the genius of other peoples and other ages. In the wake of this statue, the modern eye has gradually taken in the endless variety of those objects of so-called "savage" origin and their sumptuous display on the lyrical plane, and aware, at last, of the incomparable resources of the primitive vision, has fallen so in love with this vision that it would wish to achieve the impossible and wed it.

WOLFGANG PAALEN, 1941

Until today the waves of cultural change have found their orientation only intuitively; thus Occidental art by turns went through a certain osmosis with Asia, Africa, and Oceania; now it has become possible to understand why a universal osmosis is necessary, why this is the moment to integrate the enormous treasure of Amerindian forms into the consciousness of modern art. This integration would be the negation of all exoticism. For it presupposes an understanding that abolishes the frontiers which are unfortunately still emphasized by the quest for the picturesquely local, and preserved through intellectual provincialism. Such an effort at integration prefigures nothing less than a vision that today only the most audacious dare to entertain: the abolition of the

barriers that separate man from his own best faculties, the abolition of the interior frontiers without which no exterior frontier can be definitively abolished. To a science already universal but by definition incapable of doing justice to our emotional needs, there must be added as its complement, a universal art: these two will help in the shaping of the new, the indispensable world-consciousness.

ANDRÉ BRETON (ATTRIBUTED), 1942

Surrealism is only trying to rejoin the most durable traditions of mankind. Among the primitive peoples art always goes beyond what is conventionally and arbitrarily called the "real." The natives of the Northwest Pacific coast, the Pueblos, New Guinea, New Ireland, the Marquesas, among others, have made objects which Surrealists particularly appreciate.

ADOLPH GOTTLIEB AND MARK ROTHKO (WITH THE ASSISTANCE OF BARNETT NEWMAN), 1943

It is a widely accepted notion among painters that it does not matter what one paints as long as it is well painted. This is the essence of academicism. There is no such thing as good painting about nothing. We assert that the subject is crucial and only that subject matter is *valid which is tragic and timeless.* That is why we profess spiritual kinship with primitive and archaic art.

JACKSON POLLOCK, 1944

I have always been very impressed with the plastic qualities of American Indian art. The Indians have the true painter's approach in their capacity to get hold of appropriate images, and in their understanding of what constitutes painterly subject matter. Their color is essentially Western, their vision has the basic universality of all real art. Some people find references to American Indian art and calligraphy in parts of my pictures. That wasn't intentional; probably was the result of early memories and enthusiasms.

PABLO PICASSO, c. 1946

What annoys me even more is the fact that because I'm uninhibited and live that way, everybody thinks I don't like refined things. When I became interested, forty years ago, in Negro art and I made what they refer to as the Negro Period in my painting, it was because at that time, I was against what was called beauty in the museums. At that time, for most people a Negro mask was an ethnographic object. When I went for the first time, at Derain's urging, to the Trocadéro museum, the smell of dampness and rot there stuck in my throat. It depressed me so much I wanted to get out fast, but I stayed and studied. Men had made those masks and other objects for a sacred purpose, a magic purpose, as a kind of mediation between themselves and the unknown hostile forces that surrounded them, in order to overcome their fear and horror by giving it a form and an image. At that moment I realized that this was what painting was all about. Painting isn't an aesthetic operation; it's a form of magic designed as a mediator between this strange, hostile world and us, a way of seizing the power by giving form to our terrors as well as our desires. When I came to that realization, I knew I had found my way.

MARK ROTHKO, 1946

It is significant that [Clyfford] Still, working out West and alone, has arrived at pictorial conclusions so allied to those of the small band of Myth Makers who have emerged here during the war. The fact that his is a completely new facet of this idea, using unprecedented forms and completely personal methods, attests further to the vitality of this movement. Bypassing the current preoccupation with genre and the nuances of formal arrangements, Still expresses the tragic-religious drama which is generic to all Myths at all times, no matter where they occur. He is creating new counterparts to replace the old mythological hybrids who have lost their pertinence in the intervening centuries. For me, Still's pictorial dramas are an extension of the Greek Persephone Myth. As he himself has expressed it, his paintings are "of the Earth, the Damned and of the Recreated."

ANDRÉ BRETON, 1946

The European artist of the twentieth century can ward off the drying up of the sources of inspiration swept away by rationalism only by recalling the primitive vision, which synthesizes sensory perception and mental representation.

MAX PECHSTEIN, 1946

Wooden houses with tall, pointed gables house the natives. On these houses I now saw in the flesh, in their everyday use for which they were made, the carved and painted beams which first inspired me in Dresden and filled me with the desire to visit them in their original setting.

I see the carved idols, in which trembling piety and awe before the uncontrollable forces of nature have marked their way of seeing, their fear and their subjection to unavoidable fate.

JACKSON POLLOCK, 1947

My painting does not come from the easel. I hardly ever stretch my canvas before painting. I prefer to tack the unstretched canvas to the hard wall or the floor. I need the resistance of a hard surface. On the floor I am more at ease. I feel nearer, more a part of the painting, since this way I can walk around it, work from the four sides and literally be in the painting. This is akin to the method of the Indian sand painters of the West.

BARNETT NEWMAN, 1948

The artist today has more feeling and consequently more understanding for a Marquesas Islands fetish than for the Greek figure. This is a curious paradox when we consider that we, as the products of Western European culture, have been brought up within the framework of Greek aesthetic standards—the tradition of the Greek style—and have had no intimate contact with the primitive way of life. All we concretely know of the primitive life are its art objects. Its culture patterns are not normally experienced, certainly not easily. Yet these art objects excite us, and we feel a bond of understanding with the primitive artist's intentions, problems, and sensibility, whereas the Grecian form is so foreign to our present aesthetic interests that it has virtually no inspirational use.

One might say that it has lost its culture factor. Minoan sculpture still has some interest, but only because the overtones of its archaic resemblances, in contrast to the elegance of the Olympian style, remind us of the primitive objects we admire.

ROBERTO MATTA, 1948

The validity of Max Ernst's procedures is supported by the fact that the mind works the same way in dreams. Certainly the mind works this way in primitive cultures. I am sure that a man could die in fire without *feeling* burnt. From the viewpoint of rational history this is unintelligible; to men in primitive societies it is self-evident. In this sense Max Ernst is a primitive man, even if he doesn't live in a primitive society. But what an affinity he feels, for instance, with the Katchina images from Arizona!

WIFREDO LAM, 1948

[In reference to a Baule mask in his collection:] You see—I have spontaneously re-covered these forms! They have revived in me like an ancestral reminiscence!

GEORGES BRAQUE, 1949

After Marseille what you need is the Congo.

ANDRÉ LHOTE, 1950

Not so long ago, it would have seemed profane to establish a parallel between a carved wooden negro mask—that horror!—and a sixteenth-century face, an accepted example of classical beauty. And yet we have only to overcome habit and sentimentality and concentrate our interest on the spirit and profound implications of the plastic phenomenon itself, and the scandal vanishes.

HENRY MOORE, 1951

Looking at these sculptures, for example those from the Chamba, Ashani and Okuni tribes of Northern Nigeria, I think that even where a traditional form is followed fairly closely, there are many subtle touches which a poor artist would have missed. All these pieces have been selected for their quality, and practically every one of them has the "flicker" of originality. Of course, it is difficult often to say whether the artist merely recognised these touches and copied them or whether he thought of them himself—but the Chamba figure seems to me to have been conceived by an individual, and I should think that it has a special rhythm and set of proportions, and a unique expression in the head, for example, not to be found in any other Chamba figure.

MAX WEBER, 1951

Matisse was very proud of his small but very choice collection of African Negro sculpture, and this was before Negro sculpture overwhelmed, if not conquered, the art of the continent. He would take a figurine in his hands, and point out to us the authentic and instinctive sculpturesque qualities, such as the marvelous workmanship, the unique sense of proportion, the supple palpitating fullness of form and equilibrium in them.

427

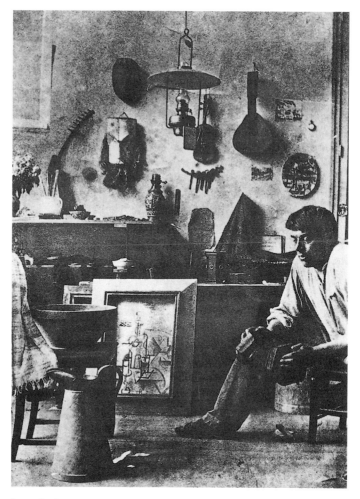

Figure 40. Georges Braque in his studio, Paris, 1911.

DAVID SMITH, 1954

Actually the artist by his working reference to art of the past is often the discoverer of new value, in historically unimportant epochs, and the first to pick out the art value in work which was previously viewed as ethnographic only.

The artist sees a wholly different set of masterpieces than those the art historians have chosen to acclaim. He first sees the forms of the Venus of Willendorf before those of Melos. He sees the structures of Braccelli before the ripples of Michelangelo. A Cameroon head, a sepik mask before a Mona Lisa. Using his visual art references he will go to an earlier and perhaps neglected period and pick out an approach that is sympathetic to his own time.

GEORGES BRAQUE, 1954

The African masks opened a new horizon to me. They made it possible for me to make contact with instinctive things, with uninhibited feeling that went against the fake tradition [late Western illusionism] which I hated.

JEAN (HANS) ARP, 1955

I think Oceanic art is a stronger influence on our modern art now than African art. . . .

Instead of cutting the paper [in collages], I tore it up with my hands, I made use of objects I found on the beach, and I composed natural collages and reliefs.

I thus acted like the Oceanians, who never worry about the permanence of their materials when making masks, and use perishable materials like shells, blood, and feathers.

JACQUES LIPCHITZ, 1960

I was not exactly looking for a direct influence or a source of inspiration, but only to enlighten and enrich my creative spirit. . . .

You will find at this exhibition, among other sculptures, a wooden painted Dahomey cup which I bought fifty-one years ago [1909]. I was sure it was Egyptian. It was only a year and a half later, while visiting the Trocadéro Museum, that I learned that it was negro. And so, by myself I discovered negro art, of which I soon became very fond.

ALBERTO GIACOMETTI, 1963

African or Oceanian sculpture, where they make great flat heads, is much closer to the *vision* one really has of the world than Graeco-Roman sculpture.

JOSEPH BEUYS, c. 1960s

Make this form of ancient behaviour as the idea of transformation through concrete processes of life, nature and history. My intention is obviously not to return to such earlier cultures but to stress the idea of transformation and of substance. That is precisely what the shaman does in order to bring about change and development: his nature is therapeutic. . . .

So when I appear as a kind of shamanistic figure, or allude to it, I do it to stress my belief in other priorities and the need to come up with a completely different plan for working with substances. For instance, in places like universities, where everyone speaks so rationally, it is necessary for a kind of enchanter to appear.

E. H. GOMBRICH, 1966

Negroes in Africa are sometimes as vague as little children about what is a picture and what is real . . . they even believe that certain animals are related to them in some fairy-tale manner . . . [they] live in a kind of dream-world. . . . It is very much as if children played at pirates or detectives till they no longer knew where play-acting ended and reality began. But with children there is always the grown-up world about them, the people who tell them "Don't be so noisy," or "It is nearly bed-time." For the savage there is no such other world to spoil the illusion. . . . If most works of these civilizations look weird and unnatural to us, the reason lies probably in the ideas they are meant to convey.

JEAN MESSAGIER, 1967

Possession or contact with a primitive object is not a luxury for the artist but a necessity.

429

It brings to him all the intensity of an absolute, savage life, it confirms his effort. It reassures him by disturbing him. The primitive object protects the artist against all kinds of academicism. It is a constant call to order and to disorder. . . . The artist doesn't choose a primitive object, he receives it.

JACQUES LIPCHITZ, 1968–1970

Although I had been collecting African sculpture (whenever I had any money) ever since I first came to Paris [1909], there are few of my works in which I feel a definite influence from Negro art.

ROBERT SMITHSON, 1969–1970

I would recommend that you read *The Savage Mind*. . . . It's a difficult book. This is probably the most difficult area, this whole idea of primal consciousness, primitive consciousness. This is really what I'm interested in. I'm not interested in what Lévi-Strauss would call the hot cultures, with their mechanistic and electronic technologies which he calls hot. It's the cool kind of cold tribal technologies where there is a sort of understanding, consciousness.

HALE A. WOODRUFF, c. 1972

You can't imagine the effect that book [*Afrikanische Plastik* by Carl Einstein] had on me. Part of the effect was due to the fact that as a black artist I felt very much alone there in Indianapolis. I had heard of Tanner, but I had never heard of the significance of the impact of African art. Yet here it was! And all written up in German, a language I didn't understand! Yet published with beautiful photographs and treated with great seriousness and respect! Plainly sculptures of black people, my people, they were considered very beautiful by these German art experts! The whole idea that this could be so was like an explosion. It was a real turning point for me. I was just astonished at this enormous discovery.

ANA MENDIETA, 1973

It was during my childhood in Cuba when, for the first time, I was fascinated by primitive cultures and arts. It seems that these cultures were endowed with an internal knowledge—a closeness to natural sources. This feeling of the magical, the knowledge and power which are found in primitive art have influenced my personal attitude towards artistic creation.

WIFREDO LAM, c. 1973

What I saw on my return, was like some sort of hell. For me, trafficking in the dignity of a people is just that: hell. To escape from this hell and to fight it, he had to admit its existence, to denounce it. For the painter every image now became an exorcism—a weapon for everybody. Here we can see how closely his determination to fight those who were destroying his people's dignity resembles that of Aimé Césaire, the poet of *Armes miraculeuses*. As I mentioned earlier, they followed similar courses of action.

Poetry in Cuba then, was either political and committed, like that of Nicolás Guillén and a few others, or else written for the tourists. The latter I rejected,

for it had nothing to do with an exploited people, with a society that crushed and humiliated its slaves. No, I decided that my painting would never be the equivalent of that pseudo-Cuban music for nightclubs. I refused to paint cha-cha-cha. I wanted with all my heart to paint the drama of my country, but by thoroughly expressing the negro spirit, the beauty of the plastic art of the blacks. In this way I could act as a Trojan horse that would spew forth hallucinating figures with the power to surprise, to disturb the dreams of the exploiters. I knew I was running the risk of not being understood either by the man in the street or by the others. But a true picture has the power to set the imagination to work, even if it takes time.

ANDRÉ MALRAUX, 1974

Primitive sculptures were once banned from the museum; now they enter it. Not only because they are the sculptures of half the earth, and of much more than half of time, but also because beyond the frontier figures of Sumer and Mexico, this crucial and ageless art, so strangely relevant to our own, is the art of our next investigation: the night side of man.

LOIS MAILOU JONES, 1977

I made a study of the African masks while in Paris in that year of 1937, walking down Boulevard Raspail and seeing an exhibition in one of the galleries of very unusual masks and fetishes, made sketches of them and went back to the studio and created the painting. I carried it down to the Académie Julian and the professors seemed surprised and remarked that "this doesn't look like a Lois Jones painting, how did you happen to do this." I mentioned that certainly after Picasso had made such fame in using the African influence in his works as well as so many of the French artists, Modigliani and Matisse and Brancusi, that certainly Lois Jones, if anyone, should have the right to use it.

JIMMIE DURHAM, 1986

There is a mistaken idea that our traditional art is religious, that art objects were made for "magical" purposes. The mistake comes from the European way of seeing. We do not have religions in the European sense; we do not have words in our own languages for "religion," "to worship," or "to pray." What is called our "religion" is much more practical and down-to-earth, less removed from life by hierarchy, and not officially controlled by institutions. Mostly, our "gods" are *real:* animals, the sun and the moon, the elements. It is a "religious" system whose practice is to allow us complex participation in the life of the earth. We need to be in conversation with everything, to dance serious dances with everything. So it is a system that attempts to break down separations, and therefore is an integral part of all other systems and activities. European culture has evolved into one of separations, of classifications and of hierarchies. I do not mean to imply that one culture is totally positive and the other totally negative, just that they are truly different. With that remarkable difference we find ourselves invaded by European culture. That directly involves artistic work with political work: two necessities that are inextricably bound to each other.

ROMARE BEARDEN, 1987

My interest in African art goes back to a show at the Museum of Modern art in the 1930's, when I was a young boy. . . .

When I began to study certain things, I began to look—in my own work—at African sculpture. But that was much later. A lot of magazines—even black magazines—wouldn't print this art. It seems people had the idea that this was something that was primitive or belonged to magic and things that people might want to forget. If it wasn't Titian or Ingres or classical Renaissance, people had no interest. And then came African sculpture, and it was looked upon as curios, ethnological things to study, not art.

I had to search out African art on my own to understand it. I didn't know how to go about looking at that time, or just how to incorporate it. And also—let us say if you look at a Titian or an El Greco, just two names that come first—the mythology of what they are talking about, or their intent, the religion, was right there: a virgin holding a baby—motherhood; or Rembrandt, the woman by the well or religious things that he did. But this African art was something that I wanted to look at and see what the philosophy was, discover what were some of the ideas that emanated from this work. I wanted to try and understand the African vision of the world—because there are so many varying African forms: some might be rather realistic like Benin bronze, and some very abstract. But this is the thing—to get a sense, a feeling—not just looking at them and admiring them as decor to put some place. But to discover what is it that motivated the art.

RASHEED ARAEEN, 1987

The "primitive" has now learned how to draw, how to paint and how to sculpt; also how to read and how to write and how to think consciously and rationally, and has in fact read all those magical texts that gave the white man the power to rule the world. The "primitive" today has modern ambitions and enters into the Museum of Modern Art, with all the intellectual power of a modern genius, and tells William Rubin [then Director, Department of Painting and Sculpture, Museum of Modern Art, New York] to fuck off with his Primitivism: you can no longer define, Sir, classify or categorise me. I'm no longer your bloody objects in the British Museum. I'm here right in front of you, in the flesh and blood of a modern artist. If you want to talk about me, let's talk. BUT NO MORE OF YOUR PRIMITIVIST RUBBISH.

MICHAEL HEIZER, 1991

We live in a schizophrenic period. We're living in a world that's technological and primordial simultaneously. I guess the idea is to make art that reflects this premise.

ELLSWORTH KELLY, 1994

In 1970 I saw the exhibition "Die Kunst von Schwarz-Afrika." . . . I realized I was at a "source" and at that moment I felt that twentieth-century painting only "depicted" what African art "presented." I saw how directly it related to my intention of making art, with its emphasis on shape, frontality, directness and spiritual strength.

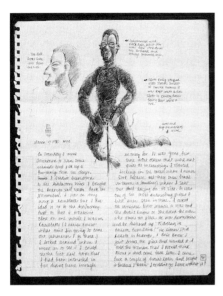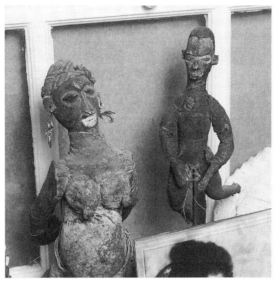

Figure 41. *Left:* Page from Renée Stout's journal, 1990, with a drawing and notes on her Yaka mask fragments. Photo by Jerry L. Thompson. *Right:* Yaka mask fragment. Democratic Republic of the Congo. Wood, fiber, pigment, metal, and cloth. Collection of Renée Stout. Photo by Jerry L. Thompson.

Western art since the Renaissance has been about depiction. African art is less involved with depiction than with making functional and ritualistic objects that exist in "literal" space. My painting and sculpture has been influenced by the "literal" aspect of tribal art of Africa, as well as other forms of art, such as pre-Columbian, Byzantine, and Romanesque.

RICHARD SERRA, 1994

I do not have any knowledge of the social and religious function or the anthropological meaning of Lobi sculpture. The original use and meaning escapes me completely.

I am left with my own subjective response to construct a new meaning. However inaccurate or false, this meaning becomes useful to me.

These works do not lead me to an analysis of form but rather to an activity, i.e., to rethink the potential of sculpture day after day.

To expose the tension between my misuse and the original function constitutes a possibility for me to learn something not implied by the original purpose.

RENÉE STOUT, 1994

As human beings, we all have a need to understand who we are and where we fit in the universe. As an African-American woman I have found this to be a particularly difficult challenge because of the history of how African-Americans came to exist in this part of the world. . . .

This is the art of my ancestors.

FRED WILSON, 1994

In my work I never use African objects that have a specific spiritual history or that have a value for their visual power or beauty. My intention is not to destroy an object that has real meaning in terms of either an African or a Western context. I am, however, aware and concerned with their symbolic meaning—in relation to their African past or their American/European present.

ARMAN, 1994

There is only one human race; our differences are merely adaptations to different environments and different situations. But man is man at the moment he asks the following fundamental questions that Gauguin asked: Who are we . . . where do we come from . . . where are we going?

The answers are religious, philosophical, and artistic. If you believe that man is the same everywhere on this planet, then you know that in every group, every *ethnie,* in every part of the world, you have the same proportion of geniuses, artists, morons, bright people, generous people, selfish people, cruel and good; and when an artist, through time, place, and culture, produces a masterpiece, this masterpiece is equal to others and tries to answer the fundamental questions about ourselves. It is as difficult to envision African art as a whole as it is to envision European art as a whole; the artistic solutions of different groups and areas vary from abstraction to naturalism. In this respect, when it comes to perfect works of art, there is no difference between African art and the masterpieces created by great artists of other cultures.

MEL EDWARDS, 1994

I began my interest in (African Art = Life) by being African-American, born in 1937 in Houston, Texas. American life was racially segregated by law and custom; as I grew up, my aesthetic experience was in a variant of that context. When I was 18 at City College in L.A., there was a Fang sculpture from Gabon, a male figure with muscular shoulders, generally strong and dynamic, and this work sat on the art-history lecture table. I drew it many times, it felt right. After that, African art was special because I knew I was a part of its reality. Eye to eye, African art is like a deep conversation with family.

BELL HOOKS, 1995

From my own experience, I could testify to the transformative power of art. I asked my audience to consider why in so many instances of global imperialist conquest by the West, art has been either appropriated or destroyed. I shared my amazement at all the African art I first saw years ago in the museums and galleries of Paris. It occurred to me then that if one could make a people lose touch with their capacity to create, lose sight of their will and their power to make art, then the work of subjugation, of colonization, is complete. Such work can be undone only by acts of concrete reclamation.

FAITH RINGGOLD, 1995

I came back from Africa [in 1976] with ideas for a new mask face, more primitive than any I had ever done before. *Primitive* is a word I use in a positive way to explain the completeness of a concept in art. I like to layer and pattern and

embellish my art in the manner of tribal art, and then, like a blues singer, I like to repeat and repeat it again. . . . I had been to the African source of my own "classical" art forms and now I was set free.

BRUNO FOUCART, 1996

Of course the African arts deserve to be in the Louvre. It would have been useless to expel the kings, emperors, and functionaries if the palace of arts was not open to the arts of all times, all places, all races, all conditions. Only our Africans are coming a little late. The Louvre, even having become so grand, too grand, is no longer and doubtless will never again be the universal museum, the Noah's Ark that it thought it should be at the time it was founded. . . . Acceptance by the Louvre is meant to make up for the outrage perpetrated on these *inferiors* that we have dared to call primitive. In such circumstances it is no use to recall that the Gothics, those barbarians, the Cubists, those idiots, were not treated much better in their time. It is of no use to intimate that the new appellation of "premier" arts sounds vulgarly parvenu. When dignity is at stake, reasoning is vain. Let them into the Louvre then, these arts supposedly unloved and disrespected. Let them make themselves at home, for long enough at least to resolve their Oedipus complex. No doubt, sooner or later they will prefer to return to their red carpet and gilded stairs, their Trocadéro, where they would find all the comforts of home awaiting them.

ROBERT COLESCOTT, 1997

I own a number of Sepik River pieces from New Guinea, and the thing that I admire about that work, and the thing that has made its way into the drawings and then the paintings, is this kind of raw, direct, unfinished look. And it's a look that a lot of this New Guinea sculpture has. Sepik River is a place, and it's a real place, but it's also to me, living with the sculptures, a very mysterious place where people make sculpture, where they decorate their bodies and become sculpture. It's about tribal religion—all these are qualities in the Sepik River sculpture that I've come to appreciate as part of my painting.

RICHARD J. POWELL, 1997

Unfortunately, the peoples and cultures of Africa were the principal objects of this primitivist mindset. An almost universal ignorance of Africa, coupled with a legacy of exploitation of African peoples, created an atmosphere in which Westerners—usually taking their cues from Edgar Rice Burroughs novels and Hollywood jungle movies—saw "Africa" as either exotic and passionate or dangerous and fearsome.

JACQUES CHIRAC, 2000

[On the opening of "arts premiers" galleries in the Louvre, on April 13, 2000:] These galleries have been conceived for visitors to the Louvre. Literally "overexposed" to masterpieces of the most varied styles and materials in other departments, upon entering this beautiful installation, they will discover, I am certain, works that can be compared to the purest treasures of the Louvre. . . . The Louvre cannot remain a great museum while ignoring the arts of 70 percent of the world's population.

SOURCES

Apollinaire, Guillaume. Circa 1908. Ms. 7460. Bibliothèque Littéraire Jacques Doucet, Paris. In *Apollinaire, Catalyst for Primitivism, Picabia and Duchamp,* trans. Katia Samaltanos, p. 13. Ann Arbor: UMI Research Press, 1984.

———. 1913. *Les Peintres cubistes: Méditations esthétiques.* Trans. Lionel Abel. *The Cubist Painters: Aesthetic Meditations.* Rev. ed. P. 14. New York: Wittenborn, Schultz, 1970.

Araeen, Rasheed. 1987. "From Primitivism to Ethnic Arts." *Third Text* 1 (Autumn): 18.

Arman. 1994. Quoted in *Western Artists/African Art.* Exh. cat. Pp. 15–16. New York: Museum for African Art.

Arp, Jean. 1955. Marcel Jean, ed. *Arp on Arp: Poems, Essays, Memories.* P. 338. New York: Viking Press, 1969.

Basler, Adolphe, and Charles Kunstler. 1929. "Exotisme Sauvage." In *La peinture indépendante en France,* vol. 2, *De Matisse à Segonzac,* pp. 13–14. Paris: G. Crès, 1929. The self-quotation is from Basler, *L'Art chez les peuples primitifs* (Paris, 1929).

Baudelaire, Charles. 1846. "Salon of 1846." In *Art in Paris 1845–1862: Salons and Other Exhibitions,* trans. and ed. Jonathan Mayne, p. 111. New York: Cornell University Press, 1965.

Bearden, Romare. 1987. *Perspectives: Angles on African Art.* P. 67. New York: Center for African Art.

Beckmann, Max. 1912 . "Gedanken über zeitgemäße und unzeitgemäße Kunst." *Pan* 2 (March): 499ff. In *German Expressionism: Primitivism and Modernity,* trans. Jill Lloyd, p. 85. New Haven: Yale University Press, 1991.

Beneš, Vincenc. 1913. *III. Výstava Skupina Výtvarných Umělců.* Obecní Dům Města. Exh. cat. Prahy: Květen-Červen.

Beuys, Joseph. Circa 1960s. Quoted by Caroline Tisdall. *Joseph Beuys.* Exh. cat. P. 23. New York: Solomon R. Guggenheim Museum, 1979.

Boccioni, Umberto. 1913. "Fondamento plastico della scultura e pittura futuriste," *Lacerba* 1 (March 15): 51. In *"Primitivism" in 20th Century Art: Affinity of the Tribal and the Modern,* exh. cat., 2 vols., ed. William Rubin, p. 405. New York: Museum of Modern Art, 1984.

Brancusi, Constantin. Circa 1923. Quoted by M. M. "Constantin Brancusi: A Summary of Many Conversations." *The Arts* 4 (July): 17.

Braque, Georges. 1949. Quoted by Georges Duthuit. *The Fauvist Painters.* P. 26. New York: Wittenborn, Schultz, 1950.

———. 1954. Quoted by Dora Vallier. "Braque, la peinture et nous." *Cahiers d'Art* 29 (October): 14.

Breton, André. 1928. *Le Surréalisme et la peinture.* 1965. Trans. Simon Watson Taylor. *Surrealism and Painting.* Pp. 3–4. New York: Harper and Row, 1972.

———. 1941. *Le Surréalisme et la peinture.* 1965. Trans. Simon Watson Taylor. *Surrealism and Painting.* Pp. 3–4. New York: Harper and Row, 1972.

——— (attributed). 1942. *First Papers of Surrealism.* N.p. New York: Coordinating Council of French Relief Societies.

———. 1946. "André Breton: Nouveau parlé." (Two-part interview with Jean Duché.) *Le Littéraire* (Oct. 5): 1–2. Reprinted in *Entretiens, 1913–1952.* Paris: Gallimard, 1952.

Carrà, Carlo. 1921. "André Derain." *Valori Plastica* 3 (March): 67–68. In *"Primitivism" in 20th Century Art: Affinity of the Tribal and the Modern,* exh. cat., 2 vols., ed. William Rubin, p. 406. New York: Museum of Modern Art, 1984.

Chirac, Jacques. 2000. *Inauguration du pavillon des Sessions.* Press release. Paris: Palais du Louvre, April.

Colescott, Robert. 1997. Interviewed by Faye Hirsch. "From Picasso to Sepik River: An Interview with Robert Colescott." *On Paper* 1 (May–June): 36.

Courbet, Gustave. 1850. Letter to Francis Wey. In *Letters of Gustave Courbet,* trans. and ed. Petra ten-Doesschate Chu, pp. 98–99. [Our translation is slightly different.] Chicago: University of Chicago Press, 1992.

Delacroix, Eugène. 1832. Journal, April 28.

———. 1855. Journal, October 1.

Denis, Maurice. 1909. "De la Gaucherie des primitifs." *Les Arts de la vie* (July 1904). Reprinted in *Theories, 1890–1910.* 4th ed. P. 176. Paris: Rouart et Watelin, 1920.

Durham, Jimmie. 1986. *Ni' Go Tlunh a Doh Ka.* Exh. cat. New York: Amelie A. Wallace Gallery, State University of New York. In *A Certain Lack of Coherence: Writings on Art and Politics,* ed. Jean Fisher, pp. 109–10. London: Kala Press, 1993.

Edwards, Mel. 1994. Quoted in *Western Artists/African Art.* Exh. cat. P. 26. New York: Museum for African Art.

Einstein, Carl. 1921. *Afrikanische Plastik.* Pp. 8–9. Berlin: E. Wasmuth.

Epstein, Sir Jacob. 1912. *Let There Be Sculpture.* Pp. 38–39. New York: G. P. Putnam's Sons, 1940.

———. 1929–31. *The Sculptor Speaks: Jacob Epstein to Arnold L. Haskell.* P. 91. London: W. Heinemann, 1931; New York: Benjamin Blom, 1971.

———. 1940. *Let There Be Sculpture.* P. 164. New York: G. P. Putnam's Sons.

Foucart, Bruno. 1996. "A Louvre ouvert." *Connaissance des arts* no. 528 (May): 102.

Freud, Sigmund. 1911. "The Case of Schreber, Papers on Technique and Other Works." Postscript. In *The Standard Edition of the Complete Psychological Works of Sigmund Freud,* trans. and ed. James Strachey, vol. 12, p. 82. London: Hogarth Press and Institute of Psycho-Analysis, 1958.

———. 1913. *Totem und Tabu.* Trans. James Strachey. *Totem and Taboo.* P. 161. New York: W. W. Norton, 1952.

Gaudier-Brzeska, Henri. 1914. Letter to the editor. *The Egoist* (March 16). In Evelyn Silber, *Gaudier-Brzeska: Life and Art,* p. 131. London: Thames and Hudson, 1996.

Gauguin, Paul. 1889. From the manuscript of Gauguin's *Notes éparses* in the Bibliothèque d'Art et d'Archéologie. In *Primitivism in Modern Art,* trans. Robert Goldwater, rev. ed., p. 66. New York: Vintage Books, 1967.

———. 1895. Letter to August Strindberg, February 5. In *Impressionism and Post-Impressionism, 1874–1904: Sources and Documents,* trans. Linda Nochlin, pp. 172–73. Englewood Cliffs, NJ: Prentice-Hall, 1966.

Giacometti, Alberto. 1963. Interviewed by Jean-Marie Drôt. *Les Heures chaudes de Montparnasse.* Part 9. In *Alberto Giacometti: A Biography of His Work,* trans. Yves Bonnefoy, p. 132. Paris: Flammarion, 1991.

Gombrich, E. H. 1966. *The Story of Art.* 11th ed. Pp. 20–30. London: Phaidon Press, 1966.

Gottlieb, Adolph, and Mark Rothko. 1943. Letter to Edward Alden Jewell, art editor. *New York Times* (June 13), sec. 2, p. 9.

Graham, John D. 1936. *Exhibition of Sculptures of Old African Civilization.* Exh. cat. Pp. 6–7. New York: Jacques Seligmann Gallery.

Gutfreund, Otto. 1913. "Plocha a prostor." *Umělecký Měsíčník* 2 (June): 242.

Heizer, Michael. 1991. Quoted in *Michael Heizer: Double Negative,* p. 13. New York: Rizzoli.

hooks, bell. 1995. *Art on My Mind: Visual Politics.* P. xv. New York: New Press.

Jacob, Max. 1927. "Souvenirs sur Picasso, contés par Max Jacob." *Cahiers d'art* 7 (1927): 202.

Johnson, William H. Circa 1935. Interviewed in "Interview of the Day with an Indian—and Negro Blood in His Veins." Copenhagen newspaper. In Romare Bearden and Harry Henderson, *A History of African-American Artists from 1792 to the Present,* p.190. New York: Pantheon Books, 1993.

Jones, Lois Mailou. 1977. Interviewed in *Black Women Oral History Project.* Arthur and Elizabeth Schlesinger Library on the History of Women in America. Vol. 6. Ed. Ruth Edmonds Hill. P. 290. Radcliffe College.

Jones, Owen. 1868. *The Grammar of Ornament.* Pp. 15–16. London: Bernard Quaritch. Reprinted in Robert Goldwater, *Primitivism in Modern Art,* p. 19. Rev. ed. New York: Vintage, 1967.

Jung, C. G. 1918. "Über das Unbewusste." *Schweizerland* 4. Reprinted in *The Collected Works of C. G. Jung,* vol. 10. Trans. Sir Herbert Read et al. Princeton: Princeton University Press, 1970.

Kandinsky, Wassily. 1912. *Über das Geistige in der Kunst, insbesondere in der Malerei.* In *Kandinsky: Complete Writings on Art,* vol.1, trans. K. C. Lindsay and P. Vergo, pp. 128, 205. Boston: G. K. Hall, 1982.

Kelly, Ellsworth. 1994. Quoted in *Western Artists/African Art.* Exh. cat. Pp. 43, 45. New York: Museum for African Art.

Klee, Paul. 1902. Journal, Berne. In *Paul Klee: Statements by the Artist,* p. 8. New York: Museum of Modern Art, 1945.

———. 1909. *The Diaries of Paul Klee, 1898–1918.* Ed. Felix Klee. P. 237. Berkeley: University of California Press, 1964.

———. 1912. *The Diaries of Paul Klee, 1898–1918.* Ed. Felix Klee. P. 266. Berkeley: University of California Press, 1964.

Lam, Wifredo. 1948. Quoted in Madeline Rousseau, "Wifredo Lam—peintre cubain." *Présence africaine* 4 (1948): 591. In *"Primitivism" in 20th Century Art: Affinity of the Tribal and the Modern,* exh. cat., 2 vols., ed. William Rubin, p. 580. New York: Museum of Modern Art, 1984.

———. 1973. In Max Pol Fouchet, *Wifredo Lam,* pp. 192–93. Barcelona: Ediciones Poligrafa, 1989.

Lhote, André. 1950. *Figure Painting.* Trans. W. J. Strachan. P. 58. London: A. Zwemmer, 1953.

Lipchitz, Jacques. 1960. In *The Lipchitz (Jacques, Yulla, & Lolya) Collection.* Exh. cat. P. 7. New York: Museum of Primitive Art.

Lipchitz, Jacques, with H. H. Arnason. 1968–70. *My Life in Sculpture*. Pp. 19–20. New York: Viking Press, 1972.

Maillol, Aristide. 1937. Interviewed by Judith Cladel. *Maillol, sa vie, son oeuvre, ses idées.* Paris, 1937. In *Arts primitifs dans les ateliers d'artistes,* n.p. Paris: Musée de l'homme, 1967.

Malraux, André. 1974. *Masterpieces of Primitive Art.* Foreword. P. 16. New York: Alfred A. Knopf, 1978.

Matta, [Roberto]. 1948. "Hellucinations." In Max Ernst, *Beyond Painting.* P. 194. New York: Wittenborn, Schultz, 1948.

Mendieta, Ana. 1973. Quoted in Claudia Laudanno, "Ana Mendieta: en-tierra; Escritos personales." *Artinf* 22 (Winter 1998): 20.

Messagier, Jean. 1967. *Arts primitifs dans les ateliers d'artistes.* N.p. Paris: Musée de l'homme.

Millier, Arthur. 1935. "African Sculpture Excels in Fundamentals of Art." *Los Angeles Times.* September 29.

Miró, Joan. 1936. Quoted in Georges Duthuit, "Où allez-vous Miró?" *Cahiers d'art* 9 (1936): 262. In *Primitivism in Modern Art,* rev. ed., trans. Robert Goldwater, p. 205. New York: Vintage Books, 1967.

Mondrian, Piet. 1931. "The New Art—The New Life: The Culture of Pure Relationships." In *The New Art—The New Life: The Collected Writings of Piet Mondrian,* trans. and ed. Harry Holtzman and Martin S. James, p. 250. Boston: G. K. Hall, 1986.

Moore, Henry. 1951. Interviewed during his visit to the "Traditional Art from the Colonies" exhibition in Great Britain. In *Henry Moore on Sculpture,* rev. ed., ed. Philip James, p. 172. New York: Viking Press, 1971.

Newman, Barnett. 1948. John P. O'Neill, ed. *Barnett Newman: Selected Writings and Interviews.* P. 165. New York: Knopf, 1990.

Paalen, Wolfgang. 1941. *DYN* 4–5, Amerindian Number (December 1943). Introduction.

Pechstein, Max. 1960. *Erinnerungen.* Wiesbaden. In *German Expressionism: Primitivism and Modernity,* trans. Jill Lloyd, p. 203. New Haven: Yale University Press, 1991.

Picasso, Pablo. Circa 1917. Quoted by Guillaume Apollinaire. Pierre Caizergues and Hélène Seckel, eds. *Picasso–Apollinaire: Correspondance.* Pp. 201–2. Paris: Gallimard, 1992.

———. Circa 1946. Quoted by Francine Gilot and Carlton Lake. *Life with Picasso.* P. 226. New York: McGraw Hill, 1964.

Pollock, Jackson. 1944. Interview. *Arts and Architecture* 61 (Feb 1944): 14.

———. 1947. *Possibilities* 1 (1947–48): 79.

Poor, Henry Varnum. 1926. "Anonymous American Art." *The Arts* 10 (July): 14.

Powell, Richard J. 1997. *Black Art and Culture in the 20th Century.* P. 60. London: Thames and Hudson.

Ringgold, Faith. 1995. *We Flew Over the Bridge: The Memoirs of Faith Ringgold.* Pp. 209–10. Boston: Bulfinch Press.

Rothko, Mark. 1946. Catalogue of the Clyfford Still exhibition at the Art of This

Century Gallery, New York, February 12–March 2. N.p. In Irving Sandler, *The Triumph of American Painting: A History of Abstract Expressionism,* p. 67. New York: Praeger, 1970.

Rousseau, Jean-Jacques. 1755. "A Discourse on the Origin of Inequality." In *The Social Contract,* trans. G.D.H. Cole, pp. 236–38. New York: Dutton, n.d.

Ruskin, John. 1857. Lecture delivered at the Art Treasures exhibition, Manchester, England, July 13. In *The Works of John Ruskin,* ed. E. T. Cook and Alexander Wedderburn, library edition, vol. 16, p. 76. London: George Allen, 1905.

Schapiro, Meyer. 1936. "Race, Nationality and Art." *Art Front* 3 (March): 11.

Serra, Richard. 1994. Quoted in *Western Artists/African Art.* Exh. cat. P. 85. New York: Museum for African Art.

Shevchenko, Aleksandr. 1913. *Neoprimitivism: Its Theory, Its Potentials, Its Achievements.* In *Russian Art of the Avant-Garde: Theory and Criticism, 1902–1934,* trans. and ed. John Bowlt, p. 45. New York: Viking Press, 1976.

Smith, David. 1954. Quoted in "David Smith." *College Art Journal* 13 (Spring): 205–6.

Smithson, Robert. 1969–70. Conversation with Dennis Wheeler. In Jack Flam, ed. *Robert Smithson: The Collected Writings.* P. 207. Berkeley: University of California Press, 1996.

Stout, Renée. 1994. Quoted in *Western Artists/African Art.* Exh. cat. P. 91. New York: Museum for African Art.

Tzara, Tristan. 1916. *Première Aventure céleste de M. Antipyrine.* Zürich: J. Heuberger.

———. 1929. "Art et Océanie." *Cahiers d'art* 9 (March–April): 59–60.

Weber, Max. Circa 1913. Quoted by Ala Story. *Max Weber.* Exh. cat. P. 12. Santa Barbara: Art Galleries, University of California at Santa Barbara, 1968.

———. 1951. Presentation at the Matisse Symposium, New York Museum of Modern Art, November 19. Museum of Modern Art Archives.

Wilson, Fred. 1994. Quoted in *Western Artists/African Art.* Exh. cat. P. 94. New York: Museum for African Art.

Woodruff, Hale A. Circa 1972. Quoted by Romare Bearden and Harry Henderson. *A History of African-American Artists from 1792 to the Present.* P. 201. New York: Pantheon Books, 1993.

Worringer, Wilhelm. 1911. *Im Kampf um die moderne Kunst: Die Antwort auf den Protest Deutscher Künstler* (The Fight for Modern Art: An Answer to the German Artists' Protest). P. 97. In *German Expressionism: Primitivism and Modernity,* trans. Jill Lloyd, p. 57. New Haven: Yale University Press, 1991.

Zervos, Christian. 1936. "Réflexions sur la tentative d'esthétique dirigée du IIIe Reich." *Cahiers d'art* 12: 56.

CHRONOLOGY OF EVENTS, EXHIBITIONS, AND PUBLICATIONS

1441	Portuguese take first African captives for slave trade. In subsequent years they establish themselves along the West African coast.
1482	The Portuguese captain Diogo Cão is the first European to explore the estuary of the Congo River.
1488	Bartholomeu Dias rounds Cape of Good Hope.
ca. 1504	Portuguese have trading monopoly in West Africa, are accepted as residents of Benin city.
1520	Albrecht Dürer praises gold objects brought back from Mexico.
1553	English traders reach Benin.
1593	Portuguese invade Angola, establish large slave trade to Brazil.
ca. 1600	Expanded slave trade from Africa to the Americas run by several European nations.
1759	British Museum opens (founded 1753 by Sir Hans Sloane).
1768–71	Captain James Cook makes the first of three voyages of discovery in the Pacific (the second was 1772–75, the third 1776–79). South Sea objects from Cook's explorations enter Montague House and later become part of the British Museum collections.
1796	Mungo Park travels to the Niger River at Ségou.
1799	East India Marine Society founded in Salem, Mass.; acquisition of Oceanic collections begins during the first quarter of the nineteenth century.
ca. 1800	Vienna begins acquiring some of Cook's materials for the Hofmuseum.
1822	Foundation of Liberia.
1823	Aztec sculpture acquired by the British Museum.
1833	First paleolithic art found in Veyrier.
1841	A department of ethnography is added to the Danish National Museum, Copenhagen.
1850	An ethnographic collection is established in Hamburg.
1851	British occupy Lagos in Nigeria.
	Pitt-Rivers Museum founded at Oxford; joins the University in 1883.
1853	Gobineau publishes *Essai sur l'inégalité des races humaines.*
1854	French begin expansion in West Africa, occupy Dakar in 1857.

1855 In Paris, plans are formulated for an ethnographical museum, in connection with the Universal Exposition. Becomes Musée Permanent des Colonies, at the same site.

1856 In Berlin, the Antikensammlung Museum establishes an ethnographic section.

1859 Darwin publishes *The Origin of Species.*

1860 Gottfried Semper, *Der Stil in den technischen und tektonischen Künsten oder Praktische Aesthetik.* Edouard Lartet publishes Chauffaud bone; this is the first identification of an object as paleolithic.

1863 Vicomte de Lastic-Saint Jal offers paleolithic objects to the Louvre; after hesitation, they are acquired by the British Museum

British war with Ashanti.

1864 First report of cave paintings: by Félix Garrigou, who visited many sites, including Niaux (which would be rediscovered in 1906).

1866 Harvard University's Peabody Museum founded.

Yale University's Peabody Museum founded.

1867 Universal Exposition in Paris includes 51 paleolithic pieces in "History of Work" exhibition.

1868 Discovery of cave at Altamira in Spain, by a hunter. Paleolithic bone batons found in France.

1869 American Museum of Natural History founded in New York.

The U.S. government begins placing all Indians on reservations.

1871 Sir John Lubbock, *The Origin of Civilization.*

1871 Edward Tylor, *Primitive Culture.*

The Indian Appropriation Act declares that tribal affairs would be managed by the U.S. government without consent of the tribes.

1873 Georg Schweinfurth, *Im Herzen von Afrika.*

1874 Ethnographical Museum opened in Leipzig.

1875 Museo Preistorico ed Etnografico founded in Rome.

1877 Hamburg's ethnographical collection becomes the Museum für Völkerkunde.

1879 In Paris, a "Musée Africaine" is installed in the lobby of Théâtre du Châtelet for a few months beginning in September; Adolphe Belot's *La Vénus noire* (based on Schweinfurth's African journey among the Zande and Mangbetu) produced at the theater.

Musée d'Ethnographie du Trocadéro founded (the first museum devoted entirely to material culture of living non-Western peoples). Its predecessor, the Musée Ethnographique des Missions Scientifiques had been founded January 1878.

Musée Guimet founded in Lyon.

De Sautuola discovers wall paintings in the cave at Altamira.

1881 E. Harlé writes that Altamira paintings are too good to have been done by prehistoric savages.

The Museum of Archaeology and Ethnology at Cambridge University is founded.

1884–86 Congress of imperialist powers at Berlin West Africa Conference, at which Africa is partitioned. King Leopold of Belgium recognized as sovereign of Congo Free State. In 1884 Germans occupy Togo and Kamerun. In 1884, first goldfields opened in South Africa. In 1886 French occupy Ivory Coast.

1885 By this time, ethnological museums exist in Florence, Milan, and Turin.

The Musée Guimet moves from Lyon to Paris.

1887 Colonial Exposition, London.

U.S. Congress passes the General Allotment Act (Dawes Severality Act) providing for the eventual end to the Indian reservation system and the abolition of tribal organizations. Each head of a family would be allotted 160 acres of reservation land and each single adult would get 80 acres.

1888 University of Zurich ethnographic collection begun.

1889 Oceanic and West African objects are shown at the Universal Exposition in Paris. Gauguin makes sketches of Aztec sculpture.

1890 Sir James Frazer, *The Golden Bough*.

Hjalmer Stolpe, *On Evolution in the Ornamental Art of Savage Peoples*.

1891 Gauguin goes to Tahiti for the first time.

1893 Ethnographic Museum founded in Basel.

Field Museum of Natural History founded in Chicago.

1894 End of Dahomean wars (begun 1877) seen as triumph of faith and reason over "degrading fetishism."

1895 Alfred Haddon, *Evolution in Art*.

Leo Frobenius, *Die Kunst der Naturvölker*.

1897 Tervueren expedition to the Congo; provides basis for the Musée du Congo Belge at Tervueren.

British Punitive Expedition to Benin in Nigeria.

Discovery by F. Regnault of animal paintings at Marsoulas; but he is mocked by Cartailhac and Cau-Durban, who believe the paintings to have been done by children.

Ernst Grosse, *The Beginnings of Art*.

Leo Frobenius, *Die Bildende Kunst der Afrikaner*.

1899 The first authenticated paleolithic lamp is found in France; this makes the case for lamps having been available to painters in the darkness of the caves.

1900 African villages constructed at Universal Exposition in Paris.

1901 Gauguin goes to Marquesas Islands.

Discovery of cave of Les Combarelles (Les Eyzies); visited by L. Capitan and H. Breuil; subsequent discovery of Font de Gaume cave.

1902 Jacob Epstein starts visiting the Trocadéro while a student at the École des Beaux-Arts.

Oskar Kokoschka discovers the Oceanic collection at the Vienna Museum.

Cartailhac, having long denied the authenticity of cave art, changes his mind about Marsoulas; he publishes an article in *L'Anthropologie* about Altamira, "Mea Culpa d'un sceptique."

The state ethnographical museum is founded as a department of the Swedish Museum of Natural History in Stockholm.

Joseph Conrad, *Heart of Darkness;* based on his experiences in the Congo in 1890.

1904 André Level begins collecting African art.

"Les Primitifs français" exhibition at the Louvre.

Ernst Ludwig Kirchner discovers the African and Oceanic collections in the Dresden Museum.

1905 Southwestern Indian Hall opens at the Brooklyn Institute of Arts and Sciences (now the Brooklyn Museum of Art).

1906 In Dresden, Emil Nolde develops interest in Primitive art through his contact with Brücke artists.

In March, Derain studies the African objects in the British Museum.

In Paris, the Louvre exhibits late Iberian reliefs from Osuna.

Matisse sees African art in a shop on the Rue de Rennes in the spring.

Vlaminck acquires his first African objects.

Derain buys a Fang mask from Vlaminck and hangs it in his studio.

Major Gauguin retrospective at the Salon d'Automne (227 works, including sculpture).

1907 Kandinsky greatly impressed by African art at the Berlin Ethnographic Museum.

Picasso visits the Trocadéro museum in the spring while working on *Les Demoiselles d'Avignon.*

Major Cézanne retrospective at the Salon d'Automne (220 works).

1908 Congo Free State becomes Belgian Congo, under authority of Belgian parliament.

Wilhelm Worringer, *Abstraktion und Einfuehlung.*

1909 Modigliani, in Paris, sees African sculpture, and his works show the in-

fluence of Baule masks; he is befriended by Brancusi, who shares his interest in African art. Jacques Lipchitz moves to Paris.

1910 Africa Hall opens at the American Museum of Natural History, New York.

Oceanic Hall opens at the Trocadéro Museum, Paris.

Lucien Lévy-Bruhl, *Les Fonctions mentales dans les sociétés primitives.*

1911 Franz Marc studies African and Peruvian sculpture at the Berlin Museum.

Franz Boas, *The Mind of Primitive Man.*

Exhibition of African and Oceanic art in Budapest at "Oriental Exhibition" ("Keleti Kiàllitàs") at the House of Artists under the aegis of Joszef Rippl-Ronai and Karoly Kernstock.

Henri Bergson, *L'Evolution créatrice.*

1912 African art exhibition at Folkwang Museum, Hagen.

Jacob Epstein visits Paris and begins collecting African art (collection later expands to include Maori and Marquesan works). Jacques Lipchitz starts his own collection.

In Paris, *Impressions d'Afrique* by Raymond Roussel opens, based on his 1910 book; attended by Duchamp, Picabia, and Apollinaire. Apollinaire writes "Zone," the first of his poems with an African theme. Elie Faure publishes *L'Art médiéval,* the second volume of his *Histoire de l'art,* with a chapter on the "The Tropics"; this is the first inclusion of Primitive art in a general history of art.

Northwest Coast Indian Hall opens at the Brooklyn Museum.

1913 The "Armory Show" opens in New York.

Emil Nolde joins the German Colonial Office expedition to the South Seas.

Works by Picasso exhibited with African sculptures at the Neue Galerie in Berlin and later in Dresden.

In Paris, Galeries Levesque exhibits the collection of Charles Vignier, which includes some African sculptures.

In Prague, The Plastic Artists Group (Skupyna Výtvarných Umělců) exhibits folk art and African sculptures along with works by its members and foreign artists.

Sigmund Freud, *Totem und Tabu.*

1914 Paul Guillaume opens a gallery of modern and Primitive art in Paris.

In New York, Stieglitz's Little Gallery of the Photo-Secession ("291") mounts "Statuary in Wood by African Savages: The Root of Modern Art," an exhibition of African wood carvings (November 3–December 8); this marks the first time in the United States that Negro statuary was shown solely from the point of view of art.

1915 Carl Einstein's *Negerplastik,* the first book on African sculpture.

1916 Exposition Lyre et Palette in Paris shows works by Kisling, Modigliani, Matisse, and Picasso with sculptures from Africa and Oceania.

Opening of Cabaret Voltaire, Zurich; masks and pseudo-African chants are used in performances. Blaise Cendrars writes poems inspired by African art: *L'Anthologie nègre.*

Five exhibitions of African sculpture and modern art and one exhibition of African art at the Modern Gallery, New York.

Georgia O'Keeffe travels in West and Mexico for the first time and is profoundly impressed by the landscape and the Indians.

Bronislaw Malinowski begins publishing on the Trobriand islanders.

1917 The Galerie Corray "Dada Exhibition" in Zurich (January and February) includes work by Arp and Richter and Negro art.

African sculpture exhibited along with works by avant-garde artists at the Galerie Paul Guillaume, Paris.

Paul Guillaume and Guillaume Apollinaire publish *Sculptures nègres,* the first book in French on African art.

1919 Miró first sees Primitive art in Picasso's Paris studio, initiating his own interest in Oceanic art.

In Paris, "Première Exposition d'art nègre et d'art océanien" shown at Galerie Davambez. Paul Guillaume organizes "Fête nègre" at Théâtre des Champs-Elysées. *Gazette des Beaux-Arts* publishes articles on African and Oceanic art. Aragon and Breton start publishing *Littérature.*

1920 Exhibition of African art at the Chelsea Book Club, which draws articles by Roger Fry, Clive Bell, and André Salmon.

In Paris, *Action* produces opinions on African art, and Félix Fénéon publishes a survey about whether African art should be in the Louvre.

The painter John Sloan organizes "The Indian Exhibit" at Fourth Annual Exhibition of the Society of Independent Artists, New York, the first exhibition of living Native American art shown as art in the United States.

1921 African sculpture shown at 13th International Exhibition of art in Venice.

Henry Moore starts to study Primitive art at the British Museum.

Carl Einstein, *Afrikanische Plastik.*

Exhibition of Negro sculpture at the Leipzig museum.

Eckart von Sydow, *Exotische Kunst: Afrika und Ozeanien.*

1922 *Ahnenkult* exhibition in Leipzig.

Colonial Exposition in Marseilles, which includes a large exhibition of Dahomean art.

"Works of Artists of Modern French School and Collection of African Negro Sculpture," Brummer Gallery, New York.

Lucien Lévy-Bruhl, *La Mentalité primitive.*

Museum of the American Indian founded by George Gustav Heye, New York.

1923 "Primitive Negro Art" exhibition at the Brooklyn Museum.

Herbert Kuehn, *Der Kunst der Primitiven.* Leo Frobenius, *Das unbekannte Afrika.*

Jackson Pollock, living in Arizona, witnesses Indian rituals.

Pavillon de Marsan, Paris, "Exposition de l'art indigène des colonies françaises d'Afrique et d'Océanie."

Eckart von Sydow, *Der Kunst der Naturvölker und der Vorzeit.*

1924 G. H. Luquet, *The Art and Religion of Fossil Man.* Abbé Henri Breuil, *Les Origines de l'art décoratif.* André Breton, *Surrealist Manifesto.*

1925 Musée des Arts Décoratifs, Paris, "L'Art des colonies françaises et du Congo belge.

Exhibition of Negro art at Galerie le Portique, Paris; catalogue by Carl Einstein.

Robert Lowie, *Primitive Religion.*

1926 Galerie Surréaliste, Paris, "Tableaux de Man Ray et objets des îsles."

Munich museum reorganized to display ethnographic material in a manner that emphasizes the aesthetic quality.

Südsee Plastiken exhibition, Galerie Flechtheim, Berlin; catalogue foreword written by Carl Einstein.

Eckert von Sydow, *Primitive Kunst und Psychoanalyse.*

1927 Alain Locke organizes the Harlem Museum of African Art—the first museum in the United States dedicated to African art; however, an independent physical site for the museum is never attained. The inaugural exhibition was "The Bland-Theater Arts Collection of Primitive African Art," held at J. B. Neumann's New Art Circle, New York.

André Masson makes his first "sandpaintings."

Franz Boas, *Primitive Art.*

1928 Reorganization of the Trocadéro Museum collections to display pieces as works of art as well as evidence of "material culture."

Bureau of Indian Affairs (BIA) issues the *The Problem of Indian Administration* report criticizing the General Allotment Act and the BIA for showing little interest in retaining Indian culture.

1929 *Cahiers d'art* devotes March–April issue to arts of Oceania.

1930 Galerie Pigalle, Paris, "Exposition d'art africain et d'art océanien."

International Colonial Exhibition, Antwerp.

The collection at the Vienna museum is reorganized according to a cultural documentary method.

Valentine Gallery, New York, "Rare African Sculpture from the Collection of Paul Guillaume."

1931 "Exposition Coloniale," Paris. Musée des Colonies founded in Paris.

Aragon, Thirion, Sadoul, Éluard, and Tanguy organize an anticolonial exhibition in response to the Colonial Exposition in Paris.

Auction in Paris of African, Oceanic, and Native American works from the collections of André Breton and Paul Éluard.

Opening of Exposition of Indian Tribal Arts at the Grand Central Galleries in New York. After this exhibition closes, the College Art Association arranges for a two-year tour to fourteen cities in the United States.

"Dakar-Djibouti Expedition" begins at the Trocadéro Museum.

1932 Exhibition of Benin art at the Trocadéro Museum.

"Afrikanische Plastik," Berliner Secession, Berlin.

1933 *Minotaure* founded by Albert Skira and E. Tériade; the first two numbers contain articles on African art and ritual.

"American Sources of Modern Art" exhibition at the Museum of Modern Art, New York.

Exhibition of African sculpture at Lefèvre Galleries, London.

1934 Exhibition of the art of Dakar and the Marquesas at the Trocadéro Museum.

U.S. Congress passes Indian Reorganization Act containing several important reforms, including dispersing land to the tribes, reversing the 1887 Dawes Act award of individual land allottments to Indians.

1935 "African Negro Art" exhibition at the Museum of Modern Art, New York.

Adolph Gottlieb begins collecting Primitive art.

Hans Himmelheber publishes *Negerkünstler,* the first study of African aesthetics (on the Atutu and Guro).

"La Mission au Cameroon de M. H. Labouret" exhibition at the Trocadéro Museum.

The Musée des Colonies reopens as the Musée de la France d'Outremer.

1936 "International Surrealist Exhibition," New Burlington Galleries, London, includes Oceanic, African, and American objects.

Surrealist exhibition of objects including Oceanic art at Galerie Charles Ratton, Paris.

1937 Trocadéro Museum reorganized as the Musée de l'Homme.

"Prehistoric Rock Pictures in Europe and Africa" at the Museum of Modern Art, New York.

Exhibition of arts of the Belgian Congo, Antwerp.

1938 Gottlieb paints in the Arizona desert.

Breton tours Mexico, stays with Diego Rivera.

Robert Goldwater, *Primitivism in Modern Painting.*

1939 Wifredo Lam joins the Surrealists in Paris. Wolfgang Paalen visits British Columbia, Alaska, and Veracruz (later writes on Olmec art).

G. Vaillant, *Indian Arts in North America.*

1940 "Exposición internacional del surrealismo," at Galería de Arte Mexicano, Mexico City, organized by Breton, Paalen, and Miró.

"Twenty Centuries of Mexican Art" at the Museum of Modern Art, New York.

"Art Thoughout America" exhibition at the Brooklyn Museum.

1941 "Indian Art of the United States" exhibition at the Museum of Modern Art, New York.

Max Ernst, André Masson, Breton, and Claude Lévi-Strauss leave France and go to the United States via Martinique. They settle in New York.

1942 *First Papers of Surrealism,* New York.

1943 Ernst moves to Arizona.

1944 Barnett Newman writes catalogue for exhibition of Pre-Columbian sculpture.

1945 Breton makes trip through western United States, visiting Hopi and Zuni reservations; then travels to Haiti and sees voodoo ceremonies.

Wolfgang Paalen's collection of Northwest Coast Indian art shown at Museo Nacional, Mexico City.

1946 "Arts of the South Seas" exhibition at the Museum of Modern Art, New York.

Indian Claims Commission is created, empowering Congress to settle all Indian land claims against the government.

1947 Barnett Newman writes catalogue for Betty Parsons Gallery show of Northwest Coast Indian Art.

1948 De Young Museum, San Francisco, exhibits African Negro sculpture.

"40,000 Years of Modern Art: A Comparison of Primitive and Modern" exhibition at the Institute of Contemporary Arts, London.

1949 Royal Anthropological Institute, London, has exhibition of African art.

1951 Colonial Office, London, sponsors the exhibition "Traditional Art from the Colonies."

Internal self-rule for Ghana (independent in 1957).

1952 Ernst lectures on "The Influence of Primitive Art in Modern Art" in Hawaii.

Rietberg Museum (Baron von der Heydt collection) founded in Zurich.

	Internal self-rule for southern Nigeria (independent in 1960).
1953	British Museum exhibits Webster Plass Collection of African art.
1954	Museum of Primitive Art founded in New York by Nelson Rockefeller (originally named the Museum of Indigenous Art). Opens to the public in 1957.
	"Masterpieces of African Art" at the Brooklyn Museum.
1955	Claude Lévi-Strauss, *Tristes Tropiques.*
1956	African sculpture exhibited at University Museum, Philadelphia.
	French concede local autonomy to African colonies.
1958	Museum of Primitive Art, New York, holds major exhibition of African sculpture.
	Claude Lévi-Strauss, *Anthropologie structurale.*
1959	"Sculpture of Three Tribes: Senufo, Baga, and Dogon" at Museum of Primitive Art, New York.
1960	In Paris, Musée des Colonies (de la France d'outremer), reorganizes its collections on an aesthetic basis and becomes the Musée des Arts Africains et Océaniens.
	"Bambara Sculpture from the Western Sudan" at Museum of Primitive Art, New York.
	Belgian Congo becomes independent state, Republic of the Congo (later Zaire).
	Dahomey gains its independence from France; name changed to Benin in 1975.
	Nigeria gains its independence from Great Britain.
	Gabon and Côte d'Ivoire gain their independence from France.
1961	Cameroon gains independence from France and Great Britain.
1962	Claude Lévi-Strauss, *La Pensée sauvage.*
1963	March on Washington, D.C., led by Martin Luther King.
1964	Civil Rights Act passed in the United States.
	Museum of African Art founded in Washington, D.C.
1965	Race riot in Watts, Los Angeles, California.
	Cook Islands choose self-government in association with New Zealand.
1967	Race riot in Detroit, Michigan.
	Michel Leiris, *Afrique noire.*
1968	Museum of Primitive Art becomes the Department of Primitive Art of the Metropolitan Museum of Art.
	Metropolitan Museum holds "Before Cortes" exhibition as part of its Centennial Exhibition program.
1970	Fiji gains independence from Great Britain.

1972 "World Cultures and Modern Art," exhibition at the Games of the Twentieth Olympiad in Munich.

1976 Solomon Islands gain independence from Great Britain.

1978 U.S. Congress passes American Indian Religious Freedom Act protecting traditional practices.

1981 "Gauguin to Moore: Primitivism in Modern Sculpture" exhibition at the Art Gallery of Ontario, Toronto.

 The Museum of African Art in Washington becomes the National Museum of African Art.

1982 Michael C. Rockefeller Wing opens at the Metropolitan Museum of Art to display works from the museum's Department of Primitive Art.

1984 "'Primitivism' in 20th Century Art" exhibition at the Museum of Modern Art, New York.

 Center for African Art opens in New York.

 Margaret Mead Hall of Pacific Peoples opens at the American Museum of Natural History, New York.

1987 National Museum of African Art moves to new building on Mall.

1989 "Magiciens de la Terre" exhibition at the Centre Pompidou, Paris.

 The National Museum of the American Indian is established in Washington, D.C.

1991 "Africa Explores" exhibition at the Center for African Art; the New Museum for Contemporary Art, New York, presents the work of contemporary African artists.

 The Metropolitan Museum of Art renames the Department of Primitive Art as the Department of the Arts of Africa, Oceania, and the Americas.

1993 Center for African Art in New York becomes the Museum for African Art.

1994 "Western Artists/African Art" exhibition at the Museum for African Art, New York.

1996 *Connaissance des arts* publishes a survey about whether African Art should be admitted to the Louvre.

2000 Works of African and Oceanic art are put on exhibition at the Louvre.

SELECTED BIBLIOGRAPHY

Dates in brackets identify the actual year of the event described. Sources of texts included in this anthology are marked with an asterisk. Sources for Coda quotations are listed at the end of the Coda.

PART I. DISCOVERY · 1905–1918

Anonymous. 1913. *Collections de M. Charles Vignier consistant en sculptures, peintures et objets d'art anciens de l'Asie, ainsi qu'en quelques pièces d'art égyptien, d'art nègre et d'art aztéque exposées du 16 mai au 15 juin 1913, dans les Galeries Levesque.* Exh. cat. Paris: Levesque.

Anonymous. 1913. "Ausstellungen." *Kunstchronik* (Leipzig), 12 (December 12): columns 184–85.

Anonymous. 1914. "Ausstellungen: Die neue Malerei in Dresden." *Kunstchronik* (Leipzig) 25 (January 30): columns 288–91.

Apollinaire, Guillaume. [1902–18]. *Apollinaire on Art: Essays and Reviews, 1902–1918.* Ed. Leroy C. Breunig. New York: Viking Press, 1972.

———. 1907. "Henri Matisse." *La Phalange* 2, no. 18 (December 15): 481–85. In *Matisse on Art,* ed. Jack Flam. Berkeley: University of California Press, 1995.

———. 1908. Preface to *Catalogue de l'Exposition Braque.* Kahnweiler Gallery, November 9–28. In *Apollinaire on Art.*

*———. 1909. "Sur les musées." *Le Journal du soir* (October 3). In *Oeuvres en prose complètes,* vol. 2, ed. Pierre Caizergues and Michel Décaudin. Paris: Gallimard, 1993.

———. 1912. "Exotisme et Ethnographie." *Paris-Journal* (September 12). In *Apollinaire on Art.*

———. 1914. "Arts d'Afrique." *Paris-Journal* (June 1).

———. 1916. *1re Exposition du 19 novembre au 5 décembre 1916: Kisling, Matisse, Modigliani, Ortiz de Zarate, Picasso, Sculptures Nègres.* Exh. cat. Paris: Lyre et Palette.

*———. 1917. *Sculptures nègres: 24 photographies précédées d'un avertissement de Guillaume Apollinaire et d'un exposé de Paul Guillaume.* Paris: Paul Guillaume. Reprint. New York: Hacker Art Books, 1972.

———. 1917. "Mélanophilie ou mélanomanie?" *Mercure de France* (April 1).

———. Circa 1917. Manuscript. In *Picasso-Apollinaire: Correspondance,* ed. Pierre Caizergues and Hélène Seckel. Paris: Gallimard, 1992.

———. 1918. "Sculptures d'Afrique et d'Oceanie." *Les Arts à Paris* (July 15). In *Apollinaire on Art.*

*Bahr, Hermann. 1916. *Expressionismus.* Munich: Delphin-Verlag. Trans. R. T. Gribble. *Expressionism.* London: Frank Henderson, 1925.

Beneš, Vincenc. 1913. Introduction. *III. Výstva Skupyna Výtvarných Umělců.* Obecní Dum Města. Exh. cat. Prahy: Květen-Červen.

———. 1913. "Nové Umění." *Umělecký Měsíčník* 2 (June): 176–87.

Boas, Franz. 1911. *The Mind of Primitive Man.* New York: Macmillan.

Bouret, Jean. 1911–18. "Une Amitié esthétique au début du siècle: Apollinaire et Paul Guillaume, 1911–1918, d'après une correspondance inédite." *Gazette des Beaux-Arts* 85 (December 1970): 373–99.

Bowlt, John, ed. *Russian Art of the Avant-Garde: Theory and Criticism, 1902–1934.* New York: Viking Press, 1976.

*Burgess, Gelett. 1910. "The Wild Men of Paris." *Architectural Record* (May): 400–414.

*Caffin, Charles H. 1914. "The Root of Art Negro Carvings." New York *American* (November 2): 9. In *Camera Work,* 48 (October 1916): 13. Reprint. Nendeln, Liechtenstein: Kraus, 1979.

*Čapek, Josef. 1918. "Sochařstvi Černochů." *Červen* Rok 1. Čislo 18: 251–53.

*Derain, André. [1906.] *Lettres à Vlaminck.* Ed. Maurice de Vlaminck. Paris: Flammarion, 1955. Reprint. Paris: Flammarion, 1994.

Einstein, Carl. 1913. Introduction to *Erste Ausstellung.* Neue Galerie, Berlin. October–November. In Ron Mannheim, "Carl Einstein: Zwei Katalogvorworte von 1913/1914." *Kritische Berichte* 13 (1985): 6–7.

*———. 1915. *Negerplastik.* Leipzig: Verlag Der Weissen Bücher. 2d ed. Munich: Kurt Wolff, 1920.

*Faure, Elie. 1912. "Les Tropiques." In *Histoire de l'art: L'Art médiéval.* Vol. 2. Paris: Cres. Trans. Walter Pach. *History of Art: Medieval Art.* 5 vols. New York: Harper & Bros., 1922.

Filla, Emil. 1911. "O Cnosti Novoprimitivismu (On the virtues of Neoprimitivism)." *Volné Směry* 15: 62–70.

Friederberger, Hans. 1914. "Ausstellungen. Berlin." *Der Cicerone* (Leipzig) 6 (January): 23

*Fry, Roger. 1910. "The Art of the Bushmen." *Burlington Magazine.* 334ff. In *Vision and Design* by Roger Fry. New York: Bretano's, 1921.

Gutfreund, Otto. 1913. "Plocha a prostor." *Umělecký Měsíčník* 2 (June): 240–43.

Hartley, Marsden. 1918. "Tribal Esthetics." *The Dial* 65 (November): 399–401

*Hewett, Edgar L. 1916. "America's Archaelogical Heritage." *Art and Archaelogy* 4 (December): 257–66.

———. 1918. "Primitive Art vs. Modern Art." *El Palacio* 5 (August 25): 133–34.

Kandinsky, Wassily. 1912. *Über das Geistige in der Kunst.* Munich: R. Piper. In *Kandinsky: Complete Writings on Art.* Vol. 1. Ed. K. C. Lindsay and Peter Vergo. Boston: G. K. Hall, 1982.

Kirchner, Ernst Ludwig. 1910. Letter to Erich Heckel and Max Pechstein. March 31. Altonaer Museum, Hamburg. In Long, *German Expressionism.*

———. 1913. *Chronik der Brücke.* In Long, *German Expressionism.*

Klee, Paul. 1898–1918. *Tagebücher von Paul Klee, 1898–1918.* Ed. Felix Klee. Cologne:

M. DuMont Schauberg. *The Diaries of Paul Klee, 1898–1918,* edited by Felix Klee. Berkeley: University of California Press, 1964.

Le Chevrel, M. 1917. "Devant l'Atlantide." *Le Gaulois* (Dec. 18).

Lévy-Bruhl, Lucien. 1910. *Les Fonctions mentales dans les sociétés inférieures.* Paris: Alcan.

Long, Rose-Carol Washton, ed. *German Expressionism: Documents from the End of the Wilhelmine Empire to the Rise of National Socialism.* New York: G. K. Hall, 1993.

*Macke, August. 1912. "Die Masken." In *Der Blaue Reiter.* Ed. Wassily Kandinsky and Franz Marc. Munich: Piper Publishing. Trans. H. Falkenstein. *The Blaue Reiter Almanac.* Ed. Klaus Lankheit. New York: Viking Press, 1974.

*Malevich, Kazimir. [Written in 1915.] *Ot kubizma i futurizma k suprematizmu: Novyi zhivopisnyi realizm.* Moscow, 1916. In Bowlt, *Russian Art of the Avant-Garde.*

Malinowski, Bronislaw. 1916. "Baloma: Spirits of the Dead in the Trobriand Islands." *Journal of the Royal Anthropological Institute* 46: 354–430.

*Malraux, André. [Picasso, 1906–7.] *La Tête d'obsidienne.* Paris: Gallimard, 1974.

*Marc, Franz. 1911. Letter to August Macke, January 14. In *Briefwechsel.* Cologne: M. DuMont Schauberg, 1964. Trans. Donald E. Gordon, "German Expressionism," in *"Primitivism" in 20th Century Art: Affinity of the Tribal and the Modern.* Exh. cat. Vol. 2. Ed. William Rubin. New York: Museum of Modern Art, 1984.

*Markov, Vladimir. [Written in 1913.] *Iskusstvo negrov.* Peterburg: Izd. Otdela izo-brazitel'nykh iskusstv Narodnogo Komissariata po proveshcheniiu. 1919. Excerpts trans. Jacqueline and Jean-Louis Paudrat, "L'art des nègres." *Cahiers du Musée national d'art moderne.* Vol. 2. Paris: Centre Georges Pompidou, 1979.

———. 1914. *Iskusstvo ostrovo Paskhi.* Petersburg: Sooioouz molodezhi.

*Matisse, Henri. [1906.] Henri Matisse interviewed by Pierre Courthion in 1941. Pierre Courthion Papers. Archives of the History of Art, Getty Center for the History of Art and Humanities, Los Angeles.

Museum Folkwang. 1912. *Moderne Kunst: Plastik, Malerei, Graphik.* Vol. 1. Hagen: Im Selbstverlage des Museums.

*Nolde, Emil. [1912.] "Kunstaeusserungen der Naturvoelker." In *Jahre der Kämpfe 1902–1914.* Berlin: Christian Wolff, 1934. In *Theories of Modern Art* by Herschel B. Chipp, Peter Selz, and Joshua Taylor. Berkeley: University of California Press, 1968.

Salmon, André. 1912. *La jeune peinture française.* Paris: Société des Trente.

Scheffler, Karl. 1913. "Kunstausstellungen. Berlin." *Kunst und Künstler* (Berlin), 12 (December 1): 176.

*———. 1914. "Kunstausstellungen. Berlin." *Kunst und Künstler* (Berlin), 12 (January): 229.

Shevchenko, Aleksandr. 1913. *Neo-primitivizm. Ego teoriya. Ego vozmozhnosti. Ego dostizheniya.* Moscow. In Bowlt, *Russian Art of the Avant-Garde.*

*Stein, Gertrude. [1906–7.] *The Autobiography of Alice B. Toklas.* New York: Literary Guild, 1933.

*Tzara, Tristan. 1917. "Note 6 sur l'art nègre." *SIC* 21–22 (September–October). Reprint. *SIC: Société d'étude du XX siècle.* Paris: Editions de la Chronique des lettres françaises, 1973.

*Vlaminck, Maurice de. [1906.] *Portraits avant décès*. Paris: Flammarion, 1943.

————. [1906.] *Tournant dangereux: Souvenirs de ma vie*. Paris: Stock, 1929. Trans. Michael Ross. *Dangerous Corner*. New York: Abelard-Schuman, 1966.

*Waldmann, Emil. 1914. "Kunstausstellungen. Dresden." *Kunst und Künstler* (Berlin) 12 (March): 344–45.

*Warnod, André. 1912. "Arts décoratifs et curiosités artistiques: l'art nègre." *Comoedia* (January 2).

Weber, Max. 1910. "The Fourth Dimension from a Plastic Point of View." *Camera Work* 31 (July): 25.

Worringer, Wilhelm. 1908. *Abstraktion und Einfühlung*. München: R. Piper.

Wright, Willard Huntington. 1915. *Modern Painting: Its Tendency and Meaning*. New York: Dodd, Mead.

Zayas, Marius de. 1912. "Sun Has Set." *Camera Work* (July): 17–21. Reprint. Nendeln, Liechtenstein: Kraus Reprint, 1969.

*————. 1914. Introduction. *Statuary in Wood by African Savages: The Root of Modern Art*. Exh. cat. New York: "291" Gallery. In *Camera Work* 48 (October 1916): 7. Reprint. Nendeln, Liechtenstein: Kraus, 1979.

*————. 1916. *African Negro Art: Its Influence on Modern Art*. New York: Modern Gallery.

PART II. NEW ATTITUDES AND AWARENESSES · 1919–1940

Adam, Leonhard. 1923. *Nordwest-amerikanische Indianerkunst*. Berlin: E. Wasmuth.

Aldrich, Charles Roberts. 1931. *The Primitive Mind and Modern Civilization*. London: K. Paul, Trench, Trubner & Co.; New York: Harcourt, Brace. Reprint. New York: AMS, 1969.

Anonymous. 1920. "The Indian Exhibit." In *Fourth Annual Exhibition of the Society of Independent Artists*. Waldorf-Astoria Hotel, New York. Exh. cat. New York: Society of Independent Artists. Catalogue in the Archives of American Art, Smithsonian Institution, Washington, D.C.

Anonymous. 1930. *Exposition d'art africain et d'art océanien*. Exh. cat. Paris: Galerie Pigalle.

Anonymous. 1930. "Chronique: Une Exposition d'art nègre." *Art et Décoration* 57, sup. 5 (March): v.

Anonymous. 1930. "A Controversy over Negro Art." *Art News* 28 (April 19): 7.

Anonymous. 1931. "Exposition of Indian Tribal Arts." *Connoisseur* 88 (September): 209–10.

Anonymous. 1931. "Exposition of Indian Tribal Arts." *American Magazine of Art* 23 (December): 516–17.

Anonymous. 1931. "The Tribal Arts Show." *Art Digest* 6 (December 1): 11.

Anonymous. 1931. "Indian Tribal Art." *Brooklyn Eagle* (December 6).

Anonymous. 1935. "African Negro Sculpture Confronts America." *Art Digest* 9 (May 1): 19.

*Anti, Carlo. 1923. "The Sculpture of the African Negroes." *Art in America and Elsewhere* (December): 14–26.

Barnes, Albert. 1925. "Negro Art and America." *Survey Graphic* 6 (March): 668–69.

[Barnes, Albert?]. Foreword to *Primitive African Sculpture*. 1933. London: Alex, Reid & Lefevre.

Basler, Adolphe. 1928. "Opinions récentes sur l'art et la psychologie nègres." *Mercure de France* I: 593–610.

———. 1929. *L'Art chez des peuples primitifs: Afrique, Océanie, Archipel malais, Amérique et Terres arctiques; styles et civilisations*. Paris: Librairie de France.

Basler, Adolphe, and Charles Kunstler. 1929. "L'Exotisme sauvage." *La Peinture indépendante en France*. Vol. 2. *De Matisse à Segonzac*. Paris: Crès.

*Bataille, Georges. 1930. "L'Art primitif." *Documents* 7: 389–97.

———, ed. 1929. *Documents* 1 (April–June).

*Bearden, Romare. 1934. "The Negro Artist and Modern Art." *Opportunity: Journal of Negro Life* (December): 371–72.

Bell, Clive. 1920. "Negro Sculpture." *The Athenaeum* (August 20): 247–48. In Clive Bell, *Since Cézanne*. London: Chatto and Windus, 1922.

Boas, Franz. 1927. *Primitive Art*. Oslo: Aschehoug.

Breton, André. 1924. *Manifestes du surréalisme*. Paris: Jean-Jacques Pauvet. Trans. Richard Seaver and Helen R. Lane. *Manifestoes of Surrealism*. Ann Arbor: University of Michigan Press, 1969.

Cahill, Holger. 1934. "American Sources of Modern Art." *London Studio* (August): 59–64.

Chauvet, Stéphen. 1924. *Les Arts indigènes des colonies françaises*. Paris: A. Malone et Fils.

———. 1930. "Les Arts indigènes d'Afrique et d'Océanie." *Variétés* (April 15): 849–63.

*Clouzot, Henri, and André Level. 1919. "L'Art sauvage: Océanie-Afrique." In *Première Exposition d'art nègre et d'art océanien*. Exh. cat. Paris: Galerie Devambez.

———. 1920. "L'Art du Congo Belge." *Art et décoration*.

———. 1921. "L'Art nègre." *Gazette des Beaux-Arts* (July–September): 311–24.

———. 1923. "La Décoration des textiles au Congo Belge." *L'Amour de l'art* 1 (January): 569–72.

———. 1925. "Caractéristiques de l'art des noirs." *L'Art vivant* 1 (March 1): 11–13.

*———. 1925. "La leçon d'une exposition." *Sculptures africaines et océaniennes: Colonies françaises et Congo Belge*. Paris: Librarie de France.

Culin, Stewart. 1923. *Primitive Negro Art, Chiefly from the Belgian Congo*. Exh. cat. Brooklyn, New York: Department of Ethnology, Brooklyn Museum.

Digby, Adrian, et al. 1935. *Catalog of an Exhibition of the Art of Primitive People*. Exh. cat. London: Privately printed for the Burlington Fine Arts Club.

Doussin, Gustave. 1932. "Une Exposition des provinces de France." *Beaux-Arts* 10 (March): 19.

Duchartre, Pierre-Louis. 1930. "Poids et figurines nègres." *Art et décoration* 57 (May): 145–52.

Einstein, Carl. 1921. *Afrikanische Plastik*. Berlin: E. Wasmuth. *La Sculpture africaine*, Paris: Crès, 1922.

———. 1926. Foreword to *Südseeplastiken*. Exh. cat. Berlin: Das Kunstarchiv. Trans. "Masks and Magic in the South Seas." *Art and Archeology* 1 (1927): 125–28.

Einstein, Carl, and Daniel Henry Kahnweiler. [1921–39.] *Correspondance 1921–1939*. Marseille: André Dimanche, 1993.

*Eliot, T. S. 1919. "War-Paint and Feathers." *The Athenaeum* (October 17): 1036.

*Éluard, Paul. 1929. "L'Art sauvage." *Variétés* (Brussels), special issue, *Le Surréalisme en 1929* (June).

Fels, Florent. 1923. "Chronique artistique. Propos d'artistes. Picasso." *Nouvelles littéraires* (August 4): 2.

*———. 1923. "L'Art mélanien au Pavillon de Marsan." *Nouvelles littéraires* (October 27): 4.

*———, ed. 1920. "Opinions sur l'art nègre." *Action* 1 (April): 23–26.

*Fénéon, Felix, ed. 1920. "Enquête sur des arts lointains: Seront-ils admis au Louvre?" *Bulletin de la vie artistique* 1 (November 15, December 1 and 15): 662–69, 693–703, 726–38.

Fierens, Paul. 1930. "Oceanic and African Art at the Pigalle Galleries." *Art News* 28 (April 5): 26–27.

*Fry, Roger. 1920. "Negro Sculpture at the Chelsea Book Club." *The Athenaeum* 94 (April 16): 516. In *Vision and Design*. New York: Bretano's, 1921.

———. 1939. *Last Lectures*. Cambridge: Cambridge University Press.

Gallotti, Jean. 1931. "Les Arts indigènes à l'Exposition Coloniale." *Art et décoration* 60 (September): 69–100.

*George, Waldemar. 1930. "Le Crépuscule des idoles." *Les Arts à Paris* 17 (May): 7–13.

Golden Gate International Exposition. 1939. *Pacific Cultures: Department of Fine Arts, Division of Pacific Cultures*. Exh. cat. San Francisco: Golden Gate International Exposition.

Goldwater, Robert. 1938. *Primitivism in Modern Painting*. New York and London: Harper and Bros. Rev. ed. *Primitivism in Modern Art*. New York: Vintage Books, 1967. Enlarged as *Primitivism in Modern Art*. Cambridge, Mass.: Belknap Press, 1986.

Graham, John D. 1937. *System and Dialectics of Art*. New York: Delphic Studios. Baltimore: Johns Hopkins Press, 1971.

*———. 1937. "Primitive Art and Picasso." *Magazine of Art* 30 (April): 236–60.

Guillaume, Paul. *Les écrits de Paul Guillaume*. Neuchâtel: Ides et Calendes, 1993.

*———. 1919. "Une Esthétique nouvelle, l'art nègre." *Les Arts à Paris* 4 (May 15): 1–4.

———. 1925. "L'Art nègre et l'espirit de l'époque." *Paris-Soir* (November 21). In *Les écrits de Paul Guillaume*.

———. 1926. "La Sculpture nègre et l'art moderne." Transcript of a speech given at the Barnes Foundation. April 4. In *Les écrits de Paul Guillaume*.

———. 1926. "The Triumph of Ancient Negro Art." *Opportunity, Journal of Negro Life* 4 (May): 146–47.

———. 1927. "Nos Enquêtes: Entretien avec Paul Guillaume." *Feuilles Volantes*. 2, no. 1, supp.: 1–3.

Guillaume, Paul, and Thomas Munro. 1926. *Primitive Negro Sculpture*. New York: Harcourt, Brace.

*Hartley, Marsden. 1920. "Red Man Ceremonials: An America Plea for American Esthetics." *Art and Archeology* 9 (January): 7–14.

Hewett, Edgar L. 1922. "Native American Artists." *Art and Archaeology* 13 (March): 103–11.

Hodge, Frederick W., Oliver La Farge, and Herbert J. Spinden, eds. 1931. *Introduction to American Indian Art: To Accompany the First Exhibition of American Indian Art Selected Entirely with Consideration of Esthetic Value*. Exh. cat. 2 Vols. New York: Exposition of Indian Tribal Arts.

Jacob, Max. 1927. "Souvenirs sur Picasso, contés par Max Jacob." *Cahiers d'art* 7: 199–202.

Kjersmeier, Carl. 1935–38. *Centres de style de la sculpture nègre africaine*. 4 vols. Paris: Morance; Copenhagen: Illums bogafdeling. Reprint New York: Hacker Books, 1967.

Lévy-Bruhl, Lucien. 1922. *La Mentalité primitive*. Paris: Alcon.

*Locke, Alain. 1924. "A Note on African Art," *Opportunity, Journal of Negro Life* (May): 134–38.

*———. 1925. "The Legacy of the Ancestral Arts." In *The New Negro: An Interpretation*. New York: Albert and Charles Boni.

*———. 1935. "African Art: Classic Style." *American Magazine of Art* 28 (May): 271–78.

———. 1936. *Negro Art: Past and Present*. Washington, D.C.: Associates in Negro Folk Education. Reprint. New York: Arno Press/New York Times, 1969.

*Luquet, G. H. 1930. *L'Art primitif*. Paris: G. Doin & Cie.

M. M. 1923. "Constantin Brancusi: A Summary of Many Conversations." *The Arts,* 4 (July): 15–17.

Minotaure. 1933–39. 6 vols. Paris: Albert Skira. Reprint New York: Arno Press, 1968.

Naudeau, Ludovic. 1922. "L'Afrique occidental." *L'Illustration* (October 21): 388–90.

*Pach, Walter. 1920. "The Art of the American Indian." *The Dial* 68 (January): 57–65.

———. 1931. "The Indian Tribal Arts." *New York Times* (November 22): sect. 7, p. 13.

Poncetton, François, and André Portier. 1929. *Les Arts sauvages: Océanie*. Paris: Éditions Albert Morancé.

———. 1931. *La Décoration: Océanie*. Paris: Librairie des arts décoratifs.

Poor, Henry Varnum. 1926. "Anonymous American Art." *Arts* 10 (July): 5–14

*Porter, James A. 1937. "The Negro Artist and Racial Bias." *Art Front* 3 (July–August): 8–9.

Portier, André, and François Poncetton. 1929. *Les Arts sauvages: Afrique*. Paris: Éditions Albert Morancé.

Purrmann, Hans. 1933. "Südseekunst." *Kunst und Künstler* 32 (March): 115.

Ratton, Charles. 1931. *Masques africains*. Paris: Librairie des arts décoratifs.

————. 1935. "Exposition d'art nègre au Museum of Modern Art de New York." *Cahiers d'art* 10: 133–34.

Saiko, George. 1934. "Why Modern Art Is Primitive." *London Studio* (December): 274–77.

*Salles, Georges. 1927. "Réflexions sur l'art nègre." *Cahiers d'art* 7: 247–49.

Salmon, André. 1919. *La Jeune Sculpture française*. Paris: Société des Trente.

*————. 1920. "Negro Art." Trans. D. Brinton. *Burlington Magazine* 205 (April): 164–72. "L'Art nègre." *Propos d'atelier*. With additional text. Paris: G. Cres et Cie., 1922.

*Sloan, John, and Oliver LaFarge. 1931. Introduction to American Indian Art. In Hodge, La Farge, and Spinden, *Introduction to American Indian Art*.

Spinden, Herbert J. 1931. "Indian Art on Its Merits," *Parnassus* 3 (November): 12–13.

*Sweeney, James Johnson, ed. 1935. *African Negro Art*. Exh. cat. New York: Museum of Modern Art. Reprint. New York: Arno Press, 1966, 1969.

Tzara, Tristan. 1929. "L'Art et l'Océanie." *Cahiers d'art* 2 (March–April): 59–60.

Vaillant, George Clapp. 1939. *Indian Arts in North America*. New York: Harper and Brothers. Reprint. New York: Harper and Row, 1973.

von Sydow, Eckart. 1921. *Exotische Kunst: Afrika und Ozeanien* Leipzig: von Klinkhardt und Biermann.

————. 1927. *Primitive Kunst und Psychoanalyse*. Leipzig: Internationale Psychoanalytischer Verlag.

*————. 1932. *Die Kunst der Naturvölker und der Vorzeit*. Berlin: Im Propyläen. 3rd ed.

Zervos, Christian. 1927. "L'Art nègre." *Cahiers d'art* 7: 229–30.

*————. 1929. "Oeuvres d'art océaniennes et inquiétudes d'aujourd'hui." *Cahiers d'art* 2 (March–April): 57–58.

————. 1936–37. "Réflexions sur la tentative d'esthétique dirigée du III Reich." *Cahiers d'art* 12: 51–61.

PART III. THE ASCENDANCE OF PRIMITIVISM · 1941–1983

Alfert, Max. 1972. "Relationships between African Tribal Art and Modern Western Art," *Art Journal* 31 (Summer): 387–96.

Anonymous. 1954. *Masterpieces of African Art*. Exh. cat. Brooklyn: Brooklyn Museum.

Anonymous. 1968–71. *First World Festival on Negro Arts, Colloquium: Function and Significance of African Negro Art in the Life of the People and for the People, March 30–April 8, 1966*. 2 vols. Dakar, Senegal. Paris: Présence africaine.

Anonymous. 1969. *Art of Oceania, Africa, and the Americas from the Museum of Primitive Art*. Exh. cat. New York: Metropolitan Museum of Art.

Anonymous. 1972. *World Cultures and Modern Art*. Exh. cat. Munich: Bruckmann.

Barr, Alfred. 1950. Letter. *College Art Journal* 10 (Fall): 57.

Bateson, Gregory. 1946. "Arts of the South Seas." *Art Bulletin* 28 (June): 119–23.

Bearden, Romare. 1946. "The Negro Artist's Dilemma." *Critique* 1 (November): 16–22.

Bell, Michael. 1972. *Primitivism*. London: Methuen.

Breton, André. 1965. *Le Surréalisme et la peinture*. Paris: Editions Gallimard. Trans. Simon Watson Taylor. *Surrealism and Painting*. New York: Harper and Row, 1972.

Breuning, Margaret. 1946. "Art of the South Seas Dramatized at the Modern Museum." *Art Digest* 20 (February 15): 5.

Caspers, Frank. 1941. "Review of Indian Art of the United States." *Art Digest* 15 (March 1): 27.

Coleman, Floyd. 1976. "African Influences on Black American Art." *Black Art* (Fall): 4–15.

Cowling, Elizabeth. 1978. "The Eskimos, the American Indians, and the Surrealists." *Art History* 1 (December): 484–500.

Davies, I. 1973. "Primitivism in the First Wave of the Twentieth Century Avant-Garde in Russia." *Studio International*. 186: 80–84.

Donne, J. B. 1978. "African Art and Paris Studios 1905–20." In *Art in Society*, edited by Michael Greenhalgh and Vincent Megaw. New York: St. Martin's Press.

*Douglas, Frederic H., and René d'Harnoncourt. 1941. *Indian Art of the United States*. Exh. cat. New York: Museum of Modern Art. Reprint. Arno Press, 1969.

Driskell, David C. 1976. *Two Centuries of Black American Art*. Los Angeles County Museum of Art. Exh. cat. New York: Alfred A. Knopf.

*Dubuffet, Jean. 1951. Lecture at the Arts Club of Chicago. December 20. Published as "Anticultural Positions." *Arts Magazine* 53 (April 1979): 156–57.

DYN 1, nos. 4–5, Amerindian number (December 1943).

Ernst, Max. 1952. 30 lectures on primitive and modern art. University of Hawaii, Honolulu.

Ettlinger, L. 1968. "Expressionism and Primitive Art." *Burlington Magazine* 110: 191–201.

Fanon, Frantz. 1952. *Peau noire, masques blancs*. Paris: Éditions du Seuil. *Black Skin, White Masks*. New York: Grove Press, 1967.

Firth, Raymond. 1951. *Elements of Social Organization*. New York: Philosophical Library.

Fouchet, Max-Pol. 1976. *Wifredo Lam*. Barcelona: Ediciones Polígrafa.

Fraser, Douglas. 1957. "The Discovery of Primitive Art." *Arts Yearbook I: The Turn of the Century*. Ed. Hilton Kramer. New York: Art Digest. Reprint. *Anthropology and Art*. Ed. Charlotte M. Otten. Garden City, New York: Natural History Press, 1971.

Gauguin, Paul. 1957. *Noa, Noa*. Trans. O. F. Theis. New York: Farrar, Straus and Giroux.

Gibson, Anne. 1983. "Painting Outside the Paradigm: Indian Space." *Arts* 57 (Feb): 96–104.

Giedion, Siegfried. 1952. "Transparency: Primitive and Modern." *Art News* 51 (June): 47–50, 92–96.

Goldwater, Robert. 1969. "Judgments of Primitive Art, 1905–1965." In *Tradition and Creativity in Tribal Art*, ed. Daniel P. Biebuyck. Berkeley: University of California Press.

Gordon, Donald L. 1966. "Kirchner in Dresden." *Art Bulletin*. 48 (September–December): 335–65.

*Gottlieb, Adolph, and Mark Rothko. 1943. Interview by Hugh Stix. "The Portrait and the Modern Artist." Radio broadcast on "Art in New York." WNYC. 13 October. Transcript in *Adolph Gottlieb: A Retrospective*. Exh. cat. Text by Lawrence Alloway and Mary Davis MacNaughton. New York: Arts Publisher, 1981.

Gottlieb, Adolph, and Mark Rothko (in collaboration with Barnett Newman). 1943. Letter. *New York Times* (June 13), sec. 2, p. 9.

Graham, John D. 1961. "Art." *Art News* 60 (September): 47–48.

Greub, Suzanne, and H. Greub, eds. 1984. *Resonances: Tribal art—modern art: Traditional Works of Art of African, Oceanic, North American Indian Cultures with Arp, Beuys, Braque, Dubuffet, Giacometti, et al.* Exh. cat. Basel: Galerie Greub.

Gunther, Erna. 1950. "Material Culture, the Museum and Primitive Art." *College Art Journal* 8 (Spring): 290–94.

Hobbs, Robert, ed. 1982. "Earthworks: Past and Present." *Art Journal* special issue (Fall).

Holm, Bill, and William Reid. 1975. *Form and Freedom: A Dialogue on Northwest Coast Indian Art*. Exh. cat. Houston: Institute for the Arts, Rice University.

Holme, Bryan. 1941. "The United States, Commentary: New York." *Studio* 122 (August): 50.

James, Philip, ed. 1966. *Henry Moore on Sculpture*. New York: Viking Press.

Janis, Sidney. 1942. Foreword to *First Papers of Surrealism*. New York: Coordinating Council of French Relief Societies.

Johnson, R. 1975. "Primitivism in the Early Sculpture of Picasso." *Arts Magazine* 49: 64–68.

Jonaitis, Aldona. 1981. "Creations of Mystics and Philosophers: The White Man's Perceptions of Northwest Coast Indian Art from the 1930's to the Present." *American Indian Culture and Research Journal* 5 (1981): 1–45.

*Kahnweiler, Daniel Henry. 1948. "L'Art nègre et le cubisme." *Présence africaine* 3: 367–77. Trans. Peter Watson. *Horizon* (December 1948): 412–20. Reprint. *Confessions esthétiques*. Paris: Gallimard, 1963.

LaFarge, Oliver. 1941. "Indians at the Museum of Modern Art." *New Republic* 104 (February 10): 181–82.

Lam, Wifredo, et al. 1992. *Wifredo Lam and His Contemporaries, 1938–1952*. New York: Abrams.

*Laude, Jean. 1968. *La Peinture française (1905–1914) et "l'art nègre."* 2 vols. Paris: Editions Klincksieck.

Laude, Jean, and Gaëcon Picon. 1967. *Arts primitifs dans les ateliers d'artistes*. Exh. cat. Paris: Société des amis du Musée de l'homme.

Leiris, Michel. 1967. *Afrique noire*. Paris: Gallimard. Trans. Michael Ross. *African Art*. New York: Golden Press, 1968.

Lévi-Strauss, Claude. 1955. *Tristes Tropiques*. Paris: Plon.

———. 1958. *Anthropologie structurale*. Paris: Plon. Trans. *Structural Anthropology*. Garden City, N.Y.: Doubleday, 1963.

———. 1962. *La Pensée sauvage*. Paris: Plon.

*Linton, Ralph, and Paul S. Wingert, in collaboration with René d'Harnoncourt. 1946. *Arts of the South Seas.* Exh. cat. New York: Museum of Modern Art. New York: Arno Press, 1972.

Lippard, Lucy. 1966. "Heroic Years from Humble Treasures: Notes on African and Modern Art." *Art International* 10 (September): 17–25. In *Changing: Essays in Art Criticism,* by Lucy Lippard. New York: Dutton, 1971.

Malraux, André. [Written in 1974.] Foreword to *Masterpieces of Primitive Art.* New York: Alfred A. Knopf, 1978.

Mark, Peter A. 1981. "African Influences in Contemporary Black American Painting." *Art Voices* 4 (January–February): 15–22.

Masheck, J. 1982. "Raw Art: 'Primitive' Authenticity and German Expressionism." *RES* 4 (Autumn): 93–117.

Maurer, Evan. 1974. "In Quest of the Myth: An Investigation of the Relationships between Surrealism and Primitivism." Ph.D. diss., University of Pennsylvania.

Michaelson, K. J. 1971. "Brancusi and African Art." *Artforum* 10 (November): 72–77.

Mirimanov, V. B. 1981. "L'Epoque de la découverte de l'art nègre en Russie." *Quaderni PORO* 3 (June–July): 59–73.

Monnerot, Jules. 1945. *La Poésie moderne et le sacré.* Paris: Gallimard.

*Moore, Henry. 1941. "Primitive Art." *The Listener* 25, no. 641 (April 24): 598–99. In *Henry Moore: Sculpture and Drawings.* 3rd rev. ed. Vol 1. London: Percy Lund, Humphries & Co. 1949.

———. 1981. *Henry Moore at the British Museum* London: British Museum Publications.

Musée de l'homme. 1965. *Chefs-d'oeuvre du Musée de l'homme.* Exh. cat. Paris: Caisse nationale des monuments historiques.

*Newman, Barnett. 1946. "Las formas plásticas del Pacífico." *Ambos Mundos* 1 (June): 51–55. Trans. "Art of the South Seas" *Studio International* 179 (February 1970): 70–71.

*———. 1946. Foreword to *Northwest Coast Indian Painting.* Exh. cat. New York: Betty Parsons Gallery. In *Barnett Newman: Selected Writings and Interviews,* ed. John P. O'Neill. New York: Knopf, 1990.

———. 1947. "The First Man Was an Artist." *The Tiger's Eye* (October): 57–60.

Pearson, Ralph M. 1946. "A Modern Viewpoint." *Art Digest* 1 (March 1): 25.

Pierce, James Smith. 1976. *Paul Klee and Primitive Art.* New York: Garland.

Polecari, Stephen. 1982. "Intellectual Roots of Abstract Expressionism: Clyfford Still." *Art International* 25: 18–34.

Pollock, Jackson. 1944. Interview. *Arts and Architecture* 61 (February): 14–16.

Porter, James A. 1943. *Modern Negro Art.* New York: Dryden Press.

Ratcliff, Carter. 1975. "On Contemporary Primitivism." *Artforum* 14: 57–65.

Read, Sir Herbert. 1957. "Tribal Art and Modern Man." In *The Tenth Muse: Essays in Criticism.* New York: Horizon Press.

Read, Herbert, W. G. Archer, and Robert Melville. 1948. *40,000 Years of Modern Art: A Comparison of Primitive and Modern.* Exh. cat. London: Institute of Contemporary Arts.

Rothko, Mark. 1946. Introduction. *Clyfford Still.* Exh. cat. New York: Art of This Century Gallery.

Sandler, Irving. 1971. *The Triumph of American Painting.* New York: Harper and Row.

Schapiro, Meyer. 1957. "The Liberating Quality of Abstract Art." In *Modern Art.* New York: G. Braziller, 1978.

Shapiro, Harry L. 1946. "South Seas Primitives for Sophisticates at the Museum of Modern Art." *Art News* 45 (March): 37.

Story, Ala. 1968. *Max Weber.* Santa Barbara: Art Galleries, University of California.

Underwood, Leon. 1948. "Abstraction in African and European Art." *Studio* 136: 182–85.

Weiss, Jeffrey. 1983. "Science and Primitivism: A Fearful Symmetry in the Early New York School." *Arts Magazine* 57 (March): 81–87.

Wentinck, Charles. 1974. *Moderne und Primitive Kunst.* Netherlands: Smeets Offset BV Weert. Trans. Hilary Davies. *Modern and Primitive Art.* Oxford: Phaidon Press, 1979.

Wilkinson, Alan. 1981. *Gauguin to Moore: Primitivism in Modern Sculpture.* Toronto: Art Gallery of Ontario.

Wingert, Paul S. 1951. "American Indian Sculpture: A Study of the Northwest Coast." *Magazine of Art* 44 (December): 340.

Zilczer, Judith. 1977. "Primitivism and NY Dada." *Arts* 51: 140–41.

PART IV. THE MUSEUM OF MODERN ART'S 1984 PRIMITIVISM SHOW AND ITS AFTERMATH

Archer Straw, Petrine. 2000. *Negrophilia: Avant-garde Paris and Black Culture in the 1920's.* New York: Thames & Hudson.

Ashton, Dore. 1984. "On an Epoch of Paradox: 'Primitivism' at the Museum of Modern Art." *Arts Magazine* 59: 76–79.

Bach, F. T., et al., eds. 1995. *Constantin Brancusi, 1876–1957.* Philadelphia: Philadelphia Museum of Art.

Barkan, Elazar, and Ronald Bush. 1995. *Prehistories of the Future: The Primitivist Project and the Culture of Modernism.* Stanford, Calif.: Stanford University Press.

Bearden, Romare, and Harry Henderson. 1993. *A History of African-American Artists, from 1792 to the Present.* New York: Pantheon Books.

Berlo, Janet Catherine, ed. 1992. *The Early Years of Native American Art History.* Seattle: University of Washington Press.

Bois, Yve-Alain. 1985. "La Pensée sauvage." *Art in America* 73: 178–89.

Bonnefoy, Yves. 1991. *Alberto Giacometti.* Paris: Flammarion.

Burgard, T. A. 1991. "Picasso and Appropriation." *Art Bulletin* 73 (September): 479–94.

Center for African Art. 1987. *Perspectives: Angles on African Art.* Exh. cat. New York: Center for African Art and Harry N. Abrams.

*Clifford, James. 1985. "Histories of the Tribal and the Modern." *Art in America* 73 (April): 164–215.

Connelly, Frances. 1995. *The Sleep of Reason: Primitivism in Modern European Art and Aesthetics, 1725–1907.* University Park, Penn.: Pennsylvania State University Press.

Coombes, Annie. 1994. *Reinventing Africa.* New Haven: Yale University Press.

Craven, David. 1991. "Abstract Expressionism and Third World Art: A Post-Colonial Approach to 'American' Art." *Oxford Art Journal* 14: 44–66.

Dagen, Philippe. 1998. *Le Peintre, le poète, le sauvage: les voies du primitivisme dans l'art français.* Paris: Flammarion.

Danto, A. C. 1984. "Defective Affinities: " 'Primitivism' in 20th Century Art," *The Nation* (December 1): 590–92.

Driskell, David, ed. 1995. *African American Visual Aesthetics: A Postmodernist View.* Washington, D.C.: Smithsonian Press.

Eisenman, Stephen. 1997. *Gauguin's Skirt.* New York: Thames and Hudson.

Errington, Shelly. 1998. *The Death of Authentic Primitive Art and Other Tales.* Berkeley: University of California Press.

Fernando, Tanya. 1999. "The Distance from 'Primitivism'." *Third Text* (Winter 1999–2000): 73–82.

Fineberg, Jonathan, ed. 1998. *Discovering Child Art: Essays on Childhood, Primitivism and Modernism.* Princeton, N.J.: Princeton University Press

Flam, Jack. 1984. "The Spell of the Primitive: In Africa and Oceania Artists Found a New Vocabulary." *Connoisseur* 214 (September): 124–31.

Flam, Jack, and Daniel Shapiro. 1994. *Western Artists/African Art.* New York: Museum for African Art.

Flam, Jack, et al. 1996. "A Louvre ouvert." *Connaissance des arts* 528 (May): 100–103.

*Foster, Hal. 1985. "The 'Primitive' Unconscious of Modern Art, or White Skin Black Masks." *October* 34 (Fall): 45–70.

———. 1993. "Primitive Scenes (Depiction of Primitive People in Art)." *Critical Inquiry* 20 (Autumn): 69–102.

Gilroy, Paul. 1993. *The Black Atlantic, Modernity and Double Consciousness.* Cambridge, Mass.: Harvard University Press.

Halle, David. 1993. "The Audience for 'Primitive' Art in Houses in the New York Region." *Art Bulletin* (September): 397–414.

Harrison, Charles, et al. 1993. *Primitivism, Cubism, Abstraction: The Early Twentieth Century.* New Haven: Yale University Press.

Hiller, Susan, ed. 1991. *Myth of Primitivism: Perspectives on Art.* New York and London: Routledge.

hooks, bell. 1995. *Art on My Mind.* New York: New Press.

Jahoda, Gustav. 1999. *Images of Savages: Ancient Roots of Modern Prejudice in Western Culture.* London: Routledge.

Jordan, Glenn, and Chris Weedon. 1995. *Cultural Politics.* Oxford: Blackwell.

Langhorne, Elizabeth, L. 1989. "Pollock, Picasso, and the Primitive." *Art History* 12 (March): 66–92.

Leighten, Patricia. 1990. "The White Peril and L'Art Nègre: Picasso, Primitivism and Anticolonialism." *Art Bulletin* 72 (December): 609–30.

*Lemke, Sieglinde. 1998. *Primitivist Modernism: Black Culture and the Origins of Transatlantic Modernism*. New York: Oxford University Press.

Linsley, Robert. 1988. "Wifredo Lam: Painter of Negritude." *Art History* 11 (December): 527–44.

*Lippard, Lucy. 1990. *Mixed Blessings: New Art in a Multicultural America*. New York: Pantheon Books.

———. 1993. "Jimmie Durham: Postmodernist 'Savage'." *Art in America* 81 (February): 62–69.

Lloyd, Jill. 1991. *German Expressionism: Primitivism and Modernity*. New Haven: Yale University Press.

Magnin, André. 1999. "Les Musées d'art moderne sont-ils racistes?" *Beaux-Arts Magazine* (June): 11.

Martin, Jean-Hubert. 1989. Preface to *Magiciens de la Terre*. Exh. cat. Paris: Editions du Centre Pompidou.

*McEvilley, Thomas. 1984. "Doctor, Lawyer, Indian Chief, ' "Primitivism" in 20th Century Art' at the Museum of Modern Art in 1984." *Artforum* 23 (November): 54–60.

———. 1985. Letters. *Artforum* 23 (February): 46–51; (May): 65–71.

*———. 1990. "Marginalia: Thomas McEvilley on the Global Issue." *Artforum* 28 (March): 19–21.

Millet, Catherine. 2000. "Shared Exoticisms and Modern Primitivism." *Art Press* (July–August) : 22–33.

Ndiaye, Francine, and Michèle Moutasher. 1991. *L'Art d'Afrique noire dans les collections d'artistes*. Arles: [s.n.].

Newton, Stephen. 1996. *The Politics and Psychoanalysis of Primitivism*. London: Ziggurat.

Obeyesekere, Gananath. 1992. *The Apotheosis of Captain Cook: European Mythmaking in the Pacific*. Princeton, N.J.: Princeton University Press. Honolulu, Hawaii: Bishop Museum Press.

Peppiatt, Michael. 1984. "Sujet tabou, exposition risquée," *Connaissance des Arts* 391: 84–95.

Powell, Richard J. 1997. *Black Art and Culture in the 20th Century*. New York: Thames and Hudson.

Price, Sally. 1989. *Primitive Art in Civilized Places*. Chicago: University of Chicago Press.

Rhodes, Colin. 1994. *Primitivism and Modern Art*. New York: Thames and Hudson.

Rubin, William. 1985. Letters. *Artforum* 23 (February): 42–45; (May): 63–65.

*———, ed. 1984. *"Primitivism" in 20th Century Art: Affinity of the Tribal and the Modern*. Exh. cat. 2 vols. New York: Museum of Modern Art.

Rubin, William, and Kirk Varnedoe. 1985. Letters. *Artforum* 23 (February): 42–46.

Rushing, W. Jackson. 1988. "The Impact of Nietzsche and Northwest Coast Indian Art on Newman's Idea of Redemption in the Abstract Sublime." *Art Journal* 47 (Fall): 187–95.

————. 1995. *Native American Art and the New York Avant-Garde: A History of Cultural Primitivism*. Austin: University of Texas Press.

Sahlins, Marshall. *How "Natives" Think: About Captain Cook, for Example*. Chicago: University of Chicago Press, 1995.

Shannon, Helen Marie. 1999. "From 'African Savages' To 'Ancestral Legacy': Race and Cultural Nationalism in the American Modernist Reception of African Art." Ph.D. diss., Columbia University.

Solomon-Godeau, Abigail. 1989. "Going Native." *Art in America* 77 (July): 119–61.

Tompkins, Calvin. 1984. "Talismans." *New Yorker* (October 29): 118–21.

Torgovnick, Marianna. 1990. *Gone Primitive: Savage Intellects, Modern Lives*. Chicago: University of Chicago.

*Varnedoe, Kirk. 1985. "On the Claims and Critics of the 'Primitivism' Show." *Art in America* 73 (May): 11–21.

————. 1985. Letter. *Artforum* 23 (February): 45–46.

Vogel, Susan, ed. 1991. *Africa Explores: 20th Century African Art*. Exh. cat. New York: Center for African Art.

Wade, Edwin L., ed. 1986. *The Arts of the North American Indian*. New York: Hudson Hills Press.

Wardlaw, Alvia, ed. 1989. *Black Art / Ancestral Legacy: The African Impulse in African-American Art*. Exh. cat. Dallas Museum of Art. New York: Harry N. Abrams.

INDEX

Page references in italics refer to illustrations.

Abomey: bas-reliefs of, 291n3; shark-man of, 362

Aboriginal art: Australian, 278, 407; bark painting, 356

Aboriginals: Australian, 46n4, 235; temporal perception of, 360

Abstract Expressionism, 248n; effect of Native American art on, 261n

Abstraction: in African design, 190, 434; versus figuration, 11; in Northwestern art, 283; in Primitive art, 283, 354

Academicism, 6, 317, 425; effect of Primitive art on, 430

Achebe, Chinua, 363

Action (periodical), 129n, 143, 300

Adam, Leonhard: *Primitive Art*, 271

Adam, Paul, 157–58

Adorno, Theodor, 385, 392

Aesthetics, 373; and anthropology, 358–59, 361, 363–64; cross-cultural, 411, 413; effect of racial segregation on, 434; institutionalized system of, 356; Kantian, 398; postromanticist, 409; Primitive, 343; of primitivist modernism, 410; of realism, 410; universality of, 336, 373, 398

Affinities, artistic, 366n3, 373, 385; classical with Renaissance, 326–27, 330; versus influences, 326–27, 343; modern with tribal, 326, 330, 341, 342, 344, 352, 367n3, 388, 398, 409; in "'Primitivism' in 20th Century Art," 354–55, 356, 382nn3–4; between signifiers, 328; as universalizing allegory, 352

Africa: civilization of, 54–55, 164; contemporary artists of, 405–6; as Dark Continent, 7; stone monoliths of, 66; stylized depictions of, 357–58; travelers to, 66n4

Africa, Central: sculpture of, 62

Africa, French West: art of, 12

Africa, West: art of, 61; sculpture of, 136

"Africa Explores" (Center for African Art, 1991), 19

African American artists: conception of art, 239; development of, 239; early Ameri-can, 253; exhibitions by, 240; influence of African art on, 15–16, 197–201, 252n, 253–54, 256, 403, 434; modernist, 406; purchase of African art, 408n7; racial bias against, 252–56; radical idiom of, 198, 200, 255, 256; sculptors, 255; segre-gationists on, 253–54; versatility of, 256; white influences on, 238–39, 240

African Americans: contributions to Ameri-can culture, 197n, 252, 253, 255; cultural history of, 253; music of, 157–58, 197; Westernization of, 197–98

African art, 54–56; abstract design in, 190; aesthetic meaning of, 187, 423; African American use of, 403; of Agni-Baule, 148, 427; anthropological view of, 21n12; apologies for, 187; archaeological study of, 190, 191; autonomous existence of, 286; avant-garde interest in, 214; Baluban, 143, 149; Bamileke, 362; Bantu, 64, 94, 183; bias against, 77; of Bobo-Dioulasso, 125; borrowings from, 302–4; Bushmen's, 41–46; Bushongo, 201; of Cameroon, 148, 185; collections of, 299; collective, 75; collectors of, 78, 107; conceptual qualities of, 286; cultural significance of, 187; dating of, 78; dealers in, 243; decoration in, 201; demand for, 243–44; depiction of nature in, 75; dis-covery of, 27n, 299–300, 303–4, 306–8; diverse interpretations of, 304–6; diver-sity of, 420; duality in, 7; early writers on, 7–8; effect on modern abstraction, 7; European appreciation of, 243; Euro-pean influence on, 165, 203; European perception of, 4, 77, 79–82; evolution of, 97; exhibitions of, 281n2, 301; as exotic, 246; facial expression in, 91; as fad, 187, 308n5; folk tradition in, 201; forgeries of, 13, 245; function of, 5, 433; of Gabon, 19, 27–28, 29n, 140, 158, 214, 250; genres of, 191; geometrical, 64, 98–99, 114; Igbo, 363, 371, 373; immo-bility of form in, 254–55; influence on

469

Compositor:	Star Type, Berkeley
Text:	10.5/13.5 Bembo
Display:	Gill Sans
Printer–Binder:	Malloy Lithographing, Inc.
Indexer:	Roberta Engleman